Donatello
Sculptor

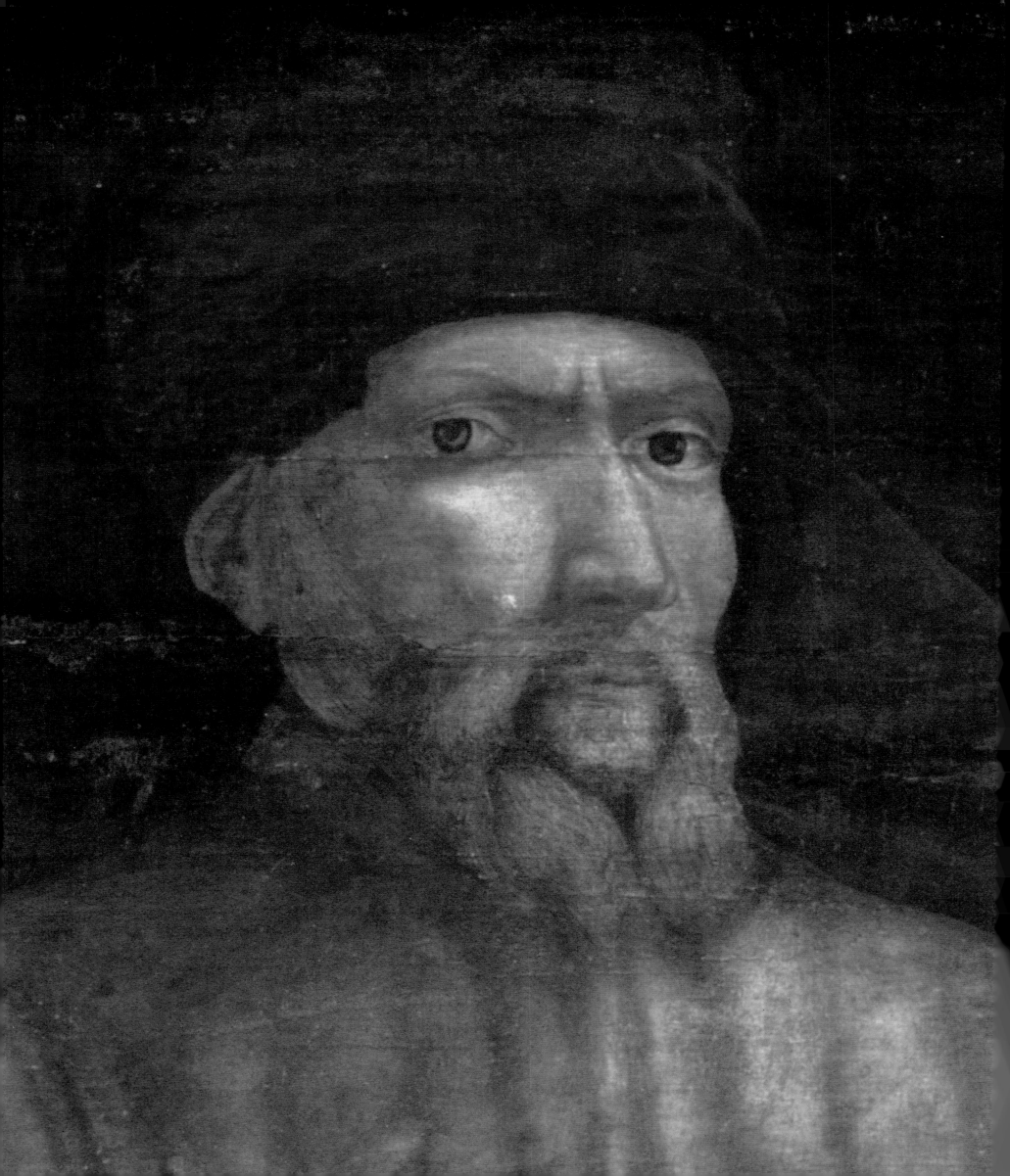

Donatello
Sculptor

JOHN POPE-HENNESSY

ABBEVILLE PRESS · PUBLISHERS

NEW YORK · LONDON · PARIS

Front cover: Donatello, Head of bronze *David*. Museo Nazionale, Florence.
Back cover: Donatello, Head of Holofernes from *Judith*. Bronze, Palazzo della Signoria, Florence.
Frontispiece: Paolo Uccello, *Portrait of Donatello*. Panel, H. 42 cm (16 ½ in.). Musée du Louvre, Paris.
Page 9: Donatello, Signature above *Resurrection*. North Pulpit, San Lorenzo, Florence.

Manuscript Editor: Alan Axelrod
Project Editor: Sarah Key
Designer: Philip Grushkin
Picture Researcher: Jonathan Nelson
Production Supervisor: Simone René

First edition

Library of Congress Cataloging-in-Publication Data
Pope-Hennessy, John Wyndham, Sir
Donatello : Sculptor / John Pope-Hennessy.
p. cm.
Includes bibliographical references and index.
ISBN 1-55859-645-3
1. Donatello, 1386?–1466—Criticism and interpretation.
2. Sculpture, Italian. 3. Sculpture, Renaissance—Italy.
I. Title.
NB623.D7P63 1993
730'.92—dc20 93-19726

Contents

IN MEMORIAM
ULRICH MIDDELDORF

Preface

THIS BOOK IS THE OUTCOME of an association (I dare not say an intimacy) spanning almost half a century. My intention, when I started working on this book, was to describe what is conventionally known as an artistic personality. But ineluctably the artistic personality became an individual. With Donatello the relation between art and life is very close. Without some sense of his creative intentions, in the context of the society in which he lived, his work cannot be understood. This is a monograph, but it is also, in embryo, a biography.

Donatello's bibliography is longer and more elaborate than that of any other quattrocento artist. There is one fundamental, heavyweight catalogue of his work. Conceived by Jeno Lányi and written by H. W. Janson, it is so thorough as to exonerate any later scholar from traversing the same ground. Certain sculptures accepted by Janson as the work of Donatello have been omitted from this book. They include the *Martelli David* in the National Gallery of Art in Washington (which is now generally accepted as a work of Antonio or Bernardo Rossellino); the *Martelli Baptist* in the Museo Nazionale in Florence (which is by Desiderio da Settignano); the bronze *Bust of a Youth* also in the Museo Nazionale; the bronze statuette of David in Berlin; the *Apostles' Door* in the Old Sacristy of San Lorenzo (which is by Michelozzo); and the reliefs of the *Agony in the Garden*, the *Crucifixion*, and the *Entombment* on the south pulpit in San Lorenzo in Florence (of which the first two are by Bellano and the third is by Bertoldo). The list of works that I accept is nonetheless longer than Janson's, since it includes one further documented relief, the *Chellini Madonna* in London, and a number of autograph Madonna reliefs ignored in Janson's book.

Since 1957, when Janson's catalogue appeared, many of Donatello's sculptures have been cleaned, with the result that the Donatello we see now is a different artist from the Donatello he discussed. The tabernacles on Or San Michele look today much as they must have looked when they were new. Donatello's *St. Mark* has been transformed, as has the Coscia monument in the Baptistry. The bust of Niccolò da Uzzano in the Bargello, the *Crucifix* in Santa Croce, the *Magdalen* in the Museo dell'Opera del Duomo, the *Baptist* in the Frari, the bronze doors in the Old Sacristy of San Lorenzo, the *Madonna* from the Porta del Perdono at Siena, and that great masterpiece the *Judith*, now in the Palazzo della Signoria, have been admirably cleaned. The most notable of these achievements has been the restoration of the stucco reliefs in the Old Sacristy. In each case the physical constitution of the cleaned sculptures has been systematically analyzed, and new light has been thrown on the methods by which they were produced. The only major works awaiting technical

investigation are the pulpit reliefs in San Lorenzo; their present condition is reflected in the tentative account of them given in this book. My own view of Donatello as an artist is (partly as a result of this campaign of restoration) more radical and I hope more truthful than that which I expressed in 1966 in a lecture commemorating the fifth centenary of Donatello's death, which forms the text of a current picture book (*Donatello*, Florence, Cantini Edizioni d'Arte, 1985).

The most constructive contributions to our knowledge of Donatello are the earliest and the most recent, Semper's great pioneering studies, *Donatello, seine Zeit und Schule* (1875) and *Donatellos Leben und Werke* (1879) on the one hand, and the *Regesti Donatelliani* (1979) and other articles by Volker Herzner on the other. What lies between is far from valueless (least of all the work of Bode and the synthesis presented in Kauffmann's monograph of 1937), and is discussed in the annotation to this book. In reading the early Donatello literature it is important to remember that certain sculptures were at one time difficult of access—the statues of Prophets now in the Museo dell'Opera del Duomo were removed from the Campanile only in 1936—and that external sculptures that were of easy access (among them the Prato Pulpit reliefs) were better preserved in the nineteenth century than they are today.

In this volume cleaned sculptures are reproduced in their cleaned state. Account was invariably taken by Donatello of the height or angle at which his sculptures would be seen, and an effort has been made to ensure that the photographs give at least some general indication of the intended viewing point. In this area I am obliged to a number of photographers, and especially to that master photographer Elio Ciol.

Over the fifty odd years in which I have been studying Donatello, my debt to other scholars has been very great. I recall with special gratitude the names of Jeno Lányi (with whom, until his early death in 1940, I used to discuss Donatello's works in London), of Peter Janson (with whom I disagreed on many points), and of Ulrich Middeldorf, to whose memory this book is dedicated. I owe much to successive directors of the Museo Nazionale and the Opificio delle Pietre Dure, and to the staff of the Kunsthistorisches Institut in Florence. I must record, with special warmth, the names of Rolf Bagemihl for invaluable documentary research; of Jonathan Nelson, who has coordinated the photography; of Matthew Kennedy for stimulating seminar reports on Donatello as an architect; and of Sarah Key for her tireless editorial work. Redoubled gratitude must go to Michael Mallon, who has been involved at every stage with the preparation of this book.

Florence, 1992 JOHN POPE-HENNESSY

Donatello

I
Sculptures for the Cathedral

THIS BOOK IS ABOUT one of the greatest artists who has ever lived. Artists are private people whose identities are hidden in their work, but it is possible, by looking closely at Donatello's sculptures, to establish some of the respects in which his mind and aspirations and the work that he produced differed from those of his contemporaries. His style was subject to constraints imposed not only by personal convictions, but by the social role his sculptures were intended to fulfill, by the intellectual climate in which they were produced, and by the velleity of the patrons by whom he was employed. Unless these can be hypothetically reconstructed (hypothetically because they are matters on which there is little direct evidence) his achievement cannot be satisfactorily explained.

Donatello di Niccolò di Betto Bardi, known to posterity as Donatello, was born in Florence in 1386 or in the following year.[1] His father, Niccolò di Betto Bardi, a minor member of the commercially successful Bardi family, was a wool carder (*tiratore di lana*) and had a modest but acknowledged place in the bourgeois society of Florence. Politically, he was a supporter of the conservative Parte Guelfa and acquired some notoriety at the time of the left-wing Ciompi revolution of 1378, when he was involved at Christmas in a plot against the government and was expelled to Pisa. There, in 1380, in the presence of the chronicler Buonaccorso di Luca Pitti, he attacked and killed a supporter of the Ciompi administration. Condemned to death in Florence, he fled, with Pitti, to Lucca and Genoa to enlist political support. When the Ciompi government fell in January 1382, he returned to Florence and in November was reinstated at the head of a list of condemned Parte Guelfa members from the district of Santo Spirito.[2] He lived on in Florence till 1415, and was survived by his wife, Madonna Ursa; a daughter, Tita, who was born in 1382; and a nephew Giuliano. Their names are recorded in a *catasto* (tax) return put in by Donatello in 1427. There is no reason to suppose that Niccolò di Betto Bardi's family was indigent, and the little that we know tends to support the view

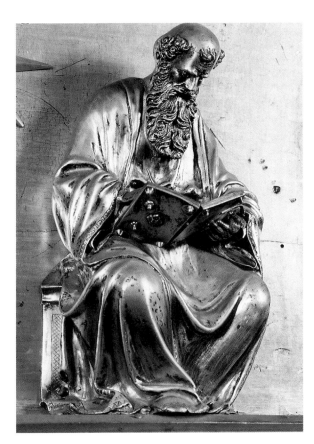

FIGURE 1.
Filippo Brunelleschi, *Father of the Church*.
Silver, H. 28.3 cm (11 in.).
Silver Altar of St. James, Duomo, Pistoia.

that Donatello was a reasonably well-educated member of a recognized middle-class family.

It was claimed in the sixteenth century by two friends of Vasari's, Luigi and Pandolfo Martelli, that Donatello was brought up in the house of their ancestor Roberto Martelli.[3] Martelli was considerably younger than Donatello, and though he and the sculptor were in contact at a later stage, there is no proof of Donatello's adoption by a patrician family.

A number of stories contained in the two editions of Vasari's life of Donatello (1550 and 1568)[4] and in a late fifteenth-century volume of *Facetie, Motti e Burle, di diversi Signori e persone private* published in 1548 by Ludovico Domenichi[5] suggest that he inherited his father's hair-trigger temper. Though not historically credible, these tales are of interest in that they establish the kind of man people believed him to have been. Vasari describes an incident in which the sculptor hurled a thinly cast bronze head out of the window when the Genoese merchant for whom it had been made claimed he was being overcharged. Another story tells how he smashed the head of the statue of Gattamelata with a hammer when the pressure of his patrons became intolerable. Yet another story records that his violent temper, stirred by the defection of a member of his workshop staff, abated rapidly. He is said to have had a caustic Florentine sense of humor. Asked what he regarded as Ghiberti's most notable achievement, he allegedly replied: "Selling Lepriano," an unproductive country property Ghiberti owned, and when asked by a beggar for alms "per amore di Dio," he gave him them with the words: "Non per l'amor di Dio, ma perchè tu n'hai bisogno." A story is told by Vasari in the first edition of his life of Donatello— it was omitted from the second—that on one occasion when Donatello was ill, Brunelleschi, in an effort to counter the common view that men of genius were agnostics, urged Donatello to confess and to receive communion as an example to members of his guild who would otherwise conclude that he did not believe in

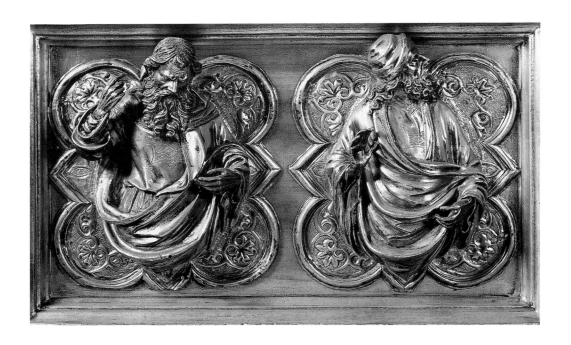

FIGURE 2.
Filippo Brunelleschi, *Two Prophets*.
Silver, H. 15.8 and 16.2 cm (6¼ and 6⅜ in.).
Silver Altar of St. James, Duomo, Pistoia.

Christ. This legend may have some relevance to Donatello's highly individual religious iconography. By all accounts he was uninterested in money and was incapable of handling it, depending late in life on what was, in effect, the charity of Cosimo il Vecchio and Piero de' Medici. Contrary to a frequent claim, there is no evidence whatever of his sexual proclivities.

Frontispiece

Donatello's appearance is recorded in a painting by his friend Paolo Uccello in the Louvre.[6] It contains five head-and-shoulders portraits representing, according to an old inscription, on the left Giotto and Uccello, on the right Brunelleschi and the mathematician Antonio Manetti, and in the center Donatello. The panel has a respectable provenance—in the late fifteenth century it was owned by the architect Giuliano da Sangallo—and though the only likeness in it that can be corroborated is the profile portrait of Brunelleschi, which corresponds in a convincing fashion with Brunelleschi's death mask, the authenticity of all five portraits was widely accepted in the cinquecento. A copy of the head of Donatello, on panel, exists in Padua; another copy was made by Francesco Salviati; Vasari used it once more in 1573, in a fresco in the Sala delle Arti e degli Artisti in his own house in Borgo Santa Croce, and a seventeenth-century version is in the Uffizi.[7] The five portraits in the Louvre are lit from the right and, though they are not uniform in scale, seem to depend from a common source, probably a fresco. Donatello is shown in three-quarter face. The light catches his cheeks, eyelids, and forehead, leaving in shadow his cavernous eye sockets and his deep-set eyes, which look out at us with smoldering intensity. The right ear is pressed down by what remains of his *cappuccio* (the headdress is recorded in greater detail in Vasari's fresco). The protruding cheekbones and the furrow of concentration above the nose are registered with great fidelity. The chin is concealed by a sparse, bristly beard, and the obstinate mouth is framed by a full moustache, which extends—as was the practice in the early fifteenth century—below the level of the jaw.

Fig. 3

It has been repeatedly suggested that a portrait of Donatello by Masaccio survives in the Brancacci Chapel. Brunelleschi's portrait appears on the extreme right of the fresco of the Enthronement of St. Peter at Antioch beside a manic self-portrait of Masaccio, but though there are two other portrait heads in the same group, neither can be Donatello's. The putative portrait occurs in the fresco of St. Peter Curing the Sick with His Shadow beside the altar, where two figures are interpolated in the narrative, one advancing with hands clasped in prayer and the other a nonparticipant wearing a *cappuccio* and holding a cane between his legs. The relation of this second head to the head in the Louvre painting is not wholly convincing,[8] but whether or not Donatello is portrayed, Masaccio's fresco, with its narrow street flanked by a recently built stone palace and more modest houses with painted surfaces surmounted by the campanile and façade of a church, illustrates the claustrophobic urban setting in which he lived and worked.

All early sources are agreed that Donatello was, from the first, closely associated with the architect and sculptor Brunelleschi, and he seems, like Brunelleschi, to have been trained as a metalworker.[9] Our first documentary reference to him records that at Pistoia in January 1401, aged fourteen or fifteen, he was involved in a scuffle with a German, Anichino di Pietro, whom he hit on the head with a stick,

FIGURE 3.
Masaccio, *St. Peter Curing the Sick with his Shadow* (detail). Fresco. Brancacci Chapel, Santa Maria del Carmine, Florence.

13

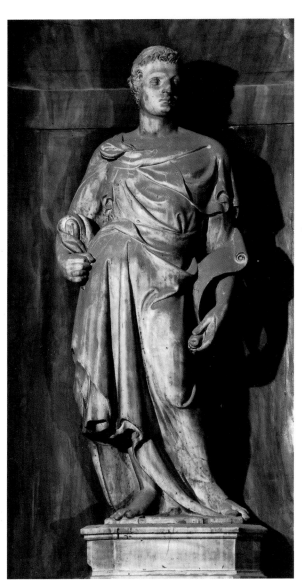

FIGURE 4.
Nanni di Banco, *Isaiah*.
Marble, H. 193 cm (76 in.).
Duomo, Florence.

Figs. 1, 2

drawing blood.[10] Brunelleschi was working in Pistoia at the time on the silver altar of St. James in the Cathedral, and Donatello may have been an apprentice in his shop.[11] For all we know, he may have assisted Brunelleschi in his trial relief of the *Sacrifice of Isaac* in the competition for the bronze door of the Baptistry in Florence.[12] When in 1402 the commission for the bronze door was awarded to Ghiberti, Brunelleschi left Florence for Rome, and, according to Vasari, Donatello did so too. "Filippo and Donato met," Vasari tells us, "and determined to leave Florence and go to Rome for a year or so, the one to study architecture and the other sculpture. . . . He and Donato were constantly going about and spared neither time nor money. They left no place unvisited either in Rome or in its neighborhood, and took measurements of everything when they had the opportunity."[13] There can be little doubt that this journey did in fact take place, since Donatello, by 1408, evinces in his first great statue, the *St. John the Evangelist* for the façade of the Cathedral, a knowledge of Roman sculpture more comprehensive than that of any other sculptor since antiquity.

At the time the journey took place, it was already accepted in humanist circles that the city of Florence was the heir to republican Rome. Classical texts were voraciously collected not simply as exemplars of style, but as a key to the philosophical, historical, and social thinking of the past. On every side, however, a discrepancy was manifest between the medieval appearance of the city and its historical identity. What was required if this were to be redressed was a new classical architecture adapted to contemporary needs and a new type of sculpture that would form a bridge between the Florentine present and the Roman past. The search on which Brunelleschi and Donatello were engaged was not, therefore, in a narrow sense artistic. For Brunelleschi it involved study of the syntax of Roman buildings and investigation of the way in which they had been planned, while for Donatello it encompassed not only imagery and technique, but the equation between Roman sculpture and Roman life.

Donatello's visit to Rome with Brunelleschi can have lasted no more than a year, since in 1404 his name appears in a list of assistants employed by Ghiberti on the first bronze door of the Baptistry.[14] Presumably, Donatello was employed in the making of preliminary drawings and in the preparation of Ghiberti's models for casting, as well as in the cleaning and chasing of the casts. No indication is given of his salary or length of service. The first contract for the door was revised in 1407, when Donatello's name appears once more.[15] At this time he enjoyed a salary of seventy-five florins a year; only two other assistants were paid at so high a rate, an unknown metalworker called Bandino di Stefano and Ghiberti's long-term collaborator, Giuliano di ser Andrea, both of whom received sums in excess of their minimum entitlement under the contract. Donatello, on the other hand, was paid only eight florins and four lire of the seventy-five to which he was entitled. His contract, therefore, is likely to have ended after no more than a few months. The reason it did so was that in the winter of 1406 he joined the marble workshop of the Cathedral.

The Opera del Duomo was the main hub of artistic life in Florence. From the early 1390s on, the sculptures it commissioned are well documented. Initially,

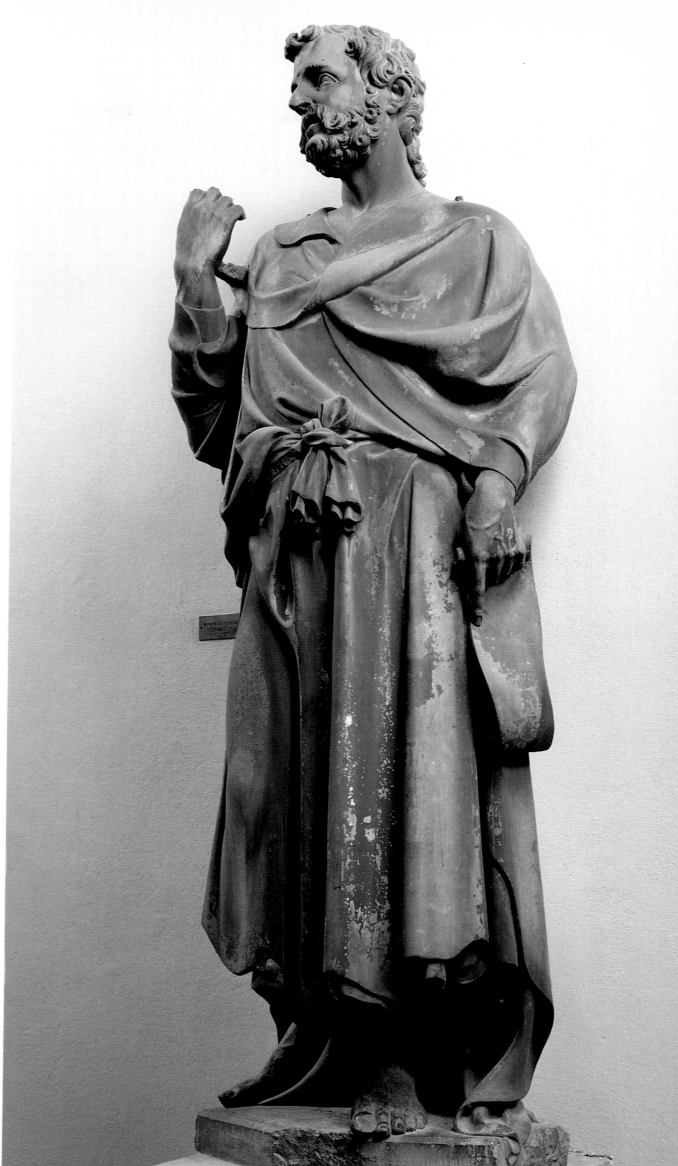

FIGURE 5.
Donatello, *The Prophet David*. Marble,
H. 188 cm, W. 65 cm, D. 40 cm
(H. 74 in., W. 25½ in., D. 16 in.).
Museo dell'Opera del Duomo,
Florence.

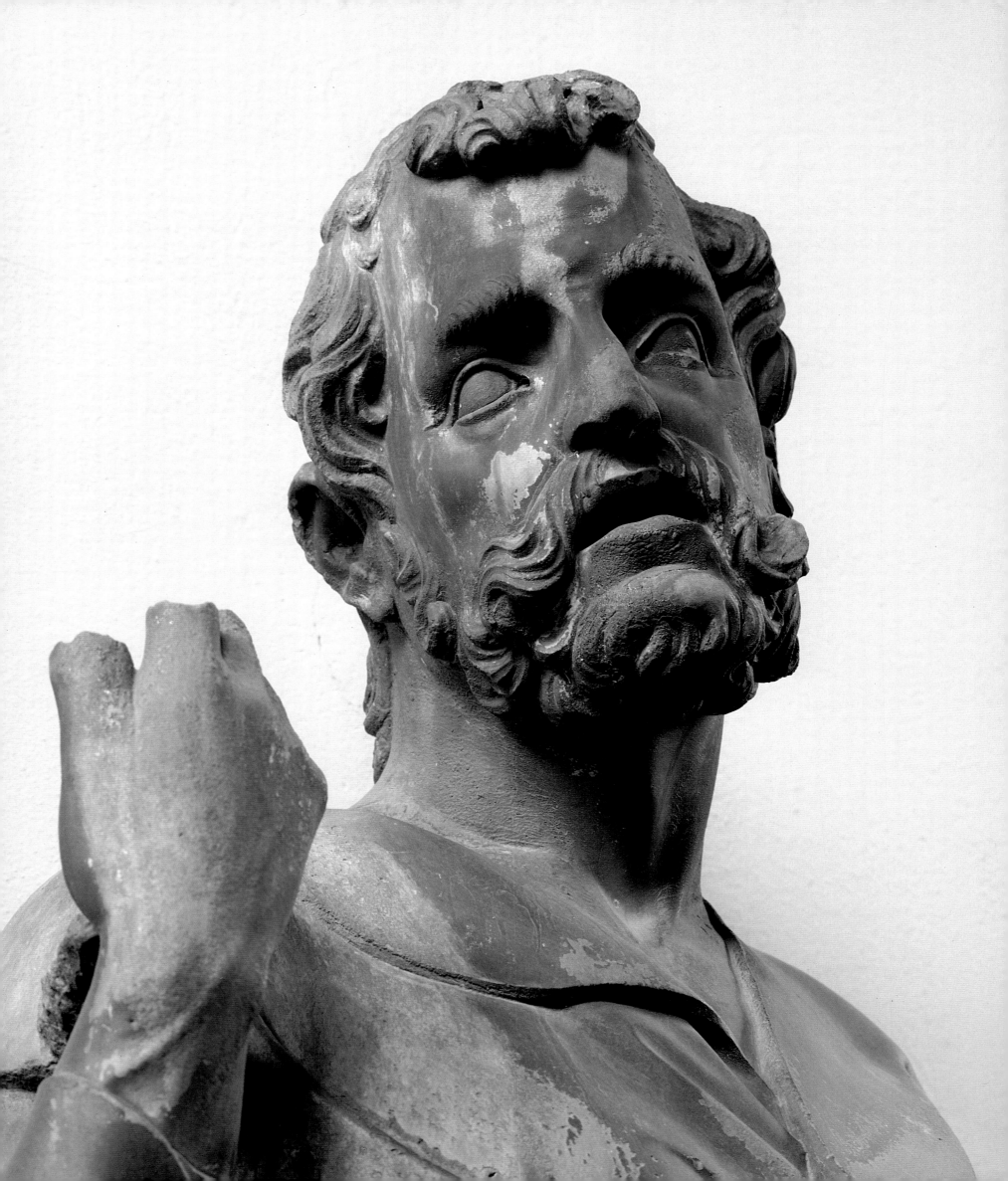

Donatello's involvement was with the Porta della Mandorla, at the north side of the church, on which most of the highly regarded sculptors in the Duomo workshop were employed. Work on the archway above the imposts was begun at the end of 1406 by three sculptors with whom Donatello was, for some years, to be associated: Antonio di Banco and his son Nanni di Banco, gifted, conventional artists who were descended from families of artisans employed by the Cathedral; and an archaizing, late Gothic sculptor, Niccolò di Pietro Lamberti. The flat surfaces at the top of the lateral supports were to be decorated with two figures of prophets, and it is in connection with one of these that the name of Donatello is first recorded as a marble sculptor. The companion figure was commissioned from Nanni di Banco. A payment of ten florins was made to Donatello at the end of November 1406 for one of the two figures, and the balance of six florins was made over to him in February 1407.[16] For many years these payments were thought to refer to two statuettes that stood over the doorway, but when they were taken down, it became clear that neither could be identical with the figures referred to in the document,[17] since their height (128 cm [50 in.], 131 cm [54 in.]) is considerably greater than the one-and-a-third *braccia* stipulated in the contract.

In February 1408 a commission for a full-scale statue was awarded to Donatello.[18] The figure was one of a projected series of twelve statues of Prophets for the external *sproni*, or buttresses, of the Cathedral. A companion statue, of Isaiah ("unam figuram Isaie profete, marmi, longitudinis brachiorum trium et quarti unius"), was commissioned from Antonio di Banco and Nanni di Banco. The subject of Donatello's statue was the prophet David ("de uno de duodecim profetis ad honorem David profetae"). Both figures were destined for buttresses on the north side of the church. Payments for them continue till June 1409, when they were complete. One of them was hoisted into position in July, but was immediately taken down again, presumably because it looked smaller than had been expected and was imperfectly legible from the ground. Nanni di Banco's *Isaiah* now stands in the interior of the Cathedral.[19] A bold figure covered with cursive drapery, with left knee bent and a scroll in the left hand, it has a low pentagonal base that corresponds in shape to the buttress it was to occupy.

But what of the companion statue? Full-scale marble figures were objects of some commercial value, compounded of the cost of the material and the fee paid to the sculptor for carving them. For this reason it is unlikely that Donatello's *David*, after being rejected for its intended position, was not put to use by the Opera del Duomo. We have no documented earlier work by Donatello with whose aid it could be identified, but special importance attaches to three points. The first is iconography. If the *David* formed part of a projected series of twelve Prophets (as we know it to have done), we would expect it to have shown David as King or Psalmist, not the young David triumphant over Goliath. In this event the figure would have been clad in the generic robe that Prophets in sculpture habitually wear, possibly in the act of singing with parted lips. The second is style. If Donatello worked with Brunelleschi, the figure is likely to have been in some way related to the silver figures added by Brunelleschi to the altar at Pistoia. The third consideration is more concrete. If the base of Nanni di Banco's *Isaiah* conforms to the pentagonal shape of

Fig. 4

opposite: FIGURE 6.
Donatello, Head of *The Prophet David.*

overleaf: FIGURE 7.
Donatello, Robe of *The Prophet David.*

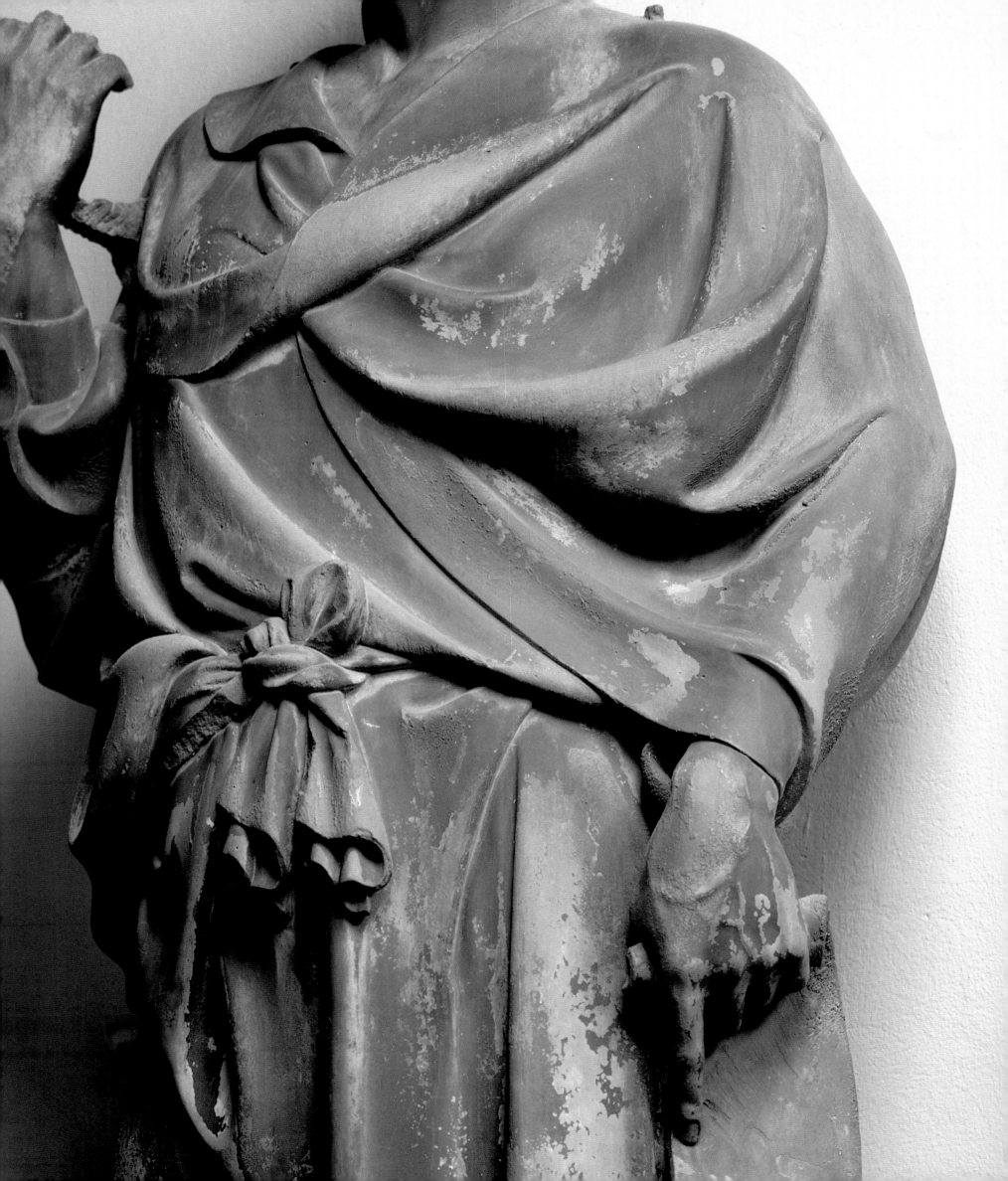

the buttresses of the Cathedral, the base of Donatello's *David* is likely to have done so too.

One surviving statue satisfies these three conditions. Originally on the Campanile and now in the Museo dell'Opera del Duomo, it shows a figure that can reasonably be regarded as the Prophet David.[20] Its lips are parted, as though in song, and its head is slightly turned. Whereas Nanni di Banco's *Isaiah* is supported by folds of cloak reaching to the ground, here the dress terminates in front above the ankles and both feet are exposed. The dress hangs forward of the legs, and the folds at its front edge are treated with deceptive naturalism. The right knee is bent in a way that suggests movement, and the dress, especially the knotted belt, is carved with exceptional skill. The right forearm is raised, and is attached by a marble bridge to the shoulder. The whole surface is seriously abraded, and the tips of the fingers of the right hand are missing, but the veining on the hands is rendered realistically. There are no parallels for the inspired head in other statues carved for the Duomo, but in the half-length silver figures made by Brunelleschi for the Pistoia altar the same emotional repertory is employed. The third condition also is fulfilled, in that the base of the figure is pentagonal.

There are, moreover, in the Museo dell'Opera del Duomo, two small prophets, which were installed in 1431 over the east entrance to the Campanile. One of these,

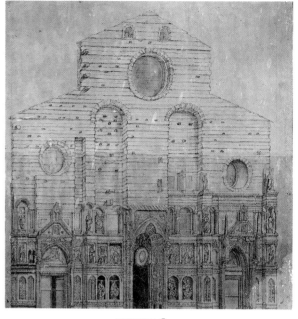

FIGURE 8.
Poccetti, *Facade of the Duomo in Florence* (1587). Pen on paper. Museo dell'Opera del Duomo, Florence.

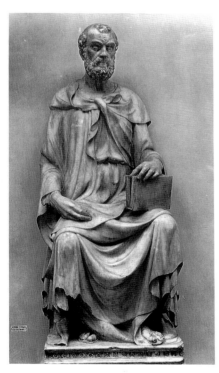

FIGURE 9.
Bernardo Ciuffagni, *St. Matthew.* Marble, H. 224 cm (88⅛ in.). Museo dell'Opera del Duomo, Florence.

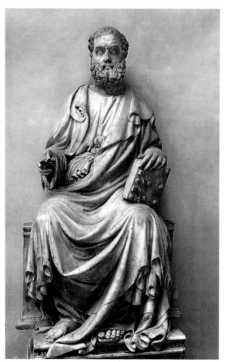

FIGURE 10.
Niccolo di Pietro Lamberti, *St. Mark.* Marble, H. 215 cm (84⅝ in.). Museo dell'Opera del Duomo, Florence.

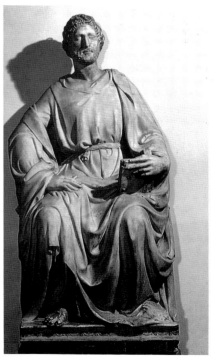

FIGURE 11.
Nanni di Banco, *St. Luke.* Marble, H. 207.5 cm (81⅝ in.). Museo dell'Opera del Duomo, Florence.

with bare head turned back, is by Nanni di Banco (though other names have also been attached to it), while the other, also with head turned back and holding a scroll in the right hand, is by the same hand as the *David*.[21] The form of the dress is very similar, with long vertical folds below the hips and cursive horizontal folds above, and the lower edge once more reveals the ankles and the feet. It has been suggested that these are the two Prophets originally commissioned for the Porta della Mandorla. They approximately correspond with the recorded heights of the statuettes for the Porta della Mandorla (one measures 87.5 cm and the other 88 cm [34 in.]).

At the end of 1408 the commission for the *David* was followed by one for a colossal statue. On the façade of the Cathedral, alongside the central doorway, were four rounded niches destined for seated figures of the Evangelists. In May 1405 two sculptors employed by the Cathedral were dispatched to Carrara to purchase four blocks of marble of the requisite dimensions. The war between Florence and Milan prevented their transfer to Florence, and they were left at Carrara where they were measured, weighed, and reduced "a braccia quadre," that is, to a form in which they could be worked.[22] Moved to Florence in 1408, three of them were allocated in December to sculptors selected by the Cathedral board: one, the *St. Mark*, to Niccolò di Pietro Lamberti; another, the *St. Luke*, to Nanni di Banco; and the third, a *St. John the Evangelist*, to Donatello.[23] The fourth Evangelist, *St. Matthew*, was reserved for the sculptor of whichever of the first three figures was deemed to be the most successful. This would have involved a long delay in the filling of the niches, and in February 1409 the *St. Matthew* was commissioned from another of the sculptors employed by the Duomo, Bernardo Ciuffagni. To ensure privacy, the blocks were installed in 1410 in locked chapels in the Cathedral.

The completion of the Evangelists was delayed by other work. Niccolò di Pietro Lamberti's *St. Mark* was not finished till March 1415, when it was valued at a hundred thirty gold florins; Ciuffagni's *St. Matthew* was completed in October 1415 and was valued at a hundred fifty florins; and work on Donatello's *St. John* ended in the same month, when it was valued at ten florins more.[24] There is no valuation of Nanni di Banco's *St. Luke*, which must have been finished at about the same time. The basis of payment for the four figures seems to have been qualitative, and a bonus was paid to Donatello, "civi florentino, magistro intagli figurarum marmorarum dicte opere." It is a reasonable assumption that their design dates from 1408, but the payments for them are not spread evenly through the succeeding seven years. Those to Donatello begin in 1409. In 1410 no payment is recorded. Two small payments were made in 1411, two larger payments are recorded in 1412 and 1413, and, after a void in 1414, substantial sums were paid over in 1415, culminating in October with a final payment of sixty-five florins. The incidence of payment suggests that the blocking out of the *St. John* was completed by the end of 1409, that little work was done on it in the two following years, and that work was resumed in 1412 and 1413, followed by a further pause before the statue was completed, under pressure, in 1415.[25] Payments for the other Evangelists follow this same pattern.

A drawing of the Duomo façade made in the 1580s by Bernardino Poccetti shows the four statues in the niches for which they were carved. Nanni di Banco's *St. Luke* and Ciuffagni's *St. Matthew* are to the left of the doorway and Donatello's

Fig. 10

Fig. 9

Fig. 11

Fig. 8

opposite: FIGURE 12.
Donatello, *St. John the Evangelist*. Marble,
H. 210 cm, W. 88 cm, D. 54 cm
H. 83 in., W. 35 in., D. 21 in.).
Museo dell'Opera del Duomo,
Florence.

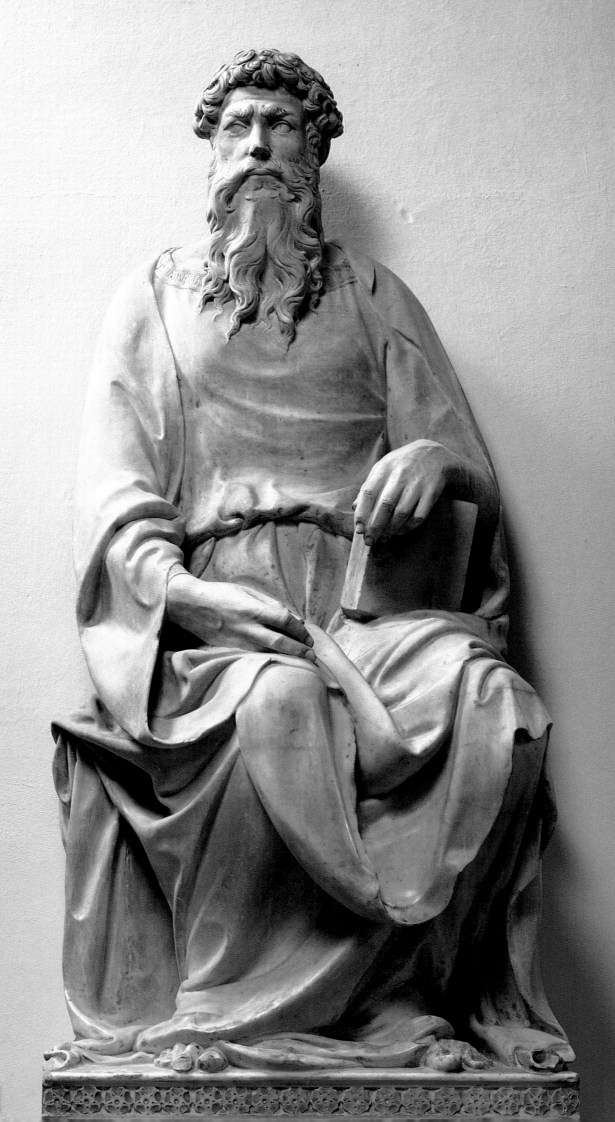

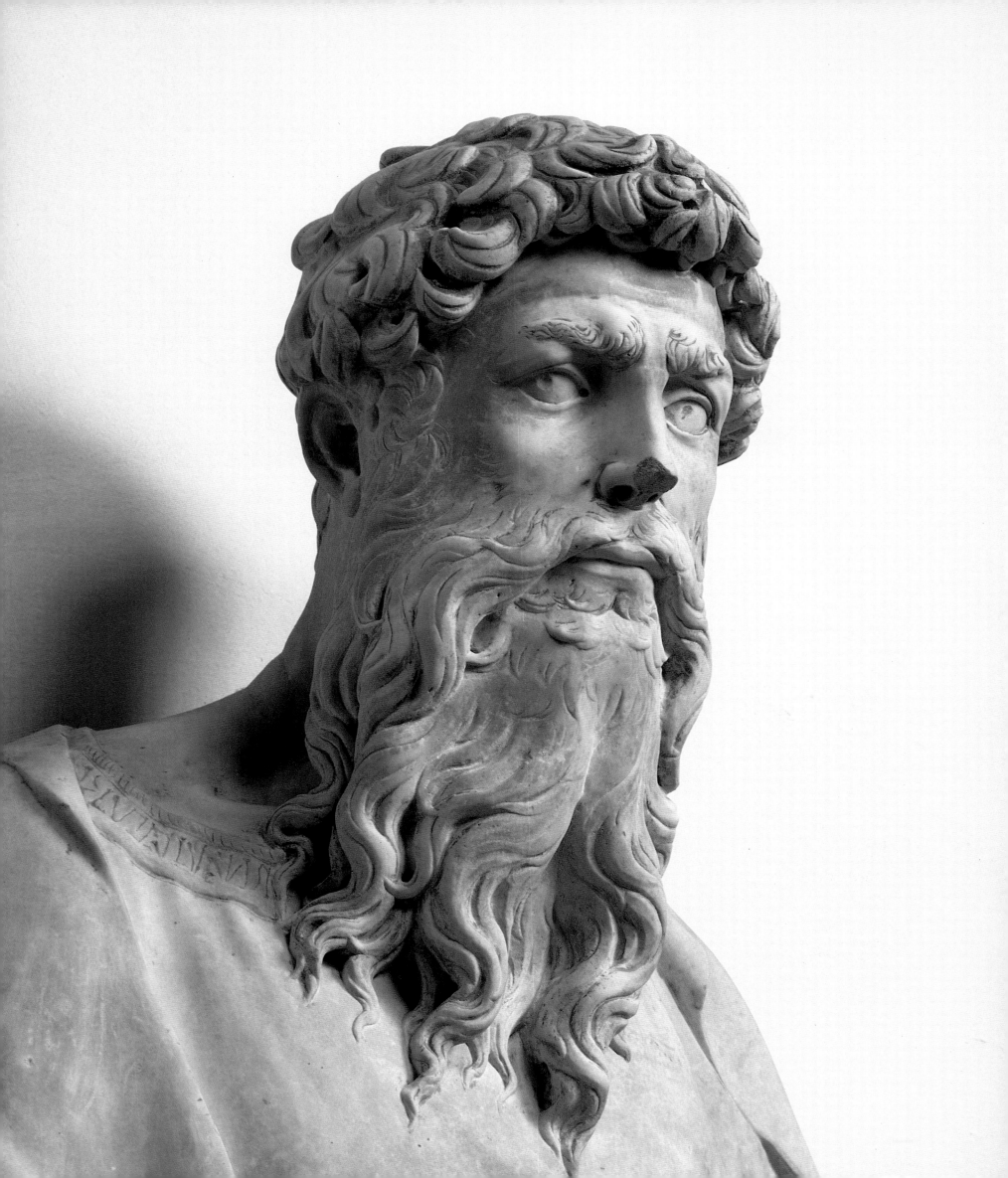

left: FIGURE 13.
Donatello, Head of *St. John the Evangelist*. Museo dell'Opera del Duomo, Florence.

right: FIGURE 14.
Donatello, *St. John the Evangelist*. Museo dell'Opera del Duomo, Florence.

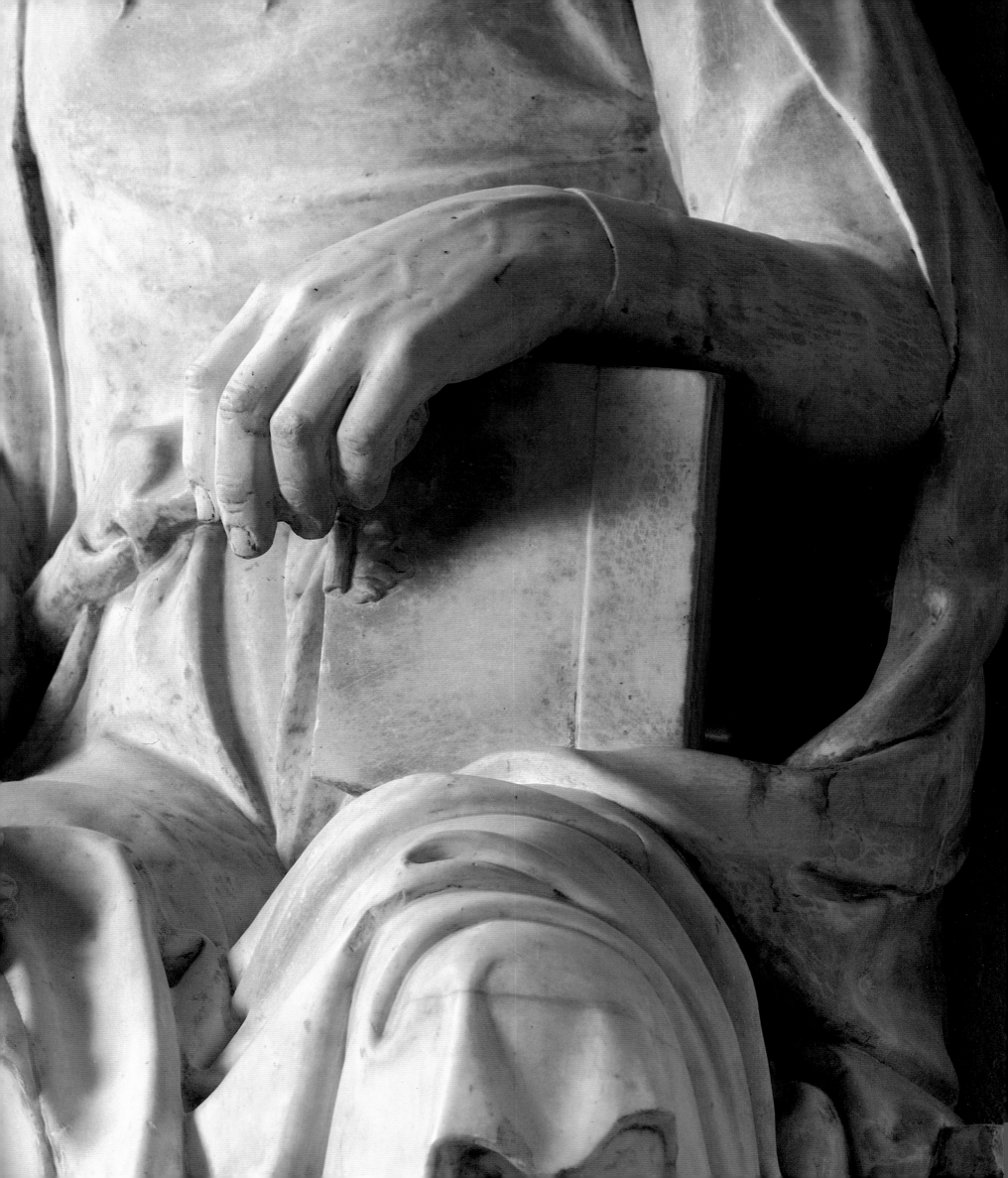

St. John and Niccolò di Pietro Lamberti's *St. Mark* are to its right.[26] The depth of the statues was determined by the depth of the niches, and the four figures are in practice very deep reliefs. The blocks employed for them had a depth of about 60 centimeters (24 in.), a width of about 90 centimeters (35 in.), and a height of about 220 centimeters (87 in.). The base of the niches was well above eye level, seemingly three meters (10 ft.) from the ground. The commission therefore involved two problems, that of producing figures in relief that would read like statues in the round, and that of adjusting their design to the height at which they would be seen. Both problems were ignored by Niccolò di Pietro Lamberti, whose *St. Mark* is posed frontally, with the head in full face, the upper arms pressed against the body, and the forearms extended, one pointing at the spectator and the other resting on a book. One knee is set on the front plane and the other is drawn slightly back, but the effect is neutralized by heavy drapery resolved in artificial cursive patterns at the sides. In Nanni di Banco's *St. Luke*, on the other hand, the first problem is handled skillfully. The head is inclined forward so that the shoulders appear fully in the round, the elbows are advanced, and the forearms are set on two diagonals with the left hand on the Gospel and the right hand on the thigh. The treatment of the features and of the hair and beard and the column of the neck is strongly classical, while the tunic, pulled out over a girdle, and the heavy cloak covering the knees, also result from study of Roman art. When the figure was in its niche, however, the heavy, intrusive cloak covering the knees would have impaired the effect made by the head and by the body above the waist.

Figs 12–15 Donatello's solution of these problems is more radical. If the figure were to be posed freely, it was essential to deepen the platform at the base, and the area filled by the Saint's seat had therefore to be reduced. The feet are equidistant from the edges of the platform, but the knees are inclined strongly to the right. One shoulder is withdrawn, the head is turned slightly to the left, and the hands are shown in different planes. What confronts us is a figure capable of movement, caught in a seemingly spontaneous pose. At eye level in the Museo dell'Opera del Duomo the extended length of the body between the base of the book and the shoulders is disconcerting; but looked at from beneath, the height diminishes and the upper and lower parts of the figure prove to be planned in calculated equilibrium.[27] If the depth of the seat were reduced, the depth of the figure had to be reduced as well, and at the back it is severed through the shoulder blades. The hands are represented with gross realism—beside the hands of Nanni di Banco's *St. Luke* they read like the scarred hands of a manual laborer—the heavy beard falls as it might in life, and the eyebrows are indicated with irregular vertical gashes, which, like the matted hair, would have been legible by a spectator in the street. None of this could have been achieved without close study of classical sculpture, but the image is not derivative. It is born of an imaginative faculty that brings the Saint of the Apocalypse to life before our eyes.[28]

Another detail in the *St. John* should be mentioned here, since it recurs in Donatello's later works. Whereas in Nanni di Banco's *St. Luke* the front face of the platform is decorated with a shallow foliated design, on the *St. John* the front face is filled with rosettes or five-petalled flowers so deeply undercut as to deprive it of its

opposite: FIGURE 15.
Donatello, Robe of *St. John the Evangelist.*
Museo dell'Opera del Duomo,
Florence.

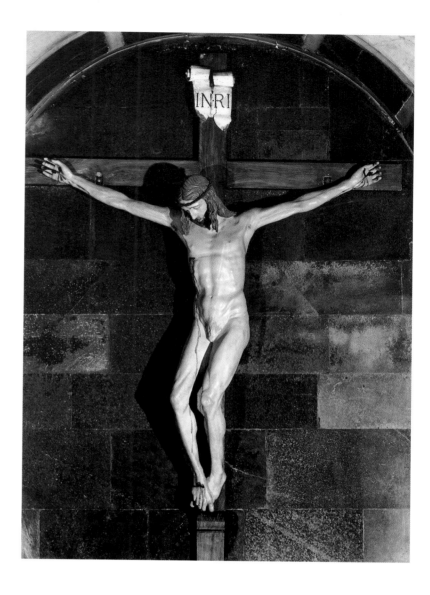

solid, weight-bearing character. The sole precedent for the Saint's pose is the silver figure of a Church Father made by Brunelleschi for Pistoia in 1401,[29] the first classicizing seated figure of the Florentine Renaissance. The knees and legs, the horizontal folds of cloak, and the free treatment of its head have the character almost of a model for the great statue carved by Donatello. An interval of seven years separates the two.

One of the staple tasks of Tuscan sculptors from the late thirteenth century on was the production of full-scale wooden Crucifix figures. Since no wooden Crucifix is signed or dated, the surviving images can be attributed only on the basis of other documented works. The *Libro di Antonio Billi* describes a wooden *Crucifix* by Donatello in Santa Croce and is followed in this by Vasari and other sources. There

Fig. 16 can be no reasonable doubt that the Santa Croce *Crucifix* is a work by Donatello of about 1412 or 1415.[30] The treatment of the feet and hands is closely related to that in

Fig. 17 the *St. John*, and the folds of loincloth drawn across the thighs have the same power

opposite: FIGURE 16.
Donatello, *Crucifix* (after cleaning).
Pigmented pear wood,
H. ca. 168 cm, W. ca. 173 cm (H. 66 in., W. 68 in.).
Santa Croce, Florence.

top, left: FIGURE 17.
Donatello, *Crucifix* (during cleaning).
Santa Croce, Florence.

top, right: FIGURE 18.
Filippo Brunelleschi, *Crucifix*.
Pigmented wood, H. 170 cm (67 in.).
Santa Maria Novella, Florence.

of definition as the horizontal folds of the robe pulled across the chest of the Evangelist. A factor that distinguishes the body of Christ from that of earlier Crucifixes is its weight. The body slumps forward from the Cross, and the head, with its high cheekbones and coarse hair, has the same part realistic, part visionary quality as the *St. John.* A story is recorded by Vasari and other sources that Donatello's *Crucifix* was criticized by Brunelleschi for its excessive realism, and led him to carve a *Crucifix* for Santa Maria Novella. The ideality of Brunelleschi's Christ stands in marked contrast to the veristic idiom of Donatello's, and it is probable on other grounds that Brunelleschi's is the later of the two.

Fig. 18

The *David* was not the end of Donatello's involvement with the statuary for the Cathedral buttresses. In August 1410 there occurs for the first time a reference to the making of a modeled figure for a buttress on the north side of the church.[31] It was very large ("ille homo magnus et albus," it is called in one document), had a brick core, and was covered with gesso and whitewashed; in mid-December it was complete. A payment of June 1412 specifies its subject, the Prophet Joshua, and another payment at the end of July shows that Donatello received a fifty-florin advance on a total sum of a hundred twenty-eight florins for making it. But terracotta painted to resemble marble was not a satisfactory solution, and in October 1415 Brunelleschi and Donatello received ten florins for a stone statuette clothed in gilded lead, made as a model for "the large figures which they are to make for the buttresses of Santa Maria del Fiore."[32] The project for lead figures seems to have proved abortive, but the statue of Joshua ("el ch'ene dallato de'lignaiuoli") remained in position on a buttress at the north side of the church. Repaired in 1426, it is mentioned in the *Codice Magliabecchiano* as a work of Donatello ("E il gigante che è a pie della cupola dalla porta Assuntione di Nostra Donna") and can be seen, isolated on its buttress, in a fresco by Pocetti of 1586 in the cloister of San Marco. In the fresco, the figure looks gigantic. When, in the 1460s, a marble statue was commissioned from a later sculptor, Agostino di Duccio, for another of the buttresses, its projected height was nine *braccia,* or 5.3 meters (17 ft., 5 in.). The *Joshua* may have been on the same scale. Though it is lost, the records of it have some value in establishing two points that are essential for an understanding of Donatello's later work: his empirical attitude toward technique and his bias toward modeled sculpture.[33]

II

Or San Michele

THE UNIT OF PROFESSIONAL LIFE in Florence was the *Arte*, or guild. Each guild had its own hall—sometimes, with minor guilds, a comparatively modest one; sometimes, with major guilds, a more imposing modern structure. In addition, each major guild had an interest in a corporate building, the guild hall of Or San Michele. Originally a grain market, Or San Michele was constructed in the second quarter of the fourteenth century as an open loggia. In 1339 its twelve supporting piers were allocated to the seven major and five minor guilds, which were required to erect tabernacles containing statues of their patron saints. The guilds looked askance at this costly plan, but in 1340 tabernacles were built by the Arte della Lana, whose patron was St. Stephen, and the Arte della Seta, whose patron was St. John the Evangelist. Late in the century, about 1380, the arcades of the loggia were filled in, and the building, save for two openings on the north and south sides, assumed the form we know today. Thereafter, two more tabernacles were built, one in 1399 by the Arte dei Medici e Speziali (the guild to which painters belonged) to house the emblem of the guild, a group of the Virgin and Child, and the other in 1403 by the Arte dei Guidici e Notai to house a statue of St. Luke. Both statues were entrusted to the artist who would later be responsible for the *St. Mark* on the façade of the Cathedral, Niccolò di Pietro Lamberti. So dilatory was progress that in 1406 a time limit was imposed upon the operation, and those guilds whose piers were vacant were required, on pain of forfeiture, to fill them within ten years.

At this point the project took a more ambitious turn. It resulted from the claim, by the state chancellor Coluccio Salutati, that the city of Florence had been founded not by imperial but by republican Rome. This thesis was developed in the first half-decade of the fifteenth century by Salutati's successor, Leonardo Bruni, in two books, the *Laudatio Florentinae Urbis* and *Urbis Petrum Dialogus*, which celebrate the integrity of the Florentine state and the orderly character of its republican institutions. The chancellor of the conservative Parte Guelfa, ser Pietro Sermini, was a

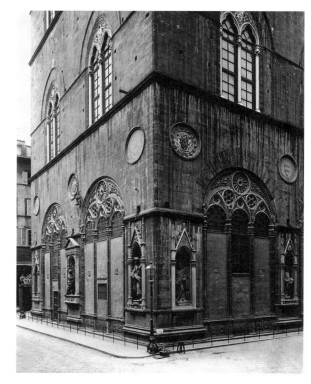

FIGURE 19.
The Guild Hall of Or San Michele.

participant in the discussion recorded in the second of these books, and when the Parte Guelfa statutes were revised in 1419–20, the draft was supervised by Bruni.[1] Another participant was Niccolò Niccoli, who is remembered today not only as a scholar but as an obsessive collector of antiquities, which were available for study by the new generation of Florentine sculptors. The Parte Guelfa was the dominant political party in the city, and the speeches of its leaders, filled with sophisticated classical allusions, reflected its prerogatives. In the statues commissioned after 1406 for Or San Michele this historical thinking assumed a visual form. Through the fourteenth and the first half-decade of the fifteenth centuries, the taste governing the commissions had been conventional, but thereafter the statues—with one exception, the *St. James* of the Arte dei Viai, by Niccolò di Pietro Lamberti—were allotted to progressive artists, three to Ghiberti, three to Nanni di Banco, one conjecturally to Brunelleschi, and three to Donatello.[2]

The width of the tabernacles on all but two of the piers was preordained, but decision on the medium and style of the statues was reserved to committees of the individual guilds. The statues on Or San Michele, therefore, as we see them today, do not form a coordinated aesthetic scheme; they are the fruit of civic rivalry. Our knowledge of the dates at which the individual statues were commissioned and installed is incomplete. The three statues by Ghiberti have firm dates. With the first, the bronze *St. John the Baptist* of the Arte della Calimala, the tabernacle was commissioned from an architect, probably Giuliano d'Arrigo, and the statue was cast in 1414 and was installed two years later. The second, the *St. Matthew* of the Arte del Cambio, was commissioned in 1418, modeled in 1420, and installed, in a tabernacle designed by the sculptor, in 1422. The third, the *St. Stephen* of the Arte della Lana, was executed, as a replacement for a trecento marble figure, in 1427–28, and placed in a pre-existing niche. Donatello's three statues for Or San Michele can also be approximately dated. The earliest, the marble *St. Mark* for the Arte dei Linaiuoli, was commissioned in April 1411 and seems to have been completed in 1413. The second, the *St. George* for the Arte degli Spadai e Corazzai, is not documented, but was installed in a tabernacle for which a block of marble was purchased in 1417. The third, the bronze *St. Louis of Toulouse* for the Parte Guelfa, was finished before November 1425. Nanni di Banco's statues are not documented. All of them seem to have been carved after work was begun on the *St. Luke* for the Cathedral, that is, after 1410. The earliest is probably the *St. Philip* for the Arte dei Calzolai and the latest the *St. Eligius* for the Arte de Maniscalchi. Nanni di Banco's most important and elaborate work on Or San Michele, the *Four Crowned Saints* for the Arte dei Maestri di Pietra e Legname, which contains four figures and would have taken longer to complete, is plausibly assigned to the years 1410–16.

The niche containing Nanni di Banco's *Four Crowned Saints*, on the north face of Or San Michele, is considerably wider than the earlier tabernacles. The Saints are shown standing, as though in conversation, before a curtain at head height knotted over the pilasters at the sides. The device of the curtain is classical, and the four Saints themselves are shown in classical dress; three wear a form of toga, and their heads depend from classical busts. Neither in the *Saint Luke* for the Cathedral nor in his only datable late work, the relief of the Assumption over the Porta della

Fig. 21

Mandorla of the Cathedral, does Nanni di Banco approach the rigid classicism of these statues. In painting, the Four Crowned Saints were represented very differently; in a panel by Niccolò di Pietro Gerini, executed in the first decade of the century, they wear contemporary costume. The thinking behind Nanni di Banco's group seems to have rested on the concept of historicity. The Saints are portrayed as they might have appeared at the time when they were martyred under Diocletian, at the end of the third century A.D. In a carved predella beneath the niche, the figures from the tabernacle are shown employing the same skills as their successors in the fifteenth century. On the left, one of the Saints depicted in the main group builds a wall; next to him, the second figure from the right in the main group is shown carving a spiral column; next, facing to the right, is the bearded figure on the left of the main group; and on the extreme right, facing to the left, is the figure in the left background of the tabernacle carving a classical likeness of a child. Since there was no evidence of the working dress employed in antiquity by artisans, their clothing is

left: FIGURE 20.
Ciuffagni, *St. Peter.* Marble,
H. 237 cm, W. 72.5 cm (H. 93 in., W. 28½ in.).
Or San Michele, Florence.

right: FIGURE 21.
Nanni di Banco, *Quattro Santi Coronati.*
Or San Michele, Florence.

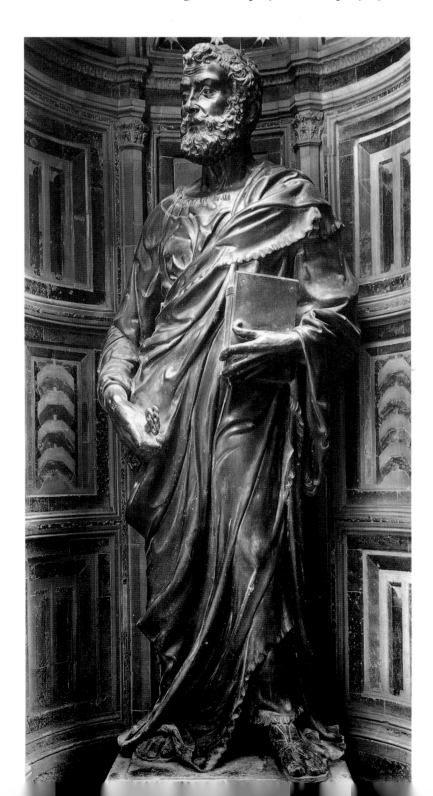

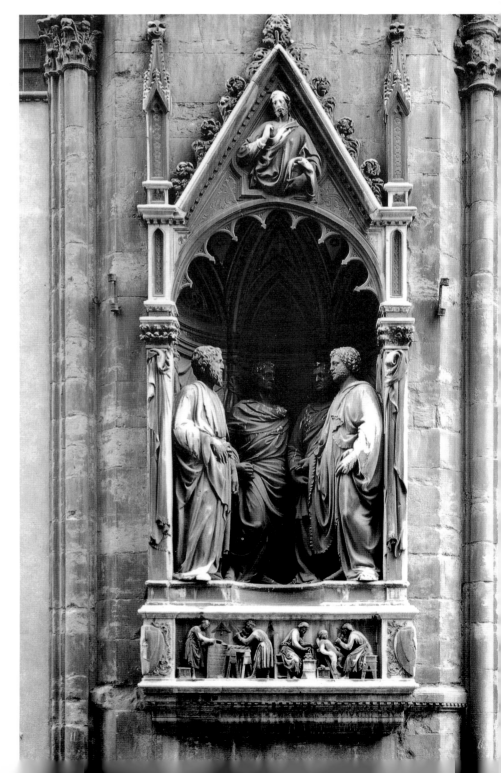

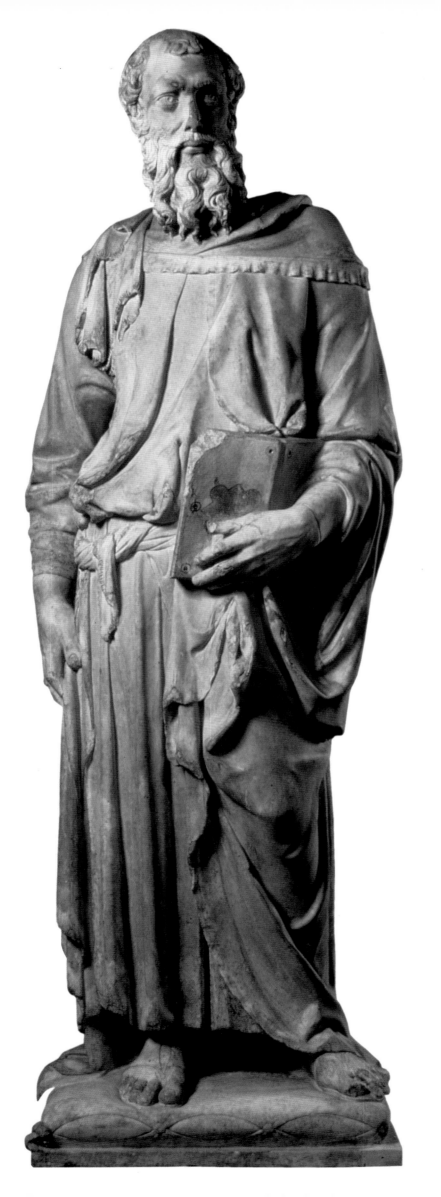

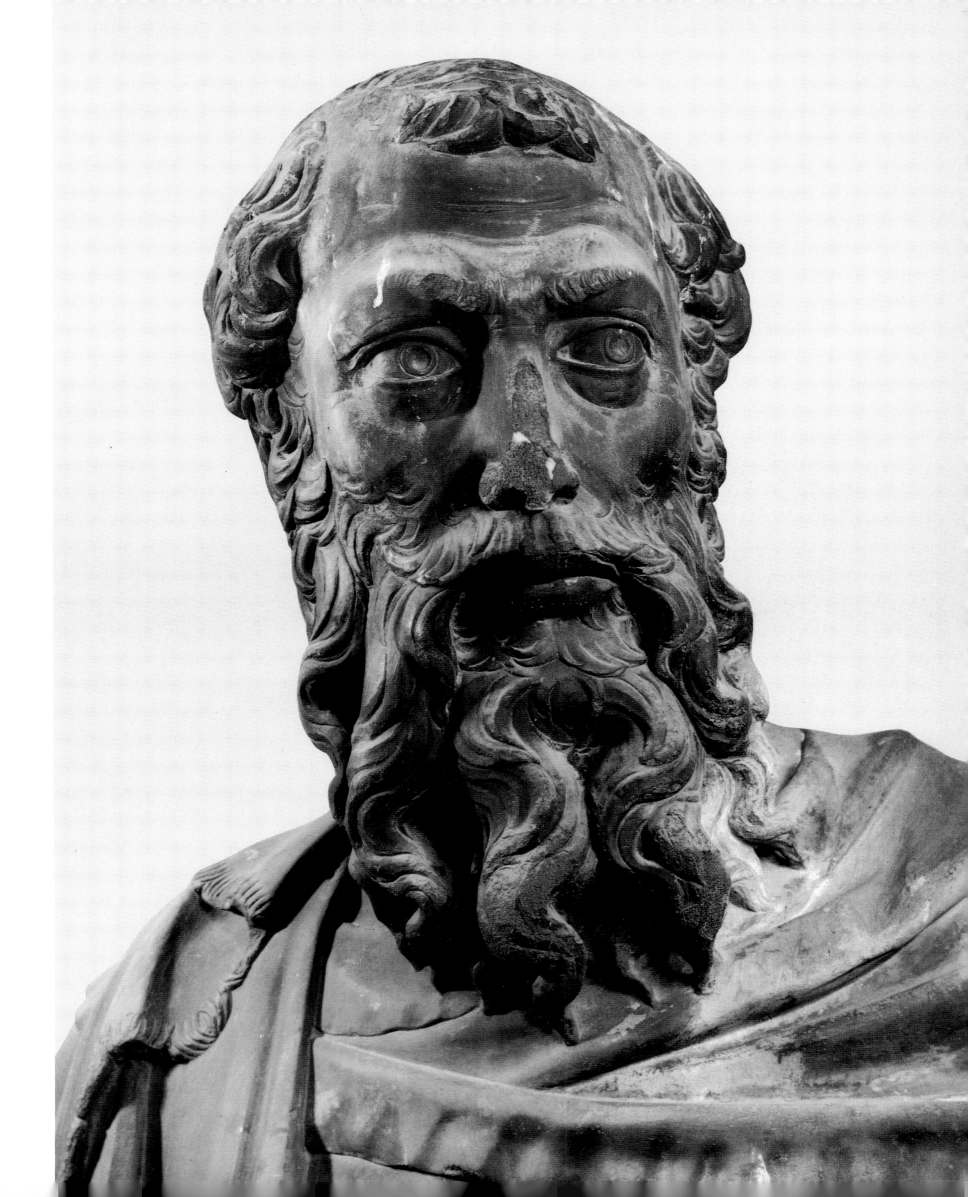

that usual in the fifteenth century, with hair protected from the dust by round caps or cloths. Here past and present are one.

Historical considerations were also fundamental for two other marble statues on Or San Michele, the *St. Peter* of the Arte dei Beccai[3] and the *St. Mark* of the Arte dei Linaiuoli.[4] In the *Uomini singolari in Firenze* of about 1470, both statues are described as the work of Donatello, but the reliable *Libro di Antonio Billi*, in the early sixteenth century, credit them to Brunelleschi, who "received the commission for them jointly with Donatello." This claim is repeated in 1550 in Vasari's life of Brunelleschi, where it is explained that Brunelleschi "left the statues for Donatello to carry out alone, since he himself had taken on other commitments, and Donatello brought them to completion." Each of the statues presupposes the presence of an antecedent model, without which it could not have been carved, so they confront us with two questions: By whom was the model prepared, and by whom was the statue executed? The superficial uniformity of the figures is very plain. Each saint wears an undergarment reaching to the ankles covered by a heavy cloak, and in both the posture and the head are classical. The two figures, like Nanni di Banco's *Four Crowned Saints*, proceed from a common interest in evoking how, in their lifetime, the apostles might have looked. Sculpturally, however, they are incompatible. The rigid, inflexible *St. Peter* may well depend upon a model by Brunelleschi, the more so that its niche, alone of the niches on Or San Michele, is lined with geometrical inlay of a strongly Brunelleschan stamp. But its execution is dull and dry, and the tightly carved hair and beard, the sharp plane of the cheek bones, and the limp folds of the robe and cloak are by the author of the *St. Matthew* carved for the façade of the Cathedral, Ciuffagni.

Fig. 20

Donatello's *St. Mark*, on the other hand, is a revolutionary work. The block of marble for it was procured at Carrara early in 1409 by Niccolò di Pietro Lamberti and was formally accepted in February 1411 by five members of the guild, who were instructed to assign it to a sculptor. Their choice fell on Donatello, who agreed in the first week of April to deliver the figure, "gilded and with all other appropriate decorations," by November 1, 1412. Work on it was all but completed by April 29, 1413, when the five newly elected *sindachi* of the guild were authorized "fare finire la figura et tabernachulo di sancto Marcho che debbe stare a Orto San Michele di quanto vi mancha" (to arrange for the completion of anything that may be lacking in the figure and tabernacle of St. Mark, which is to stand at Or San Michele). Work on the tabernacle went ahead concurrently with work on the statue. In the last week of April 1411, its construction was entrusted to two masons, Perfetto di Giovanni and Albizzo di Pietro, who had already submitted a preliminary drawing. It was enjoined by the syndics that the interior of the niche should follow that of the trecento niche of the Arte della Lana (which now houses the *St. Stephen* by Ghiberti) and be lined in with panels of black marble with white foliated inlay. As executed, its front face is more closely related to the tabernacle of the Arte di Calimala containing Ghiberti's *St. John the Baptist*, in the interior of which spiral half-columns are also employed. The framing pilasters, however, differ; in the Arte di Calimala tabernacle they are decorated with diamond-shaped inlay, whereas in the tabernacle containing the *St. Mark* they bear deeply carved diamond-shaped lozenges with

Figs. 22, 2[

Fig. 24

opposite: FIGURE 24.
Tabernacle of the Arte dei Linaiuoli with a replica of Donatello's *St. Mark*. Or San Michele, Florence.

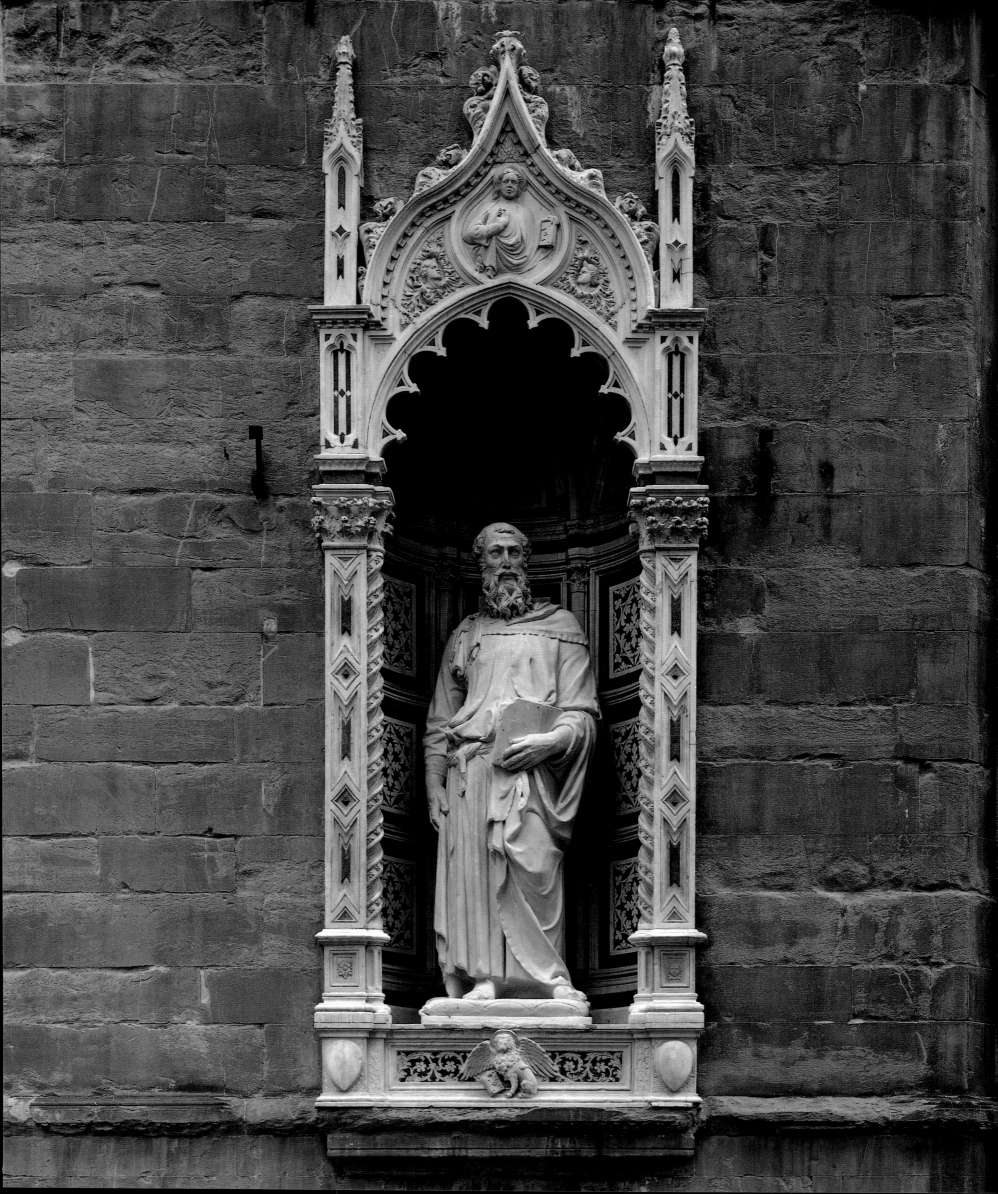

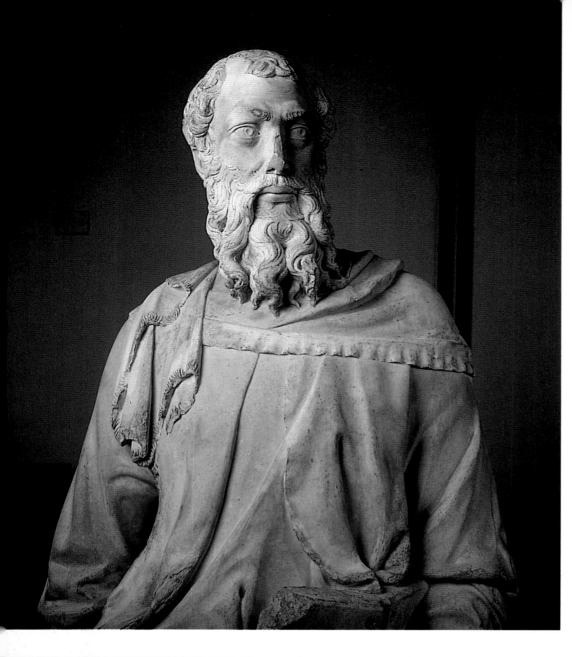

FIGURE 25.
Donatello, Head of *St. Mark*.
Or San Michele, Florence.

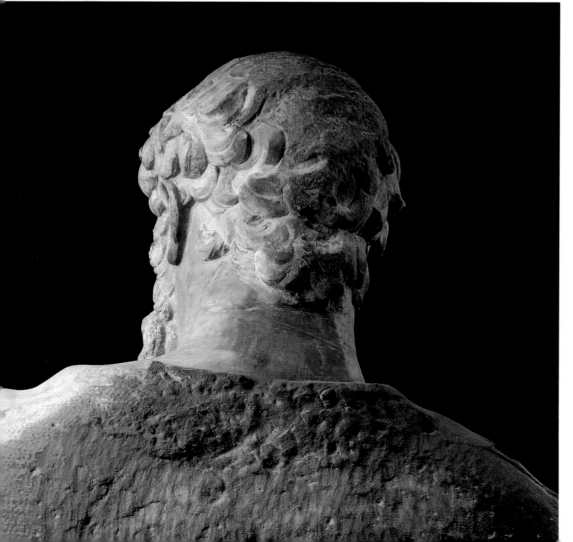

FIGURE 26.
Donatello, Back of *St. Mark*.
Or San Michele, Florence.

opposite: FIGURE 27.
Donatello, Robe of *St. Mark*.
Or San Michele, Florence.

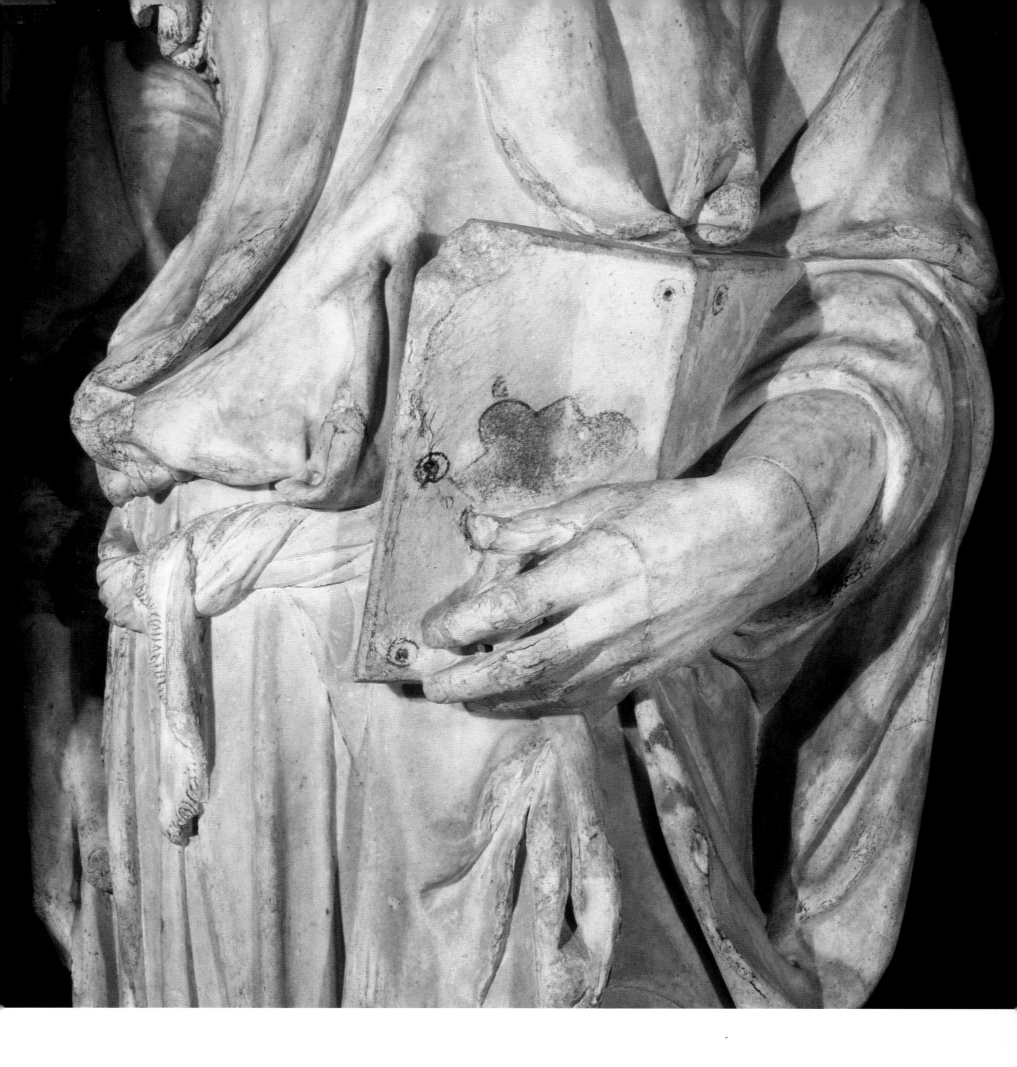

half-lozenges at the top and bottom, which provide stronger support for the statue. These pilasters may have been planned by Donatello. As was laid down in the commission, the lining of the niche follows that of the Arte della Lana *St. Stephen*. Seen from street level, the molded frame of the uppermost of the inlaid panels cuts the statue at the neck and serves to isolate its head.

Like the *Four Crowned Saints* of Nanni di Banco, the model for the *St. Mark* must have involved a period of intensive study. The bearded head is not based on a known classical original, but presupposes knowledge of Roman commemorative portraits of the class of third-century heads like those of M. Didius Julianus in the Louvre, the Museo Capitolino, and the Vatican, or, more generally, of antique philosopher busts.[5] The carving of the furrowed forehead, however, and of the beard, eyebrows, and eye sockets is freer and more animated than in any Roman bust. The strongly individualized features and the penetrating eyes have a dynamic yet reflective character that is a quintessential product of their time, and the head transcends reality in the same ratio in which the entire figure transcends the human frame. The dress, which is notionally, though not authentically, classical, would have been accepted as authentic at the time the statue was produced. The undergarment is covered by a heavy cloak, looped up over the right shoulder and left forearm, and is fastened with a knotted fabric belt. Falling in vertical folds down the right leg, it is portrayed as comparatively thin in texture, whereas the cloak, which has the pleated border of the cloaks on Roman sarcophagus reliefs, is made of heavier material and falls in horizontal folds over the left leg. A recent cleaning has revealed, especially on the borders of the dress and cloak, extensive traces of gilt stenciling. Whereas the *St. Peter* of Ciuffagni and the *St. John the Baptist* of Ghiberti rise from molded plinths, the *St. Mark* stands on a cushion with a brocaded cover decorated with tassels at the corners and buttoned at the front. The cushion has been explained as an allusion to the work of the *rigattieri*, who subscribed to the Linen Drapers' Guild, but it fulfills a no less important sculptural function, in that the physical dominance of the statue is enhanced by the indentation made on the surface of the cushion by the Saint's heavy feet.

The deep niche of the *St. Mark* admits no lateral views, and though the figure, like the *St. John the Evangelist* for the Cathedral, registers as a statue fully in the round, it is once more a very deep relief. The Saint is represented in arrested movement. His weight is borne on the right leg, the right shoulder is retracted, and the right arm and hand hang down at his side. The left foot rests on the extreme edge of the cushion, the left knee is bent and the left shoulder is advanced, and the heavy Gospel volume, held in place by the left hand, is supported on his thigh. His eyes look outward to his left, and the head is turned slightly in the same direction. The sense of energy communicated by the figure is due partly, as it is in the *St. John the Evangelist*, to the veristic carving of the feet and hands as well as to the strength of the shoulders and the decisive movement of the head. But no less important are the dress and cloak; the vertical folds of the undergarment hanging free of the right leg and the heavy folds of cloak caught up by the left hand could not have been achieved without the use of a draped large-scale model. The employment of a model must also be inferred on other grounds. The base of the tabernacle is 2.4 meters (8 ft.)

Fig. 23, 25

Fig. 27

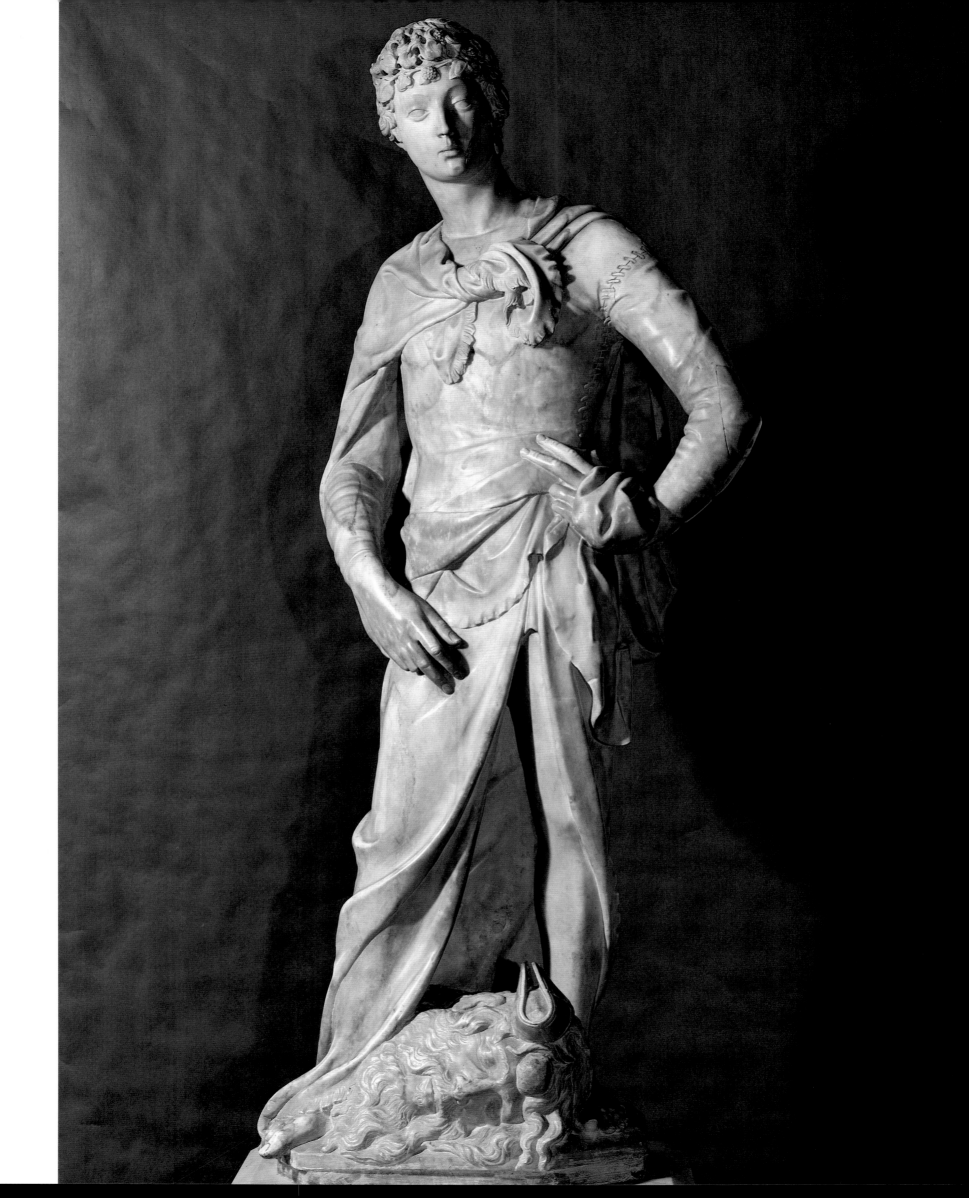

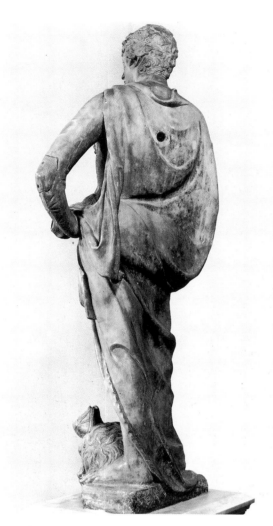

FIGURE 30.
Donatello, Back of *David*
with the Head of Goliath.
Museo Nazionale, Florence.

opposite: FIGURE 31.
Donatello, Head of *David.*
Museo Nazionale, Florence.

above the level of the street (some 60 centimeters [2 ft.] less than the niche containing the *St. John* on the façade of the Cathedral), and Donatello has recourse to the same system of distortion as in the *St. John*, an extension of the body between the hips and shoulders, which reads awkwardly when the statue is studied at eye level, but convincingly from a low viewing point. This vital factor of distortion for purposes of visual effect has been contested by some recent students, but was evident to Vasari, who records that the statue "was executed by Donatello with so much judgment that when it was on the ground its excellence was not recognized by unskilled persons, and the consuls of the Guild were not disposed to accept it; but Donatello asked them to allow it to be set up, as after he had retouched it the figure would appear quite different. This was done, the figure was veiled for fifteen days, and then, without having done anything more to it, he uncovered it, and filled everyone with admiration."

Hardly was the *St. Mark* installed than Donatello must have started work on a major statue for the seat of government, the Palazzo della Signoria.[6] There is no record of the date of the commission, and the first reference to it occurs in the summer of 1416, when, on the instructions of the Priors of the Guilds and the Gonfaloniere di Giustizia, the Operai of the Cathedral were ordered to transport to the Palazzo della Signoria "quandam figuram marmoream David existentem in dicta opera." The instructions resulted from a decision taken four days earlier "quod Johannes capudmagister et Franciscus de Mannellis, provisor dicte opere, possint mictere ad palatium et in palatio predicto dominorum quandam figuram marmoream David existentem in dicta Opera." At the end of August a payment of five florins was made to Donatello "pro pluribus diebus quibus stetit una cum aliis eius discipulis in aptando et perficiendo figuram Davit, que destinata fuit per dictos operarios in palatium dominorum priorum artium." From a further document we learn that on August 4 "due becchatelli di marmo" (two marble consoles on which the statue was to be placed) were dispatched from the Opera del Duomo to the Palazzo della Signoria, that the statue itself was moved there on August 17, and that it was set against a "champo azzurro" on the wall decorated with the lilies of Florence, painted by a certain Giovanni di Guccio. The base and the consoles were decorated with glass inlay and consumed "pezzi quaranta d'oro battute" and small quantities of silver ("ariento battuto") and blue and red paint. A further fifty pieces of *oro battuto* were set aside for the decoration of the sculpture itself. The statue was installed in the Sala dell'Orologio, where it is recorded in 1510 by Albertini and in 1550 by Vasari. Its meaning was transmitted by the words PRO PATRIA FORTITER DI MICANTIBUS ETIAM ADVERSUS TERRIBILISSIMOS HOSTES DEUS PRESTAT VICTORIAM. By 1592 the last three words of this titulus were amended to read: DII PRAESTANT AUXILIUM. The statue was moved in 1781 from the Palazzo Vecchio to the Uffizi, and in 1873 from the Uffizi to the Museo Nazionale, where it has been housed since.

Before we examine the statue, it is necessary to establish what it is that we are looking at. The very large literature devoted to it rests on two different hypotheses. The first is that the marble *David* is identical with the statue of David carved in 1408–9 for a buttress on the Cathedral. When it proved unsuited to the place for

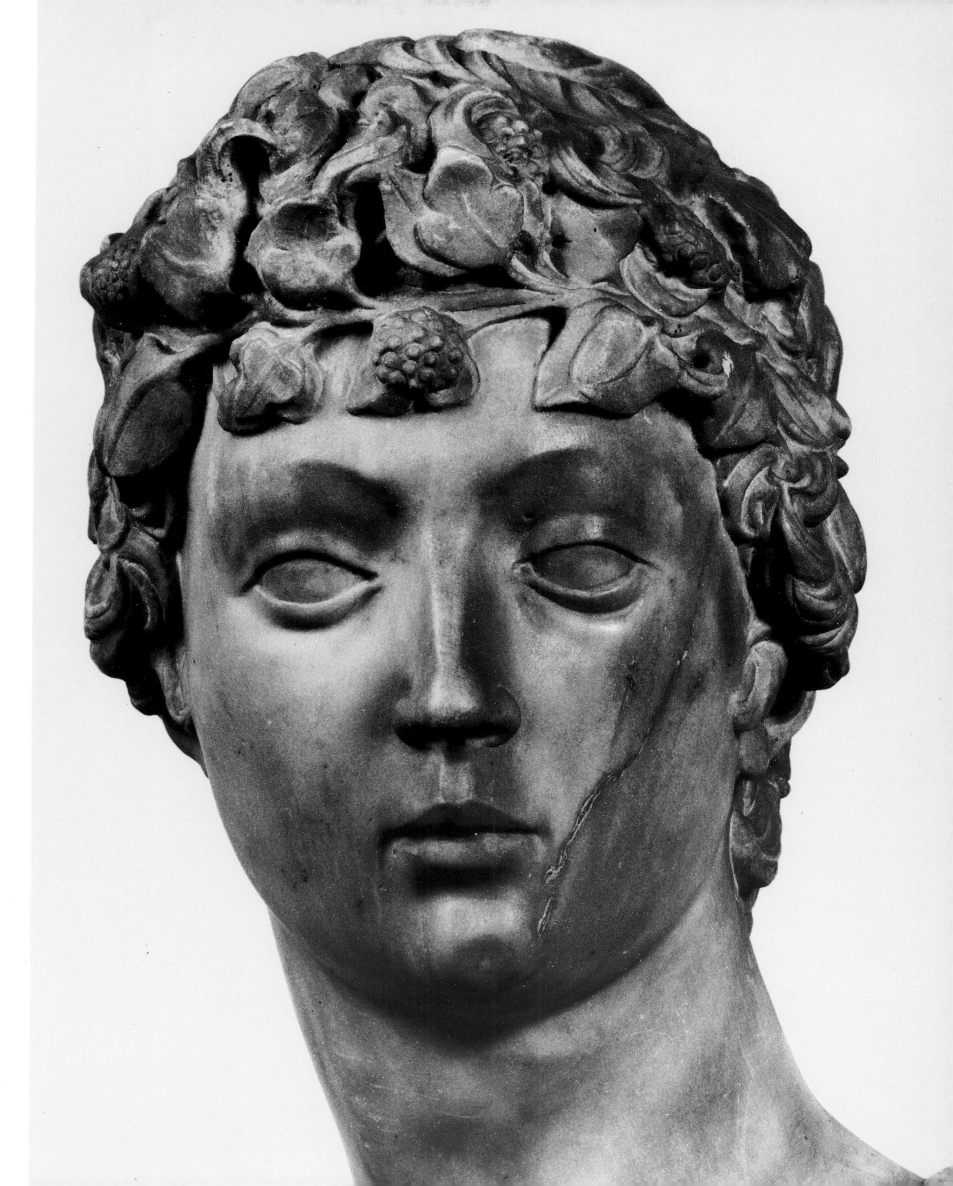

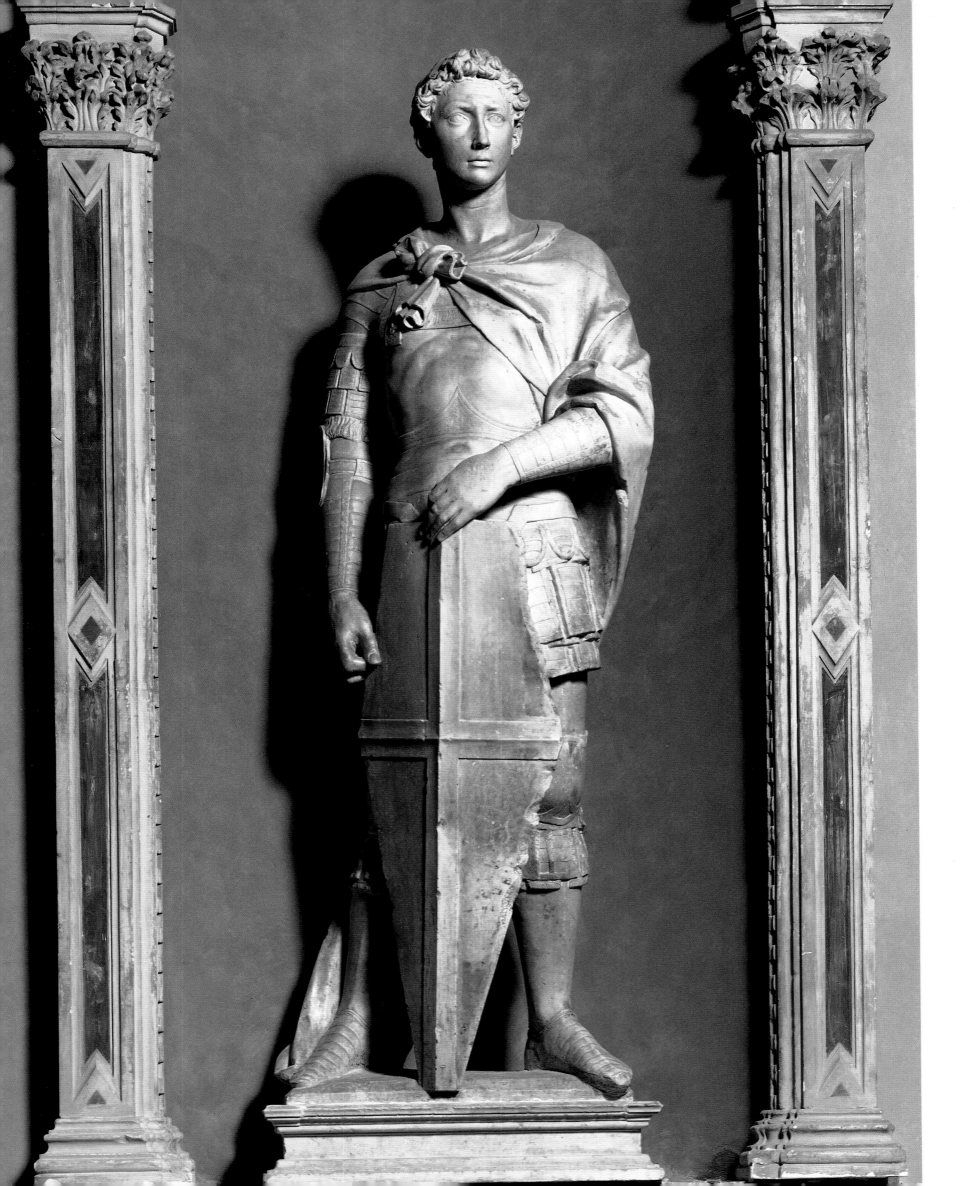

which it was designed, it was stored in the Opera del Duomo until, in 1416, it was modified for use in the Palazzo della Signoria. The second is that it was planned from the beginning for the position it eventually occupied in the Sala dell'Orologio and was commissioned for this purpose about 1412. The first, highly misleading case, put forward initially by Poggi and then elaborated, with varying changes of emphasis, by Lányi and Janson, rests on the words "pro aptando et perficiendo" (for adapting and completing), which were wrongly regarded as proof that the statue had been recut. It was suggested by Lányi that a scroll was originally held between the fourth and fifth fingers of David's left hand, and that when it was removed the small part that remained was converted into a fold of drapery. For Janson, on the other hand, the scroll was held in the right hand and survives in the form of "two faint parallel lines running downwards in a smooth curve, clearly the 'ghost' of a scroll that has been cut away." The folds of cloak would at the same time have been modified to reveal the bare left leg. The difficulty with both theories is that the statue has not been recut. The sling resting on the temple of Goliath must originally have been attached (by a leather or gilt copper strap) to the right hand of David, not the left.

The contrary case starts from the character of the statue. The base does not conform to the shape of the Cathedral buttresses or to the base of Nanni di Banco's *Isaiah*, and cannot, given the placing of the two feet and of Goliath's head, have been reduced from a pentagon. The head of Goliath would have been invisible at the height for which the *David* of 1408 was planned, and the treatment of detail throughout the figure, and especially on the arms and the lacing of the corselet, is so meticulous as to suggest that it was from the first designed for a close viewing point. Its structure is that of a figure intended to be seen against a flat wall surface, not of a figure fully in the round. The most logical course, therefore, is to assume that the *David* was commissioned officially about 1412, was still unfinished two years later, and was completed at the time specified in the documents. The imperfectly finished area requiring further work may well have been that in which the carving is most sophisticated, the Goliath head. The fingers of the left hand are still unfinished.

These points are of more than academic interest, since in a very real sense the singularity of the marble *David*, both as an icon and as a work of art, was a product of the circumstances in which it was made. It is not a statue casually adapted from an earlier work; it resulted from a creative act distinct from that of any statue that preceded or followed it, and its form was influenced in a decisive fashion by its intended setting. The prime view of the figure is naturally frontal. Though finished off behind, it has no back view, and the profile views from right and left are comparatively weak. But the main view is elaborated with two carefully calculated three-quarter views. The viewing point is on the level of the Goliath head and suggests that the platform on which the figure stood was about 1.8 meters (6 ft.) from the ground. When the statue is photographed from a central viewing point, the upper part of the body between the hips and shoulders appears to be higher than it should properly have been; in this it closely resembles the *St. Mark* and the seated statue of St. John. The right hand hangs forward across the thigh and the left hand

opposite: FIGURE 32.
Donatello, *St. George*. Marble,
H. 209 cm, W. 67 cm (H. 82 in., W. 26³/₈ in.).
Museo Nazionale, Florence.

overleaf: FIGURE 33.
Donatello, Head of *St. George*.
Museo Nazionale, Florence.

overleaf, above: FIGURES 34, 35.
Donatello, *St. George*: details of back
of head and right arm.
Museo Nazionale, Florence.

overleaf, below: FIGURES 36, 37.
Donatello, *St. George*: details of
left leg and right shoulder.
Museo Nazionale, Florence.

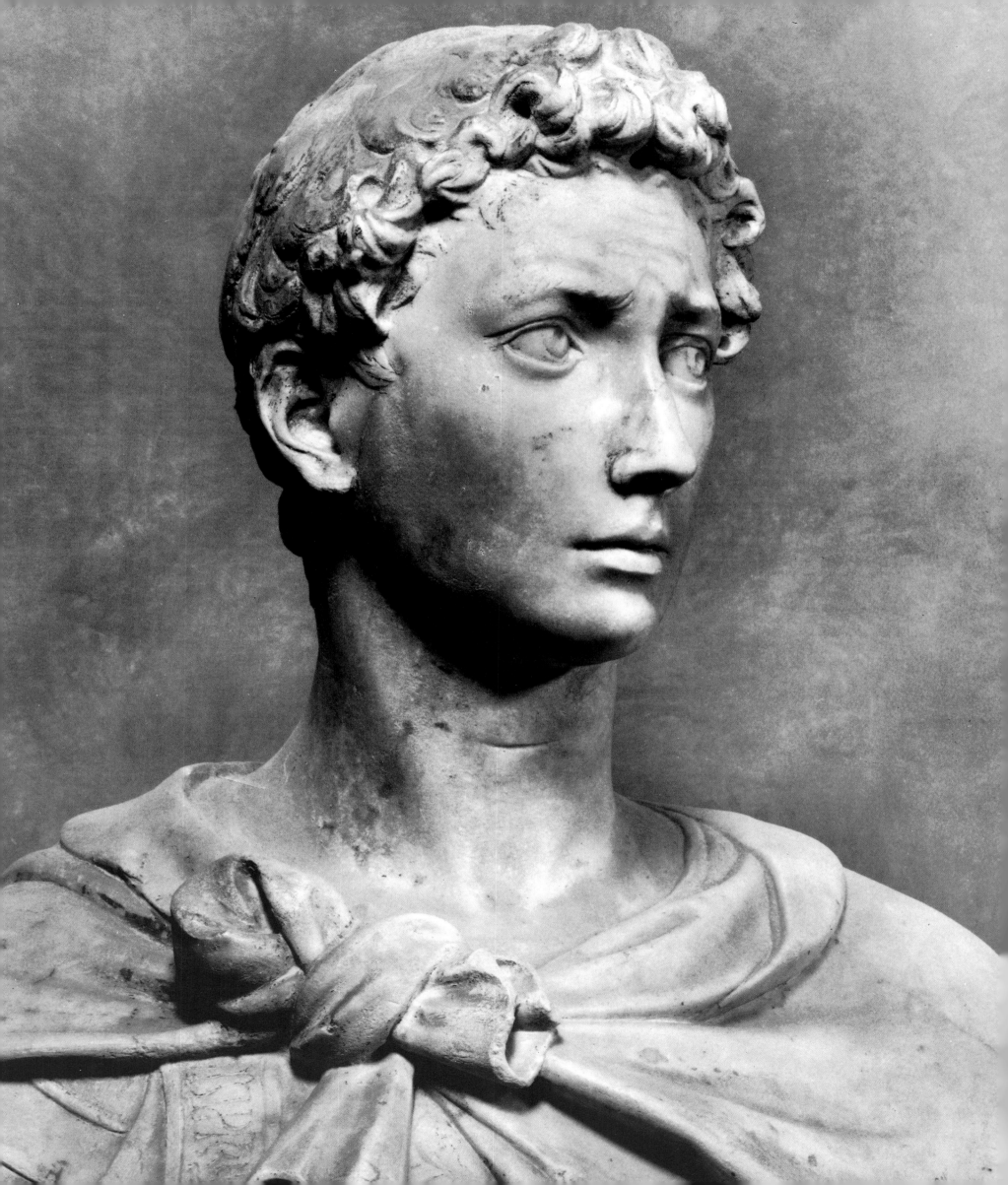

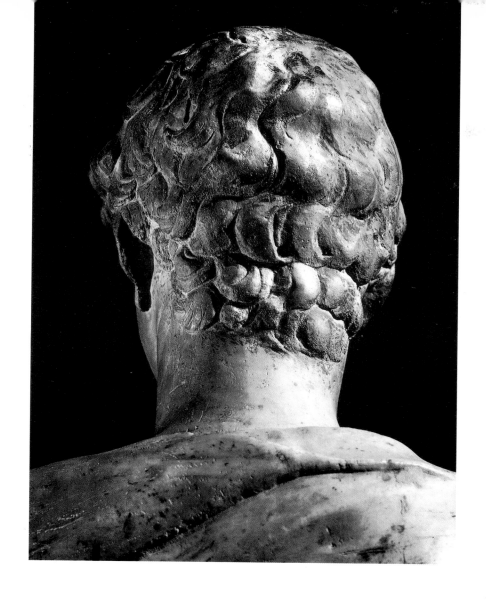

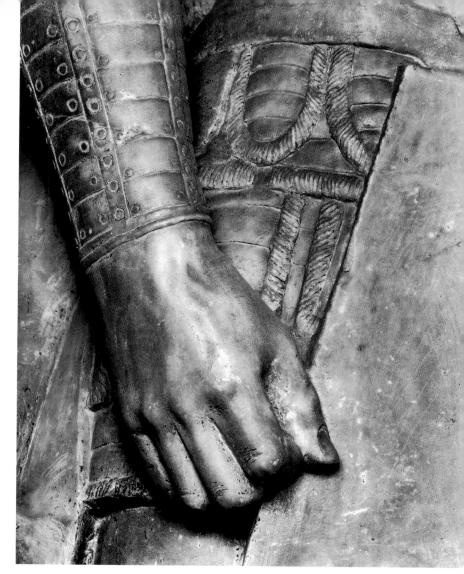

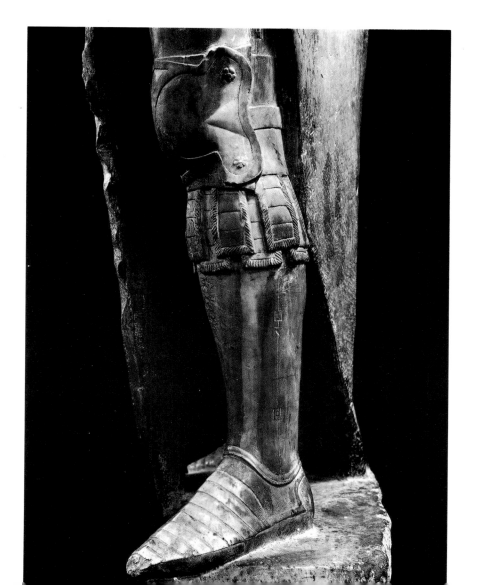

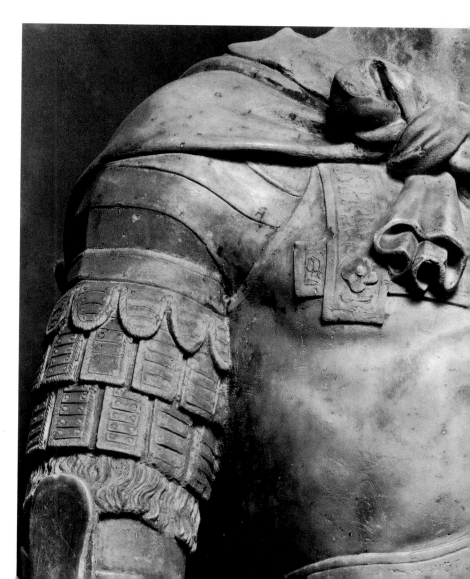

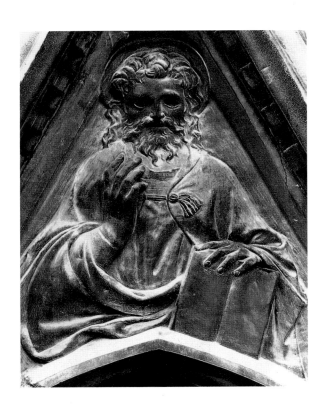

FIGURE 38.
Donatello, *God the Father*,
from the tabernacle of the Arte degli Spadai
e Corazzai, formerly containing *St. George*.
H. 68 cm, W. 64 cm (H. 26¾ in., W. 25¼ in.).
Or San Michele, Florence.

rests on the hip. It has been suggested that this pose was inspired by an Etruscan *Fig. 28* statuette of a goddess of the type of a bronze in the Museo Archeologico in Florence. Comparison of the back of the bronze statuette with the back of Donatello's statue lends some force to this view.[7] But in no Etruscan statuette do we find a pose of such resilience and subtlety. At two points—on our left, where the right foot protrudes beyond the base, and the front, where the upper molding is covered by Goliath's hair and beard—the statue breaks the confines of the plinth. At close quarters, in the Sala dell'Orologio, this must have made a powerful effect, as must the contrast between the covered and the naked legs and the contours of the two sides of the figure, one with the arm extended and knee bent and the other with the elbow bent over the column of the leg. Against a blue painted wall, the shoulders, one higher than the other, and the neck and head, at an angle to a vertical line drawn through the block, must have read more vividly than they do today. The wreath has *Fig. 31* been identified as amaranth and was presumably among the parts touched up in gold.[8] Foretastes of Donatello's future concern with surface texture are the stone in the forehead of Goliath, the leather jerkin drawn across the chest and laced tightly at the shoulder and on the sides, and the miraculously subtle treatment of the fabric of the close-fitting sleeves under which the musculature of the arms is clearly legible. So consistent is its style and so prominent was the place it occupied that some measure of humanist control over its design and iconography must be presumed.

The second of Donatello's statues on Or San Michele, the *St. George* for the *Fig. 32* tabernacle of the Arte degli Spadai e Corazzai, is no more than approximately datable.[9] The single recorded payment, of February 17, 1417, relates not to the statue but the niche. It reads:

> Item quod vendatur arti corazariorum de marmore quantum volent pro
> base quam ponere volunt sub figura de marmore quam dicta ars vult poni
> facere in facie scti. Micaelis in orte per pretio tamen soldorum vigingti pro
> quodlibet centinario.

Evidently at the time this marble was bought the statue had not been installed. Since the tabernacle was completed in 1417–18, it is reasonable to suppose that the form of the statue would have been settled at least a year earlier. Access to the upper floor of Or San Michele was by means of a circular staircase at the northwest corner of the building. For this reason the pier allotted to the Guild of Armorers could not be excavated to the same depth as the other tabernacles. This affected the architecture of the tabernacle as well as the design of the sculpture. The pilasters are adapted from those of the tabernacle containing the *St. Mark*, though with one lozenge in the center, not with two; they are not raised on imposts but continue to the base of the niche. In the gable is a low relief, of God the Father in benediction, carved by Donatello. The head of the Saint, like that of the *St. Mark*, falls on a median point between the flanking capitals. The problem it presented was not unlike that posed by the marble *David* for the Palazzo della Signoria. It, too, would be seen against a containing wall, and it is, therefore, like the *David*, carved fully in the round, and not in deep relief. Frontal though it be, it has two fully developed profile views,

which would have been visible from the street beneath. The effect is one of superb spaciousness.

One aspect of the figure was preordained, that the Saint should be shown with feet apart across the base, a stance that was usual when armor was worn. With the marble *David*, where the legs are also shown apart, stability is ensured by a cloak covering one leg. In the *St. George*, support is provided by the Saint's shield. The vertical of the cross inscribed on it runs from the base to half the height of the whole figure. This vertical is reinforced by the right arm hanging at the Saint's side and carries the eye up to the neck and head. The cloak is fastened on the right shoulder, not in the center, and the Saint's head is turned slightly to his left. In the sixteenth century, the *St. George* became Donatello's most admired sculpture, because the principles governing its structure could be exploited by sculptors dedicated to the concept of *disegno*.

The challenge presented by the subject differs from that offered by the *David with the Head of Goliath*. In place of a thin, tight-fitting leather jerkin, the St. George wears armor, and the transition at the wrists and neck between marble as flesh and marble as metal is established with unwavering skill. The suit of armor is said to be derived from a Byzantine ivory. We have, however, no reason to credit Donatello with pedagogical intentions (there is indeed every reason not to do so), and the Arte dei Corazzai must have played a significant role in planning the image. The armor is not the romantic armor a painter would have produced, but must result from careful replication of a model, which members of the armorers' guild are likely to have *Figs. 35–37* provided or, at least, on which they would have advised. In the skirt, seen from the side, the careful superimposition of one protective layer over another could have been arrived at only if the nature and function of each element were fully understood. Of the leather thongs over the knees and the protective plate on the right elbow this is no less true. For the guild, the merit of the statue may have lain in its exaltation of technique. It has been inferred from four drill holes in the head, two of them containing traces of metal, from three drill holes on the left thigh and under the left hand, and from a cavity between the right thumb and index finger that the statue originally had a metal helmet on its head, a metal scabbard strapped to its waist, and a lance or sword held in its right hand. Early descriptions of it make no reference to metal embellishments—they may indeed have been accretions of later date—and the hair can at no time have been covered by a helmet. One of the earliest *Fig. 39* reproductions of the statue occurs on an early sixteenth-century Caffagiolo dish in the Victoria and Albert Museum.[10] It is by no means an accurate record—the Saint is shown standing in a landscape setting with a different shield—but the head is there, surmounted by what appears to be a wreath, and in the right hand is an indecipherable object, probably the handle of a broken lance. A sword or scabbard is worn on the left-hand side.

The earliest published appreciation of the statue appeared in 1550 in the *Vite* of *Fig. 31* Vasari.[11] "In the head," Vasari writes, "can be read the beauty of youth, spirit and valor in arms, a proud and terrible energy and a marvelous sense of movement within the stone. Certainly in modern figures no such vivacity and spirit is to be seen in marble as nature and art effected through the hand of Donatello in this

FIGURE 39.
Cafaggiolo Majolica Dish (St. George).
Victoria and Albert Museum, London.

statue." Vasari was not alone in his admiration for the heroic symbolism of this inspired and inspiring statue. Doni, in *I Marmi* of 1552,[12] prints a dialogue between Donatello's *St. George* and a sculptor from Fiesole. "Why," asks the narcissistic statue, "do you resent my beauty? It was impossible that Donatello should represent me otherwise than as I am." The planes of the face are strongly particularized, hence the temptation (to which Doni fell victim) to invest it with a human identity. In 1571 an appreciation of the statue, *Dell'Eccellenza del San Giorgio di Donatello*, was prepared by Francesco Bocchi,[13] and, from then to our own day, it has been unanimously and enthusiastically praised, and credited with a weight of meaning it could not have carried when it was produced.

Fig. 33

Though he was trained as a metalworker, Donatello's early works were, with the exception of the gigantic figure of Joshua on the Duomo, carved in marble, and only about 1420, in his third statue for Or San Michele, did he intrude on what till then had been Ghiberti's territory, statuary in bronze. This change, which must have affected the composition of his studio, seems to have been instigated by the most powerful corporate body in Florence, the Parte Guelfa.[14]

After the Ciompi revolution in the fourteenth century, the Parte Guelfa (with which Donatello's father was in a modest fashion associated) controlled the government of the city, and though its status by the second decade of the fifteenth century had started to decline, it continued to regard itself, and to be regarded, as heir to the militia that protected Florence under republican Rome. This symbolic role is reflected in two major commissions placed by the Parte Guelfa at this time. The first, for the Sala Grande of the corporation, was entrusted to Brunelleschi and was finished in 1423. The second, on Or San Michele, was a commission to Donatello for a tabernacle and for a bronze statue of the saint who had been adopted as patron of the Parte Guelfa soon after 1386, St. Louis of Toulouse.[15]

The importance that the Parte Guelfa attached to its Or San Michele tabernacle is attested in the first place by its size. With one exception, the antecedent tabernacles are of uniform width; they are set in the center of each pier with a free area of wall at either side of roughly half the width of the tabernacle. The single exception is the tabernacle of the Arte dei Maestri di Pietra e Legname, which is constructed with sufficient width to accommodate four statues. The tabernacle of the Parte Guelfa, in contrast, covers the whole width of the pier and is thus double the width of all but one of the earlier tabernacles. Set in a preferential position in the center of the east face of the building, its style throughout is classical. The high Corinthian pilasters associated with smaller Ionic columns seem to have been inspired by the interior of the Baptistry, and the shell motif within the niche derives from an antique sarcophagus, as does the pediment. Two flying putti on the front face of the base, holding a wreath, and two double-sided bearded heads, one of them much damaged, which fill the corners, also derive from classical sarcophagi. The dominant influence on the architecture is that of Brunelleschi, who may have been responsible for advising on or supervising the design. The pilasters are Brunelleschan; in their heavier form they anticipate the pilasters that flank Masaccio's fresco of the Trinity, and other features look forward to the Loggia of the Spedale degli Innocenti. But much of the detail can be due only to the sculptor by whom the niche was executed;

Fig. 40

opposite: FIGURE 40.
Donatello, *Tabernacle of the Parte Guelfa.*
Or San Michele, Florence.

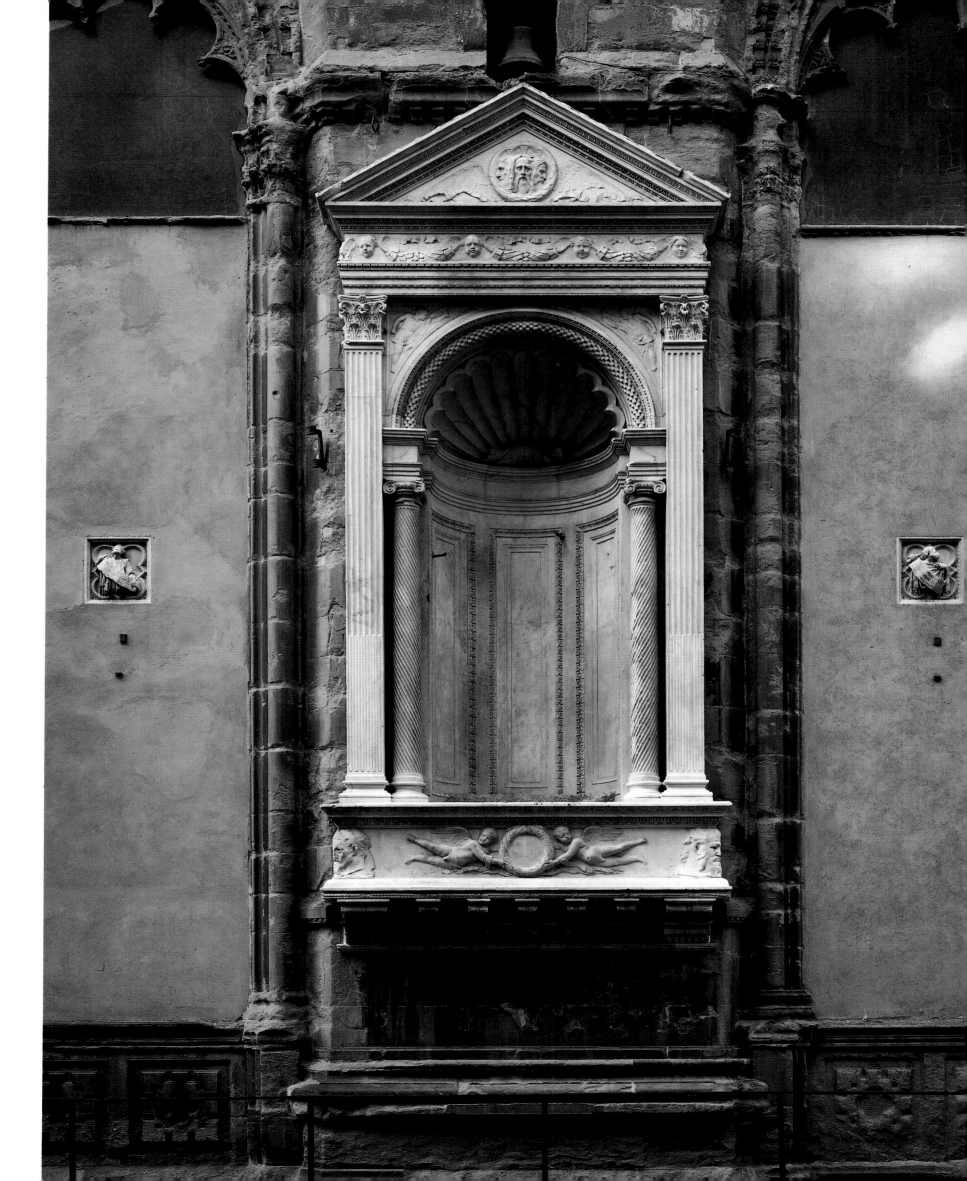

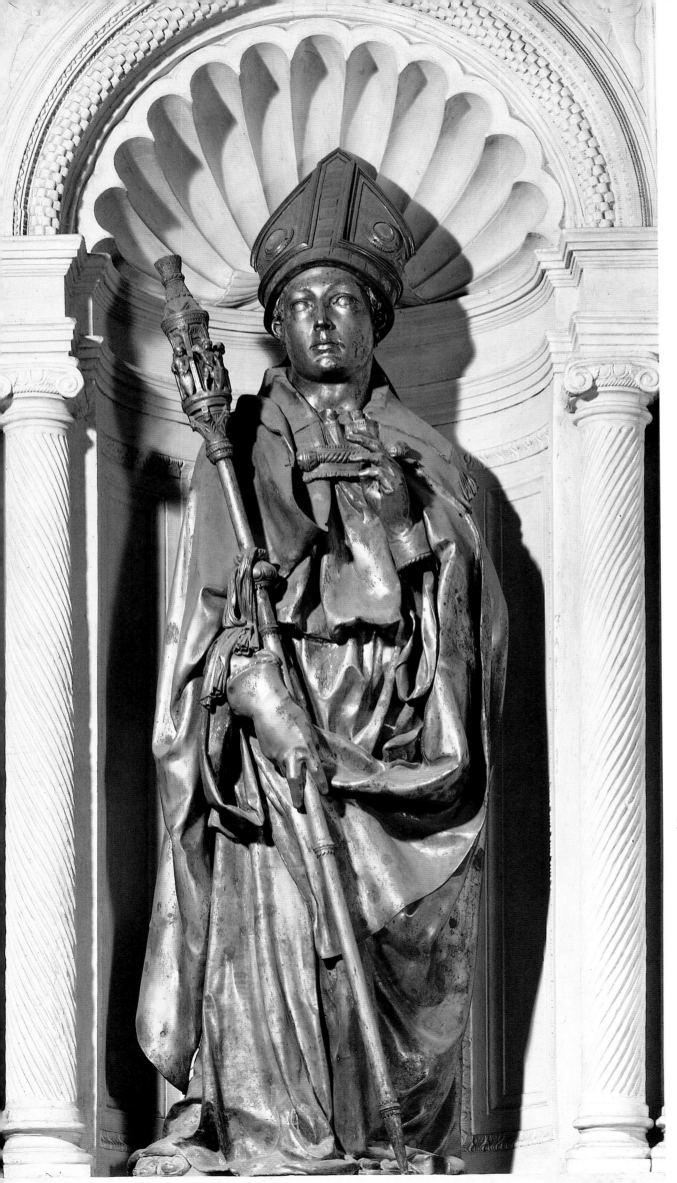

left: FIGURE 41.
Donatello, *St. Louis of Toulouse*. Gilt bronze,
H. 266 cm, W. 85 cm, D. ca. 75 cm
(H. 105 in., W. 33½ in., D. 29½ in.).
Museo dell'Opera di Santa Croce,
Florence.

opposite: FIGURE 42.
Donatello, Head and Mitre
of *St. Louis of Toulouse*.
Museo dell'Opera di Santa Croce,
Florence.

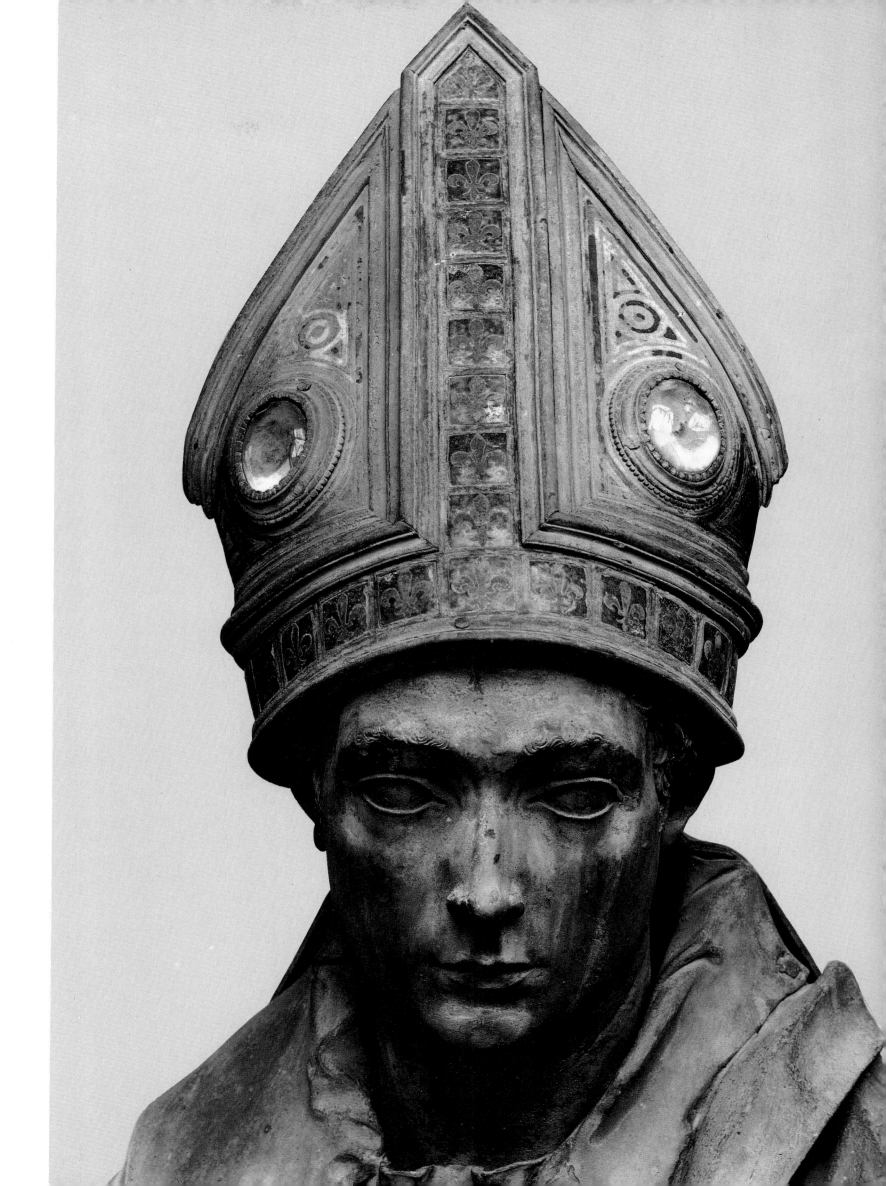

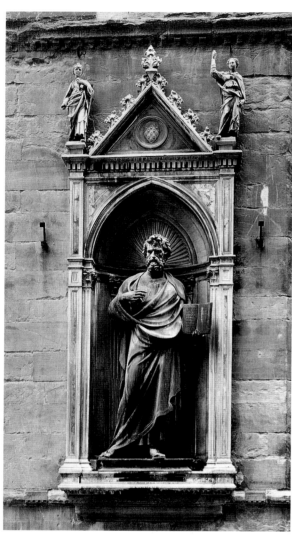

this includes the magnificent three-headed Trinity, the flying putti, the bearded heads at the base, the billet molded arch, and the strip of fictive straw matting with a tie above each of the seven consoles. The logical course, therefore, is to regard the niche as a work conceived by Brunelleschi but carried out and elaborated by Donatello.[16]

The far from complete records of the Parte Guelfa after February 1419 contain no reference to the commissioning of the statue. In May 1423 three hundred florins were voted by the commissioning body, the Council of the Parte Guelfa, for the purchase of bronze. There is reliable, though later, evidence from the codex of Buonaccorso Ghiberti that the total cost of the *St. Louis* (exclusive of its gilding) was 449 florins. The statue was completed and installed in its niche by November 1425, and two-thirds of the sum due to Donatello seems to have been paid between the summer of 1423 and the last months of 1425. Work on the figure must have followed immediately on Ghiberti's *St. Matthew* for the Arte del Cambio, which was begun in 1418 and installed in 1423.

Seen in isolation in the Museo dell'Opera di Santa Croce, the *St. Louis of Toulouse* is a strange work.[17] If it resulted, however, as is likely, from conscious competition between two commissioning authorities and two great sculptors, much that is puzzling becomes plain. Its height is roughly equivalent to that of Ghiberti's *St. Matthew* (270 cm [106 in.]) but its scale is larger, since the measurements of each of Ghiberti's statues include a molded base. The weights of the *St. Louis* and the *St. Matthew* are roughly equivalent (the *St. Louis* made use of 3,277 libre of bronze, and the *St. Matthew*, which was originally assessed at 2,500 libre, seems, to judge from a quantity of bronze bought for the purpose in Venice in May 1420, to have consumed 500 libre more). Unlike the *St. Matthew*, the *St. Louis of Toulouse* is fully gilt. The *St. Matthew* is cast in three sections—the head and body, and the base, which seems to have been faulty and was recast. The *St. Louis*, on the other hand, is cast in eleven sections. They include the elaborately decorated miter, which is cast separately from the head; the head, which is cast separately from the body; the crozier, which now lacks its separately cast crook; the gloved hands, which are likewise cast independently; and the sections of the cope, from which two pieces are missing at the back. One section, the left shoulder, was recast so that it could be elevated to correspond with the shoulder opposite. In its present state, the figure requires a rear support for stability, and though its structure must originally have been firmer, at no time can it have had the solidity of the *St. Matthew*. When the gilding of the statue was revealed by cleaning in 1945, its sectional casting was ascribed to the fact that it was to be fire gilt. Conceivably, the casting technique of the *St. Louis* was arrived at with gilding in mind; but probably this was a by-product, not the main reason for the change. Ghiberti's *St. Matthew* is a static figure set flat against its shallow niche. Though one knee is slightly bent and the right hand is raised, the figure cannot be conceived in any other than its actual pose. *St. Louis*, on the other hand, is represented, like Donatello's *St. Mark*, in arrested movement, with the right shoulder pulled back and the left foot advanced. The head, seen from its natural viewing point halfway across the street, is turned upward, as though seeking divine guidance, and the right hand is raised in a gesture of benediction directed to the

Fig. 41

Fig. 43

Fig. 47
Figs. 45, 4[6]

Fig. 44

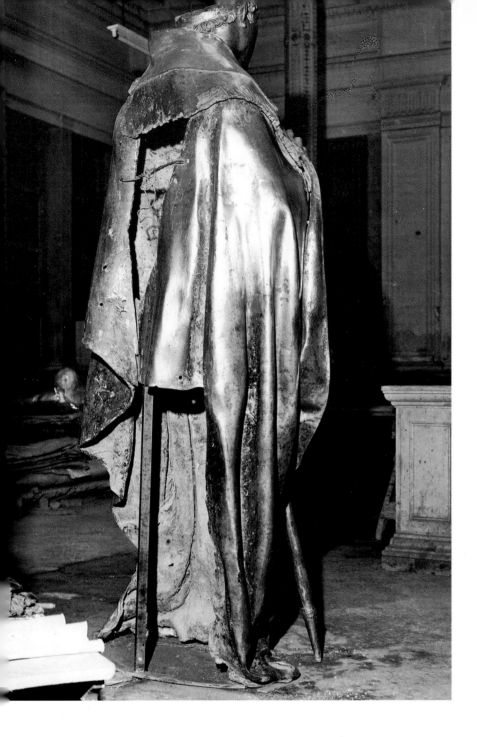

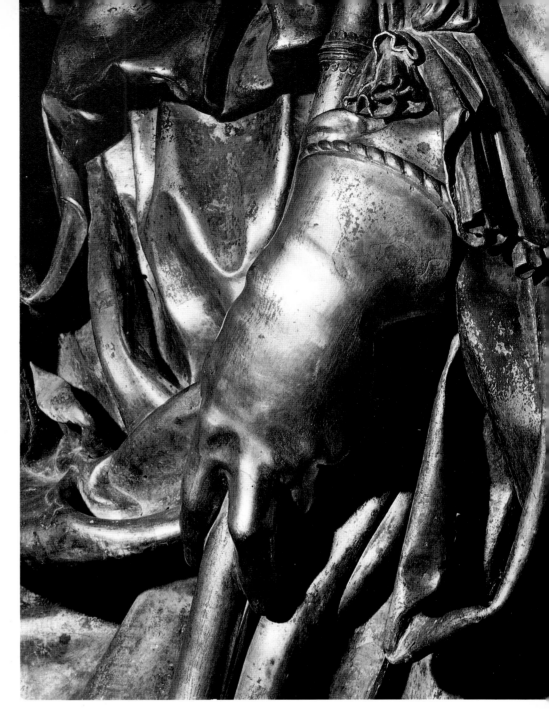

onlooker. The weight of the heavy crozier (greater then than it appears today, since the upper part has disappeared) is supported between two spread fingers, and the thumb and the fourth and fifth fingers hold up the left side of the cope, which is turned back over the shoulder. The illusion of movement extends from the cope to the alb beneath. We can visualize how the Saint's figure looked before and after it adopted the pose that it has now, when the right hand would have been lowered and the right side of the cope would have been released by the left hand. In an integral cast, this transitory effect would not have been attainable. The use of sectional casting, therefore, is likely to result not from practical considerations alone, but from the function the statue was intended to fulfill; the purpose was expressive and not simply technical. The prime advocate of sectional casting was Brunelleschi, whose trial relief of the Sacrifice of Isaac is cast in seven sections, not, like the trial relief of Ghiberti, in one.

left: FIGURE 44.
Donatello, Back of *St. Louis of Toulouse*.
Museo dell'Opera di Santa Croce,
Florence.

right: FIGURE 45.
Donatello, Left hand of *St. Louis of Toulouse*.
Museo dell'Opera di Santa Croce,
Florence.

One feature of the statue, the crozier, could not have assumed its present form unless it were cast separately from the main figure.[18] The knop beneath the missing volute is decorated with six tall shell niches divided by pilasters and separated from each other by projecting balustrades, the upper surfaces of which are represented in perspective so that the space between them is invested with artificial depth. Three of the niches are filled with classical putti holding shields. The first bronze statuettes of the Renaissance, these figures are best discussed in the context of the somewhat later angels on the Siena Baptismal Font.

In the middle of the fifteenth century the Parte Guelfa gave up its tabernacle on Or San Michele, which was sold to the Mercanzia, and between 1451 and 1459 the statue of St. Louis was transferred to Santa Croce, where it was installed high on the façade. It is now exhibited in the Museo dell'Opera di Santa Croce in a modern pilaster reproduction of the tabernacle. It is hard for this reason to gauge the effect it originally made. Its exact position in the niche can, however, be established from an old filling in the floor at the point at which the Saint's crozier originally touched the

left: FIGURE 46.
Donatello, Right hand of *St. Louis of Toulouse.*
Museo dell'Opera di Santa Croce,
Florence.

right: FIGURE 47.
Donatello, Head of *St. Louis of Toulouse.*
Museo dell'Opera di Santa Croce,
Florence.

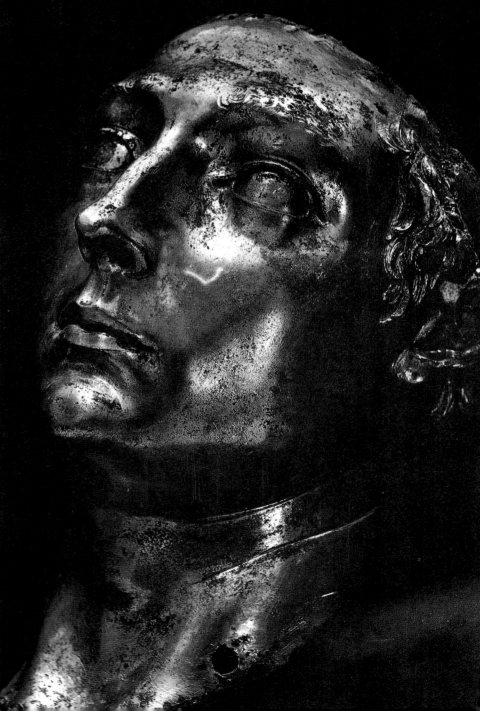

ground. The most ostentatious of the Or San Michele statues, it would have harmonized more closely with the marble of the niche than it does with its present plaster background, and with its enameled miter and its heavy crozier it must have made an opulent, indeed a dazzling effect. The simple architrave over the columns, at the correct viewing point, effectively isolates the head. Its proportions were determined by or adjusted to the pier on which it was set; the total width of the pier (4½ braccia da panno) corresponds with the height of the statue and is half the overall height of the tabernacle. Seen in isolation, the statue is deprived of this carefully contrived effect.[19]

This is among the reasons why the *St. Louis* has enjoyed a critical press. In the middle of the sixteenth century, Gelli, who knew it only on the façade of Santa Croce, described it as Donatello's "least beautiful figure. When a friend asked him one day why he had made the statue so clumsy and unlike his manner, he replied that he believed he had never made a statue that was truer or closer to nature than this one. And when his friend laughed at this he added: 'I had to show that this man renounced a kingdom for the sake of becoming a friar. What sort of person did that make him, do you think?' "[20] Vasari, also unaware that the statue had been made for Or San Michele, records it in 1550 "above the door of S. Croce . . . five braccia tall. When reproached that this was a clumsy figure and perhaps the least successful of all his works, he replied that he had made it that way on purpose, since the Saint had been a clumsy fool to relinquish a kingdom for the sake of becoming a friar."[21] In 1591, in Bocchi's *Le bellezze della città di Fiorenza*, traces of this story linger on. "The artist," says Bocchi, "did not like this figure, which through accident had been made rather hastily, and did not number it among his best efforts. Still, it is prized today as a work of a master of limitless ability, for its lifelikeness and great knowledge it betrays."[22] Donatello may well in later life have disavowed the figure, but he would have done so on different grounds. Each of his marble statues had a clearly defined identity that was a product of his own imaginative faculty. With St. Louis of Toulouse, however, he was fettered by a conventional iconography that ran in Santa Croce from a Giottesque fresco in the Bardi Chapel to the frescoes of Agnolo Gaddi in the Castellani and Alberti chapels. In the Parte Guelfa statue, the gesture of benediction is made with a gloved not a naked hand, the vestment is heavier, and the signs of office, the miter and the crozier, are more strongly emphasized, but some of the blandness of the Saint's traditional iconography remains. For that reason, a wide gulf separates the *St. Louis* from those statues in which the sculptor was a free agent, an Apelles conjuring human forms from stone.

Donatello was not a bronze caster, and we do not know in what foundry the *St. Louis of Toulouse* was cast. There is no reference to it in the 1427 *catasto* return of Giovanni di Jacopo degli Strozzi, the *calderaio* who was responsible for casting Donatello's second recorded bronze sculpture, a reliquary bust of San Rossore now in the Museo Nazionale di San Matteo at Pisa.[23]

III

The Statues for the Campanile

THE *ST. GEORGE* APART, Donatello's work in the second decade of the century is exceptionally well documented. For sculptors capable of figure carving, it was a period rich in opportunity. The only marble sculptor whose work ran a close second to Donatello's, in quality if not in inventiveness, was Nanni di Banco, who was engaged after 1415 on the time-consuming *Assumption of the Virgin* over the Porta della Mandorla. But the payments by the Duomo show very clearly that primacy among the sculptors employed there rested with Donatello. He must indeed have enjoyed the same preeminence in his own field as Brunelleschi in architecture, and fortunately for posterity their relationship remained, as it had been from the beginning, very close. So productive was Donatello that it is not always easy to establish the rhythm of his work. The execution of the *St. John the Evangelist* for the façade of the Cathedral was evidently interrupted by work on the *St. Mark* for Or San Michele. As soon as the *St. Mark* was finished, he returned to and completed the *St. John*; and when the *St. John* had been installed he was diverted to a new project, the provision of statues for the vacant niches in the Campanile of the Cathedral.

There were sixteen niches in all, four on each face. In the trecento, eight of them had been filled with statues, six by Andrea and Nino Pisano and two, conjecturally, by the painter-sculptor Maso di Banco.[1] Eight niches, therefore, were vacant at the time Donatello started work. The trecento prophets stood on plinths, whose front faces were aligned with the front face of the niche. In three cases a hesitant attempt was made to portray potential movement, but the remaining five were heavily robed frontal figures blocking the interior of the niche. A program for the filling of

56

all sixteen niches may have been drawn up at this time. Two female figures represent the Erythraean and Tiburtine Sibyls, and the niches of two of the male figures are inscribed with the names of David and Solomon. The four other trecento Prophets are unidentified. The first two statues commissioned from Donatello are also unnamed. A tantalizing record of the commission for them reads "duas figuras marmoris albi, videlicet. . . ." and in the payment for the first when it was finished the same lacuna occurs: "Una figura per eum sculta seu intaglata pro opere, que vocatur et facta est ad similitudinem. . . ." In an artist as closely concerned as Donatello was with the moral character of the figures he portrayed, these voids are a serious loss.

The Prophets from the Campanile are now displayed at eye level in the Museo dell'Opera del Duomo, and in looking at them there two points must be borne constantly in mind. The first is that the niches on the Campanile are of the order of fifty feet from the ground. The statues, therefore, were originally more than six times as distant from the eye as the *St. John the Evangelist* and the *St. Mark*. Differentiation of texture, which bulked so largely in Donatello's mind in the *St. Mark*, was here of no account. Instead there was a premium on facial expression legible at the height at which the statue would be seen and on legible movement within the niche. The second is that the size of each statue was dictated by the height of the niche. The figures are consequently smaller than the *St. Mark*, which measures 236 centimeters (93 in.), and have a height of the order of 190 centimeters (75 in.).

The first of Donatello's Prophets was carved over a period of three years. It was commissioned along with a second Prophet on December 5, 1415, and interim payments were made for it in March 1416 and in the summer and autumn of 1418.[2] The balance of the agreed fee of one hundred florins was paid to Donatello in December of that year. By this time work was proceeding on the second Prophet. An interim payment was made for it in October 1419, and it was completed in July 1420.[3] The statues were commissioned for the two outer niches on the east face of the Campanile. The only other sculptor involved in the Campanile sculptures at this early stage was Nanni di Bartolo, called Rosso, whose name first appears in 1419 in connection with a statue for the façade of the Cathedral.

Though they were commissioned simultaneously, there are substantial differences between the first two Prophets carved by Donatello. As with the *St. Mark*, so here, the carving of both figures must have been preceded by the making of full-scale clay or gesso models, which may well have been prepared concurrently. But the documents prove that the Prophets were carved in sequence, and the earlier, therefore, must logically be the figure that is most closely related to the *St. Mark*.

Fig. 49 This is the *Bearded Prophet*,[4] where the rhythmical carving of the beard, the treatment of the furrows across the forehead, and the incised eyelids must, when the surface of the figure was intact, have been all but indistinguishable from those of the statue at Or San Michele. The structure of the Campanile statue is, however, very different. The right foot, the left hand, the right hand pressed to the chin, and the head itself are set on a single vertical, while the left foot is in a forward plane and projects over the corner of the base. The meditative face is turned downward,

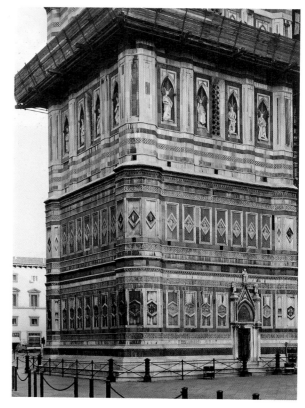

FIGURE 48.
The Campanile of the Cathedral in Florence.

FIGURE 49.
Donatello, *Bearded Prophet*. Marble,
H. 193 cm, W. 64 cm, D. 44 cm
(H. 76 in., W. 25 in., D. 17³/₈ in.).
Museo dell'Opera del Duomo,
Florence.

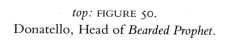

top: FIGURE 50.
Donatello, Head of *Bearded Prophet*.

below: FIGURE 51.
Donatello, Head and torso
of *Beardless Prophet*.

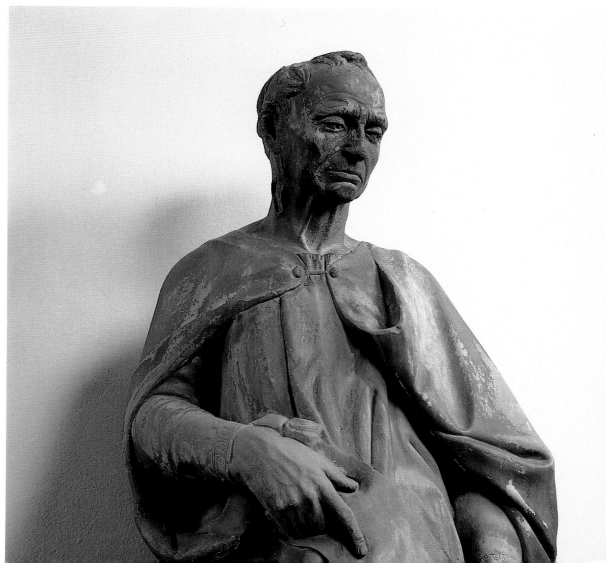

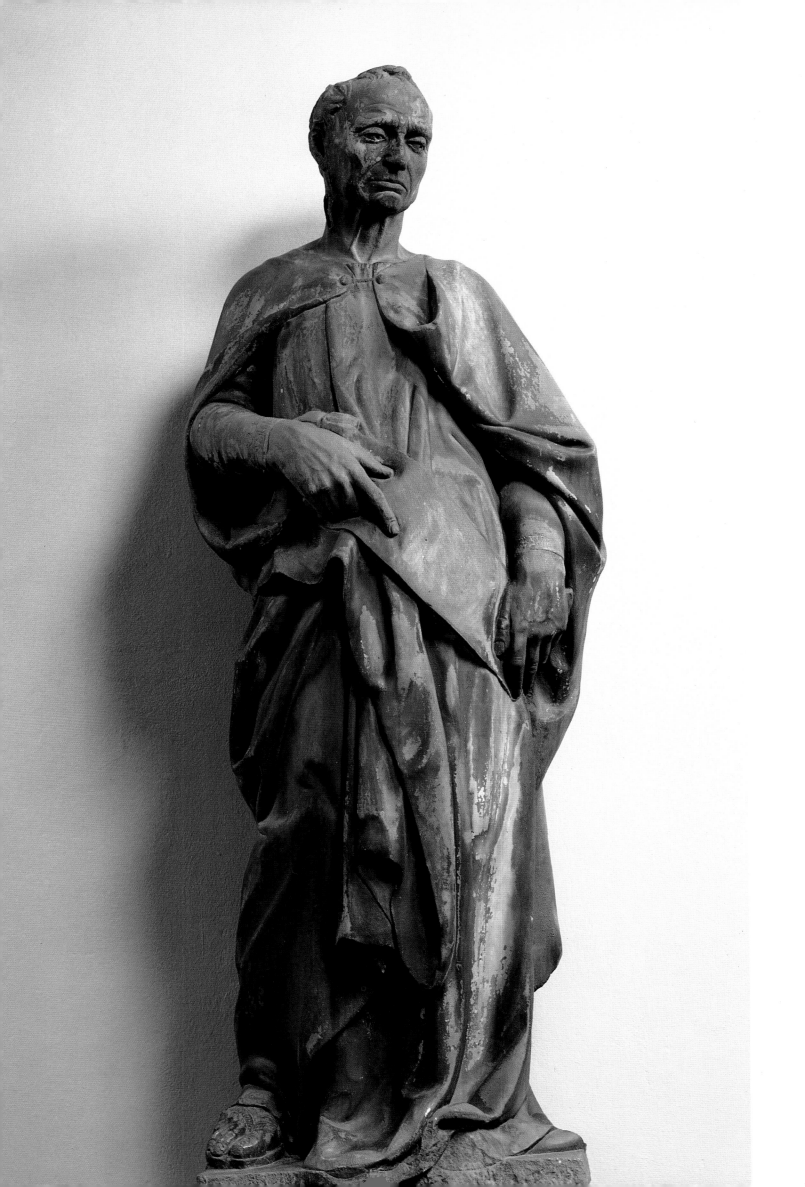

gazing at the street beneath. The dress is not a toga, but a heavy cloak, of which the bottom edges are disposed on intersecting diagonals. The linear geometry of the front plane serves to establish its sculptural identity at the distance from which it was intended to be seen.

Fig. 52
Fig. 51

The *Beardless Prophet* follows the same structural principles.[5] The controlling vertical has its base in a fold of drapery falling over the center of the plinth and continues through the thumb and pointing finger of the right hand to the point of juncture of the two sides of the cloak beneath the throat. The weight rests on the left leg, and the right foot is shown as though in movement, with the heel free of the ground. The right hand points at a scroll held diagonally across the hip, and the sense of this gesture, as one of warning or exhortation, is enhanced by the angle of the head registered in the act of addressing an onlooker below. The most surprising feature of this surprising sculpture is the face, the first occasion on which Donatello experiments in statuary with the employment of a portrait type. Its genesis is classical, in the sense not that it imitates a specific Roman bust, but that without close study of Roman portraiture it could not have been produced. In the fifteenth century this figure and the two later prophets in which realistic heads appear were regarded as portraits of leading figures of the time. This explanation may be due to some popular reaction to the statues when they were installed, and is likely to be incorrect, but the fact that this and later heads were modeled from the life is hardly open to dispute. Alberti, in his treatise on sculpture, distinguishes between sculptors who believe "that they have done enough if they have succeeded in making their work like a man, albeit a completely unknown one," and those who "strive to represent and imitate not simply a man, but the face and the entire appearance of the body of one particular man, say Caesar or Cato in this attitude and this dress, either seated or speaking in court, or some other known person."[6] In the *Beardless Prophet*, Donatello's intention was to impose on the head of an ideal figure a vividness and actuality that could only be achieved by study from the life, and a life model consequently was employed. Two separate processes must have been involved, first the modeling, in wax or clay, of a selected sitter's head, and then its transposition into marble. Some light is thrown on the whole process by a figure of Joshua carved for the façade of the Duomo about this time.[7] It was commissioned in October 1415 from Ciuffagni. Two years later Ciuffagni left Florence, and in April 1418 the statue was turned over for completion to Donatello. Nothing more is heard of it till April 1420, when it was passed on to Donatello's collaborator on the Campanile statues, Nanni di Bartolo, by whom it was finished in the following year. The commission to Rosso, however, contains one peculiar condition, that he should remove the marble head of Ciuffagni's figure and replace it with another head. As can be seen

Fig. 53

from the statue, which is now in the Cathedral, this was done. The features of the replacement head are strongly marked, and its eyes are lowered, like those of Donatello's figures for the Campanile. Though its flaccid execution precludes the possibility that it was carved by Donatello, it almost certainly depends from a Donatello model of the class of those prepared for the *Beardless Prophet* and for the later prophets on the Campanile.

Concurrently with the *Beardless Prophet*, Donatello was involved in 1418 with a

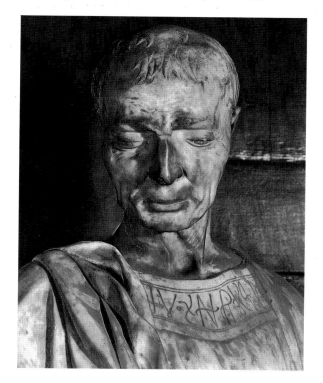

opposite: FIGURE 52.
Donatello, *Beardless Prophet*. Marble, H. 190 cm, W. 64 cm, D. 43 cm (H. 75 in., W. 25 in., D. 17 in.). Museo dell'Opera del Duomo, Florence.

FIGURE 53.
Nanni di Bartolo (after Donatello), *Joshua*. Marble. Duomo, Florence.

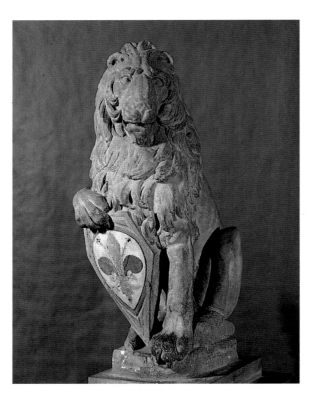

FIGURE 54.
Donatello, *Marzocco*. Pietra di macigno,
H. 135.5 cm, W. 38 cm, D. 60 cm
(H. 53³/₈ in., W. 15 in., D. 23⁵/₈ in.).
Museo Nazionale, Florence.

secondary official commission for a work in sandstone (*pietra di macigno*). A gray stone that was easier to work than marble, it was not in the long term weather-resistant, but was suitable for interior use. When Pope Martin V arrived in Florence at the end of February 1419 on his way to Rome, he was housed at Santa Maria Novella, where a new staircase was built linking the papal apartments to the large cloister. The stairway was built of *pietra di macigno*, and for the newel posts *pietra di macigno* was used once more. A passage of about 1420 later noted by Carlo Strozzi describes Donatello as "doing a sandstone lion to stand on the column of the stairs."[8] In Florence, the lion—or *marzocco*—carried a civic significance; a fourteenth-century *marzocco* standing on the *ringhiera* of the Palazzo Vecchio was decorated with a crown and a patriotic inscription by Francesco Sacchetti. When the staircase at Santa Maria Novella was demolished in 1515, Donatello's sculpture was stored, but in the early nineteenth century it was substituted for the trecento *marzocco* outside the Palazzo Vecchio. Though it gained in civic stature in its new position, it became much weathered, and in 1885 it was moved to the Bargello. Donatello's *Marzocco* is shown seated. With one foot over the front edge of its base, *Fig. 54* it holds up with its right paw an inlaid shield with the lily of Florence. The carving of the mane recalls that of the *Beardless Prophet* on the Campanile, and the treatment of the anthropomorphic head does so, too. Its features are distorted in the interests of effect, and it has indeed, casually not in intention, the character of portraiture.

A close association between Donatello and Rosso seems to have been built up through the early years of work on the statues for the Campanile, and the third work to be commissioned, a group of Abraham and Isaac, was contracted jointly to *Fig. 55* both sculptors.[9] The first reference to it occurs on March 10, 1421, in the form of an agreement approved in Donatello's absence by Rosso ("absente dicto Donato"). One of the documents is of particular importance. No reference occurs in the payments for the first two Prophets for the Campanile or for the *St. Mark* to the preparation of preliminary models. The contract for the *Abraham and Isaac*, however, distinguishes between the making or modeling of the sculpture, its blocking out, and its translation into marble ("possint facere construere intagliare et scolpire eundum figuram marmoris . . . et sic eisdem ad faciendum et sculpiendum ipsam figuram"). The group was completed very rapidly, and the final payment of ninety-five florins was made to the two sculptors on November 6, 1421. It represented the same subject that had been selected for the trial reliefs for the bronze door of the Baptistry, and in spirit, though not in form, Donatello's group reflects the heroic scene of Brunelleschi's competition relief. But the possibilities that lay open to the sculptor were limited by the width of the block and the dimensions of the niche, which made it all but inevitable that the figures should be represented in two planes, Isaac kneeling in the foreground and the towering figure of Abraham standing behind him. The moment depicted has been variously explained as the act of sacrifice and that of relaxation after the sacrifice has been suspended. That such a doubt arises is due to the unincisive carving of the much-praised head of Abraham; it conveys no sense of tension like that in the hair and beard of the *Bearded Prophet*, and it must be in great part by Rosso, sharpened up locally at a late stage by Donatello. The most strongly carved areas are the right shoulder and arm, the right *Fig. 56*

hand holding the sacrificial knife, and the right leg with its foot raised on a pile of wood. The Isaac, in profile with hands bound, kneeling on the left knee with the right knee and foot extended to the extreme front of the base, is likely to derive from some sarcophagus relief and should logically have been carved by Donatello, but its execution suggests the contrary, that it is by Rosso. It would be wrong, however, to judge the *Abraham and Isaac* solely by its surface working, for its scheme is of great originality and the model for it can only have been made by Donatello. The dominant vertical is imposed more strongly than in either of the earlier Prophets and runs through the forward knee of Isaac, the left hand of Abraham, and the folds of drapery, and is elaborated above by the contrary axis of Abraham's head and shoulders, and below by the inverted axis of hips and thighs, to which the Isaac, with his left shoulder withdrawn, forms a complement. The merit of this extraordinary design seems not to have been recognized by Donatello's contemporaries, but in the early sixteenth century it provided a source of inspiration for Andrea del Sarto.

With the completion of the *Abraham and Isaac* the first stage in the plan for the filling of the four niches on the east face of the Campanile was complete. They were occupied by Donatello's *Bearded and Beardless Prophets* and the *Abraham*. The fourth niche contained an earlier work by Donatello, the *David as Prophet*, which was originally intended for one of the buttresses of the Cathedral. The four niches on the north side of the Campanile facing the Cathedral were still vacant and were eventually filled with two further statues by Donatello, the *Jeremiah* and the *Habakkuk*, with a third statue, probably of Jonah, inscribed with Donatello's name and known, from the later inscription ECCE AGNUS DEI on its scroll, as St. John the Baptist,[10] and with the signed *Obadiah* of Rosso. The identity and authorship of the *Obadiah*, for which Rosso received a final payment at the end of 1422, is established by an inscription on its scroll: JOHANNES ROSSUS PROPHETAM ME SCULPSIT ABDIAM.

The case of the *Jonah* or *John the Baptist* is less clear cut. It is inscribed with Donatello's name, but not in the convincing form OPVS DONATELLI that is found on the companion Prophets from the same face of the Campanile, and may have been commissioned for the façade and transferred to the Campanile in 1464, when the statues on the north face were moved to the west face. Like the Prophet in the interior of the Cathedral, its head is carved separately, but, unlike the Prophet, it seems to have been planned in two sections from the start. We have indeed documentary confirmation that this is so. In July 1419 a marble statue, as usual of an unspecified Prophet, was commissioned from Rosso, who received permission to carve it in two parts, one the head and neck and the other the rest of the body. Later in the same month he was allowed to employ another marble carver to work with him on it. A final payment for it was made on March 19, 1420. These payments *Fig. 57* almost certainly refer to the so-called *St. John the Baptist* in the Museo dell'Opera del Duomo. Its stance derives from that of Donatello's marble *David*, but the diagonal folds of cloak over the right leg are more highly developed. The placing of the scroll and of the two hands holding it is more coherent than in Rosso's *Obadiah*, and the head is more compact. If the figure were carved from a model by Donatello and if

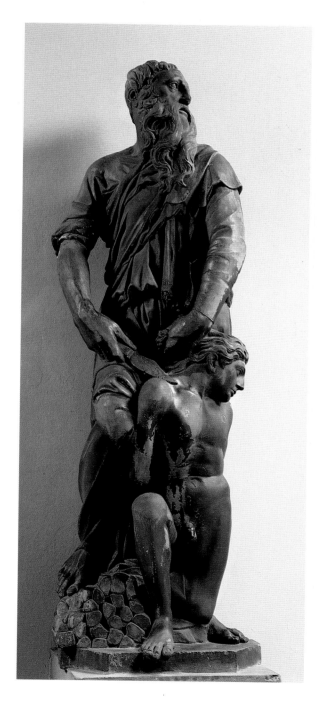

FIGURE 55.
Donatello, *Abraham and Isaac*. Marble, H. 168 cm, W. 56 cm, D. 45 cm (H. 66 in., W. 22 in., D. 18 in.). Museo dell'Opera del Duomo, Florence.

63

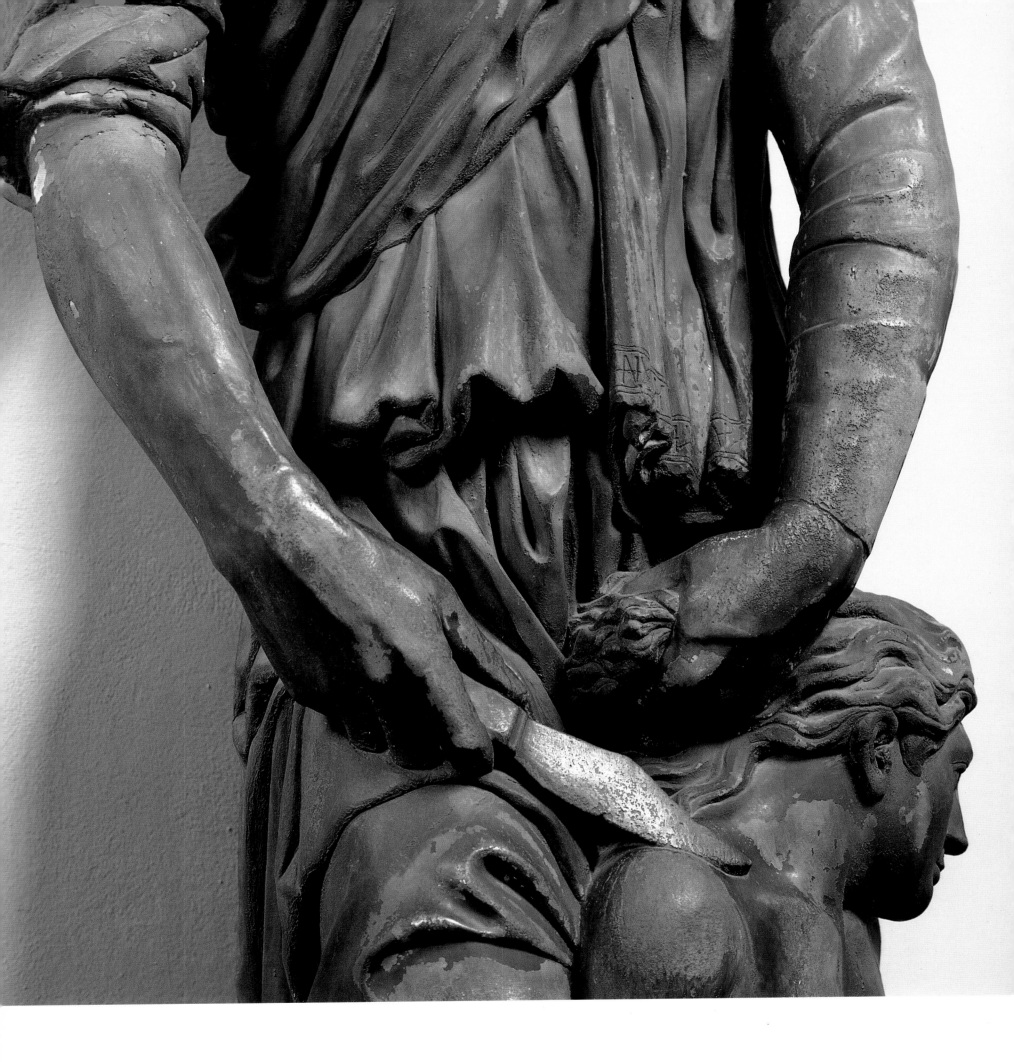

Donatello intervened in its execution only in the head, this inconsistency could be explained. But it remains inferior both to the two autograph statues made by him for the east face of the Campanile and to the two statues carved for the north face.

By 1421 the financial confidence that had sustained sculptural activity in the Cathedral workshop for the preceding fifteen years had started to abate. An investigation was ordered into the efficiency of the manufacturing activities from which Florence derived its wealth, and thought was given to mitigating the pressure of taxation. In addition, a new military threat loomed on the horizon with the attack of Filippo Maria Visconti on Genoa. As a countermeasure, the Florentine republic purchased the port of Livorno. In consequence of this and of the subsequent war with Milan, the Arte della Lana decided to renege on commissions for the Cathedral sculptures, and on September 28, 1423, work was suspended on all statues that had been commissioned but had not been begun.[11] Donatello was exempted from this ordinance, and was authorized to continue work on two Prophets for the Campanile, the carving of one of which was already under way. Exceptions were also made for a statue by Giuliano da Poggibonsi, which had been blocked out at Pisa and on which work therefore ranked as having started, and for another by Rosso, who in 1424 left Florence for Volterra and Venice. Rosso's unfinished statue was handed over for completion to Ciuffagni. Payments for Donatello's statue are recorded on March 9 and August 27, 1423, and work on it was still in progress in May 1425. In February of the following year it was valued by three assessors, and a month later Donatello was paid the customary sum of ninety-five florins.[12] An interim payment to him for another statue for the Campanile was made on February 11, 1427.[13] The statue represented Habakkuk ("una figura fa chiamata Abachucho profeta").[14] By this time, Donatello, under pressure from large-scale commissions from bodies other than the Duomo, had formed a partnership with the sculptor Michelozzo, and a tax return put in by Michelozzo in the summer of that year refers to a marble figure for the Duomo three and a third braccia high that was three-quarters finished. Continuing payments for this figure were made to Donatello alone in January 1434 and June 1435, and the statue was completed by the following January, when its value was assessed at ninety florins. Both from documents and style, the chronological sequence of these two works is reasonably clear, the *Jeremiah* being the Prophet of 1423–25 and the figure popularly known as the "Zuccone" being the *Habakkuk*. Mistaken attempts have, nonetheless, been made to invert this sequence and to establish the "Zuccone" as the figure of Jeremiah and the Prophet inscribed with the name of Jeremiah as the *Habakkuk*.[15] The relative priority of the two figures is of more than academic interest, not only for what they tell us of Donatello's development over a crucial period of thirteen years of his maturity, but because they are two of the greatest marble sculptures of the fifteenth century.

Fig. 58 The taking-off point for the *Jeremiah*[16] is the *Beardless Prophet* on the east face of the Campanile. The stance inverts that of the earlier figure in that the weight is here borne on the right leg, not the left, and the left leg is flexed. The right arm hangs down beside the body and the left forearm crosses the chest. But the differences are greater than the resemblances. The cloak leaves both feet and the left ankle exposed

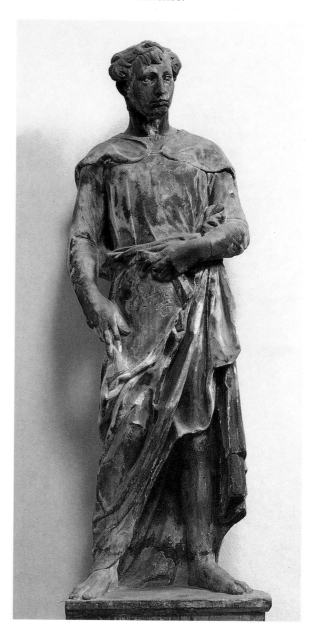

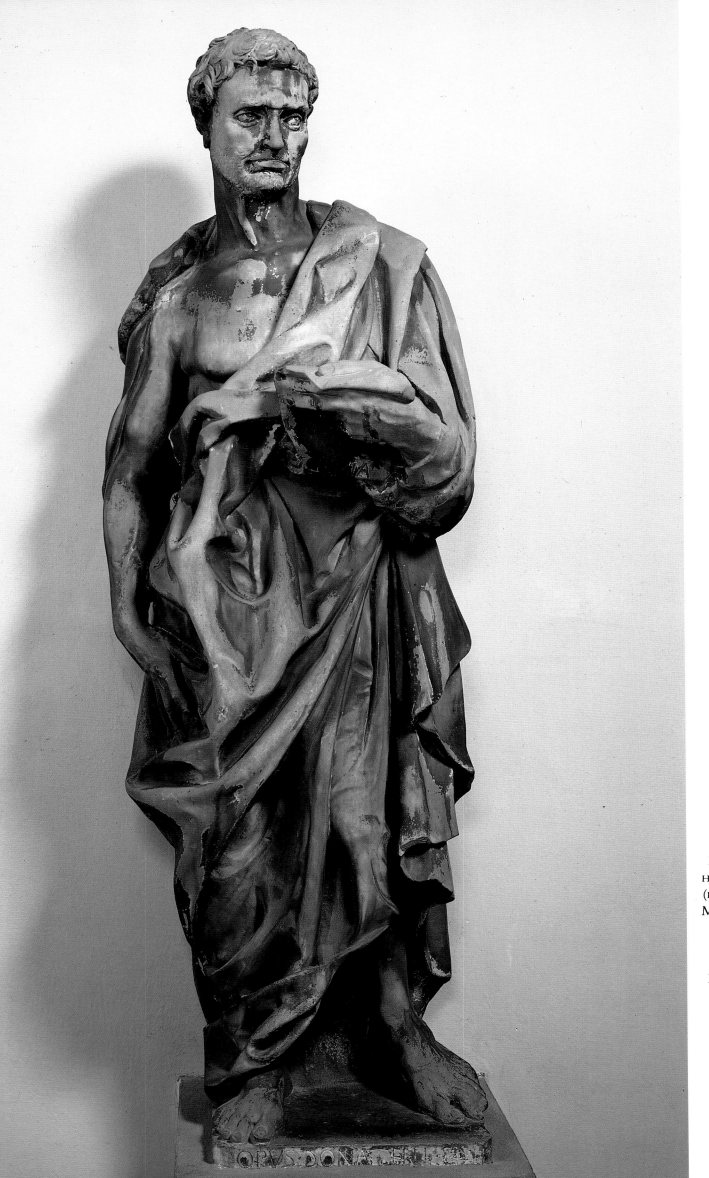

left: FIGURE 58.
Donatello, *Jeremiah*. Marble,
H. 191 cm, W. 45 cm, D. 45 cm
(H. 75 in., W. 18 in., D. 18 in.).
Museo dell'Opera del Duomo,
Florence.

right: FIGURE 59.
Donatello, Head of *Jeremiah*.

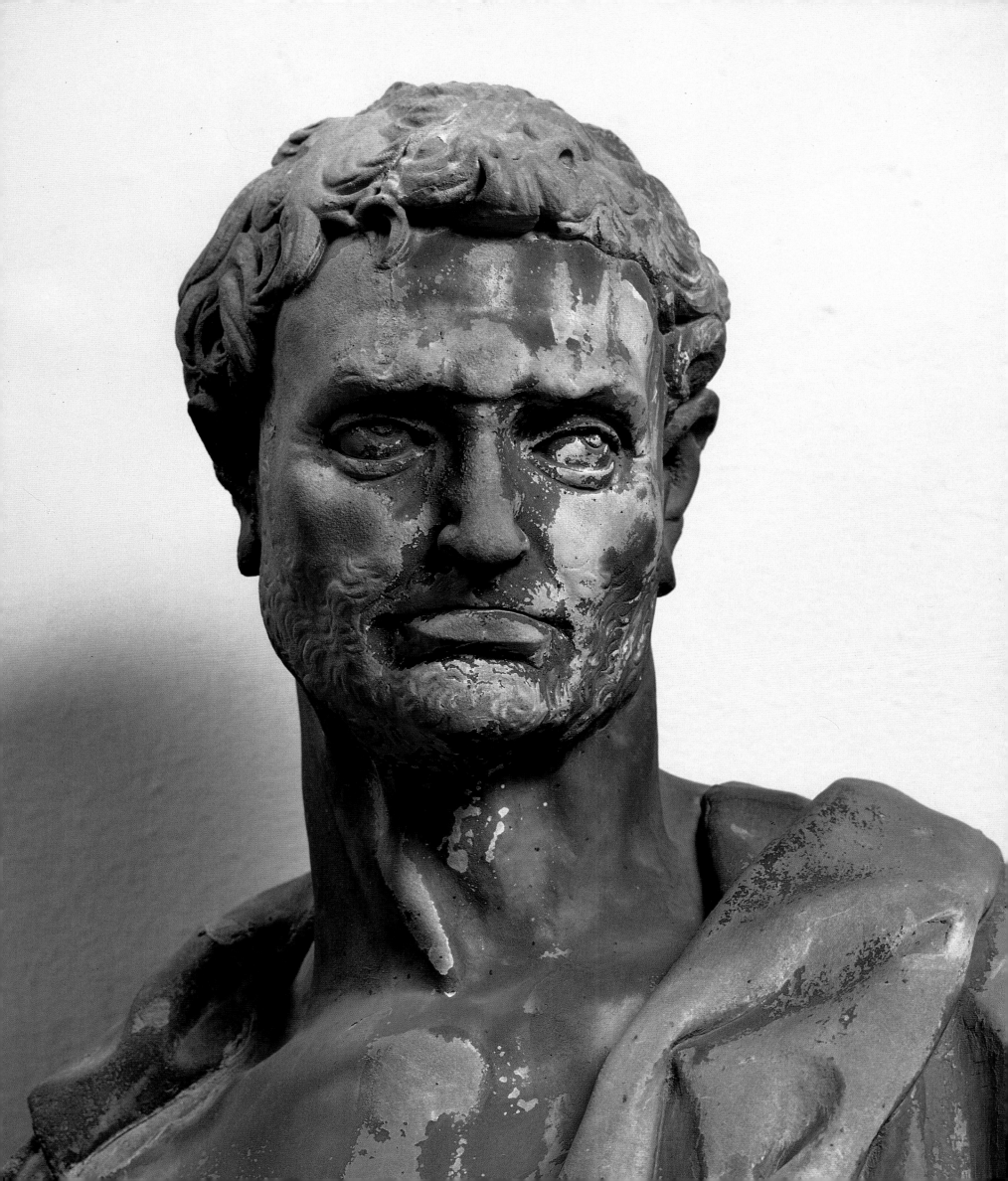

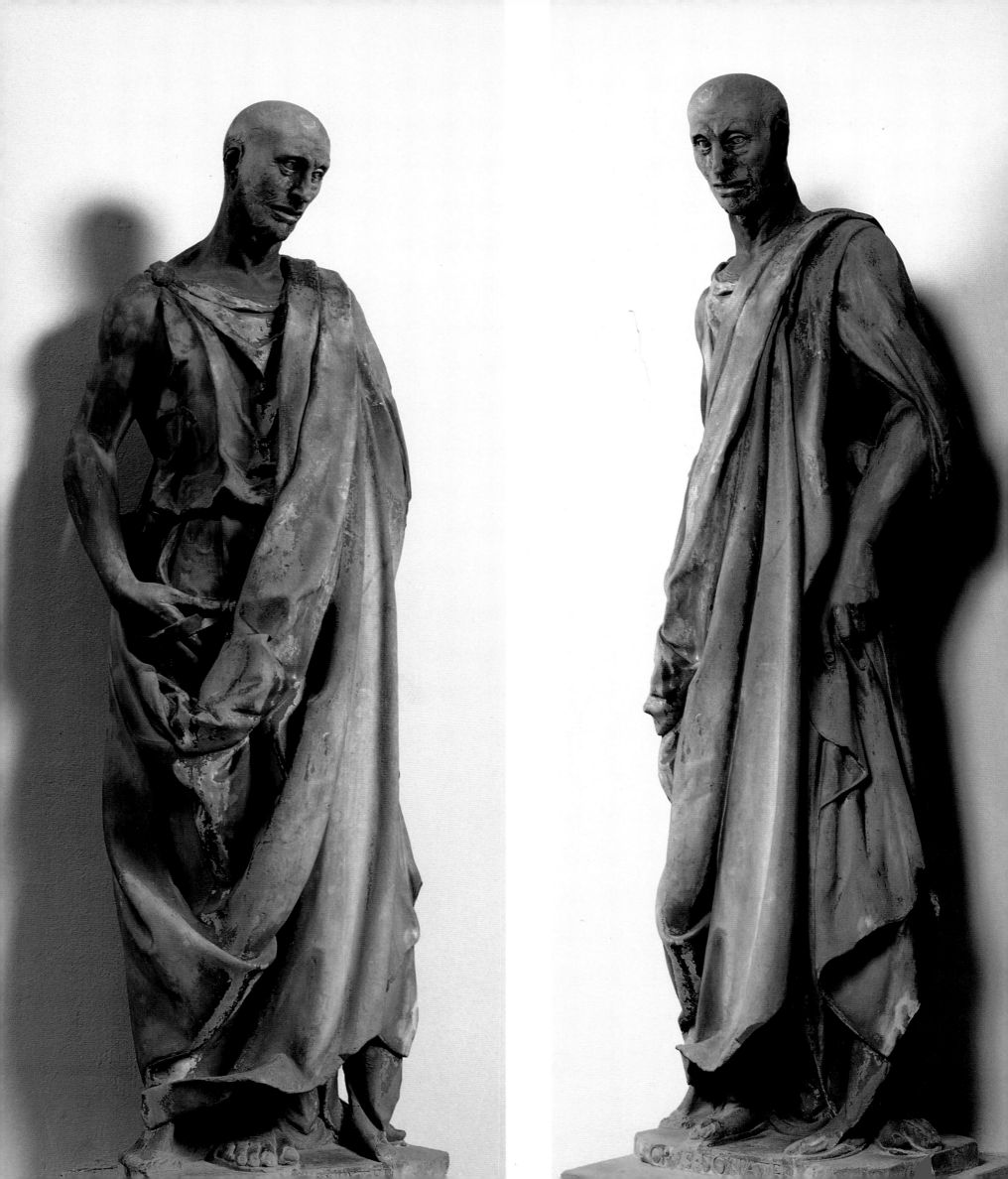

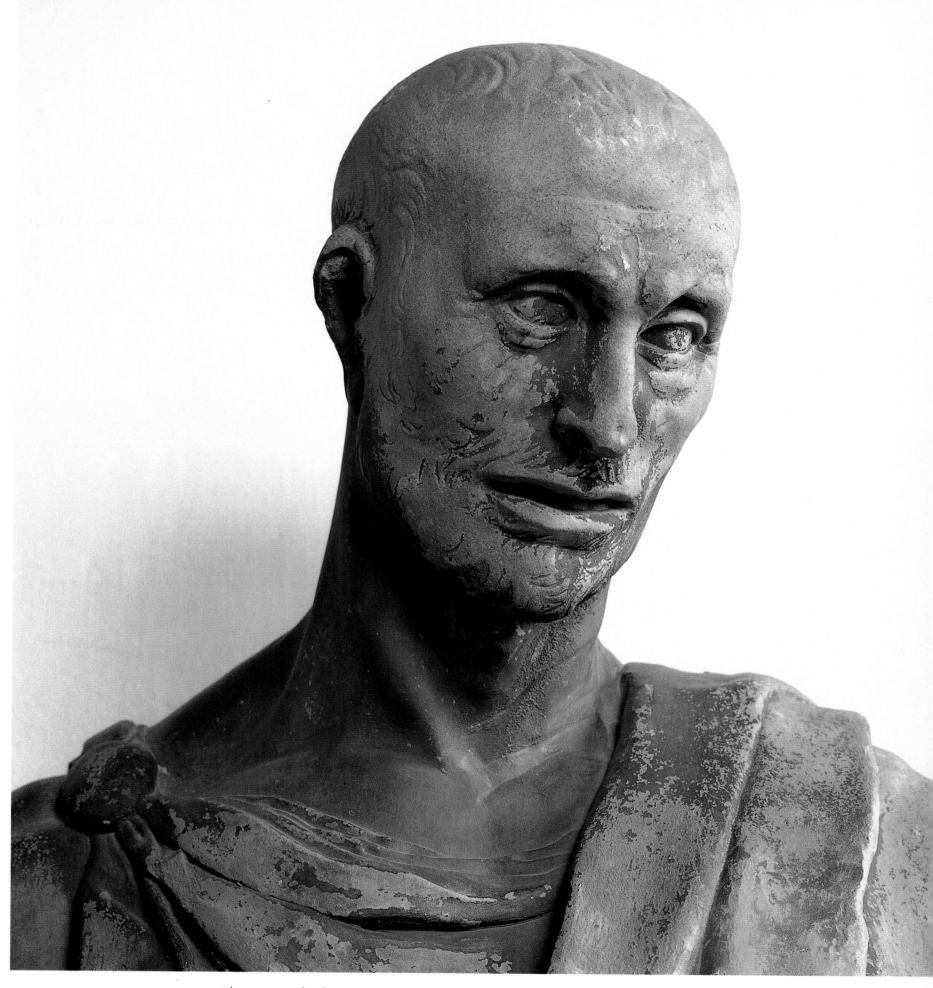

and covers the left shoulder alone, leaving the right arm and the right half of the chest free of clothing. The neck grows from the torso, not from the fabric that covers it. The effect of the figure, therefore, is that of a fully realized nude over which a heavy cloak happens to have been thrown. The definition of the body is not, as in the earlier figure, contingent on the definition of the robe. Instead, the two are for the first time conceived, as in some Roman baroque sculpture, in opposition to each other. As in the *Beardless Prophet*, the head is based upon life study, but *Fig. 59* whereas the transcription of the modeled portrait used for the earlier figure is literal—it preserves, that is to say, the same fidelity to nature as a Roman portrait bust—in the *Jeremiah* it is dramatic and rhetorical. The protruding lower lip, the deeply cut eye sockets and eyelids, the freely incised eyebrows and the heavy furrow that links them across the nose surprise us not by their veracity but by an expressiveness that transcends truth. Of the geometrical structure of the front of the two earlier Prophets there is no trace. The cloak, with its weight and apparently capricious folds, seems to possess its own organic life. Donatello at the time had embarked on a large-scale work in bronze, the *St. Louis of Toulouse* for Or San Michele, and this evidently led him to transpose the forms, which were so readily achieved in bronze, to marble sculpture. The *Jeremiah* is the first substantial work in which a deliberate attempt is made to emulate in marble properties that were peculiar to modeled sculpture. It would be wrong, however, to view the *Jeremiah* simply as a sculpture or as a work of art; it is an ethical statement, and its minatory expression is drawn from the book of Jeremiah: "The word that came to Jeremiah from the Lord saying, Hear ye the words of this covenant, and speak unto the men of Judah, and to the inhabitants of Jerusalem; and say thou unto them, Thus saith the Lord God of Israel, cursed be the man that obeyeth not the words of this covenant."

The *Habakkuk*, which likewise looks down at the populace beneath its niche, is *Figs. 60, 61* less menacing than the *Jeremiah*.[17] The body is clothed in antique dress, but the right arm and shoulder and the left forearm are shown naked, with the right hand in a strap over the hip. Though the heavy cloak falling from the left shoulder conceals part of the frame, it serves to establish, by contrast, the frailty of the spare, ascetic body beneath. The effect is one of preternatural height, leaving us with the sense that if the cloak could be removed, the stooping body under it would read like a drawing by Pontormo. The musculature of the neck is treated with consummate skill, with tough tendons at the back that reach up to the head. The surface is much weathered, but enough of it survives to establish the phrenological exactness and the smooth definition of the planes in the almost bald skull. In the fifteenth and *Fig. 62* sixteenth centuries, this figure was Donatello's most highly regarded work. Vasari describes it as "finer than anything else he did," and tells us that Donatello when working on it would look at its parted lips and exclaim: "Favella, favella che ti venga il cacasangue." The account contains a covert reference to the story of Prometheus, but it also represents, in the context of Donatello's aspirations and objectives, a credible reaction from the artist who had given birth to a sculpture that possessed every gift but speech.

IV

The Partnership with Michelozzo

IN 1422 THE HEAD OF SAN ROSSORE, a Sardinian saint, was transferred from Pisa to the church of Ognissanti in Florence. Relics involve reliquaries, and a reliquary bust to contain the head is mentioned twice in Donatello's *catasto* (tax) return of July 1427, first as the subject of a debt of thirty florins owed by the convent of Ognissanti to Donatello ("una mezza figura di bronzo di S. Rossore della quale s'è fatto mercato niuno credo restare avere più che fl. 30"), and second as the subject of a debt of fifteen florins owed by Donatello to the bronze caster Giovanni di Jacopo degli Strozzi "per cagione d'una fighura di S. Rossore mi gittò più volte al fornello e altre cose."[1] By 1426 or 1427, therefore, work on the bust was complete.[2] It is cast sectionally, in five pieces. The top of the head is hinged, but the lines of hair on it do not correspond to those on the bust. It has been suggested, inconclusively, that the collar is a sixteenth-century addition, replacing an earlier one. Despite the solid appearance it presents today, its structure is unorthodox, and the individual sections are not soldered together but are joined with screws. Each section is fire gilded, and the eyes are silvered. The arms are severed at a point midway between the shoulders and the elbow, covered on one side by armor and on the other by a cloak, and the edges of the cloak meet beneath the gorget in the center of the base. Over the right shoulder, the cloak is turned back so that the lining, with a pseudo-Cufic inscription in the border, is revealed. Since the reliquary would have been set on or above an altar the head is inclined slightly forward, and the eyes are lowered. The heavy moustache and beard are of a type common in the fourteenth, not the fifteenth century, but the whole face appears to have been modeled from the life. The ears and

Figs. 63, 64

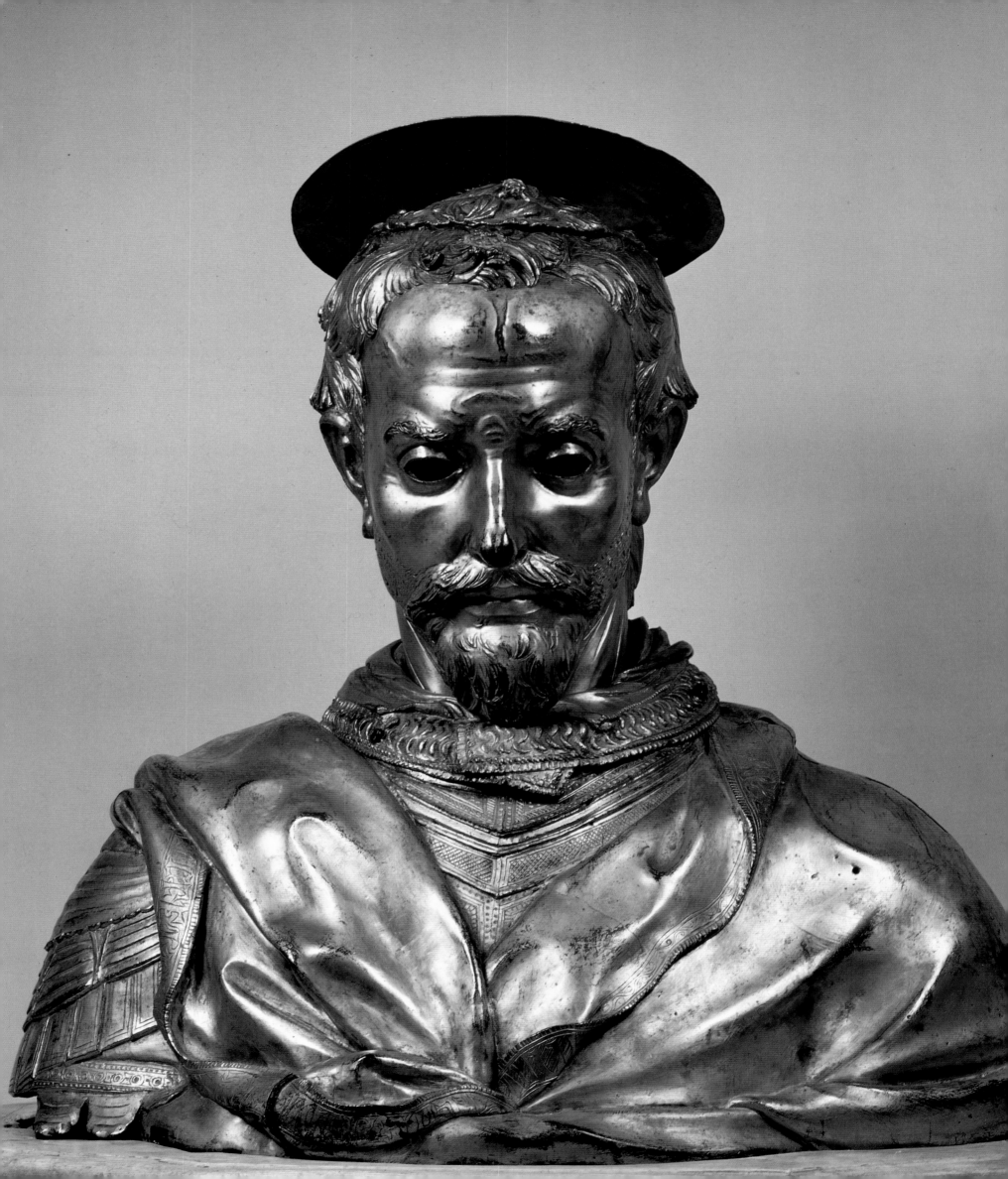

lips are treated realistically, and the eye sockets are portrayed in depth, their veracity enhanced by the freely incised eyebrows above. The cheeks are covered with stubble indicated by random incisions in the surface of the bronze. Throughout the bust the surface modeling is of a highly original, indeed unprecedented kind, and appears to be the unaided work of Donatello.

The preparation of substantial works in bronze and marble involved managerial as well as technical skills. The drawing up of estimates, the duration and costing of work, and the administration of a work force presented problems with which an impetuous genius like Donatello was ill equipped to deal. For these reasons, and for others we can no longer reconstruct, Donatello, in 1424 or 1425, formed a legal partnership with the architect and sculptor Michelozzo.[3] Partnerships normally lasted for three years but were renewable, and that between Donatello and Michelozzo seems to have terminated after nine years in 1434, though their association certainly continued to a later time. The usual practice was that earnings be divided on a fifty-fifty basis, but the input of the individual artist naturally varied with each work. Michelozzo had long experience of bronze sculpture as an assistant of Ghiberti on the bronze door of the Baptistry and as the "compagno" of Ghiberti in work on the *St. Matthew* for Or San Michele, and was a professional bronze caster; his tax return of 1427 includes expenses for a foundryman named Benedetto and for a worker "who does casting in the workshop" named Nanni di Fruosino. Michelozzo's defection was certainly resented by Ghiberti, who in a letter of April 16, 1425, complains of "the ingratitude of those who had previously been my partners and from whom I have received not only one injury but many. . . . I have decided to remain without partners and be the master of my own shop."[4] Born in 1396, Michelozzo was ten years younger than Donatello. His father was a successful tailor, two of his brothers were associated with the Arte della Seta, and Michelozzo himself over a long period of time was employed at the mint. He had, according to Vasari, a prudent, sagacious character. His reasons for leaving Ghiberti's workshop are unclear, but must have been bound up with the financial prospects opened up by partnership with Donatello and with the prospects of architectural commissions and of cooperative sculptural activity that they might involve. The partnership seems to have been entered into in connection with a commission of major impor-

Fig. 65 tance, for the Coscia monument in the Baptistry in Florence, but rapidly involved two other tombs, of Cardinal Rainaldo Brancacci in Naples, to which Donatello contributed only one small *stiacciato* relief, and of Bartolomeo Aragazzi at Montepulciano, in which Donatello played no part.

During the Great Schism, in the spring of 1410, Baldassare Coscia was elected Pope as John XXIII. In 1413 he was expelled from Rome by the imperial troops and fled to Florence, whence he summoned a Council of the Church to meet at Constance in the following year. Deposed by the Council, he was imprisoned in Germany till 1419, when, through Florentine intervention, he was released on condition that he make obeisance to his Colonna successor Martin V, who was at the time resident in Florence. His relations with the Florentine establishment were very close. It was through his agency that the Medici became papal bankers, and Giovanni di Bicci de' Medici and Niccolò da Uzzano were responsible for arranging

opposite: FIGURE 63.
Donatello, *Reliquary bust of San Rossore*.
Gilt bronze, H. 56 cm, W. 60.5 cm
(H. 22 in., W. 24 in.).
Museo Nazionale di San Matteo, Pisa.

his release from Germany. He died in December 1419, and when his will was opened it named four of the principal citizens of Florence, Bartolomeo Valori, Niccolò da Uzzano, Vieri Guadagni, and Giovanni de' Medici, as his executors. By it he bequeathed a relic, a finger of St. John the Baptist, to the Baptistry, in the hope, according to three of his executors, that he might be buried there. The Baptistry was a privileged site, and through Palla Strozzi, one of its consuls, the Arte di Calimala withheld permission for the construction of a memorial chapel that would encroach on the space inside the church. They agreed, however, to the erection of a tomb, provided that it was "breve e honestissima, siche no occupi dell'andito della Chiesa." This agreement opened the way to the commissioning of Donatello's Coscia monument.[5] The lower part of the tomb was under construction by the winter of 1424, and the entire monument appears to have been finished between the summer of 1427 and the summer of 1428. It has been argued from an over-literal reading of Michelozzo's tax return of 1427 that the monument was begun by Donatello and that Michelozzo intervened in it only at a late stage, but this is inherently improbable.

The problems that confronted the designer of the monument arose from the historic importance of the building (which was believed to have been a Roman Temple of Mars) and from its architectural character. The tomb is planned as an autonomous architectural unit standing free of the massive Corinthian columns at each side. If it were not to protrude forward of the columns, its depth could not exceed the distance between the columns and the wall, and in practice this space was reduced by a further fifty centimeters, since the monument is set not on the wall itself, but on a screen that pushes it forward from the wall surface. Regard was paid not only to the columns, but to the bands of decoration in dark green and white marble that run around the Baptistry walls. The upper edge of a band of dark green inlay establishes the position of the upper edge of the sarcophagus; the litter on which the body rests is on the level of the upper edge of a corresponding strip of dark green inlay; and the cornice of the wall behind the effigy is set on a line through the center of the bold decoration at each side. Of the difficulties the site presented, one of the hardest must have been that of height. The top of the tomb has the form of a shell niche containing a half-length Virgin and Child closed by a molded architrave; this element, which might have appeared sparse and rather dull, is redeemed by a device of great originality, a heavy curtain masking the edges of the lateral columns at either side. A number of North Italian, and especially Venetian, tombs are closed by curtains, but there is no precedent for the emphatic curtain suspended from a central ring in the Coscia monument. With its fictive fabric and its heavy, realistic fringe, it must, when it was pigmented, have ensured that attention would focus not on the rather undistinguished sculpture at the bottom of the tomb but on the gilt bronze effigy.

So far as execution is concerned, it may be well to deal first with those sculptures that are not by Donatello. The first of these is the Virgin and Child above the effigy, a work of some distinction, which is probably the earliest surviving relief in marble by Michelozzo. Another is the two lions supporting the bier, which were carved in Donatello's workshop but not by Donatello, while a third is the three slack figures

opposite: FIGURE 64.
Donatello, *Reliquary bust of San Rossore* (profile).

74

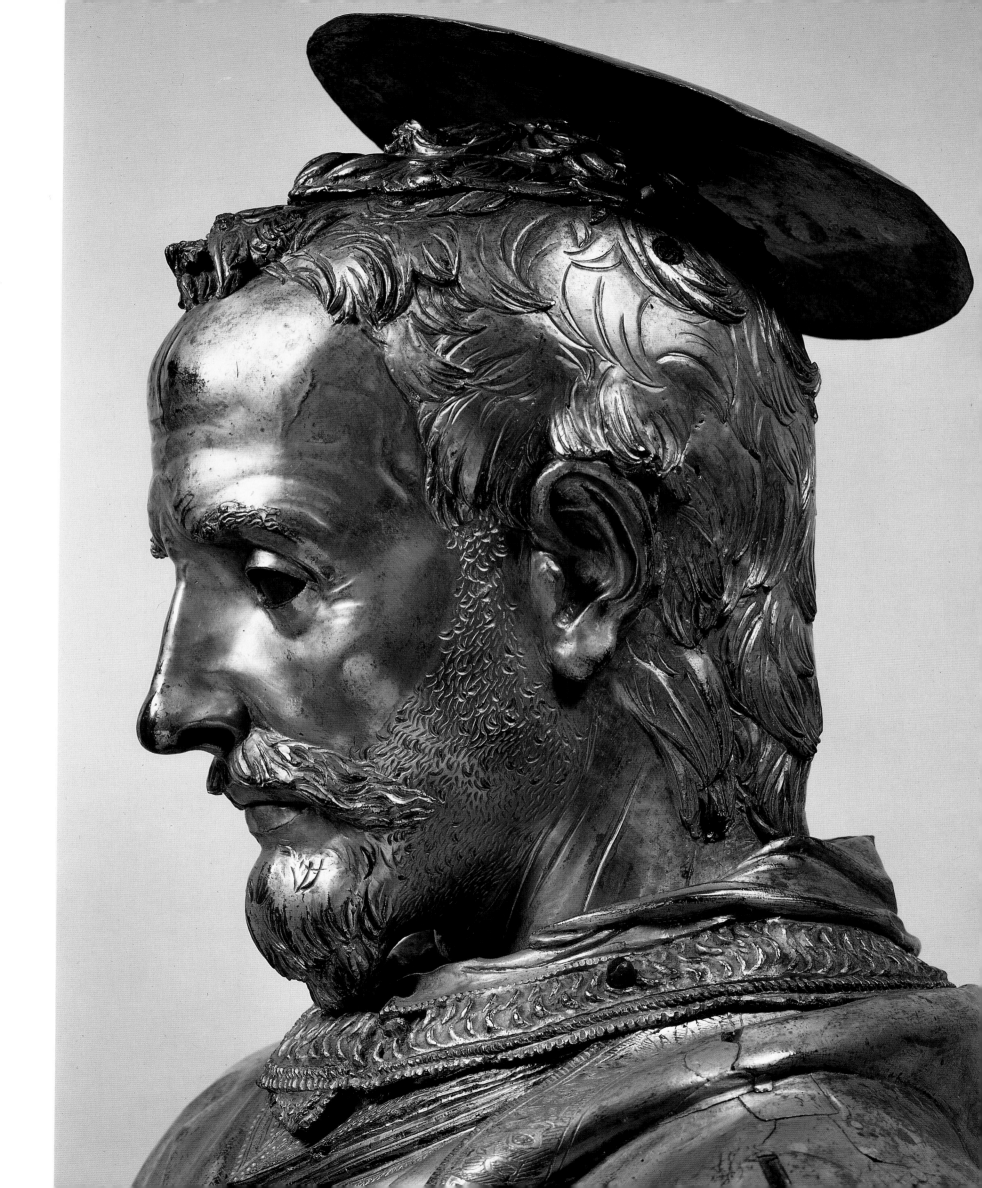

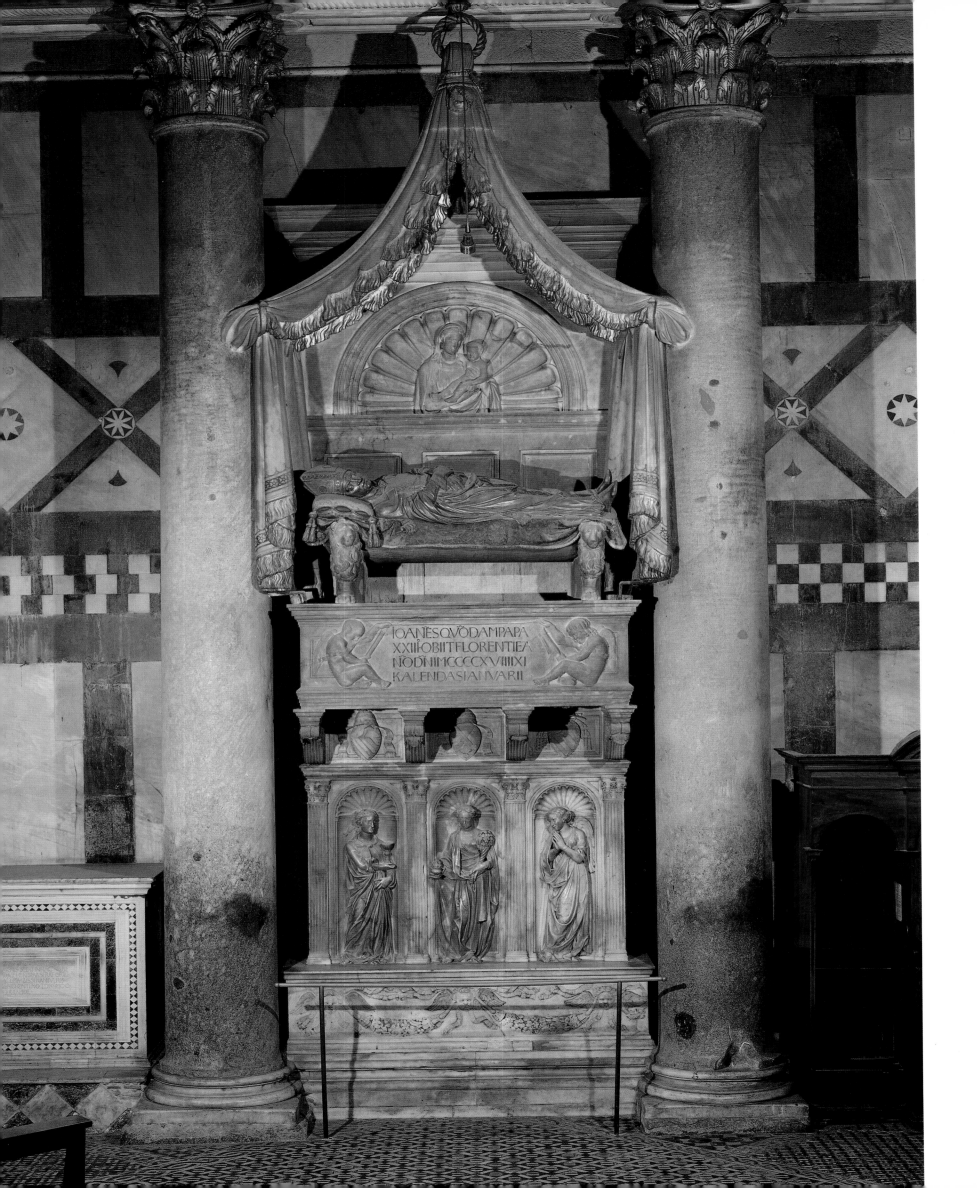

Fig. 66

of Virtues at the base, which seem to have been carved, possibly from Donatello's design, by an unknown member of the joint studio, possibly Pagno di Lapo Portigiani. Perhaps the most distinguished marble sculpture on the tomb is a seated putto in right profile on the left of the sarcophagus, where the execution, especially of the receding right forearm and the shoulder, is of great accomplishment. The one figurative element that is manifestly due to Donatello is the gilt bronze effigy, the first Renaissance monumental portrait. To judge from its angle, the effigy was intended to be seen from a fixed point in the center of the floor, and the rich medium of gilt bronze, projected forward from the marble background, gives it a prominence that it would not otherwise enjoy.

The employment of gilt bronze as the medium for the effigy of Baldassare Coscia has been credited to the wish of his executors to commemorate the Pope in a fashion that recalled the Gothic gilt bronze sepulchral effigies of France and England. This is improbable. Its use is ascribable rather to a determination to ensure that Coscia's effigy, despite the restrictions imposed by the Arte di Calimala, had a dominant position in the Baptistry. The casting may be due to Michelozzo, but the highly personal modeling and much of the chasing must be by Donatello. Whether it depends from a death mask made of the Cardinal's features or from a life drawing, we do not know, but in it no effort is spared to present Coscia as he appeared to his contemporaries. Whereas the bust of San Rossore was planned for a position a little above the ordinary viewer's eye level, the effigy is set over four meters above the floor. Particularized handling of the surface like that of the *San Rossore* was precluded on this account. But the heavy head with its incipient double chin is rendered with great care, and the two sides of the fleshy face, one resting on the cushion, the other fully visible, are scrupulously differentiated. The cheek bone of the off side of the face has the same prominence as the cheek bones of the San Rossore bust, but the full lips are treated more boldly—the effect they make is enhanced by a deep declivity above the chin and by a series of diagonal incisions beneath the nostrils—and the thick eyebrows are rendered by heavy undulating modeling beneath the forehead.

The weight of the head is supported by a thick cushion with a richly embroidered cover, fastened with two gold buttons, that opens to reveal a textured surface beneath. The compact miter sits firmly on the forehead, where it presses down a lock of hair. The bier cloth, its pattern distorted at two points where the fabric is looped up, is treated in the same detail, and the fringed ends of the pallium are shown hanging over its upper edge. Looked at from on top (a position from which no spectator in the fifteenth century would have seen it), the vestments recall the tight cloak of the *San Rossore*, but the main features visible from the floor, the embroidered gloves, the cruciform orphrey with a bold pattern of superimposed circles on the chest, and the projecting shoes, are distinguished by their brilliance and veracity. The historic importance of the Coscia effigy is reflected in its artistic quality. Though it is the effigy of an ex-Pope, not of a Pope, it is the first Renaissance papal monument.

Donatello's reputation as a bronze sculptor was not confined to Florence. In February 1423 he received from the Operai of the Duomo at Orvieto the commission for a figure of the Baptist to be placed on the Baptismal Font in the Cathedral.[6]

opposite: FIGURE 65.
Donatello and Michelozzo,
Monument of Cardinal Baldassare Coscia.
Marble with gilt bronze effigy,
H. 732 cm (24 ft.).
Baptistry, Florence.

FIGURE 66.
Donatello, *Effigy of Cardinal
Baldassare Coscia*. Gilt bronze.
Baptistry, Florence.

The statuette, which was to be made in bronze or in gilt copper, and was to carry a
cross and a cartellino with the usual inscription "Ecce Agnus Dei," is lost, but the
terms of the commission reflect the virtuosity with which, at this relatively early
time, Donatello was credited. He is described as "intagliatorum figurarum, magis-
trum lapidum, atque intagliatorem figurarum in ligno et eximium magistrum
omnium trajectorum." He was also at this time involved with the bronze decoration
of another baptismal font, that in the Baptistry under the Cathedral in Siena.

The Siena Font consists of a hexagonal basin, decorated on its six faces with gilt
bronze scenes from the life of the Baptist.[7] At the corners between the narrative
reliefs are six Gothic tabernacles designed to contain statuettes. The structure is
raised above floor level by two steps faced with polychrome inlay. Three stone-
masons or sculptors were responsible for its erection, and payments made to one of

them, Papi di Corso, for "le storie de marmo p[er] lo batesimo," prove that the narrative reliefs were originally to have been in marble. In 1416, however, Ghiberti was summoned to Siena. Six months later the principal Sienese metalworker, Giovanni Turini, visited him in Florence, and in April of the following year a relief in bronze by Ghiberti was tried out in a model of the font. It was approved, and contracts were issued for six bronze narrative reliefs. Two were allotted to the leading Sienese sculptor, Jacopo della Quercia, two to Turino di Sano and his son Giovanni Turini, and two to Ghiberti. Work on the reliefs proceeded slowly, and in 1423 the contract for one of the two scenes reserved for Quercia was transferred to Donatello. The contract proper does not survive, and the earliest intimation we have of Donatello's involvement is a payment of 50 lire, 1 soldo made to him by Quercia in May 1423. In the spring of 1425 the Cathedral authorities threatened to cancel the contracts with Ghiberti and Donatello on the ground that their reliefs were overdue, but by August Donatello's relief had been cast, and in the second week of April 1427 an emissary of the Cathedral, Antonio di Giacomo, visited Florence to collect it. Donatello's *catasto* (tax) return of July 1427 states that he was then owed one hundred eight florins by the Duomo at Siena "per cagione duna storia dottone che fej più tempo fa," and lists among his debts forty-eight florins owed to Jacopo della Quercia "per cagione di storia per lopera di Siena come disotto appare" and ten florins due to Giovanni Turini "per più tempo havuto in detta storia." The first of these payments may refer to the purchase of bronze for the relief, and the second to its gilding.[8] The words "più tempo fa" suggest that it was modeled and cast soon after 1423. The two reliefs by Turino di Sano and Giovanni Turini were delivered in May 1427 and the two reliefs by Ghiberti in November. The sixth relief, Quercia's *Zacharias in the Temple*, was begun in April 1428, some months after the arrival in Siena of Donatello's relief, and was completed in August 1430. When he modeled it, therefore, Quercia must have been fully cognizant of Donatello's scene.

Five of the gilt-bronze reliefs on the Siena Font, Ghiberti's *Baptism of Christ* and *St. John Preaching before Herod*, Quercia's *Zacharias in the Temple*, and the two reliefs by the Turini, the *Birth of the Baptist* and the *Baptist Preaching*, show single scenes. Donatello's, on the other hand, is a sequential narrative; it represents not only the scene he was required to illustrate, but an earlier scene as well. At the extreme back the Baptist's head is presented on a charger to Herodias; in the middle distance are two male figures, one of them possibly the executioner, and a musician accompanying the dance of Salome; and in the foreground Salome's dance is interrupted by the presentation of the Baptist's head. Herod raises his shocked hands in expostulation, and the man adjacent to him expresses horror with a clenched palm on the surface of the table. A second seated guest draws back, shielding his eyes from the unwelcome sight, while behind Salome a youth leans forward transfixed by the scene. On the right a man hurries from the room, and on the left two frightened children shrink from the bleeding head.

The contrast between this relief and the contiguous scene to its left, Ghiberti's *St. John the Baptist Preaching before Herod*, is very great. Ghiberti's relief is constructed with a viewing point in the center of the base. If we wish to read it as Ghiberti desired it to be read, we have to crouch down on the Baptistry floor. Its foreground

Fig. 67

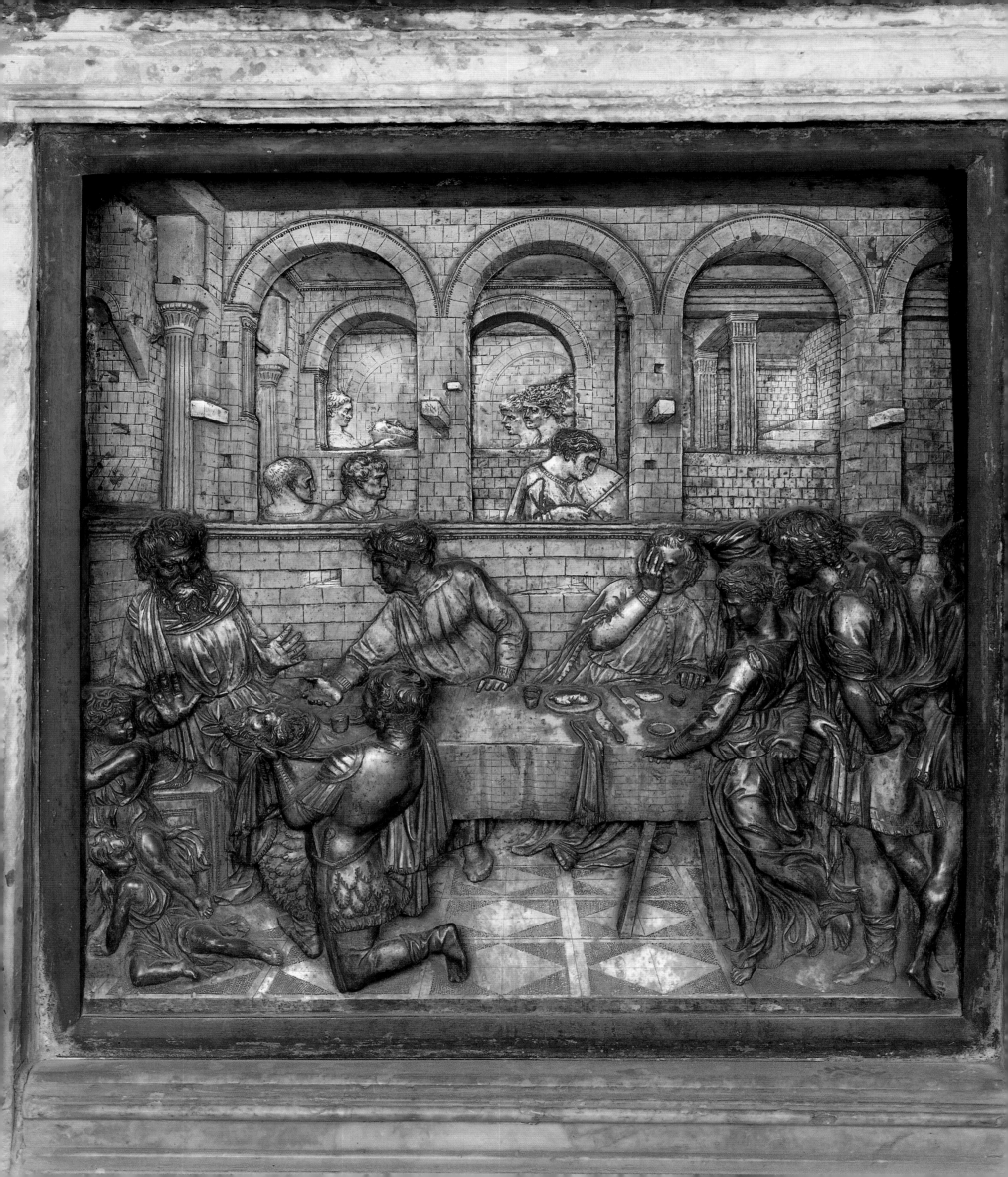

is filled with figures and behind them is a colonnaded hall that plays no part in the narrative. Donatello's relief, on the other hand, is planned with a viewing point at about the height of a spectator looking at the Font and is intended to be seen roughly from the angle at which a visitor would look at it today. Jacopo della Quercia's *Zacharias in the Temple*, which was executed after the arrival in Siena of Donatello's relief, also makes use of a high viewing point. Linear perspective presupposed inspection from a predetermined distance. In Donatello's relief the distance point from which the scene ought properly to be inspected is about 90 centimeters (36 in.), or one and a half times the width of the relief. In the foreground, the orthogonals and transversals of the inlaid pavement are firmly marked. They have a secondary narrative function in that they direct the eye to the distant figure of Herodias receiving the Baptist's head. The perspective of the main scene converges on the center of the molding of the wall behind the table, and the scale of the forward figures is established by the distance of the molding from the base of the relief. On the left, the wall and molding turn at right angles to the rear wall, but the angle is masked by the seated figure of Herod, so that the molding reads as a horizontal through the entire relief. This device arises from the need to reconcile the dual role of perspective as pattern and perspective as space. In the upper half of the relief the perspective scheme is inverted; projecting rectangular posts set in the stone or brickwork converge on a point identical with or close to the vanishing point of the front scene. They are aided in this by the diminution of the distant architecture and the receding walls at either side.

The architecture is a self-sufficient vision of an imaginary Roman palace fully thought through in every part. It may owe something to knowledge of Roman paintings, but the parallels are imprecise, and are significant not for what they tell us about Donatello's sources but for the light they throw on the creative act through which the relief was born. The depiction of the brick- and stonework is meticulously realistic, and the sheer wealth of architectural detail—the triangular cavities on the front wall, the distant staircase on the right, the succession of fluted colunnettes and pilasters on the left, and the balcony in the upper left corner, whose supporting bracket would, if extrapolated, end in the Baptist's head—is personal to Donatello and has no equivalent in the work of any other artist. To a spectator in the fifteenth century, this relentless insistence on the physical solidity of the structure would have enhanced the reality of the scene portrayed. Of the figures this is also true. The pose of Salome may have been inspired by an Aretine terracotta relief and the heads in profile in the corridor by Roman coins, but the figures are tactile and have the breath of life. The state of mind of every figure is envisaged as vividly as the space it occupies, and never is movement stalled (as it is in the exactly contemporary predella of Masaccio's Pisa altarpiece) by the geometry of the stage space. In Florence it would be fifteen years before Donatello received, in the Old Sacristy of San Lorenzo, an opportunity to follow through the principles established in this miraculous relief.

When all but one of the six narrative reliefs had been delivered, attention turned to the tabernacles at the corners of the Font. Four of the six statuettes of Virtues intended for them were allotted to Sienese sculptors and two to Donatello.[9] On

Fig. 69

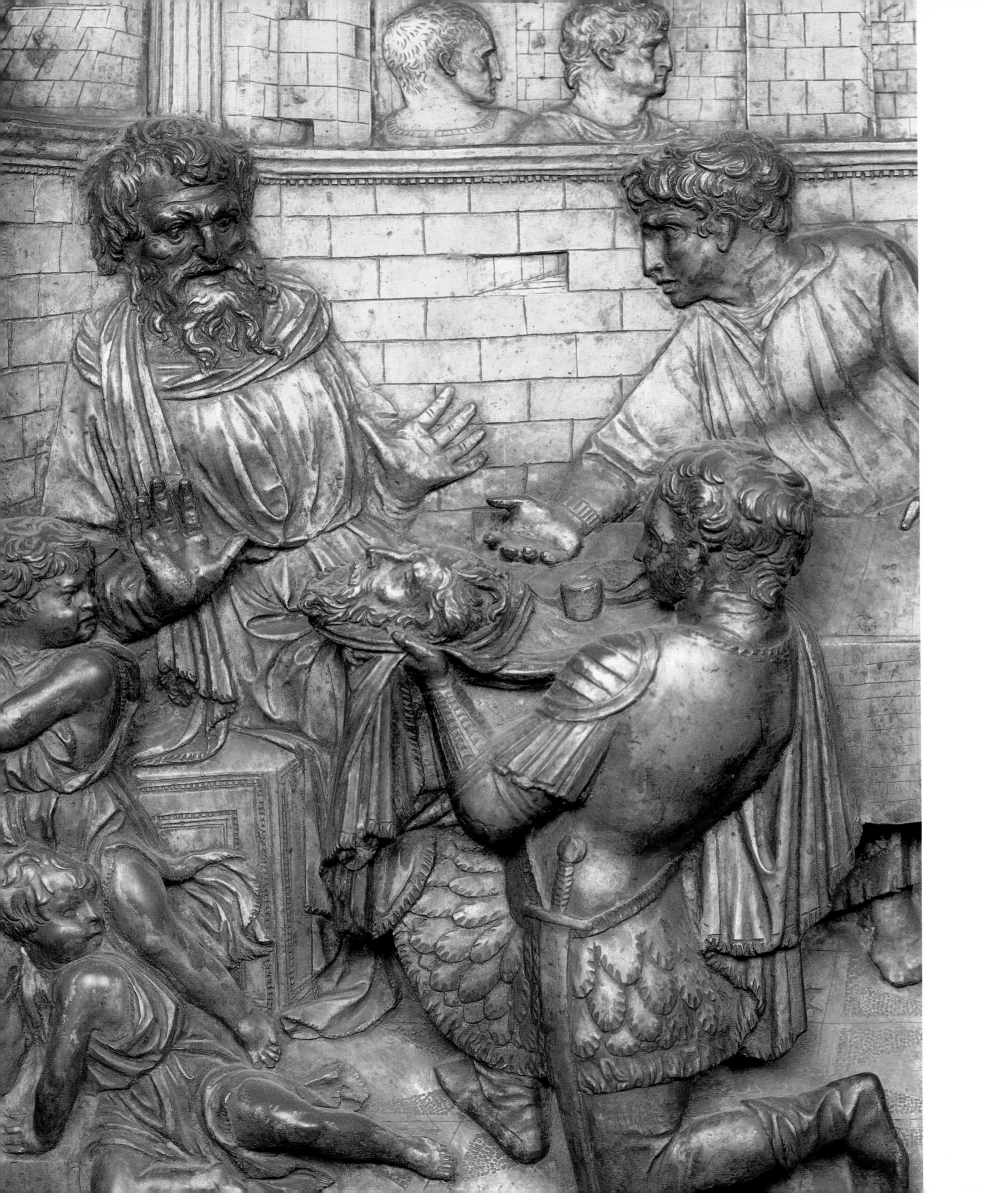

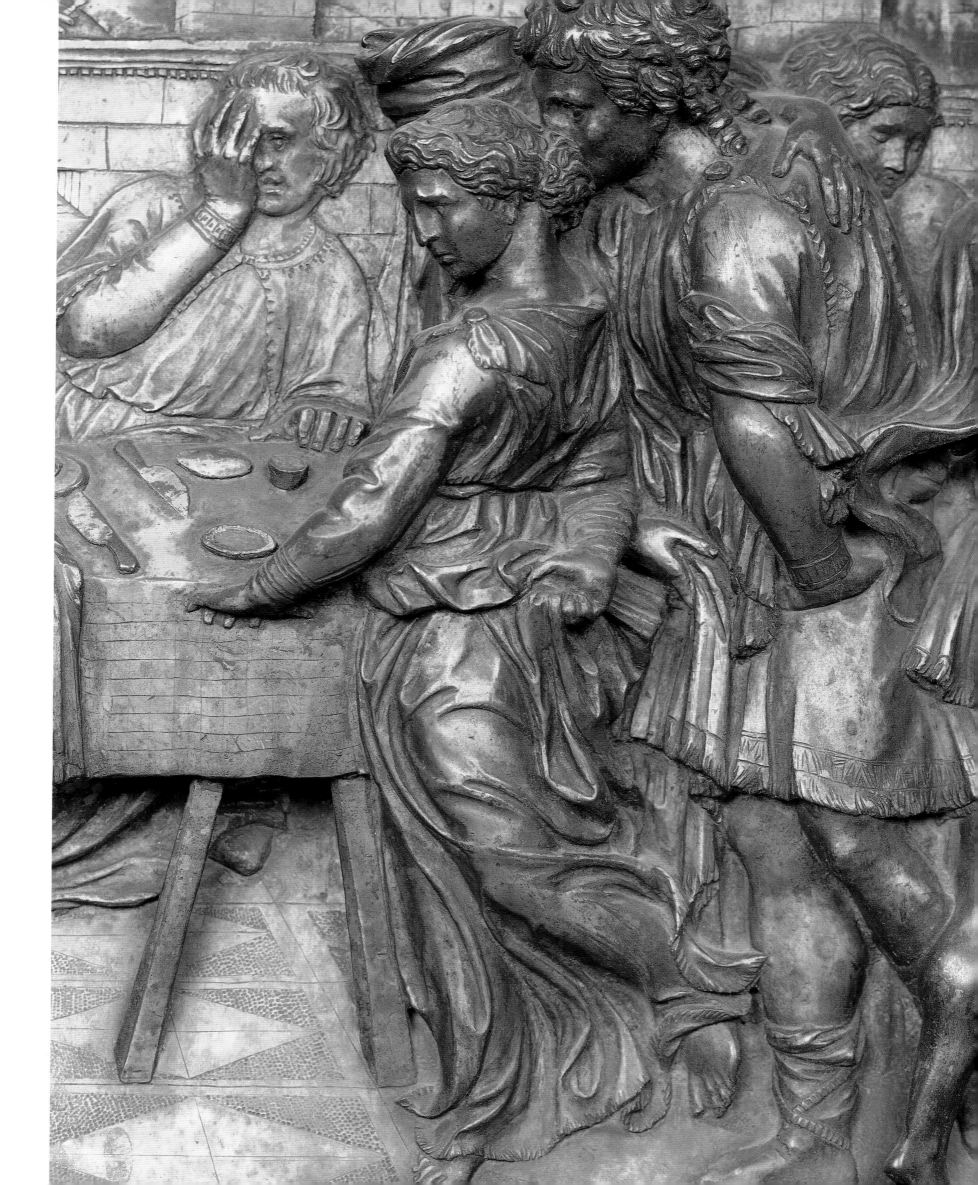

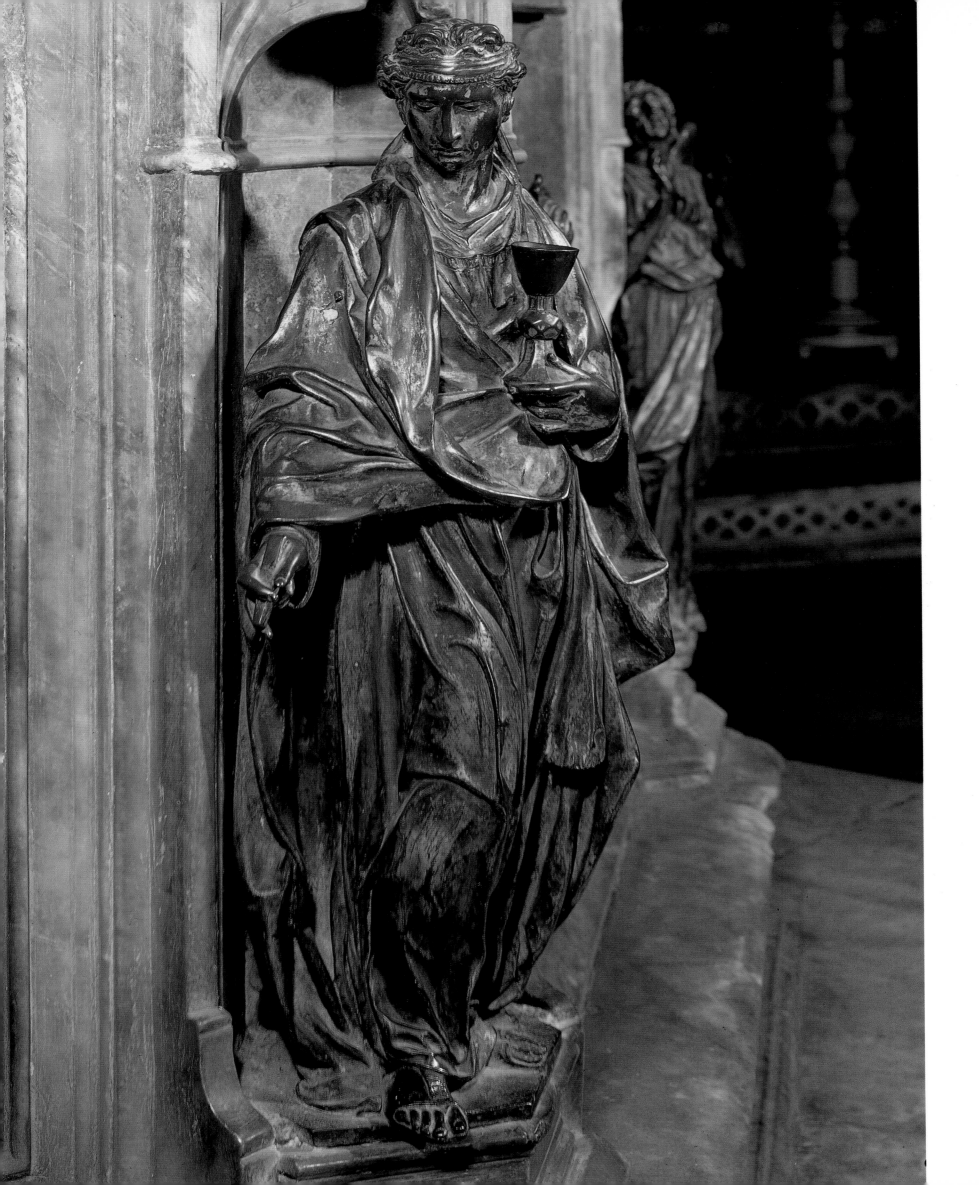

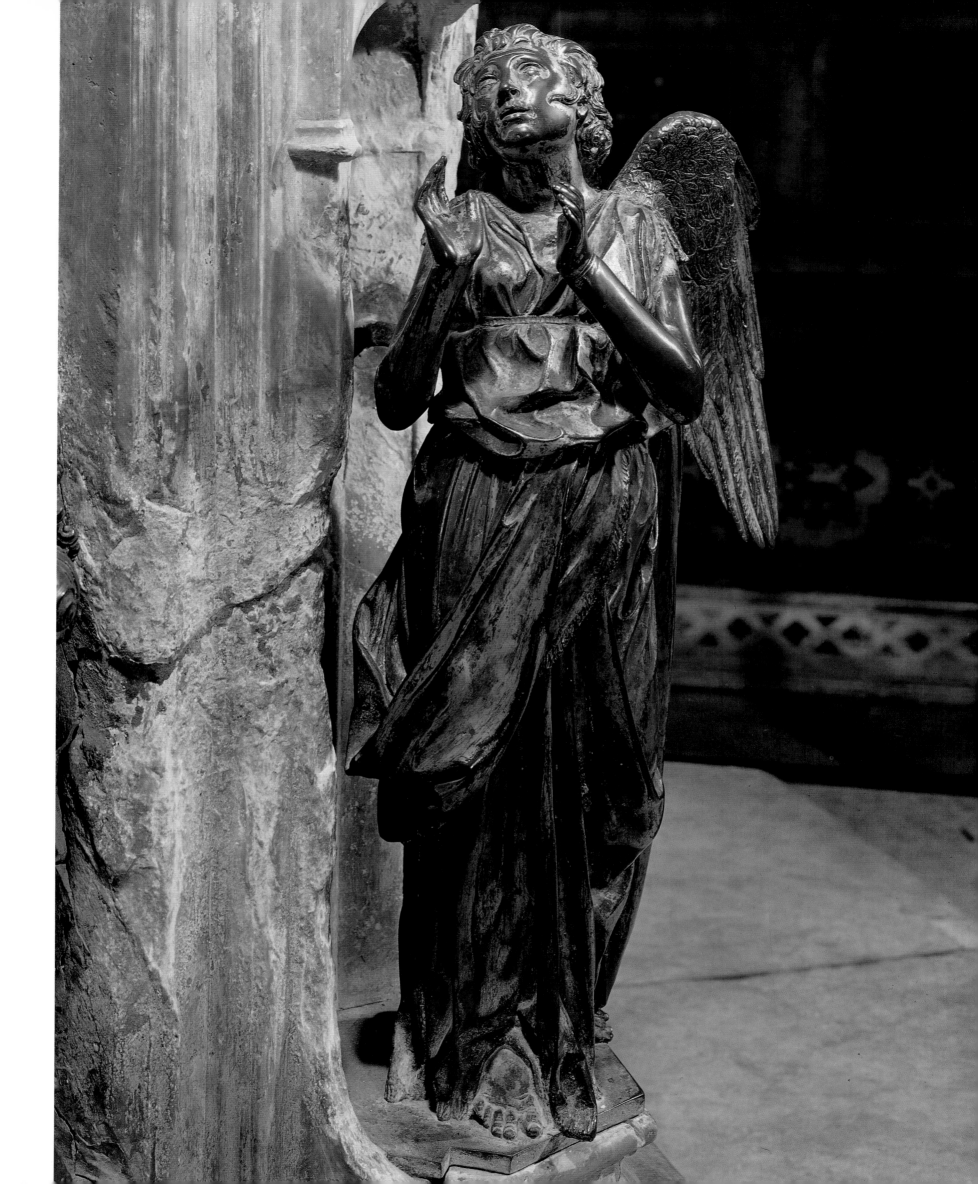

May 9, 1427, a joint letter was addressed by Donatello and Michelozzo (now Donatello's partner) to the Operaio of Siena Cathedral, inquiring which Virtues they were to represent: "vi ricordiamo che voj pigliate forma a dar nome a quelle fighure che manchano però che in questi di aremo tempo a dare loro spaccio et disposti siano servirvi bene." Their subjects were Hope and Faith. The height of the six statuettes is naturally uniform and is some eight centimeters (3 in.) less than the height of the reliefs. Turino di Sano, Giovanni Turini, and Goro di ser Neroccio took a conventional view of the commission and opted for relieflike frontal figures facing outward from each niche. Donatello's two Virtues are embryonic freestanding statues. They come from the right side of the Font, and one of them, the *Faith*, is shown with head turned and right hand extended toward Ghiberti's *Baptism of Christ*. This pose and the fact that the right foot projects beyond the edge of the shallow bronze base introduce an element of movement into the tabernacle. The head is strongly classical, and the rippling drapery has the freedom and naturalness at which Donatello aimed in the *St. Louis of Toulouse*. The *Hope* now faces sharply to the left and may originally have been centered on the tabernacle with head turned slightly to the right and the wings (which were cast separately and one of which is missing) covering the sides of the niche. The figure, like Donatello's adjacent relief, is designed to be seen from above. When looked at in this way the upturned head, which is tilted slightly backward, and the hands raised in supplication register with an intensity out of all proportion to their scale. *Fig. 70*

Fig. 71

Donatello's connection with the Font did not end here, but extended to the marble tabernacle or *pila* in the center, which was commissioned from Jacopo della Quercia in June 1427. Five of its six faces contained marble reliefs of prophets by Quercia, while for the sixth a gilt bronze tabernacle door was ordered from Donatello. It was rejected in favor of a Querciesque gilt bronze door with a standing Virgin and Child by Giovanni Turini, and we have no indication of its form or character. It must, however, have been cast in bronze since Donatello received a belated payment for it in the summer of 1434. Above the tabernacle rises a cupola, surrounded by six bronze statuettes originally of naked putti standing on upturned shells.[10] Two of them were entrusted to Giovanni Turini and three, two still on the Font and one in Berlin, are due to Donatello. Donatello's first recorded experiment with angels in the form of classical putti occurs on the crozier of *St. Louis of Toulouse*, where three tiny figures lean forward from their tabernacles, each holding a shield. On the crozier the aedicules and the pilasters between them derive from classical models, and the putti depend from Roman bronzes; they are posed forward of their background as incipient freestanding statuettes. The putti on the Siena Font, unlike those on the crozier, are fully freestanding and are indeed the first independent bronze statuettes of the fifteenth century. Though Donatello's figures have in common with Giovanni Turini's that they are balanced on inverted shells, they offer three very different solutions to the problems of posture and balance that were involved. The weight of the Berlin putto rests on its left leg. Its right leg is withdrawn so that only the front of the foot touches the base, and the receding diagonal across the hips is balanced by a contrary diagonal across the shoulders, established by the movement of the head, which is turned toward a tambourine held *Fig. 72*

Fig. 75

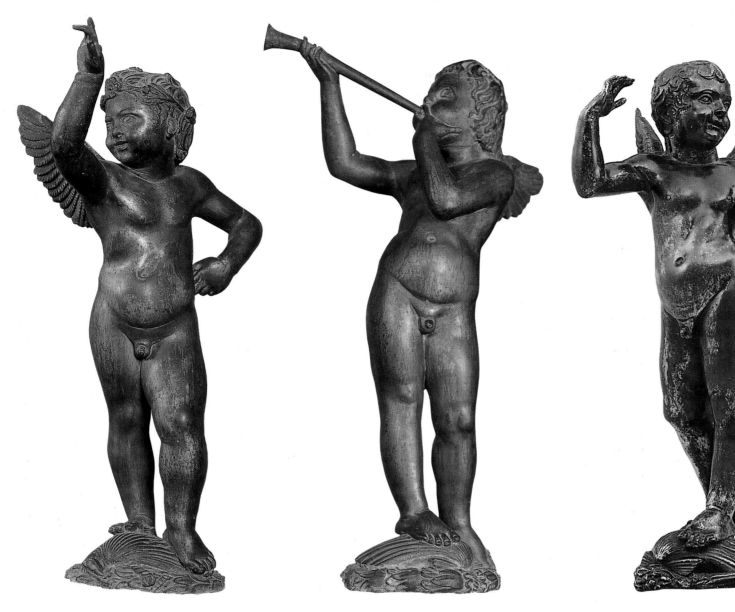

FIGURE 73.
Donatello, *Dancing Putto*.
Bronze, H. 36 cm (14 in.).
Baptistry, Siena.

FIGURE 74.
Donatello, *Putto with Trumpet*.
Bronze, H. 36 cm (14 in.).
Baptistry, Siena.

FIGURE 75.
Donatello, *Putto with Tambourine*.
Bronze, H. 36 cm (14 in.).
Staatliche Museen, Berlin.

Figs. 73, 74 in the left hand. The arms are raised as though to stress the precariousness of the balance of the putto on its rounded shell. In both of the putti still on the Font the weight rests on the right leg, not on the left, and the left foot is held forward with a contrary diagonal across the shoulders provided in both cases by the raised right arm. Whatever the origin of these figures—and no precise sources in classical small bronzes have been identified—their scheme and balance are personal to Donatello and prove that already, at this relatively early time, his mind was consciously engaged in probing the secrets of freestanding sculpture.

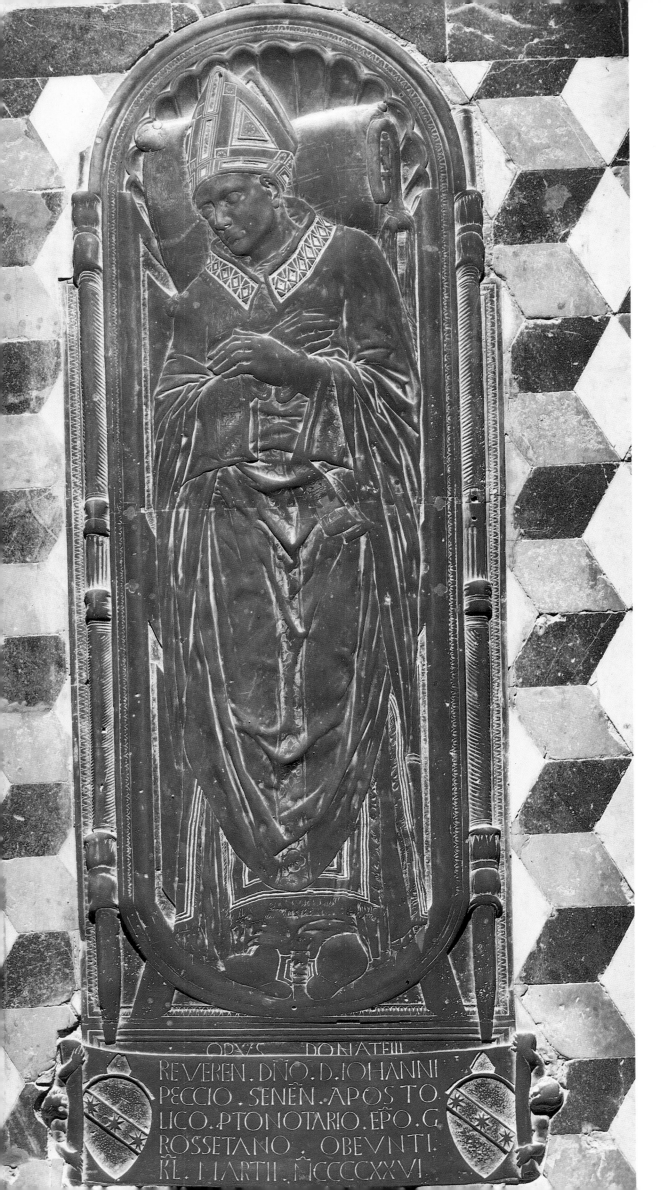

left: FIGURE 76.
Donatello, *Tomb Slab of Giovanni Pecci,*
Bishop of Grosseto. Bronze with
local enameling, H. 247 cm, W. 88 cm
(H. 97¼ in., W. 34⅝ in.).
Duomo, Siena.

right: FIGURE 77.
Donatello, Head of *Giovanni Pecci,*
Bishop of Grosseto.

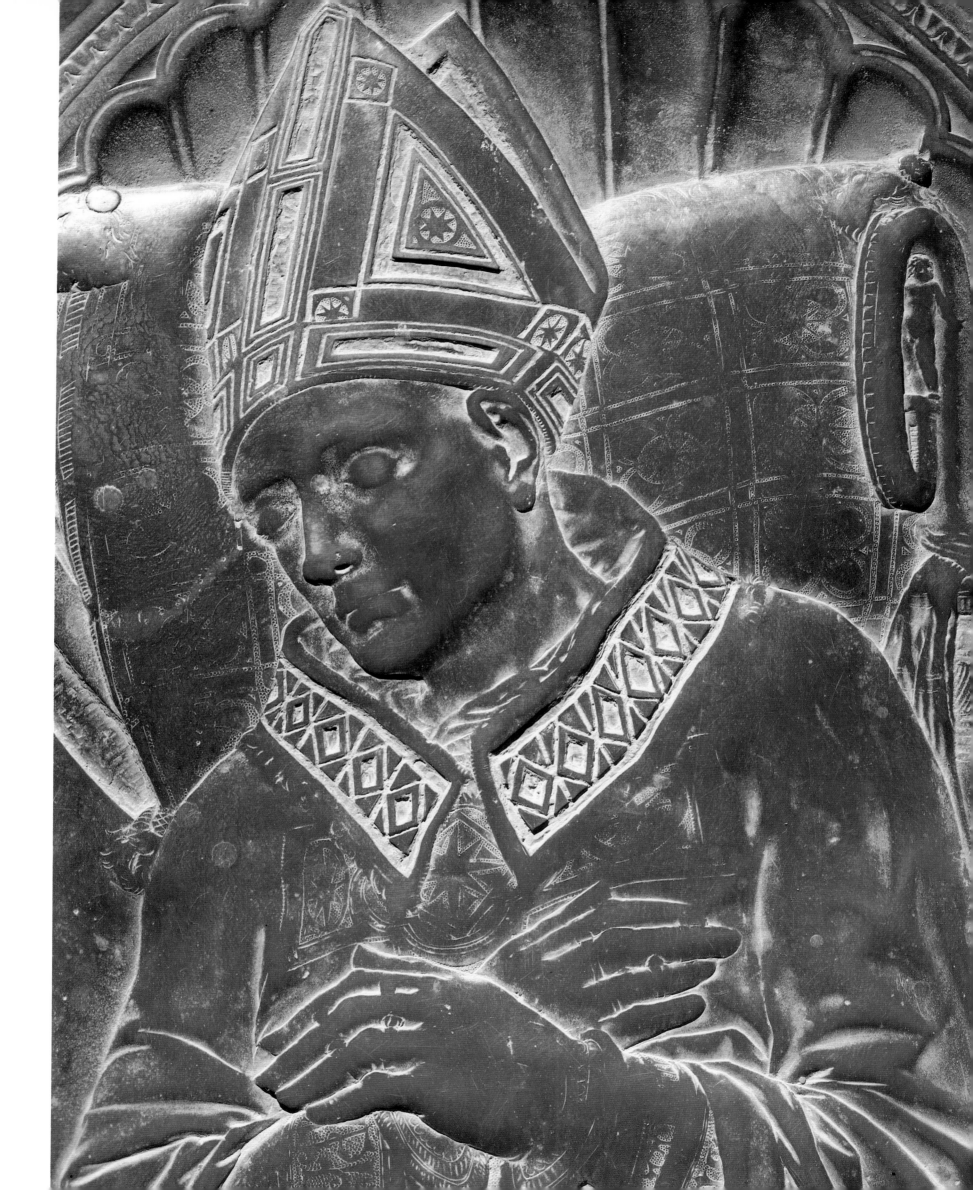

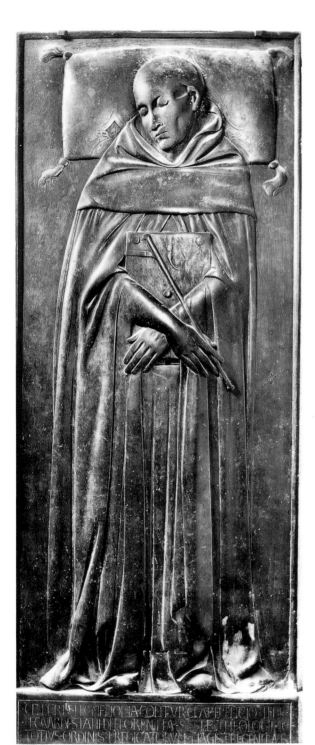

FIGURE 78.
Ghiberti, *Tomb Slab of Fra Leonardo Dati.*
Bronze, H. 229 cm, W. 87.5 cm
(H. 90⅛ in., W. 34½ in.).
Santa Maria Novella,
Florence.

Figs. 76, 77

The challenge to Ghiberti extended by Donatello in the relief for the Siena Font is repeated in one other work, the tomb slab of Giovanni Pecci, Bishop of Grosseto, in Siena Cathedral.[11] When in March 1425 the general of the Dominican Order, Leonardo Dati, died, his tomb slab was commissioned from Ghiberti for Santa Maria Novella.[12] Ghiberti's tax declaration of July 1427 mentions a sum of ten florins due to him from Santa Maria Novella for a "sepoltura ch'io feci pel gienerale," so it is reasonable to suppose that the slab was finished at that time and would, when it was laid down, have been seen by Donatello. The tomb slab is mentioned once more in Ghiberti's autobiography as that of "Messere Leonardo Dati, the general of the Dominican Friars; he was a very learned man whom I portrayed from nature; the tomb is in low relief, it has an epitaph at the bottom." Dati's head rests on a pillow and is turned three-quarters to the left; Ghiberti's "al naturale" suggests that it is based on a drawing, not a death mask. The body lies flat on the surface of the slab with hands crossed at the wrist and the feet protruding slightly above the epitaph. The Pecci tomb slab of Donatello is planned in an altogether different way. The distinction starts with the two inscriptions. Ghiberti's is on a tablet with a flat frame, whose width corresponds with the width of the bronze slab. Donatello's slab has two inscriptions, one with the upper half of the artist's name inscribed across the base and the other on an illusionistic scroll of fabric or parchment, unrolled by two putti at the sides, with the Pecci arms and the name of the deceased distorted so as to conform to the curve in the material. The inscription reads:

Fig. 78

REVEREN. DÑO. IOHANNI
PECCIO. SENEÑ. APOSTO
LICO. PROTONOTARIO. EPÕ.
GROSETTANO. OBEVNTI.
KĪ. MARTII. MCCCCXXVI.

Whereas the Dati tomb slab can be read from any viewpoint, since the background is conceived to be on the same plane as the church floor, the Pecci slab is a perspectival construction with one viewing point, from the center of the base. From this point, and this only, do the mitered head, the cushion, the crozier, and the soles of the protruding feet register as Donatello intended them to do. The body, with its cushion and crozier, rests on a catafalque, two of whose legs are visible at the base. At the top is an arched shell niche, and on either side are heavy poles with which the catafalque would have been carried to the place of burial. The orthogonals established by the molding beneath the arch and by the feet of the catafalque meet in the Bishop's hands crossed over his breast. Neither in this respect nor in the sensitively modeled head and fluent drawing of the chasuble has the slab a valid parallel in the bronze sculptures made by Donatello for the Siena Font. The perspectival construction, with sharply shelving orthogonals which have the double function of setting the image in illusionary space and of directing the eye toward a focal point, has, however, an equivalent in painting in the *Carnesecchi Madonna* of Domenico Veneziano in London, which is commonly dated in the first half of the 1430s. The date on the Pecci tomb slab relates to Pecci's death, not to the making of the bronze relief.

Fig. 256

Fig. 79

The first reference we have to it is from December 1453, when it was decided that the relief "ripongasi in duomo dove fu seppelito suo corpo, con un pezzetto di marmo all'intorno." The use of the word *ripongasi* implies that the slab had previously been taken up, though whether from the position in which it now is or from an antecedent Pecci chapel for which it was made in the mid-1430s, we cannot tell. It appears, however, to have exercised some influence on the bronze tomb slab of Pope Martin V by Michelozzo, which was dispatched from Florence to Rome in 1445.

The success of the Coscia tomb had one immediate consequence in the form of a commission for a second sepulchral monument, that of Cardinal Rainaldo Brancacci.[13] Brancacci was a figure of some importance in the church. Neapolitan by birth, he had been made a Cardinal in 1384, and was closely associated with Pope John XXIII, whose sister had married a Brancacci. There was an indeterminate connection between the Neapolitan and Florentine Brancacci families, and in the eighteen months he spent in Florence with the newly elected Pope Martin V, the Cardinal was housed by the Florentine Brancacci. A close friend of Giovanni di Bicci de' Medici—whom he named in his will in 1427 as one of his executors—and of Cosimo de' Medici, he described himself rhetorically as "a citizen of Florence." His charitable concerns were, however, Neapolitan, and the most important of them was the hospital of Sant'Andrea in Piazza di Nido in Naples, whose church houses his tomb. Brancacci died in Rome in June 1427, but the preparations for his monument must have been made under his direction in his lifetime, since the tomb is mentioned in Michelozzo's *catasto* return in July of that year. Work on it was undertaken in a joint studio set up by Donatello and Michelozzo in Pisa, from which its components were shipped to Naples. The structure, for which Michelozzo, not Donatello, must have been responsible, is an adaption of a conventional Neapolitan tomb type. The figure sculpture comprises three caryatids of Virtues supporting the sarcophagus, two angels behind the effigy holding back curtains at the sides, a lunette with a relief of the Virgin and Child between St. John the Baptist and St. Michael, a roundel with God the Father, and two angels blowing trumpets. Much of the detail is unfinished, but even when allowance has been made for that, the execution of the figures is coarse, though it is conceivable that the three caryatids (but not the angels behind the monument or the figures blowing trumpets) depend from drawings or small wax models by Donatello. The lunette, which shows the Virgin with open right hand pointing downward and the Child holding a long fold of her cloak, has nothing in common with the comparable group by Michelozzo on the Coscia monument and may also have been designed by Donatello, though the execution is so weak as to deprive it of all artistic quality. The effigy is by Michelozzo, with possible intervention by Donatello in the head. In the center of the sarcophagus, however, is one of the most remarkable of all Donatello's *stiacciato* reliefs, an Assumption of the Virgin, the subject of which must have been selected by the Cardinal in memory of his long service as Arciprete of Santa Maria Maggiore in Rome.

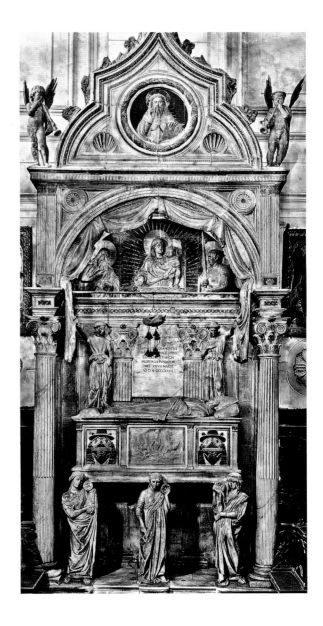

FIGURE 79.
Donatello and Michelozzo,
Monument of Cardinal Rainaldo Brancacci.
Marble, H. 907 cm, W. 387 cm
(H. 29 ft. 9 in., W. 12 ft. 8 in.).
Sant'Angelo a Nilo, Naples.

V

The Prato Pulpit
and the Cantoria

IN THE MIDDLE OF THE 1430s Donatello's creative thought centered on two interrelated works, an external pulpit for the Pieve at Prato and the Organ Loft, known as the Cantoria, in the Cathedral in Florence. The first is very fully and the second inadequately documented. The figure reliefs in both depend from Roman sarcophagi. Ostensibly the Cantoria is the later of the two—the contract for it dates from the summer of 1433—and it was installed over the entrance to the south sacristy of the Cathedral in 1439, forming a counterpart to the Cantoria of Luca della Robbia, which was commissioned in 1431. Designed to house two organs, the two Cantorie must have been conceived together, possibly in 1428 or 1429. The retarded date of Donatello's contract is due to the fact that before starting work he spent some time in Rome restudying Roman relief style and Roman architectural ornament. So far as can be judged, he did so on this occasion not from the investigative standpoint that had marked his period there with Brunelleschi, but with a mind adjusted to the creative criteria of his close friend Alberti. The contract was signed after his return to Florence. Though the Prato pulpit was commissioned from the joint workshop of Donatello and Michelozzo in 1428, the first of its seven reliefs was not carved till 1434, and the whole work was completed four years later in 1438. From the first, therefore, the two commissions were in conflict, and the extent of studio intervention is greater in the Prato pulpit than in the Cantoria, since it was the less important project of the two.

The principal relic preserved in the Pieve at Prato was the girdle dropped by the Virgin to St. Thomas, the only apostle who did not witness the Assumption. One of the most venerated relics in Tuscany, it was displayed each year on the feast of the

Assumption from an external pulpit attached to the southwest corner of the façade. The original wooden pulpit was replaced about 1360 with a marble pulpit, on the faces of which were four narrative reliefs of the *Dormition*, *Assumption*, and *Coronation of the Virgin*, and, since the girdle was strangely accident-prone, a relief of the *Recovery of the Relic*. When the Romanesque façade of the church was clad in marble, it was decided that the marble pulpit, which was linked to the chapel of the relic by a passage running across the west end of the church, should be replaced by a worthier structure. The contract for the new pulpit was signed, in Donatello's absence, by Michelozzo on July 14, 1428. Rather surprisingly, it included the provision that "il detto Michele [Michelozzo] per se e detto suo compagnio [Donatello]" would complete work on the pulpit by September 1, 1429. An additional clause provided for the refund of sums paid if work were not completed.

The ample documentation of the pulpit is important not only for what it tells us about the pulpit and its reliefs, but for the information it provides on Donatello's life and the working of his shop.[1] A sum of three hundred fifty florins was set aside by the Opera of the Cappella della Cintola to be paid over, in six installments, at stipulated intervals. There are two references to flour and firewood provided for Donatello by the Operai, and on a later occasion, in 1434, he is described rather contemptuously as "huomo ch'ogni pichole pasto è allui assai, e sta contento a ogni cosa" (a man for whom any small meal is sufficient reward, and who is content with anything he gets). On this occasion he was given a small sum of money to spend during the summer holiday over the feast of St. John the Baptist. He seems to have been viewed with constant exasperation by the authorities at Prato, and a report of 1438, when work was almost at an end, complains at the additional expenses caused by his dilatory working methods and insists that "Donatello et i compagni" have been overpaid. "And this," it declares, "is because Donatello has always led us where he wanted us to go," and had never established an office of works that could redress "sua inconstantia" (his unreliability). In the last week of November 1429 Brunelleschi, "dificatore da Firenze," paid a brief visit to Prato perhaps to advise on the structural feasibility of the suspended pulpit Donatello and Michelozzo had designed, and from December 1429 we have records of loads of marble being dispatched from Florence to Prato for use on the pulpit. In the late spring and early summer of 1430, Donatello was engaged, jointly with Brunelleschi, for fifty-six days on building a dike for military purposes at Lucca ("per providere di fare l'argine intorno a Lucca") and in Donatello's absence on this and on other occasions control of the workshop was vested not in Michelozzo, who was apparently in Pisa, but in a sculptor at one time employed in the Duomo in Florence, Pagno di Lapo Portigiani. When the partnership between Donatello and Michelozzo lapsed in 1434 Pagno di Lapo controlled the Prato shop. Documents also record the names of Matteo di Bartolomeo, a *garzone* of Donatello and Michelozzo, Papi di Piero, a *garzone* of Pagno di Lapo, and Chimenti di Luca. Another member of Pagno di Lapo's staff remained in Florence, working on the pulpit reliefs and on the Cantoria. In the final stages of work, the principal artist at Prato was the bronze sculptor, Maso di Bartolomeo, who was responsible among much else for the highly distinguished roof of the pulpit.

Work on the pulpit seems to have been suspended in 1432, when the Operai learned, to their annoyance, that Donatello, along with Michelozzo ("et il compagno"), was in Rome. The sequence of Donatello's Roman journeys at this time is far from clear. There is some indication that he was in Rome for purposes of study in the second half of 1430. On September 25 a letter sent from Rome by Poggio Bracciolini to Niccolò Niccoli in Florence contains the sentence "Ego etiam hic alicuid habeo, quod in patrem portabitur. Donatellus vidit, et summe laudavit." If Bracciolini and the object he had bought were both in Rome, and the object had been seen by Donatello, Donatello must also have been there. Donatello's documented visit to Rome in 1432–33 was looked on in the provincial climate of Prato as a gratuitous impediment to progress on the pulpit. Luca della Robbia seems to have visited Rome before he began work on his Organ Loft in the Cathedral, and Donatello may have been encouraged by Brunelleschi and the authorities of the Duomo to do so, too. Vasari, on the other hand, in his second (1568) life of Donatello, states that the sculptor was in Rome "quando vi era Gismondo imperatore per ricevere la corona di Papa Eugenio Quarto per che fu forzato . . . adoperarsi in fare l'onoratissimo spparato di quella festa, nel che si acquistò fama et onore grandissimo." The Emperor Sigismund was crowned by Eugenius IV on the feast of Pentecost (May 31) 1433, and Cosimo de' Medici is known to have been responsible for certain "apparati" on this occasion. That Donatello's absence was in some way bound up with work for Cosimo de' Medici is suggested by the fact that the Operai at Prato, having made an unsuccessful attempt to induce Donatello to return, had recourse to the intervention of Cosimo (this is the first evidence of his special relationship to Donatello). Giovanni d' Antonio de' Medici, who was in Rome, was asked by Cosimo to intercede with him. According to a letter written from Rome on October 11 by Giovanni de' Medici to Cambio di Ferro, an innkeeper at Prato serving at the time on the Opera del Sacro Cingolo, he delivered to Donatello a letter from Prato along with a message from Cosimo. In reply, Donatello assured him that he intended to return to Florence by the end of the month, and would then willingly resume his work at Prato. He made a number of excuses, one of them involving disagreement with a member of the Prato board, "et lecite siche non vi dolete di lui ne a pitizione di nesuno et massime di quello dello. . . . Non li fara cosa alchuna, che sarebbe male." Unluckily, the name of the official with whom Donatello had clashed at Prato is illegible. The Opera, wrote Giovanni de' Medici, would be well served by him, and anyone who said the contrary must be actuated by malice. He should be paid for the whole month of his return, and the Opera must recognize that it was Cosimo's message rather than any other factor that had induced him to come back. He had "no other assets than his hands," and despite the hiatus in service to the Opera, which he could alone provide, no discriminatory action should be taken against him. On his return, moreover, it should be laid down that he was answerable to Cambio di Ferro and no other official of the Opera. Donatello nonetheless failed to return at the end of November, and at Christmas arrangements were made to send Pagno di Lapo to Rome to persuade him to come back to complete the pulpit. In April 1433, Pagno di Lapo was again dispatched to Rome, and this time his mission was successful. By the time of the

next recorded payment, Donatello was once more at work in Florence on the Prato pulpit, and later in the summer he signed the contract for the Cantoria. This pattern of recalcitrance did not end with Donatello's return from Rome, and in November 1436 Maso di Bartolomeo, then acting as supervisor of work on the pulpit, was sent to Florence to induce Donatello to come to Prato. The note of expenses on this occasion ends with the words: "e fececi la beffa" (he made a fool of us).

With any work planned jointly, as the pulpit must have been, there is an unresolved area of doubt as to the contribution of each artist. At Prato we have no means of telling whether the novel and highly influential concept of a suspended pulpit originated in the mind of Donatello or of Michelozzo or was the fruit of discussion between them. Much of the carved detail of the pulpit—the supporting element, the consoles, the moldings of the balustrade, and the paired pilasters separating the reliefs—is Michelozzan, and though Michelozzo's name appears less prominently in the documents than Donatello's, it is conceivable that he, not Donatello, was responsible for elaborating the design. Alternatively the pulpit may represent an intermediate stage in Donatello's development as an architect between the completion of the Parte Guelfa tabernacle and the planning of the Cantoria. The circular platform and balustrade, which had implications for the figure sculpture, must have originated with Donatello. While he was working in Pisa on the Brancacci Monument, he would have examined the circular pulpit of Giovanni Pisano in the Duomo, with its cycle of convex reliefs, and it is to Donatello not to the less empirically minded Michelozzo that we must credit the decision to experiment with this taxing relief form.

The work contracted for differed in a number of respects from the work that we know now.[2] The base of the pulpit was originally to have been five and a quarter braccia from the ground, whereas the present pulpit is seven braccia from ground level. This change may have been decided on to ensure easier access from the gallery inside the church. Under the contract, the protruding pier on which the pulpit rested was to be "in forma di colonna quadra schanalata," but in practice no facing was applied to the rectangular support. Above the cornice of the rectangular base there were to be "due spiritelli in luogho di gocciole," each two braccia high and surrounded by foliage. These angels, which would presumably have been in the center of the east and south faces, were also eliminated. Above the "spiritelli" was to be a cornice carved with dentils and a platform five and two thirds braccia in diameter supported by foliated consoles, surrounded by a circular balustrade divided into six sections decorated with reliefs showing either "spiritelli" supporting the arms of the Commune of Prato or some other subject approved by the commissioning body. In the pulpit as executed, the balustrade contains seven, not six, reliefs of angels playing and dancing on the parapet. This change in the scheme seems to have been made after Donatello's return from Rome in 1433.

Fig. 81 Concurrently, the "spiritelli" beneath the pulpit were replaced by a bronze capital, which now covers the west face of the pier, leaving the south face void. According to Vasari the missing section was stolen by Spanish soldiers. If so, the theft would probably have occurred in 1512.[3] But it has also been argued that the present capital was designed for the south face, the section now on the north face

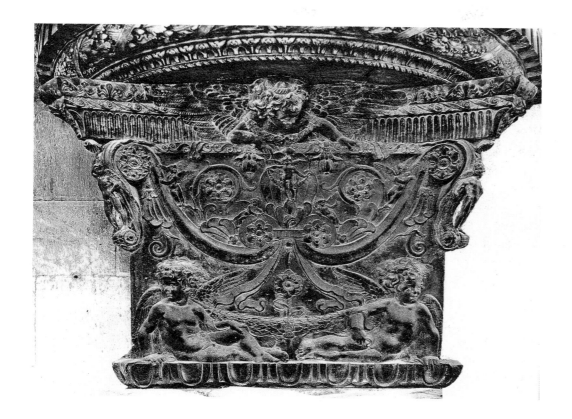

opposite: FIGURE 80.
Donatello and Michelozzo,
External Pulpit. Duomo, Prato.

FIGURE 81.
Michelozzo, *Capital.*
H. ca. 90 cm (35½ in.).
Duomo, Prato.

being accidentally damaged in casting. There is no reference in the documents to a failed bronze cast, and the narrow piece of the capital on the north face fits so tightly in its present place that it can hardly have been intended for any other position. Documents prove that the capital was originally gilt.

There is only one reference to the capital in documents. It occurs in February 1435, and relates to "the bronze capital made by Michelozzo." The common view of almost all commentators on the pulpit (with two creditable exceptions) is that despite this record the capital was modeled by Donatello, but was cast and chased by Michelozzo. It contains three putti with garlands, two on the west and one on the north face, and an angel on the west face with head turned down. They are lively, animated figures, but they are very different from the works in bronze by Donatello that precede the pulpit, that is from the sculptures of the Siena Font, and their affinities are with the work of Michelozzo. The head of the child looking over the top of the capital reads as a reduction of the Child in the terracotta Madonna by Michelozzo on the façade of S. Agostino at Montepulciano, and the three seated figures have an unmistakable relationship to the flattened figures, with bodies turned at the waist and legs apart, in the marble frieze carved by Michelozzo for the Aragazzi Monument.

On Donatello's return from Rome the plan for balustrade reliefs with two putti supporting the arms of the Commune of Prato was abandoned in favor of the dancing putti we see now. At the end of May 1434 a new contract was drawn up, whereby Donatello was paid twenty-five florins for each of the reliefs, which were

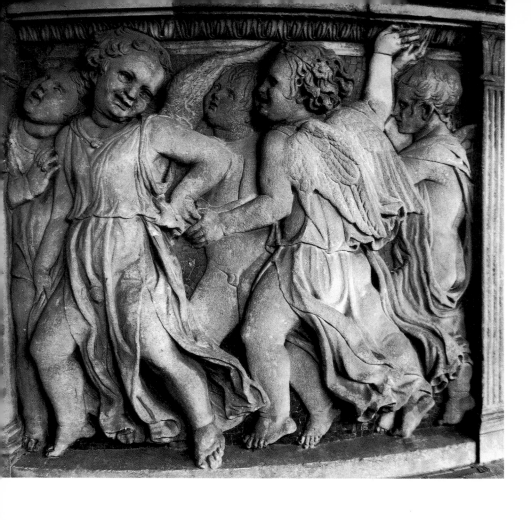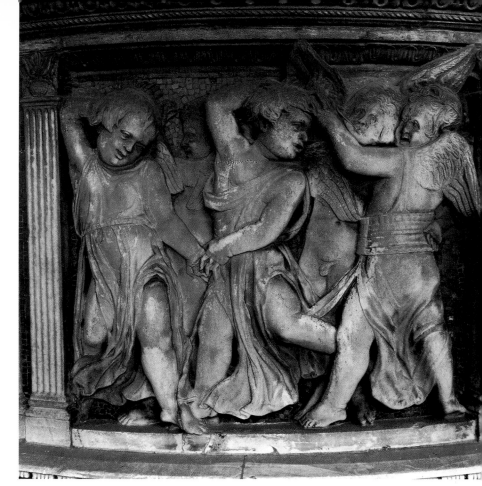
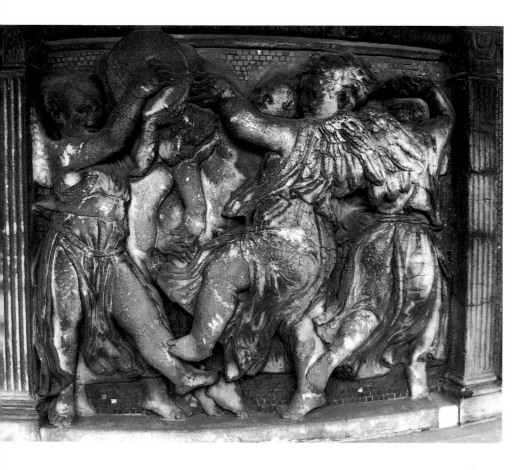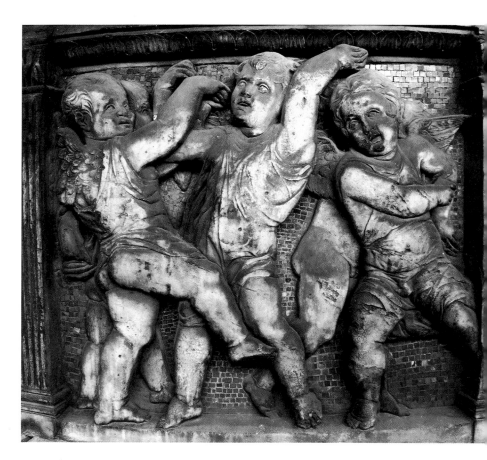

to be executed *propria manu*. At the end of June a Pratese musician working in Florence, Matteo degli Organi, informed the Operai that one of Donatello's reliefs was complete and was much acclaimed. Further reliefs were delivered in June 1436, and in July 1438 all seven reliefs were installed on the pulpit. In September 1438, Donatello and Michelozzo were paid seven hundred lire for the seven marble reliefs; this sum included the cost of the marble, but not that of the gold mosaic inlay with which the backgrounds of the reliefs were to be filled. At Prato the reliefs were greeted without enthusiasm. The payments for them, says a report, were contingent on their being "compiute non altrementi. Le qual storie in verità non sono compiute ne odimpiute." But no action was taken to dock Donatello's fee.

Figs. 82–89 Any discussion of Donatello's seven reliefs must open with the premise that they cannot be judged as works of art in the condition in which they are today. Originally brought to a higher degree of finish than is now evident, they remained in situ until 1942, when they were taken down and stored. Reinstated after the war, they suffered further weathering. Finally, too late for effective conservation, they were moved to the Museo dell'Opera del Duomo at Prato, where they are shown at eye level, not at the height at which they were intended to be seen. Their surface and much of their detail had been lost by the time the earliest recorded photographs were made, and by 1942 the finest of them, in the center of the balustrade, had suffered substantial surface losses in the naked bodies and in the drapery. The reliefs are not continuous, and the figures in them are set on a shallow platform of space closed at either side by pilasters in a forward plane and at the back by gold mosaic. At the top of the rear wall is a cornice broken by the raised hands (in one case, the raised trumpet) of the dancing figures. The relief on the extreme right shows five Fig. 88 children in a group so tightly compressed that the forms are not clearly differentiated. Three of the figures are set in a rear plane, one in the center on tip-toe and two at the sides leaving the relief with heads turned back. An element of linear pattern is imposed upon the scheme by the two forward figures, one seen from behind moving inward with his left forearm aligned on the cornice and one on the right seen frontally with right arm raised and his left hand linked to the right hand of a Fig. 87 retreating figure on the right. The second relief from the right contains four figures only, and a larger area of background is therefore visible. In the center and to the right are three angels engaged in a round dance, and on the left is the source of the music that inspires them, an angel in profile playing a pipe. The third relief from Fig. 85 the right again contains five figures, but two of them are relegated to the background and are all but concealed by two figures in front. No formal dance appears to be involved; the three figures are linked in ecstatic movement, and their transparent smocks, which reveal the naked forms beneath, are carved with far greater sophistication than the garments in the two scenes to the right. Before its surface was Fig. 86 destroyed, this was a substantially autograph relief by Donatello. The fourth relief, in the center of the front of the pulpit, though it is now gravely damaged, seems also to have been in great part autograph. At the back is a musician, hidden, save for the upturned face and legs, by four figures in the foreground. Two dancing children in the center are posed diagonally, the head of one concealed behind the other, and at Fig. 84 the sides are two angels in *contrapposto*, posed frontally. In the fifth relief, to the left

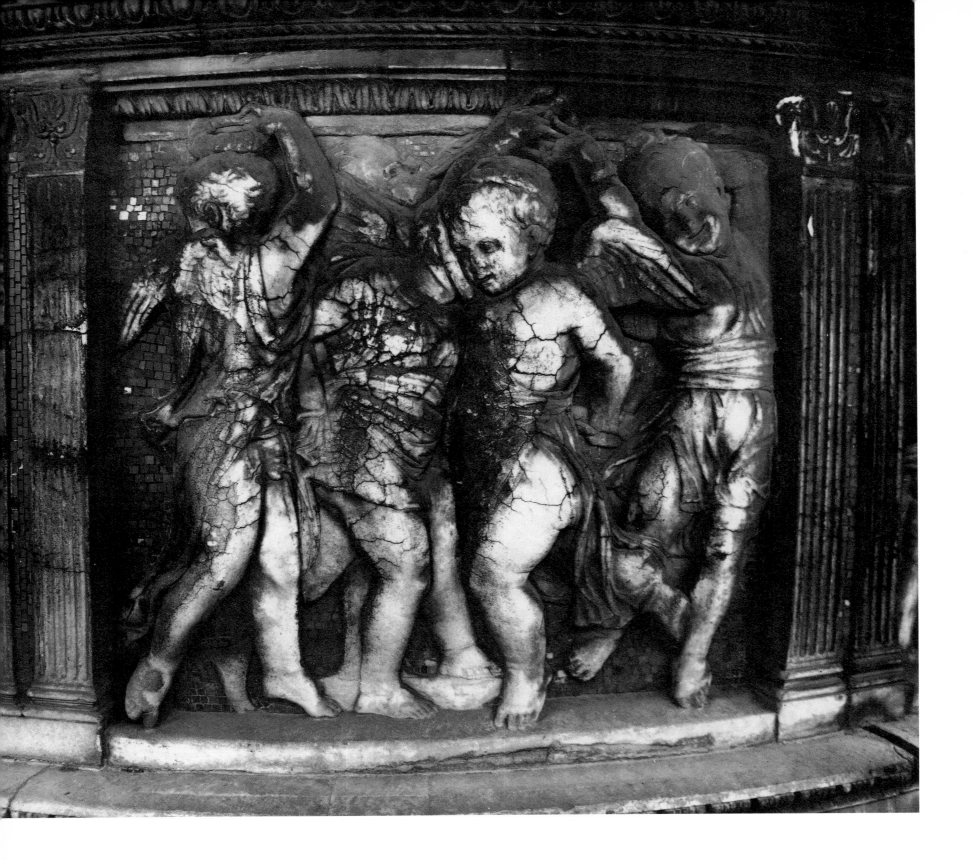

FIGURE 86.
Donatello, *Dancing Children*.
Marble with mosaic background,
H. 73.5 cm, W. 79/82 cm
(H. 28⅞ in., W. 31/32 in.).
Duomo, Prato.

of center, the same inversion is used again in the two lateral figures, one with a tambourine seen from a three-quarter frontal view, the other represented three-quarters from behind. In the center is a dancing angel in profile to the left. The interlocking of the six legs of the foreground figures provides the whole design with a strong basis of geometry. Behind in low relief are two subsidiary figures. Probably this carving is also in large part autograph. The sixth and seventh carvings on the extreme left are less lucid and less animated.

Figs. 82, 83

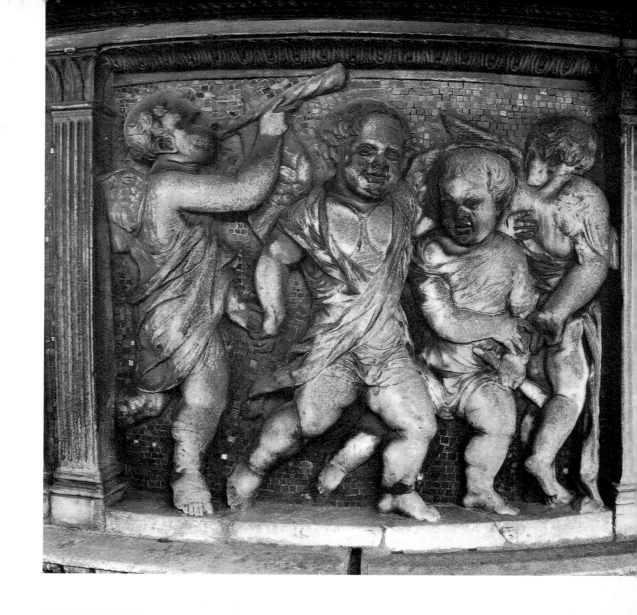

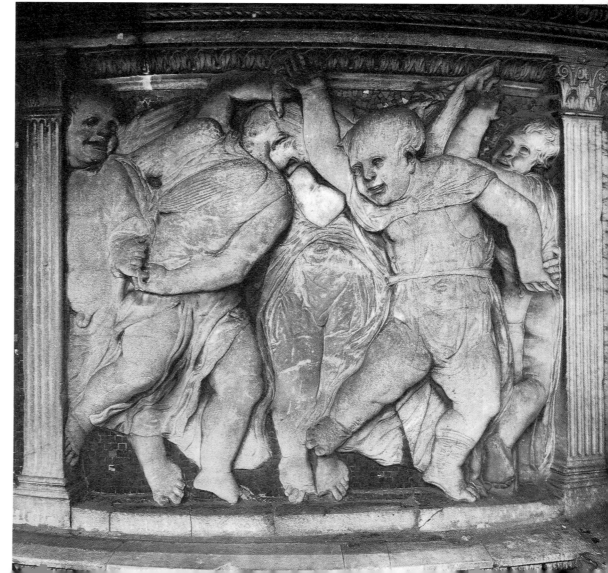

FIGURES 87, 88.
Donatello, *Dancing Children*.
Marble with mosaic background,
H. 73.5 cm, W. 79/82 cm
(H. 287/8 in., W. 31/32 in.).
Duomo, Prato.

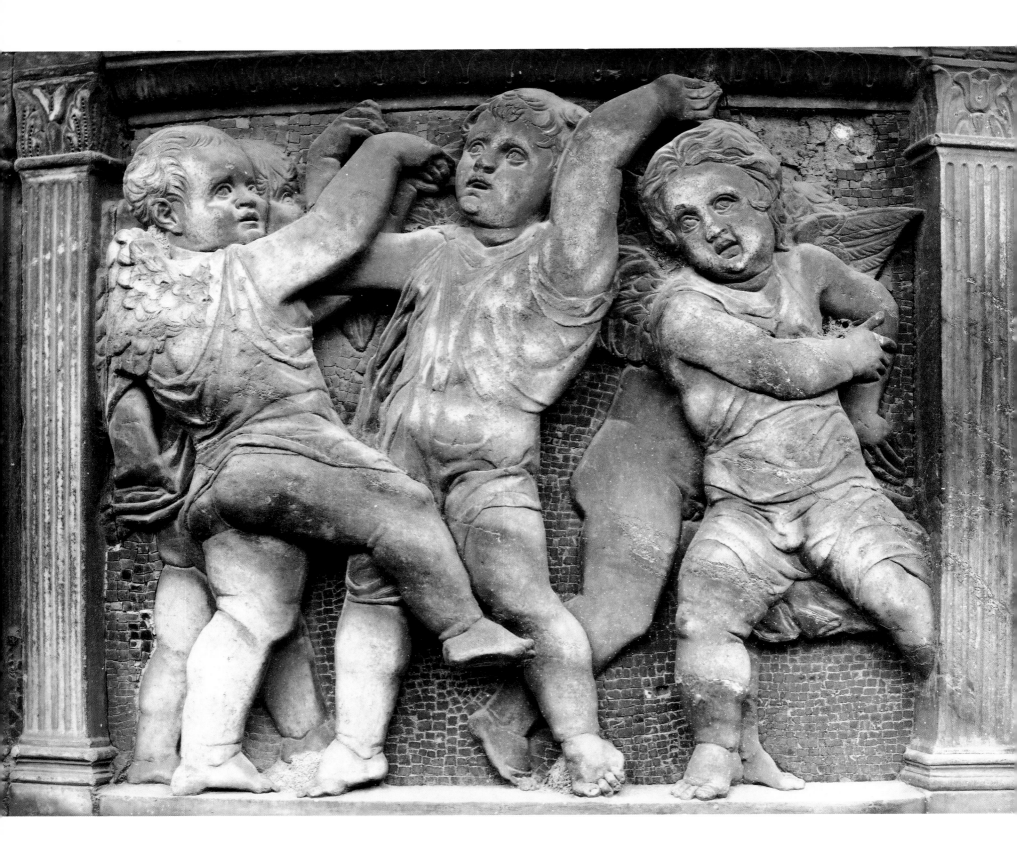

The divergent quality of the carvings is a by-product of the method by which they were produced. Each of them must have been preceded by an autograph wax or terracotta model by Donatello, which was then translated into marble in his workshop. The intervention of assistants is sometimes apparent in the drapery (which in the hands of Donatello defines, and in that of his assistants conceals, the forms), in defective spatial definition, and in the faulty juncture of the heads and limbs. The term "studio execution" does not preclude limited intervention at a late stage by Donatello. Two drawings from single panels were made by a follower of Pisanello. One, in the Ambrosiana in Milan, is a full copy of the relief to left of center, and the other, in Berlin, is a partial copy of three figures in the central relief.[4] In both, the figures are shown in deep space in a kind of box, and in both the reliefs are flat, not convex. The disposition of the figures in space is more elegant and more precise than in the marble carvings, and they are depicted without distortion from a higher viewing point. If, as is likely, they record models for the reliefs, the designs would have been subject to a double process of revision, first in the adaptation of a flat relief to the convex form demanded by the pulpit, and second by its adjustment to the height at which it would be seen.

Fig. 90

The Operai of the Chapel of the Cintola were not alone in feeling some dissatisfaction with the completed pulpit, for in April 1455 a joint letter was written by Donatello and Michelozzo requesting payment of the balance of the sum due to them and offering to rectify whatever was amiss:

> As you know, it has been many years since we worked together on the pulpit where you display the Girdle of Our Lady, and a long time ago we did everything on that work which he who was then in charge desired; and although the account has been rendered and balanced between you and us, the affair is not right in all respects, and problems exist for you and for us in respect to the many dangers and other things that could occur. And although you could answer: You could have done something about this a long time ago, we could say the same thing to you, and besides, Donatello has been away from the city for about ten years. Now having returned and having discussed this matter several times, we are disposed to take action and pray for your wisdom—for which we would be very grateful and for which you would receive great honour, so that by neglect neither injury nor shame should result to either party—we pray you to choose a specific time at your pleasure for the completion of this work. And to tell us when we should come for this purpose, and we can easily make the trip there [to Prato] without delay or fatigue, assuring you that if anything is lacking on our account in this affair, we are always prepared to accede to your every request in regard to it. And therefore may it please you to arrange what we ask of you, as much for your honour, benefit, and happiness as for ours. Nothing else is happening now. God keep you in peace.

This proposal for further intervention by the two artists was turned down.[5]

The Cantoria, on which Donatello was also working at this time, is in every respect a more vital and more brilliant work. From 1426 it had been admitted by the

103

Operai of the Cathedral that the regular organ was unsatisfactory, and that a new organ was required. This was put in hand. Arrangements were also made for the old organ to be reconditioned, and for both instruments to be installed over the doors of the two sacristies. Two organs required two organ lofts, and the contract for the first of them seems to have been placed in 1431 with Luca della Robbia.[6] The contract does not survive, but it is likely to have enjoined that the figure reliefs should illustrate the opening verses of Psalm 150, whose words are inscribed in three lines of classical formata lettering on the front face. For its architecture Brunelleschi, the dominant figure in the Duomo at the time, was probably responsible. A decision to commission the second Cantoria from Donatello must have been reached at the same time. No record of it appears, however, before July 10, 1433, when the Operai of the Duomo invested one of their members, Neri di Gino Capponi, with authority to allot to "Donato olim . . . de Florentia, aurifici seu schultori" the contract for "unum perghamum de marmore in secunda sacristia seu super porta secunde nove sacristie, in loco designato, cum illis storiis et cum illis pactis et pro eo pretio et tempore prout eidem videbitur et placebit, non tamen pro maiori pretio perghami locati Luce Simonis della Robbia."[7] The signature of the contract is recorded on November 14; it enjoined that the individual reliefs were to be paid for at the same rate as those of Luca della Robbia, namely forty florins. If the reliefs were more perfect than Luca's, Donatello might be paid fifty florins but no more. The marble would be supplied by the Opera, and each of the reliefs was to be completed within three months of its delivery.[8]

The dimensions of the two Cantorie must have been laid down by the authorities of the Cathedral, and are in close conformity. The overall height and width of Luca's are 3.28 meters (129 in.) and 5.6 meters (221 in.), and the overall height and width of Donatello's are 3.48 meters (138 in.) and 5.70 meters (224 in.). The height of the figurated reliefs on the balustrade is also uniform, 99 centimeters (39 in.) in Luca's Cantoria and 98 centimeters (38 5/8 in.) in Donatello's. Our first impression of the Cantorie today in the Museo dell'Opera del Duomo (and the impression that they must have made in situ when Luca's stood over the door of the north sacristy and Donatello's over the entrance to the south sacristy) is nonetheless one of discrepancy. Reading from the bottom up, Luca's rests on a flat frieze inlaid with an inscription with a modest molding above; Donatello's, on the other hand, rests on a frieze carved on the front face with four garlands flanked by putto heads, with above it a heavy egg-and-dart molding. In Luca's Cantoria the front faces of the five consoles above are filled with acanthus decoration and their sides with foliated ornament. In Donatello's the modillions are heavy and obtrusive and are carved with decorative floral motifs, for which analogies are found in Rome in the Temple of Concord. Above the modillions are strips carved with a bead and reel motif and above these again are two continuous patterned moldings. Extensive use was originally made of color on these surfaces, and they retain strong traces of green and gold. The rectangles between the consoles are filled in Luca's Cantoria with four figurated reliefs. In the second Cantoria the two outer rectangles show paired putti on a ground of mosaic tessere, and the two central rectangles contain circular panels of polychrome marble (which originally served as backgrounds for two bronze heads).

Fig. 92

Fig. 95

Fig. 93

Whereas the balustrade of Luca's Cantoria is filled with four figurated reliefs set between paired pilasters, the balustrade of Donatello's is filled with a single relief running the whole width of the gallery with five pairs of inlaid columns aligned with the modillions beneath. Of the topmost area it is difficult to speak with confidence since the upper parts of both galleries were moved from their original positions in 1688 for use at the marriage of the Gran Principe Ferdinando de' Medici to Violante of Bavaria. At this time the friezes of both Cantorie were broken up, and no more than a small piece of Luca della Robbia's survives. In the case of Donatello's Cantoria, the surviving fragment with a two-handled vase is so small as to make the present reconstructed frieze largely conjectural.

The columns on Donatello's balustrade are ten centimeters (4 in.) higher than the figurated reliefs, and the reliefs must originally have been set some twenty centimeters (8 in.) higher than they are now, so that the space above the figures was less than it is today and the floor on which they stood was visible from the ground. Donatello's Cantoria, with its bewildering wealth of ornament, its rich gilding, and its mosaic inlay in the columns of the balustrade and in the backgrounds of the reliefs and cornice, was calculated for the height at which it would be seen. This was evident to Vasari, who writes that Donatello "displayed much more judgment and skill than Luca . . . because he did almost the whole of the work in the rough as it were, not delicately finishing it, so that it should appear much better at a distance than Luca's. . . . Experience shows that all things seen at a distance, whether they be paintings or sculptures or any other like thing, are bolder and more vigorous in appearance if skillfully hewn in the rough than if they are carefully finished." But with the structure of the Cantoria more than roughness of execution is involved. Its style, resulting as it did from fresh analysis of Roman architecture, is anti-Brunelleschan and forms a powerful statement of Donatello's personal preconceptions as an architect.

The figurated sections of the two Cantorie depend from Roman sarcophagus reliefs, but the verb *depend* here connotes two very different processes. Luca della Robbia, before work started on his organ loft, made careful notes of individual groups and single figures in the sarcophagi he knew, some of which can be identified. His notations were then combined with study from the life to produce his ten Cantoria reliefs. In Donatello's Cantoria, precedents can be traced in Etruscan antefixae for the anthemion frieze beneath the main reliefs, in the Temple of Concord and the Baths of Agrippa for the cornice, and in the Forum of Nerva and the Temple of Concord for the scrolled brackets on which the Cantoria rests. The paired putti between the consoles are generally described, not wholly persuasively, as imitations of reliefs in the Throne of Neptune in Ravenna and the Throne of Ceres in Milan, and conform to the same classical context as the architecture. But to the frieze of figures around the balustrade any such analysis is inapplicable, and attempts to identify specific sources for figures or groups of figures in it are misleading. The reason for this is that Donatello's attention as a figurative artist centered on style, not on motifs. It lay, in other words, with the syntax, not the vocabulary of Roman art.

Donatello would have observed when he looked at sarcophagus reliefs that the

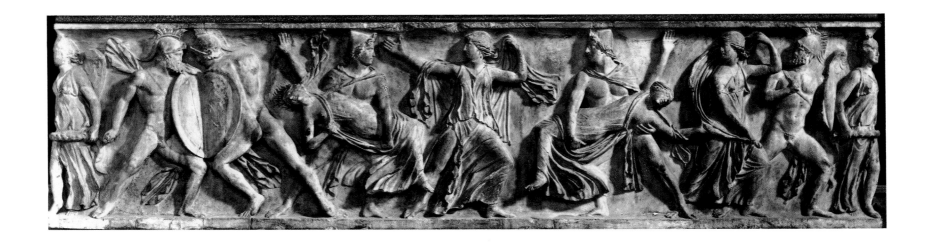

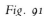Fig. 91

FIGURE 91.
Roman (Hadrianic),
*Sarcophagus front with
Rape of the Leucippids.*
Marble. Uffizi, Florence.

opposite: FIGURE 92.
Donatello, *Modillions of the Cantoria.*
Museo dell'Opera del Duomo,
Florence.

figures in them had a dual character; they could be seen two-dimensionally as pattern and three-dimensionally as figures in constructed space. Two examples (which Donatello would not necessarily have known) are the related reliefs of the *Rape of the Leucippids* in the Uffizi and the Vatican. In the center of each of them is a strong vertical, in the form of a gesticulating woman. To right and left are the figures of two abducted women set at an angle of forty-five degrees to the base of the relief, whose feet, if they were extended, would meet roughly in the center of the scene. The two men by whom they are abducted both face inward, one with his right and the other with his left arm placed vertically across the women's bodies. At the left ends are two fighting figures with a leftward bias, each with one leg extended at forty-five degrees, and at the right end are two further figures with a rightward bias, once more with legs extended, looking back into the scene. At the corners the relief is closed by two erect outward-facing female figures. But the scene at the same time takes place in space. The static figures are set on two planes indicated in part by the superimposition of one figure on another and in part by gestures establishing the space certain of the figures occupy. For Donatello, who would have been thoroughly familiar if not with these, with related sarcophagi, such reliefs provided not a lesson but a challenge, which he met on the Cantoria with unflagging zest.

The initial stage can be followed through documents. No provision was made in the contract as to the program or subject of the relief, which must have been defined at an earlier date, concurrently with that of the first Cantoria. In addition to its stipulation on the cost of the Cantoria, the authority granted to Neri di Gino Capponi includes the unusual phrase "cum illis storiis," apparently in reference not to the subject matter of the scenes but to the way in which the subject matter, a throng of rejoicing *spiritelli*, was to be portrayed. The first slab for the reliefs was delivered immediately after the contract was signed in November 1433 and was accepted by the artist. On December 23 of the same year "una lapida di braccia 5" was secured for Donatello's use; we do not know whether this was intended for the figure reliefs or for the frame. In February 1435 two more marble slabs were

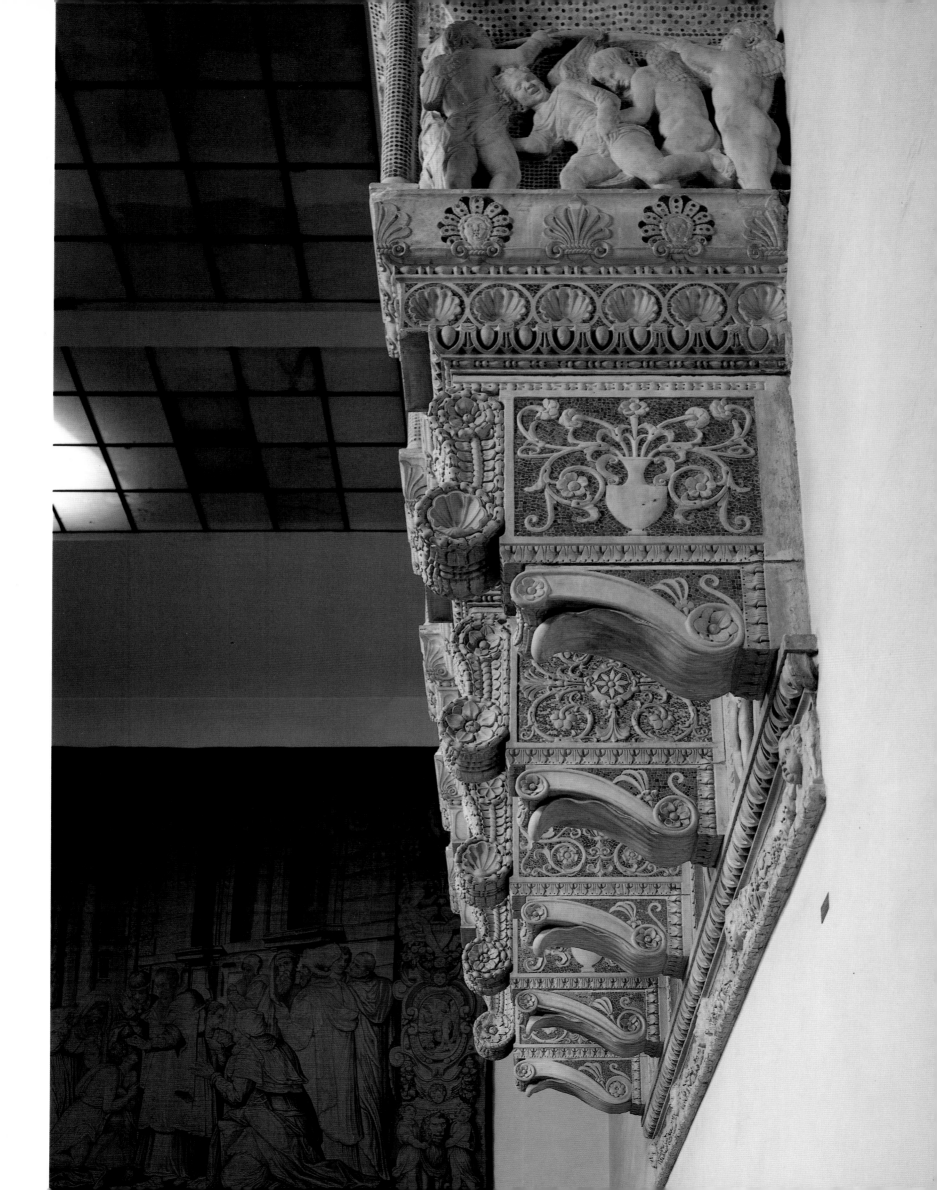

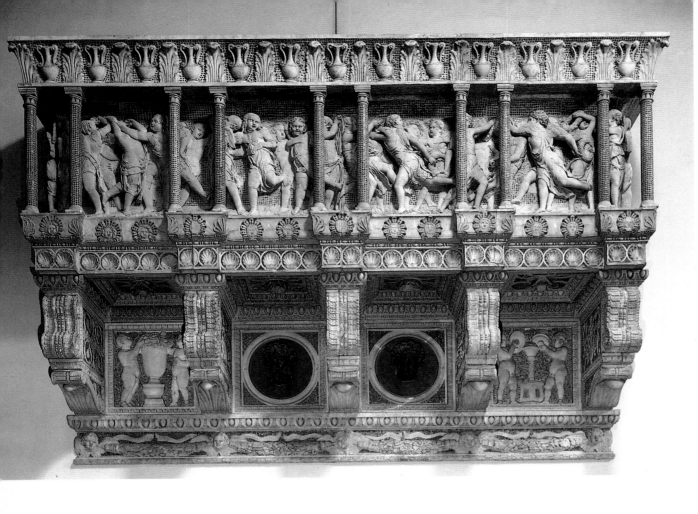

FIGURE 93.
Donatello, *Cantoria*. Marble,
with local pigmentation and
mosaic inlay, H. 348 cm,
W. 570 cm (H. 137 in., W. 224³/₈ in.).
Museo dell'Opera del Duomo,
Florence.

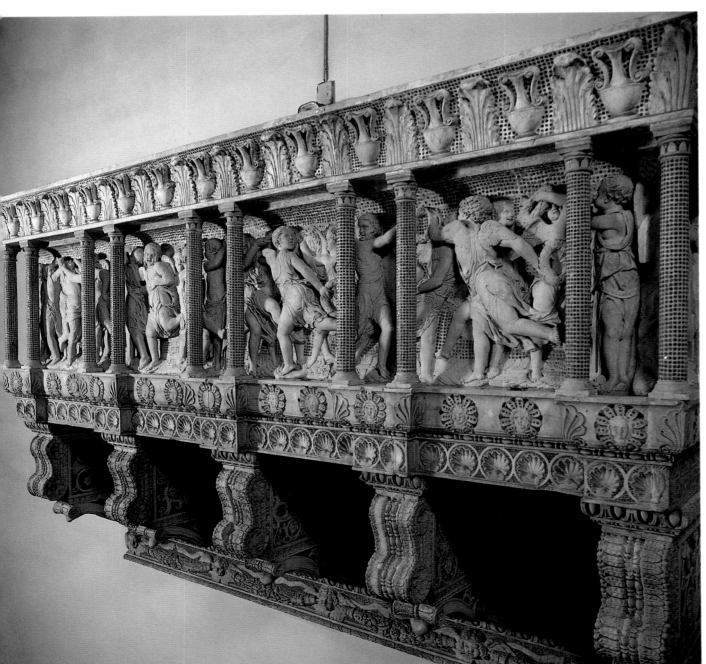

FIGURE 94.
Donatello, *Balustrade of the Cantoria*.
Marble with mosaic inlay,
H. of figurated relief 98 cm (38⁵/₈ in.).
Museo dell'Opera del Duomo,
Florence.

opposite: FIGURE 95.
Donatello workshop, *Two Putti from the
Lower Register of the Cantoria*.
Museo dell'Opera del Duomo,
Florence.

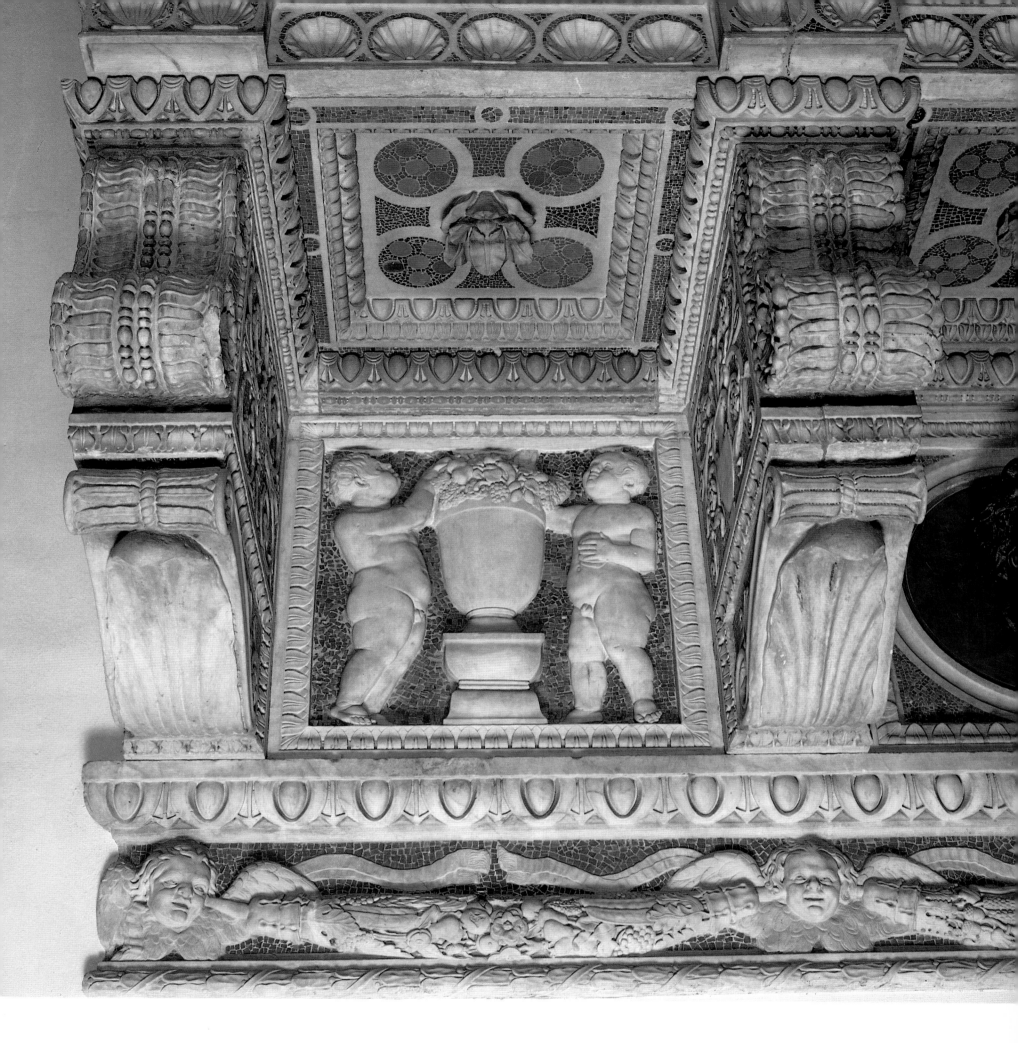

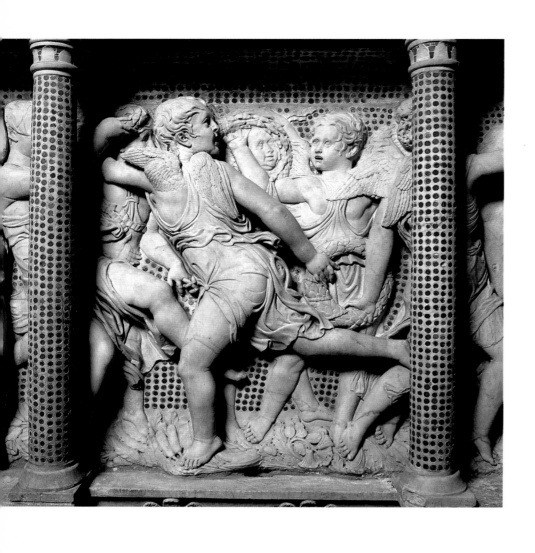

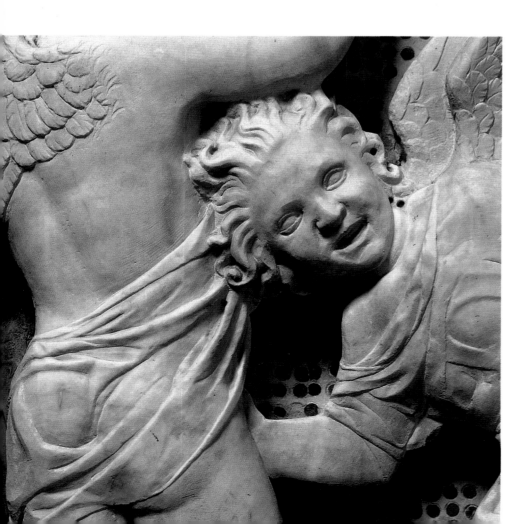

delivered, but Donatello turned them down since they were of the wrong size. Payments for work continue spasmodically through 1436 and 1437, and in October 1438 the Cantoria is reported to be almost complete. The documents show that its design was changed in one major respect. When the contract of 1433 was drawn up, the front of the balustrade was to consist of four reliefs comparable in value and, therefore, in size to those of Luca della Robbia's Cantoria, but at quite an early stage, at the end of 1433 or early in the following year, this scheme was abandoned in favor of a continuous frieze of figures carved on two adjacent marble slabs. The format was that of a sarcophagus relief, though on a greatly extended scale.

It has been said of the Cantoria that "the scene has no real beginning and no natural end," and that it must consequently have been inspired by the chain of dancing figures around a circular Greek vase. This is incorrect, for at each end of the frieze there is a stationary figure, turned inward, of a type we might find on a sarcophagus relief. The figure on the right, blowing a trumpet, stands in the front plane and is confronted by a dancing figure holding a wreath; the figure on the left is set farther back and is confronted by a dancing figure with back turned in the front plane. Reading the relief from left to right, we see first a dancing figure with its left leg extended at forty-five degrees linked with three angels in a rear plane. There follow a standing angel with arms raised, and two more dancing angels with left legs extended, one sharply turned so that the lower leg is parallel to the base of the relief and the other with a leg on the relief plane. A standing angel holding a curtain or piece of fabric brings the left side of the frieze to a decisive close. Reading across the right half of the frieze, we are conscious less of the spread legs of the angels than of their horizontality. The raised left arm of the trumpeter on the right runs parallel to the base, as do the upper arms of five figures to its left and the legs of two angels with back turned that punctuate the scene. All these devices must have resulted from critical study of Roman sarcophagus reliefs.

In two respects Donatello must have found his prototypes inadequate. The first was their imperfect command of movement and the second their often arbitrary rendering of space. On sarcophagi the scale reduction of the rear figures is seldom accurate. On the Cantoria, however, the reduction is exactly calculated, and a convincing sense of depth is created not only by the poses of single figures, but by the use of wreaths receding sometimes abruptly, sometimes less sharply into the picture space. The wreaths figure most prominently in the right half of the relief. The angels in Donatello's Cantoria stand not on clouds, like the figures in Luca's relief, but on an irregular earthy surface covered with acorns, bulrushes, and fruit. As with the *St. Mark*, so here the softness of the base accentuates the weight of the dancing figures standing on it. As Luca della Robbia recognized in his own singing gallery, a sense of movement could be obtained only by study from the life. Donatello's objective, however, was not natural movement, but accelerated movement of a speed and strength of which no child would have been capable. The cutting throughout is deeper and freer than in Luca della Robbia's reliefs.[9] The legs and arms of many of the forward figures are fully undercut, and the shadows cast by their limbs on the gold mosaic background establish the scene as taking place not in constricted space but in space that is ambiguous and indefinite. When, in the 1940s,

the Cantoria was still disassembled, the illusion of movement in the frieze was very powerful; after its reconstruction, with paired Cosmatesque columns punctuating the scene, it became more powerful still.[10] It has been claimed that Donatello here makes conscious use of what is called the Poggendorf illusion, whereby the interruption of the frieze leaves us with a sense that the severed figures have been displaced. The parsing of the frieze with paired columns seems, however, to have been envisaged from the start.

There are references in documents to unnamed members of Donatello's workshop involved in the carving of the Cantoria, and attempts have accordingly been made to isolate the hands of Buggiano and other artists.[11] This is a fruitless study on two counts. The first is that five of the reliefs on the Prato pulpit were carved by Donatello's pupils from his models concurrently with the Cantoria, and that at no point does the front face of the Cantoria reveal the disparity of quality found in the Prato reliefs. Indeed, the only carvings that do so are the two end reliefs, which seem to have been executed by a pupil, perhaps Pagno di Lapo Portigiani, from Donatello's preparatory models, and the two scenes after the antique in the lower register, which were carved by the same sculptor who executed the relief on the extreme left of the pulpit at Prato. The second count is that the quality of carving in the front relief is uniformly high and would be inexplicable were not all the preliminary models made personally by Donatello and were he not in great part responsible for the execution of much of the main relief. The Cantoria is one of the few great works of art to which attributional glosses are impoverishing and irrelevant.

No sooner was work on the two Organ lofts for the Cathedral under way than the Operai faced up to what, in the context of the choir, was a decision of great weight, the filling of the circular windows beneath Brunelleschi's cupola. One of them, the central window at the east end of the church, was of special importance, since it was visible from the whole length of the nave. In May 1433 two members of the board, Matteo Strozzi and Niccolò degli Alessandri, were empowered to commission a glass window for it from any artist of their choice within a budget of one hundred fifty florins.[12] The making of the window was to be undertaken by a stained-glass specialist, and in November glass was procured in Venice for his use. At the end of December we hear of a design for the window made by Ghiberti.[13] Though Ghiberti had been responsible for the great window of the Assumption at the west end of the church, dissenting voices seem to have been raised, and in April 1434 we learn of a second design prepared by Donatello for a window of the Coronation of the Virgin. The window was so prominent that recourse was had to consultation with "quampluribus intelligentibus" (that is, masters of sacred theology), and "pluribus pictoribus" (that is, painters and makers of stained glass) to determine which of the designs would do most honor to the church. Donatello's cartoon was judged to be more beautiful, more honorable, and more magnificent, and it was decided that the window should be executed after his design.[14] Probably the designs were made to scale, since there is a small preliminary payment for fixing them in place. The window, which is referred to loosely in documents as "in tribuna ubi est cappella s. Zenobii" or "super cappellone beati Zenobi," was the subject of a

further payment made to Donatello on October 4, 1434, for "uno disegno d'un occhio alla cappella di S. Zenobio." The payment was to be shared between Donatello "e per Bernardo e per Pagholo Uccello."[15] The painter Uccello may therefore have had some part in the execution of the cartoon. The making of the window was entrusted to Domenico di Piero, the prior of San Sisto at Pisa, and Angelo Lippi, a Florentine specialist in the making of stained glass. Work, however, was not completed till 1438. One of the payments to Donatello in Pisa was dispatched through a Florentine painter, Paolo Schiavo, whom we know, on another occasion, to have painted the frame for a small Madonna relief by Donatello.

The window of the *Coronation of the Virgin* is a good deal damaged, and part of the detail especially on the Virgin's dress has been effaced. It should be looked at, therefore, in somewhat the same way in which we look at frescoes in which detail painted *a secco* has been cleaned away. Vasari, in his 1550 life of Donatello, writes that "the design of the figures made for the glass window beneath the cupola, representing the Coronation of Our Lady, has in it more force than the windows designed by other artists." In relation to pictorial style in 1434, it is indeed a revolutionary work. The opinion of theologians must have been sought on two specific points. By whom was the Virgin crowned? The conventional Florentine answer, from the time of Maso di Banco to that of Rossello di Jacopo Franchi, was by Christ, but in two great Coronations of the Virgin by Fra Filippo Lippi—one of them, in St. Ambrogio, dating from 1441—the act of Coronation is performed by God the Father. There was, moreover, a convention, observed by Fra Angelico as well as by Lippi, that the scene should take place in the presence of a rejoicing throng. But as some earlier painters, among them Gentile da Fabriano, had recognized, the human significance of the event would become explicit only if the image were confined to the two figures of the Virgin crowned by her Son. Donatello seems to have concurred. The dress of the Virgin on the left and the cloak of Christ extend over the circular frame of cherub heads, and their feet rest on a platform at the base. The Virgin's bowed head and praying hands are silhouetted in profile against Christ's robe and dress, and the Christ himself is seated frontally with his head turned in three-quarter face. The analogies of the window are with fresco rather than panel painting, and its palette, by the standard of Masaccio's fresco of the Trinity in Santa Maria Novella, must have seemed audacious in its opulence and strength. Donatello's *Coronation of the Virgin* stands out as the most powerful treatment of the tondo form before the Doni tondo of Michelangelo.

VI

The *Stiacciato* Reliefs

THERE IS ONE CENTRAL ANOMALY in the story of Early Renaissance art in Florence, that at a time when sculpture, in the hands of Donatello, moved forward steadily on predetermined realistic lines, painters were faithful to the conventions of late Gothic style. Church patronage was conservative, and it was unthinkable that the chaste, idyllic world of the fresco and the altarpiece should be sullied by the least trace of life as it was really lived. This view was challenged by Brunelleschi, whose studies of perspective yielded a means of representing an urban architectural setting with strict fidelity, and, at Brunelleschi's instigation or on his own impulse, by Donatello. If no reform of painting was admissible, representational reform must be effected through some other means. The result was the invention of a new type of low marble relief known as flattened relief or *relievo stiacciato*. Vasari applied two adjectives to this class of relief, "amaccato" (dented or flattened) and "stiacciato" (squashed or compressed).[1] The appeal of *rilievo stiacciato* was pictorial. The lower the relief, the greater were its descriptive possibilities. Leonardo da Vinci believed that sculpture, if it were in very low relief, partook of the nature of painting and ranked as painting rather than sculpture, and Donatello seems to have regarded it in the same way.[2]

We have no account of how *stiacciato* reliefs were made. Vasari describes them as "difficili assai, attesochè e' ci bisogna disegno grande e invenzione, avvengachè questi sono faticosi a dargli grazia per amor de' contorni,"[3] and laborious and exacting work on them must indeed have been. Given the precision demanded by carving in the lowest possible relief, they probably resulted from the transfer of a drawn cartoon to the surface of a flawless marble slab. The design and geometry of the reliefs would, therefore, have been worked out initially in graphic terms. Nonetheless, the reliefs themselves transmit a sense of spontaneity, because the sculptor's chisel invests the individual heads (and for that matter, the whole relief surface) with incomparable animation and expressiveness. *Stiacciato* reliefs were

highly prized, and in every case in which they survive in situ (or in which the setting can be reconstructed) they occupy positions of special prominence.

The earliest surviving *stiacciato* relief by Donatello is a *Baptism of Christ* in the Cathedral at Arezzo, which is mentioned by Vasari under an ascription to an imaginary brother of Donatello's called Simone.[4] Vasari evidently recognized that the relief was less accomplished than the mature low reliefs of Donatello that he knew, and attributed the difference in quality to authorship, not to the date at which it was produced. The relief forms part of a hexagonal Baptismal Font. Though the font has been moved on three occasions it was surrounded from the first by six carved slabs, three at the back with the *stemmi* of the Popolo of Arezzo, the Commune, and the Operai of the Cathedral, and three in front, two relating to the patron of Arezzo, St. Donatus, and the third and most prominent showing the Baptism of Christ. The font is not dated, but the two *Scenes from the Life of St. Donatus* recall the work of Niccolò di Pietro Lamberti and reveal some knowledge of the reliefs on Ghiberti's first bronze door. The latest admissible date for them would be about 1415, and their probable date is about 1410–12. The third relief, Donatello's *Baptism of Christ*, has been slightly modified (on the right by the removal of the framing, and at the top by the addition of a garland, which corresponds to those of the two lateral scenes), but should logically date from the same time.

Christ stands to the left of center. His bowed head is turned in profile to the right, his arms are crossed, and his feet and ankles are immersed in the rippling water of the stream. His weight is borne on his left leg, which is extrapolated as a dominant vertical by a tree trunk at the back. The Baptist in three-quarter face stands on a higher level, bending slightly forward to pour the water on Christ's head. His dress is classical, and his cloak is held up tightly by his foreshortened hands, his legs under it clearly visible. Behind St. John are two classical angels in profile in very low relief, one in a robe resolved in emphatic vertical folds. To the left are two kneeling angels holding Christ's garments, with two more angels standing behind. A diminutive dove emits its rays over Christ's head. Between the angels on the left are two trees with naturalistic trunks and foliage. A withered tree of the same type appears behind the wings of the angel on the right. The river, flanked by bulrushes, floods through the bottom of the relief, and at the back is the first Renaissance landscape, closed on the right by folds of hill and terminating in the center and on the left in distant trees. From the cloudy sky a foreshortened God the Father looks down at the scene. The *Baptism* is the earliest evidence of Donatello's determination to present in carving a picture of the natural world more ambitious and more truthful than any of which painters of the time were capable.

Not till 1417–18, in the predella of the *St. George* on Or San Michele, did Donatello receive an opportunity publicly to challenge the current postulates of painting. The predella with the story of St. George and the Dragon demanded a very different type of narrative from the predellas of Nanni di Banco. It involved movement, not the frozen movement of the horse in Nanni di Banco's *Miracle of St. Eligius*, but a continuum of movement throughout the scene. The menace of the dragon, the physical force of the charging figure of St. George, the fear of the Princess had all to be portrayed.

Fig. 102

Fig. 103

opposite: FIGURE 102.
Donatello, *Baptism of Christ*. Marble.
H. 63.6 cm, W. 40.5 cm (H. 25 in., W. 16 in.).
Baptismal Font, Duomo,
Arezzo.

The *St. George and the Dragon*[5] is the first scene in any medium to employ the resources of Brunelleschan linear perspective. At first sight its use may appear tentative, but it is not invoked solely in the area in which it is most evident, the interior of the palace on the right. It establishes the spatial content of the whole scene, and it determines the distribution of the figures. This is most obvious on the right, where the receding lines of the palace façade, if they are viewed two-dimensionally, meet in the central figure of St. George. Seen three-dimensionally, they carry the eye back in depth to a distant landscape with folds of hill crowned by barren, storm-tossed trees. The palace façade contains five archways, of which the fifth, turned at right angles to the left, delimits the foreground of the scene. The marble slab is three times wider than it is high (the approximate dimensions are 120 and 40 centimeters [47 and 16 in.]), and the figurated area is divided into four equal sections, one running from the right edge to the Princess, another from the Princess to the figure of the Saint, which occupies the exact center of the scene, a third from the back of the Saint to the tail of the dragon, and the fourth, a sharply receding crag with the entrance to the dragon's lair. The depth of the rocky central platform is established empirically by the receding body of the horse, whose rear hooves are shown in close proximity to the front of the scene and whose head, carved in the shallowest possible relief, rests on a rear plane. In description, the means by which this result was reached may appear cerebral. That it does not in practice seem so is ascribable in part to the naturalistic detail—the formidable rocks surrounding the cavern on the left, the broken surface of the foreground, the differentiated trunks and branches of the distant trees—and in part to the exuberance of the figure carving.

The figure of the Princess, so placed as to mask the change of angle in the fifth of the palace arcades, has been associated with figures on Roman Aretine ware, and could only have been arrived at by an artist with close knowledge of Roman metalwork or ceramic reliefs. Nonetheless it is strikingly unclassical. Aligned on the palace façade, with her shoulders receding into space, the Princess is shown with head in profile, gazing in apprehension at the Saint. Her hands are clasped in prayer, and the thin fabric of her dress is blown back over her legs and feet as though by the movement of the plunging horse. This sense of violent action is enhanced by the Saint's cloak, which billows up against the top of the relief, and by the horse's tail. The most astonishing feature of the composition is the central group. There are countless precedents in sarcophagus reliefs for mounted horsemen engaged in combat without stirrups, but there is no precedent at all for the weight and impetus of Donatello's horse or for the posture of the Saint thrusting his lance into the dragon's throat. The fighting figures in Leonardo's *Battle of Anghiari* have their origin in this dynamic, tightly constructed group.

Between 1425 and 1428, the tomb of Cardinal Rainaldo Brancacci was in course of execution in Pisa in the joint studio of Donatello and Michelozzo, and there Donatello carved the only section of the monument for which he was personally responsible, a *rilievo stiacciato* of the Assumption of the Virgin for the sarcophagus.[6] A *catasto* return of Michelozzo in the summer of 1427 estimates that at that time a quarter of the monument was complete ("ne sia fatto il quarto d'essa"), but there is

Fig. 104

Fig. 105

Fig. 107

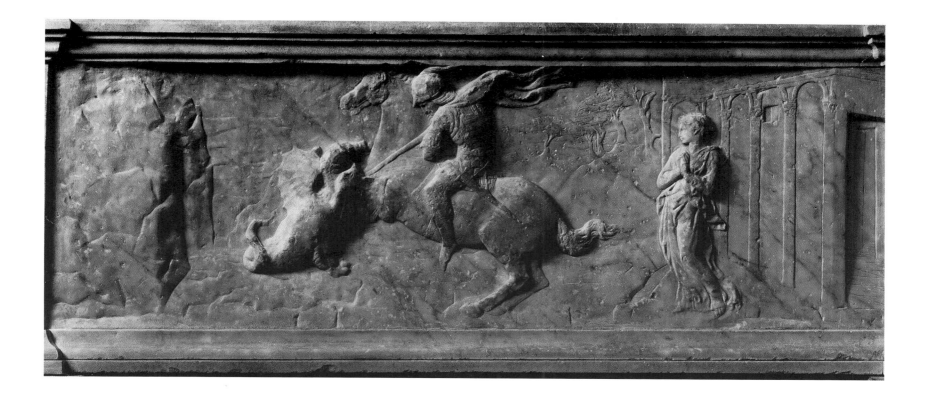

no precise date for the relief. The *Assumption* is higher (53.5 cm [21 in.]) and less wide (78.5 cm [31 in.]) than the relief on Or San Michele and occupies the center of the sarcophagus, where it is surrounded by a marble frame. Beyond it, at either side, are panels, flanked by fluted pilasters, with the Cardinal's arms and a foreshortened Cardinal's hat, whose execution Donatello is likely to have supervised.

The most celebrated sculptures of the Assumption in Florence were those by Orcagna on the back of the tabernacle in Or San Michele and by Nanni di Banco over the Porta della Mandorla of the Cathedral. In their day, both were innovative compositions. At Or San Michele, the Virgin, represented as a mature but not an elderly figure, is seated frontally on a throne framed by a mandorla. At each side are angels, two holding the mandorla and one in the center making music. In Nanni di Banco's relief, the Virgin, turned slightly to our left, drops her girdle to St. Thomas in the left corner of the scene. Once more there is a solid mandorla, supported at each side by one music-making and two weight-bearing angels. In Donatello's relief, the Assumption is portrayed actively as an event. It takes place in a cloudy sky, and the mandorla, though not depicted, is implied, first by a cavity in the clouds that cover it and second by the action of seven athletic angels straining to support its weight. The most muscular of them, in the center, raises it by pressing one leg against the base of the relief, as though lifting it from the ground. The unseen mandorla is the determining feature of the composition and is accountable for the brilliant device whereby two of the lateral angels are shown floating with arms apart and legs raised above the level of their heads. Donatello, when planning the relief, must have been cognizant of Nereid sarcophagus reliefs with figures

FIGURE 103.
Donatello, *St. George and the Dragon*.
Marble, H. 40 cm, W. 120 cm
(H. 16 in., W. 47¼ in.).
Museo Nazionale, Florence.

overleaf, left: FIGURE 104.
Donatello, *Princess*, detail
of *St. George and the Dragon*.

overleaf, above right: FIGURE 105.
Donatello, *St. George*, detail
of *St. George and the Dragon*.

overleaf, below right: FIGURE 106.
Donatello, *Storm-tossed Trees*,
detail of *St. George and the Dragon*.

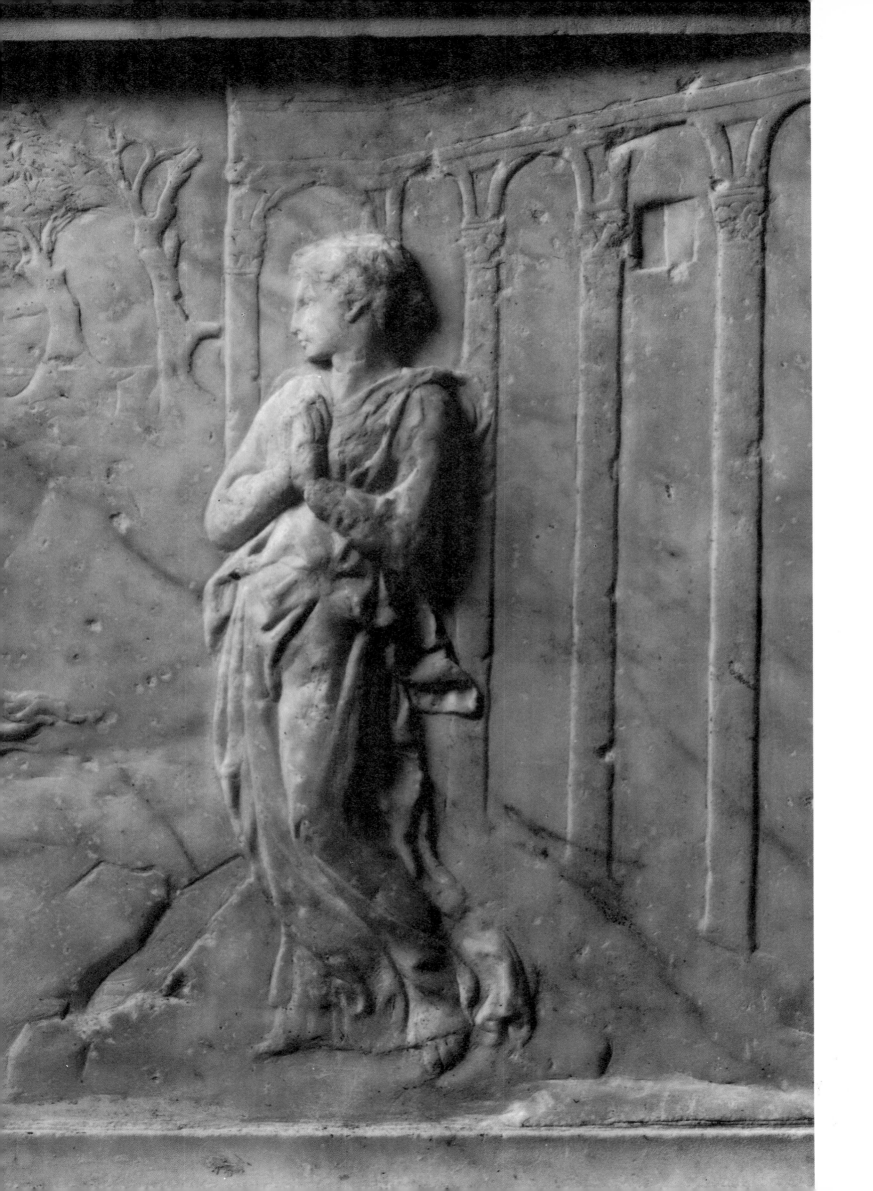

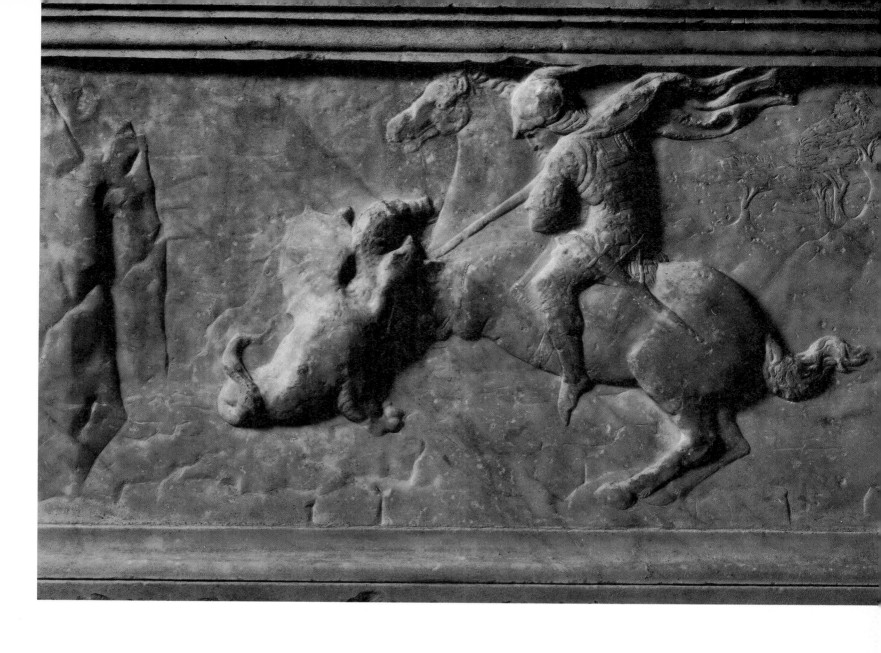

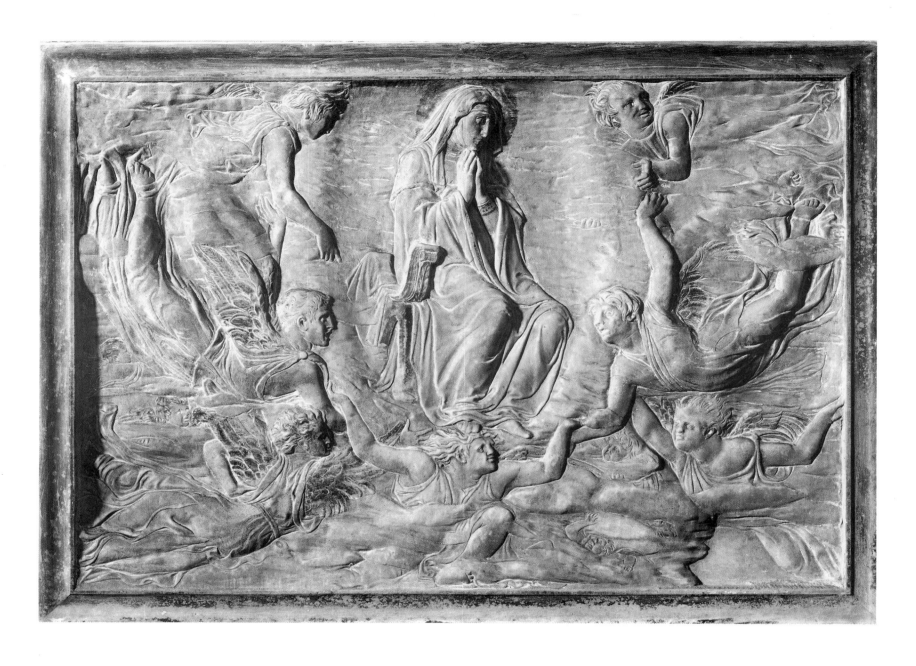

FIGURE 107.
Donatello, *Assumption of the Virgin*,
from the *Brancacci Monument*.
Marble, H. 53.5 cm, W. 78 cm
(H. 21 in., W. 30¾ in.).
Sant'Angelo a Nilo,
Naples.

swimming through water, not cloud, but in no Nereid relief are they treated with the audacity of the angels in the *Assumption*, with their embodied energy and their wild, windblown hair. Donatello's relief is frequently described as mystical, but at the time it was produced, it would have appeared unwarrantably rational, a doctrinal concept reinterpreted for the first time in a fashion that paid regard to human physique and to the law of gravity. The angels are superimposed on one another in shallow, carefully regulated planes. The heavy tridimensional Virgin sits slumped in her wooden seat, facing three-quarters to the right with shoulders hunched and head bent forward. It is from this figure that the scene derives its emotional authority. Most sculptors keep molded records of their work, and Donatello may have done so here, for though the original of his relief was installed on the Brancacci monument in Naples, its scheme was adapted twenty years later by Castagno in the

122

altarpiece of the Assumption of the Virgin painted for San Miniato fra le Torri in Florence (now in Berlin).[7]

Fig. 110

The finest of Donatello's *stiacciato* carvings, the London *Ascension*, was made for the Carmine in Florence, where a play was presented annually on the Feast of the Ascension. An account of it is given by a visitor to Florence, Abraham of Souzdal, who was taken to the church and recorded what he saw.[8] The stage represented the Mount of Olives with the city of Jerusalem at the back. At the climax of the action, Christ led the Apostles on the main stage. The Virgin moved to Christ's right and St. Peter to his left, while the apostles "barefoot, some beardless, some with beards just as they were in life," gathered round as Christ conferred on each of them their special gifts and attributes and announced his imminent Ascension. A clap of thunder resounded through the church, and a cradle was let down, masked by clouds, which, according to a document, were painted by one of the artists of the Brancacci Chapel, Masolino. In reply to the apostles' protests, Christ, taking up two keys, turned to St. Peter and addressed him with the familiar words "Thou art Peter and upon this rock I shall build my church." St. Peter received the keys, and Christ, mounting the cradle, was hoisted out of sight. In the gospel narrative, the Ascension and the presentation of the keys are two discrete events, and we must conclude, from their association in the play, that for the Florentine Carmelites the primacy of St. Peter, that is of the papacy, was an issue of sufficient moment to be intruded, for propaganda purposes, into a context in which it did not properly belong. This play inspired the greatest of Donatello's *stiacciato* reliefs, the *Ascension with Christ Giving the Keys to St. Peter* in London.[9]

Fig. 108

There is an evident connection between Donatello's relief and Masaccio's fresco of the Tribute Money. Both scenes take place before a distant landscape. In both Christ is placed in the center of the scene, and in both the apostles are grouped around him. But there are substantial differences between them. Perspectively, the *Tribute Money* is the simpler scene. Its affinities are with Donatello's *St. George and the Dragon* relief. On the right, as at Or San Michele, there is a building, this time a solid Brunelleschan edifice, so constructed that its leading edges, when protracted, meet in the figure of Christ. As at Or San Michele, so with *Tribute Money*, there the figures are disposed in a deep platform of space, and at the back are folds of hill, covered with trees and capped by cloud. The structure of the *Ascension* is more complex. In the play, the action is described as taking place on a hill, the Mount of Olives, and Donatello's scene is for that reason projected from a point considerably below the base of the relief. The feet of the apostles on the right are only partly visible, and those of the apostles on the left cannot be seen. The center of the design is a triangle of figures, with the kneeling Virgin and St. Peter in the foreground on either side and Christ, whose head touches the top edge of the relief, in a rear plane. The right side of the triangle is established by the left arm of Christ extended toward St. Peter and the Saint moving forward to receive the keys. In the void under Christ, the eye is carried down the hillside toward two distant trees. On the right are five apostles grouped not in a semicircle like the apostles of Masaccio, but on four planes; the foremost figure stands second from the right, and the most distant is depicted behind a tree trunk at the back. On the left, behind the Virgin, are five

FIGURE 108.
Masaccio, *The Tribute Money.*
Fresco. Brancacci chapel,
Santa Maria del Carmine,
Florence.

more apostles arranged in a diagonal line going down the hill. The scene is closed on the right by four trees, of which the last is evidently at a great distance from the eye; each of the trunks is half the width of that immediately in front of it. In the foreground, on the left, are two angels, and behind them, on the crest of a second hill, is a diagonal line of trees leading the eye to the distant city of Jerusalem. The sky is filled with horizontal clouds partly concealing four angels who support Christ's seat. In its totality, the relief represents by far the most ambitious and successful application of linear perspective to dramatic narrative attempted in the early fifteenth century. [10]

Were this all, it would be remarkable enough. But as we read the detail of the figures, we encounter a mastery of gesture and expression far in excess of that in any earlier work. Each figure is presented as an individual whose reaction to the two events of the presentation of the keys and Christ's departure can be clearly read. The disposition of the apostles at each side in superimposed profiles must derive from a second-century Roman processional relief, as must the robes they wear, but the range of expression in the heads and hands and in the shrouded figure of the Virgin has no parallel in Roman art and reveals Donatello as the possessor of an understanding of observed psychology that remained unique through the whole fifteenth century.

Fig. 109

So long as it rested solely on iconography, the association of the relief with the Brancacci Chapel in the Carmine, though probable, was no more than a hypothesis. [11] It was, however, fortified by one point of some significance, that the frescoes in the chapel represent the whole story of St. Peter with the exception of the pivotal scene, the presentation of the keys. If this scene were not represented on the chapel walls, it must have been portrayed elsewhere. Till recently there was no evidence as to the form of the altar in the chapel, but the cleaning of the frescoes has revealed, across the base of the original window, an angled fresco, which was clearly intended to be seen, though it is now illegible. The altar in front of it cannot have risen above this level and is likely, therefore, to have been freestanding, like the altar designed by Brunelleschi for the Old Sacristy in San Lorenzo. Altars of this type were planned in 1439 for the chapels of Saints Peter and Paul in the Cathedral, and one of them, had it been completed, would have contained on its front face a relief of a scene from the life of St. Paul after a wax model by Donatello. [12] The Ascension relief seems to have been intended to occupy a similar position on the altar of the Brancacci Chapel. Work on the chapel frescoes was suspended late in 1427 or early in 1428. There was, however, no reason after 1428 to suppose that work would not, in the near future, be resumed. The carving of the Ascension relief may therefore have been begun in 1427 or in the following year. It is mentioned for the first time in an inventory of the Palazzo Medici made after the death of Lorenzo il Magnifico in 1492, where it was shown as a carved painting in a nutwood frame. Possibly it was acquired from Felice Brancacci, the patron of the chapel, by Cosimo de'Medici, who maintained relations with him after his exile in 1434. When Lorenzo il Magnifico's daughter Lucrezia married Jacopo Salviati, the relief passed into Salviati ownership. It is described in the Palazzo Salviati in 1591 as a work greatly to be admired ("la quale per invenzione è rara, e per disegno maravigliosa. Molto è commandatá la figure di

Cristo e la prontezza, che si scorge nel San Piero: e parimente la Madonna posta in ginocchione, la quale con atto affettuoso ha sembiante mirabile, e divoto").[13] This description is a remarkable tribute to the reputation Donatello enjoyed in the Florence of Giovanni Bologna and Ferdinando I de'Medici.

The role of the *Ascension with Christ Giving the Keys to St. Peter* in the Brancacci Chapel is no more than one aspect of a larger problem, that of Donatello's relations with Masaccio. At only one point can we speak of them with any confidence. In 1426 work in the Brancacci chapel was interrupted by a new commission to Masaccio for an altarpiece for the Carmine at Pisa. Payments to Masaccio for the altarpiece were made in eight installments, and the third of them, for the sum of ten florins, was turned over on July 24 to Donatello, who was working at the time in Pisa on the Brancacci monument.[14] The record reads: "ane avuto Maso soprascritto da me contanti fiorini dieci in grossi in botegha mia, li quali di presente paghò a maestro Donatello marmoraio da Firenze." Read literally, this document seems to indicate some measure of participation by Donatello in the production of Masaccio's altarpiece.

Two earlier altarpieces by Masaccio survive, one of 1422 at Cascia, and the other, the *Virgin and Child with St. Anne* in the Uffizi, painted jointly with Masolino probably in 1424, for the church of Sant'Ambrogio. The Cascia altarpiece is a provincial work, distinguished only for its tactility, while the much subtler *Virgin*

FIGURE 109.
Roman (2nd century A.D.),
Processional Relief.
Museo Lateranense,
Rome.

FIGURE 110.
Donatello, *Ascension with Christ Giving the Keys to St. Peter.*
Marble,
H. 40.6 cm, W. 114.3 cm
(H. 16 in., W. 45 in.).
Victoria and Albert Museum,
London.

and Child with St. Anne remains an exploratory painting. From neither work could *Fig. 115* we predict the style or character of the *Madonna* from Masaccio's Pisa altarpiece in the National Gallery in London. The panel is unprecedented in three main respects. The first is its throne. In place of the not very adventurous thrones of the two earlier altarpieces, we are here confronted by a Brunelleschan throne in which the architectural elements are valid and unassailably original. The lowest of its three sections is decorated with superimposed rosettes; the central section contains a single colonnette; and the upper section has paired colonnettes. The second innovation is that the panel is projected with great precision from a low viewing point, and the third is that the nature of the imagery has changed. In Masaccio's two earlier altarpieces, the Virgin is a blocklike figure set stiffly in a forward plane. In the London panel, in contrast, the upper part of the body of the Virgin is bent forward, and the weight of her cloak is established by the broken folds in which it falls. The light comes from the left (the exact angle can be established from the shadow cast by the Virgin's head

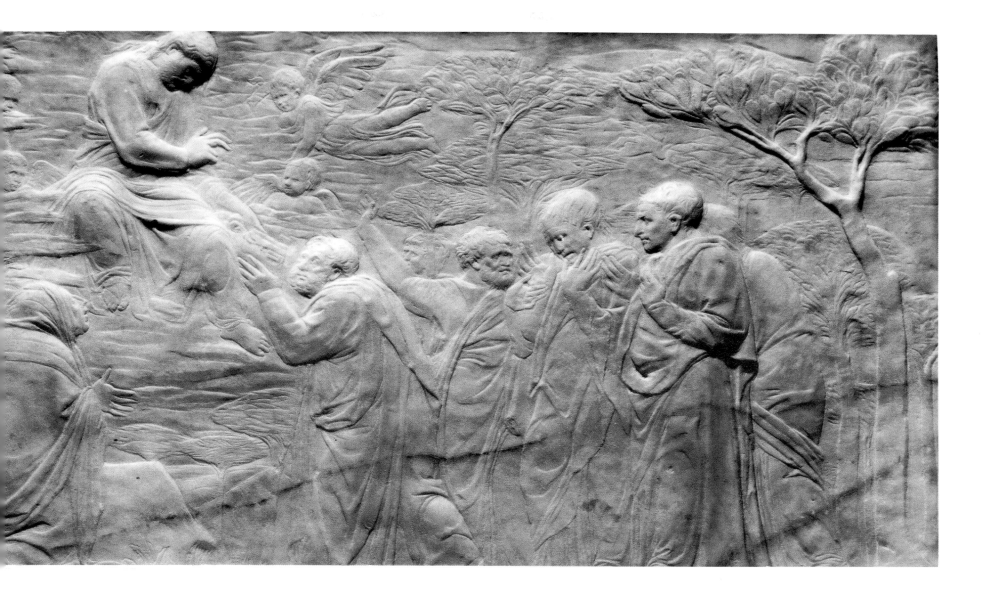

on the right side of the throne) and transforms the Virgin's face and the Child's body into living surfaces. The Child's right arm casts a horizontal band of shadow across his chest, and the device of a perspective halo establishes his position forward of the Virgin's body in free space. From all this only one inference is possible, that, for both figures, plastic models were employed. That the models for these figures were made by Donatello is very probable. The statue on which he was working at the time was the *Jeremiah* for the Campanile, where the calculated contrast between lit and shaded areas has a close parallel in the deep folds of the Virgin's cloak in Masaccio's painting.

Concurrently at Pisa, Donatello was engaged on the *stiacciato* relief of the Assumption, where the analogies with the Virgin of Masaccio's Pisa altarpiece are also too close to be ignored. The two images, Donatello's aged Virgin, transported by angels through the clouds, and the peasant Virgin of Masaccio proffering grapes to her voracious Child, spring from the same sense of the human form and the same

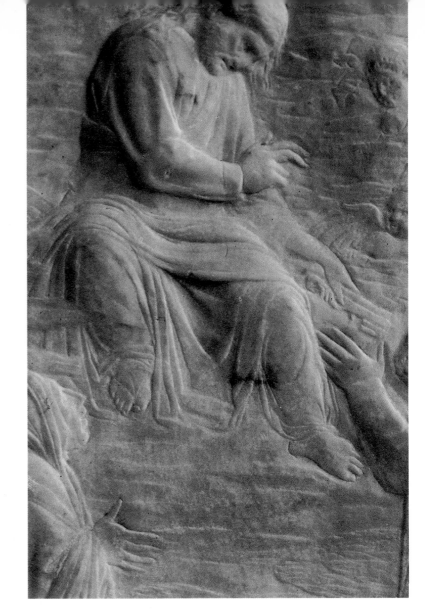

predilection for realistic imagery. On stylistic grounds alone we should be justified in supposing that the Pisa Madonna was based on plastic models and that these plastic models were made by Donatello. When, in addition, we have the record of a payment to Donatello in connection with the altarpiece, what begins as a hypothesis is all but translated into fact. There is every reason to suppose that the Brancacci Chapel was itself a collaborative enterprise, started in a conventional fashion in the lost upper register by Masolino, replanned by Brunelleschi, and executed by Masaccio partly from life study and partly from plastic models, without which the uniform lighting of the *Tribute Money* and other frescoes could not have been achieved. If figurative models were used there, they too may have been made by Donatello.[15]

Two later *stiacciato* reliefs by Donatello survive. The first, an Entombment, forms part of a tabernacle in Rome in the Sagrestia dei Beneficiati of St. Peter's.[16] Just as the Baptism of Christ at Arezzo is set in a font whose other reliefs are by a much inferior hand, and the *Assumption* in Naples forms the centerpiece of a tomb carved in great part by assistants, so here Donatello's relief forms the focal point of a tabernacle whose execution is due in the main to members of his shop. A horizontal relief, it is framed at the sides and top by a suspended curtain drawn by two standing angels who reveal the scene of the entombment to our view. This device establishes the narrative tension of the scene; the participants are depicted in hurried action, as though unaware that, through the lifting of the curtain, their grief is suddenly made visible. The relationship to sarcophagus reliefs is more evident than in the earlier low reliefs, partly because the foreground figures, if they stood erect, would fill the whole height of the field and partly because two of the anguished women are shown as maenads, one at the back with arms outstretched and the other hurrying forward from the left. The depth of cutting is somewhat greater than in the *Ascension*, and the relief, as was inevitable given its position on the tabernacle, is projected from a low viewing point. The feet of Joseph of Arimathaea and Nicodemus would be invisible did not the right foot of one project beyond the frame and were the left foot of the other not represented on tip-toe as Christ's body is lowered into the tomb. The tomb chest is of extreme simplicity and is set at an angle to the relief plane. The reaction of the participants is not diversified as it is in the *Ascension*; the prematurely aged Virgin behind the tomb, the shrouded woman to the right, and St. John, his robe lifted to his face to catch his tears, transmit a sense of desolation and despair.

The architecture of the tabernacle is strikingly unlike that of any earlier work by Donatello. It is framed at the sides by two fluted Corinthian pilasters, one on the level of the wall and the other in a forward plane. In the entablature, in addition to the forward angels holding up the curtain, two more angels appear behind, masking the angle between the tabernacle and the wall. At the base of the pilasters are six praying angels, three at each side, the rear figures covering the recession between the forward pilaster and that behind. The inner figure at each side is carved in one with the frame of the tabernacle doorway, outside which the angels wait. This is a conventional motif invested, through the freedom of the poses and the depth of cutting, with a new dramatic character. Above it is a pediment containing a small figure of the dead Christ in a wreath, and two diminutive recumbent angels whose

gs. 116, 117

opposite, above left: FIGURE 111.
Donatello, *Apostles,* detail of *Ascension with Christ Giving the Keys to St. Peter.*

opposite, above right: FIGURE 112.
Donatello, *Christ and St. Peter,* detail of *Ascension with Christ Giving the Keys to St. Peter.*

opposite, below left: FIGURE 113.
Donatello, *The City of Jerusalem,* detail of *Ascension with Christ Giving the Keys to St. Peter.*

opposite, below right: FIGURE 114.
Donatello, *Apostle,* detail of *Ascension with Christ Giving the Keys to St. Peter.*

FIGURE 115.
Masaccio, *Madonna and Child Enthroned with Four Angels.* National Gallery, London.

FIGURE 116.
Donatello, *Entombment*. Marble.
Sagrestia dei Beneficiati,
St. Peter's, Rome.

opposite: FIGURE 117.
Donatello (assisted), *Tabernacle*.
Marble, H. 225 cm, W. 120 cm
(H. 88½ in., W. 47¼ in.).
Sagrestia dei Beneficiati,
St. Peter's, Rome.

heads fit tightly under the Entombment scene. The base on which the structure rests has in the center two seated angels holding a circular frame (now filled with porphyry), and at either side is an angel facing outward holding or rotating a wheellike design.

An exceptional feature of the tabernacle is that it is not constructed with a single viewing point like most wall tabernacles, but has subsidiary views from either side. This must have been necessitated by the position for which it was originally planned. The wealth of its classical motifs, the highly unorthodox placing of the main relief in the attic as though on a triumphal arch, and the novel relationship of the angels to the architecture are redolent of the influence of Alberti. The tabernacle is likely to have been commissioned either for St. Peter's or for a chapel in the Vatican and is commonly dated to the years 1432–33, when Donatello was in Rome. There is no evidence, however, that Donatello and Michelozzo opened a studio in Rome during their short period there, and on technical and stylistic grounds this dating is improbable.[17] The tabernacle is modest in size—it measures only 225 centimeters (88½ in.) in height—and, like all such works, is carved in a number of separate pieces, which could be transported and assembled without difficulty. Only one of the angels, to the left of the Entombment relief, appears to have been carved wholly by Donatello; the others were executed by members of his studio whose hands can be recognized again in individual sections of the Prato pulpit. It is more

130

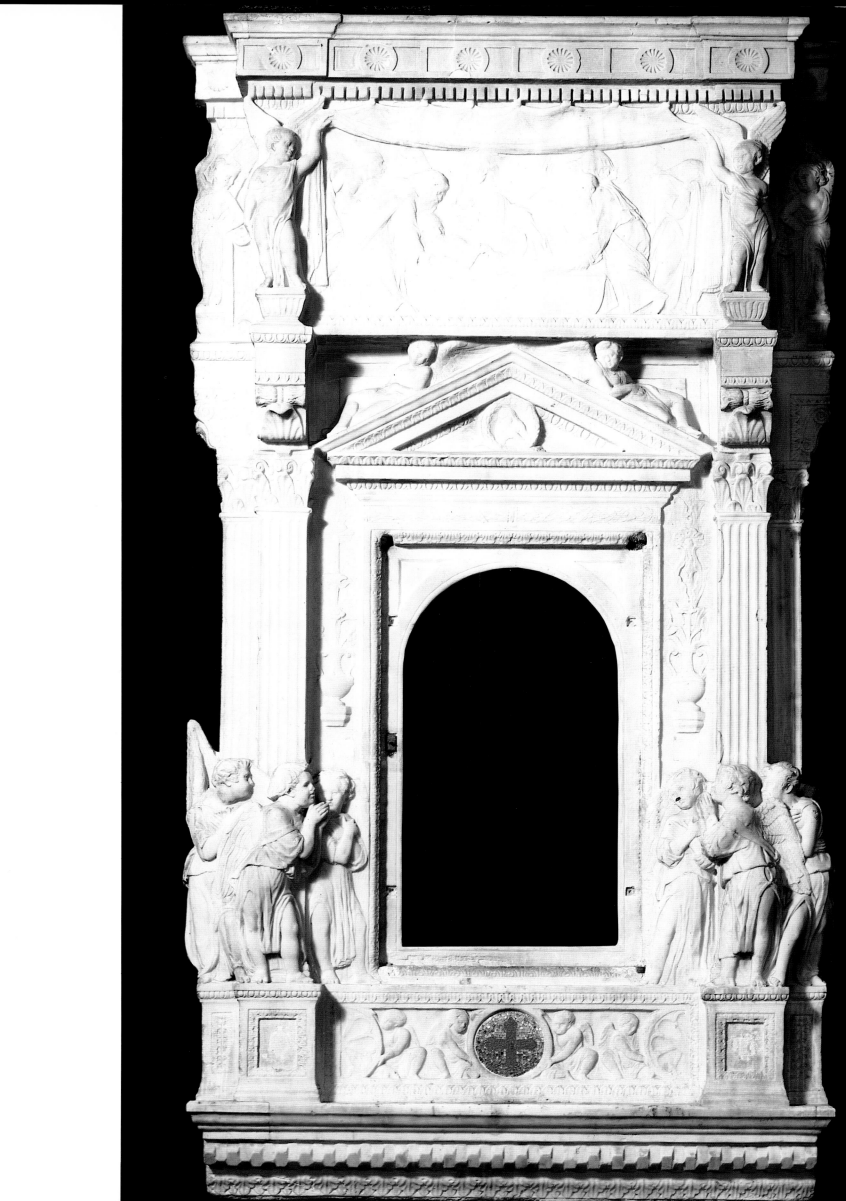

likely that the tabernacle was carved in Florence, *pari passu* with the pulpit, than that members of Donatello's shop were diverted from the Cantoria and the pulpit to work in Rome. Eugenius IV was resident in Florence from 1434 till 1443, and he may well, in the late 1430s, under the guidance of Alberti, have commissioned the tabernacle for his chapel in the Vatican. Some of the principles established in the tabernacle are reflected in the 1450s in the Marsuppini Monument of Desiderio da Settignano, where putti again stand in front of the lateral pilasters, and in Desiderio's Tabernacle of the Sacrament.

Figs. 118–1

Closely linked to the tabernacle is the most problematical of the low marble reliefs ascribed to Donatello, the *Presentation of the Baptist's Head to Herod* at Lille.[18] The Lille relief is almost certainly identical with a relief listed in the 1492 inventory of Lorenzo il Magnifico as a work of Donatello ("a panel of marble with many figures in low relief and other things in perspective, i.e. . . . of St. John by Donatello, 30 florins"). It is problematical on two grounds, first that the execution, though highly accomplished, is weaker than in the *Ascension* in London and the *Entombment* in St. Peter's, and second that its subject is treated less realistically than in the bronze relief on the Siena Font. At first sight, we are conscious only of the setting. The architecture is projected from the base line of the relief, not from the high viewing point used in the Siena *Presentation of the Baptist's Head* or from the low viewing point used in the *Ascension* in London. The setting is a Roman palace. At the left is a temple structure supported by three fluted columns, with a classical entablature and pediment showing the lower part of two recumbent figures. The rear wall has two archways, through the upper part of which we look into another building. Under the right archway is a door. The wall above the archways is decorated with two irregularly spaced reliefs showing the lower legs of what appear to be paired putti. The arches continue in the center and on the right on a more distant plane. Above them is an open corridor with a balustrade at either side, connected to the foreground by a staircase on the right. Across the balustrade, a little to the left of center, rises the foreshortened façade of another building, and to the right is the upper section of a hall, with five arched windows. The architecture throughout evinces an obsessive concern for detail that obstructs the narrative. The carefully incised orthogonals on the floor relate only to the architecture, not to the figure content of the relief. At the bottom, the panel is divided into nine sections with a module of 7.25 centimeters (3 in.), and its height comprises six sections with the same module.[19]

The scene of the presentation of the Baptist's head takes place in the foreground on the left, against a wall decorated with hangings representing a female figure, surrounded by children, and two children with a wreath. The dining table recedes diagonally into the picture space—its length can be calculated from the fact that four figures are seated at it on one side—and the head is presented by a man kneeling to its right. In the foreground is a low seat aligned on the picture plane, whose only occupant, a woman, shrinks back in horror from the spectacle. From the stairway on the extreme right, a toga-clad figure looks at the scene. Below him, on the lowest step, is a sleeping child. Under the stairway stands a group of male figures, one with drawn sword, and behind them, a little to the right of center, floats the

dancing figure of Salome. In front of the rear wall is a throng of figures that have no narrative significance but serve, through their reduced scale, to define the notional depth of the whole scene. Inside the palace on the left can be seen the heads of five men, who also have no function in relation to the narrative.

One explanation of this strange scene must be ruled out: that it is not by Donatello. *Rilievi stiacciati* were indeed carved by his shop (one of them is a lunette of the *Blood of the Redeemer* in the Ospedale Maestri at Torrita, for whose design he was certainly responsible),[20] but the definition of form in them is far less clear and the execution far less accomplished than in the Lille relief. Nonetheless, the architectural setting and the treatment of the narrative are uncharacteristic of Donatello, and the segregation of the two main incidents, the presentation of the head and the dance of Salome, runs counter to his practice in earlier reliefs. The relief is Albertian, both in its construction and in its narrative scheme, and constitutes, indeed, a didactic

Fig. 123

FIGURE 118.
Donatello, *Presentation of the Baptist's Head to Herod*.
Marble, H. 50 cm, W. 71.5 cm (H. 19⅝ in., W. 28 in.).
Musée des Beaux-Arts, Lille.

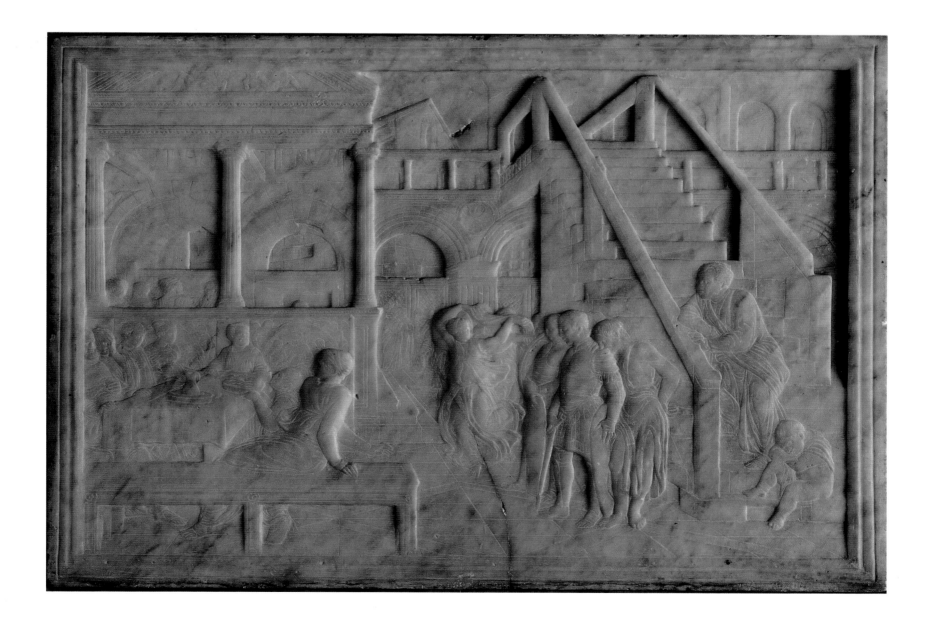

above and opposite: FIGURES 119, 120, 121, 122.
Donatello, *Presentation of
the Baptist's Head to Herod*
(details).

exposition of Alberti's *De Pictura*. Its structure, as recommended by Alberti, is based on an arbitrary centric point beneath the right-hand column of the temple, at a height equal to that of a man standing in the front plane of the relief. The width of each of the modular divisions of the base equals a third of the height of this notional figure. Through the centric point there runs a line, "a limit or boundary, which no quantity exceeds that is not higher than the eye of the spectator. As it passes through the centric point, this line may be called the centric line. This is why men depicted standing in parallel furthest away are a great deal smaller than those in the nearer ones, a phenomenon which is clearly demonstrated by nature herself, for in church we see the heads of men walking about, moving at more or less the same height, while the feet of those farthest away may correspond to the knee level of those in front."[21] The void through the center of Donatello's relief and his adherence to the principle of isocephaly in the distant figures likewise conform to Alberti's text. Alberti's attitude to pictorial content was more theoretical than that of the generation of Brunelleschi

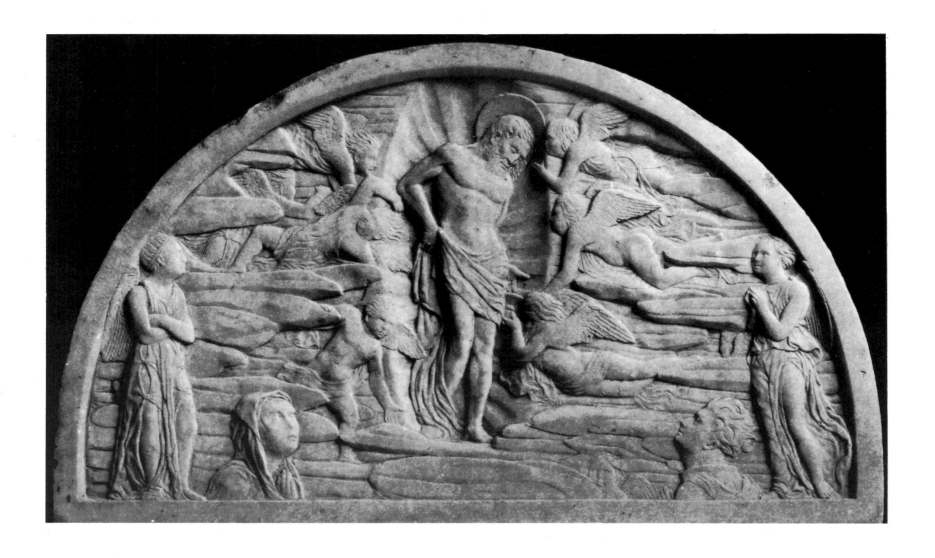

FIGURE 123.
Donatello (assisted), *Blood of
the Redeemer*. Marble,
H. 39.8 cm, W. 67 cm
(H. 15⅝ in., W. 26⅜ in.).
Ospedale Maestri,
Torrita.

and Masaccio. He was concerned with decorum ("A *historia* you can justifiably praise and admire will be one that reveals itself to be so charming and attractive as to hold the eye of the learned and unlearned spectator for a long while with a certain sense of pleasure and emotion") and with clarity ("a *historia* will move spectators when the men painted in the picture outwardly demonstrate their own feelings as clearly as possible"). He thought it desirable, moreover, that "someone in the *historia* tells the spectators what is going on and either beckons them with his hand to look . . . or points to some danger or remarkable thing in the picture."[22] This is the role of the elderly man standing on the staircase in the Lille relief.

In no fifteenth-century painting are Alberti's precepts followed as faithfully as in this relief. It is tempting indeed to suppose that he assisted in the preparation of the drawing from which it was made. It marks a break in the Brunelleschan sequence of the earlier *stiacciato* reliefs and offers a foretaste of the problems with which Donatello was confronted in bronze a few years later in the Albertian *Scenes from the Life of St. Anthony of Padua*.

VII
Florence: 1428–43

THE FIFTEEN YEARS between the commissioning of the Prato pulpit in 1428 and Donatello's move, in 1443, to Padua seem, on existing evidence, to have been some of the most productive of his whole career. Fortified by a large workshop, he was engaged in works in marble, *pietra di macigno*, terracotta, wood, and bronze. Had his style remained constant in these years, the problems that arise from them would have been simple ones, but in practice they were years of developing maturity. The Donatello of 1443 was a very different artist from the sculptor of fifteen years before, but the rate of his development cannot be conclusively established, since only one work, in wood, is dated, and for the rest we are dependent on historical or stylistic inference.

Fig. 124 The single dated work is in Venice, not in Florence, and is inscribed on the base in contemporary, seemingly autograph lettering:

MCCCCXXXVIII

OPVS DONATI DE

FLO RENTIA[1]

The statue was commissioned by the Florentine confraternity in Venice, which had secured, in 1435, a chapel or altar in the Frari and a meeting place on the convent premises. Before the inscription was discovered, the figure was commonly supposed to have been carved about 1450 when Donatello was working in North Italy. In the course of cleaning, the form of the dress was found to have been blunted by a new layer of gesso applied to facilitate regilding, and the legs proved to have been thickened by gesso additions. In reading earlier discussions of the statue, these points must be borne in mind. In its cleaned state the effect made by the sculpture is spectacular. Its most striking feature is the contrapposto of the pose, with right leg and left shoulder advanced. The left arm is pressed against the body, the right

137

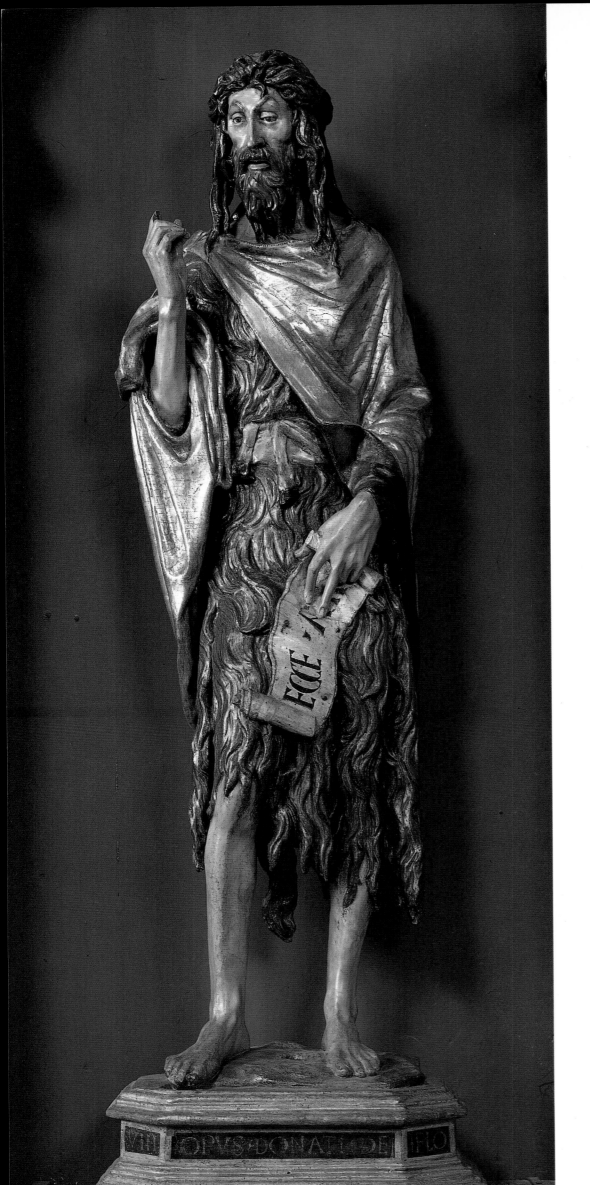

left: FIGURE 124.
Donatello, *St. John the Baptist.*
Pigmented and gilt wood,
H. 140 cm, W. 42.5 cm (H. 55 in., W. 16³/₄ in.).
Santa Maria dei Frari, Venice.

opposite: FIGURE 125.
Donatello, *Head of St. John the Baptist.*

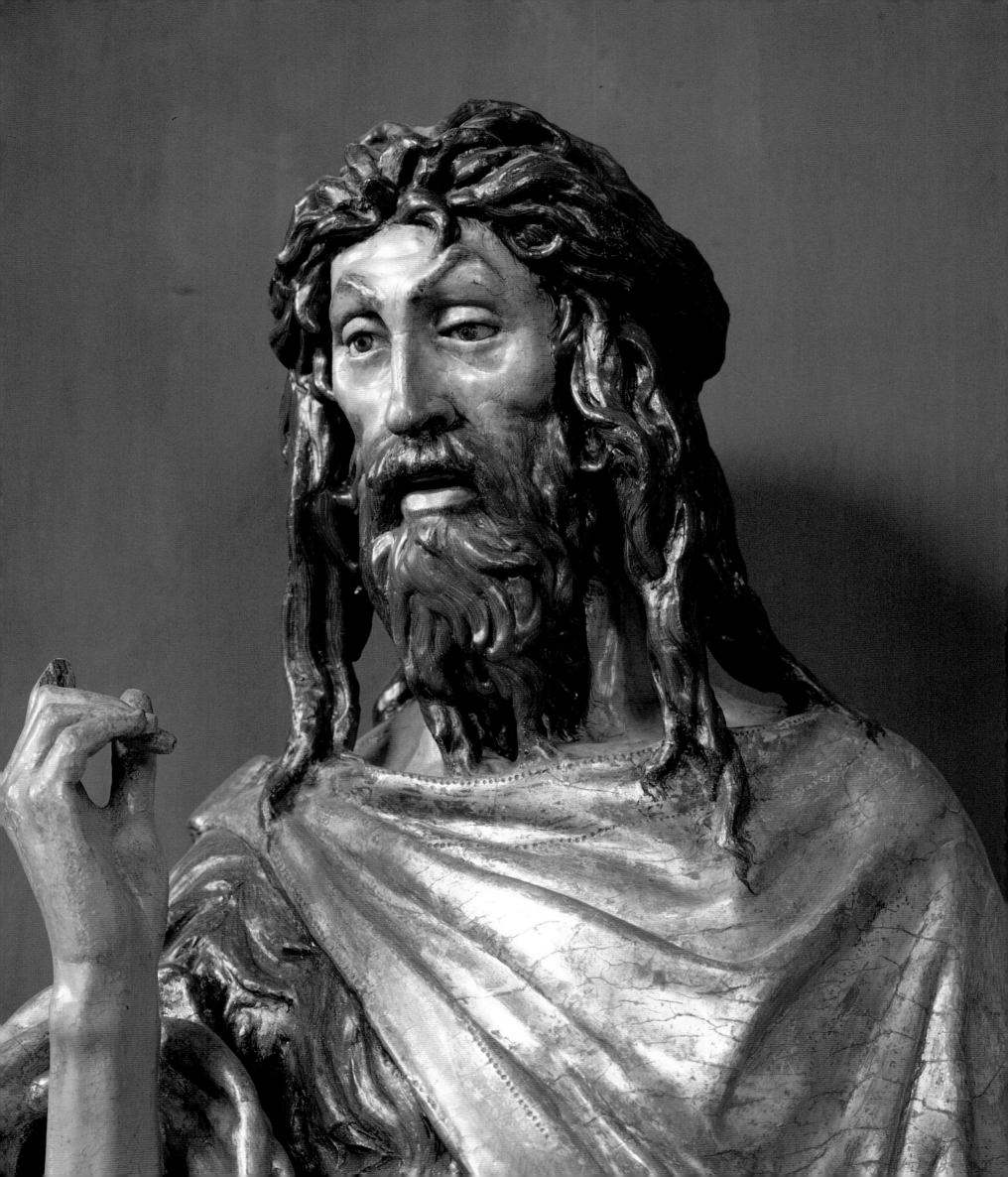

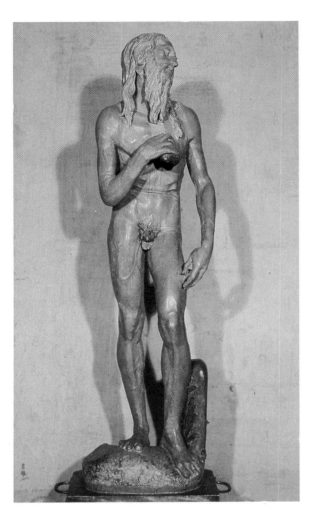

FIGURE 126.
Donatello, *St. Jerome*.
Pigmented poplar wood,
H. 139 cm, W. 36.5 cm
(H. 54³/₄ in., W. 14³/₈ in.).
Museo Civico, Faenza.

forearm is raised vertically, and the cloak crosses the chest in a strong diagonal. The head is slightly turned, and the lips are parted as though the Saint were exhorting some unseen onlooker. The illusion of movement extends even to the scroll, which is represented half unwound in the left hand. The choice of medium for the statue is bound up with the fact that wooden sculptures were easily transportable. The only earlier work in wood by Donatello is the *Crucifixion* in Santa Croce, where the handling of the medium is conventional. The *Baptist*, however, is an innovative work, in which the expressive possibilities of wood and of pigmented, pictorial sculpture are for the first time explored.

Another wooden sculpture was carved by Donatello at about this time, a statue of St. Jerome at Faenza.[2] More loosely constructed than the Frari *Baptist*, its prehensile feet press into the wooden ground, and its head is turned up in ecstasy. On historical grounds, the statue is likely to be a little later than the *Baptist*, and may have been commissioned in Florence by Astorgio II Manfredi, the ruler of Faenza, for the Manfredi Chapel in Faenza, which was made over in 1444 to the Franciscans and rededicated to St. Jerome. *Fig. 126*

The first work datable by inference is the marble tomb slab of Giovanni Crivelli, Archdeacon of Aquileia, in Santa Maria in Aracoeli in Rome.[3] Originally let into the floor of the church, but now set vertically on the entrance wall, it shows the Archdeacon's body in a niche, in which the cushion supporting the head rests on the entablature under a shell vault. In the spandrels above are two flying angels supporting a disc, which at one time showed Crivelli's arms. The slab, like other tomb slabs in the Aracoeli, has been artificially abraded, and much of its detail is effaced, but the handling of those parts that retain their surface, especially the angels, the hands of the effigy, and its foreshortened feet, indicates very clearly that the slab was originally of first-rate quality. Around the edge is an inscription ending with the words OPVS DONATELLI FIORENTINI, in which the date and month of Crivelli's death and the year of the pontificate of Eugenius IV are coarsely inserted in areas previously left void. The slab is likely, therefore, to have been carved before Crivelli's death in the summer of 1432, and not posthumously as is generally supposed. Probably, like the monument of Cardinal Brancacci, it was carved in Florence or Pisa and then sent down to Rome. *Fig. 130*

With it must be linked a perfectly preserved marble relief of the *Dead Christ Tended by Angels* in London.[4] Carved in one with its molded frame, it was evidently, on the analogy of later reliefs of the Lamentation by Desiderio da Settignano in San Lorenzo in Florence and Giovanni da Majano in the Duomo at Prato, the dossal or antependium of an altar. Its execution suggests that it was carved in close conjunction with the small relief in Boston known as the *Madonna of the Clouds*, since three angels in low relief in the background are due to the same assistant as parts of the Boston relief and of the Prato pulpit. The molding at the base, representing the front edge of the tomb, cuts the figure of Christ through the thighs and the right hand and provides a platform for the standing angels at either side. The pathetic head of Christ, turned almost in profile, and the right shoulder and the arm beneath seem to have been carved by Donatello, as does the standing angel on the left, whose diaphanous dress is treated with a liveliness lacking in the inert folds of the dress of the angel opposite. *Fig. 129*

A second work datable by inference is the much-contested portrait bust of Niccolò da Uzzano in the Bargello.[5] The bust, in the form in which it is discussed throughout the Donatello literature, was heavily overpainted and set with a false forward inclination on its base. Early accounts of it prior to its cleaning may, therefore, be ignored. In its restored state Donatello's authorship is manifest in the pose, in the modeling, and above all in the lips and deep-set eyes and in the neck and spinal column at the back. In the course of restoration it was established that the bust is based on a life, not a death, mask, that the two ears were modeled independently and attached, and that the face was cast separately from the cranium. The hair seems to have been covered with a greasy substance to facilitate the removal of a gesso cast. This technique represents a first stage in the development of the life-mask bust. In the hair there is a vent hole (which one commentator has explained as a hole for the attachment of a halo) and at the back, at the top of the spine, is a socket for attachment to the wall against which the bust originally stood. If the bust is based

FIGURES 127, 128.
Donatello, *Niccolò da Uzzano*.
Pigmented terracotta,
H. 46 cm, W. 44 cm
(H. 18 in., W. 17³/₈ in.).
Museo Nazionale, Florence.

141

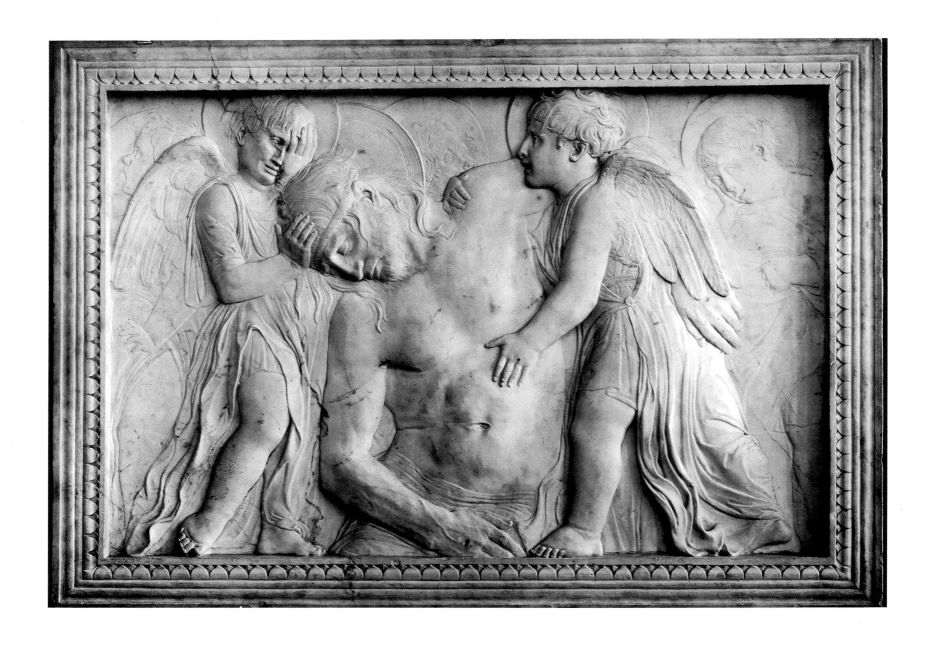

FIGURE 129.
Donatello (assisted),
Dead Christ Tended by Angels.
Marble, H. 80.6 cm, W. 114.3 cm
(H. 31¾ in., W. 45 in.).
Victoria and Albert Museum,
London.

on a life mask, the identity of the sitter is of some consequence. Here there is no reasonable room for skepticism. The bust was preserved till 1881 in the Palazzo Capponi, which was built by Niccolò da Uzzano and passed, by marriage, to his son-in-law Neri Capponi. It was accepted, at least from the middle of the seventeenth century, as a portrait of Niccolò da Uzzano and is highly unlikely, as has been suggested, to represent a later member of the Capponi family. It has in particular not the smallest resemblance to the early sixteenth-century portrait busts by Pietro Torrigiani with which it has been associated. Niccolò da Uzzano died in 1432 at the age of seventy-three, and since the bust is based on a life mask it must have been produced before Niccolò's death, that is concurrently with Masaccio's portraits in the Brancacci Chapel. Donatello at this time was working on the later Prophets for the Campanile, the *Jeremiah* and *Habbakuk*, and though there is no direct analogy

between the portrait types of the Prophets and the bust, the modeling of the cheekbones and of the slightly sunken cheeks beneath is common both to the *Jeremiah* and to the terracotta. The *Niccolò da Uzzano* is an equivalent for the portrait busts, or *imagines*, described in antiquity by Pliny. The dress is classical, and the contrast between the robe or toga over the shoulders and the complex folds across the chest is of great distinction. The muscles of the throat and neck are masterly in their modeling, and the head has a nobility of which, in 1430, no other sculptor than the artist of the Campanile statues would have been capable.

Fig. 131 A third approximately datable work is the lost statue of Dovizia carved for the Mercato Vecchio.[6] Its history goes back to the spring of 1429, when the Arte della Lana and the Operai of the Cathedral handed over to the magistracy of the Ufficiali della Torre a column that then stood near the Campanile and was wrongly supposed to have supported a figure of Mars before the Baptistry became a Christian church. In April 1430 the column was erected in the Mercato Vecchio (or "Foro Veteri," as it is described in documents), and Donatello's statue must have been commissioned for it not long afterward. A reference to it occurs in an anonymous play, *Nabucodonosor, Re di Babilonia*, in the course of a humorous conversation between Donatello (who has been summoned to undertake a gigantic gold statue of Nebuchadnezer) and the royal chamberlain. In it Donatello enumerates his current commitments: "Io ho fornire el perghamo di Prato . . . E ho fare la dovitia di mercato, la qual in sulla colonna s'ha a porre. Et hor più lavorio non posso torre." The sentence is in implied future tense, which suggests that when it was written the Prato pulpit was still incomplete and that the *Dovizia* likewise was unfinished. The statue was carved in sandstone or *pietra di macigno*, not in marble, and by 1720 was so far deteriorated that it was replaced with a new statue by Giovanni Battista Foggini. Foggini's statue, which was taken down in the second half of the nineteenth century and is now in the Cassa di Risparmio in Florence, is 2.35 meters (7 ft.) tall, and Donatello's *Dovizia* may have been roughly of the same size, that is about seven feet.

Our knowledge of the *Dovizia* depends from a number of paintings of the Mercato Vecchio that show it on its column in the market place. Filarete, who must have seen it in the original, when describing his ideal city, places a statue of Abundance on a tall column in the market. "This goddess," he writes, "should have a basket on her head filled with fruit and a cornucopia in her hand, with fruit falling from the basket as well as from the cornucopia." Donatello's *Dovizia* seems, however, to have been a more sophisticated figure than the statue Filarete describes, and an attempt has been made to associate it with the social thinking of Leonardo Bruni, which promoted the civic virtues of wealth and charity.[7] It is evident from painted reproductions that the *Dovizia* was a strongly classicizing statue. The figure was represented with the weight on the right leg and the left knee bent as though in the act of walking forward. Her dress descended to her ankles (in one enameled terracotta copy in the Casa Buonarroti the left leg and bent knee are exposed, but this seems no more than a later gloss on Donatello's design). At the back (if Vasari's *Preaching of St. Peter Martyr in the Mercato Vecchio* is to be trusted) the dress was looped up in thin folds. The right arm was raised, and the forearm, with hand resting on the edge of the basket, and the upper arm protruding at an angle of forty-five

FIGURE 130.
Donatello, *Tomb Slab of Giovanni Crivelli,
Archdeacon of Aquileia.*
Marble, H. 235 cm, W. 88 cm
(H. 92½ in., W. 34⅝ in.).
Santa Maria in Aracoeli,
Rome.

degrees from the shoulder enclosed an equilateral triangle of space. On the opposite side the cornucopia was held against the body. Its top projected above the shoulder, and it was separated from the left elbow by another void. The destruction of the *Dovizia* is a more serious loss than is generally recognized, since its style, in so far as it is reconstructible, was radically different from that of Donatello's earlier sculptures. No longer Brunelleschan, it bore the stamp of the refined, rigorous, almost pedantic classicism of Leon Battista Alberti.

Donatello must have known Alberti in Rome during his visits in 1430 and 1433. By 1436, when the *Della Pittura* with its preface addressed to Brunelleschi was published, he was, in contradistinction to "quegli altri Nencio e Luca e Masaccio," our dearest friend, "nostro amicissimo Donato scultore." Imaginary pictures have been drawn of Donatello and Alberti inspecting the antiquities of Rome in each other's company, and the two artists may indeed have met in Florence after 1426 when the ban on the Alberti family was withdrawn. But only with the arrival of Eugenius IV in Florence in 1434 did Alberti become a prime mover in the Florentine scene. In the second half of the decade, pictorial style in Florence underwent a change that affected both the structure and the palette of paintings. It is represented today by Domenico Veneziano's tondo of the Adoration of the Magi in Berlin, and by his Santa Lucia altarpiece. How far it resulted from Alberti's personal influence we cannot tell. But the visual evidence and the preconceptions of the *Della Pittura* are in such close conformity that it is reasonable to credit Alberti with at least some measure of responsibility for the transformation that occurred. It has been said that "Alberti's Della Pittura is the prophetic book of academism. . . . As a humanist and a student of Plato he believed in the absolute supremacy of the mind, and he set out to prove that painting was essentially a mental and not a manual activity."[8]

For Alberti paintings were constructs, and sculptures were constructs, too. The *De Statua* is a less illuminating treatise than the *Della Pittura*; it is largely technical, and contains tables of dimensions and proportions and accounts of the instruments an ideal sculptor would be required to use if they were to be implemented. But the dominant criteria, of *dimensio* and *finitio*, imply a view of sculpture that runs parallel to Alberti's theory of painting. It would be reasonable in these circumstances to suppose that sculptural style in the middle of the 1430s would undergo changes analogous to the changes in pictorial style, and this does indeed occur in the style of Donatello. But large sculptural projects like the Cantoria and the Prato pulpit, which originated at an earlier time, were still in course of production when the change occurred, and we have therefore to accept the chronological anomaly that in the later 1430s works in two very different styles were under production simultaneously in the same studio.

The herald of change is the Cavalcanti *Annunciation* in Santa Croce.[9] Carved like *Fig. 132* the *Dovizia* in *pietra di macigno*, it represents a synthesis of classical motifs very different from the pre-Albertian architecture of the Prato pulpit or the Cantoria. The protruding pediment is a segmental arch with terminal scrolls seemingly adapted not from Roman buildings but from cinerary urns. The tripartite entablature, with its emphatic strip of egg-and-dart molding, is supported by piers with an imbricated leaf pattern, again drawn from cinerary urns (the most often cited

FIGURE 132.
Donatello, *Annunciation*.
Pietra di macigno,
parcel gilt, and terracotta,
H. 420 cm (13 ft. 8 in.).
Santa Croce, Florence.

analogy is with the urn of Tiberius Claudius Victor in the Cabinet de Médailles in Paris). The capitals with quadruple masks are worked up from a Roman double herm, and the double bracketed scrolls at the base of the piers once more depend from cinerary urns, as do the lion feet on which they rest. The cornice of the Temple of Vespasian seems to have served as source for the tabernacle base.

In two centers with which Donatello was familiar there was a tradition of carved Annunciation groups. At Pisa it extends from the third decade of the fourteenth century to the 1360s, when a definitive Annunciation group was carved in marble by Nino Pisano for Santa Caterina. Siena witnessed the production of a number of wooden Annunciation groups, of which the finest, Jacopo della Quercia's group of 1426 at San Gimignano, was carved at a time when Donatello was employed on the baptismal font. The Angel and the Virgin Annunciate were normally separated— Nino Pisano's were set against the piers on either side of the high altar of Santa Caterina and Quercia's in tabernacles on either side of a subsidiary altar at San Gimignano—but they constituted an aesthetic unity. It is with memories of these figures, not of paintings, that the Cavalcanti *Annunciation* originates.

The interior space is treated with stylized foliage. Before it, on the right, is the Virgin's elaborate seat, and since this is conceived to be of wood, not stone or marble, and is incised with decoration related to that on the rear wall, the rear wall itself must represent simulated paneling. From a viewing point in the center of the base, the relief shows the segment of a room in which the wings of the Annunciatory Angel and the elbow and thigh of the Virgin are so cut as to suggest a continuum of space behind the frame. The relationship between the figures is more personal and more specific than in any earlier painting of the scene, and the figures, in very deep relief, are carved in one with their ground. The Virgin's left foot rests on the front edge of the relief, and the seat behind serves to establish the distance between her figure and the rear wall of the room. The angel is posed diagonally with his right foot abutting on the edge of the relief and his farther wing pressed against the wall behind. Both figures are unambiguously classical. In the Virgin the fluent modeling seems to derive from a clothed Hellenistic figure. Direct imitation of an antique model was precluded by the pose, in which the shoulders are aligned on the rear wall of the tabernacle and the head is turned toward the angel on the left. Donatello's Virgin is nonetheless depicted as she might have appeared during the early principate, and the style of hairdressing is adapted from a Roman portrait bust. Her features, marked though they are by a concern with transient emotion alien to Roman sculpture, reinforce the sense of classical authority. It has been claimed that the Gabriel derives from a crouching Venus of the type of the Venus of Doidalsas, and the positioning of the two arms, with the right elbow resting on the left wrist, may indeed have been suggested by such a source. But the connection is far from obvious and is less significant than the adoption, in the face and hair, of a manifestly classical style that derives from sarcophagus reliefs.

In the fifteenth century, the church of Santa Croce was divided by a choir screen, and Donatello's *Annunciation* was designed for the place it occupies today, immediately beyond the choir screen on the right wall of the nave. It was, therefore, like Brunelleschi's and Masaccio's *Trinity* in Santa Maria Novella, a self-consistent *Fig. 137*

146

architectural unit inserted in a Gothic space. The *Trinity* stood over the graves of the Lenzi family, and the *Annunciation* had the same relation to those of the Cavalcanti. It may originally have been associated with an altar, and was certainly so associated when, about 1460, it was supplied by Niccolò Cavalcanti with a painted predella by Giovanni di Francesco. There is no direct evidence for its date. Its figure scheme is reflected in an *Annunciation* by Fra Filippo Lippi in San Lorenzo in Florence, where the kneeling Annunciatory Angel is cut by the frame in much the same fashion as Donatello's angel, and the posture of Donatello's Virgin is reproduced. Lippi's *Annunciation* is likely to have been painted not long before the reconstruction of San Lorenzo in 1442. These considerations would admit of a dating about 1437–40 for the Cavalcanti tabernacle and relief.

Fig. 134 The pediment of the tabernacle is crowned by six angels in terracotta. The paired putti at the sides support the ends of garlands and the mutilated reclining putti must have been shown fixing their garlands to some central element. In their present stripped condition, the angels seem incongruous additions to the tabernacle, but when they were pigmented they may have appeared integral to the whole work. The probability is that they were afterthoughts, modeled, by Donatello, after the main relief was complete. The four standing angels look downward (according to Vasari, "as though afraid of the height and clinging to one another for reassurance"), and introduce an element of intimacy into what might otherwise have seemed a formidably solemn scene.

The year 1434 marked not only the arrival of the papal court in Florence, but the definitive return to Florence of Cosimo de' Medici and the opening of a period of Medici hegemony that was to last for the remainder of Donatello's life. As we know from Vespasiano da Bisticci, his relations with Cosimo were very close. This was not a new relationship, since Cosimo in 1433 acted as intermediary between the authorities at Prato and the sculptor; rather, it was an old relationship extended into a new area, that between patron and artist, and it seems to have diverted Donatello from marble and stone sculpture to the more expensive medium of bronze. What resulted was a masterpiece, the bronze *David* in the Bargello.[10] The first freestanding naked figure executed in bronze since antiquity, it has been very heavily discussed, and in looking at it, it is important to separate fact from speculation and speculation from fantasy.

The earliest reference to the statue dates from 1469, three years after Donatello's death, when it stood in the courtyard of the Palazzo Medici. It is described there by Piero Parenti, a guest at the wedding of Lorenzo il Magnifico and Clarice Orsini. At the party, Parenti tells us, there were no "pantry tables for the silverware, only tall counters covered by tablecloths in the middle of the courtyard around the beautiful column on which stands the bronze David." In 1495 after the death of Lorenzo il Magnifico and the expulsion of his son Piero, the *David* was one of the two bronze statues removed from the Palazzo Medici and transferred "cum omnibus eorum pertinentiis" (that is, with their bases) to the Palazzo della Signoria. There the David was set up first in the center and then against the wall of the courtyard. If Parenti's description of the Medici wedding is to be trusted, the statue must originally have stood above the height of the "tall counters" in the courtyard, probably 1.8 to 2.4

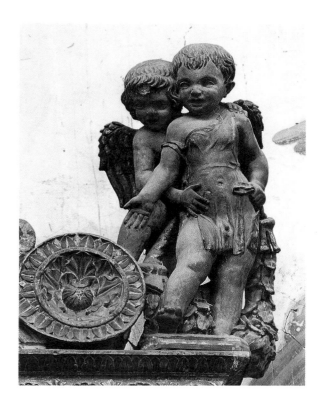

FIGURE 133, 134.
Donatello, *Angels* from *Annunciation*.
Terracotta, H. 76 cm (29⅞ in.).

147

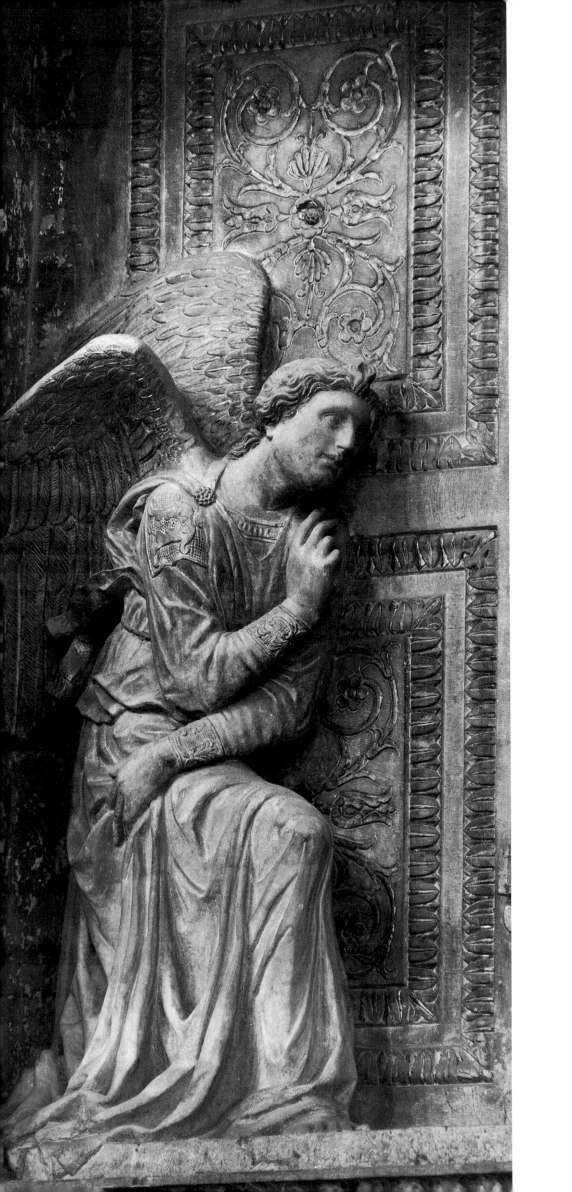

opposite: FIGURE 135.
Donatello, *Annunciatory Angel*,
from *Annunciation*.

right: FIGURE 136.
Donatello, *Virgin Annunciate*,
from *Annunciation*.

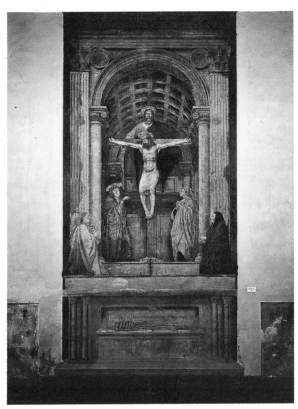

FIGURE 137.
Masaccio, *Trinity*. Fresco.
Santa Maria Novella,
Florence.

meters (6–8 ft.) from the ground. According to an account of 1510, its base was a column of variegated marble. In 1511, in the courtyard of the Palazzo della Signoria, it was struck by lightning, which "damaged a certain bronze belt in the base of the David in the courtyard" and "broke off one of the four leaves into three pieces." Vasari, in his life of Desiderio da Settignano, tells us that Desiderio "in his youth made the pedestal of Donatello's *David*, which is in the courtyard of the Palazzo Vecchio in Florence; here Desiderio fashioned some very beautiful marble harpies, and some vine tendrils of bronze, very graceful and well conceived."[11]

It has been claimed that "physically, the statue is undamaged and complete except for a square hole in the center of Goliath's helmet which must have held a knob or crest of some sort."[12] This is incorrect. The first finger of the right hand and a piece of the sword hilt adjacent to it have been broken off, and the tip of the right wing of Goliath's helmet has been broken and filed down. The surface of the base within the lower wreath beneath the helmet of Goliath is left almost in the rough and since it is bored at three points it is likely to have been covered by some object, perhaps a stone and sling, cast separately. The statue Donatello conceived, more-over, was in some respects a different image from the statue that is shown at a low level in the Bargello today.

Save for his greaves, David is naked. His long hair falls on his shoulders, and his rustic hat conceals his face, which is turned down as he gazes at Goliath's head. One foot tramples a wing of Goliath's helmet, and the other rests on Goliath's neck. The head lies on its side on a circular laurel wreath, the forehead concealed by a helmet, one wing of which touches the inside of David's right leg and thigh. On its column the physical character of the statue would have been very different. David's face would have been fully visible and would not have been concealed by the protruding hat, and the eyes would have looked down at the spectator with an expression of pride and confidence. The bent left leg would, from the front, have read in a more emphatic fashion than it does at present, and the eagle wing of Goliath's helmet would have read as what it was, a means of strengthening a vulnerable point in the structure of the statue.

In the stone *Dovizia*, the right leg bore the weight of the figure, and the left knee was bent as though in movement, while the void between the right arm and the body was balanced by a void opposite, between the cornucopia and the left elbow. The front view of the *David* is planned in somewhat the same way. The right arm, *Fig. 138* holding the sword, is free of the body, and the left arm, with hand pressed against the hip, encloses an empty triangle of space. The geometry of the front face of the statue is completed by a third void between the legs, which would, at the original height, have read with greater emphasis than it does now. The dominant effect is linear, and nowhere more so than in the contrast between the uninterrupted contour of one side and the swelling movement of the hip opposite. The statue has three other prime views. Moving around it to the right, we see the body in profile. The *Fig. 139* hand holding the stone is aligned with the shoulder and left foot and the elbow protrudes from the same axis. At the back the long hair falls between the shoulder *Fig. 140* blades, and the diagonal of the scimitar counters that of the left upper arm. On the fourth face the scimitar and right leg establish a firm vertical and the forearm and *Fig. 141*

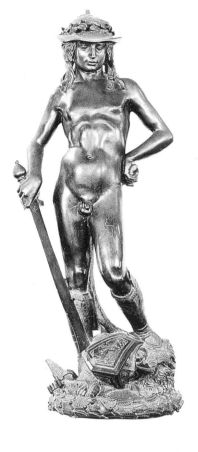

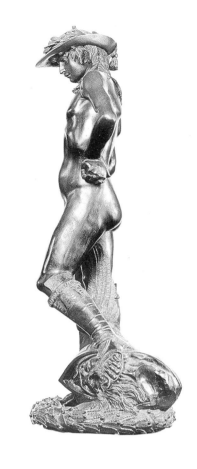

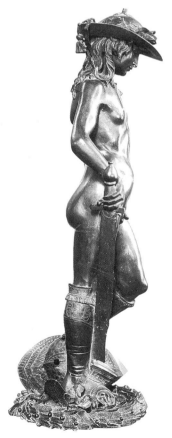

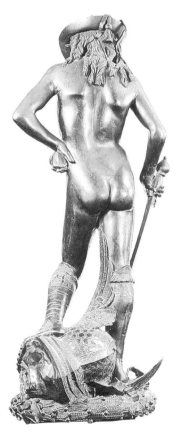

FIGURES 138, 139, 140, 141.
Donatello, *David with the Head
of Goliath*. Bronze,
H. 158 cm, D. of wreath 51 cm
(H. 62 in., D. 20 in.).
Museo Nazionale, Florence.

151

thigh a firm diagonal. Alberti, in his *De Statua*, outlines some principles for the depiction of the freestanding human form. His account is not literally applicable to the *David*, but the statue proceeds from thinking that is related to Alberti's.

The *David* is cast sectionally. The cast is relatively thin and contains a large number of flaws. The hat is cast separately from the head; the head (which depends from a classical Antinous bust) is cast separately from the body; the body is cast in one to below the level of the knees; and the sword hilt is cast in one with the right hand, though the sword blade is cast separately. The head of Goliath is cast separately from the laurel wreath on which it rests, and the severed section of the neck was also cast separately and inserted.[13]

In its present form the statue is incomplete. In the crown of the hat is a circle of eight leaves centering on a protruding stud bored to contain a plume, and in the center of the helmet of Goliath, visible behind David's right leg, is another aperture, apparently for the same purpose. The two plumes seem to have been integral to the statue as it was seen in the fifteenth century. The relief on the helmet of Goliath has been repeatedly explained as a variant of a sardonyx cameo owned successively by Pope Paul II and Lorenzo il Magnifico.[14] In fact, the two images are unrelated and move in opposite directions. The chariot on the helmet is pulled by three winged children, while a fourth child pushes it from behind and a fifth stands facing to the left on a projecting base rising from the shafts. On the upper platform sits a male figure protected by a circular umbrella, as another child in a servile pose kneels before him. The relief does not depend from the antique, but is a free invention in the style of the antique by Donatello and may represent the triumph of pride.

Fig. 142

In the fifteenth century, David embodied the belief that, with divine assistance, even the hardest tasks might be performed. So in the *De Voluptate*, Valla, when asked to arbitrate in a difficult discussion, writes, "Persuaso come sono che l'esito di qualunque cosa facciamo o intraprendiamo non dipende da noi, ma da Dio. Difatti, come si poteva sperare che un adolescente alle prime armi vincesse un guerriero, esercitato nelle battaglie fin dalla più giovane etè e inoltre di gran lunga il più forte di duecentomila uomini? Ebbene, Davide uccise il Filisteo di Palestina."[15] Donatello's *David* is a symbolic, not a narrative figure. Its imagery depends from a literal reading of the first book of Samuel, which describes how "Saul armed David with his armor, and he put a helmet of brass upon his head; he also armed him with a coat of mail. And David girded his sword upon his armor, and he essayed to go, for he had not proved it. And David said unto Saul, I cannot go with these; for I have not proved them. And David put them off." From this, read in conjunction with the account of how Jonathan after the battle "stripped himself of the robe that was upon him, and gave it to David as his garment," it was no more than one step to assuming that David, having freed himself of Saul's armor save for the greaves and sandals, went forward naked to meet the Philistine. Lack of physical protection was a parable of the role played by divine aid in David's combat with Goliath, and so convincing was the message that, before long, naked Davids became the norm. To contemporaries its appeal was on two levels. Like the marble *David* in the Palazzo della Signoria, it appealed to Florentine chauvinism and gave rise after it was installed in the Palazzo Medici to a number of bronze statuettes, by Maso di Bartolomeo,

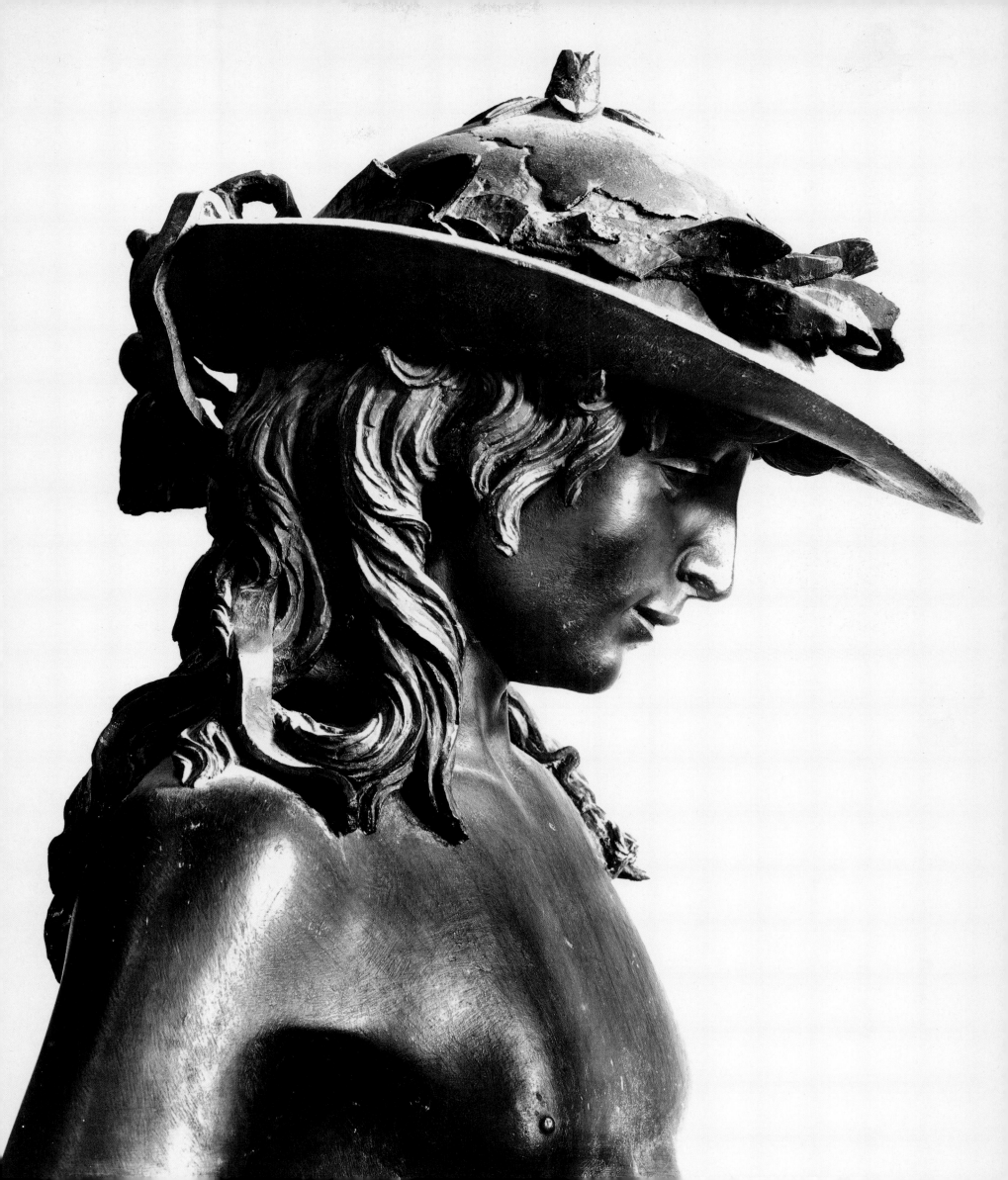

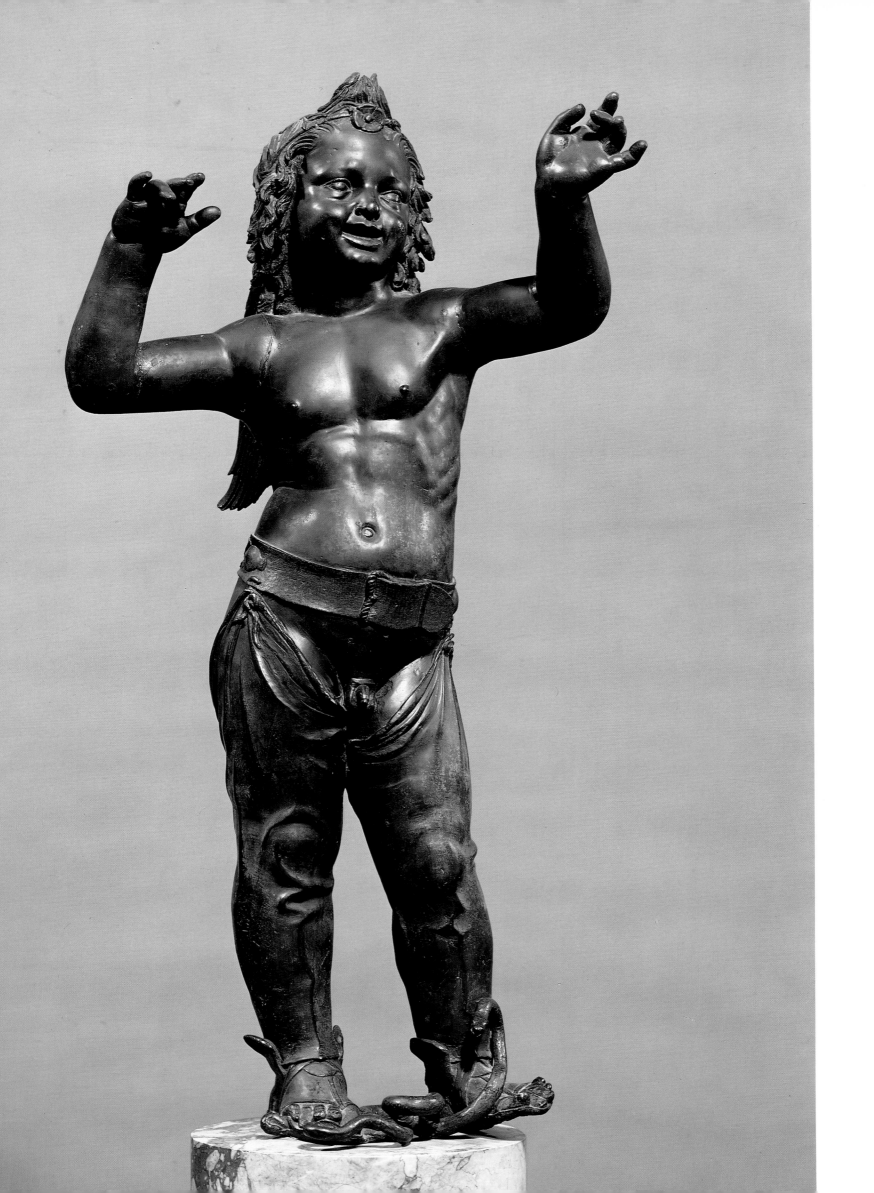

Bellano, and other artists, in which David is represented as a peasant wearing a tunic and holding a sling. Under one of them, in Philadelphia, is the scene of David, at the brook collecting stones with one of which Goliath will be felled. To educated taste, however, its significance is likely to have been a little different. The *galero* or peasant hat worn on the head would have recalled and may actually have been copied from the *petasus* of Mercury.[16] A cult of Mercury was certainly current in Florence. Niccolò Niccoli and Cyriacus owned statuettes of Mercury, and Poggio Bracciolini was presented by Cyriacus with a poem entitled "De Mercurio Sibi missi a Ciriaco Anconitano."

That the statue represents David and not Mercury, as has been suggested, is established by a recent discovery by Dr. Christine Sperling, that while it was still in the Palazzo Medici ("in domo magnifici Piero Medicis sub Davide eneo"), its base bore the inscription:

> Victor est quisquis patriam tuetur
> Frangit immanis Deus hostis iras
> En puer grandem domuit tiramnum
> > Vincite cives.
> (The victor is whoever defends the fatherland.
> All powerful God crushes the angry enemy.
> Behold, a boy overcame the great tyrant.
> > Conquer, O citizens).

This verse, in a meter derived from the Odes of Horace, leaves no doubt that the statue was intended as a symbol of civic patriotism, continuing the heroic tradition of Donatello's marble *David*, in the Sala dell'Orologio of the Palazzo della Signoria.[17]

At what date would this inscription have been appropriate? Cosimo de' Medici's return to Florence in 1434 did not inaugurate a period of peace. The position of the city was precarious, thanks to the campaign of the condottiere Piccinino and the hostility of the Albizzi. In 1438 an Albizzi was installed as Podestà of Bologna, and as Piccinino's troops advanced on Poppi and Perugia, the threat of encirclement assumed the same reality that it had had during the wars with Milan earlier in the century. In February 1440 Piccinino's forces started their advance, but in June they were decisively defeated in the Battle of Anghiari. So significant was this battle that more than half a century later it was chosen as the subject of a fresco by Leonardo da Vinci in the Palazzo della Signoria. Almost certainly Donatello's *David* was inspired by this same victory. If so, it is likely to have been commissioned late in 1440 or early in the following year, not for Michelozzo's Palazzo Medici in which it stood in 1469, but for the previous Palazzo Medici.[18] Its base by Desiderio da Settignano, who was born in 1428, must date from about 1450, when the new Palazzo Medici was ready to receive it and Donatello was himself absent in Padua.

Closely related in style to the *David*, but possibly a little earlier in date, is a bronze figure in the Bargello known by the clumsy appellation of *Atys/Amorino*.[19] It shows a boy faun with wings and winged feet standing with both arms raised, a look of contagious pleasure written on his face. The features recall those of the

s. 145, 146

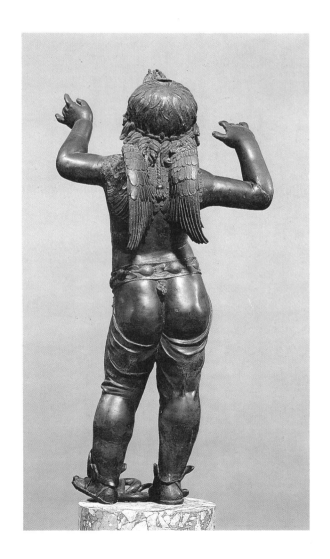

opposite and below: FIGURES 145, 146.
Donatello, *Boy Faun Treading on a Snake*. Bronze,
H. 104 cm (41 in.).
Museo Nazionale,
Florence.

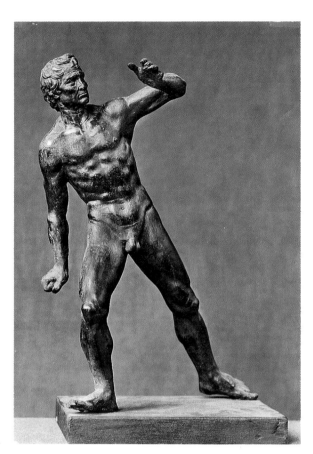

Fig. 147

FIGURE 147.
Donatello, *Pugilist*. Bronze,
H. 28.8 cm (11³⁄₈ in.).
Museo Nazionale,
Florence.

children on the left half of the Cantoria, and its structure does so as well. The upper and lower halves of the body are turned on opposing axes, and its movement, like the movement of the Cantoria figures, is established by imbalance; the left shoulder and left arm are higher than the right, and only the right foot touches the ground. The boy wears loose protective leggings suspended from a belt decorated with poppy heads and open at front and back to leave his penis and buttocks exposed. A snake twines around his feet. The figure lacks its base—the left foot is raised and the sole is open—and may originally have held a snake in either hand. A late fifteenth-century small bronze shows a young faun of this type, and a similar child in the background of an illustration of Colonna's *Hypnerotomachia Poliphili* is described as a "satyrolo" strangling a snake. The bronze is recorded by Vasari, in the 1568 edition of the *Lives*, in the collection of Giovambattista d'Agnolo Doni in Florence. Probably it was planned as a fountain figure, though on the top of the head is a disc that has also been explained as the support for a lamp.

Two bronze statuettes ascribed to Donatello should be mentioned here. The first, in the Staatliche Museen at Berlin/Dahlem, represents David with the head of Goliath.[20] It was at one time regarded as a model for the bronze *David* in the Bargello and then as the source of the marble Martelli *David* by Rossellino now in Washington. Neither of these explanations can be correct. The figure is cast in one with a shallow base, the front face of which is established by the Goliath head, and is set diagonally across it, with the left shoulder and left elbow aligned with the forward corner, the right shoulder and foot retracted, and the head turned to its left. This diagonal scheme has no parallel in the work of Donatello.

One of the most highly prized small bronzes in the Medici collection was a figure known as the "gnudo della paura," of which a number of copies are known. The bronze, of which the finest example is in the Frick collection, is by or related to Antonio Pollajuolo. A similar figure appears in reverse in the middle distance of Uccello's fresco of the Flood. The *Flood* dates from the middle of the century, and Uccello's prototype cannot, therefore, have been a statuette by Pollajuolo. In the Museo Nazionale, however, there is a small bronze figure of a Pugilist from which the raised left arm and the extended left leg of Pollajuolo's model clearly derive.[21] The triangular structure of the figure, with the right arm forming a vertical and the left leg a diagonal, is characteristic of Donatello, as is the rugged handling of the torso and the arms. Across the neck run horizontal gashes that occur again in figures on the left-hand door of the Old Sacristy. The decisive factor in the attribution is the head, where the modeling of the hair, the cheekbones, and the mouth and chin correspond with those of the *Jeremiah* on the Campanile. The bronze is unique, and proves that the revival of the classical bronze statuette was achieved not by Florentine sculptors in the last third of the fifteenth century, but about 1435–40 by Donatello.

VIII

The Old Sacristy

WHILE THE CANTORIA was still incomplete, Donatello received yet another commission from the Cathedral, for bronze doors for the entrances to the two sacristies. A model for them was available in February 1437 (and must, therefore, have been made in the preceding year), and the commission was signed on March 27.[1] The first door was to be completed by April 1439 and the second by April 1441, at a cost respectively of eleven hundred and eight hundred florins. The two-year period allotted for each door suggests that a substantial staff would have been assembled for the cleaning and chasing of each wing. Arrangements were made for the payment of a salary (or *provedigione*) for four months at the rate of twenty-five florins a month from May 1, 1437.[2] This payment probably covers the period during which full-scale models for some or all of the reliefs on the first door would have been made. In April a decorative marble sculptor who had also worked on Luca della Robbia's Cantoria, Nanni di Miniato, was attached to Donatello's staff, presumably in connection with the door frames.[3] There is no reason to doubt that work went ahead in an orderly fashion,[4] since on June 30, 1439, three hundred sixty-seven pounds of "bronzo e ottone vecchio" were bought for the casting of the sacristy doors "che dee fare Donatello."[5] Nothing further is heard of the doors till June 21, 1445, when the contract for one of them, that of the North Sacristy, was cancelled and reallocated to Michelozzo on the basis of a new model made earlier in the year. This door, the work of Michelozzo, Luca della Robbia, and Maso di Bartolomeo, was completed and set in position in 1475.[6] The contract for the door of the South Sacristy, which was never executed, was retained by Donatello, and as late as the summer of 1459 he is referred to in the Duomo records as "intagliatore e chondottore de li porti de la sagrestia."[7]

All that we know about this abortive project is the little that can be deduced from the documents in the Archivio dell'Opera del Duomo. There is no expression

overleaf, left: FIGURE 148.
Brunelleschi, *The Old Sacristy.*
San Lorenzo, Florence.

overleaf, right: FIGURE 149.
Brunelleschi, *Ceiling of the Old Sacristy.*
San Lorenzo, Florence.

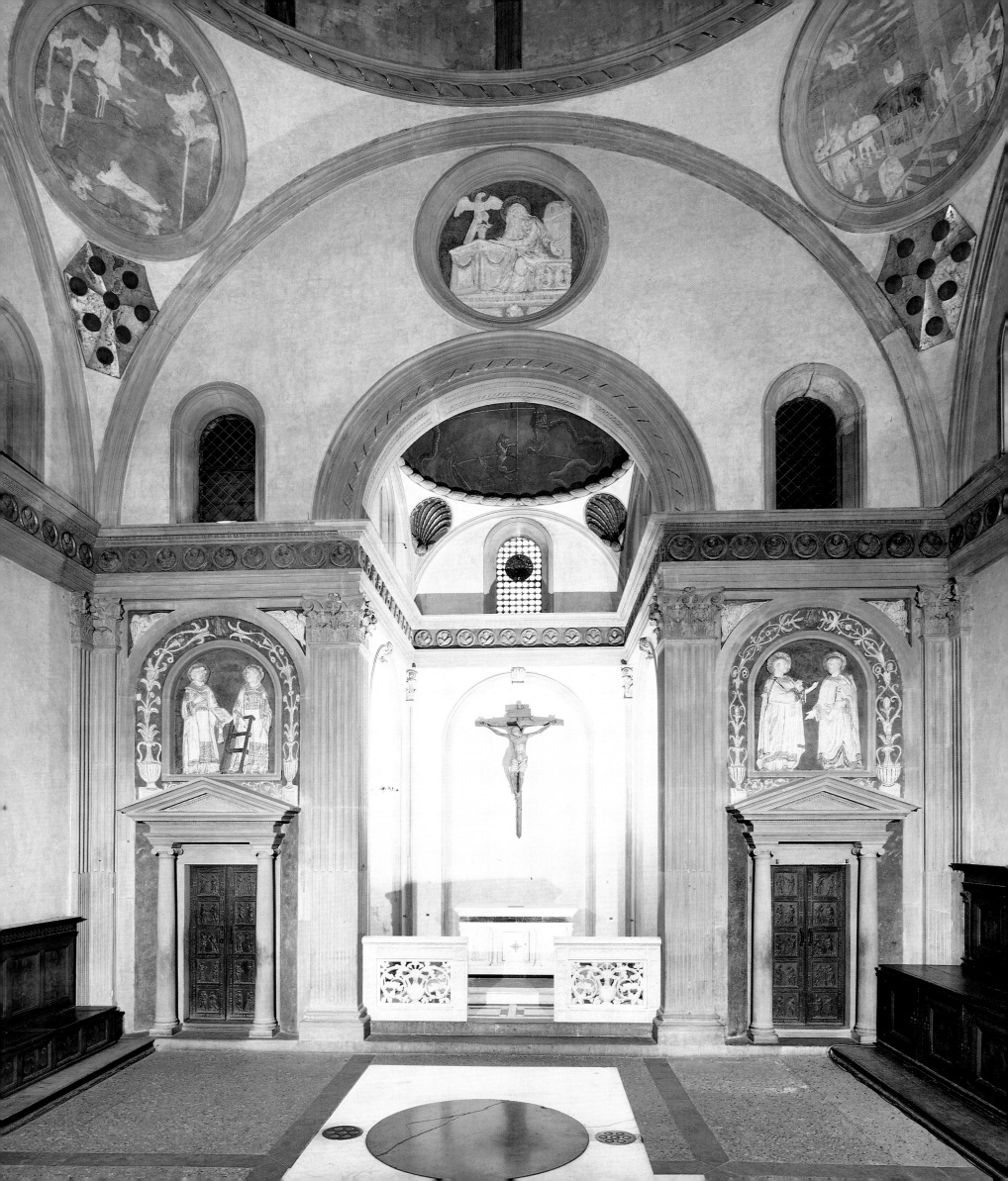

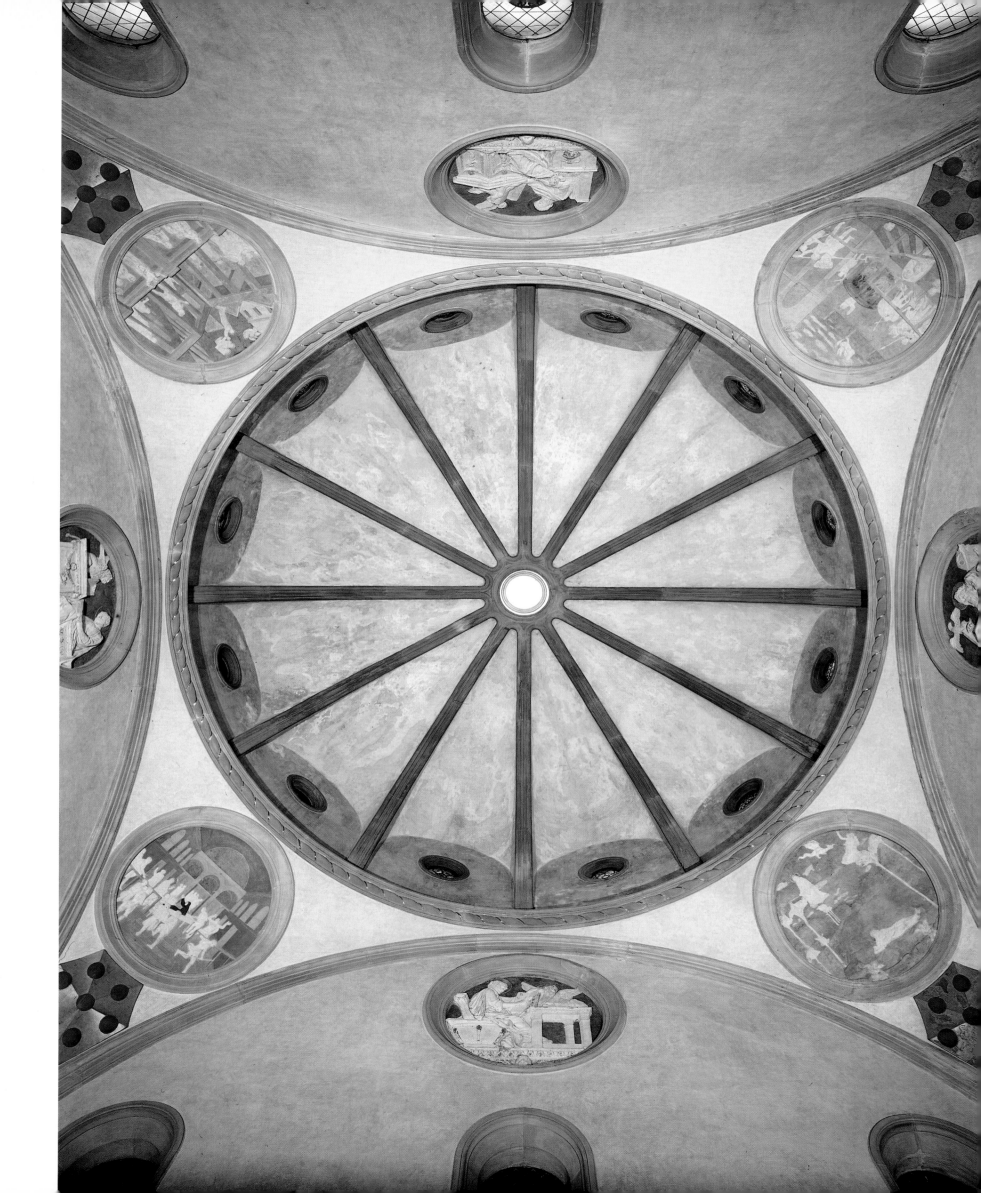

FIGURE 150.
Donatello, *St. John on Patmos*.
Stucco with local pigmentation,
D. ca. 215 cm (84⅝ in.).
San Lorenzo, Florence.

opposite, above: FIGURE 151.
Donatello, *St. John on Patmos*
(detail).

opposite, below: FIGURE 152.
Donatello, *St. John on Patmos*
(detail).

of annoyance or dissatisfaction on the part of the Opera at Donatello's failure to complete the contract, and until he left Florence in 1443 it was evidently expected that work would be resumed. It is likely, therefore, that the casting of the door was superseded, with the acquiescence of the Operai, by a more urgent project. The few indications that we have suggest that this was the decoration of the Old Sacristy at San Lorenzo. The Council of Florence, which resulted in the temporary reconciliation of the Eastern and Western Churches, ended in the summer of 1439, and Cosimo de' Medici, concerned with the completion of the Medici funerary chapel in San Lorenzo, seems to have decided, in conjunction with his theological advisors, that the Old Sacristy should commemorate the Council through a system of decoration that employed Byzantine and Roman elements. The architect of the Chapel, Brunelleschi, by virtue of his role in the Cathedral, would have been in a position to agree to the deferment of the Duomo doors in favor of an enterprise that was both more ambitious and more topical. That nothing but deferment was involved is established by the fact that Donatello retained the commission for both

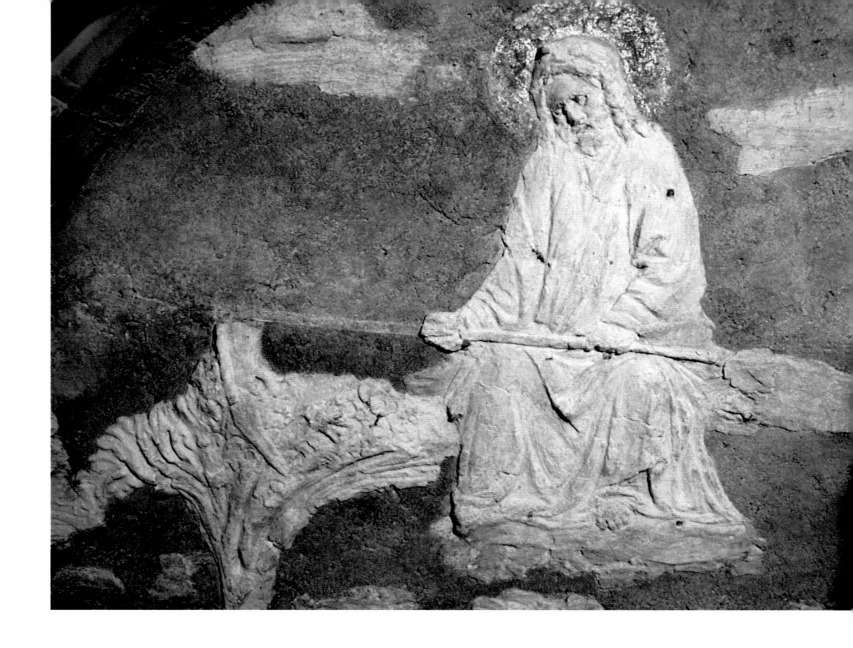

doors until his departure from Florence caused the Duomo authorities to reallocate responsibility for one of them. Though the Old Sacristy is decorated in the rapid medium of stucco, the antecedent planning period must have been long and slow. In conjunction with two pairs of bronze doors at each side of the altar wall giving access to small subsidiary rooms, it may well have occupied Donatello's mind throughout a three-year period about which we have no other information, between 1440 and his departure for Padua in 1443.

The Old Sacristy is a funerary chapel commissioned from Brunelleschi by Giovanni di Bicci de' Medici, the father of Cosimo il Vecchio, and dedicated to his patron Saint, St. John the Evangelist.[8] The commission for it dates from 1421 or 1422, and the roof was completed in 1428, a year before Giovanni di Bicci's death. The altar was constructed in 1432, and Giovanni di Bicci's tomb in the center was built by 1435. Beneath the cupola are eight circular frames or oculi in *pietra serena*, four on the walls and four in the spandrels. When the architectural structure was completed, these were naturally void. It has been suggested that the eight circular frames "may have been intended as blind oculi, and the plastic decoration may have been an afterthought at the insistence of the Medici family."[9] The arguments against that view are legion, and one of them is mandatory.

The Old Sacristy and the building by Brunelleschi that succeeded it, the Pazzi Chapel at Santa Croce, were not ideal spaces in which optional religious ceremonies could occasionally be held. They were chapels to which decorative additions appropriate to their function were envisaged from the first. In the Pazzi Chapel the walls contain twelve circular frames, which would be inexplicable had they not been designed for figures of the twelve Apostles, and the entrance was surmounted by a thirteenth frame, which still contains, as it was meant to do, a figure of the titular Saint, St. Andrew. The Old Sacristy is in precisely the same case. If the roundel over the arch above the altar was intended, as is almost certain, to hold a figure of St. John the Evangelist, the other three roundels on the walls would inevitably have been occupied by Evangelists, and the oculi in the spandrels would, from the first, have been intended for scenes from the life of the titular Saint. But in practice there was some delay in realizing this scheme. The death of Giovanni di Bicci de' Medici was followed by the war with Lucca, the war with Lucca was followed by the expulsion of the Medici, and only in 1434 did Cosimo il Vecchio return to Florence. So, on historic grounds alone, work in the Old Sacristy can barely have been resumed before 1438–40. In the cupola over the altar is a fresco of a celestial hemisphere for which a precise dating should theoretically be obtainable.[10] This has been thought variously to refer to the birth of Piero de' Medici on July 16, 1416, to July 9, 1422 (a date the significance of which cannot be established unless it refers to the commissioning of the Chapel), and to July 6, 1439 (the date of the conclusion of the Council of Florence).

In the passage in his life of Brunelleschi, Antonio Manetti describes a quarrel between Brunelleschi and Donatello over the decoration of the Sacristy.[11] What Manetti says is this:

The small doorways flanking the chapel of the sacristy were left to be

opposite: FIGURE 153.
Donatello, *Raising of Drusiana*.
Stucco with local pigmentation,
D. ca. 215 cm (84⅝ in.).
San Lorenzo, Florence.

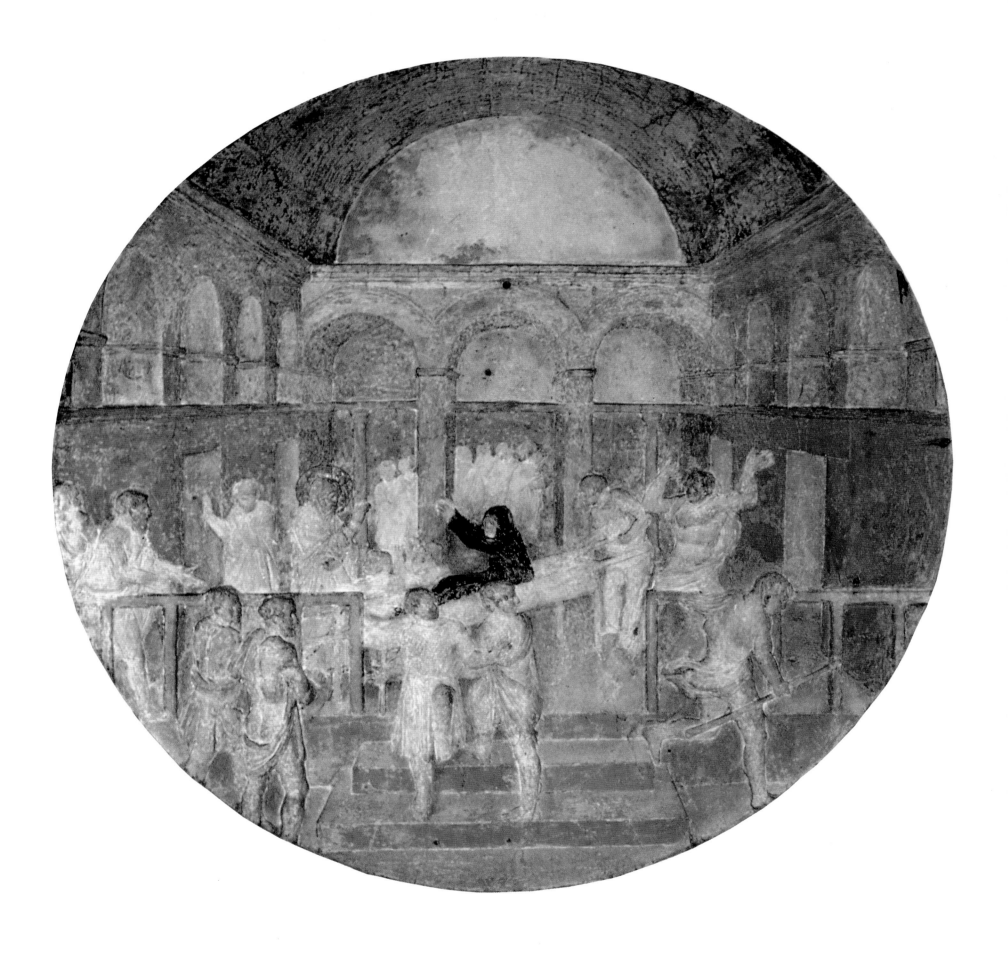

finished later, since it had not yet been decided whether the doors were to be made of wood or of some other material . . . there were then only the openings in the walls, with arches above for stability. When it had been decided that the doors should be of bronze and adorned with figures, as they are today, the commission for them was given to Donatello, who had also to design the limestone porticos and the rest of the decoration for the doorways. He did this with such pride and arrogance that he installed them without ever consulting Brunelleschi, presuming on his authority as the master of the bronze doors, even if he knew little of architectural settings, as is evident from his pulpit in Santa Maria del Fiore [that is, the Cantoria] and any similar work involving architectural design. What he did in the Sacristy individually and collectively lacked the grace of Brunelleschi's forms. When Donatello realized this, he became very indignant at Brunelleschi, and detracted as much as he could from the latter's achievement and fame. Some significant people sustained him, but Brunelleschi laughed at this talk and attached little importance to it. At last, however, when Donatello persisted in his presumptuous remarks, Brunelleschi composed certain sonnets in his own defense—some of them are still in circulation—so as to let the world know that he was not responsible for the porticos or the bronze doors or anything else on those walls between the corner pilasters.

If this account is correct (and there is no reason to doubt it since Manetti is a reliable source), Brunelleschi's objections sprang from the treatment of the walls between the pilasters at either side of the chapel, and from that area alone. The reasons are self-evident on simple architectural grounds. The door frames, whether they be by Donatello or Michelozzo, are ungainly and ill conceived, and since the cleaning of the standing Saints in gesso above them, the reasons for the disagreement are very plain. Fine though the gesso figures are as sculpture, they are totally at variance with the module of the Sacristy. The red and gold frames with which they are surrounded must have looked cruder in the fifteenth century than they do today, and it is not surprising that an architect of Brunelleschi's refinement and restraint should have thought them intrusive elements in the whole scheme. There is no suggestion in Manetti's account that harmonious relations were not maintained between Brunelleschi and Donatello when the roundels were carried out, and the narrative reliefs would indeed be inexplicable if they were not in some sense Brunelleschi-planned.

The problem posed by narrative roundels set at just under twelve meters (40 ft.) from the ground was one of formidable difficulty. Perspectival theory assumed a fixed viewing point, and in sculpture this was normally related to the width of the relief. The viewing point in the narrative roundels in the Sagrestia Vecchia is roughly equivalent to their diameter, almost two meters (6½ ft.). But the point from which the reliefs would actually be seen was far beneath, and their surfaces were concave and not flat. One of the miracles of the Sacristy is that given these conditions, an effect of harmony, indeed of uniformity, was achieved. What we know of Donatello's antecedent mastery of perspective is dependent on one bronze

opposite: FIGURES 154, 155. Donatello, *Raising of Drusiana* (details).

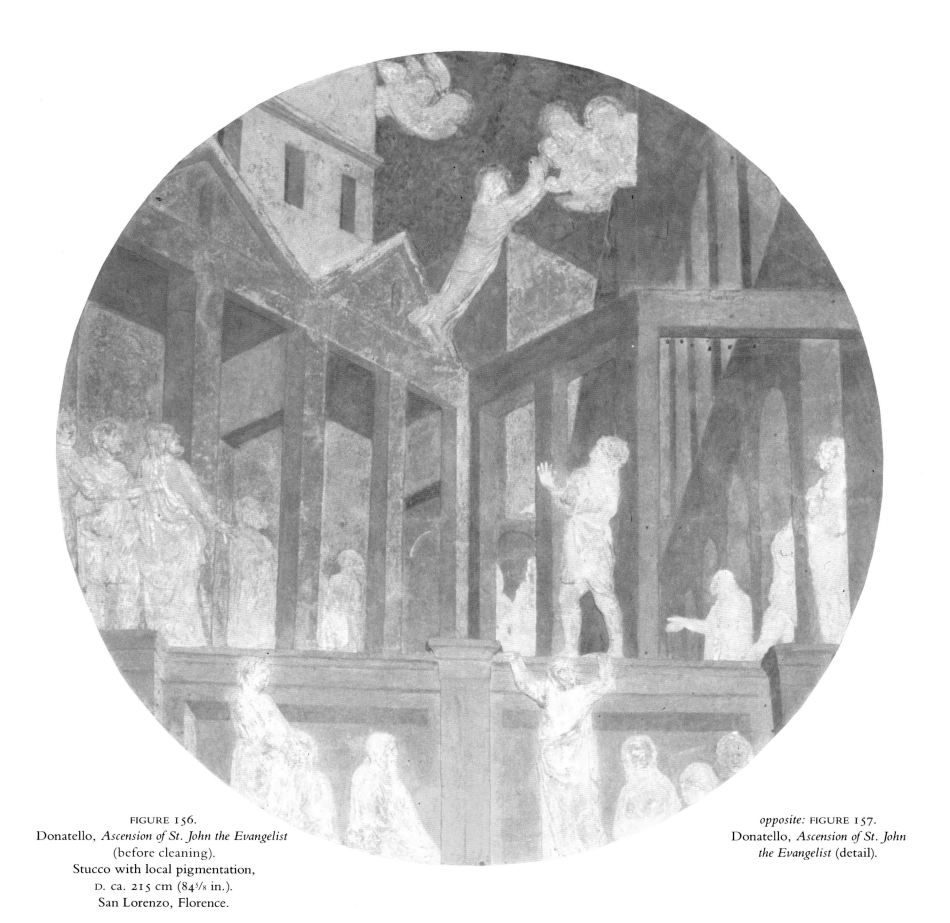

FIGURE 156.
Donatello, *Ascension of St. John the Evangelist*
(before cleaning).
Stucco with local pigmentation,
D. ca. 215 cm (84⅝ in.).
San Lorenzo, Florence.

opposite: FIGURE 157.
Donatello, *Ascension of St. John
the Evangelist* (detail).

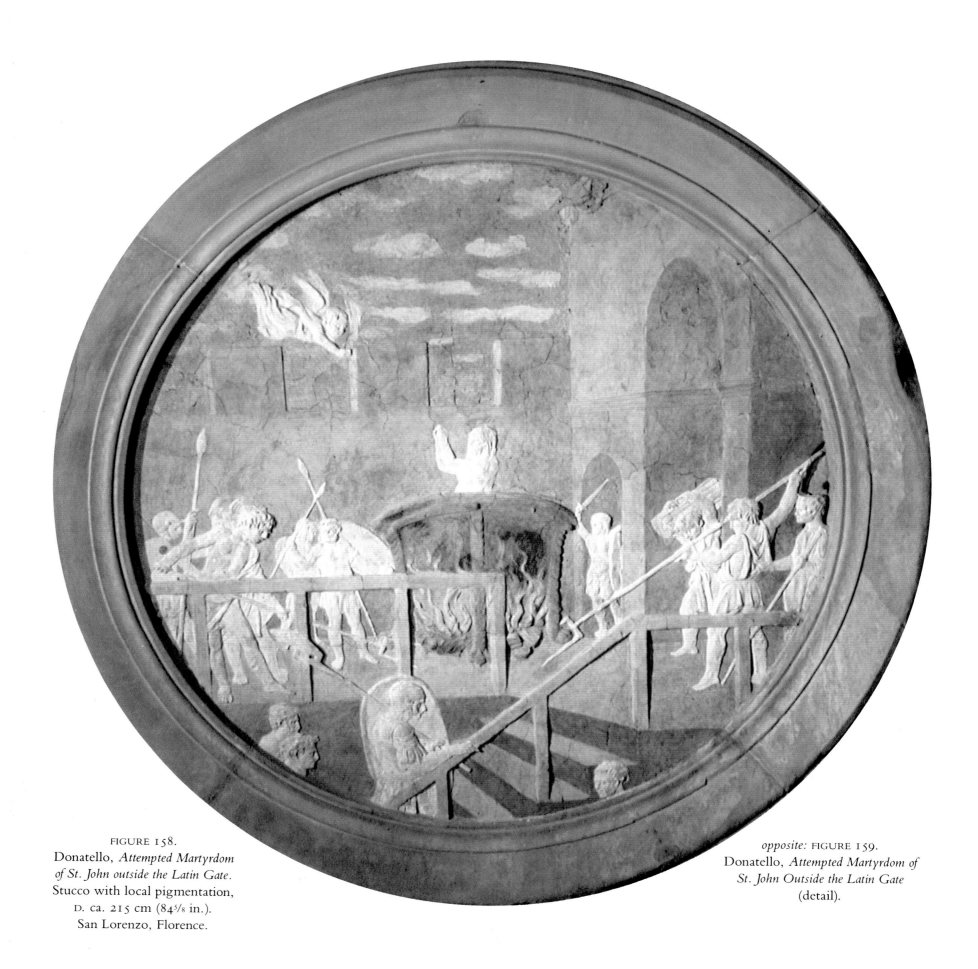

FIGURE 158.
Donatello, *Attempted Martyrdom
of St. John outside the Latin Gate*.
Stucco with local pigmentation,
D. ca. 215 cm (84⁵/₈ in.).
San Lorenzo, Florence.

opposite: FIGURE 159.
Donatello, *Attempted Martyrdom of
St. John Outside the Latin Gate*
(detail).

and four marble reliefs, discussed earlier in this book. Perspectively, the gap between these reliefs and the far more complex reliefs in the Old Sacristy is difficult to bridge, and it is easier for that reason to believe that the reliefs were produced through some loose form of collaboration between Donatello and Brunelleschi than that they were planned by Donatello alone.[12]

Given that the oculi had to be filled, of what should the narrative scenes and the Evangelists on the walls be made? Brunelleschi's preoccupation with this problem from the 1430s on was responsible for the invention, by Luca della Robbia, under his stimulus, of the technique of polychrome enameled terracotta.[13] But not till 1445 was the first of Luca della Robbia's great reliefs, the *Resurrection*, set up in the Cathedral over the north door of the Baptistry. Enameled terracotta was then invoked for the Pazzi Chapel and other buildings. In 1443, however, when Donatello left Florence for Padua, the technique was still unproved so far as public commissions were concerned. It would, moreover, have been unsuitable for use in highly detailed, small-scale narrative reliefs. There remained the obvious alternative of fresco, but frescoes painted on the concave surface of the roundels could hardly, from the standpoint of legibility, have yielded satisfactory results. So recourse was had to a bolder, wholly empirical technique, the filling of the roundels with raised paintings, scenes that read as paintings, but where the figures and other properties stood out, in white stucco, in relief.

Why stucco? Not because the medium of *cocciopesto* had been used in the fourteenth century for walls and pavements, and not because references to stucco occur in Vitruvius and Pliny, but because in the middle of the fifteenth century Roman stucco reliefs were known. They are discussed in Filarete's treatise on architecture in connection with the decoration of the ceiling of a loggia sixteen braccia high.[14] The ceiling would be decorated, Filarete assures the youth he calls "my lord's son," with the signs of the zodiac, the planets and the fixed stars. How would they be made, my lord's son asks. "I propose," says Filarete, "to mix a certain paste of lime and other things, and make low reliefs of a kind that I have seen in other places. That is, as the ancients used it in their buildings, and principally in Rome, as I believe you have seen in the Colosseum and in many other buildings as well." The boy asks Filarete to teach him how to make this mysterious paste, and Filarete replies that he will gladly do so, but on another occasion. There is very little evidence as to what Roman stucco decoration was known in the fifteenth century. Oettingen, in his edition of Filarete, was unable to find traces of it in the Colosseum, and relates the passage to "the ruins of the Palatine or some bath or other." But Roman figurated stucco decorations existed in the Colosseum and elsewhere, and the genesis of the decoration of the Old Sacristy (and, a fortiori, the enameled terracotta decoration of the Pazzi Chapel, which preserved the same contrast between white relief and its blue ground) was therefore classical.[15]

In the Sacristy, however, it was not planets and fixed stars but elaborate multi-figure compositions that were involved, and the roundels seem in practice to have resulted from a compromise. The surface of the roundel was prepared for painting, with an admixture of stucco and brick dust providing a priming for color, like the priming in the skies of frescoes, and on it were superimposed modeled figures,

opposite: FIGURE 160.
Donatello, *St. Mark.*
Stucco with local pigmentation,
D. ca. 215 cm (84⅝ in.).
San Lorenzo, Florence.

170

above and below: FIGURES 161, 163.
Donatello, *St. Mark* (details).

above right: FIGURE 162.
Donatello, Head of *St. Luke*.

trees, animals, and other details. For the most part, the stucco (in deference to whatever classical models were followed) was not pigmented. The trees in the *St. John on Patmos* were, however, green. The single fully pigmented figure in the four roundels was that of Drusiana in the *Raising of Drusiana*, whose prominence could not be established by other means. She wore, and still wears, a dark cloak of a kind that was also used for emphasis in one surviving painting, the *desco da parto* ascribed to Masaccio in Berlin. The stucco was applied damp with the support of a large number of nails, in relatively small lumps, and was modeled by hand (some finger prints are still visible), and when it dried was worked over with a tool to sharpen up the image. This technique was never imitated, partly because a durable, weather-resistant technique was developed soon after the roundels were finished, and partly because the conditions governing the commission never recurred.

We can reconstruct not only how the reliefs were modeled, but how the individual scenes were planned.[16] There were a number of representations in Florence of scenes from the life of St. John, but one was commonly regarded as supreme, the right wall of Giotto's Peruzzi Chapel in Santa Croce, and it was to the Peruzzi frescoes that the thoughts of the patron of the Old Sacristy and of the artists employed there instinctively returned. Not in an imitative sense—it is an academic myth that works of art are constructed from other works of art—but as an interpretative norm against which new images would necessarily be judged. On the right wall of the Peruzzi Chapel there were three scenes: at the top, *St. John on Patmos*; in the middle register, the *Raising of Drusiana*; and, at the bottom of the wall, the *Ascension of St. John*. These three scenes were depicted in the Old Sacristy, but since there were four roundels, another scene was added to them, the *Attempted Martyrdom of St. John outside the Latin Gate*. Sequentially, this was the earliest of the scenes, but analysis had best begin with what is chronologically the second scene and the first illustrated by Giotto, *St. John on Patmos*.

In the uppermost of Giotto's frescoes, we see St. John, as though in a deep sleep,

FIGURE 164.
Donatello, *St. Luke*.
Stucco with local pigmentation
(during cleaning),
D. ca. 215 cm (84⅝ in.).
San Lorenzo, Florence.

173

and the corporeal embodiments of his vision, the seated Christ holding a sickle, the dragon with the recumbent woman and her child, and at the bottom four angels keeping the winds at bay. This skeletal interpretation is adopted once more in the Old Sacristy, but with practical changes that are of some significance. The Saint is no longer seated, but is shown lying on the ground with a book and inkhorn at his side. His head is turned back in literal illustration of the words "I heard behind me a great voice as of a trumpet. And I turned to see the voice which spake with me." Unlike Giotto's dragon, Donatello's is single-headed; its wings are raised in flight to the extreme top of the roundel, and the head and open mouth are turned up, not down as in Giotto's frescoes. The woman is no longer shown lying on her back, but is turned in profile to protect the child; her right arm expresses not surprise or fear, but resistance, as she fends the dragon off. On the left, the seated Christ is no longer posed frontally, but in three-quarter face on the axis of a distant line of trees, and the head of the sickle is pointed inward. One flying figure, the angel with the sword, has been left out, and the four angels with the winds are differently distributed (the two in the foreground recall those in the Apocalypse fresco in the Castellani Chapel in Santa Croce) and are shown straining every muscle to discharge their roles.

Figs. 150–

There was nothing new as such in the obligation to fill a circular space. Ghiberti's window of the Assumption of the Virgin at the west end of the Cathedral was circular and, like Donatello's great *Coronation of the Virgin* beneath the cupola, was set in figure-created space. But the discipline of linear perspective in the form in which it was devised by Brunelleschi and codified by Alberti presumed the presence of a flat base line. The composition of *St. John on Patmos* (and indeed of all three of the other roundels) therefore negates the tondo form. The base line of the construction coincides with and is established by the recumbent figure of the Saint, and two of the wind-restraining angels are relegated to a neutral area beneath. At either side are vertical tree trunks, and in the distance on the left are three receding trees. From these and from rough scratches in the gesso ground, the outline of the construction is still legible. Some of the detail conforms to detail in Donatello's earlier reliefs. Two trees on the right do so, and so does the receding line of trees in the distance on the left. Similarly, the handling of St. John's robe, stretched tightly across his limbs, recalls the toga-clad apostles in the *Ascension*. But, through perspective, the limited depth of Giotto's fresco is transformed into a space that, in the present damaged condition of the roundel, appears limitless. This, so far as we can tell, had never previously been accomplished in the framework of the tondo form. The effect of the relief must originally have been even more pictorial than it is today; the same constructive scheme recurs in a well-known tondo of the Adoration of the Magi, of about 1440, by Domenico Veneziano in Berlin, seemingly a Medici commission, where the figures are disposed, like Donatello's, on a horizontal across the base of the panel, and the vertical supports of the stable have the same function as the trees in Donatello's relief.

Giotto's frescoes in the Peruzzi Chapel descend from exile on Patmos to the celebrated episode in which St. John, after the revocation of Domitian's sentence, returns to Ephesus. The multitude ran out to greet him, says Jacopo da Voragine, crying "Blessed is he that cometh in the name of the Lord. As he entered the city he

opposite: FIGURE 165.
Donatello, *St. Matthew.*
Stucco with local pigmentation,
D. ca. 215 cm (84⅝ in.).
San Lorenzo, Florence.

174

gs. 153–155

met a procession which accompanied the mortal remains of a woman named Drusiana who of old had been his most devoted friend, and yearned more than anyone else for his return." In Giotto's fresco the litter occupies the center of the scene, and the figure of Drusiana is silhouetted against the city wall behind. To the right stands a group of mourners, and to the left is the majestic figure of St. John surrounded by beseeching figures on their knees. Nothing of this appears in Donatello's roundel save that the risen Drusiana is again placed centrally, with hands raised in greeting to the Saint. The first impression of the roundel is of its geometry. The foreground is demarcated by the strongly defined horizontal of the square or platform on which the scene takes place, and a corresponding horizontal at the top is established by a molding over the triple archway at the back. The horizontal emphasis is reinforced in the center of the relief by the upper edge of a containing wall, which must logically join the rear wall at right angles at the back, but is so modified that it reads as a continuous horizontal line. This convention, whereby the angle is concealed in the interests of geometrical consistency, also occurs in a much earlier work, the *Presentation of the Baptist's Head to Herod* on the Siena Font. In the *Presentation of the Baptist's Head* the horror of the scene is heightened by the aversion of the guests, and in *The Raising of Drusiana* the miracle is likewise reflected in the faces and gestures of the participants. The bier is set diagonally in the center. One of its rear supports is held by a boy gazing downward as though unconscious of what has occurred, while his companion, on the extreme right, expresses bewilderment. The Saint, with right hand raised in benediction, stands behind and at the left end of the bier, and beneath him, with heads upturned, are two kneeling supplicants. In the segment of the circle in front, a man in profile hurries off to spread news of the miracle, and in the center two complementary figures, one with back turned, the other set frontally, comment with vivid gestures on the scene. In the archway at the extreme back stands a diminutive group of nonparticipants, opponents of the Saint presumably, whose presence seems to have been due to the exigencies of the perspective construction rather than to the narrative.

gs. 156, 157

The Sophoclean language of the *Raising of Drusiana* may well be the peak of Donatello's achievement as a narrative artist, or would be so were it not juxtaposed with the third of Donatello's roundels, the *Ascension of St. John*. This is the subject of the lowest and most admired of Giotto's frescoes. When St. John had reached the age of ninety-nine years, records Jacopo da Voragine, the sixty-seventh year of the Passion of the Lord, Jesus appeared to him with his disciples and said, "Come to me, my well-beloved, for the time has come when thou shalt sit at table with me and with thy brethren." And St. John rose and prepared to go. But Jesus said to him, "No, thou shalt come to me on Sunday." Therefore, on the following Sunday, the whole populace gathered in the church. And St. John had a square grave dug near the altar, and saw that the earth was carried outside the church. Then going down into the grave and raising his hands to heaven, he said, "Thou hast invited me to thy table, Lord: and behold I come, thanking thee for having invited me." When he had made this prayer a blinding light surrounded him. And when the light faded away,

opposite: FIGURE 166.
Donatello, Head of *St. Matthew.*

177

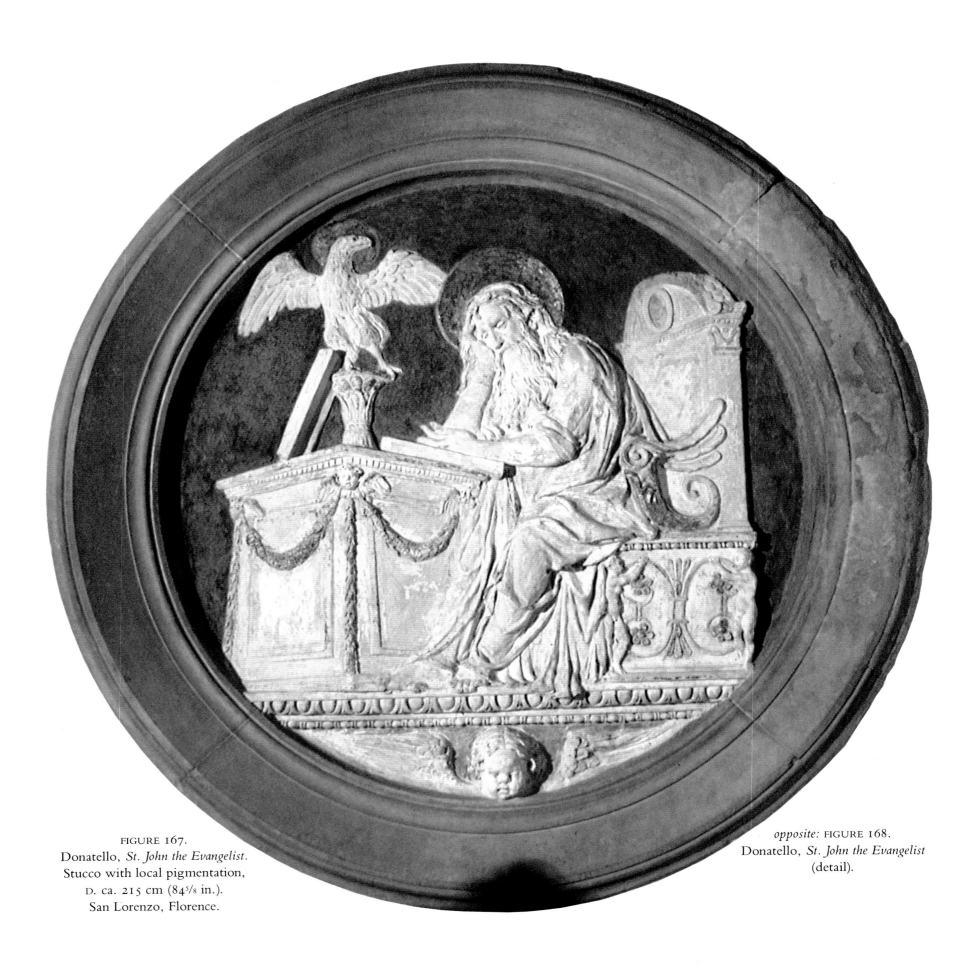

FIGURE 167.
Donatello, *St. John the Evangelist*.
Stucco with local pigmentation,
D. ca. 215 cm (84⅝ in.).
San Lorenzo, Florence.

opposite: FIGURE 168.
Donatello, *St. John the Evangelist*
(detail).

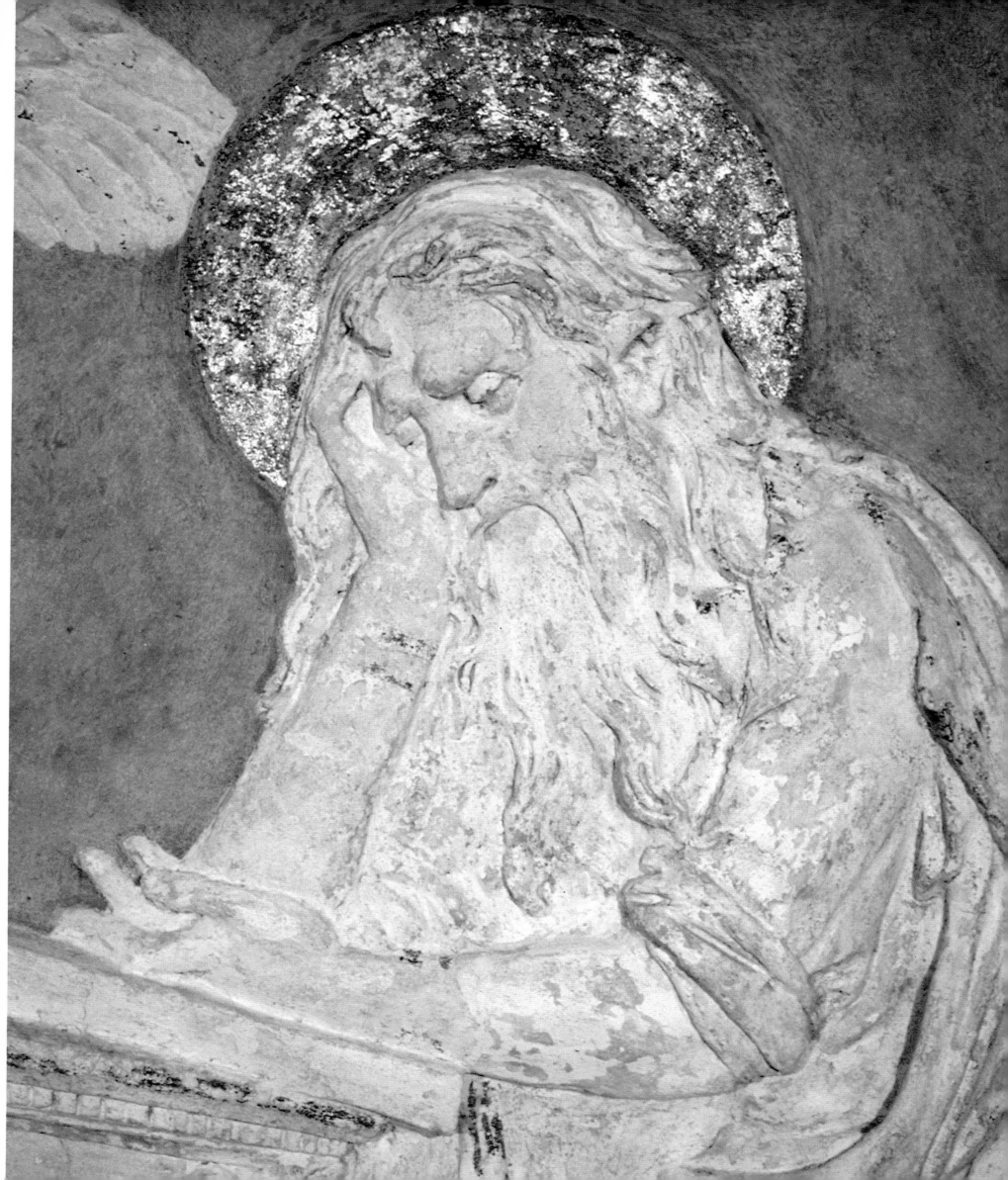

the Saint had vanished and the grave was filled with manna: and it is said that even today this manna issues from the grave, as if it were a spring.

In Giotto's fresco, a little to the left of center is the grave, with above it the ascending Saint, whose head falls in the center of the scene. To the left a group of men peer down into the grave, and to the right six standing figures look up at the ascending Saint. In the roundel the emphasis is on the miraculous ascent, not on the action that precedes it. The same geometrical principles are present as in the *Raising of Drusiana*, but are put to still more vivid use. There is the customary horizontal across the base, this time a wall with a figure clinging to it to secure a better view. In a corresponding position at the top, a second horizontal is established by the lintel of the facing building on the right, while a strongly defined vertical in the center carries the eye up to the distant figure of the Saint. Given the low viewing point, the grave could not be represented, and if there were no grave there could be no figures gazing down at it. The plunging architecture of the building on the right and the church on the left are incomparably vivid, and so are the figures, especially a man looking up to the right of center, with his tunic drawn up above his knees, and a standing figure in left profile; a donor figure on the extreme right possibly represents Giovanni di Bicci or Cosimo de' Medici.

gs. 158, 159

Chronologically, the fourth roundel is actually the first scene in the series, Domitian's condemnation of the relatively young Saint to death by boiling oil outside the Porta Latina. The occasion was celebrated in the church as an act of martyrdom, and in Donatello's roundel an angel bearing the palm of martyrdom approaches from the left, and the Porta Latina is represented on the right. There are the customary verticals, the most decisive of them a continuous line running the whole height of the design from the left side of the gate to the newel post of a staircase beneath. In front the scene is opened out with a descending staircase—this is the first example of a device that was used later by Ghirlandaio in the Sassetti Chapel—and, above, the long-handled forks held by two executioners at either side would, if protracted, meet beneath the center of the cauldron containing the figure of the Saint.

In its cleaned state, this roundel gives an unambiguous impression of the function of color and the use of paint throughout the scenes. Above the machicolated wall are traces of azurite, suggesting that the sky was originally an intense blue, broken, however, by white clouds, which are built up illusionistically as broken surfaces, like the clouds in the Brancacci Chapel. The shaded and illuminated faces of the machicolations are scrupulously differentiated. There are traces of pigment on the surface of the cauldron as well as in the flames beneath, though not, of course, on the deeply moving figure of St. John. The veristic quality of the fire is best judged if we remember that it is all but contemporary with the scene in Dublin of *The Attempted Martyrdom of Saints Cosmas and Damian by Fire* by Fra Angelico. Whether it be the heads of two soldiers at the back, a youth in profile, puzzled by the Saint's immunity from pain and gazing inquiringly at an older man, or the larger figure of a soldier mounting the staircase at the front, the scene has the cumulative character of extended verbal description.

The narrative roundels are far more than a sequence of experiments in the use of

opposite: FIGURE 169.
Donatello, *St. Lawrence and St. Stephen.*
Pigmented and gilt stucco,
H. ca. 215 cm, W. ca. 180 cm
(H. 84⅝ in., W. 71 in.).
Old Sacristy, San Lorenzo,
Florence.

FIGURE 170.
Michelozzo, *St. Cosmas and St. Damian.*
Pigmented and gilt stucco,
H. ca. 215 cm, W. ca. 180 cm
(H. 84⅝ in., W. 71 in.).
Old Sacristy, San Lorenzo,
Florence.

FIGURE 171.
Donatello, Head of *St. Stephen*.
Old Sacristy, San Lorenzo,
Florence.

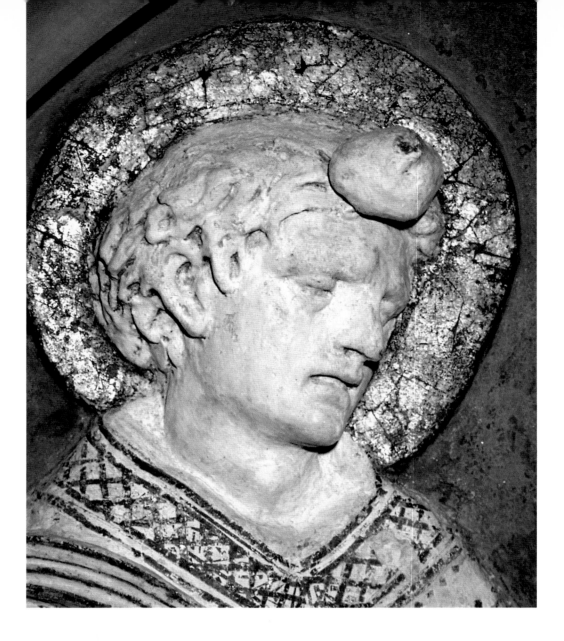

perspectival space. Their primacy lies in the area of narrative, and they constitute the first fully rational reinterpretation of a religious legend achieved in Florence since the Brancacci frescoes of Masaccio. As we follow the image of the Saint from the half-length figure protruding from the cauldron, through the experience of Patmos and the miracle at Ephesus, till the moment when, above the roof tops, he is reunited with Christ and the Apostles, the story of the protagonist is told with unique nobility and power.

Throughout the four roundels, the perspective schemes have it in common that we read them both as space and as geometry. The space content seems to have been determined throughout by the nature of the subjects depicted, not by optical considerations, and we would be more conscious of—or disturbed by—its diversity were there not a compensating factor in the four roundels of the Evangelists, where the projection is orthodox and uniform. The surface of the reliefs is flat. The problem of attachment was, therefore, less great than in the concave narrative scenes, and for that reason the substance of the stucco is marginally different. The most impressive is the seated figure of St. John. One of a sculptor's central problems is that of transferring to a durable medium an image that results from intuition and

Figs. 167, 16

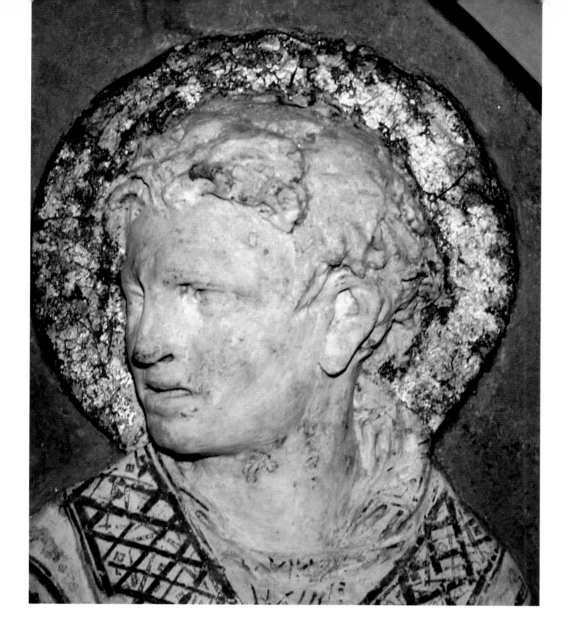

FIGURE 172.
Donatello, Head of *St. Lawrence*.
Old Sacristy, San Lorenzo,
Florence.

is first recorded as a model. We know nearly nothing about Donatello's modeled relief sculpture, but it is a large-scale model that confronts us here, and the profound emotion that we feel before it arises from the fact that it brings us into unimpeded contact with Donatello's mind and hand. The head apart, however, the relief is less spontaneous than it seems, and in the left arm resting on the Gospel and the right arm raised parallel to a book propped up on the left, the image is subordinated to the same constraints of style as the narrative reliefs.

The *Scenes from the Life of St. John the Evangelist* are conceived as events in time. They are the product of historical and not simply of dramatic imagination, and the same sense of historicity is evident through the four roundels of the Evangelists. It manifests itself in the first place in typology. The prime antecedent Early Renaissance representations of the four Evangelists occur in the quadrilobes beneath Ghiberti's first bronze door. The types used by Ghiberti are generic. St. Matthew and St. Mark are represented with beards, as is St. Luke, whose features differ from theirs only in that his head is shown in profile, not full face. Throughout the fourteenth century St. John was conceived as an elderly, meditative, bearded figure, and this convention is maintained on the bronze door. The heads in Donatello's

FIGURE 173.
Donatello, *Martyrs' Door*. Bronze,
H. 235 cm, W. 109 cm
(H. 92½ in., W. 43 in.).
Old Sacristy, San Lorenzo,
Florence.

roundels, however, are sharply differentiated. St. Matthew is a gaunt, strong-featured figure with a beard extending to his chest; St. Mark has close-cropped hair and a short beard; St. Luke is beardless and ascetic; and St. John is no longer the bland figure of Florentine tradition, but a visionary, with one hand extended on his desk and the other pressed against his head. To anyone who asked himself, as the patron of the chapel must have done, how, in historical terms, the Evangelists would have looked, there was only one valid point of reference, East Christian manuscript illumination, where the types of Saints Matthew and Mark are individualized as they were individualized by Donatello, and which record the tradition of a beardless St. Luke. Byzantine manuscripts were available in Florence—one such manuscript is still preserved in the Biblioteca Laurenziana—and there is a high degree of probability that, whether on his own initiative or at the direction of Cosimo de' Medici and his advisors, they were consulted by Donatello. That this was so is confirmed by the character of the roundels themselves.

The composition of each of the four Evangelists of Ghiberti on the first bronze door is vertical. St. Matthew sits frontally at a small Gothic desk, with his emblem, an angel, on his left and a lectern running the whole height of the relief field on the right. St. Mark is also posed frontally, with his desk, supported by classical colonettes and a lectern on his left, and his symbol, the lion, in the upper quadrilobe on the right. St. Luke sits in right profile on a folding chair, once more at a Gothic desk surmounted by a lectern, beyond which his symbol, the ox, looks up at him. In the *St. John* these elements are reversed, and the lectern and symbol are both shown on the left-hand side. The compositions of Donatello's roundels, on the other hand, are horizontal. As in the narrative scenes, the lower segment of each circle is neutralized, on this occasion by a classical molding common to all four roundels. St. Matthew's seat is aligned on the base with a vase or ewer in the space beneath it, and the desk, in the form of a classical altar, is set on the projection plane. The same scheme is preserved in the *St. Luke*, who faces to the right before an altar with four rectangular supports, the front face of which is set in the same way, while the scheme of the *St. John*, who faces to the left, is an inversion of that of the *St. Matthew*. There is a strong presumption that all four designs were influenced by the rectangular compositions common in Byzantine manuscripts, where similar attention is given to the siting of the seats, platforms, and desks and their position in the illuminated field. There are medieval precedents for one feature of the designs, that no lecterns are portrayed and that the volumes of Gospels are supported by the symbols of the Evangelists. The precedents are, however, so heterogeneous—they occur in ivories, in thirteenth- and fourteenth-century frescoes, and in the sculptures by Niccolò di Pietro Lamberti on the façade of St. Mark's in Venice—that we need not assume Donatello to have been familiar with specific earlier works.

The architectural and decorative motifs employed throughout the roundels are Roman, not Greek. In the *St. Matthew* they include the throne, with its lion armrest and its fluted back, the metal amphora placed beneath it, and the altar doing service as a desk, with swags of foliage and putti on the two faces that are visible. In the *St. Mark* they comprise the scroll work on the seat, the cinerary altar with its lower and upper pilasters and upper molding, and the relief on its face, with two playing

gs. 163, 164

Fig. 165

FIGURE 174.
Michelozzo, *Apostles' Door.* Bronze,
H. 235 cm, W. 109 cm
(H. 92½ in., W. 43 in.).
Old Sacristy, San Lorenzo,
Florence.

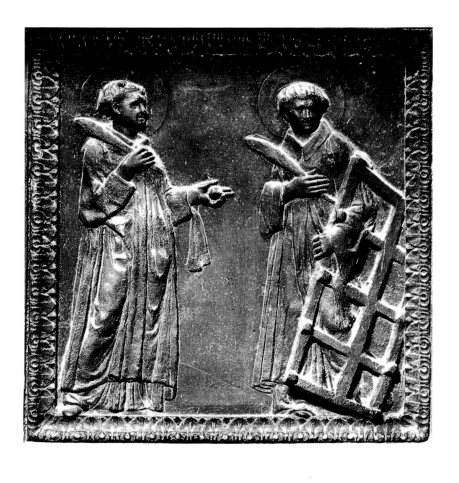
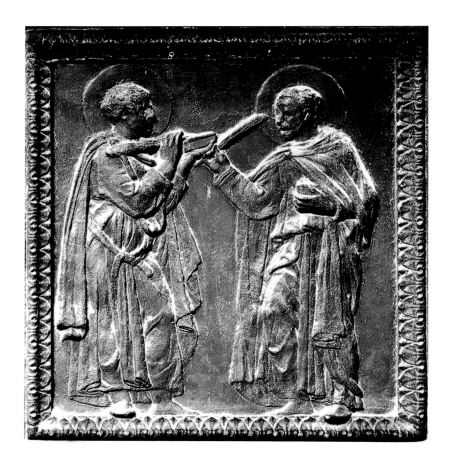
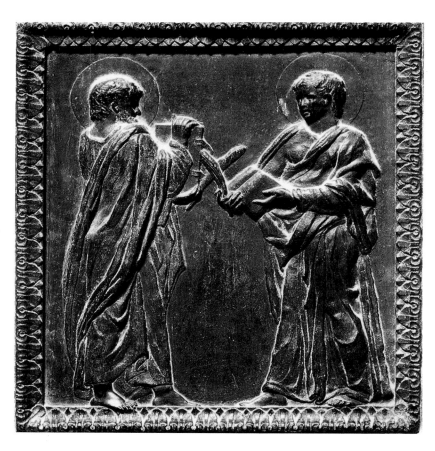
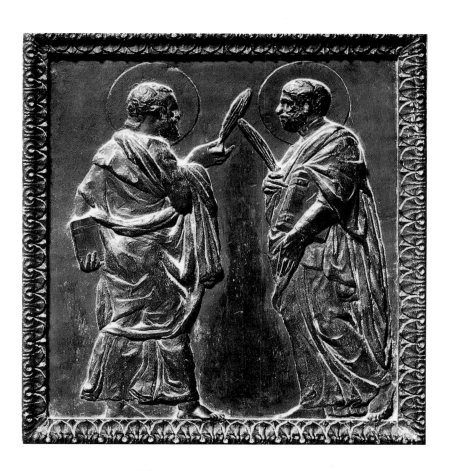

Erotes beneath a garland surmounted by a shell, and the stool on which the Saint rests his right foot. The back of the throne of St. Luke is a scrolled acroterion, set on a drum-shaped base for which the source has been sought in earthenware pyxides. A cinerary altar seems again to have served as a prototype for the desk of St. John, whose seat is once more classical, with an Ionic acroterion adapted to form an armrest. The total significance of these references must remain in doubt. They do not necessarily form an index to the corpus of archaeological images assembled in the mind of Donatello, may well represent a synthesis of motifs gained partly from antiquarian model books, translated into a consistent, homogeneous style that conveys, as Donatello must have intended it to do, the illusion of authenticity.

In Byzantine illumination the Evangelist is commonly shown in the interior of a room. No indication of setting is given in Donatello's roundels, and the effect of projection from a low viewing point, which conforms to that of the narrative scenes, and of a uniform blue ground invests each Evangelist with the character of a figure on the stage seen from the front row of the orchestra. In the *St. Matthew* the recession of the group is established by the altar, the symbolic angel flying forward, and the pages of the book. In the *St. Mark* it is conveyed through the abrupt perspective of the right side of the altar and the three-quarter posture of the Saint. In the *St. Luke* it is arrived at by a view of the underside of the table and of one of its rear supports, and in the *St. John* it results from the depiction of the altar and from the sharply foreshortened volume standing on it. In all four tondi there is a compelling sense of space.

The roundels completed, attention turned to the facing walls on each side of the altar. That their treatment represents the final phase in the decoration of the Chapel is indicated very clearly by the terms of Manetti's account: "The small doorways flanking the chapel of the sacristy were left to be finished later, since it had not yet been decided whether the doors were to be made of wood or of some other material. . . . There were then only the openings in the wall with arches above for stability. When it had been decided that the doors should be of bronze and adorned with figures, as they are today, the commission for them was given to Donatello, who had also to design the limestone porticos and the rest of the decoration for the doorways." Brunelleschi's single contribution was a molded arch in *pietra di macigno* at each side between the pilasters, the proportions of which correspond with the archways in the intervening chapel. The additions made to it by Donatello were the two door frames, the bronze doors with which they are filled, and two molded frames over the entablature. Incompatible both in height and width with Brunelleschi's archways, they contain two pairs of standing figures in pigmented stucco, surrounded by a wide strip of foliated stucco decoration painted in red, white, and gold. There was every reason why Brunelleschi should object to the interpolation of these elements, which are stylistically irreconcilable with the remainder of the sacristy. Though blame for the door frames is credited, in Manetti's account, to Donatello, they appear to have been designed by Michelozzo, not by Donatello. Michelozzo, moreover, for reasons that cannot, in the absence of documents, be accurately reconstructed, seems also to have played a major part in the execution of one pair of doors and one of the large figure reliefs.

Figs. 160–162

opposite, above: FIGURES 175, 176. Donatello, *Martyrs' Door*, upper reliefs.

opposite, below: FIGURES 177, 178. *Martyrs' Door*, central reliefs.

opposite: FIGURES 179, 180, 181, 182.
Donatello, *Martyrs' Door*, central reliefs.

Donatello's *Saints Stephen and Lawrence* over the left-hand door are miracles of sensibility. Since cleaning, they have acquired some of the most delicately modeled features in quattrocento sculpture. The *St. Stephen*, turned slightly toward center, holds in one hand a small palm leaf and in the other an open book. His dalmatic falls in strong vertical folds and gives way at the base to a rumpled alb. The *St. Lawrence* stands a little farther back, with a half grille resting against his thigh. His free side, from foot to shoulder, corresponds with the curved form of the niche, and he holds a closed book under his left arm. His eyes are turned toward St. Stephen, and his lips are parted in speech. The white vestments of both figures are decorated with great subtlety. The *Saints Cosmas and Damian* are treated very differently. Both figures stand on a single forward plane. They communicate by expository gestures, not by expression, and they wear conventional Roman dress resolved in academic folds. Their domed heads and close-cropped hair are based on Roman portrait busts. Nowhere do we find the subtle contact that is shown in the companion relief or the equilibrium established there between the figures and the frame. The analogies for their drapery and their heavy stance are with the work of Michelozzo. No full-length modeled figure by Michelozzo is known before the life-size terracotta *St. John the Baptist* made in the late 1440s for the Santissima Annunziata. But a gesso model for the frontal *Virtue* of the Aragazzi Monument at Montepulciano would have looked very like the Saints in the Old Sacristy, and the tight vertical folds of the interior of the cloak of the Annunziata *St. John* strongly recall those of the cloak worn by the figure of St. Cosmas. The same division of hands can be traced in the doors beneath.[17]

The two doors have it in common that each contains reliefs of paired full-length figures linked in conversation or in some other relationship. An attempt has been made to identify their source in the Byzantine door jambs of the Baptistry at Pisa, where paired figures are represented in action in a way that loosely recalls the paired figures in the twenty panels of the doors. But it is more likely that the source of the paired figures (like that of the Evangelist roundels above them) was a Byzantine manuscript. A number of manuscripts showing paired figures of the apostles in simulated conversation survive; one of them is in the Vatican Library (Gr. 1208). In another Vatican manuscript (Gr. 796) the apostles are shown hurrying forward, with their cloaks blowing behind them, in a manner that could well have suggested the vigorous action and animated drapery of Donatello's left-hand door.

The typological character of the two doors is uniform. Each of the panels shows two confronting Saints, and in the right-hand or Apostle's Door, the Saints can be readily identified. Reading across the right-hand door, we find Saints John the Baptist and John the Evangelist (top left), Saints Peter and Paul (top right), Saints Andrew and James the Great (second row left), Saints Philip and Bartholomew (second row right), Saints James the Less and (?) Thomas (third row left), Saints Simon and Thaddeus (third row right), Saints Mattias and Matthew (fourth row left), Saints Luke and Mark (fourth row right), Saints Augustine and Jerome (bottom row left), and Saints Gregory and Ambrose (bottom row right). Though there is some doubt as to the identity of certain of the younger apostles, the figures clearly

Figs. 169, 172

Fig. 170

Figs. 173,

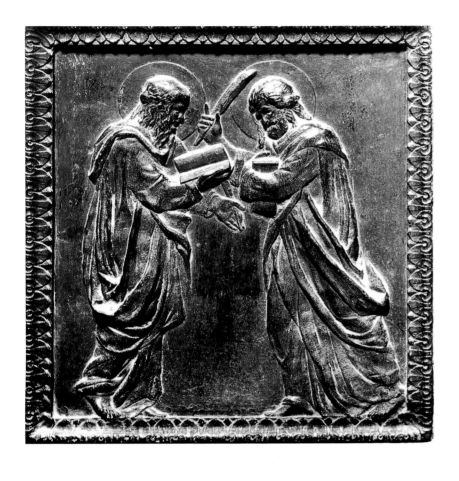

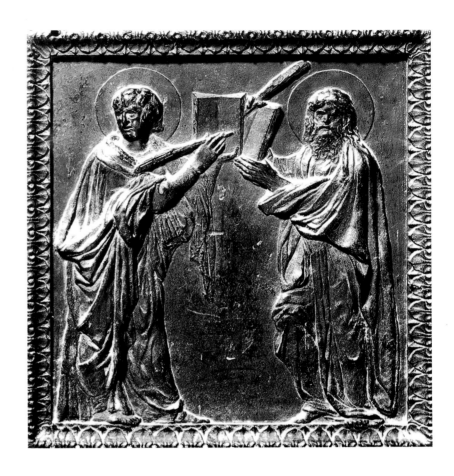

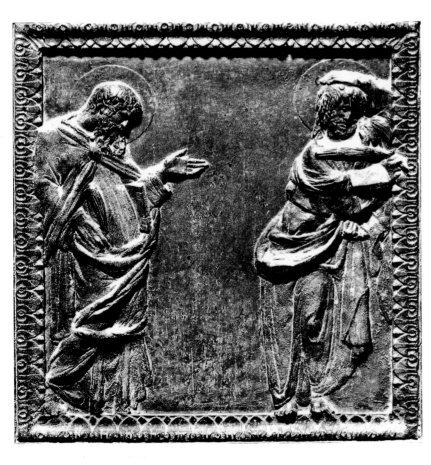

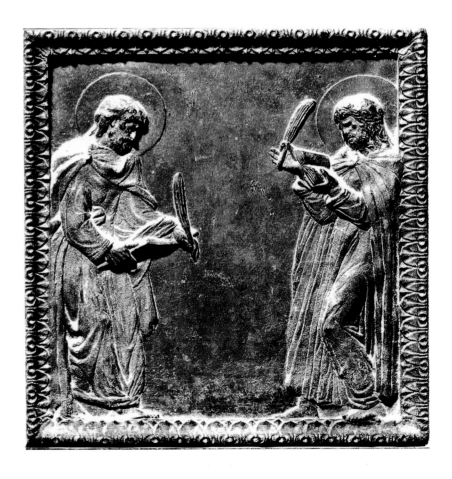

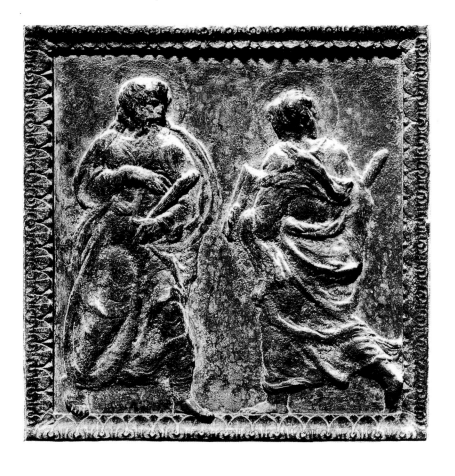

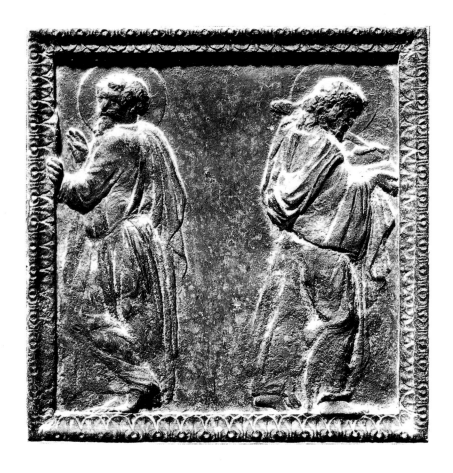

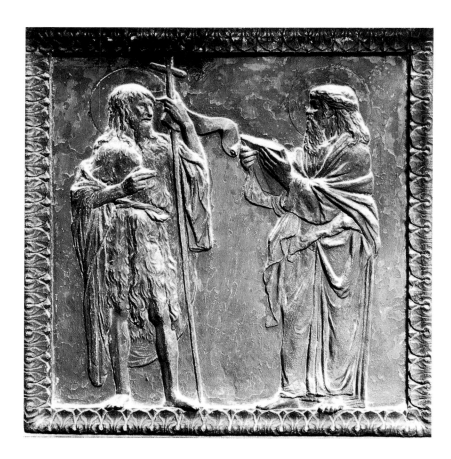

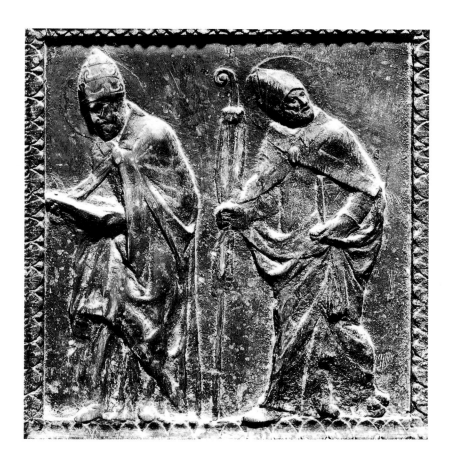

comprise the Apostles and Evangelists, with St. John the Baptist, and four Fathers of the Church.

The imagery of the left-hand door is more mysterious. At the top we have Saints Stephen and Lawrence (left) and Saints Cosmas and Damian (right), each of whom is accompanied by his appropriate symbols. In type the Cosmas and Damian are very different from the gesso figures of the same Saints over the right-hand door. The other pairs of Saints on the left door have been described as "identified only by their books and palm fronds," but the plain fact is that, since they have no symbols, they are unidentified. Each of them holds a book and what is commonly described as a palm frond (hence the description of the figures as Martyrs). But in two of the panels on the right door, the palms are used as pens, and since on the left door they are invariably associated with a book, it is likely that pens, not palms, are represented. The relation of each pair of figures is that of disputants or contestants, and the subject of the door (as was appropriate in a work commissioned at the time of the Church Council) is theological dispute. The difference between the subject matter of the two doors seems to have been apparent to early commentators. "If you do apostles," writes Filarete of the Apostle, or right-hand, door, "do not make them look like fencers as Donatello did in San Lorenzo in Florence." The analogy to fencing occurs also in Alberti, but in terms that apply to the left door, not the right. "It befits a runner," says Alberti, "to flail his arms as much as his legs, but a discoursing philosopher should show restraint rather than behave like a fencer." And it may well be discoursing philosophers or theologians who are represented on the left-hand door. With one exception, some connection is postulated between each pair of figures. In the second row on the left, a beardless theologian draws the attention of an older theologian to the open pages of his book. In the corresponding relief on the right, two bearded figures advance toward each other as though to speak, one holding a closed book behind his back and the other a closed book under his arm. In the third row on the left, two bearded figures, one in profile reading an open book, the other in three-quarter face with finger pointing heavenward, are shown in close proximity. In the corresponding relief on the right, a beardless figure looking back over his shoulder holds his open book erect, while opposite a bearded man in full face raises his open book to shoulder height. In the relief on the left of the fourth row, a figure on the right is represented, with hand resting on his head, reading a book balanced on his right elbow as he leans against a wall on the right side of the relief. Separated from him by a neutral area of bronze is another bearded figure in right profile, whose back is severed by the left edge of the relief. The corresponding relief on the right shows a similar scheme, with two figures at the sides turned inward toward a central void. The most surprising of the reliefs are those in the bottom row, where all four figures are highly animated, two on the left moving forward diagonally, one with head averted, and two on the right set back to back, one resting his palm against the left edge of the relief and the other reading as he leaves the scene. The formal logic in the ten reliefs is the only aspect of them that is clear; they read as a series of increasingly free and increasingly ambitious variations on a single theme.

Some light is thrown on the movement of Donatello's mind in these reliefs by an

gs. 175, 176

Fig. 177

Fig. 178

Fig. 179

Fig. 180

Fig. 181

Fig. 182

gs. 183, 184

opposite, above: FIGURES 183, 184. Donatello, *Martyrs' Door*, bottom reliefs.

opposite, below left: FIGURE 185. Michelozzo, *St. John the Baptist and St. John the Evangelist* from *Apostles' Door.*

opposite, below right: FIGURE 186. Michelozzo, *Two Episcopal Saints* from *Apostles' Door.*

Fig. 187

Figs. 185, 1

FIGURE 187.
Donatello, *Lamentation over the Dead Christ*. Bronze, H. 32.6 cm, W. 40 cm (H. 13 in., W. 15¾ in.). Victoria and Albert Museum, London.

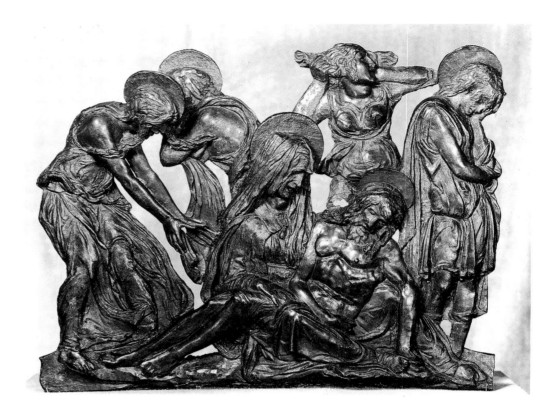

independent bronze relief of the same date in the Victoria and Albert Museum in London.[18] This relief, a *Lamentation over the Dead Christ*, is roughly executed and is unfinished, and the background between its figures has been excised. Because it is a moving and rough work, it has been repeatedly described as a late work of Donatello, but neither in design nor execution does it resemble the late reliefs on the pulpits in San Lorenzo. In the foreground is a triangle formed by the seated Virgin and the body of Christ. The balance between the extended legs of the two figures has a parallel in the reliefs of the left-hand door, and the type of Christ is indeed closely similar to the right-hand figure in the central relief in the right wing. The Magdalen on the extreme left extends her arms on a diagonal, which terminates in the center of the base, and another female figure at the back raises her arms so that the left forearm is aligned on the base. On the right, the St. John, in a pose related to that of the St. John on the St. Peter's *Entombment*, but with his face fully revealed, closes the marvelously compact design. Not only is this relief in expressive terms a masterpiece, but it offers a clue to the type of aesthetic calculation that lies behind the reliefs of the bronze door.

In the *Apostles' Door*, an attempt is made to establish the same psychological connection between the figures that Donatello had accomplished on the door opposite, but the figures themselves are stolid and ponderous. Though the feet sometimes protrude beyond the base of the relief and the heels are sometimes raised, one and all are tethered firmly to their base. The Saint Paul is related to a small bronze *Baptist* in the Bargello, commonly ascribed to Michelozzo, and the lower

figures are also Michelozzan. For two panels in the center, in which an ineffective attempt is made at movement, models or drawings by Donatello may have been employed. The build of the participants is stockier than with Donatello (witness the hunched figure of St. Philip addressing St. Bartholomew), the figures are set not in implied space but on a single plane, and the drapery forms are, in an academic sense, more classical. Donatello's chasing of the *Martyrs' Door* conveys a sense of speed and lightness, whereas the chasing of the *Apostles' Door* is clumsier and more pedestrian. Some of these differences have been noted by earlier students, one of whom drew from them the mistaken inference that the *Apostles' Door* was the earlier of the two. Michelozzo enjoyed a considerable reputation as a bronze caster (on the strength of his door in the Old Sacristy, he was first in line to carry out the bronze door of the north sacristy of the Cathedral when hope was finally abandoned that Donatello would undertake it), but we know very little of his small-scale work in bronze, and the *Apostles' Door* is on that account a document of special interest. In the 1440s he was certainly a more productive sculptor than is suggested by critics who have written on his earlier works, and he seems indeed to have been responsible for another large commission for a work in bronze sometimes given to Donatello, the tomb slab of Martin V in St. John Lateran, in Rome, which makes use of motifs from the Pecci tomb slab in Siena.[19] There is a record of its transport from Florence to Rome two years after Donatello left for Padua, in 1445.

It has been recognized by every writer on Donatello that his decision to move to Padua, where he was actively employed from January 1444, marks a decisive break in his career. The move was deemed to be abrupt when a document recording the rental of studio premises in Florence was misascribed to 1443 and not to its correct year of 1454, and the pattern of work revealed by cleaning in the Old Sacristy is most readily consistent with the view that his decision really was precipitate. His work in the Old Sacristy was broken off when only one pair of bronze doors and one wall face beside the central chapel had been finished. He had, according to Manetti, incurred the hostility of Brunelleschi, whose word was law until his death in 1446. The single door he finished was criticized for its apparent eccentricity. In a world dominated by the pictographs of Fra Filippo Lippi, the *Annunciation* in Santa Croce may have seemed an improvidently secular portrayal of the scene. We know too little about artistic psychology in the middle of the fifteenth century to claim that Donatello's abandonment of work in the Old Sacristy was prompted by a sense of alienation from the colleagues and clients with whom he worked. But it is clear that his ambitions as an artist were broader and more aspiring than they had previously been. Orthodox Florentine aesthetic thinking was no longer a spur but a constraint, and when, therefore, an offer came from Padua, he accepted it regardless of its long-term consequences.

IX

Padua

PADUA, AT THE TIME Donatello arrived there, was a Venetian city. Its inhabitants spoke a different dialect, almost a different language, from that of Florence. It contained one major Tuscan monument, Giotto's frescoes in the Arena Chapel, and in the Oratorio di San Giorgio near the Santo was a fresco cycle by Altichiero, which was still, in 1444, a source of pride. Fra Filippo Lippi had worked in Padua briefly in the middle of the 1430s, leaving behind him a painted tabernacle in the Santo and a Coronation of the Virgin in the Palazzo del Podestà, and in the early 1440s Uccello executed a celebrated grisaille fresco cycle of Giants for the Casa Vitaliani. But the painters most highly prized there were the Venetian Antonio Vivarini and the perspectivist Jacopo Bellini. The principal indigenous artist was Squarcione, a didactic painter whose deference to antiquity was manifest in a collection of casts on which his pupils were trained. A half-length Madonna by Squarcione in Berlin is based on a lost Madonna relief by Donatello, and Donatello's most gifted Paduan assistant, Niccolò Pizzolo, became in due course the collaborator of Squarcione's most gifted pupil, Andrea Mantegna.

There was no lack of humanist patronage. The palace of the Bishop, the Venetian Pietro Donato, was renowned for its splendor and the quality of its contents, and collections of medals, inscriptions, and antiquities existed in the houses of Francesco Contarini and Giovanni Marcanova. A gust of innovation blew from the Alberti-dominated climate of Ferrara, where a well-known Paduan humanist, the doctor Michele Savonarola, was in constant contact with the Este court. The influence of Alberti, and especially of the *De Re Aedificatoria*, on which he was engaged from 1444 till 1452, is among the bonds that link the young Mantegna to the sixty-year-old Donatello.

The powerful Florentine colony in Padua was headed by Palla Strozzi, a remote kinsman of Donatello (his mother was a member of a superior branch of the Bardi family). Donatello must often have encountered Strozzi before his banishment from

Florence in 1434, and in Padua he lived for a time in the Casa del Pesce, not far from Strozzi's house in Prato della Valle. In due course Strozzi's son Onofrio became the intermediary for payments for Donatello's principal Paduan commission, the statue of Gattamelata. The university of Padua was larger and more broadly based than that of Florence—till 1444 it boasted the presence, as Rettore degli Artisti, of the great Greek scholar Argyropoulos—and the most powerful religious institution was the Franciscan convent of Sant'Antonio, by which Donatello was employed throughout his years in Padua. The convent of the Santo was very large. Seventy resident friars were established there in 1437, and eighty in 1446, when Michele Savonarola, in his *Libellus de Magnificis Ornamentis regie civitatis Padue*, describes it as an academy of students. At the time of Donatello's arrival, the Lector Philosophiae was Francesco della Rovere, the future Pope Sixtus IV, and the professor of pontifical law was an Aretine, Francesco Roselli.

Nowhere can the idiosyncracy of Padua have been more bewildering than in the intangible area of devotional climate. No cult in Florence was as powerful as that of St. Anthony in Padua, which ranked in popularity second only to that of St. Francis at Assisi. Its appeal rested on a basis of practical expediency. Not only was the Saint a patron of the city, which he had freed from the tyranny of Ezzelino, but his shrine, a marble sarcophagus supported on four columns in the left transept of the church that bore his name, was a place in which miracles might occur at any time. No fewer than six took place in 1433–34. A high proportion were naturally concerned with healing, but those listed in the *Liber Miracolorum* touched many other aspects of daily life. Working simultaneously on the high altar of the church and on the statue of Gattamelata, Donatello was serving two very different constituencies, one based on reason and the other on irrationality.

Donatello seems to have left Florence late in 1443,[1] and at the end of January 1444 was already engaged on his first Paduan commission, a bronze *Crucifix* for the Santo. In the summer of 1444 he was supplied with twenty-one lire worth of white wax for modeling the Christ.[2] Work on the *Crucifix* proceeded slowly. A year later Donatello was in debt to the Santo for the sums he had received in connection with it, and only in 1449 was it finished. A copper *diadema* was delivered by the bronze caster Andrea del Caldiere at the end of January to be gilded, and the *Crucifix* was installed, on a blue-and-gold wooden cross painted by Niccolò Pizzolo, in the middle of the church, where it remained till it was moved in 1487 to a position over the entrance to the choir. At no time in the fifteenth century was it associated, as it is now, with the sculptures on the high altar.

Donatello's *Crucifix*[3] is an unprecedented masterpiece. Life-size wooden Crucifixes were a comparatively common feature in churches throughout Tuscany. From the personalized, emotive Gothic Crucifixes of Giovanni Pisano, they subside during the fourteenth century to a level of orthodoxy, in which each figure may be redolent of the convictions of its sculptor, but the convictions are themselves conventional. One of the most individual of them was carved by Orcagna for Or San Michele. The first substantive rethinking of the theme occurred in the Crucifix figures executed by Donatello for Santa Croce and by Brunelleschi for Santa Maria Novella. Brunelleschi's shows a linear, perfectly proportioned body, where

gs. 188, 189

overleaf, left: FIGURE 188.
Donatello, *Crucifix*. Bronze,
H. 180 cm, W. 166 cm
(H. 71 in., W. 65³/₈ in.).
Basilica del Santo, Padua.

overleaf, right: FIGURE 189.
Donatello, *Head of Christ*
from *Crucifix*.

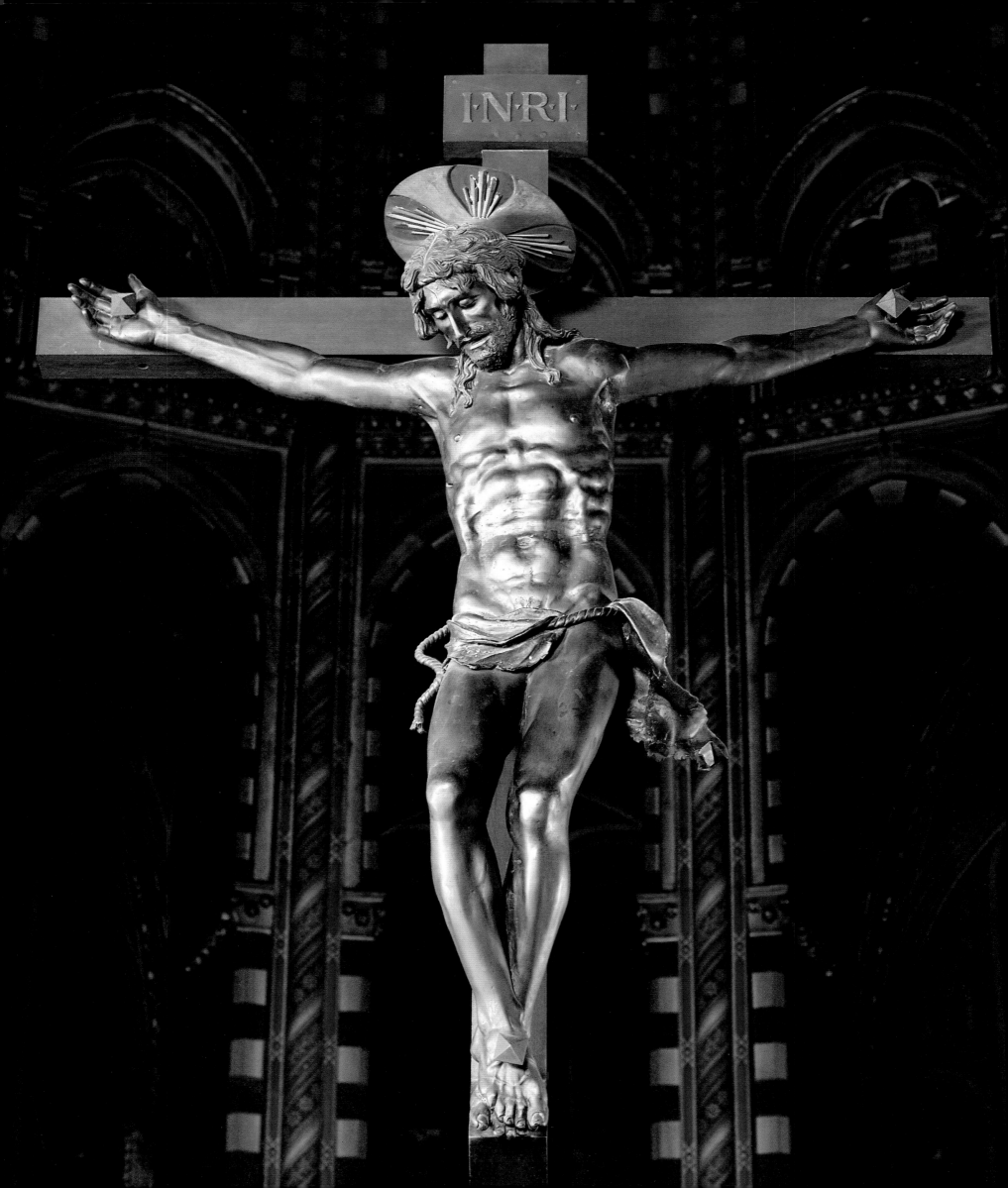

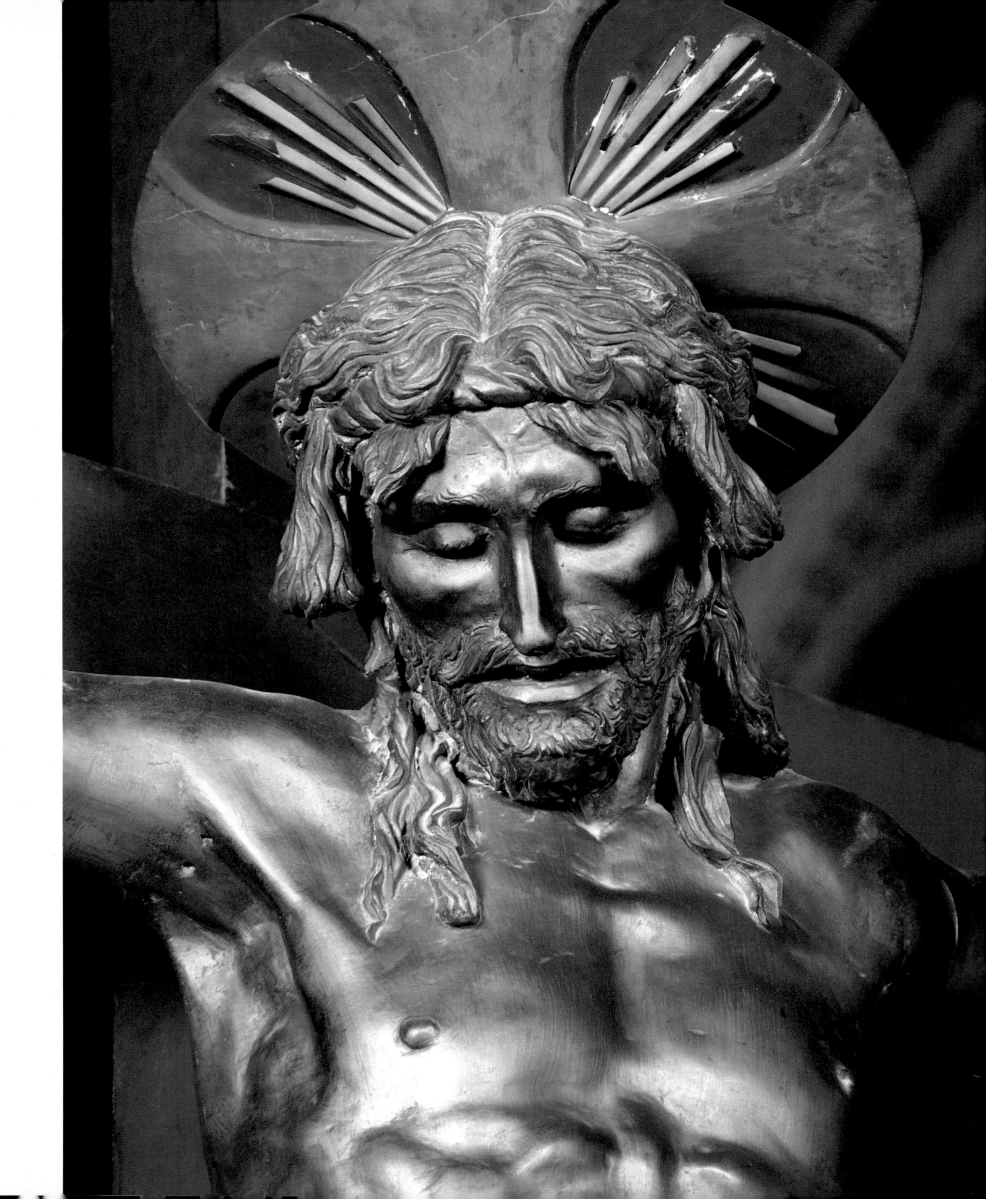

Donatello's Christ is stockier and more muscular. Particularly striking is the contrast between their torsos: by Brunelleschi the torso is represented undistorted, as that of a standing, not a hanging, figure, whereas Donatello portrays the distended musculature of the body and its weight. Neither figure was copied by other sculptors, and in general the notable wooden Crucifixes produced in the second and third quarters of the quattrocento reflect the individual concerns of the artists by whom they were planned, of Michelozzo in San Niccolò oltr'Arno, of Luca della Robbia in Santa Maria in Campo, and of Desiderio da Settignano at Bosco ai Frati. If, however, we compare the Padua *Crucifix* with the wooden *Crucifix* by Donatello in Santa Croce, though its style is different, its imaginative character proves to be very similar.

Donatello's is the first full-scale bronze Crucifix. It is lifesize—it measures 180 centimeters (71 in.) in height and 166 centimeters (65 in.) across—and though it is now shown over the high altar in a position in which it cannot be easily examined, it is a virtuoso cast of incomparable skill, whose chasing must be, in large part, autograph. The body is the first anatomically precise rendering in these dimensions of the adult human form in the Renaissance. As description, it is bold, truthful, and

below and opposite: FIGURES 190, 191.
Donatello, *Equestrian Statue of Gattamelata.* Bronze, on marble base, H. of statue ca. 340 cm., L. 390 cm (H. 134 in., L. 152½ in.).
Piazza del Santo, Padua.

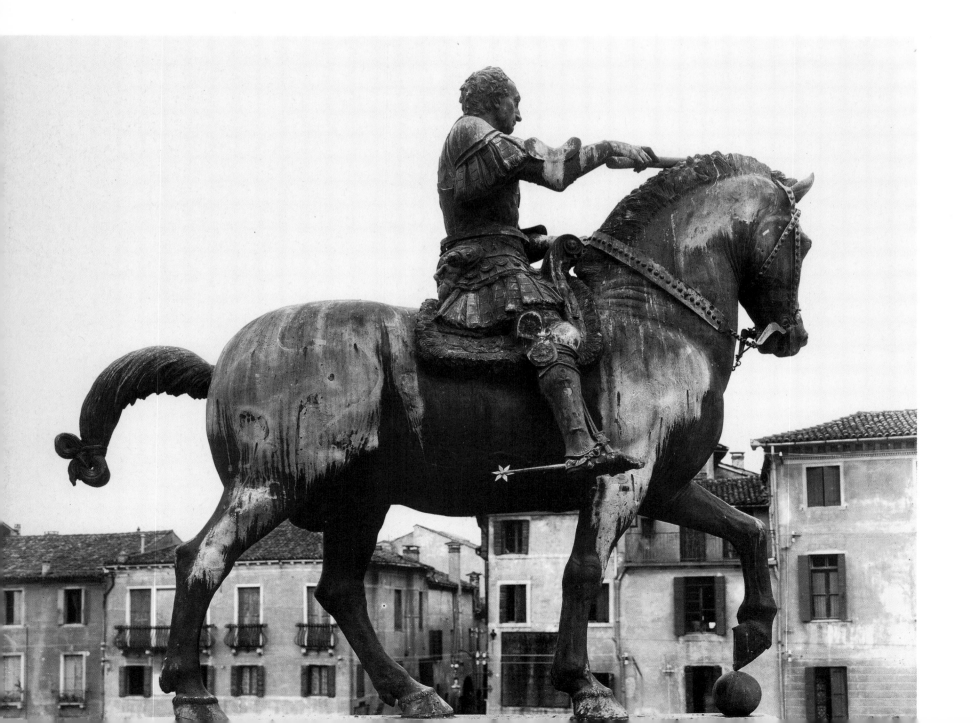

exact. The care with which it was worked out is evident in the hands, one, the right, turned upward with thumb forced back by a nail. The contrasting tensions extend to the two arms, which were cast separately, to the bent knees and to the feet, nailed brutally to the surface of the Cross. But as in Donatello's later statues for the Campanile, aggressive realism is put to spiritual use. The veins protruding on the forehead, the lightly indicated eyebrows, the high cheekbones, the closed, deep-set eyes, the sweat-coagulated hair, parted in the center and falling on the shoulders, are treated with absolute consistency. From an interpretative standpoint this inspired, emotive sculpture speaks a language which anticipates that of Donatello's last and greatest works.

Figs. 190, 191 What Padua offered, and what may originally have attracted Donatello there, was the occasion of creating one great masterpiece, a work posing technical and interpretative problems that had never, since antiquity, been confronted by any sculptor. Standing as it still does outside the Santo, the statue of Erasmo da Narni—known as Gattamelata—represented, for contemporaries as well as for posterity, the exaltation of the individual. The idea of a contemporary bronze equestrian statue was not in itself new. At the instigation of Leonello d'Este, an equestrian monument was

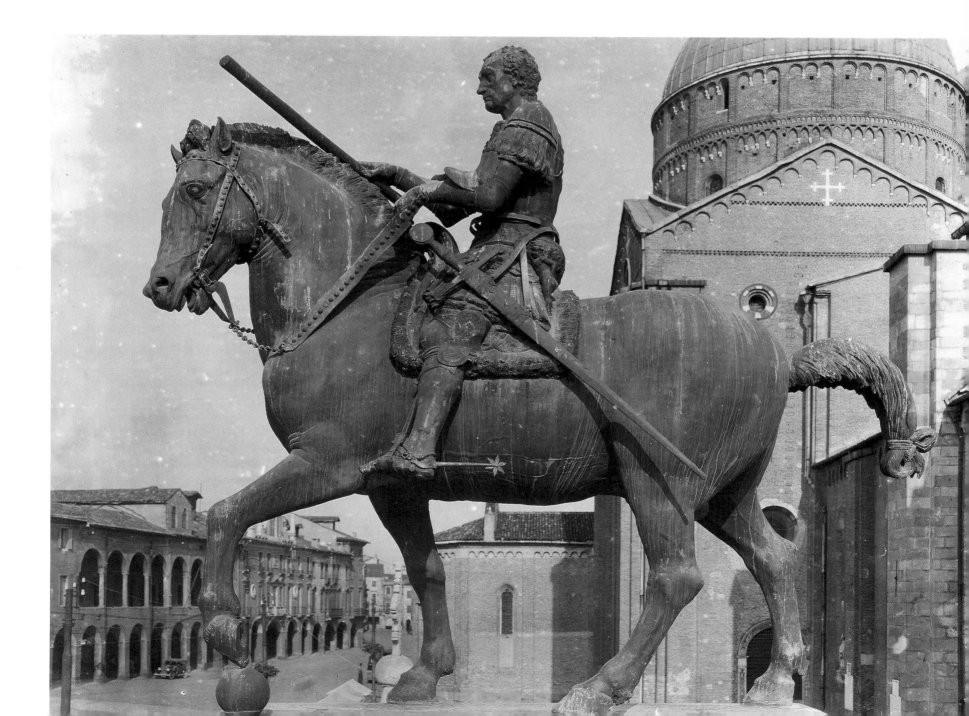

erected at Ferrara to his father, Niccolò III, but it derived its authority from the status of Niccolò as a beneficent hereditary ruler, not from the respect that he had won through a lifetime of achievement. Gattamelata, on the other hand, was the protector of the richest state in Italy. Michele Savonarola, in the *Libellus de Magnificis Ornamenti regie civitatis Padue*, writes of "that mighty warrior and commander of the successful army of the illustrious republic of Venice, Gattamelata, who was held in such high repute in battle in our times, he emerged always as the fortunate victor. He is shown life size with great decorum in bronze and on a bronze horse, seated just like a triumphant Caesar, and with scarcely less magnificence."[4]

Writing on the monument is bedevilled by two questions, by whom was the statue commissioned, and what function was it intended to fulfill. When Erasmo da Narni died in 1443, he was accorded a state funeral in Venice, which was attended by the Doge, Francesco Foscari, and it was widely believed in the fifteenth and sixteenth centuries that the statue at Padua was an official Venetian commission. Cyriacus of Ancona, writing probably in 1448–49, states that the Venetian Senate "decreed that this equestrian monument be made as a monument to his loyalty and virtue in the year of Our Lord 1447." Five years later, in 1452, Gianantonio Porcello records that he had composed an epitaph for Gattamelata, at the request of Gattamelata's widow and son, which read:

> Munere me insigni et stattua decoravir equestri
> Ordo Senatorum et mea pura fides.[5]

In a poem of about 1455, Rome reproaches the Venetians for having honored Gattamelata as no Roman hero had been honored.[6] The decisive witness is Sanudo, who in his *Vite de' Duchi di Venezia*, after describing Gattamelata's expensive funeral in Venice, declares that the Signoria "in recognition of his faithful service, caused an equestrian statue to be made of him by the Florentine Donatello." At a time when the monument was still unfinished, it was supposed that Donatello was in Venetian employment, and when Alfonso I of Naples wished to secure the reversion of his services, his letter was addressed not to Gattamelata's executors, but to the Doge of Venice.[7] Vasari, in the first edition of the *Vite*, records that "the Signoria of Venice, having heard of his [Donatello's] fame, sent for him in order to have him do the memorial to Gattamelata in Padua."[8] The recorded payments for work on the statue[9] are confined to the year 1447; they run from May to an undetermined point later in the same year, when they totalled eleven hundred forty lire. They were made through a Paduan banker, Giovanni Orsato, on instructions from Onofrio, the son of Palla Strozzi, who seems throughout to have acted on Donatello's behalf. The sums were paid by Gattamelata's executors. When the statue was finished, the parties to the arbitration in the summer of 1453 were Donatello, on the one hand, and two representatives of Gattamelata's executors, his secretary Michele da Foce and Valerio da Narni, on the other. These documents show that expenditure in connection with the monument was controlled by the executors, but not that the executors were wholly responsible for its cost. Possibly after Gattamelata's death, a sum was paid over by the Venetian Signoria to Gattamelata's family covering the cost, or part of the cost, of the monument.

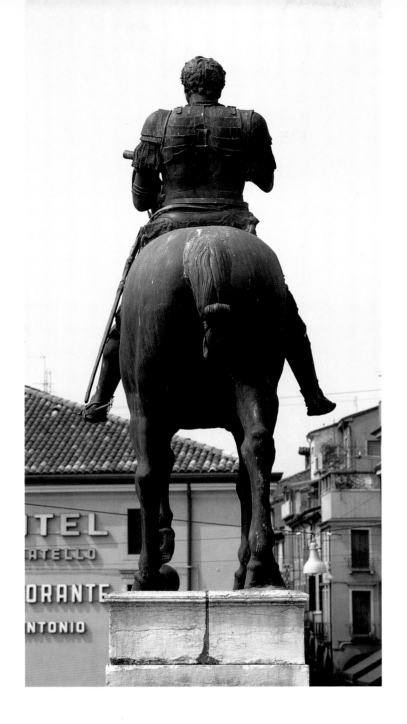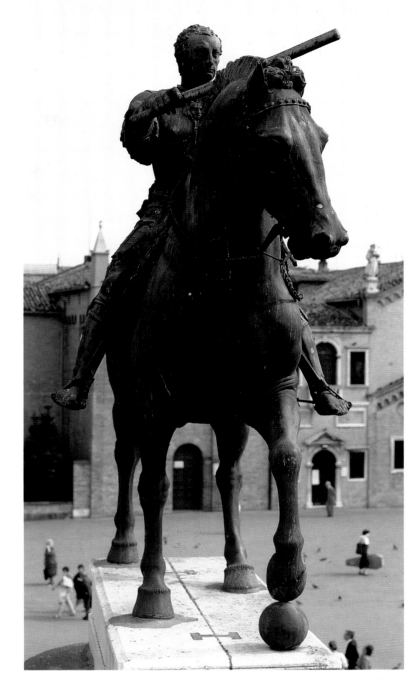

FIGURES 193, 194.
Donatello, End views of
Gattamelata.

The function of the statue does not admit of serious doubt. Gattamelata was survived by a son, Giovanni Antonio (who was under age at the time of his father's death), and by his widow, Giacoma della Lionessa. In a will signed by Gattamelata two years before his death, his widow, his secretary Michele da Foce, and a kinsman, Gentile della Lionessa, were named as executors. They were instructed to provide for an appropriate stone tomb in the Santo (whose cost, including funeral expenses, was not to exceed five to seven hundred ducats) and were empowered also at their discretion to build a chapel in the Santo dedicated to St. Francis. Gattamelata's son died in 1455, and a year later his widow, in accordance with the terms of her husband's will, began work on a funerary chapel in the Santo dedicated to Saints Francis and Bernardino, with tombs for her husband and her son. On this tomb was an inscription by Porcello, which incorporates, in a slightly different form, the epitaph intended for the equestrian monument. The equestrian monument was on consecrated ground in the *sagrato* of the Santo, and on three occasions it

is referred to as a tomb. In 1447 a mason, Antonio di Giovanni, received a partial payment from Donatello for work "in sul pilastro della sepultura di Gattamelata"; another stonemason was paid for sixteen days' work "in sul pilastro della sepultura di Gattamelata"; a further payment was made for twenty days' work "in sul pilastro della sepultura di Gattamelata." In the final act of arbitration, however, in which Donatello was awarded a sum of one thousand six hundred fifty ducats, the statue is referred to as a monument, not as a tomb.[10] Read in sequence, therefore, all that the payments demonstrate is that the stonemasons working on the plinth in 1447 believed it to be a tomb and not a monument.

Whether a tomb or cenotaph, its purpose is honorific. It has been said that "the new elements are the dedication of the statue to a commoner, and the location of what is largely a pagan work within a Christian context," but neither of these considerations is likely to have affected the form of the monument or to have been present in the sculptor's mind. In the statue, Donatello's concern was with actuality, that is, with producing an equestrian monument more lifelike and more powerful than the equestrian statues he knew. Two classical equestrian figures were readily accessible, the *Marcus Aurelius*, then standing in Rome outside the Lateran basilica, and the *Regisole* at Pavia. Donatello must, during his visits to Rome, have studied the *Marcus Aurelius* with close attention, both as a monument and as a model of bronze casting. We do not know if he visited Pavia, though he seems to have moved freely from Padua to other Northern Italian centers, and may well have seen the *Regisole* in the original. Closer at hand were the bronze horses on St. Mark's.

Fig. 192

In the modeling of the horse, classical precedents were of limited value. The horse of the *Marcus Aurelius* was, in breed and build, slighter than the horses used in battle in the fifteenth century, and the processional bronze horses in Venice were slighter still. The movement potential of these horses would, in a realistic contemporary monument, be unattainable. The prime factor, therefore, was study of the living horse. Nothing is known of the form of Baroncelli's horse in the Este monument at Ferrara, save that its base was designed by Alberti and that it gave rise to a treatise, *De Equo Animante*, in which Alberti "began to reflect more carefully not on the beauty and shape, but upon the nature and behavior of horses."[11] The erection of the Este monument was preceded by a competition, in which Alberti was the arbiter. The eventual decision, according to some sources, was to allot the horse and riding figure to two separate sculptors. Donatello must have been cognizant of Alberti's thinking at this time, but his aim was more ambitious, to create an equestrian monument in which the horse, rider, and plinth were the product of a single mind and formed a unitary work of art.

The representation of horses was a North Italian, not a Tuscan dilemma. On the basis of surviving evidence, the artist who attacked it most assiduously was Pisanello, whose careful drawings of the slit-nosed horses from the Palaeologus stable at Ferrara made possible the diminutive but physically convincing equestrian figures on the reverses of the medals bearing the likenesses of Gianfrancesco Gonzaga, Marquess of Mantua, Filippo Visconti, Duke of Milan (ca. 1441), Sigismondo Malatesta, Lord of Rimini (1445), and Lodovico III Gonzaga (ca. 1447). Donatello's horse must have been preceded by countless life drawings or models in wax or clay,

opposite: FIGURE 195.
Donatello, Head of *Gattamelata*.

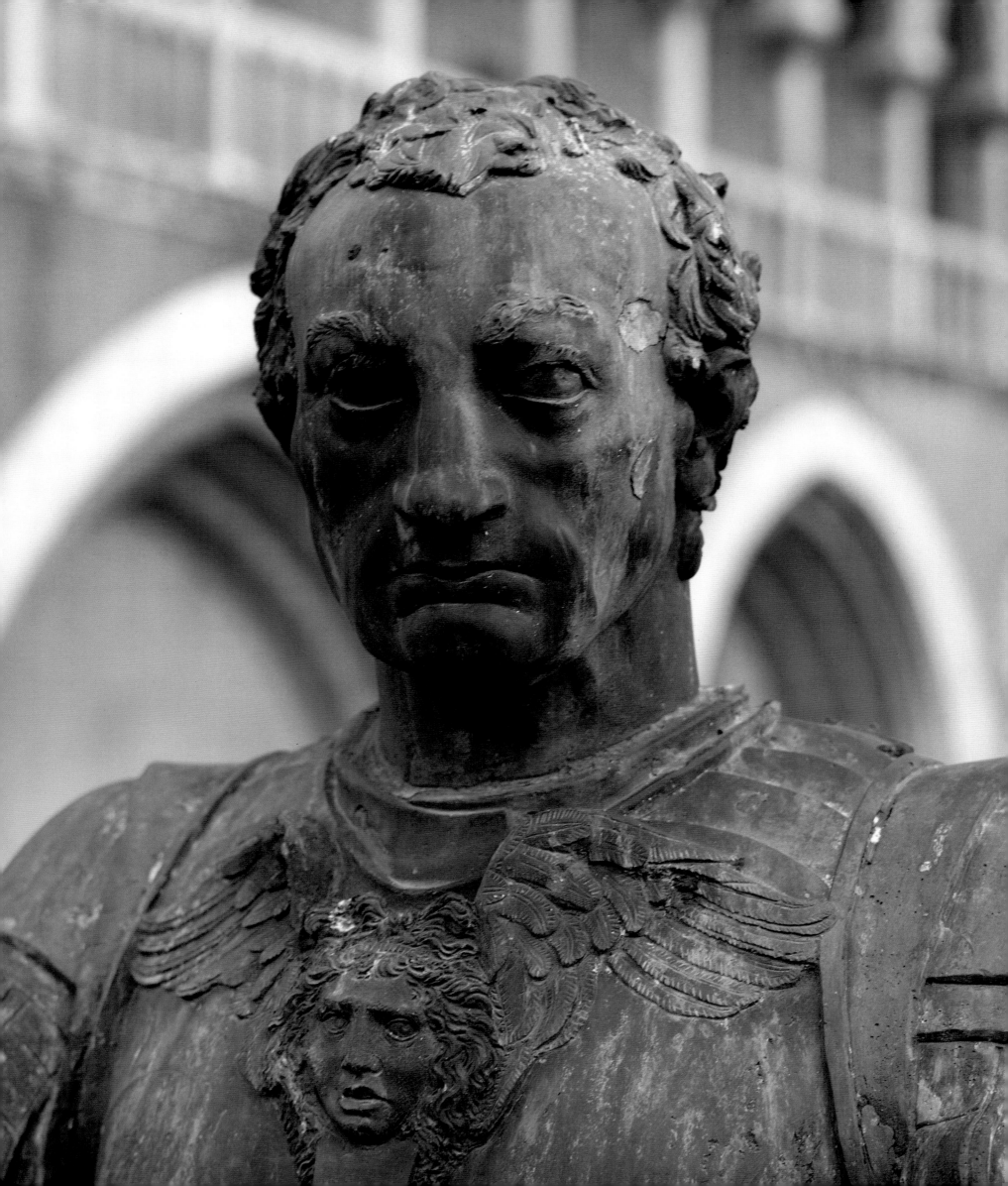

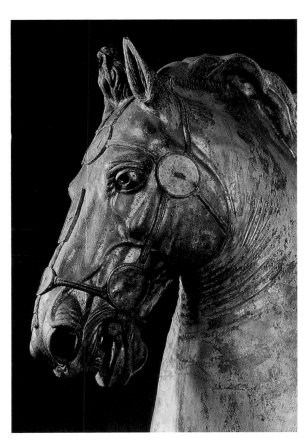

FIGURE 196.
Roman (CA. A.D. 176),
Horse of *Marcus Aurelius*.

Fig. 197

which were then synthesized in the work we know. Looking at the horse's head, with it tremulous muzzle, its inlaid eyes, and powerful neck, we can only speculate as to the analytical and imaginative act through which it was produced. Our knowledge of the dressing of the manes and tails of horses in Italy in the fifteenth century is incomplete, and it is difficult on that account to gauge how far what Donatello represented was tempered by the horses he had seen. It has been claimed that the mane of the Gattamelata horse is imitated from antique bronze statues, and the flamboyant fashion in which its tail is tied certainly recalls that of one of the bronze horses on St. Mark's. But for all we know, experiments in classical horse-dressing in the fifteenth century may have originated with living horses, not with statues.

Fig. 196

Filarete, in his *Treatise on Architecture*,[12] observes, in a characteristically dismissive fashion, that the statue of Gattamelata is "so inappropriate as to have received little praise. For if you have to portray a man of our own time, do not show him in ancient costume, but in clothes he would actually be wearing." The armor worn by Gattamelata belongs, however, to the middle of the fifteenth century, but is enriched with detail that would be inappropriate in any other context than a commemorative monument. In the center of the cuirass is a large Medusa head, whose hair is extended at the sides, and whose feathered wings reach up to the neck of the cuirass and to the shoulder joints. Its open lips are legible from the base of the podium. Around the waist beneath the sword belt is a row of music-making putti, and below these is a fringe of metal plates decorated with male heads. Similar heads appear on the knee pieces (*ginocchietti*). The high saddle is likewise contemporary; it rises in front to a scroll level with the rider's waist and is supported at each side by a putto in very deep relief with one arm above its head. Two more mourning children appear on the back of the saddle, and the area between them is filled by two riding figures framed in scroll work. The edges of the saddle cloth are fringed and are decorated at either side with flying putti supporting the same heraldic ropes that appear on one of the marble reliefs on the plinth. These details do not constitute a coherent program, but have, save for the dancing putti under the cuirass, a generic funerary or valedictory character.

Looking together at the horse and rider, we are at once conscious of a fundamental difference between the *Gattamelata* and the *Marcus Aurelius*. The Emperor sits passively on the horse's back with feet hanging at either side. In the fifteenth century, however, the act of riding presupposed the use of stirrups, and in Donatello's monument the sense of dominance communicated by the statue grows from the rider's masterful control over his horse. Though the movement potential of the classical horse is greater than that at Padua, the capacity for action embodied in Donatello's riding figure is more powerful than that of any figure in antiquity. It has been asserted recently that the head of Gattamelata is not a portrait and "as a likeness is no more authentic than the head of St. Francis in the Santo."[13] The features of military leaders in the fifteenth century were, however, often recorded in profile or three-quarter face drawings (of which we would know almost nothing but for the medals depending from them), and there is no reason to doubt that some such representation was available to Donatello when he modeled the firm contours of

Fig. 195

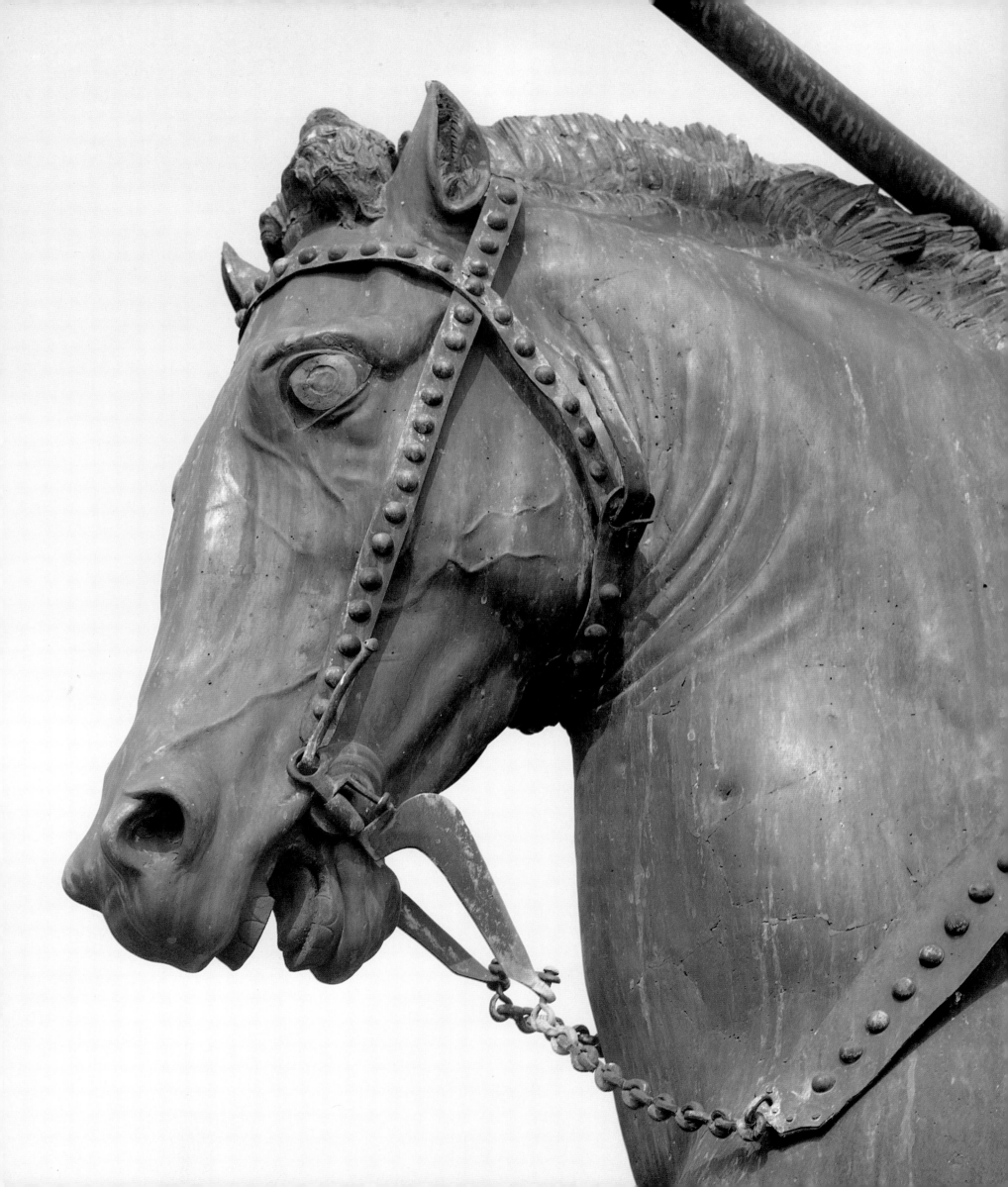

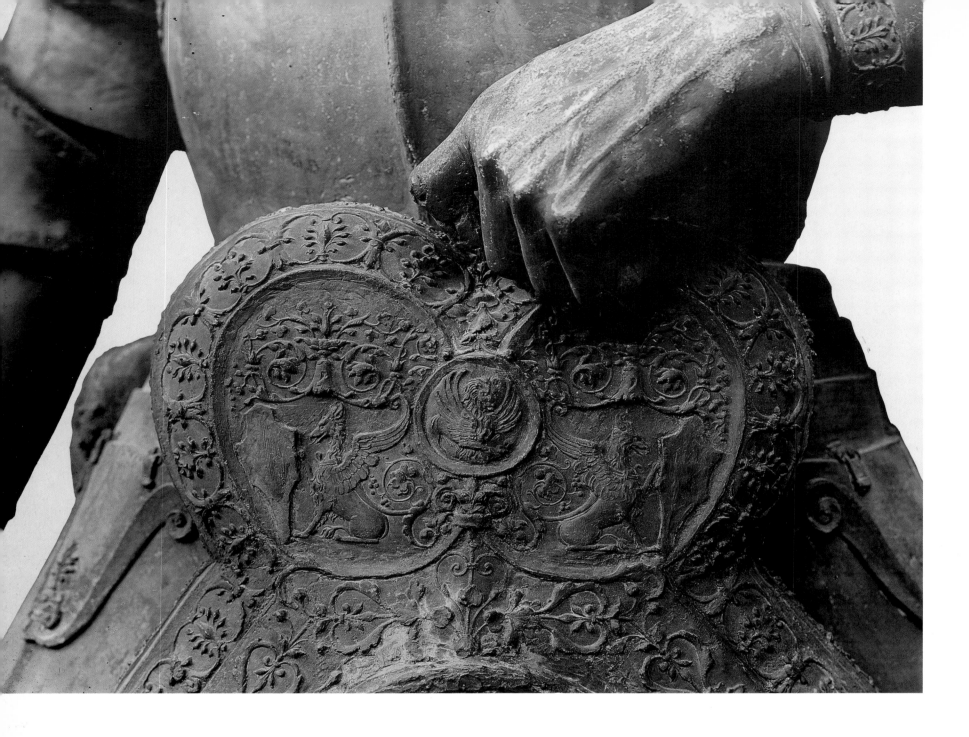

FIGURE 198.
Donatello, Waist of *Gattamelata*.

FIGURE 198.
Donatello, Waist of *Gattamelata*.

opposite: FIGURE 199.
Donatello, Breastplate of *Gattamelata*.

Gattamelata's head. The figure was accepted by Gattamelata's executors, in the words of the arbitration of 1453, as "una figure haeris per ipsum mag. Donatellum facti, ad similitudinem ipsius condam magnifici Gattemellatae et pro insigni fama ipsius," and nothing would have surprised them more than to be told by some modern scholar that the head really represented Julius Caesar and was intended to establish a parallel between Caesar and Gattamelata.

Donatello's aim, however, was not representation; it was to create an artistically valid monument.[14] The *Marcus Aurelius* has no front view. The heads of the horse and emperor are turned slightly to the right, but not so decisively as to establish from which of the two sides the monument is intended to be seen. Donatello's bronze *David* in Florence, however, has a front view, a rear view, and views from the two sides, and at Padua these principles are applied to the equestrian statue. The front face is the view in profile from the west, and lest this should be in doubt, the heads of the riding figure and the horse are turned decisively toward a spectator

Fig. 191

206

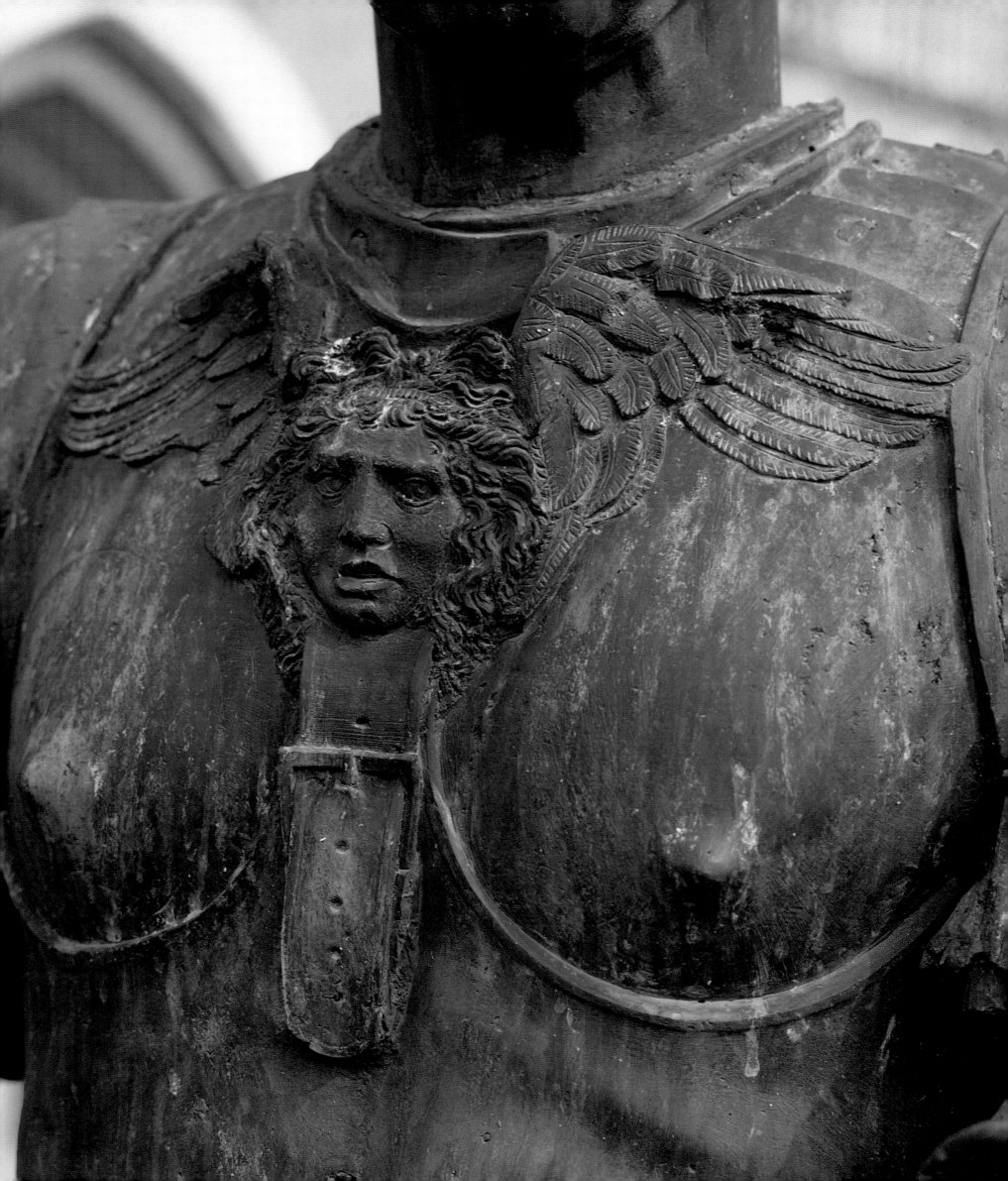

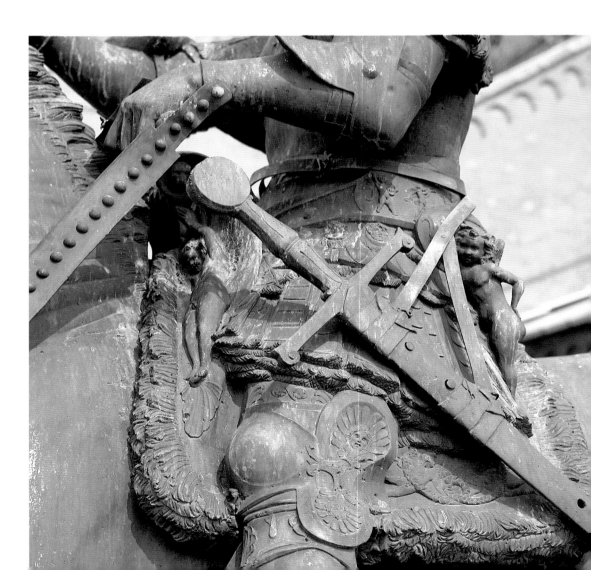

viewing it from that side. The upper part of the rider's body establishes a strong vertical in the center, which is extended by the eye to the horizontal of the plinth. The soles of the feet run parallel to the upper surface of the podium, and so do the extended spurs terminating in a six-pointed star at the center of the body of the horse. The long sword marks a decisive diagonal at about forty-five degrees from the upper surface of the plinth, and a corresponding diagonal is established by the bridle of the horse. The gaze of the horse and rider is directed at a single focal point. On the east face, the horizontals of the foot and spur are once more dominant. The same calculation is apparent in the two end views. From the back the eye is led up from the horse's tail to the center of the foliated decoration of the saddle and the back of the cuirass, and at the front the view centers on the horse's chest and the baton of command crossing its neck, which also links the front and the rear views. A number of drawings by Jacopo Bellini evince the same concern with the end views of an equestrian monument.

The equestrian figure of Niccolò III d'Este at Ferrara was relatively small. From the length of its base, which survives in the Volta dei Cavalli and measures about two meters (6½ ft.), it appears that Baroncelli's statue was about half the size of Donatello's. The Ferrara base, for which Alberti was responsible, is an archway supported by fluted columns with composite capitals. The spandrels of the arch are filled with circular reliefs with molded frames, and these are repeated in double size in the frieze above. The height of the Gattamelata pedestal and base is about 7.8 meters (25½ ft.), or a little more than twice the height of the statue (about 3.4 m [11 ft.]), and the length of the base (about 4.1 m [13½ ft.]) exceeds the length of the statue by about 20 centimeters (8 in.). The base of the Gattamelata is integral to the conception of the monument. Three steps of increasing height support an oval tomb chamber with, in the center of its front and back, a door frame and a doorway, that on the west face closed, that on the front face ajar. Above is a rectangular platform on which is set a second oval base of the same length and depth as that below. In the center of the sides are two marble reliefs (now replaced by copies) showing winged angels supporting, on the front, the shield and helm of Gattamelata and, on the back, other military accoutrements. The width of the two reliefs corresponds with the width of the door frames beneath. Above is a rectangular marble platform on which the statue stands. A parallel for the lower part of the podium occurs on an *aes* of Domitian, but Donatello may well have encountered similar structures in marble on a larger scale.[15] As the Cavalcanti *Annunciation* in Florence testifies, he had an extensive knowledge of Roman funerary altars, either through drawings or in the original. The base was built in the course of 1447, when, in the early summer, payments were made to a stonemason, Lazaro, for excavating the area under the monument; subsequent payments relate to the building of the foundations for the plinth, the construction of the surrounding steps, and the carving of a fictive doorway on one of its two sides. Open doors are a relatively common feature of classical sarcophagi, and there is no reason to suppose that the doors on the *Gattamelata* podium carry more than a conventional funerary significance.

The payments attested by Onofrio Strozzi in the course of 1447 are for the most part of a comparatively trivial kind; they even include small payments for "spese di

Fig. 190

gs. 193, 194

Fig. 205

Fig. 204

gs. 206, 207

FIGURE 204.
Donatello, *Equestrian Statue of Gattamelata*.
Bronze, on marble base
with limestone cenotaph. Piazza del Santo, Padua.

FIGURE 205.
Alberti, *Arco del Cavallo*.
Volta dei Cavalli,
Ferrara.

opposite: FIGURES 200, 201, 202, 203.
Donatello, Armor of *Gattamelata*.

 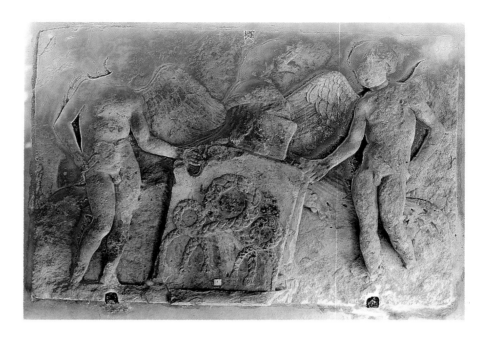

bocca" to the sculptor. But they also record the purchase of metal in Venice for the chest and body of the horse.[16] A sum was paid to Donatello for work between March and May "per portatura delle forme del cavallo et dell'uomo da casa sua al Maggio e per terra et altre spese," and a later payment covered its return. The sparse documentation of the horse throws little light on the procedure that was employed. The caster was Andrea del Caldiere, on whose premises a trench was dug in which parts of the monument were cast. The casting, like that of the *Marcus Aurelius*, was sectional, but it has never been determined (nor does it greatly matter) how many pieces are involved. At an uncertain time in the year 1447, Andrea del Caldiere was paid "per più getti del cavallo," that is, for the casting (or recasting) of individual sections of the horse. Prima facie, these payments suggest that the whole group was cast by the end of 1447, but the documentation is too scrappy for this to be assumed with complete confidence. The chasing and surface working of the horse and rider were completed only in 1453. The rate of progress must have been geared to work on Donatello's other Paduan commitments (especially for the Santo, over which the Gattamelata statue seems to have had priority). It is likely that at least some of the sculptors named in the contract for the angels and symbols of the Evangelists for the high altar of the Santo also worked on the *Gattamelata*. In the sixteenth century the sculptor Baccio Bandinelli told the Grand Duke Cosimo I that Donatello had eighteen or twenty assistants in his Paduan workshop,[17] and though this cannot be corroborated, it is clear, from the freedom with which he traveled and from the commissions that were offered him, that his studio must have been a very large one. In the settlement of 1453 Donatello bound himself to place the *Gattamelata* on its base by the end of September, and little more than a year later, with his work for the Santo still incomplete, he returned to Florence.

For the community of the Santo, the high altar of the church was a matter of constant concern. The shrine of Saint Anthony stood in the fifteenth century where it stands today, in the left transept, whereas the high altar stood some distance to the east of the position it now occupies in the high Gothic choir. Late in 1366 a certain Antonia da Capodilista bequeathed a sum of "libras centum parvorum" as a contribution to the cost of a new high altarpiece. In 1402 a further sum was allotted "pro aptando altar magnum conventus et anchonam de," that is, for modifying and enriching the high altar and its altarpiece, and in the summer of 1424, a thousand lire were bequeathed to the community "pro faciendo capellam mayorem altaris ecclesiae Santi Antonii" (for building the Cappella Maggiore of the altar of the church of St. Anthony). Reconstruction of the choir screen of the church was in progress in 1442–44, and plans for the building of a new high altar must have been under discussion before Donatello arrived in Padua. They assumed actuality, however, only in April 1446, when a prosperous wool merchant, Francesco Tergola, presented the church with a sum of fifteen hundred lire. The terms of the donation made the building of the altar mandatory; the money, says the deed of gift, was to be spent on a new high altar only and was not to be diverted to any other use. The sum was to be paid from a bequest made to Tergola by another wool merchant, ser Pietro da Florio, and Tergola's arms were to be shown on the new structure. In April 1447 a further five hundred lire bequeathed by a widow, Beatrice d'Avanzo, for distribution "inter pauperes Christi et pios uxus," was credited to the new altar. Expressed in lire, these donations appear substantial, but the total of Tergola's gift was just over two hundred sixty ducats, roughly a tenth of the total cost. For that reason his arms were eliminated from the finished work. The financing of the altar seems from the first to have been precarious. It was funded largely from relatively small sums given by private individuals, and for the feast of St. Anthony in June 1448 and 1450, components of the altar were assembled on a temporary structure in the church as a stimulus to fund raising.

Work on the high altar is very fully documented, but one vital document, the original commission, has not survived. If the contract existed, we should know more than we do about the architecture of the altar, which can be reconstructed only from later payments and from a few fragments of decorative carving that have been preserved.[18] Four volumes of account books from the Archivio dell'Arca are lost. Running from the beginning of July to the last day of June, they covered the years 1442–43, 1445–46, 1450–54, and 1455–59. Tergola's gift was made on April 13, 1446, and the initial contract for the high altar would, therefore, almost certainly have been included in the lost volume ending in June of that year. The first contract of which we have a record is a secondary contract of April 27, 1447, in which certain bronze components of the altar—two statues, ten reliefs of angels, four reliefs with symbols of the Evangelists, and four Miracles of St. Anthony, which were not covered by the initial contract—are entrusted to Donatello and to individual members of his shop.

The catena of ideas running through the altar are those of Alberti's *De Re Aedificatoria*.[19] A double-sided structure facing toward the congregation and toward the choir behind, it was conceived as an altar in Alberti's ideal temple. Its form was a

FIGURE 208.
Reconstruction of the
High Altar of the Santo
(after Planiscig, 1947).

FIGURE 209.
Reconstruction of the
High Altar of the Santo
(after White, 1969).

opposite: FIGURES 210, 211.
Front and back of
High Altar of the Santo (1895).
Basilica del Santo,
Padua.

low rectangle with a canopy supported by four piers and four fluted columns. Within the center of the pediment was a cupola or "chua" containing a relief of God the Father. The front of the canopy may have been related to that of the Cavalcanti *Annunciation*. Alberti advocates the use in temples of bronze figures, up to three in number, forming a group or, in Christian terms, a Sacra Conversazione, in which the participants would, "through their expressions and the movement of their bodies, appear to breathe, and by so doing communicate to the faithful a grace worthy of their divine status, greeting them benevolently with their heads and hands as though disposed spontaneously to hear their prayers." This seems to have been the prime objective of the Padua altar. There is, however, no record of how the altar originally looked, and though efforts have been made to reconstruct it with precision, the evidence by which they are supported is inadequate.

The earliest reference to it, in Facio's *De Viris Illustribus*,[20] written soon after Donatello left Padua, reads: "He made in Padua the St. Anthony as well as images of certain other saints on that same famous altar." A description of it was made about 1520 by a Venetian observer, Marcantonio Michiel:[21] "In the church of the Santo above the high altar the four bronze figures in the round grouped round the Madonna, and the Madonna; and below these figures on the retable the two storiated bas-reliefs in the front and two at the back; and the four evangelists at the corners, two in front and two behind, in bronze bas-relief, but half-length figures; and behind the altar, beneath the retable the Dead Christ with other figures round him, together with the two figures on the right and the two on the left, also in bas-relief but of marble; [all these] were made by Donatello." Vasari, in the first edition of his *Vite*,[22] mentions only that Donatello undertook four scenes from the life of St. Anthony for the predella, and "for the front of the altar he similarly made the Marys weeping over the dead Christ." Thereafter all is silence, until in 1579, a decision was taken to dismantle it and to promote a competition for a new high altar. The competitors consisted of Vittoria, Segala, Girolamo Campagna, and Cesare Franco, and the victor was Campagna, who included a number of Donatello's sculptures in the altar he designed.

The present reconstruction of the altar dates from 1895. In it the seven statues are arranged from left to right in the sequence *St. Louis of Toulouse, Santa Giustina, St. Francis,* the *Virgin and Child, St. Anthony of Padua, St. Daniel,* and *St. Prosdocimus.* With few exceptions, all scholarly reconstructions of the interior of the altar have likewise been based on the assumption that in one fashion or another all six Saints were disposed around the Virgin and Child. Sometimes they are set in diagonal lines leading back to the Virgin; sometimes they are disposed irregularly in space; sometimes they are shown standing in a single plane, like actors taking a curtain call. According to Michiel, however, there were "four bronze figures in the round grouped around the Madonna." Michiel's descriptions of paintings can occasionally be faulted, but he was in general an accurate observer, and what he saw on the altar was a Virgin and Child surrounded by four Saints, not six. The only scholar to take Michiel's description literally is Planiscig, who presumed that four of the Saints were grouped around the Virgin and that the remaining two stood on independent plinths beside the altar steps. He identified the independent Saints as Prosdocimus

Figs. 210, 2

Fig. 209

Fig. 208

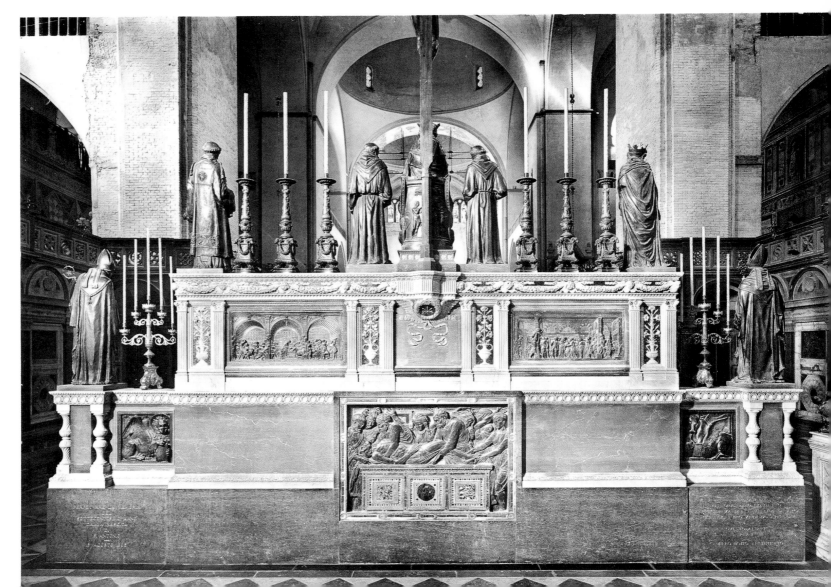

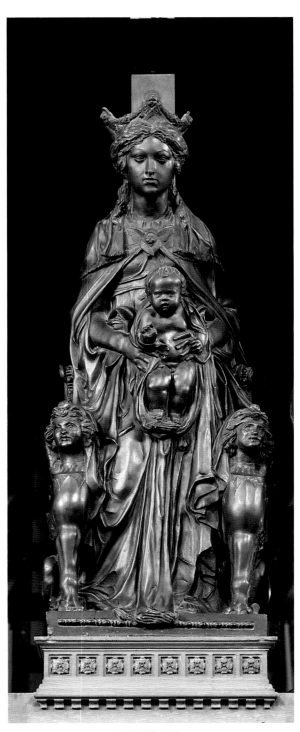

FIGURE 212.
Donatello, *Virgin and Child Enthroned.*
Bronze, parcel gilt,
H. 159 cm (62½ in.).
Basilica del Santo, Padua.

opposite: FIGURE 213.
Donatello, *Virgin and Child Enthroned*
(detail).

and Louis of Toulouse, both of whom wear miters, and his criterion in doing so was one of symmetry.[23] But symmetry was not a factor of importance in this context. The less so that the answer to the riddle is given in a secondary contract of June 23, 1447, which establishes the rate of payment for two supplementary statues, those of the Franciscan saints Louis of Toulouse and Francis of Assisi.[24] Where they stood, whether beside the altar or in front of it at the entrance to the choir, we cannot tell. The seven large statues ("le qual figure serano poste a l'altaro grande de la giexia") are mentioned together for the first time in June 1448.

 The initial contract, therefore, must have provided for five figures, the Virgin and Child and four Saints, all of whom were patrons of Padua. This can be confirmed on formal grounds. Whereas the Saints Francis and Louis are represented frontally, St. Louis with his right hand raised and St. Francis holding a book and crucifix, the four other Saints are shown as participants in an active group. St. Daniel extends his left hand and Santa Giustina her right hand to the Child, while the two remaining Saints stood in a rear plane, St. Prosdocimus, to judge from the position of his feet, on the left, and St. Anthony, for the same reason, opposite.[25] This disposition of the figures can be confirmed by the degree of finish of their heads. In the Cavalcanti *Annunciation* in Florence, the visible side of the Virgin's head is fully finished, whereas the side facing the background, including right cheek and eye, is left relatively in the rough. Donatello follows the same practice in the four Saints on the Padua Altar. The right sides of the heads of Saints Daniel and Prosdocimus are more highly finished than the left sides, and the left sides of the heads of Santa Giustina and St. Anthony of Padua are more highly finished than the right. The heads of the Saints Francis and Louis of Toulouse, on the other hand, are brought to an equal degree of finish on both sides, and since their backs are also somewhat more highly worked up than those of the other Saints, they are likely to have been freestanding and set in the vicinity of the altar, but not part of the main group.

 In the center of the double-sided altar was the Virgin, who is depicted rising from her throne with the Child held in front of her.[26] The pose is unusual, and attempts have been made to explain the figure as an adaptation of a Florentine dugento painting, as an imitation of a Byzantine panel, and as a copy of a lost black Madonna in the Santo. But the intention is naturalistic, not archaeological. The Virgin, as she rises, holds the Child forward on the level of her stomach, and the group is indeed a literal illustration of a verse of the *Salve Regina*: "Eia ergo advocata nostra, illos tuos misericordes oculos ad nos converte. Et Jesum benedictum fructum ventris tui nobis, post hoc exilium, ostende." The Child, much younger than the children in most Madonnas, is displayed as the blessed fruit of the Virgin's womb. His right fist is raised by the Virgin in a tentative gesture of benediction. The front of the throne, or *Sedes Sapientiae*, from which the Virgin rises is in the form of two sphinxes with lion feet. On the back of the throne is the Fall, now partially concealed by the shaft of the bronze Crucifix erected over it. Originally this beautiful relief, in which Eve is shown with arms extended toward the serpent and the left hand crossed over the right, and Adam is represented turned to the left greedily eating the forbidden fruit, must have been intended to be fully visible, but

Figs. 221, 2

Fig. 219

Fig. 220

Fig. 223

Figs. 222, 2

Figs. 212, 2

Figs. 216, 2

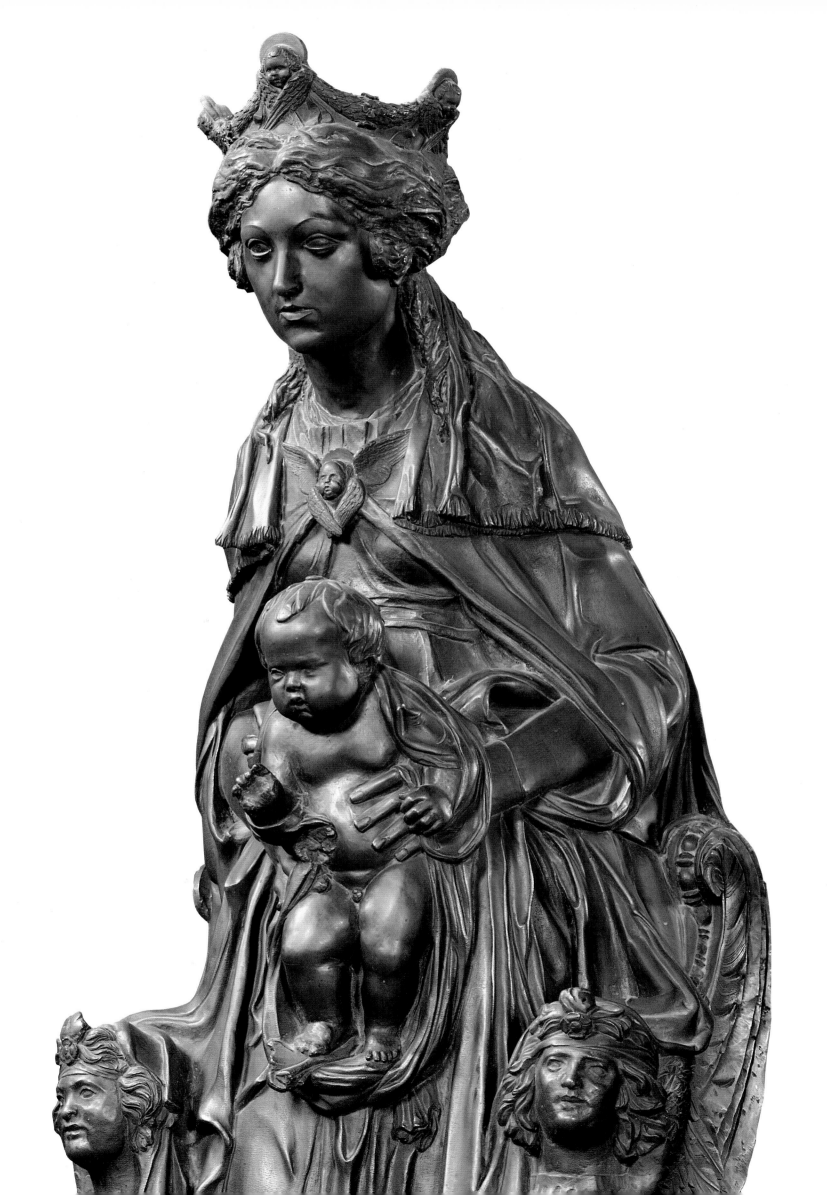

there is reason to suppose that at some stage it was hidden by a grille or tabernacle at the back. Over a robe bound with a girdle at the waist, the Virgin wears a heavy cloak fastened on the chest. Though the effect is, in a loose sense, classical, the only feature of the figure that has a close classical precedent is the heavy fold in the skirt, which falls downward from the Child to the center of the front edge of the platform supporting the throne. The Virgin's face is bland and inexpressive and her freely modeled hair is drawn back at either side. She wears a crown, rising at the front and sides to three points and decorated with the heads of haloed seraphim. The headdress recalls the elaborate gesso crowns found in seated Madonnas by Antonio Vivarini, whose work was of prime importance for religious iconography in Padua. There is much in the central figure that is uncharacteristic of Donatello, but this may be ascribable to the commissioning body, not the artist.

Fig. 214

The Virgin's crown is not the only concession Donatello made to Paduan taste. The five statues, individually striking as they are, seem to have been intended from the first for inspection, not singly, but as a group. The relative degree of finish of the detail confirms the pictorial nature of the scheme. In the Virgin, which could only be seen frontally, the hair is carefully chased over the forehead beside the central parting and is treated more cursorily at the sides. The hair of the Santa Giustina, facing to our left, is finished on the visible side with the same care as the hair over the Virgin's forehead. In the St. Daniel, which occupied a corresponding position on the opposite side of the altar, the right half of the face, which would have been visible from the front, is more carefully worked up than the left half, which would have been visible only at a distance from the back. This is especially evident in the treatment of the eyes. With none of the Saints is the modeling or chasing comparable in quality to that of the bronze *Crucifix*. There is a record of wax supplied to Donatello in February 1447 for modeling "le figure de la anchona" and "le teste delle figure de la anchona."[27] The sums paid by the Santo for individual figures or reliefs were not, unnaturally, related to the work that they entailed. The price of the Saints Louis and Francis was forty ducats each.

Fig. 229

Fig. 227

Reading between the lines of the immense number of documents relating to the sculptures, one would judge that Donatello, during the six years he worked on it, came to view the altar with increasing disillusionment. He did not stay in Padua to supervise its installation. After he left, the commissioning authorities complained that many of the sculptures were unfinished, as indeed they were.[28] Parts of the faces of the Saints were left in the rough, the winged seraph on the chest of the Virgin in the center was virtually unchased, the sphinxes on the throne were, by Donatello's normal standards, clumsy and inelegant, and some of the reliefs of symbols of the Evangelists, which are known from documents to have been entrusted wholly to assistants, were in sharp contrast to the reliefs designed by Donatello. In Donatello's mind, the altar seems to have ranked second to that autonomous masterpiece, the *Gattamelata*.

Of the seven full-scale figures, the only one for which a precedent exists in Donatello's work in Florence is the *St. Louis of Toulouse*. But the earlier *St. Louis*, with its ample cope and firmly modeled head, is in every way superior to the figure of the Saint at Padua, where, to simplify the casting, the cope and habit adhere

Figs. 211, 22

216

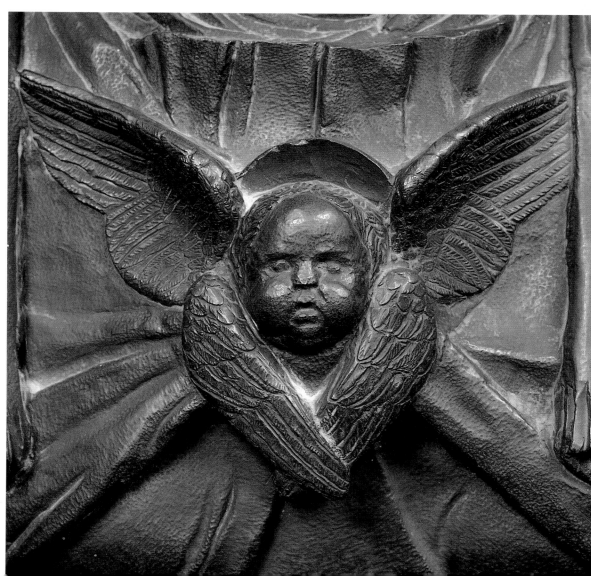

FIGURES 214, 215.
Donatello, *Virgin and Child Enthroned:*
seraph heads (*above*) from the
crown, and (*below*)
from the breast of the Virgin.

FIGURE 216.
Donatello, Eve, from back
of Virgin's throne.

closely to the body, and the shaft of the crozier is pressed against the shoulder and left arm. The miter, which is cast separately, is damascened. The torsion of the *Santa Giustina*, turning toward the central group, looks back to the Virgin in the *Annunciation* in Santa Croce, though the pose, owing in part to the heavy folds of drapery around the waist, lacks the clarity of its predecessor. The most effective of the figures is the least highly worked, the *St. Daniel*, where the pose recalls that of an earlier deacon Saint, the stucco *St. Stephen* in the Old Sacristy. Here a sequence of ideas that originated in relief is developed fully in the round, and the beautiful modeling of the dalmatic with a fringed base that falls free of the amice beneath, of the putti embroidered on it, and of the thin veil that blows across the body, is comparable to Donatello's Florentine works.

Fig. 229

Figs. 227, 22

Fig. 228

In January 1447 a number of assistants are for the first time named.[29] Their identities are established by a contract of April 27 listing "magister Nicholaus pictor, filius ser Pietri, publicus mercator" (the painter Niccolò Pizzolo, who later worked with Mantegna in the Ovetari Chapel), "magister Urbanus, habitator Paduae in contrata Sancti Georgii" (the sculptor Urbano da Cortona, who later worked with Donatello in Siena Cathedral), "magister Iohannes, filius Cheechi, de Pisis habitator Paduae in contrata Stratae" (the sculptor Giovanni da Pisa, later responsible for a terracotta altarpiece in the Eremitani), "magister Antonius, filius Choelini de Pissis de contracta Sancti Georgii" (the sculptor Antonio Chellini), and "magister Franciscus, filius Antonii, de Florentis habitator Paduae in contracta Sancti Antonii in domo a pisce" (the sculptor Francesco del Valente). Payments to these sculptors were made through Donatello, and though the name of each is preceded by the word *magister* in the records of payment for their work, their role is more clearly defined in an alternative description used throughout the document, "so garçon." The recorded payments to them terminate on July 1, 1447, though one assistant, Antonio Chellini, continued working for the Santo till mid-December of that year.

The task on which individual members of this work force were engaged was the modeling, casting, and chasing of four reliefs with symbols of the Evangelists and ten reliefs of angels. Two of the Evangelist symbols were intended for the front of the altar and two for the back. All four had been modeled in wax by the end of April "prout pinguntur" (following painted designs for which Niccolò Pizzolo may have been responsible). The symbols were modeled and chased by Giovanni da Pisa, Antonio Chellini, Urbano da Cortona, and Francesco del Valente. Two of them, the Lion of St. Mark and the Bull of St. Luke, are clumsily designed and coarsely executed. Finer in quality is the Angel of St. Matthew, shown on a ground decorated with a pattern of gilt circles, with the right half of the Gospel volume protruding from the frame. A partial copy of this relief in marble by Urbano da Cortona is in Siena Cathedral, and the bronze relief may be due to the same hand. The Eagle of St. John is a stronger, more distinguished work and is the only one of these reliefs in which some participation by Donatello is possible. Across the book in the lower left corner is a patterned veil recalling that in the statue of St. Daniel. Different as the symbols are from one another, there is no means of establishing conclusively which of the four sculptors was responsible for which relief, save that the Bull of St. Luke is

related to the angel blowing a pipe, and the Angel of St. Matthew to the angel playing a rebec.

The rate of payment for each of the symbols of the Evangelists was sixteen ducats, and that for each of the ten reliefs of angels was twelve. There is no indication in the documents of the purpose the ten reliefs of angels were designed to serve. In reconstructions of the altar they are sometimes presumed to have been set on top of one another in the supports at the corners of the altar, like pilaster panels in a painted altarpiece; or on the level of the predella, four at each end and two at the back. They are wrongly shown in the Santo today as an antependium on the front face of the altar itself. Though some of them are looking down, the thin documentation suggests that they were set under the level of the platform on which the large figures stood. In their original position, they lauded the vision of the Virgin and Child. That they were from the beginning intended to stand together as a single unit is confirmed by a provision in the contract enjoining that the artist should, if so required by the commissioners, provide "unam canale vel redundinum circa cornicem ipsorum angelorum," that is, a single frame around all ten angels. They were to be delivered cleaned and ready for extensive gilding ("quod ipsi angeli possint deaurari notabiliter").[30]

The authorship of the angel reliefs has been the subject of widely divergent views.[31] In the nineteenth century individual reliefs were commonly ascribed to individual documented sculptors. Nowadays, however, attempts to break them down among assistants in the workshop on the basis of published documents are dismissed as "classic instances of connoisseurship-at-any-price," and all ten reliefs are attributed to Donatello. In practice, they are very different from one another both in style and quality, and the latitude allowed to those assistants who were paid for executing them seems to have been at least as great as used to be assumed. We know from the recorded payments that six of the angels were executed by assistants and only four by Donatello; the latter are referred to in a document of June 30, 1448.

Figs. 230–232
Donatello also executed three other reliefs of the same height, a sublime relief with Christ in the tomb mourned by two lamenting angels (for which he was paid on June 23, 1449, and which seems to have had a deep influence on the work of Giovanni Bellini) and two reliefs beside it of paired putti chanting from books. On the basis of these three reliefs, the four single angels for which Donatello was personally responsible can be identified as the angel turned to the right playing a Figs. 233–236 diaulos (where the pose with head in lost profile and the flimsy dress leaving the near side of the body exposed are of enchanting elegance), the angel with cymbals (where the definition of the body beneath the dress is of extraordinary accomplishment), the angel holding a tambourine (where something of the Dionysiac quality of the Cantoria is preserved), and the angel turned to the left playing a double pipe (where the beautifully realized contrapposto affords clear evidence of Donatello's authorship).

Fig. 218
The center of the back of the altar at ground level is a large relief in *pietra di Nanto* (a form of limestone) of the Entombment,[32] now regarded as "the only piece of sculpture on the high altar that has always been acknowledged as entirely by Donatello's own hand." The relief is first mentioned in mid-April 1449, when

FIGURE 217.
Donatello, Adam, from back
of Virgin's throne.

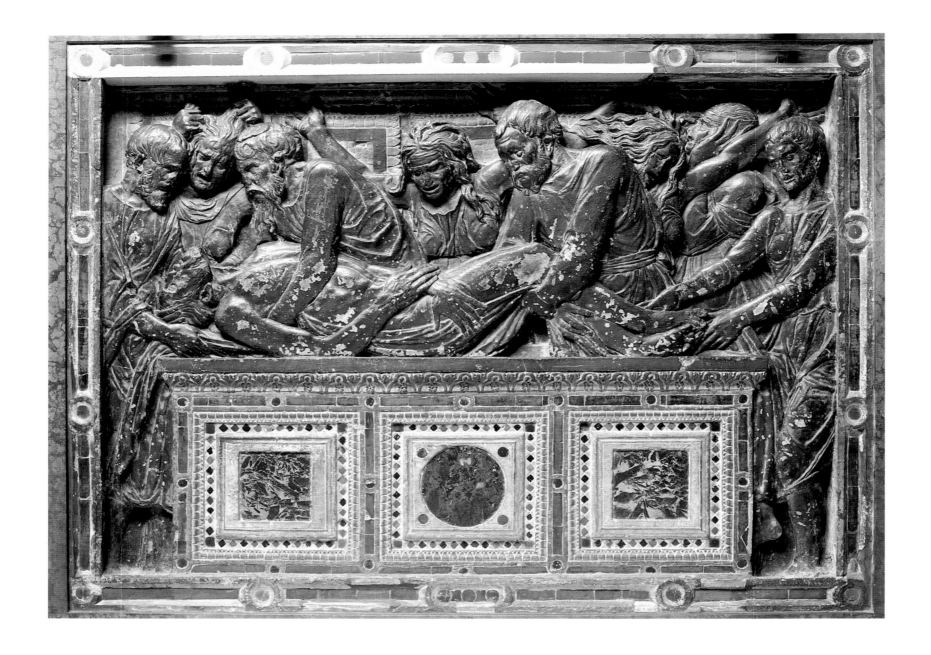

Donatello received the small sum of five hundred lire for "5 priede grande lavorade a figure, cum sepulcro del nostro Signore, e che lui s'à dourado in più logi per la fabricha che è d'acordo." The body of Christ is shown in silhouette above the tomb, carried by four male figures, and at the back three Holy Women register grief in a manner that recalls the classical Meleager sarcophagi that had inspired Donatello's *relievo stiacciato* of the Entombment over the St. Peter's tabernacle. The relief, though moving and evidently deeply felt, is summarily executed. Set at a low level, it has a median viewing point, from which, at two points, we look into the interior of the tomb. The weight-bearing arms of the two bearded figures lowering Christ's body are slack and flat, as is the standing youth, presumably St. John, holding Christ's feet. The mourning women, two of them with arms outstretched diagonally

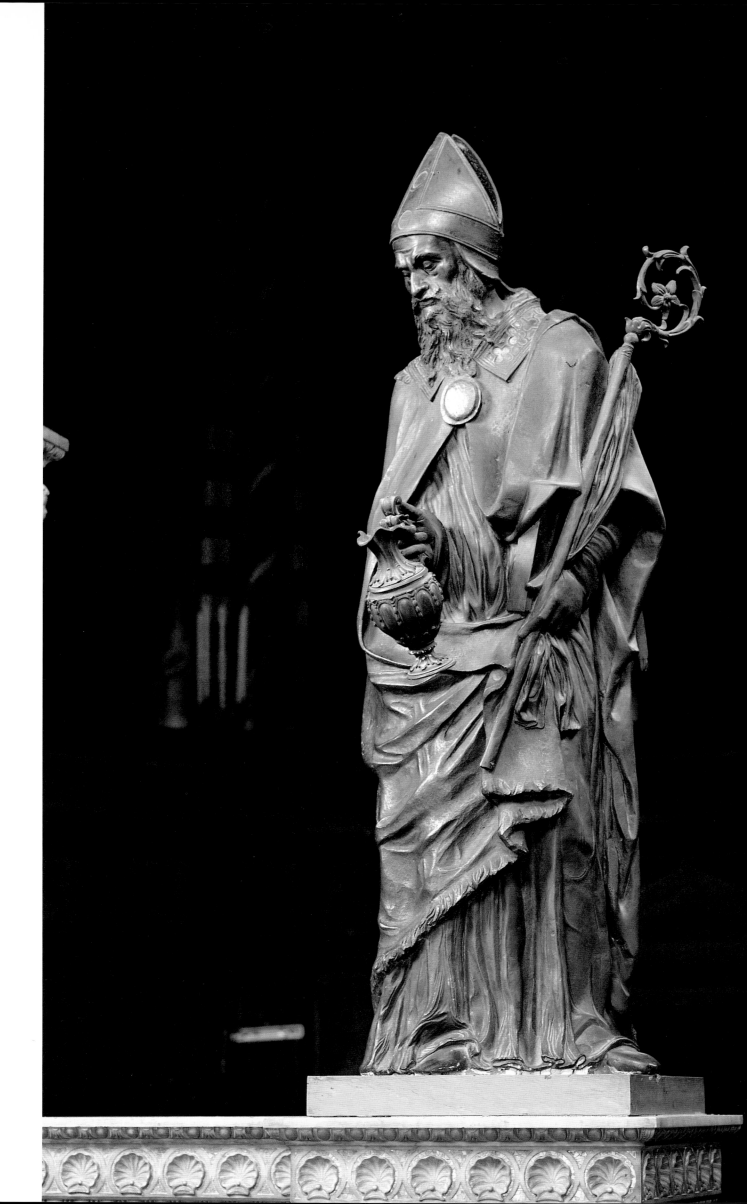

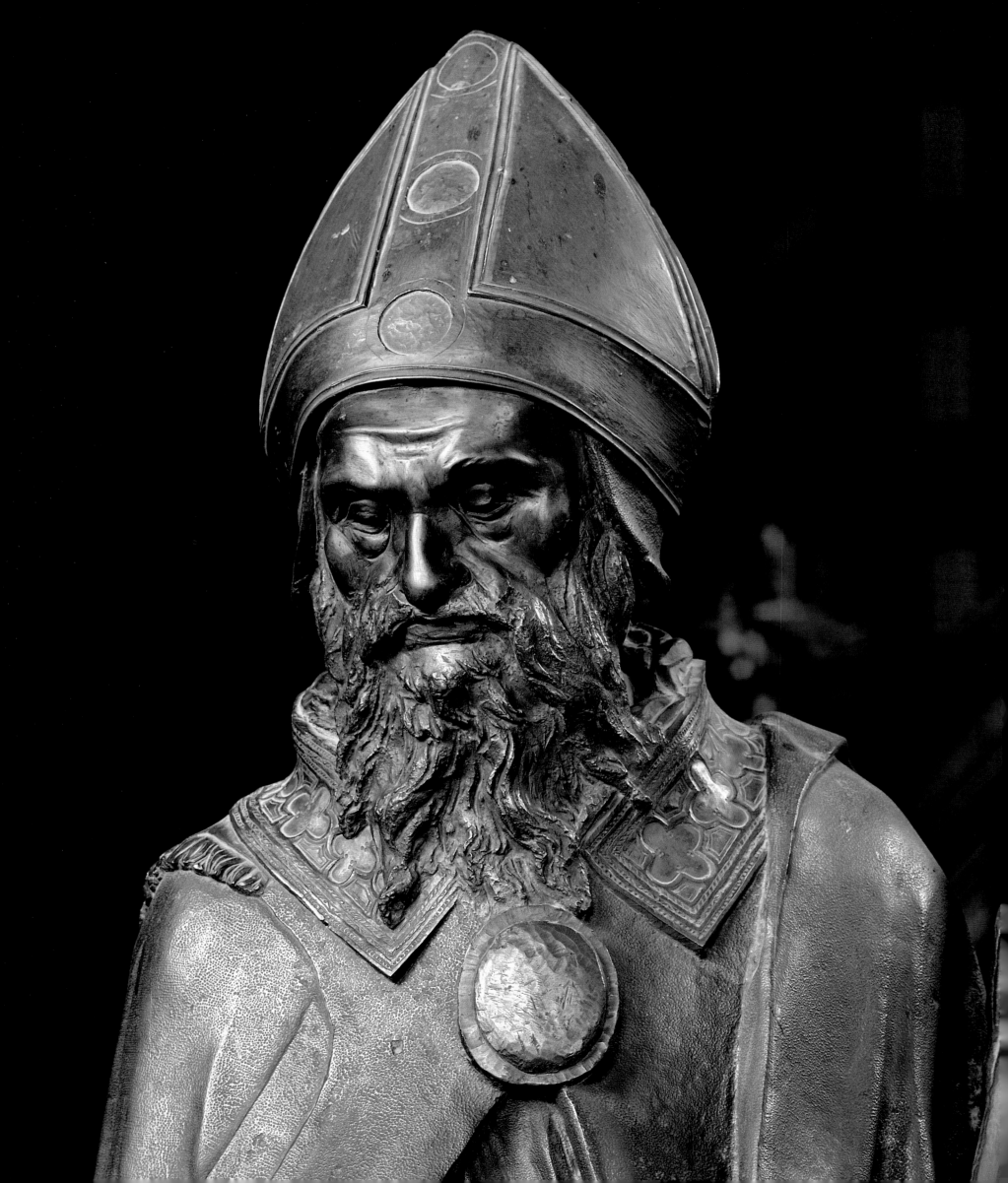

against the background and a third woman on the left tearing her hair, have no true parallel either in Donatello's earlier work in marble and sandstone or in the later bronze reliefs on the San Lorenzo pulpits.

gs. 237, 240, 244, 247

From the standpoint of the Franciscan community, the key parts of the altar were its four reliefs of Miracles of St. Anthony, two designed for the front predella and two for the back. Their height (57 cm [22 in.]) corresponds with that of the *Imago Pietatis* in the center of the front predella (58 cm [23 in.]), and their width is 123 centimeters (48 in.). They were expensive (in the contract of June 23, 1447, their cost is estimated at eight-five ducats each as against forty ducats apiece for the *St. Francis* and *St. Louis of Toulouse*), partly no doubt because they would be highly worked and parcel gilt.

In the middle of the fifteenth century there grew up, among humanists in a number of unrelated centers, a conviction that the historical value of the lives and miracles of Saints, accounts of which rested in part on hearsay or superstition, should be reassessed. In Padua this view was espoused by Michele Savonarola, and the task of rewriting the life of St. Anthony was taken over by Sicco Polentone, a notary from Trent who had written on Seneca, Dante, Petrarch, and Boccaccio. We first hear of Sicco Polentone in 1414 when he was in correspondence with Niccolò Niccoli in Florence; later he was in contact with Lorenzo Valla. His life of St. Anthony was written in 1434–35. Its main sources were five early lives of the Saint, the *Vita Assidua* (ca. 1232), the *Vita Secunda* by Giuliano da Spiro (ca. 1235), the *Legenda Raymundina* by a Franciscan from Toulouse (1293), the *Vita Rigaldina* (early fourteenth century), and the *Liber Miraculorum* (1369), and it was divided into two parts, one dealing with the Saint's life and the other with eighty miracles grouped by category in twelve chapters. Polentone's life of Saint Anthony was followed by short lives of the Beato Antonio Pellegrino (a long-term runner-up for canonization) and the Beata Elena Anselmini, a forebear of his wife. A manuscript containing the three lives, with miniatures by Cristoforo Cortese, was presented in 1439 to the Santo, where it was attached with a chain to a desk in the sacristy, so that it could be consulted, but not removed. This was the text that Donatello illustrated.[33]

Though Donatello's four scenes on the altar are some of the subtlest and most ambitious relief sculptures of the fifteenth century, they were intended as a manifesto in which the Saint's miracles would be presented in convincing contemporary terms. Four of the miracles described in Polentone's *Santi Antonii Confessoris de Padua Vita* were selected for illustration on the altar. In the secondary contract of June 23, 1447 their subjects are described:[34]

Istoriae vero de quibus supra sunt: primo miraculum beati Antonii de ostia Corporis Christi; aliud de puero quondam illustris Marchionis Ferrariae; aliud de abscissione pedis cuiusdam pueri quem miracolose sanavit; quartum vero miraculum, quod superest ad formandum et similiter ad perducendum a principio isque ad finem ut supra, de corde avari reperto in thesauro.

These four miracles were chosen because they were representative. The Miracle

opposite: FIGURE 220.
Donatello, Head of *St. Prosdocimus.*

223

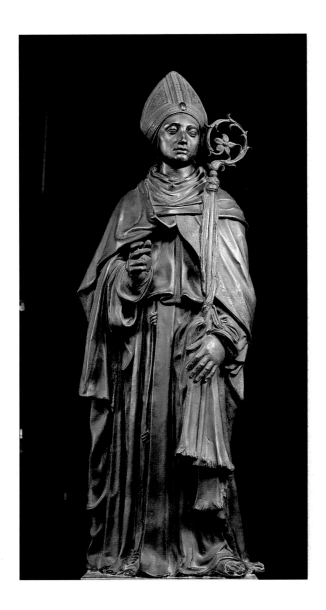

FIGURE 221.
Donatello, *St. Louis
of Toulouse*. Bronze,
H. 164 cm (64½ in.).
Basilica del Santo, Padua.

opposite: FIGURE 222.
Donatello, Head of
St. Louis of Toulouse.

overleaf, left: FIGURE 223.
Donatello, Head of
St. Anthony of Padua.

overleaf, right: FIGURE 224.
Donatello, Head of
St. Francis of Assisi.

of the Mule illustrated the Saint's devotion to the Divine Presence; the Miracle of the Miser's Heart brought to mind his sermons against usury; the Miracle of the Severed Leg typified the power of healing that the Saint exercised; and the Miracle of the Newborn Child (for which Sicco Polentone seems to be the earliest source) affirmed his interest in the family. In all four reliefs Donatello closely followed Sicco Polentone's text.

To judge from the reliefs themselves, there was a second requirement, that the narrative scheme should be one indigenous to Padua. A number of Altichiero's frescoes in the Santo and the Oratorio di San Giorgio portray miraculous events, and in each of them the miracle takes place in the center of the fresco field and is segregated from spectators who react to or comment on it at each side. The architectural backgrounds are frequently of great complexity and are almost always extraneous to the main scene. Each of Donatello's reliefs is similarly planned in triptych form, with the miraculous event in the center of the field and witnesses at either side, and each is housed in an elaborate setting of Albertian architecture of a type adumbrated in the marble relief at Lille of the *Presentation of the Baptist's Head to Herod*.

By the early summer of 1447, three of the reliefs had been cast in rough from Donatello's wax models ("istorias beati Antonii confessoris, quas alias praedictus magister Donatus sub offitio praefatorum Dominorum Massariorum formavit in cera, et in presenti fusae sunt ex ramo rudes et imperfectae"). The model for the fourth relief, the *Miracle of the Miser's Heart*, was handed over to the bronze caster Andrea del Caldiere on August 4 of the same year. If, therefore, there were a change in style in the reliefs, we would expect it to occur in the fourth scene. There is indeed a change in style, but it occurs between the *Miracle of the Newborn Child* and the two reliefs that were cast at the same time, and not between these and the fourth relief. The *Miracle of the Newborn Child* is modeled in much greater depth than the remaining scenes, and its space projection is less logical. Probably work on it was begun soon after the donation of April 1446, and not in June 1447, when it and the companion scenes are first mentioned in a contract. If that be so, models for the four reliefs would have been brought to a point at which they could be cast over a period (still a very short one) of eighteen months. The reliefs seem to have been planned in an altogether different way from the reliefs in the Old Sacristy in Florence. Their perspective constructions must have been made from precise, detailed drawings to scale, and account has therefore to be taken of five productive stages: first the planning and drawing out of the architectural settings, then the preparation of the figure groups and their insertion in the scenes, then the casting and chasing (so elaborate that it can hardly have been completed before the trial assembly of the sculptures for the altar in the summer of 1448), and finally gilding, silvering, and damascening, which would have been carried out, no doubt, under Donatello's supervision; for the damascening he was not personally answerable. One of the most mysterious figures in Donatello's studio at this time is "Niccolo dipentore, suo disipollo over garcon," that is, the painter Niccolò Pizzolo, who was employed by the Santo from February to June 1447, when he was engaged to paint alongside Mantegna in the Eremitani. He is the only painter mentioned as such in the

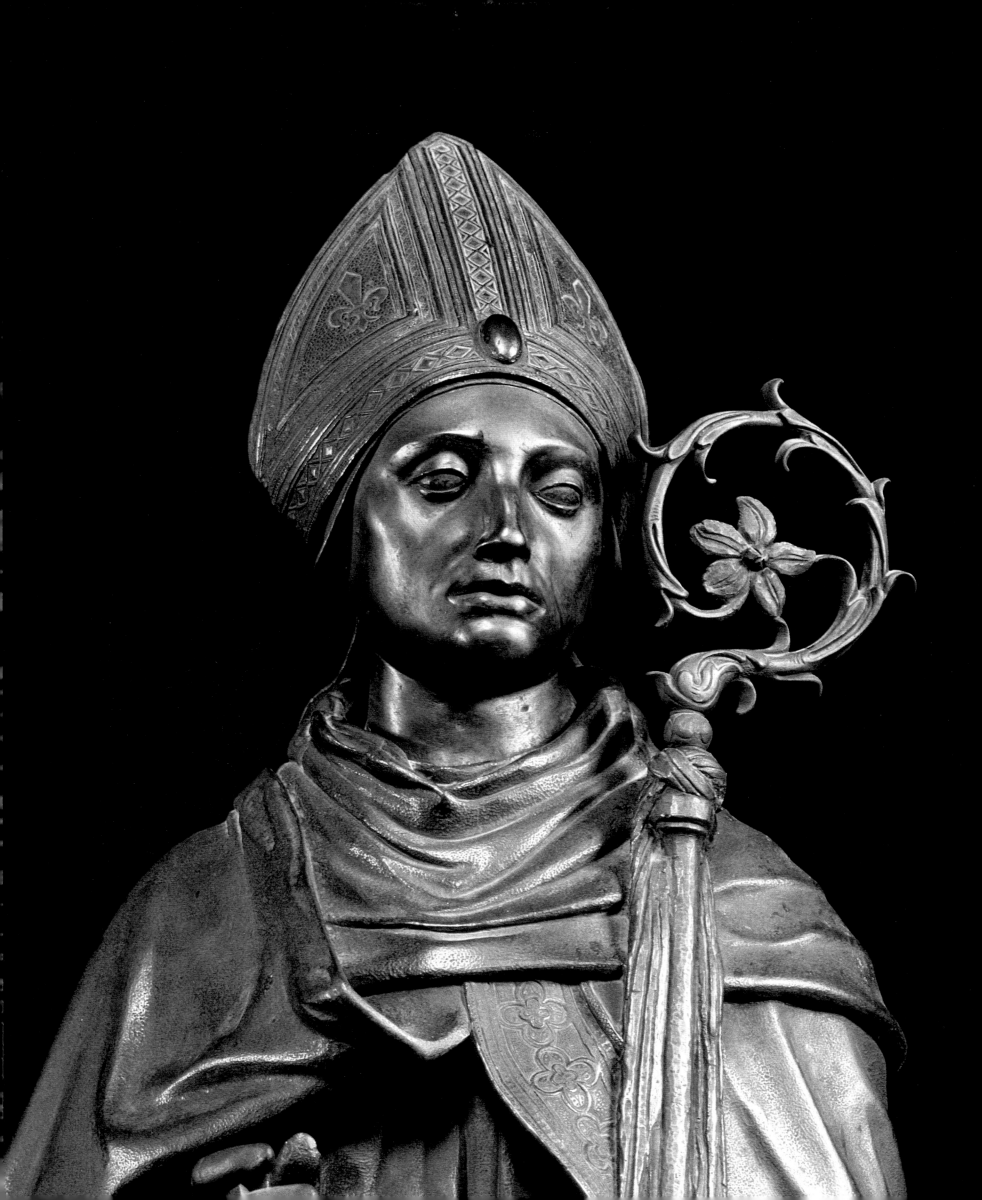

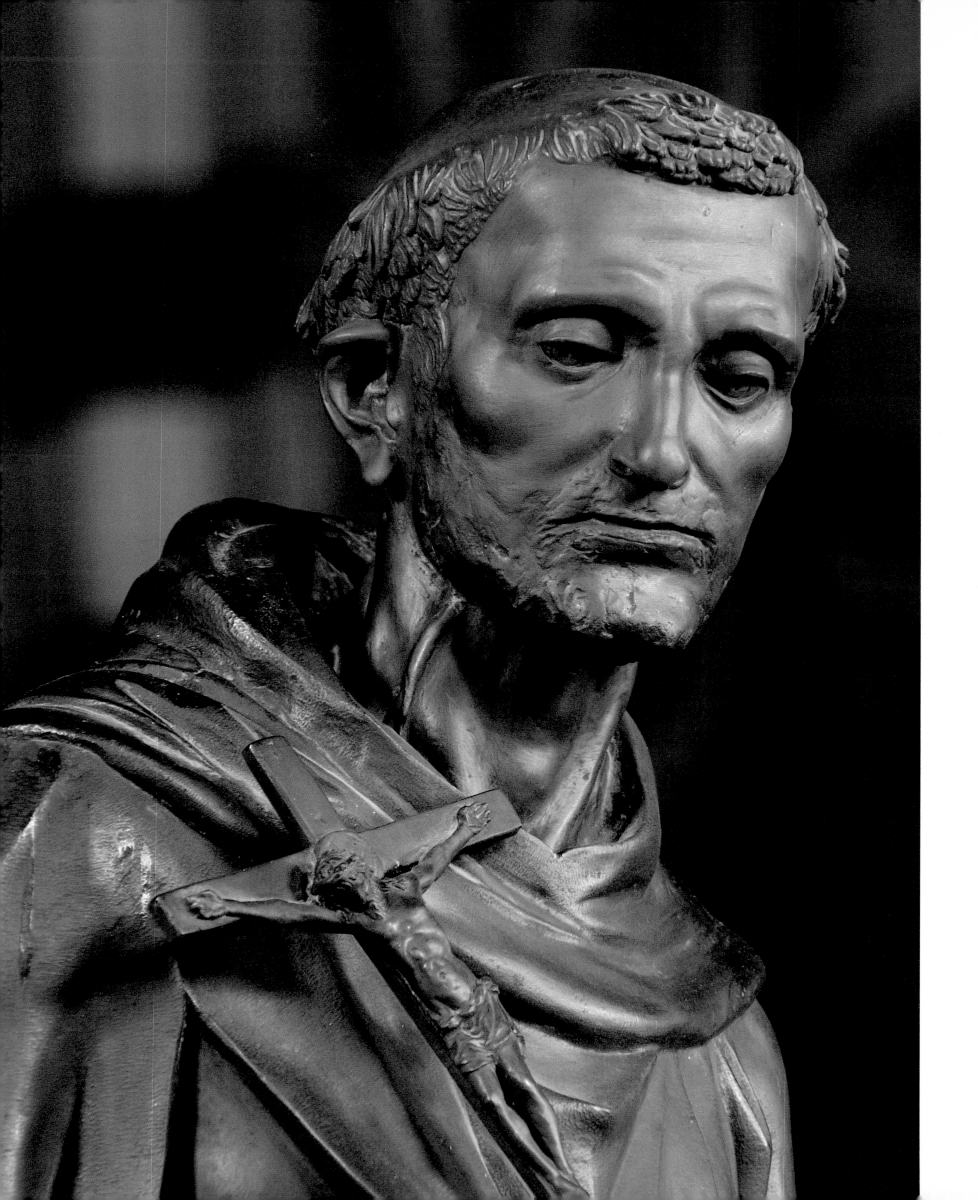

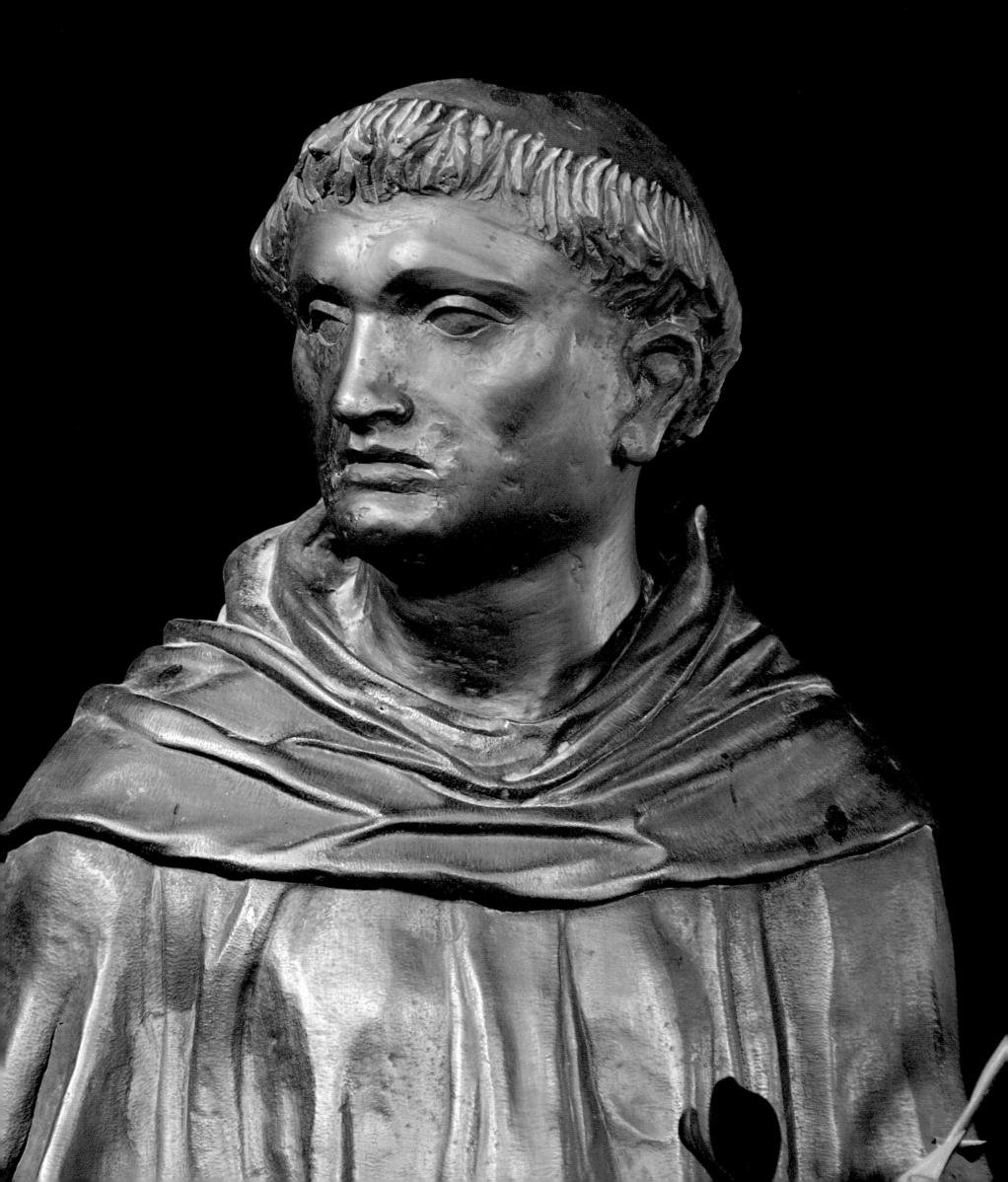

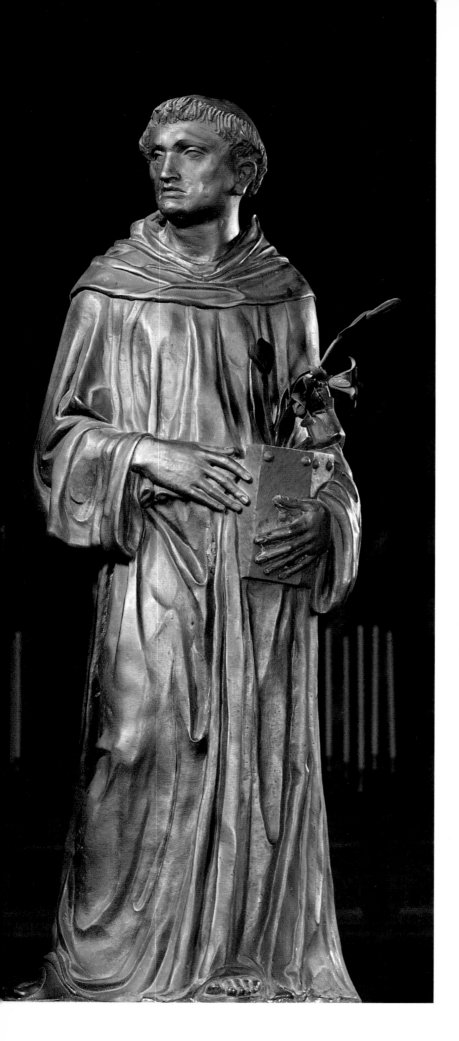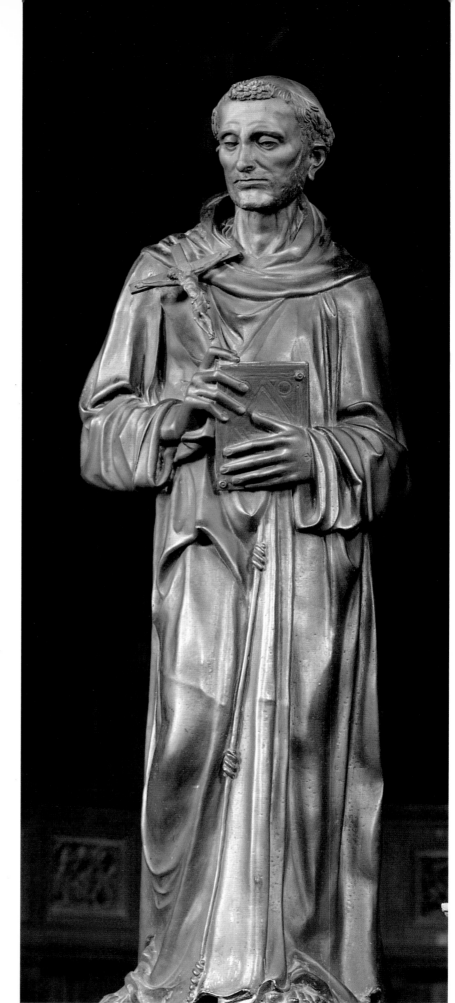

Fig. 237

documents, and he could well have assisted in the preparation of drawings for Donatello's reliefs.

Fig. 237

The Miracle of the Newborn Child, says Sicco Polentone,[35] was a great and true miracle, in which the Saint enjoined a boy born a few days earlier to speak and reply to his questions. So firmly was the father, sometimes described as a Marquess of Ferrara, convinced that the birth resulted from his wife's adultery that he would neither touch the child nor look at it. The Saint, therefore, taking the child in his hands, addressed it with the words: "I adjure thee, through virtue of Jesus Christ who is the true God and was born as man by the Virgin Mary, to tell who is thy father." Thereupon the child, "not gurgling as children do, but with a clear voice as though he were ten years old," replied, "This is my father," and the Saint, turning toward the father, said, "Lift up thy son." Along the top of the building in which the scene takes place runs a decorative strip punctuated by squares within an oval. There are six of these studs, corresponding with demarcations in the rear wall, so that the scene is effectively divided into fifths, that in the center circumscribing the miracle, two to right and left defining the areas occupied by the spectators in the room, and two more at the ends establishing the width of the figurated sections at the sides. This device is not used in any of the three other reliefs. All four reliefs are, however, contained in a frame divided by studs; the spaces between the studs number eleven in the first scene and ten in the other three, and may, like the sections in the foreground of the Lille *Feast of Herod*, represent a module used in the reliefs. In the first relief, the miracle proper occupies the central three-fifths of the scene and comprises a tightly constructed isocephalic group, with female figures on the right and male figures on the left. All the participants wear contemporary dress of a type they might have worn had the miracle taken place in Ferrara in the middle of the fifteenth century. The figures of the Saint and of the mother are isolated by a hanging at the back. The moment of depiction is immediately before the miracle takes place; the child is passed by its mother to the Saint, and the father, with left arm extended, stands skeptically at the side. In the center, the figure of a kneeling man establishes the distance of the mother and the Saint from the rear wall. Especially fine is the classical group of supportive women in profile behind the mother, which was much copied by draftsmen in the sixteenth century. In the narrow section on the extreme right the scale of the central figures is preserved, and two women leaning open-mouthed across the pier at the end of the dividing wall maintain the continuity of the narrative. In the corresponding position on the left, however, this is destroyed by the presence in the doorway of a gigantic soldier holding a shield and pike. To his right is a small figure, seemingly in far deeper space than the space actually portrayed. Forward of the pier, there stands a youth, on a scale disproportionately larger than the husband in the center of the scene, with arm extended to conceal the meeting point of the forward and rear walls. The groups in the center and on the right seem to have been planned independently and then inserted in a predetermined perspectival scheme. The viewing point is in the center of the base, and the vanishing point, as we might expect, is in the speaking child. The squares in the shallow ceiling in all three sections are not foreshortened, but are of uniform depth. On the rear wall are semicircular apertures, which recall

Fig. 239

Fig. 238

opposite, left: FIGURE 225.
Donatello, *St. Francis of Assisi.*
Bronze, H. 147 cm (58 in.).
Basilica del Santo,
Padua.

opposite, right: FIGURE 226.
Donatello, *St. Anthony of Padua.*
Bronze, H. 145 cm (57 in.).
Basilica del Santo,
Padua.

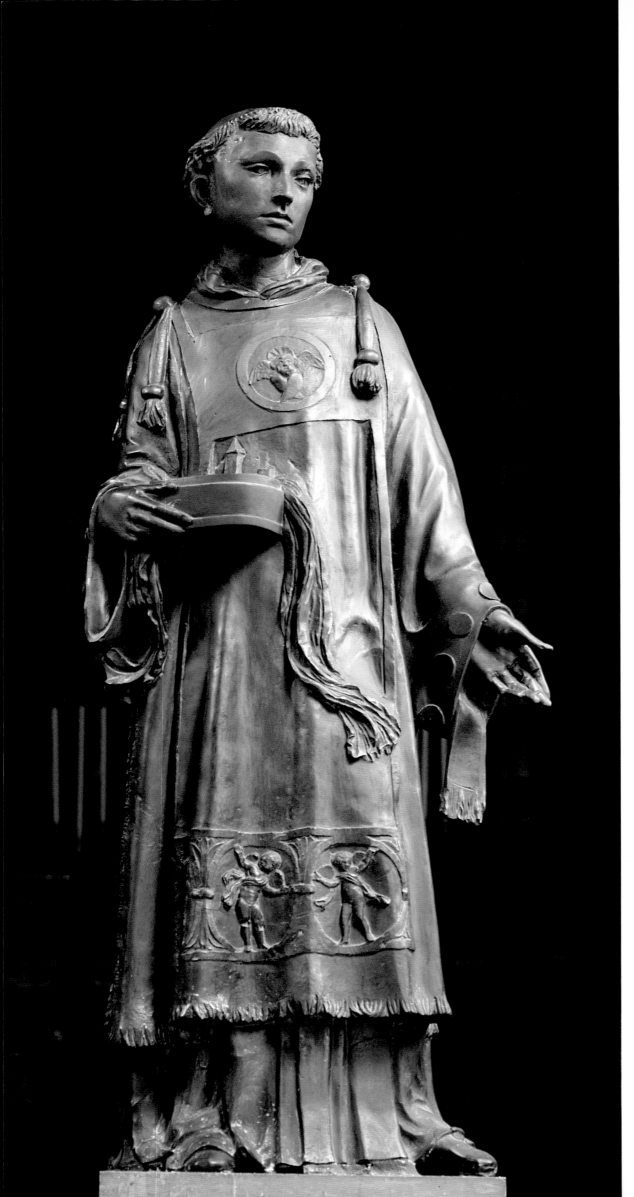

FIGURE 227.
Donatello, *St. Daniel*.
Bronze, H. 153 cm (60 in.).
Basilica del Santo,
Padua.

those in the Siena *Feast of Herod*; that in the center contains a circular Madonna relief. The application of gilding, which is handled so skillfully and with such intelligence in the other scenes, counteracts the spatial content of the relief. In the drawings of Jacopo Bellini, with whom Donatello must have been in contact from the time of his arrival in Padua, a similar relationship between architectural structure and narrative content is maintained. As in the marble relief at Lille, the architectural idiom is Albertian.

Fig. 240 In the second of Donatello's interior reliefs, the *Miracle of the Mule*,[36] the depth of modeling is reduced, and the flattening of the surface permits full integration between the figures and their majestic setting. The Miracle of the Mule took place in Toulouse, where, according to Polentone, the leader of a heretical cult vowed that he would return to the faith and acknowledge the authority of the Church if he could see a dumb animal pay reverence to the Host. On the appointed day the Saint, after saying Mass and still wearing his chasuble, reverently carried the body of Christ to the place selected for the contest. There the challenger derisively led in an ass, which had been unfed for three days. When his servant offered it hay, St. Anthony addressed the ass with the words: "By virtue and in the name of thy creator whom I hold in my hands, I address thee, animal, and enjoin that thou shalt forthwith show the reverence due to him, so that this wicked heretic shall learn that every creature is the servant of his creator, and is drawn by the priestly dignity to the altar." Hardly had the Saint finished than the hungry mule, ignoring the fodder, lowered its head as though moved by human reason, and genuflected on the ground. The stupefied heretic and a multitude of followers became faithful Christians, praising Almighty God. Polentone's account is closely followed in Donatello's relief. The Saint stands before an altar in the center with one foot on the altar step and one foot on the ground. To the right kneels the mule with its front legs on the altar step, and behind are the heretic's servants, carrying hay and a basket of oats. To the right, on a higher level, is the heretic with hand pressed in wonder to

Fig. 243 his mouth. To the right and left are groups of the faithful and of heretics volubly expressing their consternation at the miracle. The triple arcade above them, with pilasters running the full height of the relief but short of the front plane, depends from that familiar Albertian prototype, the Basilica of Maxentius. The keystones and spandrels of the three arches are filled with angels. The viewing point is lower than in the earlier relief, and the orthogonals of the lateral walls and of the ribs of the three archways meet in the center of the base. Not even the most credulous Franciscan could have believed that such a structure existed in Toulouse, and the setting must have read, as it still reads today, as an inspired aesthetic device. It has been rightly pointed out that the use of gilding is subtler than in the earlier scene, and that the ribs of the three arches are gilded unevenly, most strongly in the center, less strongly on the right and still less strongly opposite. The gilding achieves its maximum intensity on the altar. The rear wall terminates in a molding at the height of the figures adjacent to it, and above it are three open lunettes with metal grilles through which we look into a further space, again crowned by three arches. At the back, through another grille, the wall of a more distant building is visible. This extension of the background continues an area of experiment opened up by

FIGURE 228.
Donatello, Dalmatic of *St. Daniel*.

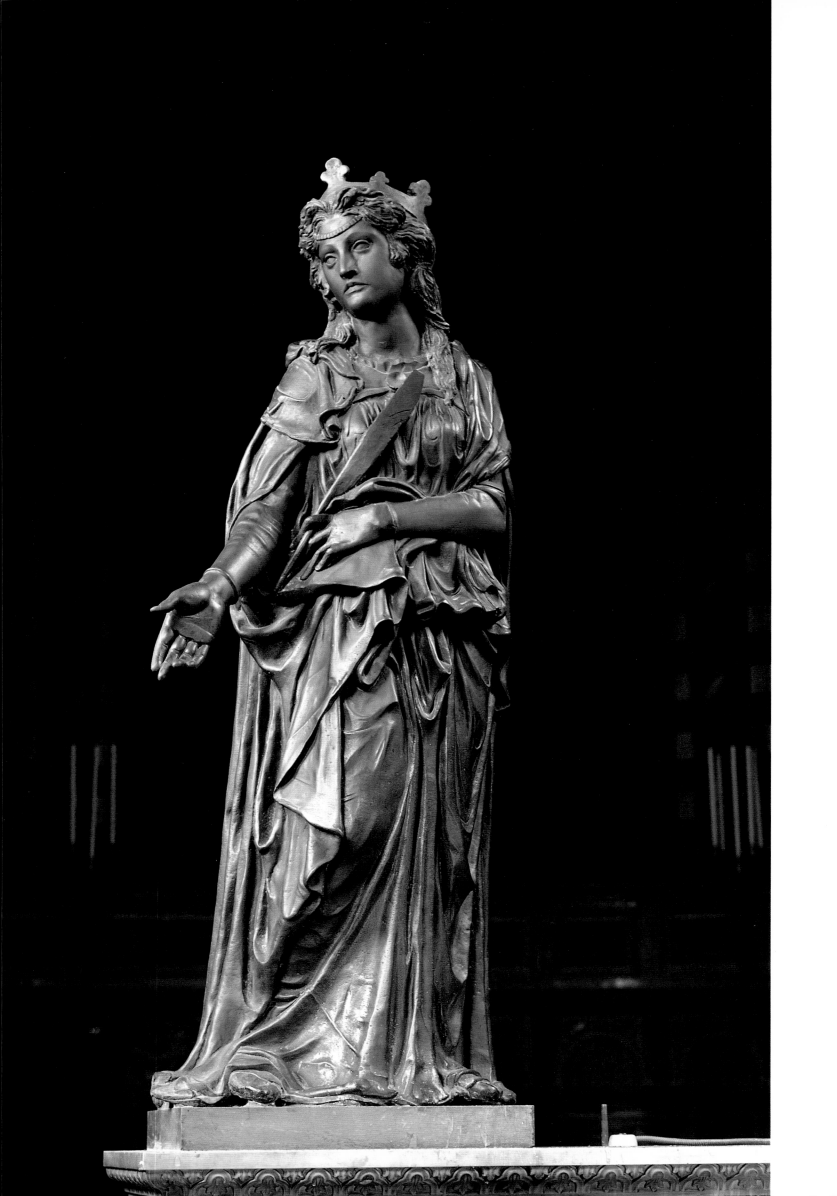

Donatello twenty years earlier in the *Feast of Herod* at Siena, and is the supreme example in the quattrocento of the employment of spatial perspective for decorative purposes. The figure style of the relief reflects a change in its narrative character. No single figure in it stands out as decisively as the husband and the youth balanced against a pier in the earlier relief. Though the reactions of individual onlookers are carefully defined, the groups have an inner coherence for which the *Miracle of the Newborn Child* offers no precedent. In the section on the right the extended right arm and the upraised forearms of two women and a kneeling man are mutually supportive and communicate surprise. In front of the pilasters two standing men serve as a frame for the miraculous event.

Fig. 244

Fig. 246

The Miracle of the Wrathful Son is described in some detail in Polentone's text. The boy's name was Leonardo, and he admitted in confession to the Saint that he had kicked his mother. In the confessional St. Anthony unwisely told him that "the foot that kicks a father or a mother deserves to be cut off," so the simpleminded boy, impressed by the Saint's rebuke, returned to his parents' house and cut off his own foot. When the news of this act spread, the Saint hurried to the scene. Making the sign of the cross, he stroked Leonardo's leg and reattached the foot. Donatello's relief takes place in the open air.[37] On the ground lies Leonardo, supported by his father, who puts one hand on his cheek and with the other raises his knee. A second man behind holds the boy's arm. The Saint kneels in right profile, with one hand on the victim's foot and with the other on his leg. On the right is a group of older men, with arms extended horizontally, and on the left are four women kneeling behind the Saint. The figure of the wrathful son is adapted from a sarcophagus relief with the death of Pentheus in the Campo Santo at Pisa. In the extreme left corner sits Leonardo's mother, with one hand to her face. Behind her, a young man, with a basin, and a girl holding a spindle, discuss the scene, and to their right, visible through an archway, are two River Gods.[38] The vanishing point is in the center of the foreground, as it is in the *Miracle of the Mule*. At either side are flights of steps

Fig. 245

leading, on the left, to a public building and, on the right, to a house whose upper stories are severed by the frame. Behind is an expanse of tiered seats, perhaps the tiered forum described in Alberti's *De Re Aedificatoria*, and behind it, at the extreme back, is the corner of a large building. The illusion of great distance is due in part to the presence of diminutive and diminishing figures in the tiered area behind. The perspective construction is more complex than that of the *Miracle of the Mule*, and the use of gilding is related to a specific light source, a gilt sun that appears in the cloudy sky to the left of center of the scene. The golden light falls most strongly on the faces of the buildings to left and right and on the facing wall behind the seats, but the gilding was originally diversified more strongly with the use of silver damascening on the surface of the right-hand steps. In photographs the relief looks small and schematic. On the altar, however, it reads not as a theorem in geometry, but as a vast, sun-saturated space.

Fig. 247

According to Polentone's narrative, the Miracle of the Miser's Heart took place in Tuscany, where the Saint came upon the funeral procession of a wealthy miser. Moved by anger, he exclaimed: "This dead man should not be interred in sacred ground, but should be buried like a dog outside the city walls. His soul is

233

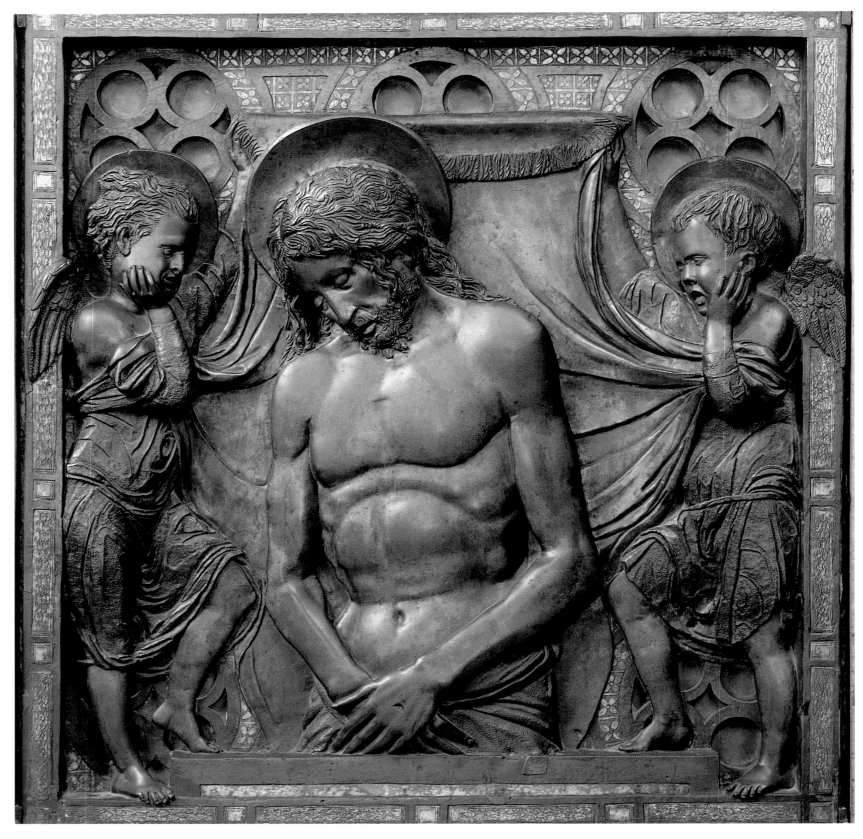

FIGURE 230.
Donatello, *Christ in the Tomb Mourned by Two Angels*.
Bronze, H. 58 cm, W. 56 cm (H. 22¾ in., W. 22 in.).
Basilica del Santo, Padua.

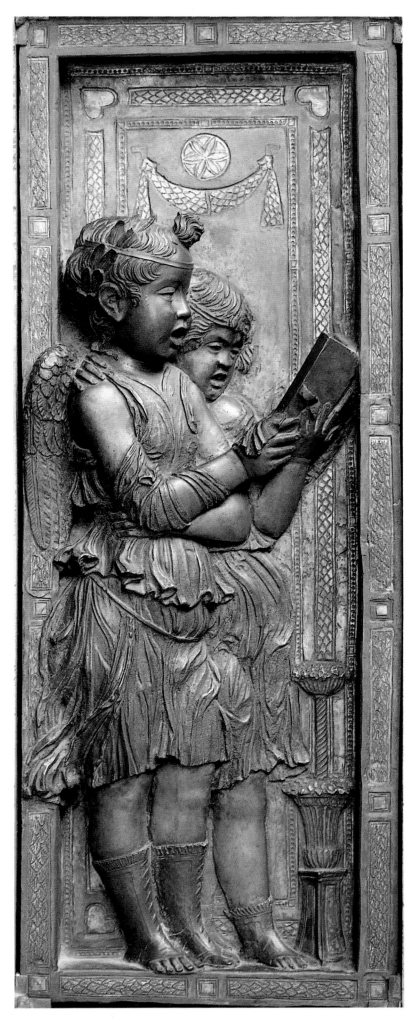

FIGURE 231.
Donatello, *Two Angels Singing
from a Book*. Bronze,
H. 58 cm., W. 21 cm (H. 22¾ in., W. 8¼ in.).
Basilica del Santo, Padua.

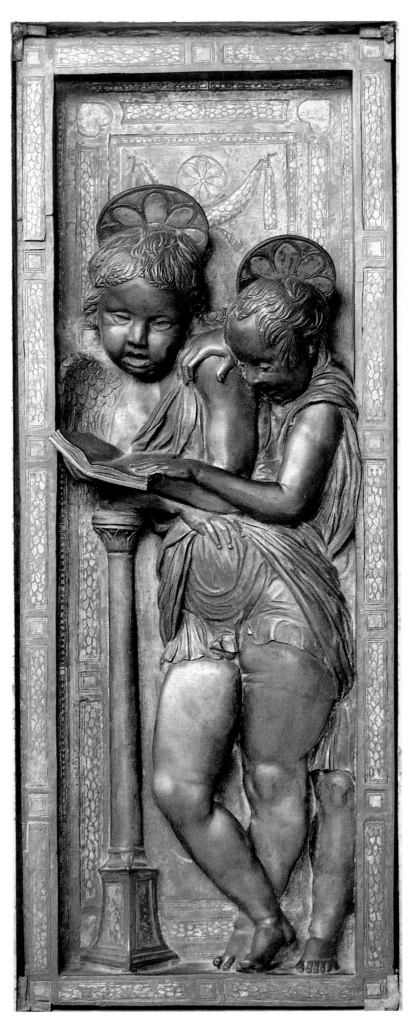

FIGURE 232.
Donatello, *Two Angels Singing
at a Lectern*. Bronze,
H. 58 cm. W. 21 cm (H. 22¾ in., W. 8¼ in.).
Basilica del Santo, Padua.

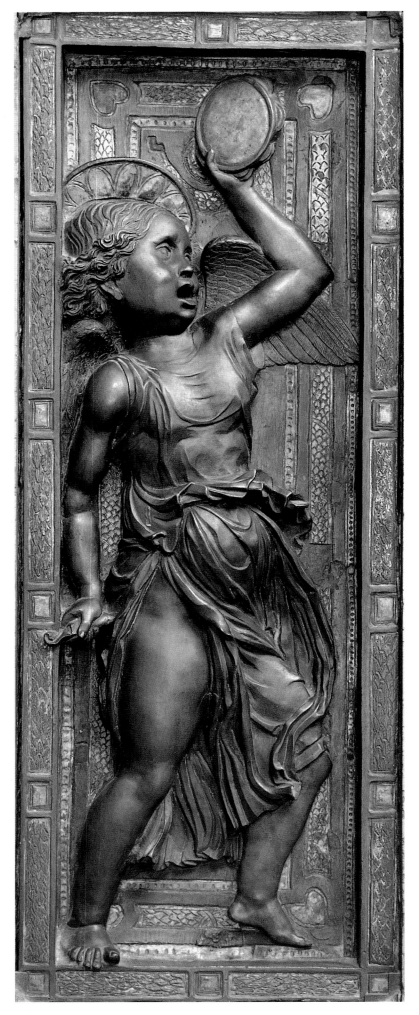

FIGURE 233.
Donatello, *Angel with a Tambourine*.
Bronze, H. 58 cm, W. 21 cm (H. 22¾ in., W. 8¼ in.).
Basilica del Santo, Padua.

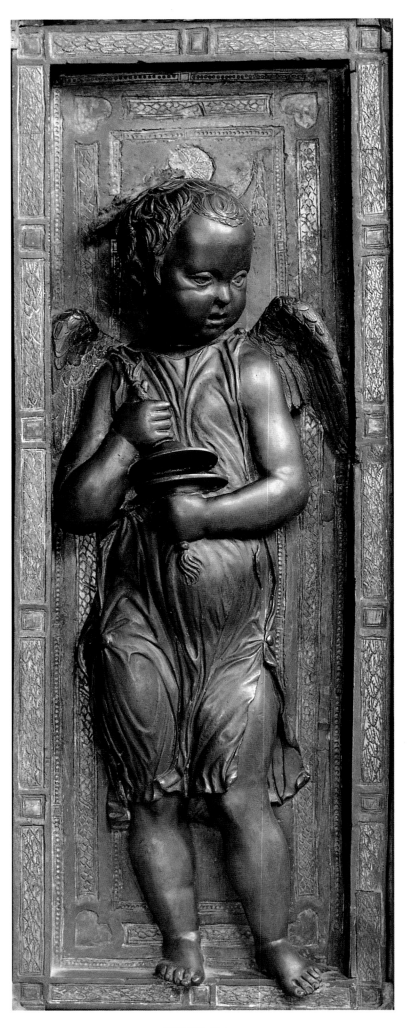

FIGURE 234.
Donatello, *Angel with Cymbals*.
Bronze, H. 58 cm, W. 21 cm (H. 22¾ in., W. 8¼ in.).
Basilica del Santo, Padua.

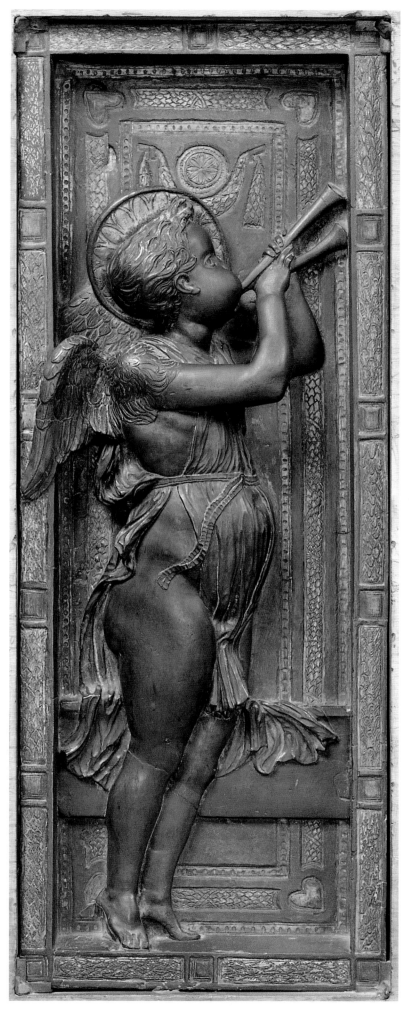

FIGURE 235.
Donatello, *Angel Playing a Diaulos.*
Bronze, H. 58 cm, W. 21 cm (H. 22³/₄ in., W. 8¹/₄ in.).
Basilica del Santo, Padua.

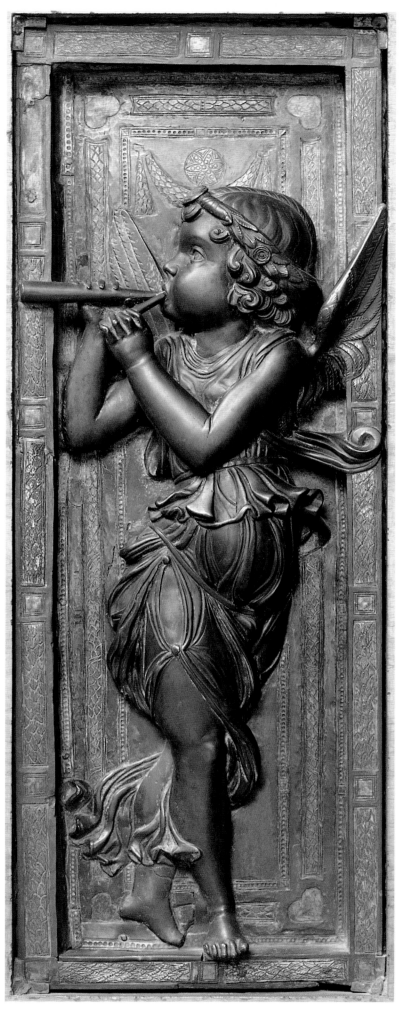

FIGURE 236.
Donatello, *Angel Playing a Double Pipe.*
Bronze, H. 58 cm, W. 21 cm (H. 22³/₄ in., W. 8¹/₄ in.).
Basilica del Santo, Padua.

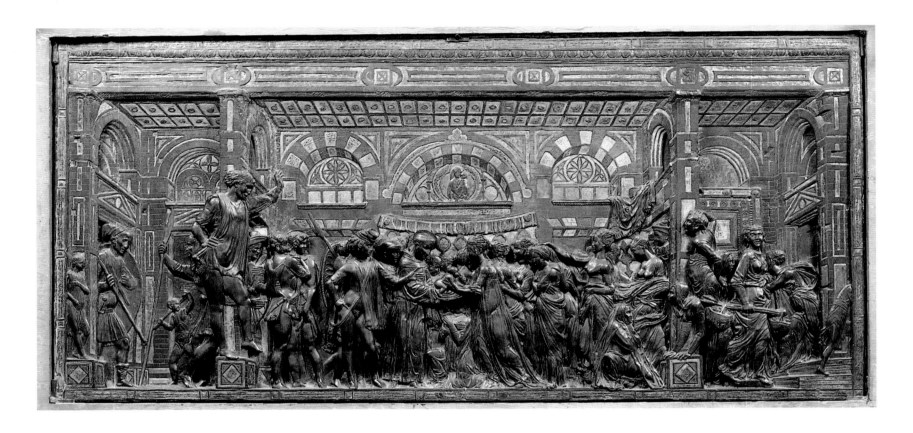

FIGURE 237.
Donatello, *Miracle of the Newborn Child.*
Bronze, parcel gilt, H. 57 cm, W. 123 cm
(H. 22½ in., W. 48½ in.).
Basilica del Santo,
Padua.

condemned to hell, and his heart will be found not in his body, but, as the Evangelist St. Luke records in the words of Our Lord: Where his treasure is, there his heart will be." Hearing the Saint's reproof, the crowd scattered. Those who remained cut open the corpse, but could find no trace of the heart, which, as the Saint predicted, was then discovered in the chest where his money was stored. Donatello's relief illustrates two separate events, the funeral and the finding of the heart.[39] At the back is a church façade, the center of which falls in the middle of the scene. The vanishing point is in the center, midway between the top and bottom edges of the relief. To right and left are rooms in the miser's house. The viewing point is to the right of center, so that the open end of the chamber on the right recedes more sharply than the corresponding wall of the room opposite. This imbalance lends dramatic force to the two lateral scenes, which show the discovery of the miser's heart and the discomforture of his family.

Figs. 249, 2.

In the four great Miracles of St. Anthony of Padua it is essential to distinguish between the figure content and the setting. The settings are North Italian, not Tuscan. At Padua Donatello seems to have been at first bewildered and then captivated by Venetian perspectivism. The richness of experience it offered can be judged today from the mosaics in the Mascoli Chapel in St. Mark's and from the sketchbooks of Jacopo Bellini. The visual evidence for Donatello's dependence in the Padua reliefs on Jacopo Bellini is incontrovertible.[40] Sometimes the parallel is specific, as it is in the relation between the façade in Bellini's drawing of the *Flagellation by Torchlight* (Louvre, 5) and the structure of Donatello's *Miracle of the Mule.* Sometimes it is schematic, as it is in the relation between Bellini's *Adoration of*

Fig. 242

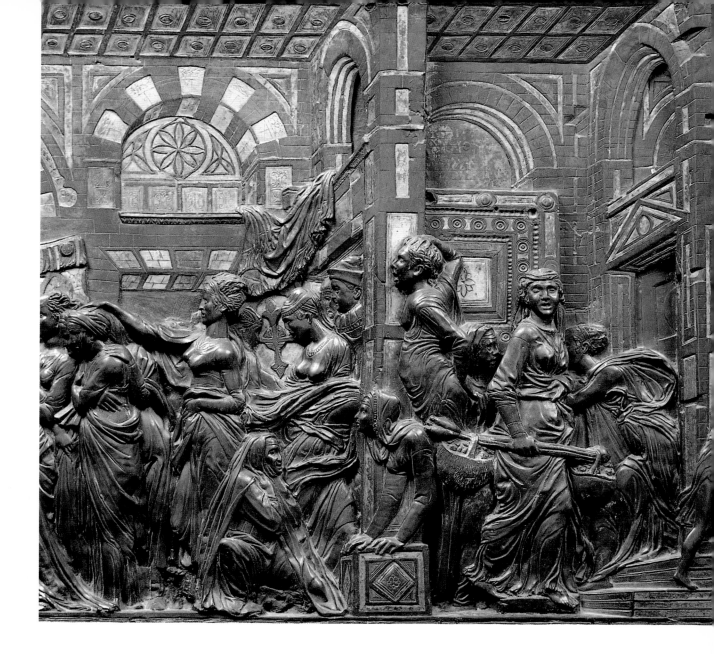

FIGURE 238.
Donatello, *Miracle of the
Newborn Child* (detail).

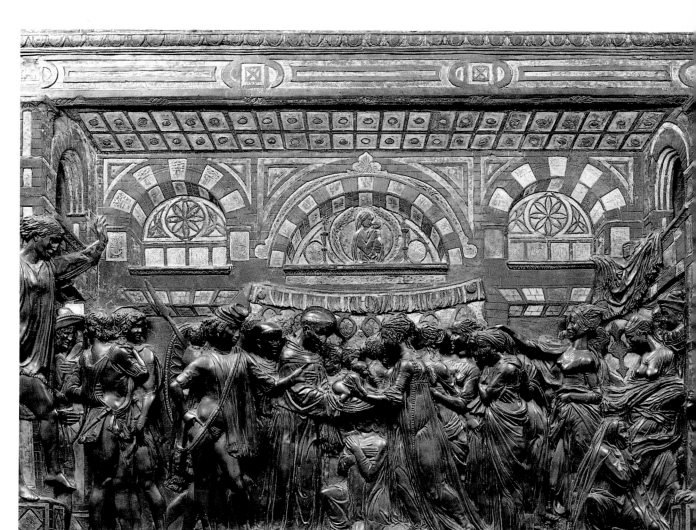

FIGURE 239.
Donatello, *Miracle of the
Newborn Child* (detail).

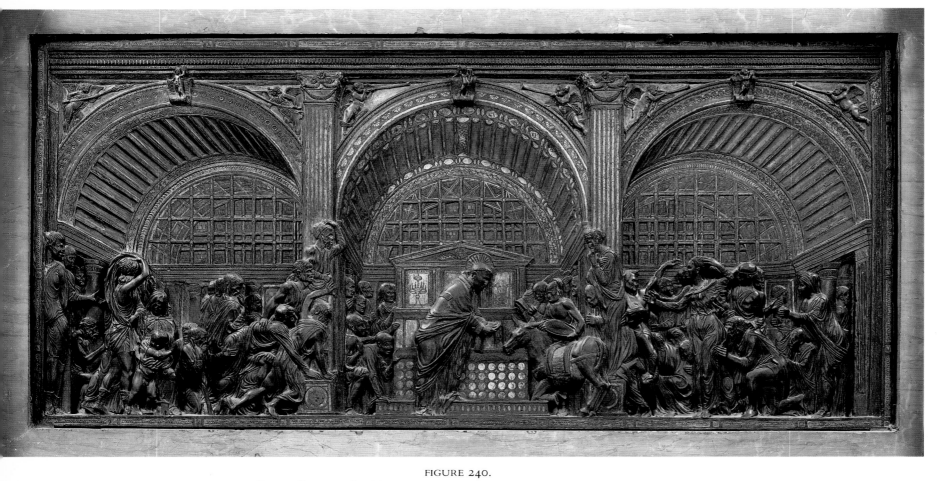

FIGURE 240.
Donatello, *Miracle of the Mule*. Bronze, parcel gilt, H. 57 cm, W. 123 cm
(H. 22½ in., W. 48½ in.). Basilica del Santo, Padua.

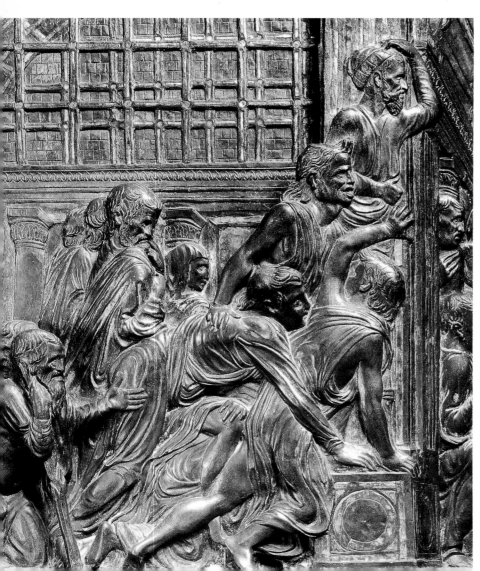

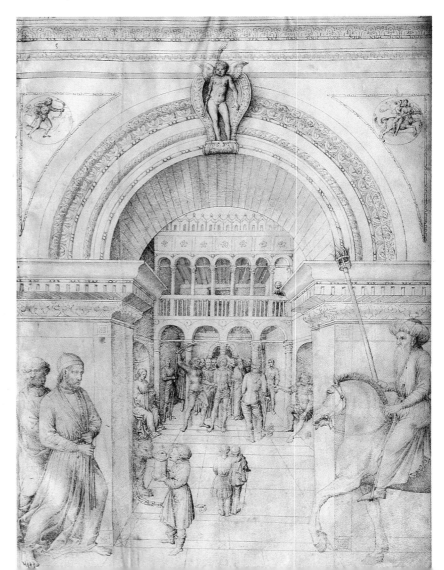

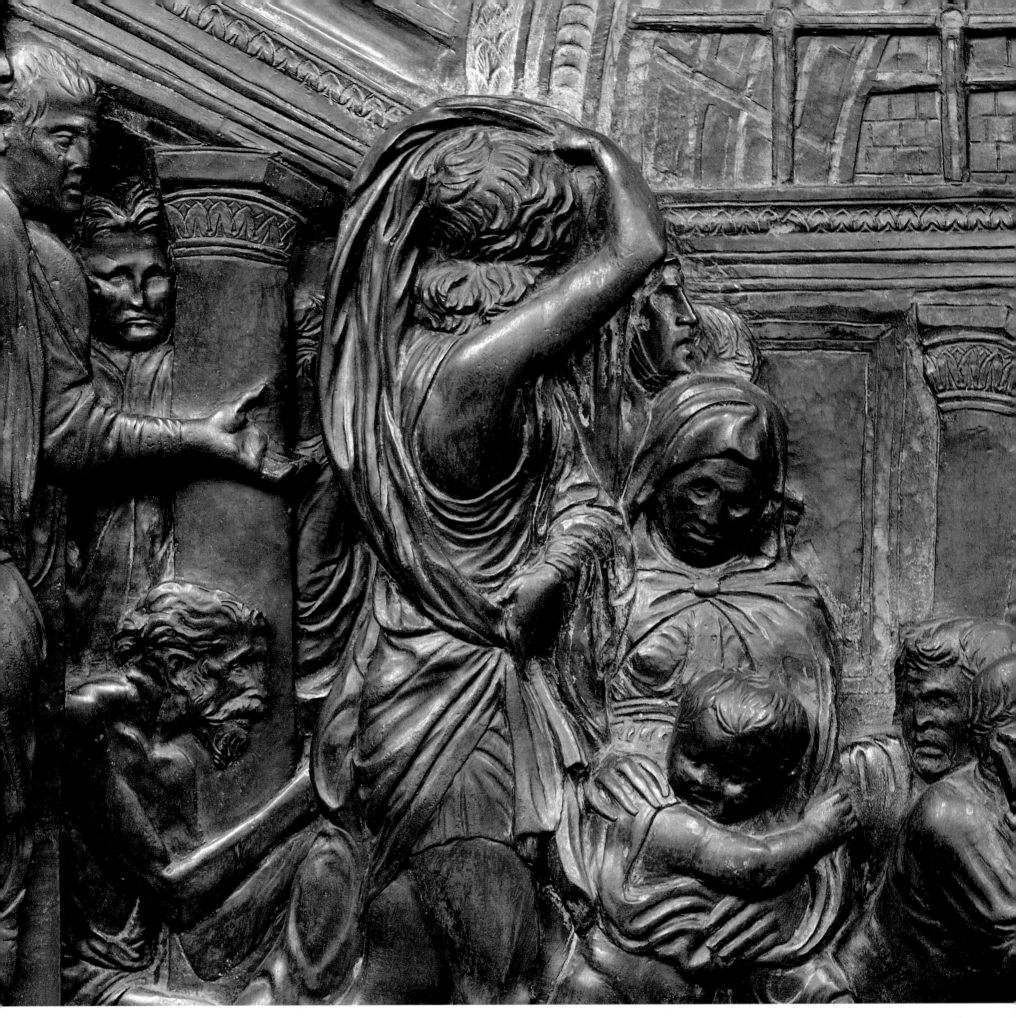

opposite, below left: FIGURE 241.
Donatello, *Miracle of the Mule*
(detail).

opposite, below right: FIGURE 242.
Jacopo Bellini, *Flagellation by Torchlight.*
Ink on vellum.
Musée du Louvre,
Paris.

above: FIGURE 243.
Donatello, *Miracle of the Mule*
(detail).

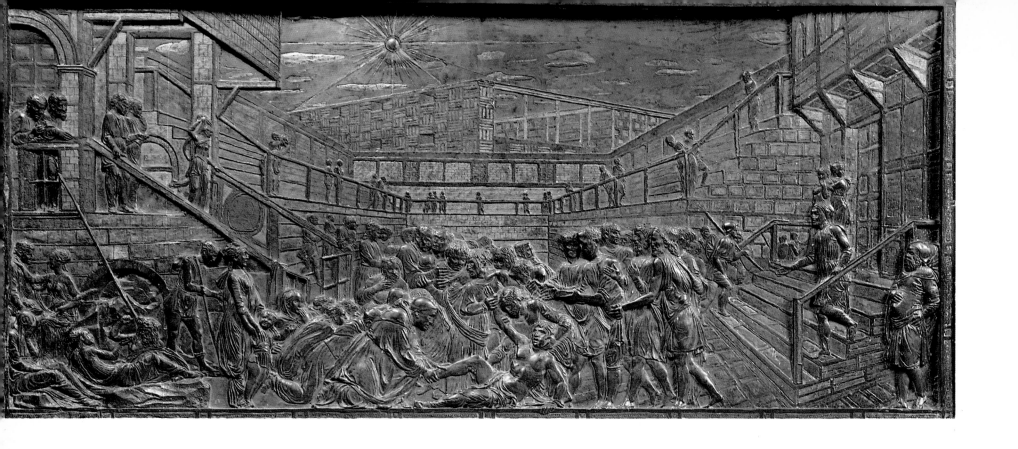
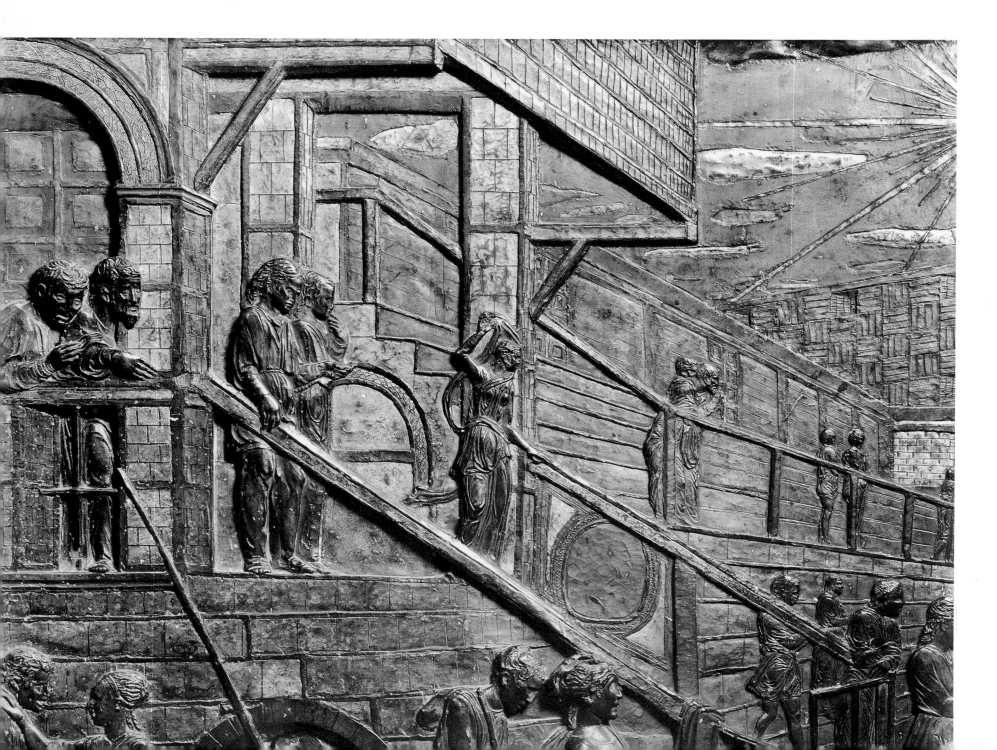

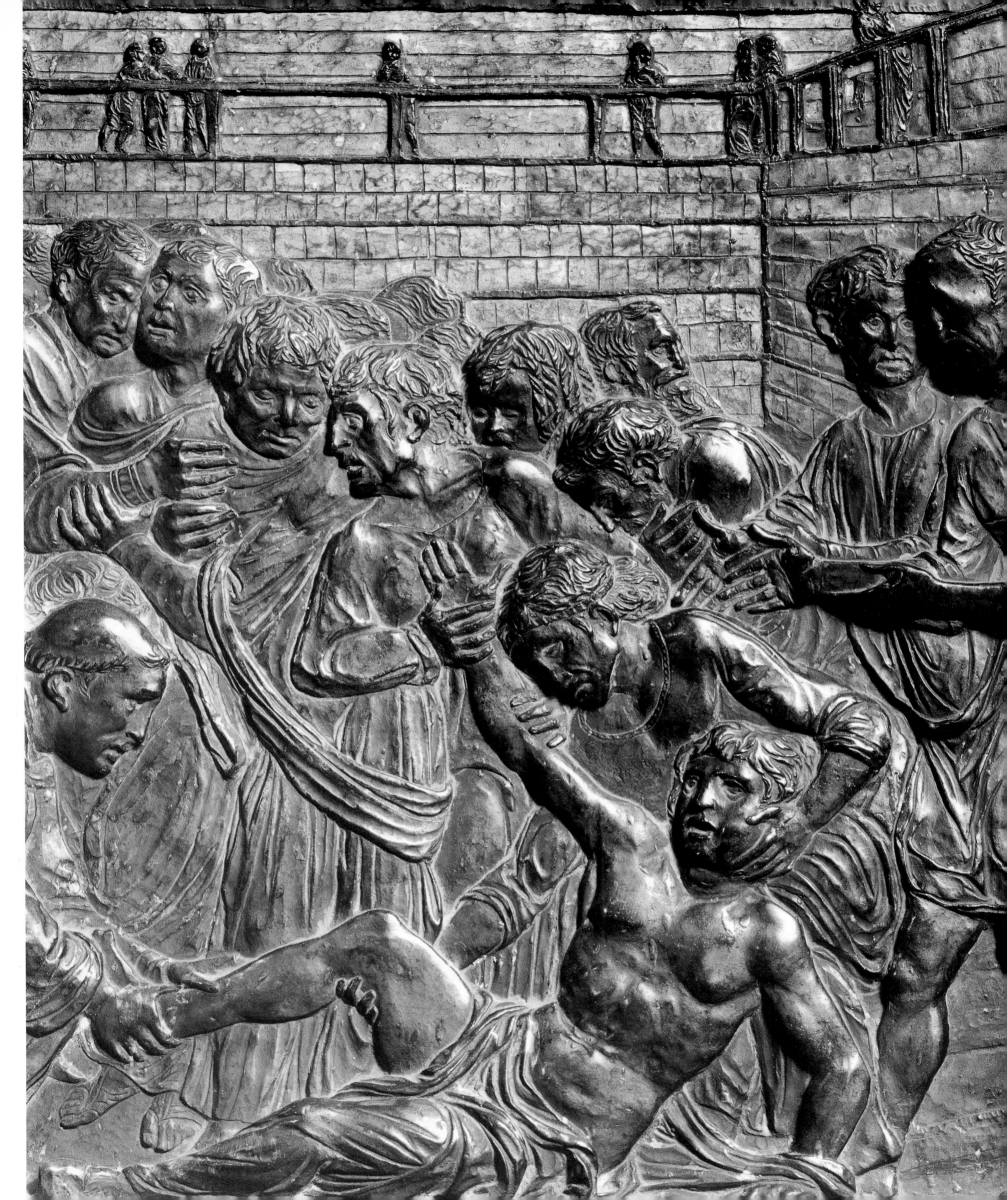

the *Shepherds* (Louvre, 37) and *Nativity* (British Museum, 64, 99) and the girders or glazing bars seen through the windows in Donatello's reliefs. Sometimes it is a common visual problem, like the representation of distant figures looking forward from a balcony, and sometimes it is a simple matter of topographical detail, like the arch under a stairway on the left of Donatello's *Miracle of the Wrathful Son.* In all four cases, the scenic language is a Venetian dialect, but a dialect employed with greater imagination and control than it had been by Jacopo Bellini or any other contemporary Venetian artist. Jacopo Bellini was primarily a graphic artist, and when his schemes were transferred from drawing to painting, as they are in the predella of the Annunciation altarpiece at Brescia, they lost much of their logic and their quality. In Donatello's reliefs, on the other hand, the logic of the setting is retained, partly through the agency of a more powerful mind that had, a quarter of a century before, lived through the perspective revolution of Brunelleschi, and partly through the introduction of an element of color in the form of refined local gilding and of silvering, which is now in large part lost. The gilding is not the overall gilding used in the Siena *Feast of Herod* and the *Gate of Paradise* of Ghiberti; it is a technical expedient that is used purposefully and with great discretion to invest the relief field with an unprecedentedly pictorial character.

The figurative content of the scenes is of the utmost vividness. It reveals a mastery of expression that goes back to the marble *Ascension with Christ Giving the Keys to St. Peter* in London. But whereas the Apostles in the *stiacciato* relief register a relatively small gamut of emotions—consternation, surprise, regret—the reactions of the figures in the Padua reliefs are more diverse. The miracles are transposed to the fifteenth century. As we read from silhouette to silhouette and head to head, they represent responses—sometimes supportive, sometimes hostile—which record the working of the artist's imagination and the observations of his eyes. While the mastery of gesture looks back to the reliefs in the Old Sacristy, at Padua definition is taken a stage further, with portrayals of the Saint in the world in which Donatello himself lived. This is the public that responded with such enthusiasm to the sermons delivered in Padua by San Bernardino in 1443. The reliefs combine a sense of emotional excitement—witness the two lateral scenes of the *Miracle of the Miser's Heart,* with the opening of the coffer on one side and on the other the miser's frightened family—with total intellectual control, manifest in the steep triangle of figures beside the left-hand pier in the *Miracle of the Mule* and the cursive group of women spectators opposite. The structure of the groups, like the structure of the settings, can have resulted only from a long period of study and analysis.

That Donatello in Padua continued working as an architect is attested by a lawsuit in which he was involved.[41] He was, by his own account, approached in August 1447 by a Florentine named ser Petruzo, who told him that certain members of an unnamed confraternity in Venice were anxious to construct a chapel. If Donatello wished, he could have this commission. According to the notary, Donatello replied, "Sum contentus habere istam fabricam et sum paratus eam facere." At ser Petruzo's request, Donatello thereupon prepared a wood and wax model of the work. The model was "pulcram et ingeniosam," but no payment for it was received. Its value

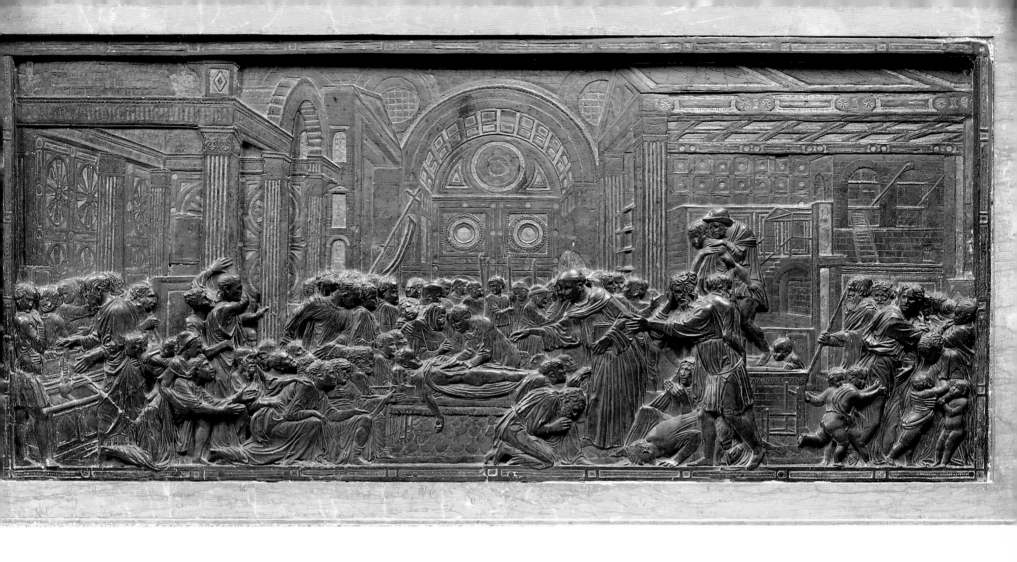

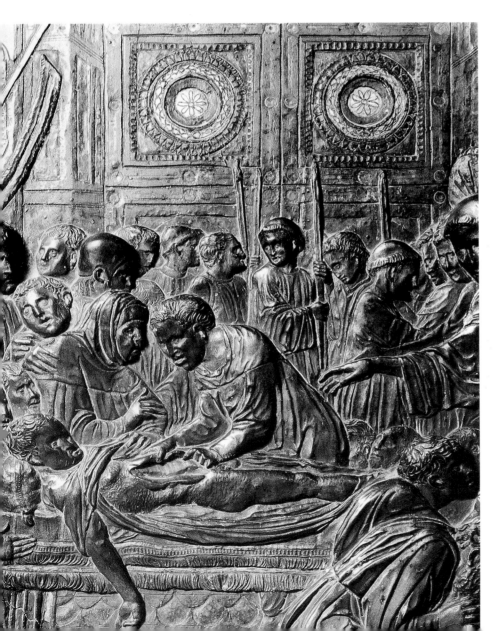

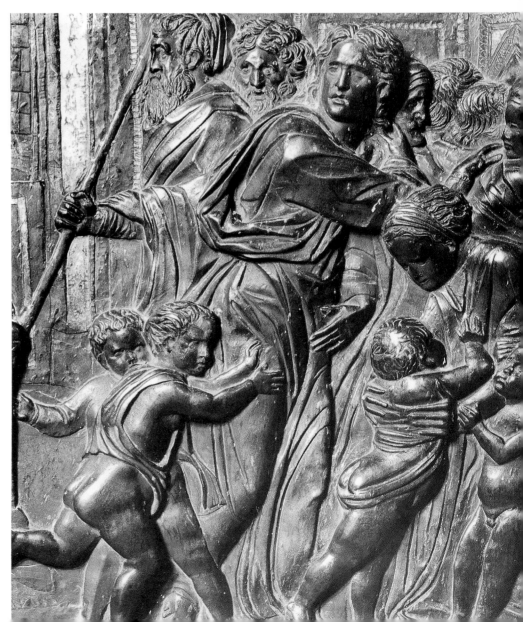

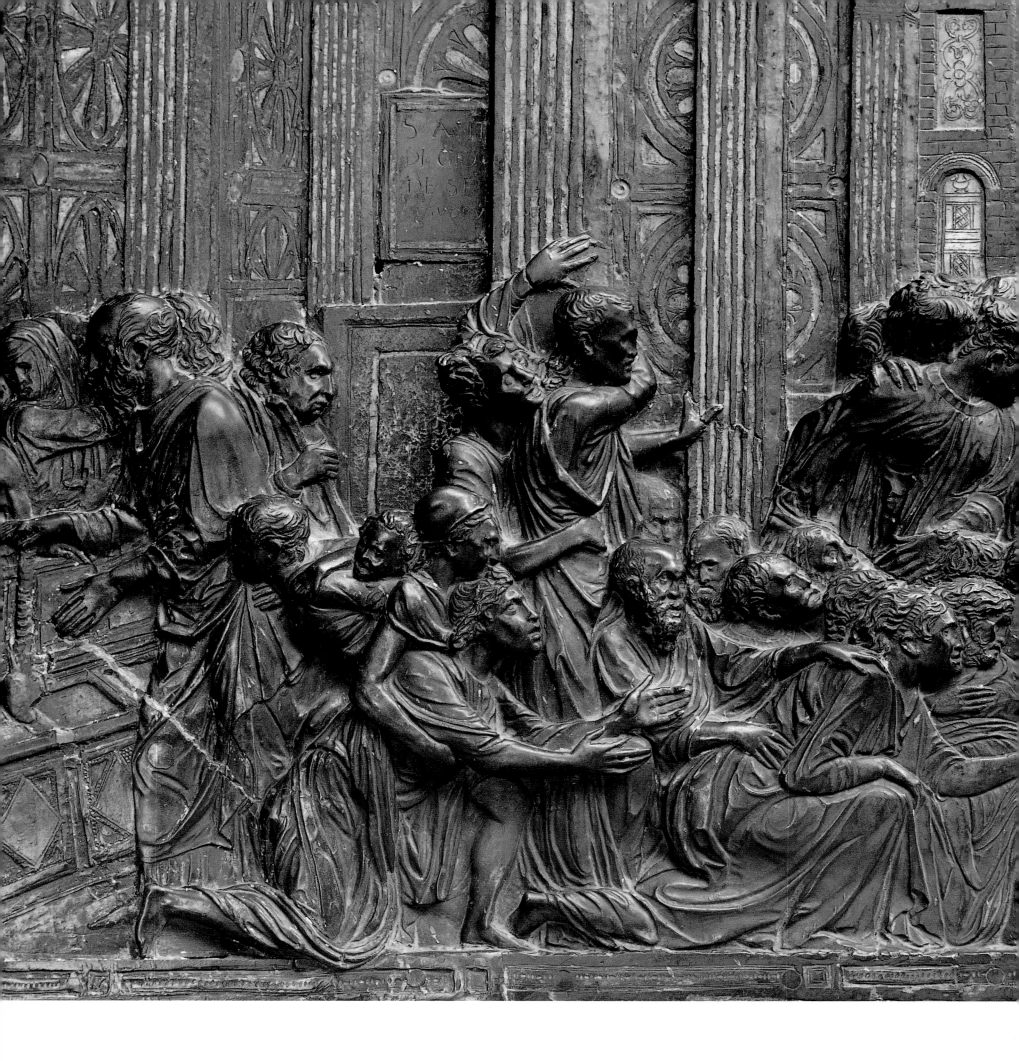

246

was assessed at twenty-five ducats. The claim dragged on for three years, and in April 1450 evidence on Donatello's behalf was given by three witnesses. The first, Giovanni di Stefano da Padova, when asked whether ser Petruzo was aware of the existence of the model, replied that he was; he had requested Donatello to bring the model to Venice, but Donatello was unwilling to agree to this, since local Venetian artists ("alii magistri ipsius civitatis") would then see it. The second witness, Giovanni da Feltre, reported telling Donatello that he had heard of the existence of the model. "Quis vobis haec dixit?" asked Donatello. The witness replied that he had this information from ser Petruzo. Lastly, Francesco d'Antonio, a bronze sculptor, said that the model had been completed, and that he had witnessed the conversation with ser Petruzo, which had taken place in the cloister of the Franciscan convent at Bovolenta in the presence of a certain Paolo da Ragusa and "quodam puero cujus nomen non recordatur." Judgment was given in favor of Donatello.

In his last years in Padua, Donatello's services were in great demand. In October 1450 the Council of the Commune of Modena decided to erect a marble statue in honor of Borso d'Este, Duke of Ferrara, with an inscription recording the city's gratitude to him for abolishing the tax on salt and for reducing another tax.[42] A formal letter of gratitude dispatched two days later to the Duke contained a request that he would supply a painting of himself so that work on the statue could proceed, and asked in what clothes he should be shown. A standing figure seems to have been required, and Donatello, when he visited Modena at the beginning of March 1451, explained to the Consiglio del Comune that it would be better to commission a bronze, not a marble statue, since in marble the ankles might not afford the necessary support. If it were in bronze, it could be fire gilt. Next day the Council voted, by ten to one, that the statue should be in bronze "secondo il disegno già eseguito," and rejected, by three to eight, a suggestion that other designs should be considered. A day later, on March 10, a bronze gilt statue was commissioned from Donatello, to be finished and installed within a year at a cost of three hundred florins. The statue was to be of the same height and width as a portrait in the hands of the Council. The scale might be increased, but was not to be reduced, and Donatello would himself supervise the marble carvers responsible for the base. He was paid ten florins and, at the beginning of April, with four companions and a guide, spent six days "in montagne" selecting marble for the plinth. In August 1452 it was arranged that Donatello, who had returned to Padua, should be paid twenty-five florins a month against his salary from Modena. There is no further reference to the statue till January 1453 when it was decided by the Consiglio del Comune at Modena to send an emissary to Padua to see Donatello. In March a representative of the Council visited Padua and reported on his return that Donatello would shortly come to Modena to execute the statue. The project seems to have been abandoned when Donatello returned to Tuscany.

Throughout his last four years in Padua, Donatello was also engaged on work for Lodovico Gonzaga, Marquess of Mantua. The commission was for a shrine or altar for the remains of Sant'Anselmo, which were preserved in Mantua Cathedral.[43] At the end of May 1450 a letter from Lodovico to his Vicario at Revere

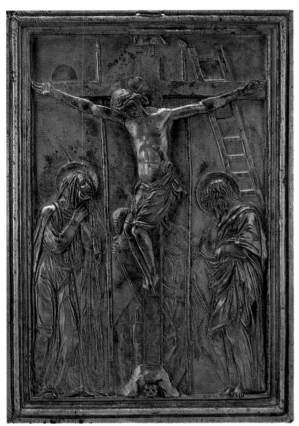

FIGURE 251.
Donatello, *Crucifixion*. Bronze,
H. 46 cm, W. 28.8 cm
(H. 18 in., W. 11³/₈ in.).
Musée du Louvre,
Paris.

enjoins that special care should be taken of "sette figure mandate per Donatello." The figures were evidently fragile and presumably were made of wax, since this medium is mentioned in a further letter of June 10 from Lodovico to his wife, Barbara of Brandenburg, which refers to the dispatch from Padua of works by Donatello and Giovanni da Milano, which would require especially careful handling. They consisted of three fluted columns with their capitals and bases, three Madonnas, one in tufo and two in terracotta, a head of a putto carved from living rock, a tufo figure of St. Andrew, and two wax reliefs. Donatello must have visited Mantua in connection with the Arca, since a reproachful letter to him from Lodovico Gonzaga complains that for some months his return had been awaited "a fundere e finire la Archa che altra volta formasti qui del glorioso S. Anselmo." The Arca, declared the Marquess, could not be left incomplete, and if Donatello did not propose coming to finish it he would have no alternative but to hand it over to other artists. The commission is mentioned again at the end of November in a letter from Barbara of Brandenburg to her husband enclosing a further letter written by "M.ro Nicolo taiapreda de Fiorenza" to Giovanni da Milano, reporting on "el bon portamento di Donatello." The term "bon portamento" suggests that Donatello had given some satisfactory assurance over the completion of the shrine. Nothing more is heard of the Arca till the summer of 1458, when Donatello, then domiciled in Siena, expressed his willingness to move to Mantua. A model for the Arca was certainly made, since it is referred to in a letter from Lodovico Gonzaga of August 23, 1470, insisting that a certain Pietro Filippo da Cortona should get in touch with Battista da Cermino "perchè lui se trovò qua cum Donatello quando el fece quelle forme de l'archa, s'el vora venire, cum el nome di Dio, so non, lassaremo stare l'archa, ma, volendo venire, el voglia avisarcene et a quel tempo el delibera trovarsi qua, a ciò sapiamo quello che fare. Ogni altro bisognaria andare a tastone, perchè lui era presente quando Donatello la formò." A single relic of Donatello's work for Mantua survives in the form of a much-weathered tufo relief of the Blood of the Redeemer carved by a member of his Paduan workshop from his design.[44]

The third major commission offered to Donatello while he was in Padua came from Alfonso I of Naples,[45] who wrote on May 26, 1452, to the Doge of Venice, Francesco Poscari, expressing the hope that Donatello would move to Naples after the *Gattamelata* was complete. "You will know," declared the King, "how great is the pleasure we take in bronze and marble statues and sculpture." The King was certainly in earnest. A second letter bearing the same date was delivered to the Venetian orator in Naples, Zaccari Vallreso, explaining that the King, having learned of the "subtilitate et solertia de ingenio de Donatello mastru de fare statue di bronço et de marmore" was anxious Donatello should enter his employment, and was prepared to pay him whatever he had been paid, "ad instantia di quella Illma. S.," for the Gattamelata statue. Parallel representations, it was explained, were also being made on the King's behalf in Venice by the Neapolitan ambassador, Fra Puig Clavero de Montesa. There is no record of the Venetian reply to these communications, but a direct approach must also have been made to Donatello, who, resisting a temptation that most sculptors would have considered irresistible and faithful to his sense of destiny, turned the proposal down.

Donatello's work at Padua presents one final problem, which has never been properly investigated. In the 1430s in Tuscany, his output was spectacularly large. In the 1440s, however, in Padua, he is commonly credited only with the production of major documented works. The two productive patterns are irreconcilable, and we are bound to assume that in Padua he continued to turn out a large number of minor sculptures. A good many of his Madonnas date from this time. A letter of Lodovico Gonzaga mentions Madonnas supplied to Mantua, one of which was in tufo, and no sooner was Donatello back in Florence than we learn of the purchase by Giovanni de' Medici of two Donatello Madonnas sent down to Florence from North Italy. It is through these Madonnas (discussed here in a separate chapter) that his relations with Mantegna (who was twenty-three when Donatello left Padua for Florence) can be most clearly read. The Donatellesque Madonnas of Mantegna, with their reflective, rigorously classical features, almost without exception date from after 1453, but without the precedent of reliefs modeled by Donatello in Padua, they might well have taken an altogether different form. What is involved is not interdependence; it is, rather, that the emotional language and the formal standards of both sets of images are uniform.

Fig. 251

Facilities for casting being readily available in Padua, Donatello must while there also have produced independent bronze reliefs. One of them appears to be a *Crucifixion* in the Camondo collection of the Louvre,[46] where the modeling of the torso of Christ is strikingly similar to that of the *Imago Pietatis* in the predella of the Padua High Altar. The similarity extends to the two figures of the Virgin and St. John, whose compact silhouettes and particularized drapery are closely similar to those of figures in the *Miracle of the Newborn Child*. At the back, propped against an arm of the Cross, is a diagonal ladder, and parallel to the central vertical are the lance and the spear that held the sponge. On a lower level behind are a number of soldiers. Given its strange iconography, this is likely to be identical with a Crucifixion relief described by Borghini in the sixteenth century in the Medici guardaroba, "un altro quadro pur di metallo in cui si vede Christo in Croce con altre figure appartenenti all'istoria." Presumably the relief was sent down to Florence or was taken there by Donatello when he left Padua.

Fig. 252

Another relief for which a Paduan origin can be confidently postulated is a small *Martyrdom of St. Sebastian* in the Musée Jacquemart-André, which depends from a classical Flaying of Marsyas.[47] The splendid figure of the Saint bound to a column, with his elbows set on a diagonal leading from the upper left corner of the frame, the angel at the back holding a palm of martyrdom, and the two soldiers with their arms extended horizontally half way across the scene, are more explicable in the academic climate of Padua than they would be in Florence.

Fig. 253

One of the last works produced in Padua is a bronze relief in the Bargello, at one time in the Medici *guardaroba*.[48] Its Paduan origin can be established from the fact that extensive use is made throughout of damascening, a technique used extensively in the *Miracle of the Miser's Heart*. It has been suggested that the Bargello relief is identical with a parcel gilt "hystoria domini nostri Jesu Christi de passione in aere commissa cum auro" recorded in an inventory of Francesco di Roberto Martelli in 1523, which was sold to the Grand Duke at some time prior to 1568. It may also be

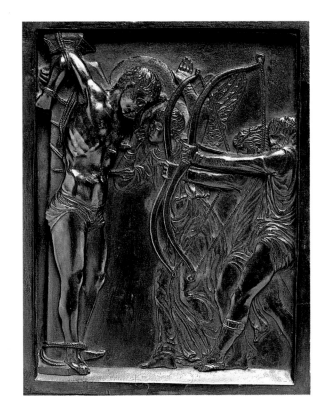

FIGURE 252.
Donatello, *Martyrdom of St. Sebastian*.
Bronze, parcel gilt, H. 26 cm, W. 24 cm
(W. 10¼ in., H. 9½ in.).
Musée Jacquemart-André,
Paris.

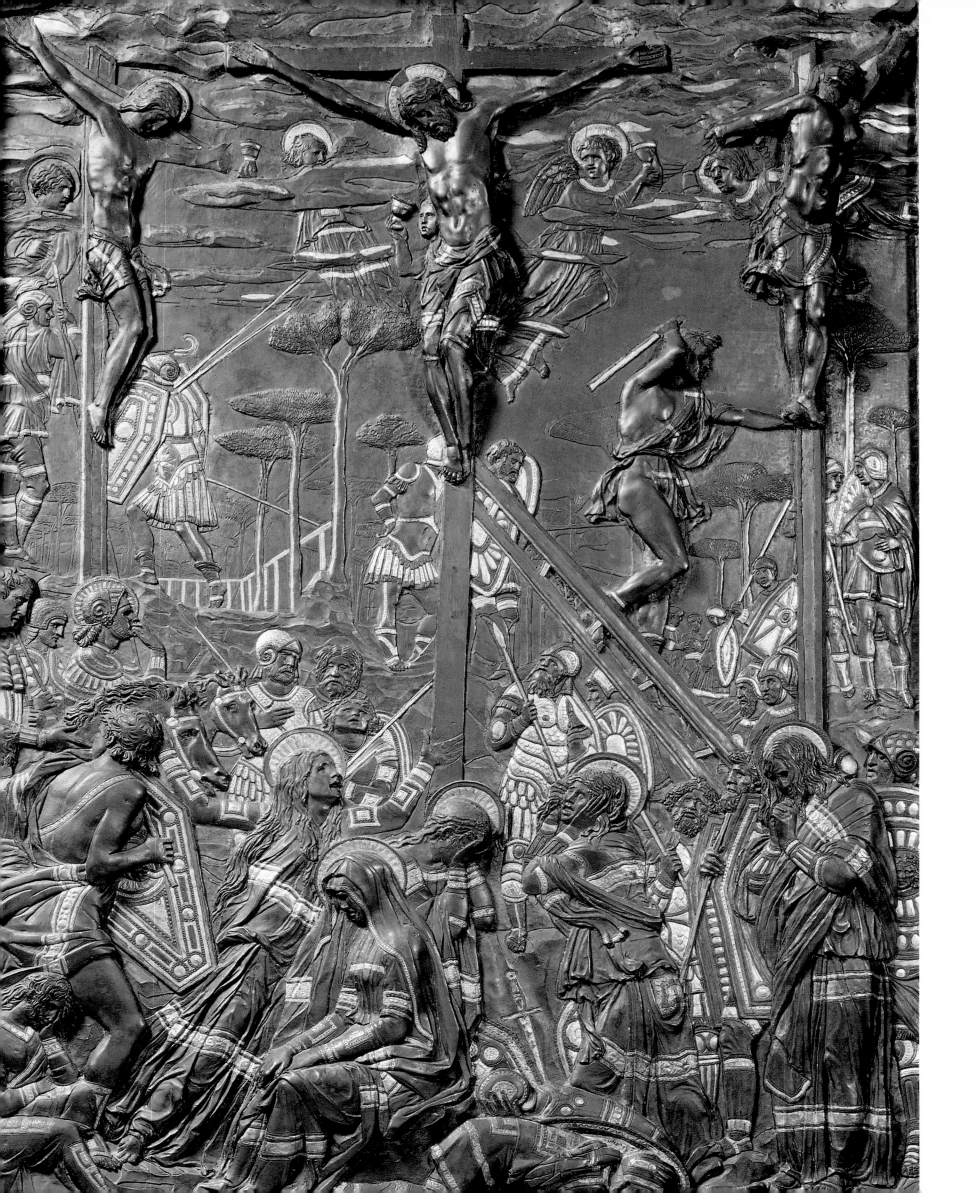

identical with a bronze relief sent down from Padua to Florence with other works by Donatello in 1454.

The relief is planned in two superimposed sections. Designed with a low viewing point, the lower section is crowded with lamenting figures, in the center the Virgin, behind her St. Mary Magdalen, and on the extreme right St. John. One of the most impressive figures in this part of the scene is a youth with back turned, holding a shield on the extreme left. The upper half is projected from a higher viewing point and is dominated by the crosses, that of Christ flat on the relief plane, those of the two thieves receding through the picture space. In the distance, beyond the cross of the Repentant Thief, we look, as we might look in a drawing by Jacopo Bellini, down a hill with a receding line of trees and a gilded fence, while on the right we see, still farther back, a group of soldiers and spectators. The two scenes are linked by a diagonal ladder leading downward from the cross of Christ, on which there stands a youth in right profile breaking the legs of the Unrepentant Thief. Much of the damascening with which the scene was originally relieved has disappeared. The cross of the Good Thief retains a vertical silver strip on its main shaft, but lacks the silver inlay that originally ran across the arms, and the cross of the Unrepentant Thief retains its gold inlay on the arms but lacks the strip of gold that originally ran down the shaft. In the ground there are a number of irregular lozenge-shaped recesses that were originally filled with silver (a few of these insertions still survive), and similar recesses are found in the sky, where the undersides of the clouds were originally silver and their upper sides were gold. The use of damascening is atmospheric as well as coloristic and postulates light coming from the right. Difficult as it is to read, the *Crucifixion* is a work of great imaginative power and its damascening may be due to the same silver- or goldsmith who worked on the *Miracle of the Miser's Heart*.

opposite: FIGURE 253.
Donatello, *Crucifixion*. Bronze,
parcel gilt, with gold and silver inlay,
H. 97 cm, W. 73 cm
(H. 38 in., W. 28¾ in.).
Museo Nazionale,
Florence.

X

The Madonna Reliefs

NO ASPECT of Donatello's legacy is more controversial than his reliefs of the Virgin and Child. In the nineteenth century the list of Madonna reliefs ascribed to Donatello was uncritical and long, whereas the Donatello catalogue of Janson admits only two reliefs. The credulity of the first position and the skepticism of the second are both unwarranted. The central difficulty arises from the currency of a large number of reliefs carved or modeled by unknown members of Donatello's Florentine and Paduan workshops. Superficially, they resemble the work of Donatello. In sculpture, however, similitude is not a matter of surface likeness, as it is with painting; it rests on the creative structure of each individual relief, and only when its structure corresponds closely with the structure of some authenticated work is attribution justified. It may be well to take one practical example of the type of judgment that is involved. Some of the most widely diffused reliefs ascribed to Donatello are two bronze plaquettes showing the Virgin in half-length. The first,[1] with the Virgin in right profile, is approximately datable, since a pigmented squeeze from it in London is contained in a tabernacle painted by a known artist, Paolo di Stefano, about 1435. In the second[2] the Virgin is shown in left profile against an apse. Though the reliefs look very similar, they are constructed differently. In the first the Virgin's right arm forms a diagonal running from the lower left corner to the Child's head, and the Child's legs are extended horizontally, parallel with the base. Looking outward to the right, the Child presses the Virgin's breast. The relief is distinguished by its unusual imagery as well as by the geometry of its design. In the second relief the imagery and design are both conventional. The shapeless Child

Fig. 254

Fig. 255

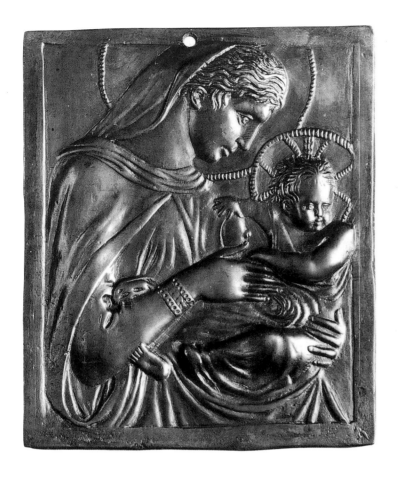

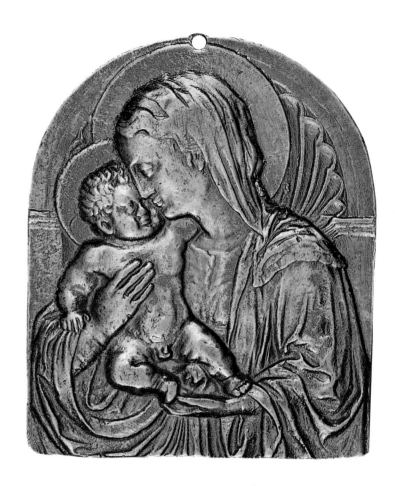

is held against the Virgin's shoulder, and the Virgin wears not the boldly defined robe of the first relief, but a cloak broken across both arms in a succession of small folds. Two different minds, therefore, lie behind the two reliefs, one of which, the first, is Donatello's, while the second is that of a Donatello imitator.

The market in Florence for pigmented terracotta reliefs of the Virgin and Child, for display in external tabernacles and in chapels as well as for personal use, seems to have been created at the end of the second decade of the century by Ghiberti. A few of the reliefs appear, from their intrinsic quality, to have been modeled by Ghiberti in the later stages of work on the first door of the Baptistry. Perhaps the most beautiful is the Ford *Madonna* at Detroit, in which the Virgin holds the Child against her shoulder, and the Child fondles her chin.[3] An inferior copy of this work is at La Quiete,[4] and, given its ingratiating character, others must have been made. The most popular of Ghiberti's Madonnas were two interrelated groups in which the half-length figure of the Virgin rises from a molded base.[5] Holding the Child in her left arm, she places her right hand on his left leg. The second composition differs from the first in that the Child's body is turned and is pressed against the Virgin, and the position of his legs is reversed. These reliefs were still in demand in the third quarter of the fifteenth century; three of them are mounted on bases with a figure of Eve cast from the *Gate of Paradise*, and are likely, therefore, to have been made after the installation of the door in 1452. No modeled original of them exists, but if it did,

left: FIGURE 254.
Workshop of Donatello, *Madonna and Child*.
Bronze, H. 11.6 cm, W. 9.4 cm
(H. 4½ in., W. 3¾ in.).
Victoria and Albert Museum,
London.

right: FIGURE 255.
Michelozzo (?), *Madonna and Child*,
Bronze, H. 9.5 cm, W. 7.5 cm
(H. 3¾ in., W. 3 in.).
Kress Collection, National Gallery of Art,
Washington, D.C.

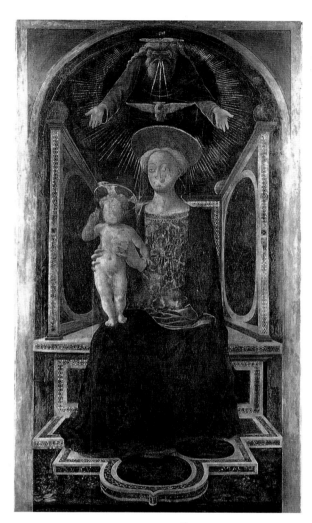

FIGURE 256.
Domenico Veneziano, *Madonna and Child Enthroned*. Fresco transferred to canvas, H. 241 cm, W. 120.5 cm (H. 94⁷/₈ in., W. 47³/₈ in.). National Gallery, London.

opposite: FIGURE 257.
Donatello, *Pazzi Madonna*. Marble, H. 74.5 cm, W. 69.5 cm (H. 29³/₈ in., W. 27³/₈ in.). Staatliche Museen, Berlin.

it would closely have resembled a magnificent half-length Madonna and Child in the National Gallery of Art in Washington, D.C., which has been variously ascribed to Ghiberti and to Donatello.[6]

Nanni di Bartolo, Donatello's companion on the Campanile statues, also had a sideline in pigmented terracotta sculptures. The most notable are a full-length processional Virgin and Child in the Ognissanti in Florence[7] and a small seated Madonna at Detroit.[8] From about 1417 till about 1423, Ghiberti had as partner a progressive artist, Michelozzo, and it appears to have been Michelozzo who, in the first half of the 1420s developed the terracotta Madonna on Renaissance lines. He was responsible for a masterly standing Madonna in pigmented terracotta in Washington, D.C., which, from the time of Bode, has been intermittently regarded as a work by Donatello,[9] and for two exceptionally fine half-length reliefs, an ingenious and beautifully constructed Madonna with the frightened Child in the Museo Bardini,[10] and a much damaged Madonna in the Bode Museum in Berlin,[11] in which the Virgin's head closely recalls those of the two small marble figures carved by Michelozzo for the niche on Or San Michele containing Ghiberti's *St. Matthew*. Both reliefs have likewise been ascribed to Donatello, but impressive as they are, they have no valid point of contact with his authenticated works. It seems, indeed, that at this early stage he played little or no part in what must have been a profitable market for high-quality, polychrome *bon-dieuserie*.

Donatello's earliest surviving Madonna and Child is the relief known as the *Pazzi Madonna* in Berlin.[12] Nothing is known about its provenance save that it was purchased for the Kaiser Friedrich Museum in 1886 from a vendor who had secured it from the Palazzo Pazzi. The marble slab is broken into upwards of fifteen pieces, and there is no means of establishing whether this damage occurred when it was removed from the wall in the Palazzo Pazzi prior to its transport to Berlin or when it was transferred to the Palazzo Pazzi from whatever site it originally occupied. It is not recorded in any Florentine church. From the time it was first published it was presumed to have been carved about 1420, on the strength of supposed resemblance between the Virgin's head, and the classical head of a Sibyl carved by Donatello in 1422 for the Porta della Mandorla of the Cathedral.[13] The carving of the hair and eye sockets is subtler than in the *Sibyl*, and the fingers are depicted in a less schematic way. Two other reasons preclude a dating from about 1420. Donatello's heroic Virgin stands at a casement, with head bowed, so that her profile covers the front of the Child's face. She supports him with the spread fingers of her left hand as he reaches up to touch her veil. The source of this image is the class of Roman processional reliefs that inspired the superimposed profiles of *The Ascension with Christ Giving the Keys to St. Peter*, and the *Madonna* is likely to date from the same time—about 1428–30. The second reason is the perspective of the casement. Generally misread, it has been claimed to have three vanishing points. The vanishing point of the upper section is in the center of the base, and it is from this point, not from the center of the carving, that the relief is intended to be read. The diagonals established by the corners of the ceiling are relevant to the relief as pattern, not to the relief as space. The closest parallel in painting occurs about 1434 in the Carnesecchi *Madonna* of Domenico Veneziano, in the National Gallery in London,[14] where the

Fig. 257

Fig. 256

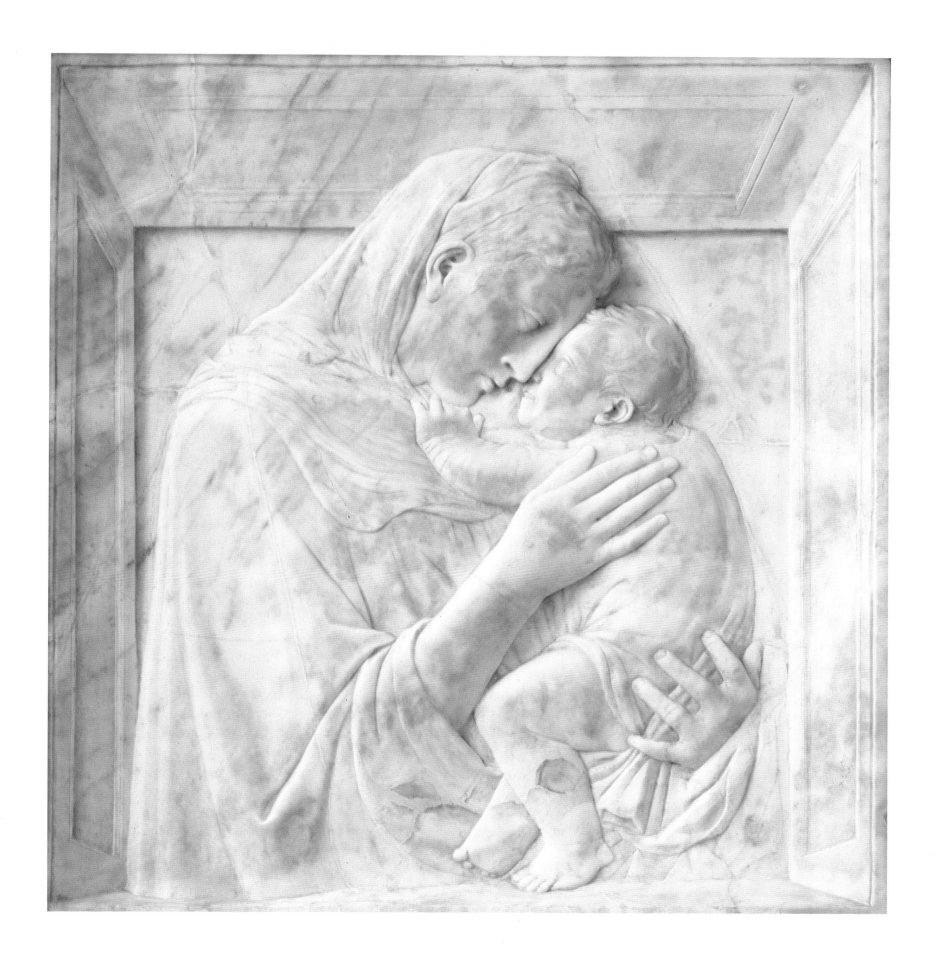

255

Virgin is again enclosed in a cat's cradle of orthogonals. The few paintings of the Virgin and Child in half-length in interior space produced in Florence in the second half of the 1420s are relatively trivial in character. Even in the finest of them, a Virgin and Child painted by Masaccio between 1426 and 1428 for a Sienese patron, Cardinal Casini, the figures are treated anecdotally, the Child smiling as the Virgin tickles his throat. Donatello's *Pazzi Madonna* is very different. The two figures have no halos and no emblems that would divorce them from reality. In a day when child mortality was high, children were prized possessions that fate might wrest away at any time, and the protective relationship between the Virgin and the Child in Donatello's relief is a metaphor for contemporary life. The perspectival structure of the casement enhances the tactility of the incomparably sensitive low-cut figures, while imposing a coherent surface pattern on the relief.

The second of Donatello's marble Madonna reliefs is a small, exquisitely delicate *rilievo stiacciato* in the Boston Museum of Fine Arts known as the *Madonna of the Clouds*.[15] Carved at about the same time as the Naples *Assumption of the Virgin*, its subject is a Madonna of Humility, seated not on the ground, but in the sky. She is surrounded by five cherubim, flying through clouds so dense that, with one exception, only their heads and wings are visible. The crown of the Virgin's head abuts on the upper edge of the relief, and in the corners, on a more distant plane, are two angels, one on the left in profile and the other flying to the right. Elevated Madonnas of Humility seated on clouds occur in earlier paintings—for example, in a triptych by Lorenzo Monaco in Siena and in Northern miniatures—but never with the same illusionistic character as in this extraordinary relief. The Virgin, shallow as the carving is, is tridimensional; one knee is raised, and the other protrudes into a forward plane. Between them is the Child Christ, who is supported by her with both hands. If there were any doubt as to the realistic intention behind this strongly tactile image, it would be dispelled by the distribution of the cherub heads in space and by the flying angels in the upper corners, whose changed scale determines the notional depth of the whole scene. The two-dimensional relief surface is organized with the utmost skill. The head of the central cherub on the right is set at half the height of the relief, and the Virgin's arm and foreleg and the Child's left arm establish a diagonal through the relief field. Carved with a flat surround, the relief must originally have been set in a painted frame or tabernacle, from which it was removed in the early sixteenth century, when a new tabernacle was painted for it by Fra Bartolomeo. It has been convincingly identified with a relief recorded by Vasari in 1568 in the *scrittoio* of the Grand Duke Cosimo I ("Nostra Donna col Figliuolo in braccio dentro nel marmo di schiacciato rilievo, de la quale non è possibile vedere cosa più bella, e massimamente avendo un fornimento intorno di storie fatte di minio di fra' Bartolomeo, che sono mirabili.") The wings are now in the Uffizi. When closed, they showed a grisaille Annunciation; and when opened, they revealed the Nativity and Circumcision. According to Vasari, they were commissioned by the owner of the relief, Piero del Pugliese, the patron of Filippino Lippi, and the carving may, therefore, have been bought by an earlier member of Pugliese's family. That it was intended for private use there can be little doubt, since no fifteenth-century derivative from it is known. It was, however,

Fig. 258

opposite: FIGURE 258.
Donatello, *Madonna of the Clouds.*
Marble, H. 33.5 cm, W. 32.2 cm
(H. 13 in., W. 12⅝ in.).
Museum of Fine Arts,
Boston.

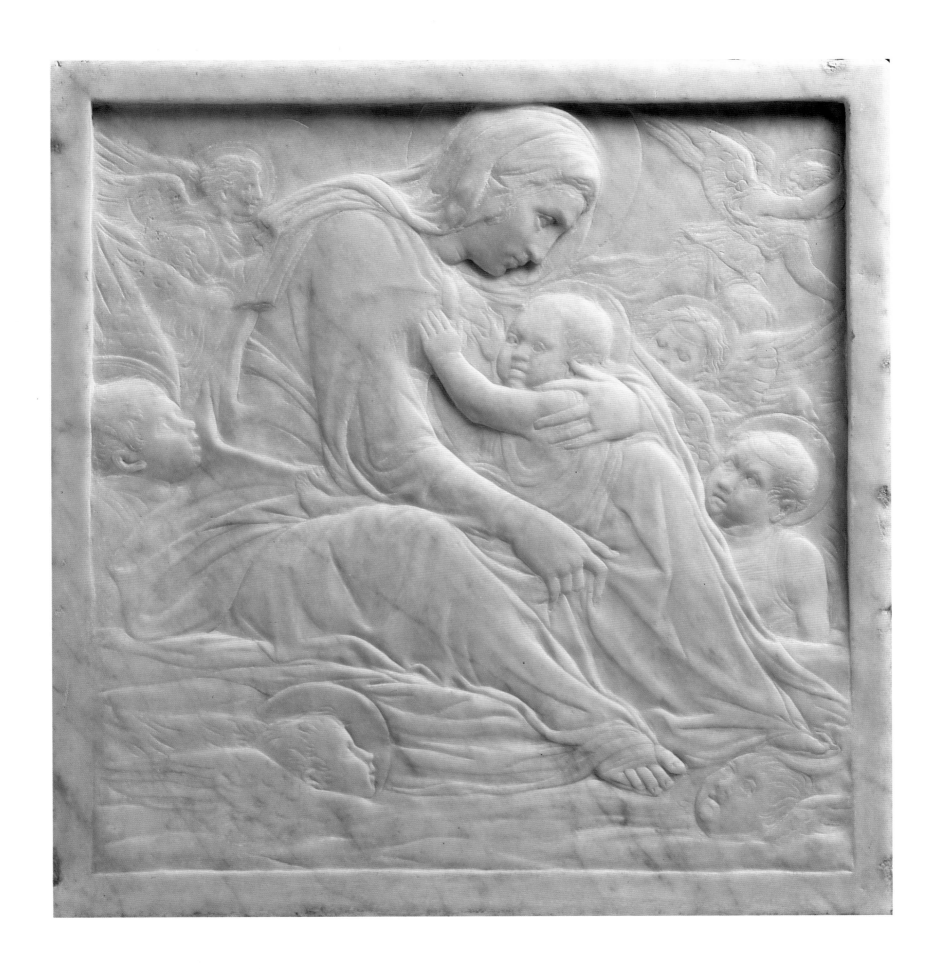

257

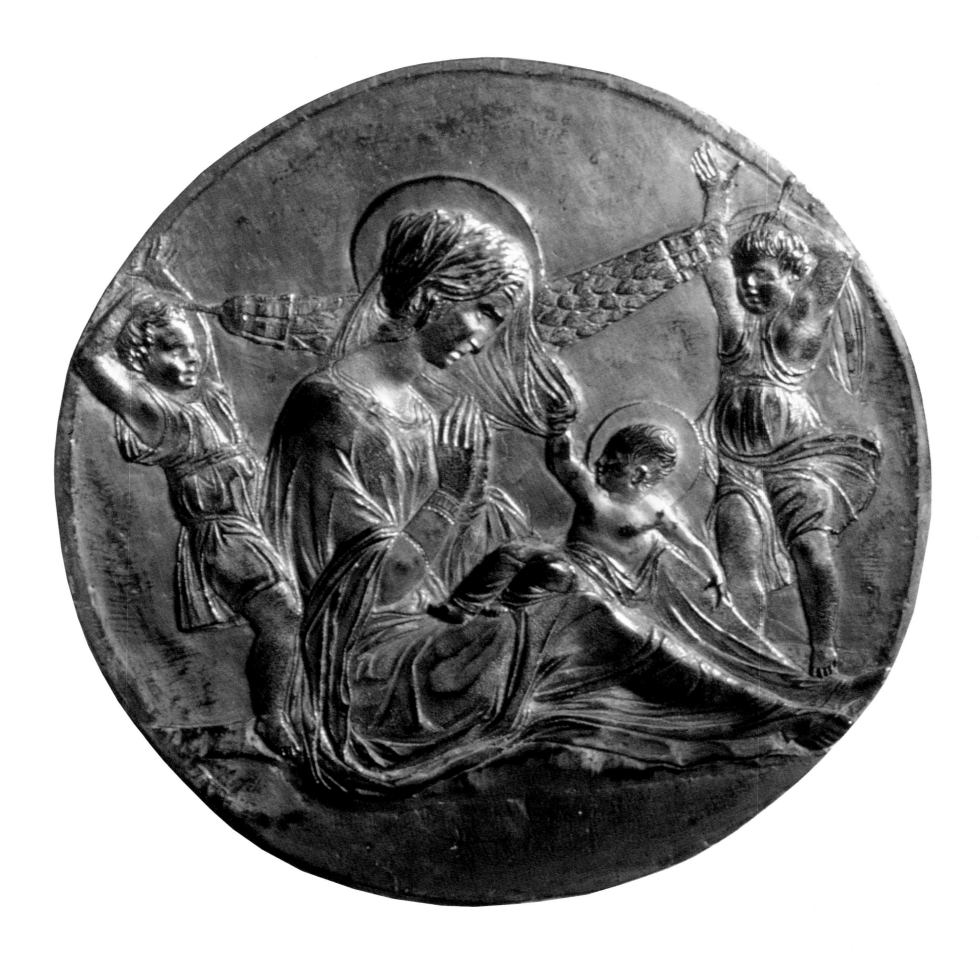

258

Fig. 259

studied by the young Michelangelo while he was engaged on the *Madonna of the Steps.*

The theme of the Madonna of Humility is treated once more in an entrancingly intimate circular gilt-bronze relief in Vienna in which the Virgin is seated on the ground, again in profile to the right, accompanied by two playful angels holding a garland behind her head.[16] The tondo is in very low relief; the Virgin's forward leg does not protrude as it does in the *Madonna of the Clouds*, but is set flat on the relief plane. Probably the Madonna was from the first designed for reproduction; a version in pigmented stucco exists in Berlin, and other casts are likely to have been made. The Virgin is seated on a horizontal drawn across the base of the relief. The long line of her right foreleg establishes a diagonal through the circular field, which terminates in the head of the angel on the left. The two angels stand in different planes; the right leg of that on the left is forward of the Virgin's cloak, while that on the right is set farther back. The forward arms of both figures abut symmetrically on the edge of the relief, and the raised right arm of the right-hand angel falls on the same vertical as his right leg. All of these structural devices have parallels in the stucco reliefs of the Old Sacristy, and the bronze is likely, therefore, to date from about 1440. Like the *Madonna of the Clouds*, the roundel was treated with great respect, and was set, about 1475, in an elaborate marble frame carved by Verrocchio's pupil Francesco di Simone.

Fig. 269

In Padua, Donatello must have made a large number of Madonna reliefs. They were transportable, and there is evidence of their dispatch both to Mantua and to Florence. A roundel with a half-length Virgin and Child in the center of the *Miracle of the Newborn Child* affords an abbreviated indication of their likely character. As in Tuscany, they fall into two broad categories: works designed for reproduction and works that were unique. In the first category, special popularity was enjoyed by the *Verona Madonna*, so called from the fact that a cast of it, accompanied by casts of two of the angels on the Padua altar, appears on a house in the Via della Fogge at Verona.[17] In this the Virgin is shown in half-length on a molded base with her left hand around the Child's head and shoulders and her right hand covering his thigh. His left foot is advanced to the center of the base, and his left forearm rests on the horizontal of the Virgin's collar. His head is pressed against the Virgin's cheek, and he looks out shyly as he sucks the fingers of his right hand. The figures have no background. The subject of the relief is a human mother comforting a startled child. Flatter than the unique modeled reliefs of the same time, it seems from the first to have been designed for ready reproduction in *cartapesta*, stucco, or terracotta. A large number of examples of it are known. There is no means of determining how many of them date from the fifteenth century; the only example in terracotta subjected to thermoluminiscence testing, in New York, was made within the bracket 1517–1750. The relief was intended for general circulation, and its emotional language is generic and impersonal. Many of the surviving versions are colorless, either because they were unpainted or because they have been stripped of paint, but an example in pigmented *cartapesta* in the Louvre gives some indication of the coloristic intentions behind the relief. Its distribution was not confined to Padua or to North Italy, and it was also known in Florence, where its influence is reflected

opposite: FIGURE 259.
Donatello, *Madonna of Humility with Two Angels*. Gilt bronze, D. 27 cm (10⅝ in.). Kunsthistorisches Museum, Vienna.

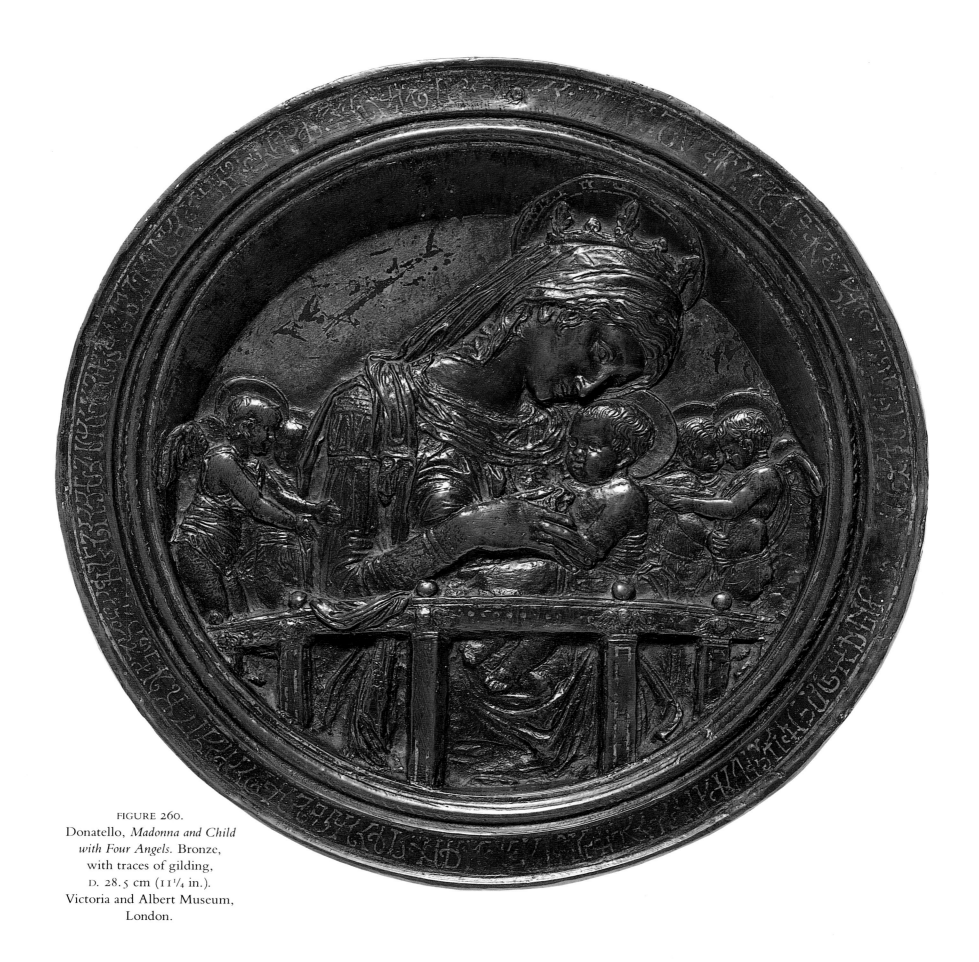

FIGURE 260.
Donatello, *Madonna and Child with Four Angels*. Bronze, with traces of gilding, D. 28.5 cm (11¼ in.). Victoria and Albert Museum, London.

in a weak terracotta Madonna by a member of Donatello's studio in a tabernacle in the Via Pietra Piana, in which the limp Child is shown in swaddling bands.[18] A second, not dissimilar, Madonna in which the Virgin is shown in left profile and the Child is represented to her left is recorded in a painting by Squarcione in Berlin.[19]

In Padua Donatello seems also to have created a number of unique fully modeled pictorial reliefs, which are among the most profound and most moving Madonnas of the fifteenth century. In form and content they exercised a deep influence, especially on Mantegna. Two of them survive. The first, in pigmented terracotta, in the Louvre,[20] shows the Virgin in left profile confined in a relatively shallow space between the foliated front arm of her seat and a curtain at the back suspended from the upper edge of the relief. Her body is slightly turned and her head, in pure profile, is centralized. Her right shoulder occupies a median point in the exact center of the picture space, and her left shoulder rests on its right edge, with the left forearm parallel to the base of the relief. The Child looks outward to the left; his body is turned at the waist, and his extended legs form a diagonal through the composition corresponding with the diagonal of the Virgin's right shoulder and neck. A central horizontal is established by the left shoulders of the Virgin and the Child. The first impression of the relief, however, is not of its geometry, but of its privacy and tenderness. The Virgin's head is covered by an elaborate silken veil, and one end of her scarf is twisted around the Child. The paint surface in the flesh areas and on the dress is exceptionally rich and may well be due to Donatello.

A second fully pigmented relief must also have been made in Padua. Now in the Staatliche Museum (former Bode Museum) in Berlin,[21] it was severely damaged in the war, and the surviving fragments lack their color and most of their priming. The head of the Child in its stripped state corresponds so closely with the head of the Child in the high altar of the Santo that it can hardly have been produced elsewhere than in Padua or substantially earlier than 1447. It differs from that of the Louvre relief in that the Virgin's eyes are lowered, and that the Child wears a swaddling band and is set on a diagonal from the lower right to the upper left corners of the relief with his head pressed against the Virgin's cheek. The left forearm of the Child and the left forearm of the Virgin rest on a common horizontal, and the Virgin's hands, clasped in prayer, form a focal point in the center of the scene. The upper corners are filled with winged seraphim. The effect of the relief when the Virgin's cloak was a dark blue and the Child's swaddling bands were touched up in gold was one of overwhelming strength. Its formal composition was not followed by any Tuscan painter, but the concept of a prescient classicizing Virgin in prayer over the Child prefigures the painted Madonnas of Mantegna.

One of the four narrative scenes at Padua, the *Miracle of the Newborn Child*, contains, in a lunette over the central doorway, a circular foliated frame. The frame is represented perspectively, and is broken by the halo of the Virgin, which protrudes at the top. From this Donatello seems to have developed a circular relief of the Virgin and Child with four angels behind a balustrade. The composition survives in two examples, one in the National Gallery of Art and the other in a private collection.[22] Neither is autograph, but the second retains its patination and local gilding, which recalls that of the *Miracle of the Miser's Heart*. There is no way of

Fig. 263

Fig. 262

FIGURE 261.
Donatello, *Madonna and Child with Four Angels* (reverse).

overleaf, left: FIGURE 262.
Donatello, *Madonna and Child with Four Cherubim.*
Pigmented terracotta, H. 102 cm, W. 72 cm
(H. 40 in., W. 29 in.).
Staatliche Museen,
Berlin.

overleaf, right: FIGURE 263.
Donatello, *Madonna and Child.*
Pigmented terracotta, H. 102 cm, W. 74 cm
(H. 40 in., W. 29 in.).
Musée du Louvre, Paris.

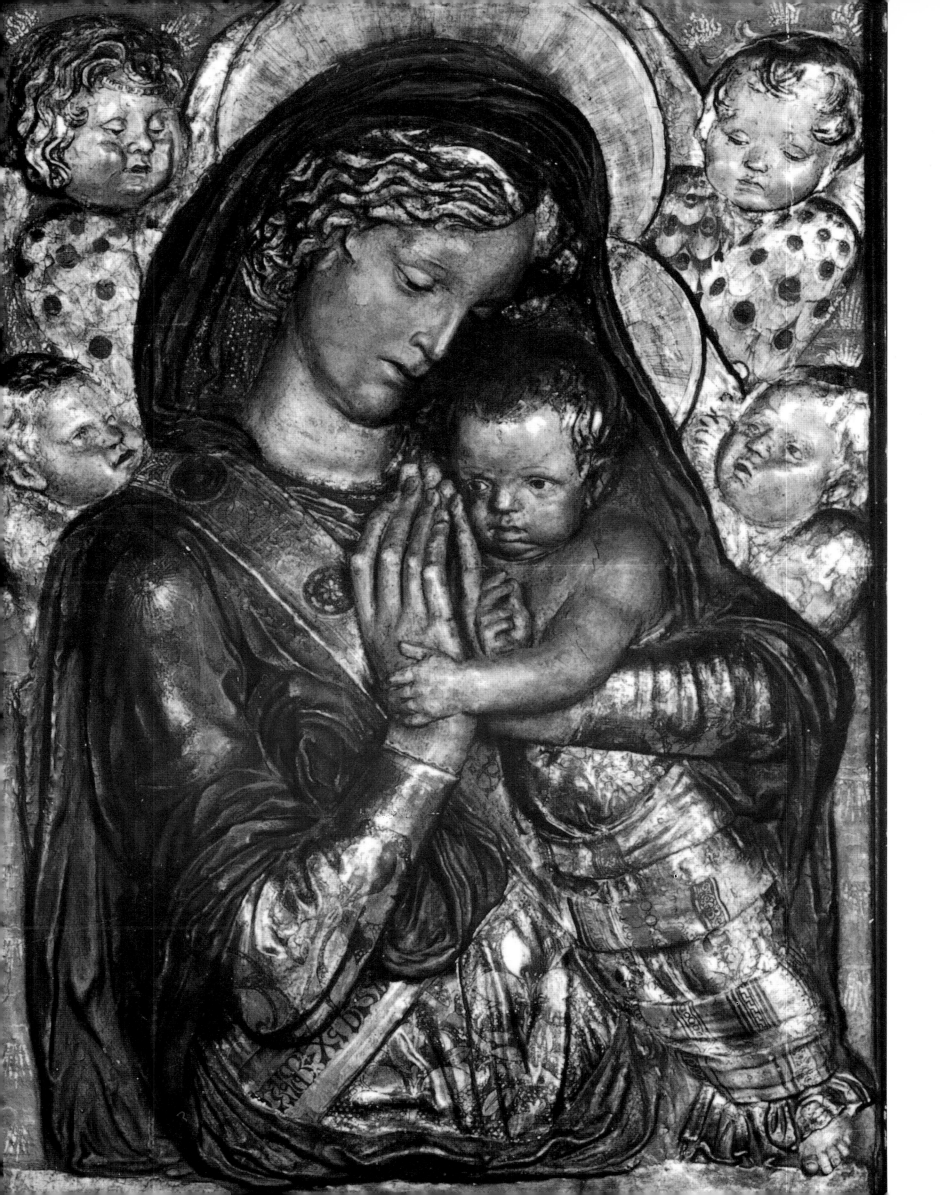

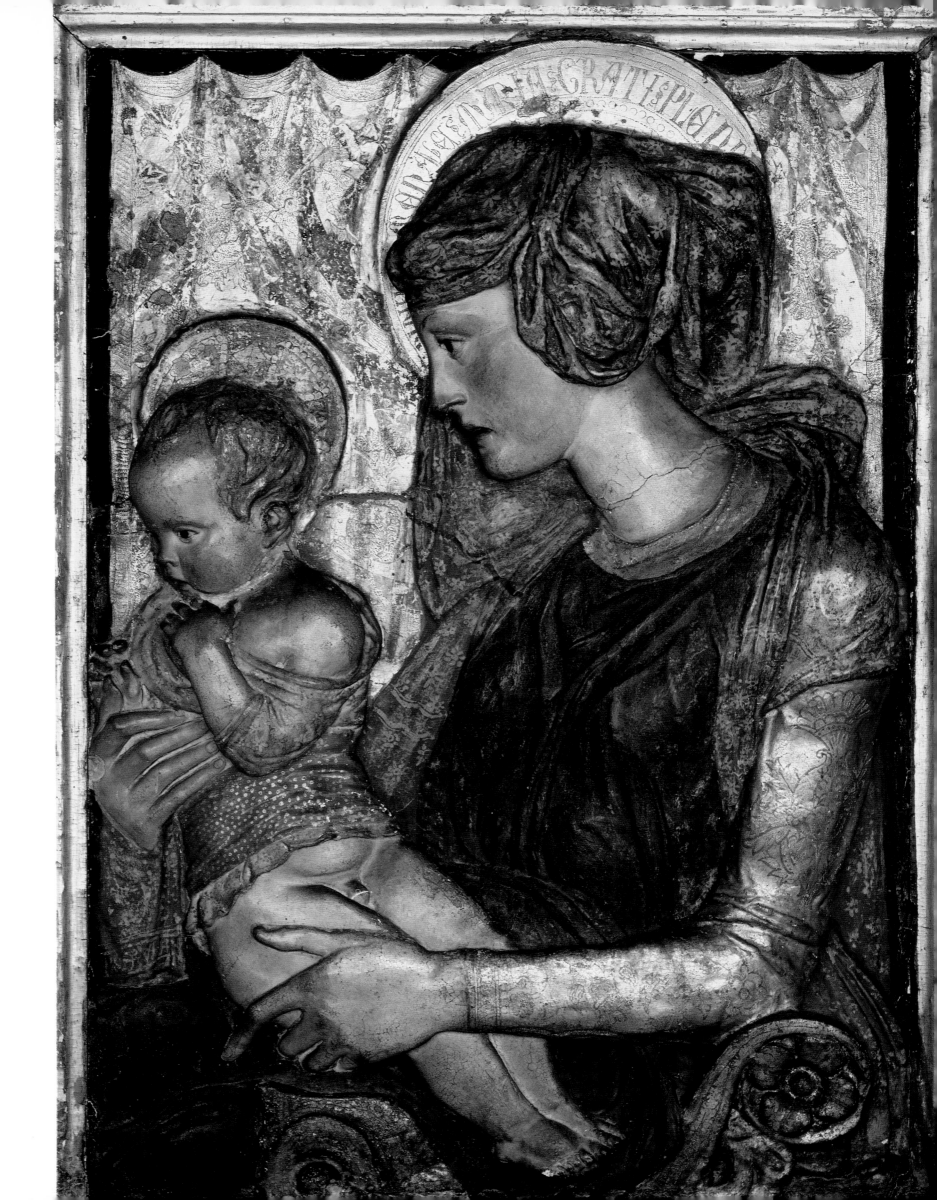

telling whether the reliefs depend from a superior original, but on Donatello's return to Florence they were developed into what is perhaps the subtlest and most intimate of his bronze reliefs.

In 1453 in Padua Donatello became gravely ill. We know this from a conversation reported in a letter of Leonardo Benvoglienti, in which Donatello declared himself anxious "per non morire fra quelle ranochie di Padova; che poco ne manchò."[23] The importance of this sentence is not due to its often quoted reference to Paduan frogs, but to the assertion that Donatello almost died in Padua. After his return to Florence he was treated successfully by his doctor, Giovanni Chellini. A professor of medicine in Florence, Chellini was a member of a cultivated professional circle that centered on Neri Capponi and the historian Matteo Palmieri. In 1456 his bust was carved by Antonio Rossellino, and when he died at an advanced age in 1462 his tomb in San Domenico at San Miniato al Tedesco was designed by Rossellino's brother, Bernardo. In an account of his own life,[24] he records how, on August 27, 1456

> medicando io Donato chiamato Donatello, singulare e precipuo maestro di fare figure di bronzo e di legno e di terra e poi cuccerle, avendo fatto quello uomo grande che è sullo alto di una cappella sopra la porta di Santa Reparata che va a Servi e cosi che avendo principiato un altro alto braccia nove, egli per sua cortesia e per merito della medicatura che avevo fatta e facevo del suo male mi donò un tondo grande quant'uno tagliere nella quale era scolpita la Vergine Maria col bambino in collo e due Angeli da lato, tutto di bronzo e dal lato di fuori cavato per potervi gittare suso vetro strutto e farebbe quelle medesime figure dette dall'altro lato.

The relief was preserved as an heirloom by Chellini's descendants, the Samminiati, till 1748–49, when it was purchased by an Englishman, the future Marquess of Rockingham. Now in the Victoria and Albert Museum, it shows the Virgin and *Fig. 260* Child with four small angels behind a protruding balustrade. The scene is projected from a low viewing point, and the figures and balustrade were originally heightened with gilding. The relief is recessed and is surrounded by a flat rim containing a gilt inscription in imitation Cufic. Chellini's statement, that reproductions cast from the incuse mold on the back could be made in glass ("suso vetro strutto"), has been *Fig. 261* taken more seriously than it deserves;[25] the only known reproductions of it in the fifteenth century are in pigmented stucco. The prime interest of the mold is that it represents an effort to ensure that facsimiles of the relief conformed in every respect to the original, and latex casts made from the mold, in fact, yield a result that is in every detail identical with the front face. That the composition did not enjoy great popularity must have been due to the fact that it remained in private hands and was not put to use in Donatello's shop. The protruding circle of the balustrade is continued behind the Virgin by two pairs of angels who merge into the shallow space, completing a circle around the central group. In one other, still later relief by Donatello, the motif of the semicircular balustrade is used once more, but transformed into a solid block of masonry, above which the Virgin playfully lifts up the Child.[26] Three versions in pigmented stucco of this relief are known, all of them of *Fig. 271*

opposite: FIGURE 264.
Donatello, *Madonna and Child with Three Angels* (detail).

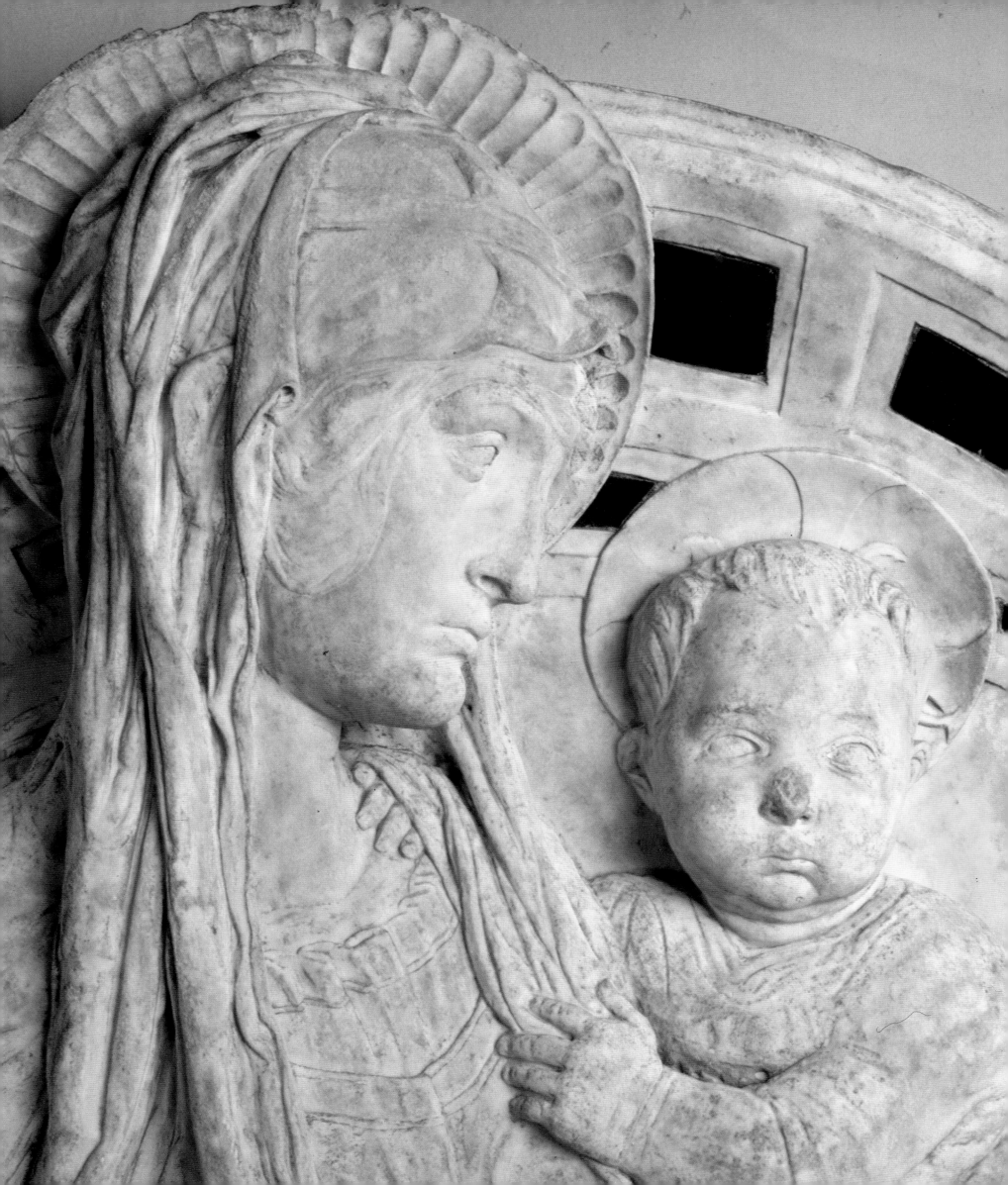

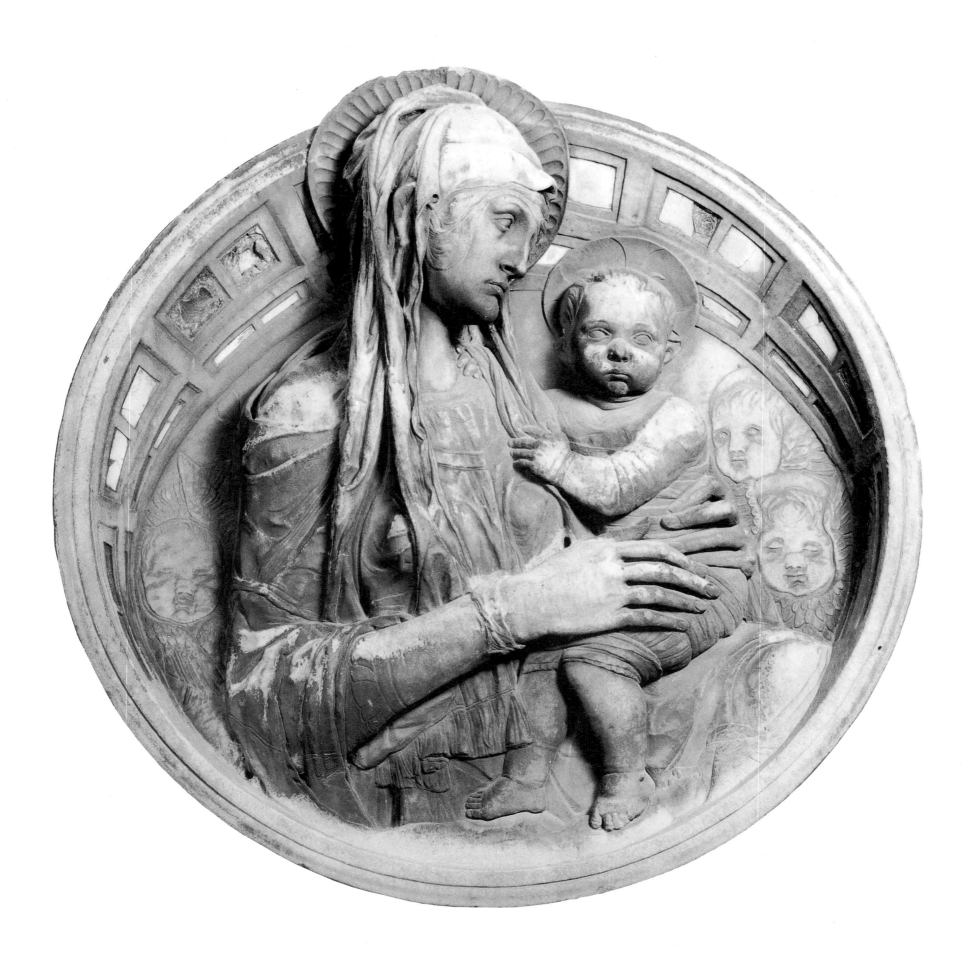

266

poor quality, but the delicate linear cartoon of the Virgin and Child can only be due to Donatello. Looking at them we have the sense that they, like the Chellini *Madonna* itself, admit us to a private imaginative world that would have appeared as mysterious in the early 1460s as it still does today.

Concurrently, Donatello continued to experiment with larger representations of the Virgin and Child. The only relief exactly datable was carved for the Chapel of St. Calixtus in Siena Cathedral in 1457–58.[27] A tondo, its perspectival surround is planned in the same fashion as that of the Chellini roundel. The Virgin's head, however, protrudes beyond the frame. One of the most important sculptures produced in Florence in Donatello's absence in North Italy was Bernardo Rossellino's Bruni Monument in Santa Croce. Since Bruni died in 1444, it is a reasonable assumption that the tomb, and its lunette with a tondo of the Virgin and Child, was in position when Donatello started work on the Siena relief. Rossellino's Virgin is represented on a flat ground with the Child standing with one hand raised in benediction, at her side. In Donatello's relief the space occupied by the figures is defined in more positive terms. The Virgin is severed at the knees, and the heavy, rather sulky Child is seated on her thigh. Her head (which recalls that of the bronze *Judith*) is set forward of the frame, and her sad gaze is directed to the Child. The execution of the dress and background in this relief may have been entrusted to assistants, but the whole work, and especially the Virgin's head, bears the imprint of Donatello's inexorably serious personality.

Two of Donatello's late Madonna reliefs have as their subject the Virgin adoring the Child. In the first, a tondo in the Louvre,[28] the Virgin is represented not in pure profile but with her head slightly turned, so that the left eyelid is partly visible. The transparent veil over her head and the light fabric of her sleeve are treated with great elaboration and suggest that the relief may be identical with a Madonna recorded by Vasari in the Palazzo Gondi, in which Donatello "scherzasse nell'acconciatura del capo e nella leggiadria dell'abito, ch'ella ha indossa." The Virgin's praying hands are set in the exact center of the tondo and the reclining Child is so posed that his head is on the same horizontal as the Virgin's hands while his feet fall in the center of the base. The background consists of interconnected circles filled with urns and putto heads in verre eglomisé, many of which have unfortunately been made up in plastic. Damaged by overzealous cleaning in 1959, the relief now looks less than the masterpiece it was, and the freedom and originality of its design are more evident in stucco copies made from it than in the skinned original. One of these, in the Acton collection in Florence, retains its original painted frame, which appears to date from about 1460.

The second relief of the Virgin adoring the Child is in gilded terracotta and is in London.[29] The massive figure of the Virgin fills the entire scene. As in the Louvre relief, her hands and the head of the Child rest on a horizontal drawn through the middle of the field. Her head is turned at the same angle as the Madonna in the Louvre, and her hands are clasped in prayer. The Child, who places his right hand between the Virgin's hands, is shown lying on a seat or cradle whose two supports protrude forward from the relief plane. The gold is well preserved in the recesses between the fingers and in the Virgin's dress, but it is lacking in the flat background

igs. 265, 264

Fig. 267

Fig. 266

Fig. 268

FIGURE 265.
Donatello, *Madonna and Child with Three Angels.* Marble with green marble inlay, H. 89 cm, W. 95 cm (H. 35 in., W. 37 in.). Museo dell'Opera del Duomo, Siena.

FIGURE 266.
Workshop of Donatello, *Madonna and Child with two Angels.* Pigmented stucco. Acton collection, Florence.

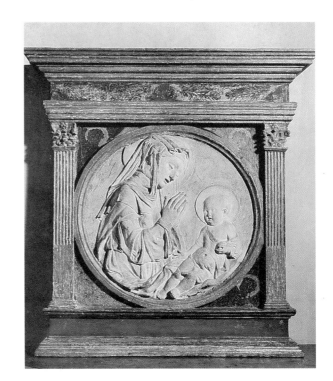

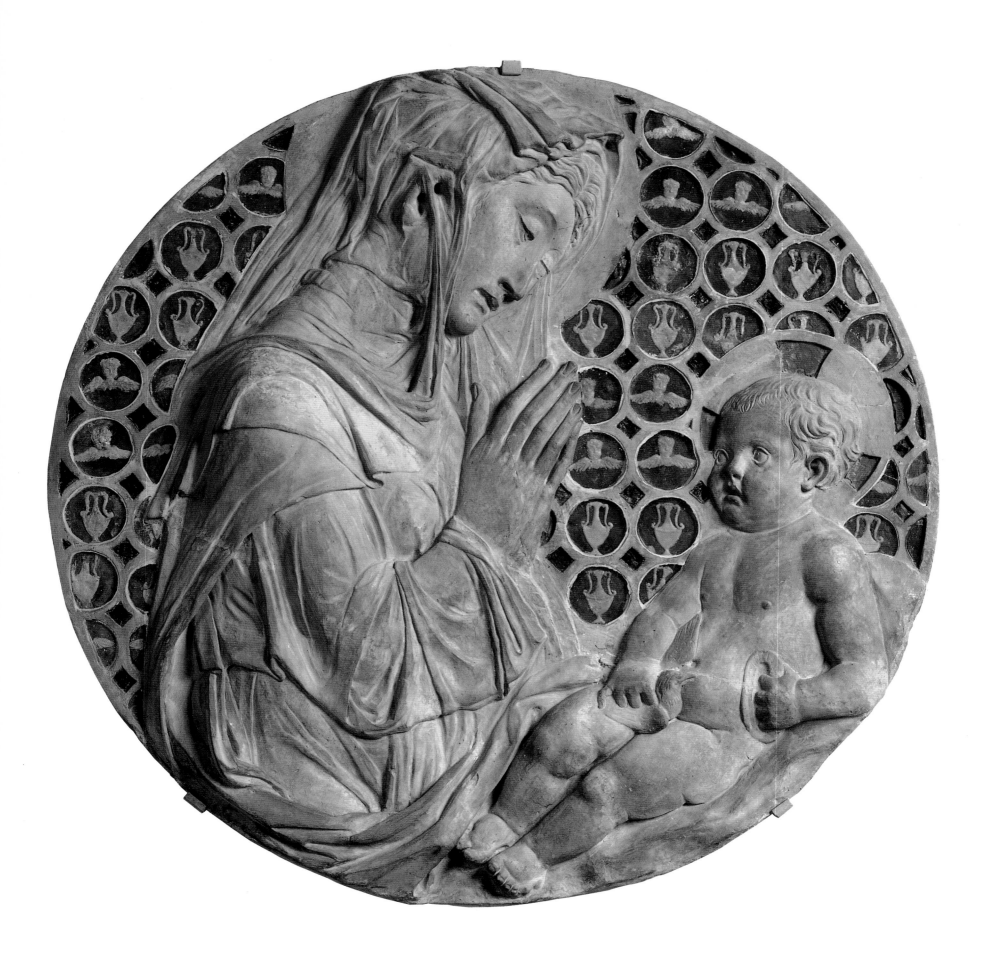

268

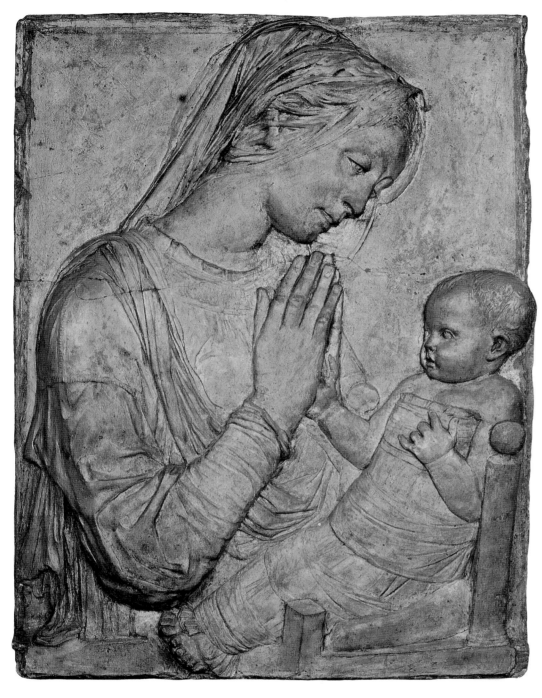

opposite: FIGURE 267.
Donatello, *Madonna and Child*. Terracotta,
with traces of priming for pigmentation and
some *verre eglomisé* in the background,
D. 73 cm (28¾ in.). Musée du Louvre, Paris.

FIGURE 268.
Donatello, *Madonna and Child*. Gilded terracotta,
H. 74.3 cm, W. 55.9 cm (H. 29¼ in., W. 22 in.).
Victoria and Albert Museum, London.

and in the raised surfaces, which are covered with bronze paint. The handling of the thin fabric of the dress and of the Child's swaddling band is masterly. This magnificent relief was reproduced in simplified form with a background of sky and five cherubs above the Virgin's head as a raised painting. These pigmented derivatives are Florentine, and the prime relief is likely to have been made in Florence, not in Padua.

A pigmented version of this composition was in turn adapted as part of a Holy Family, of which coarse versions in stucco exist in the Museo Bardini in Florence and in Berlin.[30] This relief, in which the head and hands of St. Joseph are introduced

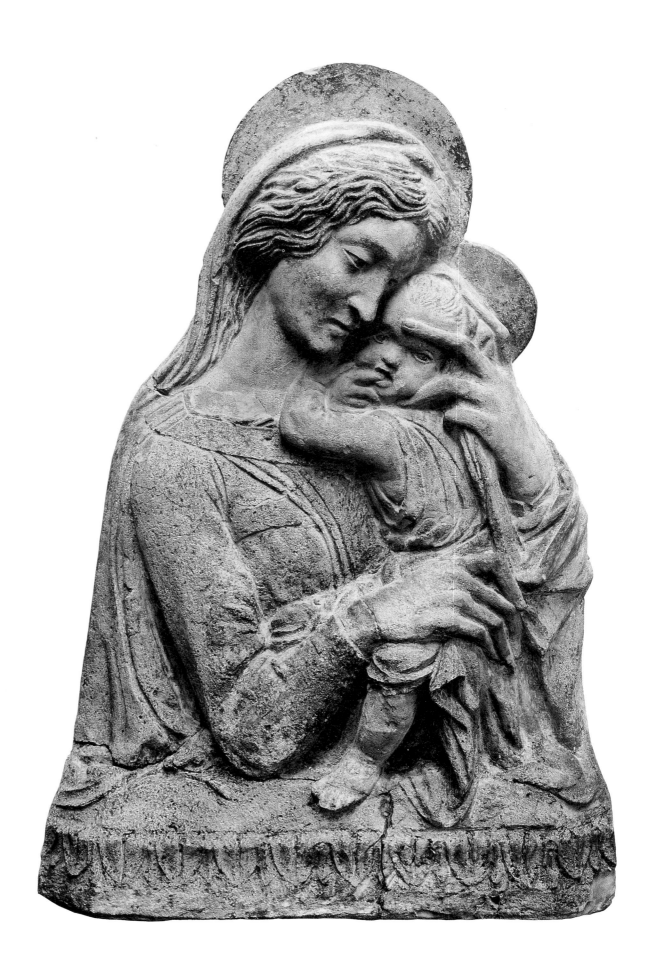

FIGURE 269.
After Donatello, *Verona Madonna*.
Terracotta, H. 95.3 cm (37½ in.).
Metropolitan Museum of Art,
New York.

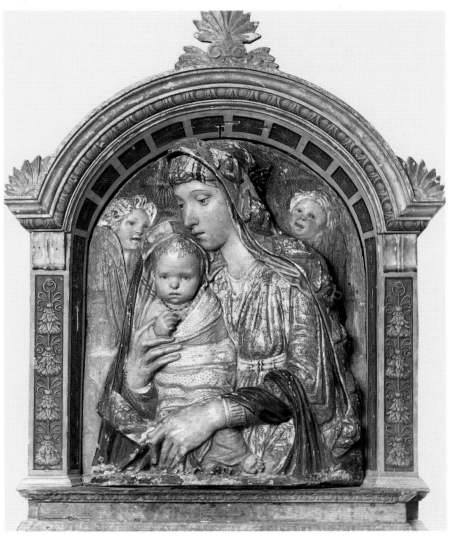

FIGURE 270.
Donatello, *Madonna and Child
with Two Angels.* Pigmented terracotta,
H. 85.5 cm, W. 68 cm
(H. 33⅝ in., W. 26¾ in.).
Cryan collection,
Boca Raton, Florida.

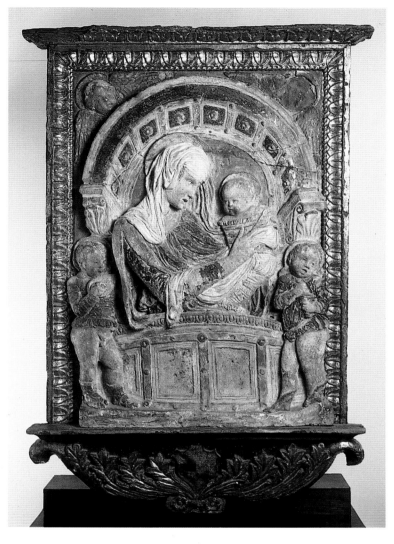

FIGURE 271.
After Donatello, *Madonna and Child
with Two Angels.* Pigmented stucco,
H. 62 cm (H. 24½ in.).
Kunsthistorisches Museum,
Vienna.

in the lower left corner and the heads of the ox and ass appear above the Child Christ, is by the same sculptor as two further reliefs of the Holy Family. A typical example of the first of these is an almost square relief in the Museo Bardini, in which the Virgin is turned to the left, the head of the ox and ass appear once more over the Christ, and the head of the sleeping St. Joseph, resting on his left hand, appears on the right. The second relief is circular and shows, in the spandrels of a rectangular version in London, the heads of the Evangelists. The Evangelist heads in this last version correspond closely with heads in the documented marble reliefs of the Birth of the Virgin and the Apostles taking leave of the Virgin by Urbano da Cortona in Siena Cathedral. All three reliefs seem to be products of this artist's studio, probably dating from a time when Donatello was himself resident in Siena.

These limp reproductive reliefs are in striking contrast to the last Donatello Madonna relief of which we have a record.[31] Said to have been made for San Felice in Florence, it was at the beginning of this century in the hands of the dealer Bardini and is now in a private collection in Florida. It shows the Virgin in half-length turned to the left, with the Christ in swaddling bands in her right arm. His fist is clenched, as though he were about to make the same weak gesture of benediction as the Child on the Padua high altar. The Virgin wears a scapular decorated with raised seraphim, and behind her shoulders are two angel heads. The paint surface is in part original, and the colors—a striped white-and-pink cloth for the covering of the Child, a white-and-black girdle for the Virgin's gold brocaded dress, and the abraded gold of the scapular—afford some impression of the pictorial effect the relief would originally have made.

Donatello's Madonna reliefs are works of great profundity and of the utmost seriousness. They emerge from an imagination and a temperament that are unlike those of any other artist, and both in planning and content they fit more readily into the sixteenth than the fifteenth century. In the Florence of the High Renaissance, they were greatly prized. According to Vasari, a "marble Madonna in half-length considered a most rare work" was owned by the heirs of Jacopo Capponi;[32] a "marble panel by Donato's hand contained a half-length figure of Our Lady in bas-relief" was owned by the treasurer of Cosimo I, Antonio de' Nobili, who "esteemed it equivalent to all his other possessions";[33] a "Madonna in half-length made by Donato with incomparable love and diligence, [which] must be seen in order to realize the light touch of the master in the poise of the head and the arrangement of the draperies" was owned by Bartolomeo Gondi;[34] and a "marble panel of Our Lady by Donatello's hand" was owned by Cosimo I's secretary, Lelio Torelli.[35] The remarkable thing about this list is the proof it offers that, at a time when the generality of Florentine reliefs, by Desiderio da Settignano and Rossellino and Benedetto da Majano, had become objects of simpleminded popular devotion, the reliefs of Donatello spoke an ideal language that members of the court of Cosimo I, familiar as they were with the Pitti and Taddei tondi of Michelangelo, could appreciate and understand.

Fig. 270

XI

The Late Works

WHEN PAYMENT for the *Gattamelata* was settled at the end of October 1453, Donatello made arrangements to leave Padua. For the previous twelve months he had been living in a house in the *contrada* of Borgo dei Rogati leased from Giampietro di Bartolomeo de' Galeazzi; the last installment of the rent was paid on November 19.[1] At the end of November he was involved, on behalf of the Arca, in demanding the return, by the brother of his former assistant Niccolò Pizzolo, of twelve marble slabs, the carving of five of which had already begun,[2] and his departure seems to have been delayed till the beginning of the following year, when we learn that a goldsmith, Niccolò del Papa, was entrusted by the Massari of the Arca with the completion of bronze sculptures for the high altar; with two assistants he was to fix and gild the bronze symbols of the Evangelists and the angel reliefs, and to undertake other work. Once more the Massari were unlucky, and when Niccolò died in 1469 he was accused of failure to fulfill his contract.[3] The first evidence of Donatello's reappearance in Florence comes from a lease of November 1454, in which he is described as domiciled in the parish of San Lorenzo and leasing, for one month less than three years, a house with a workshop, garden, and other buildings at the Canto dei Bischeri in the parish of San Michele Visdomini at an annual sum of fifteen florins.[4] The house had previously been rented to Michelozzo, whom he reimbursed for expenses arising from the repair of the roof and other work. This was the same house that, according to a lost document, he had leased immediately before he left for Padua.[5] Of what may have been his intimate relationship with Michelozzo during his years in Padua nothing is known. The Massari of the Arca were angry that the sculptures for the High Altar were left unfinished, and as late as mid–March 1456 Donatello, through a procurator, Simone Muratori of Ravenna, was endeavoring to obtain the money due to him.[6]

In Florence Donatello at once resumed contact with Piero and Giovanni di Cosimo de' Medici. Piero gave instructions in September that certain cases

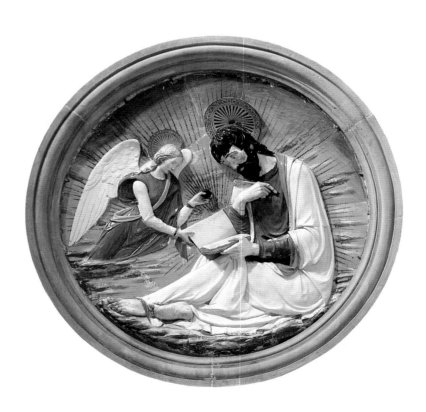

containing his own property and that of friends should be transported from Faenza, including "una tavola di bronzo, una testa di bronzo, una capsa vechia, sono di Donatello."[7] A year later, in October 1455, a letter from Giovanni di Luca Rossi in Florence to Giovanni de' Medici, who was at Trebbio, states that Rossi, on Giovanni's behalf, had given Donatello three florins "per resto di due Vergine Marie," but that Donatello thought the sum inadequate. The Madonnas had, however, been handed over to the chaplain of an unnamed church at Fiesole (presumably San Girolamo, which was adjacent to Giovanni's Villa Medici), and Donatello had himself left for Volterra, at Giovanni's charge, to look for marble for the *scrittoio* in the new house. One of the marble carvings was already finished and was ready for submission to Giovanni.[8]

It is generally assumed that Donatello, when he moved to Padua in 1443, cut his ties with Florence, working exclusively on North Italian commissions. We know, nonetheless, that he visited Florence in October 1445, when, jointly with Luca della Robbia, he appraised a lavabo carved by Buggiano for the sacristy of the Cathedral.[9] He may well have paid other visits too. Nonetheless, Florence in 1454 was very different from the Florence he had left over a decade earlier. The Porta del Paradiso of Ghiberti was installed in the doorway of the Baptistry facing the Cathedral and, in the Cathedral and elsewhere, use was being made of the new medium of enameled terracotta. Young marble sculptors, Desiderio da Settignano and Antonio Rossellino, had come to the fore, and the influence of Alberti had penetrated to Santa Croce in the triumphal arches of the Bruni and the Marsuppini monuments. The doctrinal climate had been transformed by the appointment as Archbishop in 1446 of Sant'Antonino and was manifest in painting in the puritan figure of Andrea del Castagno. Donatello must have known Castagno before he left for Padua, and may well have encountered him on more than one occasion in Padua or Venice, where he was engaged in 1442 in painting the apse of the church of the Benedictine convent of San Tarasio. Like Castagno, he had encountered the work of Antonio Vivarini and Giovanni d'Allemagna. At San Tarasio Castagno's central God the Father was based on a Vivarini cartoon. Passed on from one Benedictine convent to another, he had in Florence decorated the refectory of Sant'Apollonia with a Last Supper and Passion scenes, which made (as can be deduced from later sculptures) a profound effect on Donatello, and soon after Donatello's arrival he produced three revolutionary frescoes for Michelozzo's chapels in the Santissima Annunziata. The relations between Donatello and Castagno are complex and mysterious, but of Florentine painters it was Castagno—in an altarpiece of 1449–50 of the Assumption of the Virgin for San Miniato fra le Torri, which reveals some knowledge of Donatello's relief on the Brancacci Monument, and in the frescoes of Uomini Famosi in the Villa Carducci (before 1451)—who responded with most conviction to Donatello's style and imagery.[10] After 1454 the relationship seems to have been reversed, and features from Castagno's repertory were adopted by Donatello as the basis of a cycle of bronze reliefs.

A new factor in Florentine sculpture in the decade of Donatello's absence in Padua was technical, the invention of enameled terracotta. Its decorative value in an architectural context and its expressive possibilities were abundantly apparent from

opposite: FIGURES 272, 273, 274, 275.
Donatello and Andrea della Robbia,
Roundels with the Evangelists.
Enameled terracotta,
D. of frames, 170 cm (5 ft. 9 in.).
Pazzi Chapel, Santa Croce,
Florence.

Luca della Robbia's lunettes over the sacristy doorways in the Duomo and in the Pazzi Chapel, and facilities for the making of enameled terracotta reliefs were available in the Della Robbia shop. One major work involving the use of enameled terracotta was still incomplete, the Pazzi Chapel adjacent to Santa Croce. Provision for its completion was made in the *Portata al Catasto* of Andrea de' Pazzi of 1457. The drum of the cupola is dated 1459, and at some time during the 1450s, four polychrome enameled terracotta roundels of the Evangelists were commissioned for its pendentives. At one time wrongly ascribed to Brunelleschi, they seem, in fact, to be due to Donatello, who must have been responsible both for their designs and for their strident coloring.[11] That Donatello in fact worked for the Pazzi Chapel is recorded in 1510 by Albertini, who after describing the bronze *St. Louis of Toulouse* "a mano di Donato" then on the façade of Santa Croce, adds the words: "il quale con Luca de rubea e Desiderio feciono assai cose nel Capitolo bellissimo de' Pazzi."[12] The attribution of the four roundels to Brunelleschi or to Andrea della Robbia (in whose workshop they were executed) is plainly incorrect.[13] The figures are shown seated on a cloud, two facing to the right, two to the left. Their forward legs fall on a horizontal across the base of the reliefs; their forward knees are slightly and their rear knees are more steeply raised. In each, the symbol of the Evangelist is represented on a rear plane, and the Saint's shoulders recede at an angle of forty-five degrees into the picture space. In all these respects, and as well as in the soles of the carefully rendered feet, the figures read as monumental transcriptions of the marble relief of the *Madonna of the Clouds* in Boston and the gilt bronze roundel in Vienna. The background is not the neutral, deep blue surface of Luca della Robbia's roundels, but a strongly naturalistic sky, which reads as though the roundels were apertures punched in the surface of the wall. In all these respects the four figures are, in the context of fifteenth-century enameled terracotta sculpture, unique. They are unique also in their palette, especially in their use of yellow in the halos and in the lining of the cloak worn by St. John. In the flesh areas the application of the color is of extraordinary accomplishment.

Figs. 272–2⅃

Evidence of Donatello's interest at this time in pigmentation is afforded by a great wooden sculpture, which appears to have been carved soon after his studio reopened in Florence. This is the St. Mary Magdalen, formerly in the Baptistry and now in the Museo dell'Opera del Duomo.[14] The traditional imagery of the Magdalen as a naked or almost naked figure covered with unkempt hair, goes back in Tuscany to the late thirteenth century. In the earliest and most influential of the Magdalen paintings, the Saint carries a *cartellino* with the words "Ne desperitis vos qui peccare soletis exemploque meo vos reparate Deo," and this message must have resonated in the mind of anyone who contemplated later representations of the Saint. The first significant Early Renaissance sculpture of the Magdalen was due to Brunelleschi. Carved at a date not far removed from that of the Santa Maria Novella *Crucifix*, it stood in the church of Santo Spirito until it was destroyed by fire in 1471. It was still in existence when Donatello's statue of the Magdalen was carved. Donatello's statue can be dated with some precision. A coarse wooden Magdalen at Empoli, which is evidently based on it, carries the date 1455, so the Magdalen for the Baptistry is likely to have been carved in 1454 immediately after Donatello's

Figs. 276, 27⅃

return from Padua. A context for it, and for the human response it was intended to inspire, is provided by the *Opera a ben vivere*, written by Sant' Antonino for Diodata Adimari.[15] For Sant' Antonino, the Magdalen was "prima gran peccatrice e poi molto di Cristo amatrice." Though the Magdalen's corporeal virginity was irrecoverable, she regained mental virginity and her saintly crown through penitence. "Lo esercizio," Sant' Antonino continues, "dove era occupata Maria, cioe di contemplare il Signore, non doveva mai avere fine." She was a mirror for penitents, "perseveranda nella penitenza con grande affetto." The commission for the statue may well have been inspired by the Saint. Once a charismatic figure standing majestically in the Baptistry, Donatello's *Magdalen*, the repository of these convictions, is now shown in clinical conditions in the Museo dell'Opera del Duomo, and a good deal of imagination is required if we are to recapture its original significance. Without its gilded *diadema*, which was made in 1500 by a goldsmith, Jacopo Sogliani, and without the austere background of the Baptistry walls, it makes an impoverished impression. Submerged in the flood of 1966, it was later cleaned, revealing its full pigmentation and the striated gilding that covered the hair and dress. In this condition it spoke with the utmost power, but the surface was later painted with a preservative varnish, which has the effect of diminishing the rough handling of the wood and the emotive cutting of the head. A work that once looked like a ferocious Kamakura sculpture has been domesticated. But the brilliant white of the teeth, the surface of the hair and dress, and the flesh areas, not only in the head and hands and legs, but in the right thigh seen through the torn dress and in the firmly modeled left shoulder, still afford some impression of the effect it must originally have made. About 1460 another wooden statue of St. Mary Magdalen, based on Donatello's, was commissioned for Santa Trinità from Desiderio da Settignano, and in the 1490s Donatello's image was popularized in the form of painted terracotta reliefs and statuettes.

The *Magdalen* apart, the precise chronology of the sculptures Donatello executed after his return to Florence is far from clear. It is, however, likely that almost at once he received commissions for two major statues. One of them was a bronze Baptist for Siena Cathedral, which was delivered in September 1457 and may therefore have been commissioned in 1455 or early in 1456. The other was the great bronze group of Judith with the Head of Holofernes. A more taxing and elaborate work igs. 279, 280 than the *St. John*, it may have been begun late in 1454 or early in 1455. When casting a full-scale figure, it was common practice to assemble the necessary bronze or its constituents from whatever sources were available. This was the practice followed in Padua for the *Gattamelata*, for which the bronze (or part of it) was purchased piecemeal in Venice. In Padua the cost of bronze was paid or refunded by authorities of the Arca in the case of the High Altar, or by Gattamelata's executors. In Florence, on the other hand, the initial cost seems to have fallen on the sculptor. We know, from the Cambini account books, that Donatello was advanced a sum of a hundred florins by an intermediary, Bartolomeo Serragli, and that with this money he purchased in October and November nine hundred sixty-five pounds of bronze.[16] Similarly, in September 1457, Urbano da Cortona, who was working in Siena for the Opera del Duomo, secured twenty-five ducats from a banker, Galgano di Jacopo

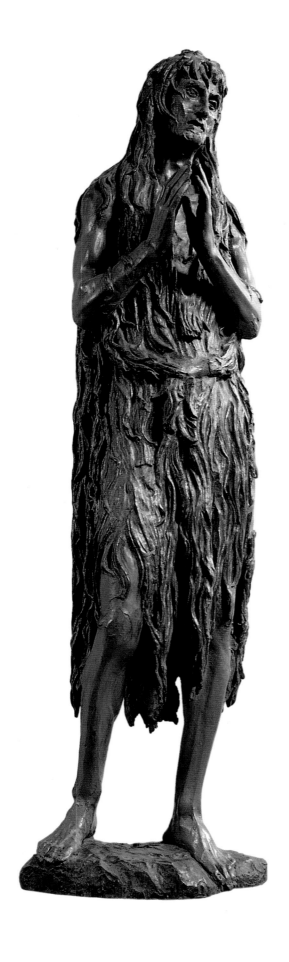

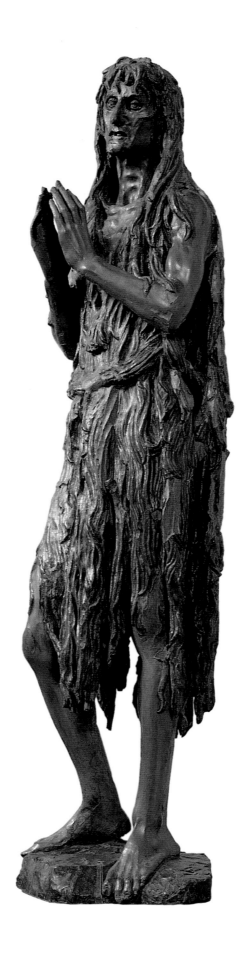

left and right: FIGURE 276, 277.
Donatello, *St. Mary Magdalen.*
Pigmented and gilded poplar wood,
H. 184 cm (72½ in.).
Museo dell'Opera del Duomo,
Florence.

opposite: FIGURE 278.
Donatello, Head of
St. Mary Magdalen (during cleaning).

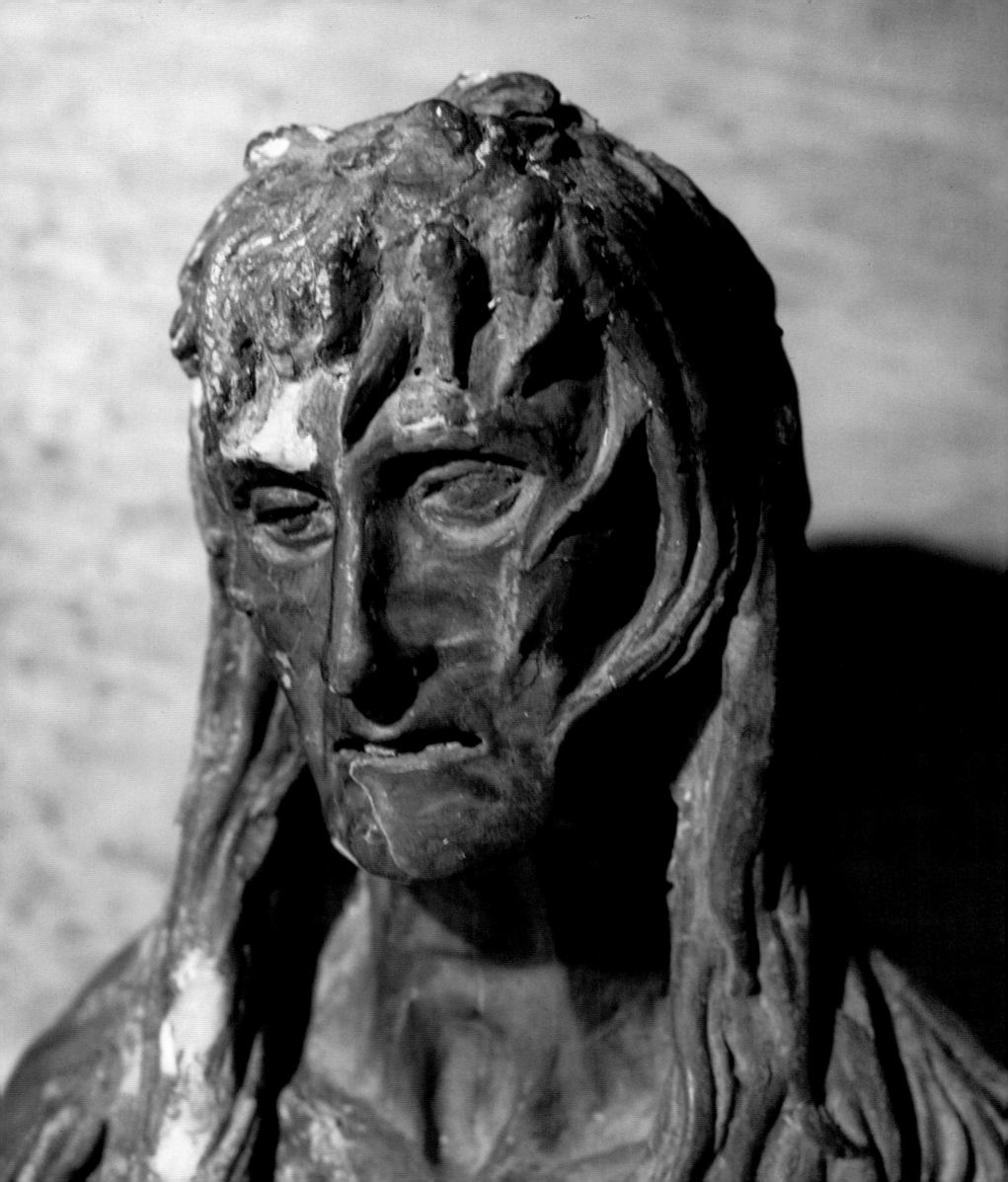

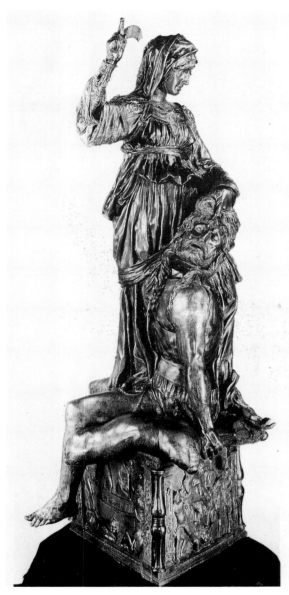

FIGURE 279.
Donatello, *Judith*. Bronze,
parcel gilt, H. 236 cm, W. 185 cm
(H. 93 in., W. 73 in.).
Palazzo della Signoria,
Florence.

Bichi, to purchase metal on Donatello's behalf "per fare mezza fighura di Guliatte."[17] This document has been wrongly interpreted as meaning that the *Judith* was commissioned for Siena.[18] It is an exceptionally heavy figure (its weight has been calculated at a little more than one and a half times the weight of the Siena Baptist), but the total of bronze purchased was in excess of the quantity its casting would demand. The most probable deduction, therefore, is that the bronze (along with other metal of whose purchase we have no record) was for the casting of both statues, and possibly of other works.

After the expulsion of Piero di Lorenzo de' Medici in 1495, the bronze *David* in the courtyard of the Palazzo Medici was transported to the Palazzo Vecchio. A second bronze statue "in the garden of the same palace" was moved as well. This is our first reference to Donatello's *Judith*.[19] It is likely that the *Judith* stood in the small garden of the Medici Palace. Its column carried two inscriptions. The first, on the front, read:

REGNA CADUNT LUXU, SURGUNT VIRTUTIBUS URBES
CESA VIDES HUMILI COLLA SUPERBA MANU
(Kingdoms fall through luxury, cities rise through virtue.
Behold the proud neck severed by a humble hand)

A second inscription, on the back, read:

SALUS PUBLICA. PETRUS MEDICES COS. FI. LIBERTATI SIMUL
ET FORTITUDINI HANC MULIERIS STATUAM QUO CIVES
INVICTO CONSTANTIQUE A[N]I[MO] AD REM. PUB.
REDDERENT DEDICAVIT.
(The public weal. Piero son of Cosimo de' Medici dedicated the statue
of this woman to liberty and to the fortitude with which the citizens,
with resolute and unvanquished spirit, bring to the public good.)

The second inscription, which associated the statue with Piero de' Medici, was removed after the statue was taken over by the Operai of the Palazzo Vecchio, and was replaced with the words "Exemplum sal[utis] pub[licae] cives pos[uerunt] MCCCCXCV." It seems reasonably clear that the two earlier inscriptions were of different dates, and that the first represents the original intention of the statue. The second would have been added later, after the death of Cosimo il Vecchio in 1464. It has been suggested, not wholly implausibly, that the second inscription relates to Piero de' Medici's suppression of the Pitti conspiracy in 1466. Just as the bronze *David* carried an inscription referring generically not to the story of David and Goliath, but to "quisquis patriam tuetur," and ending with the rousing line "Vincite cives," so the second inscription on the *Judith* has a strongly patriotic character.

The Book of Judith in the *Apocrypha* describes the heroic conduct of a wealthy, beautiful, and pious Jewish widow, who entered the camp of the invading Assyrian army outside Bethulia accompanied by her maid. Winning the confidence of Holofernes and invited to his tent, she persuaded him to drink till he became

intoxicated and then severed his head with his own sword, returning with it to her countrymen in Bethulia. Throughout the Middle Ages representations of David and Judith were often linked. This association was preserved in Florence in the third quarter of the fifteenth century. To take only two examples from a long list cited in Kauffmann's *Donatello*, a Medicean Psalter illuminated about 1460 for the convent of Saints Cosmas and Damian, now in the Museo di San Marco, shows on the first page a miniature of St. Francis flanked by Judith and David, and an Evangelary, presented by Piero de' Medici to the Duomo in Florence in 1466, likewise shows David and Judith as ancillary figures in an illumination of the Last Judgment. It cannot be deduced from this that the bronze *David* and the bronze *Judith* were commissioned as part of a single program, but when, after the installation of the *David* in the courtyard of the Palazzo Medici, another freestanding bronze statue was required, the choice of subject, Judith and Holofernes, was all but preordained.

Donatello's *Judith* impresses us, as it must have impressed his own contemporaries, in the first instance as drama; it is the first sculpture since antiquity to explore the potential of a full-scale, freestanding, active group. It stands at the head of a long line of bronze sculptures that culminates in the nineteenth century in Rodin. But before considering the interpretative or artistic implications of the statue, we should examine how it was designed and executed. Like the bronze *David*, it is a formal construct, but a construct of a far more powerful kind. Its base is a triangle set on a circular plinth. The triangle supports a rectangle, the wineskin, which in turn supports the group. It is not, therefore, like the *David*, a figure with four faces rising from a circle. Instead, it has seven interrelated views, three from the angles of the triangle and four from the edges of the wineskin. The front faces of the triangle and wineskin correspond, and establish the prime view of the group. At the back the legs of Holofernes, hanging over the wineskin, are straddled across the rear point of the triangle, which in turn serves as a base for the strong vertical folds of the back of Judith's dress. Moving around the statue, we find two subsidiary views correlated with the front angles of the triangle. Behind them the sides of the wineskin offer two more emphatic views. On the right, the rigid vertical of Holofernes' arm leads the eye up to the raised arm of Judith and her avenging sword, while, on the left, Judith is once more seen in profile, with a look of glazed repugnance on her face, as, with her formidably strong left arm, she holds back the hair of Holofernes in preparation for the final blow.

Study under cleaning[20] has revealed that construction of the preliminary model involved, first, a skeleton of the standing figure covered with waxed fabric in which the folds of the robe were defined—a single piece of fabric survives over the forehead, where the bronze coating imposed on it has come away—and, second, the progressive modeling, in wax rather than clay, of the heads and limbs of both figures. The casting was undertaken sectionally. The head, chest, and shoulders of Judith were cast in one, but her two arms were cast separately, as was the sword and the right hand. Also cast in one was the body of Judith from the waist to a point above the knees. The point of juncture is hidden at the back by a horizontal veil. The left hand of Judith, the body of Holofernes, and, possibly, the wineskin

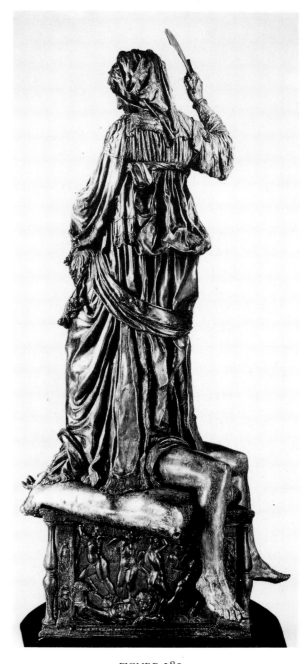

FIGURE 280.
Donatello, Back of *Judith*.

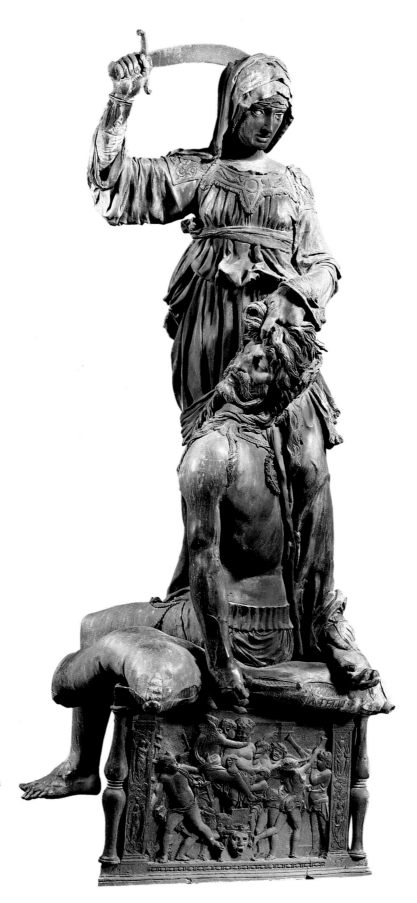

FIGURE 281.
Donatello, *Judith*. Bronze,
parcel gilt, H. 236 cm, W. 185 cm
(H. 93 in., W. 73 in.).
Palazzo della Signoria,
Florence.

opposite: FIGURE 282.
Donatello, Head of *Judith*.

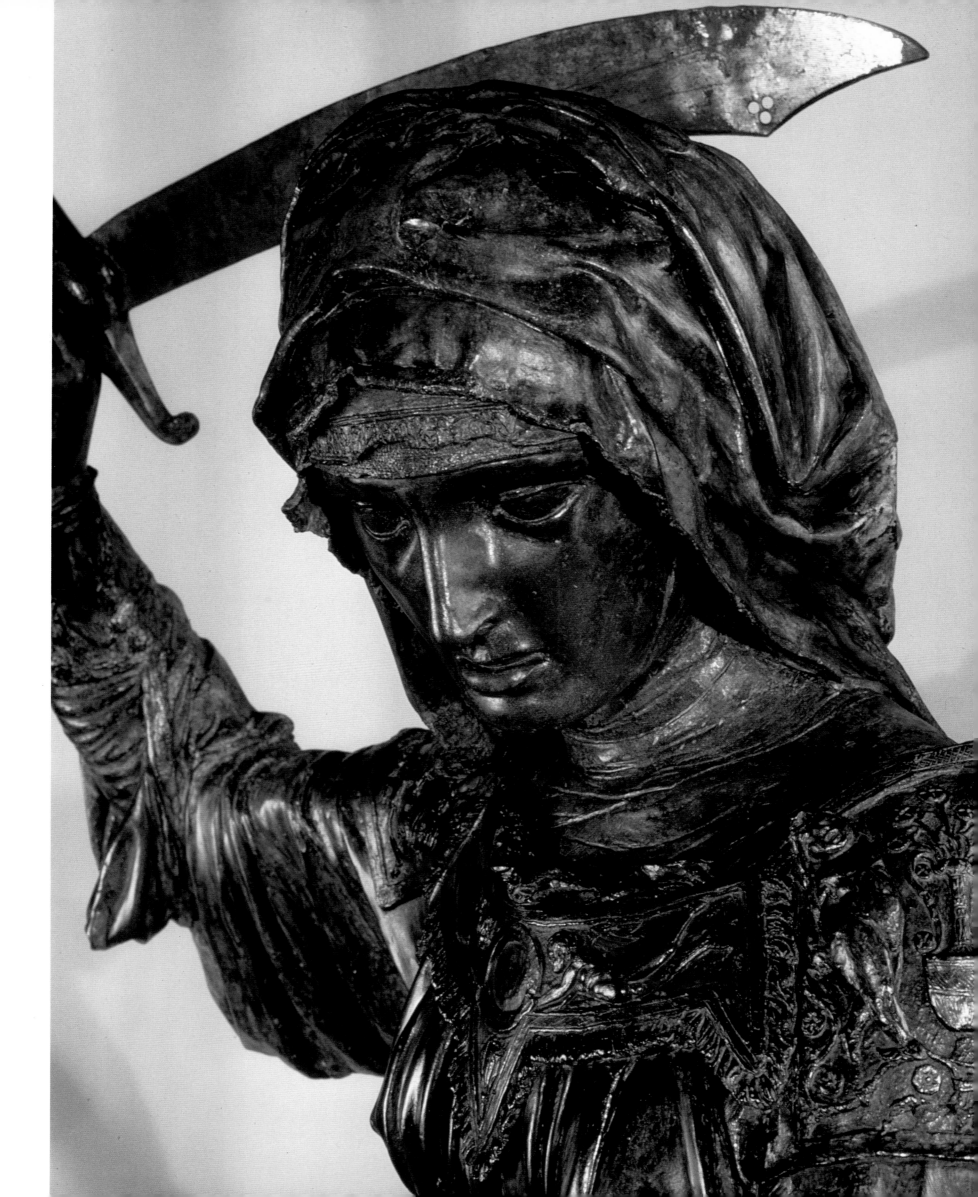

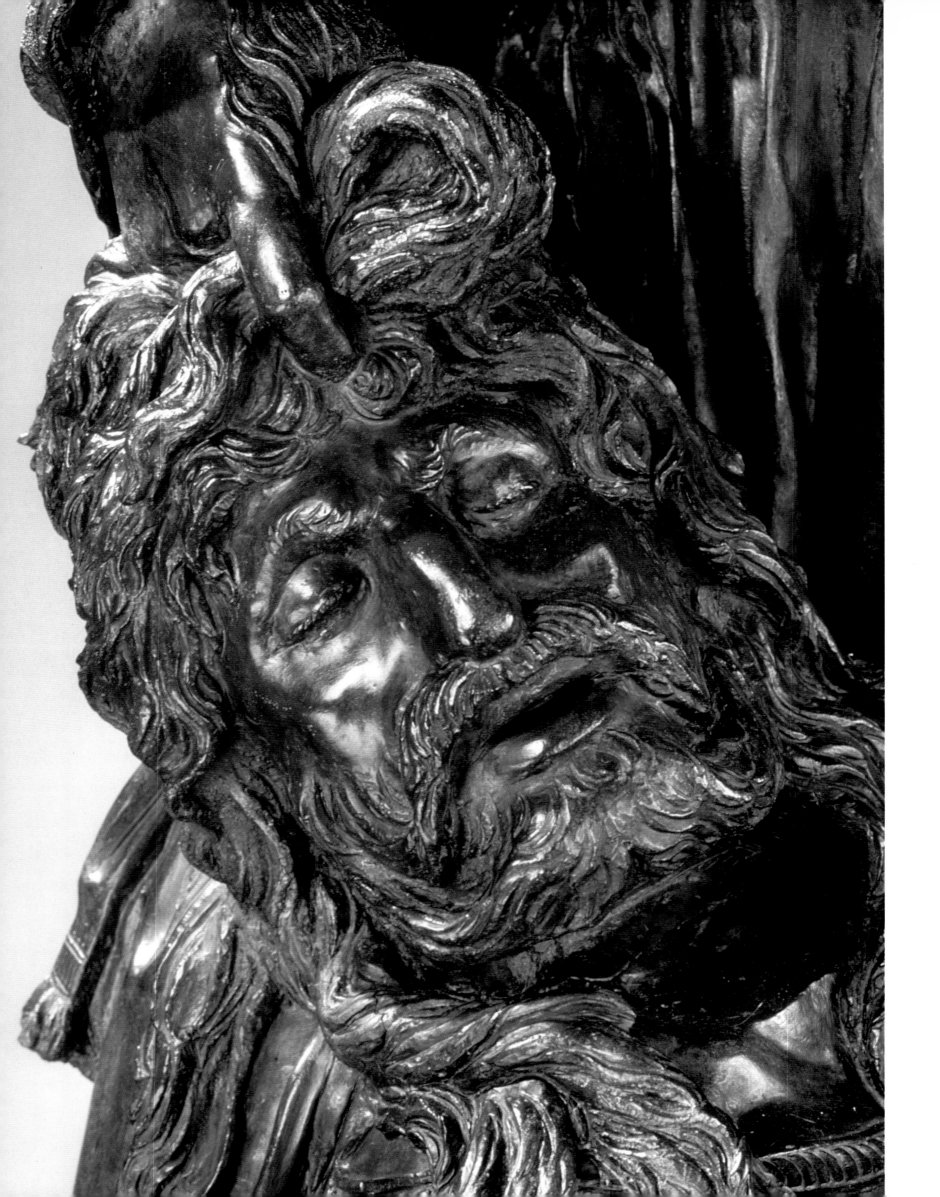

were cast in one, but the two legs of Holofernes are nature casts made separately. The composition and, therefore, the color of the bronze varies throughout the statue.

Two features in it only are anticipated in Donatello's earlier work. The first is the wineskin, which looks back to the cushion beneath the *St. Mark* on Or San Michele. In bronze the handling is bolder and more irregular, but the concept of imbalance between a solid figure and the insecure support offered by a cushion is common to both works. The second is Donatello's only earlier two-figure group, the *Abraham and Isaac* on the Campanile. In it, Donatello was compelled by the limited width of the niche the statue occupied to show Isaac under and in front of Abraham; the two figures constitute a single vertical. In the *Judith* it was necessary that the two figures be cast as one. This could be achieved only if they were planned, like the statue on the Campanile, as a single column of form. With the *Abraham and Isaac* there is some doubt as to whether the moment of depiction precedes or follows the announcement of the angel that Isaac's life is to be spared. The *Judith* admits no such uncertainty. In realistic terms, the validity of the whole scene would have been prejudiced had it not shown Judith in the act of severing Holofernes' head. Hence his head is forced back by Judith's left hand against her thigh, as she brandishes the sword, and with her left foot stamps in triumph on his hand.

Donatello's objective in the *Judith* was not realism, in a narrow, modern sense, but actuality. Just as in the *Ascension with Christ Giving the Keys to St. Peter* he recreates the state of mind of each of the Apostles present at the scene, just as in the *Scenes from the Life of St. Anthony of Padua* he distinguishes the responses of each participant, so here, on a life-size scale, he depicts the scene in three dimensions, as his creative imagination told him that it occurred. The *Judith*, a figure in early middle age, not the young heroine portrayed by painters, wears her richest dress. Across her forehead runs a raised band of ornate brocade. Over her neck hangs a fringed plaque, seemingly of stump work, with two flying putti holding a circular frame. The same plaque is repeated at the back. On the shoulders of her dress are panels of embroidery with paired putti beside a vase filled with flowers. Both her underdress and overdress have deep, richly embroidered cuffs. The effect of these decorative devices must have been much enhanced when more of the surface gilding was preserved. The scimitar of Holofernes above Judith's head is fully gilt. Painters in the fifteenth century tended to avoid the scene of Holofernes' execution, representing instead the discovery of his decapitated body and the return of Judith to Bethulia. Donatello, on the contrary, shows the story at its climactic point. For him it was a simple fact that no woman with a scimitar could cut off a man's head with a single blow, and the moment of action depicted in the statue is that at which a first mortal stroke has been delivered, leaving a gash across the neck, and Judith's arm is raised to complete her task. But the problem was not simply one of action. At Padua the heads of six Saints were modeled separately from the bodies and were differentiated with the utmost care. The head of St. Francis, with its high cheek bones and tight mouth, is conceived in different terms from that of St. Daniel, with eyes turned toward the Child Christ and loose lips parted as though about to speak. The

problem presented by the head of Judith was more demanding. Though a divine agent, she must, as a woman, have felt repugnance at the task she was destined to perform. In full face she is presented in her allotted role as a heroine of the Old Testament, but in the profile views from right and left, her lips are parted as though in prayer. The retracted upper lip, contrasted with the protruding lip beneath, reveals her true emotional ambivalence. The only contemporary painting that reflects, in a less subtle fashion, this plunge into psychology is Castagno's fresco of the guilt-ridden St. Julian in the Santissima Annunziata, which was painted after 1453. That there was at this time close contact between Donatello and Castagno is proved also by Castagno's fresco, in the adjacent chapel, of the Trinity appearing to Saints Jerome, Paula, and Eustochium, where we know from a *sinopia* that the two female Saints originally stood in three quarter face, but were represented in the fresco in profile in heavy cloaks that may well depend from the side views of Donatello's statue.[21]

The triangular base of the *Judith* is composed of three reliefs, that in front *Figs. 284–.* showing a Bacchic orgy and those at the back the harvesting of grapes by a group of winged erotes and the treading of grapes. In subject the reliefs derive from Hadrianic sarcophagi of drunken putti like that in the Camposanto at Pisa. The *Apocrypha* describes Holofernes as intoxicated at the time that he was killed, and drunkenness is depicted in the three scenes.[22] The reliefs are variations on an antique theme, not imitations of the antique. The problem they present in their cleaned state is not that of meaning, but of authorship. Looking back, as we must inevitably do, to the reliefs of angels on the Padua high altar, we need feel no doubt that the orgiastic relief on the front of the base is the work of Donatello. The superimposition of one putto on another, the use of poses that establish the planar depth of the relief, and the diagonals created by the head and left leg of the foreground putto on the left and the right arm and left leg of the putto on the right, meeting at a common point beneath the central mask, afford proof that the relief was designed and modeled by Donatello. In the relief of the harvesting of the grapes, on the other hand, the figures are taller and flatter, and the mannered contrapposto of the second figure from the left would be unthinkable in a work modeled by Donatello. The center of the third relief, the treading of grapes, is filled by a circular wine vat with a frieze of garland-bearing putti round it. The winged figures treading the grapes inside the vat are both shown in profile and have the same flatness as the drunken putti in the foreground at either side. In the case of the Padua angels, we know from documents that certain figures were modeled and finished by Donatello while others were commissioned from members of his shop. Very possibly the second and third reliefs on the *Judith* base were entrusted to Bertoldo.

We do not know how the *Judith* was originally displayed. The four corners of the wineskin and the mouths of the central masks in the three reliefs are bored for the extrusion of water, and it is generally assumed from this that the *Judith* was a fountain figure on a circular basin. Though the original base appears to have been moved to the Palazzo Vecchio in 1495, the group, when it was installed there, was placed on a new circular granite baluster base, which is still shown in its immediate vicinity inside the palace. The height of this base was established by the need to

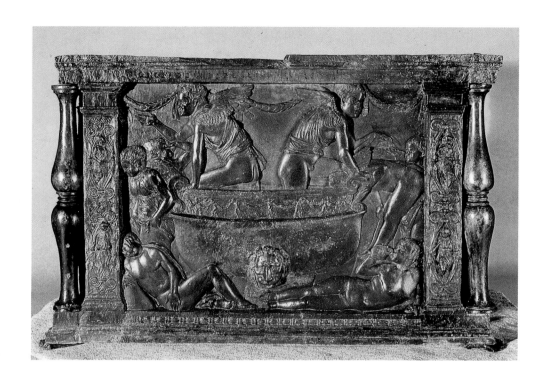

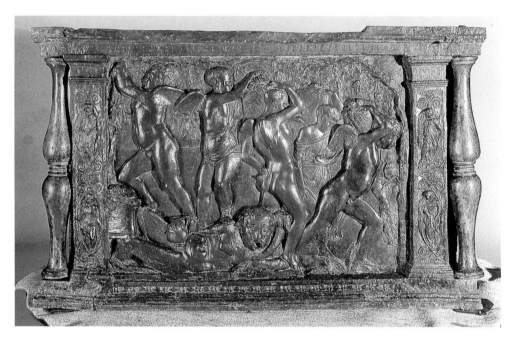

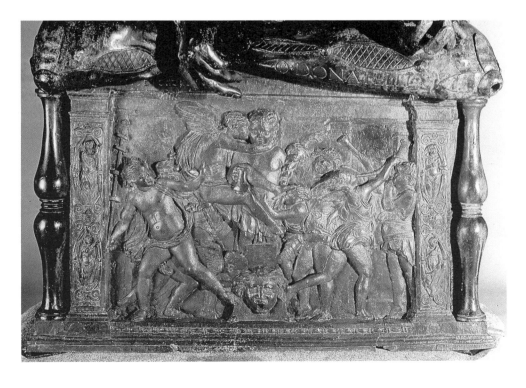

FIGURES 284, 285, 286.
Donatello (assisted),
Allegory of Drunkenness. Bronze,
H. 43.5 cm, W. 57 cm
(H. 17¹/₈ in., W. 22¹/₂ in.) each.
Palazzo della Signoria,
Florence.

287

ensure its prominence in its new position to the left of the stairs leading to the entrance to the palace.

The first reference to the bronze statue of the Baptist cast for Siena Cathedral occurs *Figs. 287,* in September 1457, when an export tax (*gabella*) was paid for the transport to Siena of "a half-length figure of St. John the Baptist by the hand of Donatello."[23] The rest of the figure followed, and at the end of October the three pieces were weighed. They comprised one piece with the head (*Libre* 224), one piece with the middle of the figure from the waist to the knee (*Libre* 221), and one piece from the knee to the bottom of the base (*Libre* 143). On the arrival of the three pieces in Siena, the right arm proved to be missing. In its present state the statue has a hole beneath the right elbow, suggesting that the lower right arm was originally to have been attached in a rather different position from the present right arm of the statue. The earliest reference to the right arm dates from June 1474, when "el braccio di bronzo de la figura di sto. Giovanni fe' Donatello" was received by the Operaio of the Duomo, Savino Savini. The words "fe' Donatello" qualify the statue, not the arm, and do not constitute evidence that the arm is itself the work of Donatello. The modeling of the right hand differs from that of the left, and the respect shown in the method of attachment, as a result of which the flaw at the elbow is left visible, suggests that it must be the work of a later Sienese bronze sculptor, perhaps Giovanni di Stefano. Donatello may have intended that the right hand should point upwards like that of the Venice Baptist. The present arm, with the hand directed toward the left shoulder, brings the figure into line with the conventional Sienese iconography of the Baptist represented, at the time that the figure was cast, by the Baptist of Matteo di Giovanni and Giovanni di Pietro in an altarpiece in the church of San Pietro Ovile. The statue in its unfinished state was not exhibited—in 1467 it stood "nello ridotto di sotto"—and not till the missing arm had been attached did it find a place in the Sacristy. It was later placed in the position it occupies today, in the Chapel of San Giovanni.[24]

The back of the statue, which is left almost in the rough, proves that it was intended to be set in a tabernacle or against a wall. The lack of fully developed side views would be inexplicable had it been intended for a position in which the side views were fully visible. Though the base and back recall those of the wooden *Baptist* of 1438 in Venice, the pose has been thought out afresh. The weight is born on the forward, not the rear leg, as though the figure were in motion, and the body, no longer restricted by the dimensions of a wooden block, is more dynamic and more muscular. Whatever privations this Baptist has endured, they have not impaired his spiritual resilience or his physical strength. No pain is spared to invest the statue with the attribute of lifelikeness. The legs, feet, and left hand, like the legs of Holofernes in the *Judith*, seem to be nature casts. The face is framed between two twisted strands of matted hair. They, and the hair hanging down over his forehead, and, to a less extent, the goatskin covering his body, are chased more regularly than is usual in Donatello's work; this may be due to the intervention of one of Donatello's Paduan assistants, Bartolomeo Bellano, whose presence is recorded in Florence from October 1456 ("portò Bartolomeo di Belano da Padova iste cho 'lui")

till May 1458.[25] In a city like Siena, where archaic paintings of the Baptist were to be found in almost every church, this brutal figure, haranguing his onlookers with parted lips, would have assumed an almost frightening intensity.

Before the statue was delivered, events took an unexpected turn. During the summer of 1457 Donatello decided that he wished to move from Florence to Siena. This was not a simple operation, and much of the information concerning it comes from the deliberations of the Sienese Balia.[26] On September 16, 1457, it was reported that Donatello, "maestro di scultura excellentissimo," had arrived in Siena anxious, as he put it, to live in your city, "piacendo alla S.V., et in esso come città nobilissima d'Italia fare qualche singularissimo lavoro in honore d'essa vostra città, et sua memoria, et liberamente rimettersi in essa V.S., pur che lui habbi da vivere; Et però acciò che loro citta et maxime la vostra Chiesa sia ornata di qualchuno delle sue opere." The proposal was received with caution, and it was agreed "che sia rimesso in nel loro magnif. misser l'Operaio, quale debba eleggiare tre del presente collegio. E quali tre insieme con lui debono provedere con effetto che il detto Donatello si fermi qui per lo tempo della vita sua, per quello miglior modo lo[ro] parra piu utile e piu honorevole per la vostra citta, provedendo de' beni de l'Opera." The committee of three members of the Balia, with the Operaio of the Cathedral Cristoforo Felici, decided on October 7 to make provision that "Donatellus excellentissimus scultor, seu magister sculture, se firmet in hac civitate ut suis operibus ornet Ecclesiam predictam; et providendum ut toto tempore vite sue possit vivere de bonis dicte opere ac etiam ad exequendum circa cappellam Virginis Marie delle Grazie."[27]

In 1457 Donatello reached what in the Renaissance was the advanced age of seventy-one.[28] Both in Padua and Florence, as we know from two different sources, he had been gravely ill. In Padua his living expenses were defrayed by the Santo, but in Florence he had no stable source of income. The threat of an indigent old age must have appeared imminent. If we disregard those expressions in his application that are conventionally rhetorical—the wish to live and die in Siena, the noblest city in Italy—we are left with one crucial clause: "pur che lui habbi da vivere." This may have been the reason for his request. That it was recognized as being so is indicated by the agreement of the committee appointed by the Balia that he should receive a life stipend from the Opera del Duomo. The Balia was a thrifty body, and from the first it was stipulated that the sums paid to Donatello should be contained within the budget of the Cathedral. In addition, as a guarantee that Donatello did not break his contract and leave Siena, the sum due for the *Baptist* was withheld; as late as 1461 the debt for it was not discharged. In Siena money was short, and it was decided that Donatello should be employed initially on the completion of work in the chapel of Santa Marie delle Grazie (which had hitherto been the preserve of Urbano da Cortona) and then on the new chapel of St. Calixtus, for which he carved a marble tondo of the Virgin and Child with Angels (later installed over the Porta del Perdono of the Cathedral). In July 1458 he was commissioned to carve a marble statue of San Bernardino for the Loggia di San Paolo at a fee not exceeding sixty florins "vel ad plus vantagium opere."[29] One "singularissimo lavoro" was dangled before his eyes, the making of bronze doors for the Cathedral.[30]

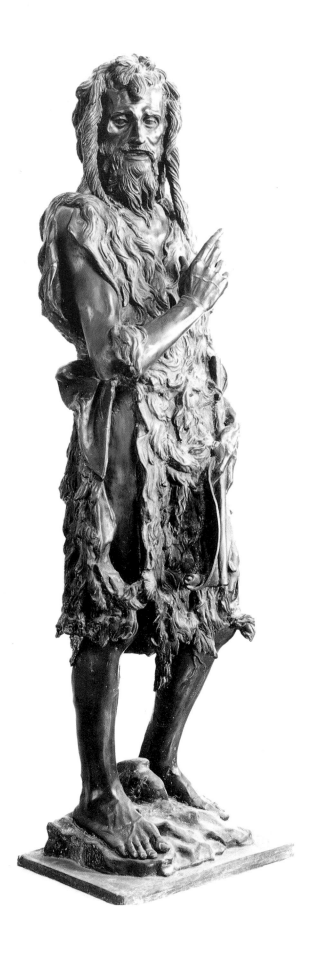

FIGURE 287.
Donatello, *St. John the Baptist*.
Bronze, H. 185 cm (73 in.).
Duomo, Siena.

opposite: FIGURE 288.
Donatello, Head of *St. John the Baptist*.

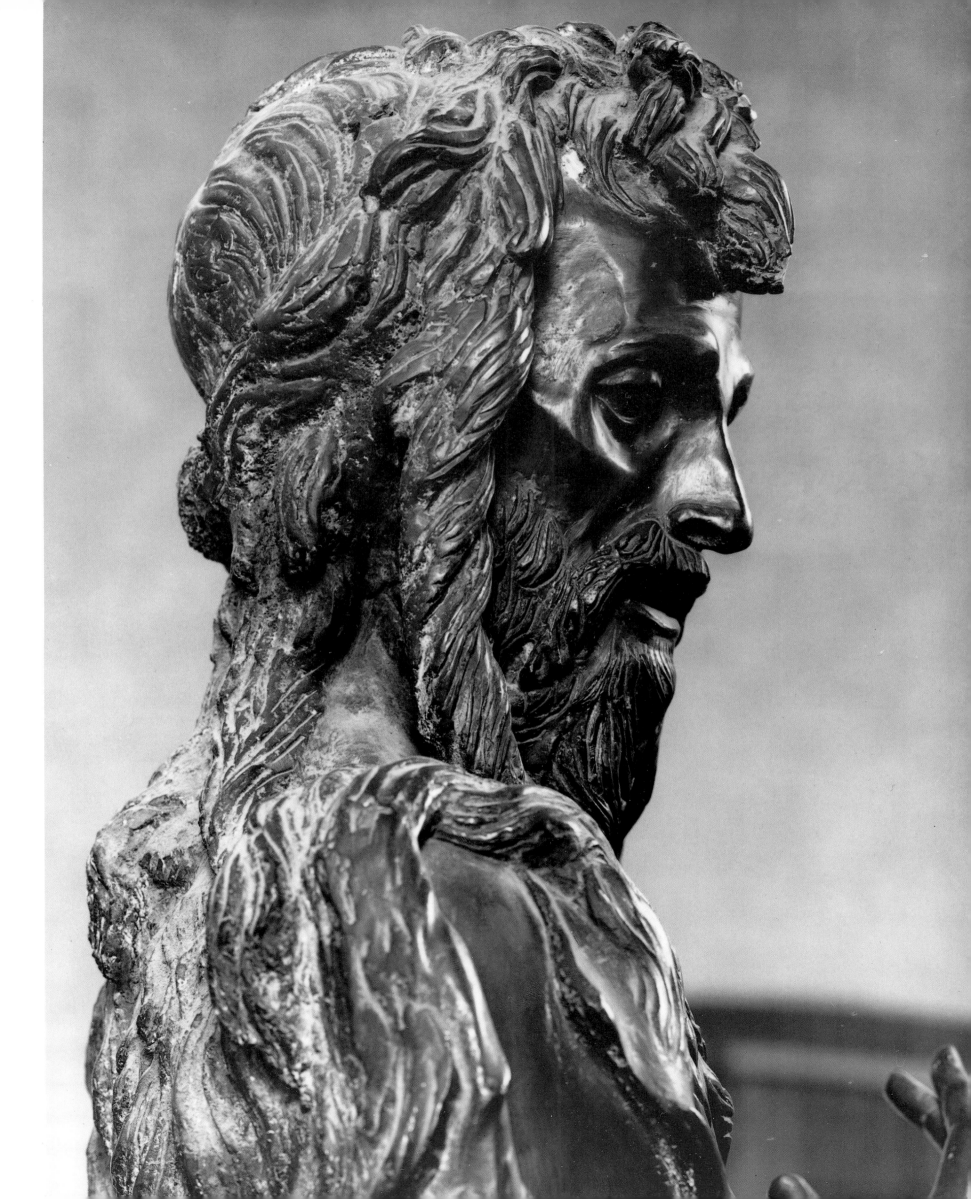

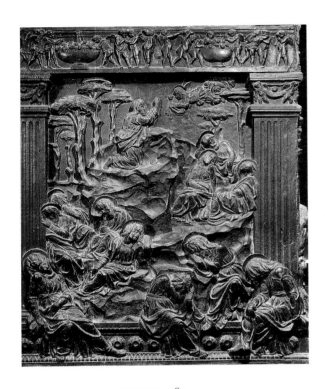

FIGURE 289.
Bellano, *Agony in the Garden*.
Bronze. South pulpit,
San Lorenzo, Florence.

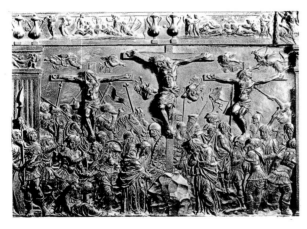

FIGURE 290.
Bellano, *Crucifixion*.
Bronze, South pulpit,
San Lorenzo, Florence.

From the end of 1457 through the first months of 1458, there are repeated references to the supply of wax for the doors, and a letter from Rome of April 1458 addressed to Cristofano Felici includes the sentence "Et salutate el maestro delle porti, maestro Donatello, da mia parte. E veramente bene atto a farvi grande honore; a cosi m'avesse creduto misser Mariano, che gia 4 anni fa lo menavo da padova." All that we know about the doors is that they contained narrative scenes, and that models for them were made in Donatello's workshop in Piazza Manetti, adjacent to the Bishop's garden. An inventory of 1467 mentions the presence, in a marble workshop of the Cathedral, of "Duo quadri per disemgno delle porti del Duomo fecie Donatello con ficure suvi di ciero una cierata et una no."

Sculptors continued to seek work in Siena. One of them was a former assistant of Donatello's, Andrea dell'Aquila, who appears to have worked for Cosimo de' Medici in the Palazzo Medici and was then employed in Naples. His case was presented by the Sienese spokesman in Naples, Niccolò Severini, who recommended that the Operaio "conferitine prima con Donatello." But by the summer of 1458 it must have become evident that, in the current recession, the casting of bronze doors was unlikely to go ahead.

In June 1458, therefore, Donatello, through Bartolomeo Suardi, then Capitaneus Senarum and himself a Mantuan, volunteered to return to Mantua to continue work on the Arca di Sant' Anselmo.[31] Lodovico Gonzaga accepted this proposal, but recognized that Donatello's character was "intricato" and that he might not come. It would be necessary first to ensure his release by the Sienese. When Donatello applied to Felici and his committee for permission to move to Mantua, the necessary permit was refused. The last we hear of Donatello in Siena is on April 23, 1459, when the Opera del Duomo bought a bed and a "capezzale di penna" for his use so long as he was working for the Cathedral. But by June 1, 1459, he had returned to Florence, where the Opera del Duomo paid him fifteen florins for the balance of rent on a house in Via del Cocomero, the present Via Ricasoli.[32] He seems to have left Siena hurriedly. According to Vasari, "Benedetto di Mona Papera, a Florentine goldsmith and his friend and familiar, arrived upon the scene, having come from Rome, and succeeded in carrying him off to Florence, whether for his own needs or for other reasons."[33] A more elaborate version of this story was included in the first edition of the *Vite*, according to which Benedetto, "poco amico de' Sanesi," anxious to frustrate the project for the door, persuaded Donatello, on a feast day on which his assistants were on holiday, to mutilate the models and leave Siena.[34]

Back in Florence, he became a pensioner of the Medici, and his financial problems were resolved. Our prime source for this information is Vasari, who writes:

When he could work no longer, he was assisted by Cosimo and other friends. It is said that when Cosimo was on his deathbed he recommended Donato to his son Piero, who diligently executed his father's wish and gave the artist a property in Cafaggiolo, which brought in sufficient income to permit him to live in comfort. At this Donato was greatly rejoiced, thinking himself more than assured against the fear of dying in

hunger. But he had not possessed it a year before he returned to Piero and publicly renounced it, declaring that he would not give up his peace of mind to think of household affairs and the troubles of the country, which bothered him one day out of three, as either the wind blew down his dovecote, or his beasts were seized by the commune for taxes, or a tempest destroyed his vines and fruits. He had had enough of this, and would rather die of hunger than be obliged to think of such things. Piero laughed at his simplicity, and to relieve him from this vexation took back the estate and assigned to Donato a pension of the same value or more in money to be drawn from the bank weekly. This gave him the utmost satisfaction, and as the servant and friend of the house of Medici he lived happily and carefree all the rest of his days.[35]

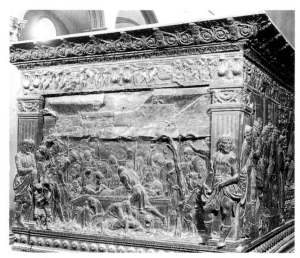

FIGURE 291.
Bertoldo, *Entombment.*
Bronze. South pulpit,
San Lorenzo, Florence.

At the beginning of his life of Michelozzo, Vasari again refers to Donatello's predicament: "Seeing the stigma that attaches to those who have descended from affluence to penury, everyone ought to endeavor by an honorable and temperate life not to be obliged to beg in his old age. Whoever will act like Michelozzo, who in this respect did not imitate his master Donato, only copying his ability, will live honorably all his life, and will not be obliged to go about miserably seeking a livelihood in his last years."[36] In reading Vasari's comments, it must be recognized that he attached preternatural importance to solvency, status, and social success—among artists his sympathies lay with Raphael, who "did not live like a painter but as a prince"—and that he was incapable of understanding the psychology of a great creative artist who was uninterested in money beyond whatever sum may have been needed to maintain the modest livelihood that he required.

Our main source for the work of Donatello's last years is Vespasiano da Bisticci,[37] who writes in his life of Cosimo il Vecchio: "He had a particular understanding for sculpture, being a generous patron of sculptors and of all worthy artists. He was a good friend of Donatello and of all painters and sculptors, and because in his time the sculptors found scanty employment, Cosimo, in order not to have Donatello be idle, commissioned him to do some bronze pulpits for San Lorenzo and some doors which are in the sacristy. He ordered the bank every week to pay enough money for the master and his four assistants, and in this way supported him." This is amplified by Vasari in two passages in the 1550 edition of the *Vite.* The first praises the San Lorenzo pulpit reliefs for "their design, force, invention, and an abundance of figures and buildings. As he could no longer work on them because of his age, his pupil Bertoldo finished them and added the final touches."[38] The second tells us that Donatello "left all his work to his pupil Bertoldo, and especially the bronze pulpits of San Lorenzo, which Bertoldo then chased and brought to their present state."[39] We have, therefore, to picture the pulpit reliefs as the product of an old, reclusive, probably arthritic artist who was able at the time to undertake little or no other work, and whose once wide-ranging imagination was restricted, for physical reasons, to the narrow confines of a cycle of bronze reliefs. He worked with four assistants, one of whom was Bertoldo. There is no record of the names of his three other assistants, though one of them, Bellano, can be identified from analysis of the reliefs.[40]

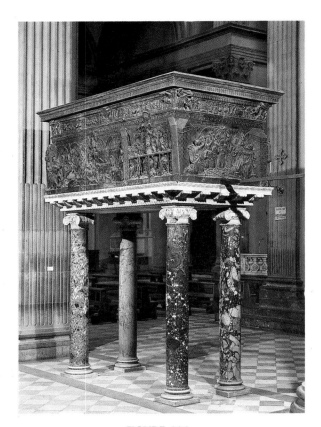

FIGURE 292.
North Pulpit.
San Lorenzo, Florence.

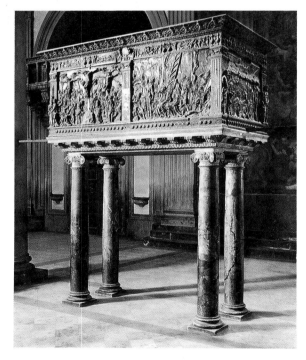

FIGURE 293.
South Pulpit.
San Lorenzo, Florence.

Not unnaturally, the pulpits have a vast literature; the best account of them was published in the nineteenth century by Semrau.[41] They were set up only in 1515, and the effect they make as one walks up the nave of San Lorenzo is a puzzling one. The pulpit on the left contains scenes the best of which are in relatively low relief, and which appear to constitute a homogeneous whole. The pulpit on the right, however, contains a continuous front relief, which projects awkwardly at both sides, and whose front corners are unrelated to those of the two end reliefs. Can these reliefs, you ask yourself, really have been intended for use on a rectangular pulpit? Despite this doubt, the literature of Donatello prior to 1972 deals with the pulpits as paired pulpits. If, however, the reliefs on one of the pulpits were made for some other purpose and were later adapted to their present role, discussion of the meaning and tradition of paired ambones is irrelevant. A brilliant article by Herzner has established, with a high degree of probability, that that is so. As first noted by Middeldorf, the *Ragionamenti* of Vasari record that, for the church of San Lorenzo, Donatello made "il modello dell'altar maggiore con la sepoltura a' piedi," and it would now be generally agreed that the reliefs on the right-hand pulpit were originally made in connection with this project. The relevant dates are the death of Cosimo il Vecchio on September 1, 1464, and the death of Donatello on December 13, 1466.

The first of the narrative scenes on the right-hand pulpit shows the Marys at the Sepulchre.[42] It represents a fundamental change in Donatello's relief style, and has its source in painting. In the refectory at Sant' Apollonia, which was completed about 1447, Castagno was required to paint the conventional subjects for such decoration, the Last Supper and three Passion scenes. The room is less high than the Gothic refectories at Santa Croce and Santo Spirito, and in order to distinguish the Last Supper from the Crucifixion, Entombment, and Resurrection above it, he adopted the unprecedented course of portraying it as though it protruded forward from the wall. The setting is a room with receding lateral walls ending in ornate pilasters, a receding perspectival ceiling, and a receding perspectival floor. Its roof is tiled and runs back to the surface of the wall. Donatello's tomb chamber in the Marys at the Sepulchre is planned in the same way, as a solid structure projecting forward from the relief plane. The figures move freely in real space, in an area the depth of which is defined by receding pediments on the roof. Beyond the roof are treetops in very low relief. In the foreground at either side are shallow walls with grilles over the windows, against which the spears and shields of the protectors of the tomb are stacked, and in the center is a column used in the same way. Above the column is a protruding section of a ruined barrel vault. At the back of the tomb chamber is a metal fence, through which the trunks of the trees seen over the roof are visible. To the left of center there protrudes a strigillated sarcophagus, part of which is hidden by the central column and by an angel on the right. A second angel, on the left, is shown with raised right arm and swirling drapery rebutting one of the three Marys, who in her astonishment clasps the front pier of the building. Another holy woman, with head hidden, holding a small vial, walks down the steps, and a third, with head in profile, peers into the tomb. Three sleeping soldiers fill the right-hand side of the relief. The scene results from a conflation of the Gospels of St.

Figs. 294,

Fig. 295

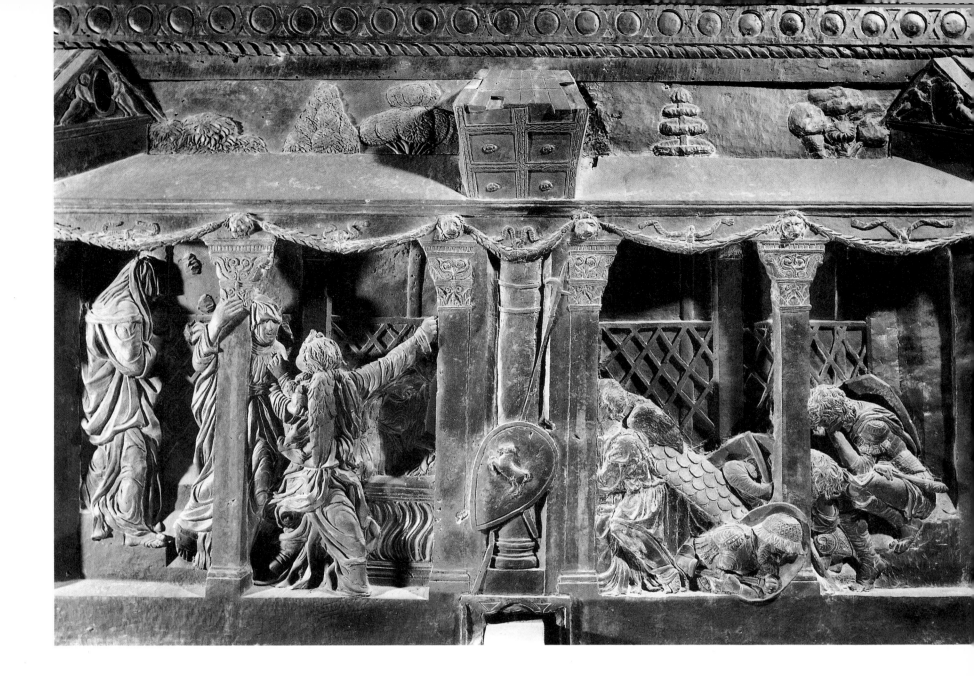

Matthew and St. Luke. From St. Luke comes the second angel, and from St. Matthew the angel on the left, "his countenance like lightning and his raiment white as snow." Brightness could not be portrayed in bronze, and Donatello instead represents the angel from behind, leaving his wind-blown robe to indicate the turbulence of his descent.

Fig. 297

 The three scenes on the front[43] are projected from the same low viewing point as the *Marys at the Sepulchre*. A sense of continuity is established by the setting, a wall surface with three paired archways, only the central one of which is given some individual character, by a grille across the back. From the background there project four sharply receding walls, which separate the individual scenes. The first and

igs. 300, 301

second of them, *Christ in Limbo* and the *Resurrection*, are among the most liberated and most eloquent of Donatello's works. The dominant figures in the first scene are the central Christ, bent forward with his banner on his farther shoulder, a bearded man, seemingly Adam, appealing to Christ from the left, the head of Eve in the doorway on the left, and the emaciated Baptist with one arm extended, greeting Christ. The subsidiary figures are crowded pell mell into the scene, sometimes with

FIGURE 294.
Donatello, *Marys at the Sepulchre*.
Bronze, H. 75 cm, W. 145 cm
(H. 29½ in., W. 57⅛ in.).
North pulpit, San Lorenzo,
Florence.

FIGURE 295.
Castagno, *Last Supper and
Three Scenes from the Passion.*
Fresco. Sant'Apollonia,
Florence.

opposite: FIGURE 296.
Donatello, *Marys at the Sepulchre*
(detail).

feet over the edge of the relief, sometimes with their free legs severed at the knee. In the center below Christ are two female figures, one in profile and the other in violent foreshortening with head turned up to the Redeemer. Donatello's limbo is a concentration camp from which the inmates demand release. In the central *Resurrection* the sarcophagus, of an altogether different type from that in the *Marys at the Sepulchre,* stands to left of center, and Christ, clad in his cerecloth, with a look of anguish on his face, cautiously climbs out of it, his banner clasped firmly in his hands. The cartoon used for the Christ depends from that of a male figure on a Meleager sarcophagus, interpreted, however, in terms that are deeply anticlassical. The third scene, though modeled by Donatello, does not touch such heights, partly because the chasing of the heads, other than that of Christ, is drier and more mechanical. This scene, in which Christ is lifted by four angels off the ground, stands in marked contrast to the earlier *rilievo stiacciato* of the Ascension. The west end of the right-hand pulpit is filled with the scene of Pentecost,[44] backed by the same system of archways as the three scenes on the front and likewise with projecting walls. This scene, like the *Ascension,* seems to have been modeled by Donatello, but chased by a far heavier hand, and neither the Paraclete in the form of a dove emitting tongues of flame at the top nor the praying Virgin nor the symbols of the Apostles scattered across ground have the distinction they would have possessed had they been refined by Donatello.

At right angles to this relief is the *Martyrdom of St. Lawrence.*[45] The space shown is deeper than in the other scenes, and the diminution of the ceiling and of the lateral walls is rendered with great skill. Above the level of the roof are the piers and columns of a distant loggia. The figures are smaller in scale than those in the companion reliefs. The naked figure of the Saint recalls the thieves in the Medici *Crucifixion,* and the long horizontal of the fork pressing the Saint's neck is reminiscent of the Padua reliefs. At the left is a youth carrying the Saint's discarded clothes, and on the right is a flying angel holding the palm of martyrdom. The relief carries the date 1465, but this may represent no more than the year in which the model was cast. In style, indeed, it appears to be the earliest of the reliefs, since the figures and space construction are strongly reminiscent of the Padua reliefs. There is no means of telling why the altar or monument for which these reliefs were destined was not completed. Perhaps they were unacceptable to Cosimo de' Medici, who in 1467 was buried at the instance of his son Piero in a nonfigurated Albertian tomb.

The effect made by the left-hand pulpit is very different. Its front face consists of two reliefs, on the left the *Crucifixion* and on the right the *Lamentation over the Dead Christ.* The *Lamentation* is an inspired design,[46] once more projected, like the scenes opposite, from a low viewing point. In the center, a ladder is propped up against the vacant cross. The three crosses are set at an angle to the relief plane, so that, on the cross on the left, only the feet and forelegs of one of the two thieves is shown, whereas on the further cross the torso and legs but not the head of the thief are visible. In the center foreground Christ's body lies across the Virgin's lap, his head supported by one of a group of mourning women, two more of whom kneel beside the Virgin, and his knees held by a bearded man. Through the cross we see St. John, with head turned away from the spectator, to the right is Nicodemus holding the

Fig. 302

Fig. 303

Fig. 304

Fig. 310

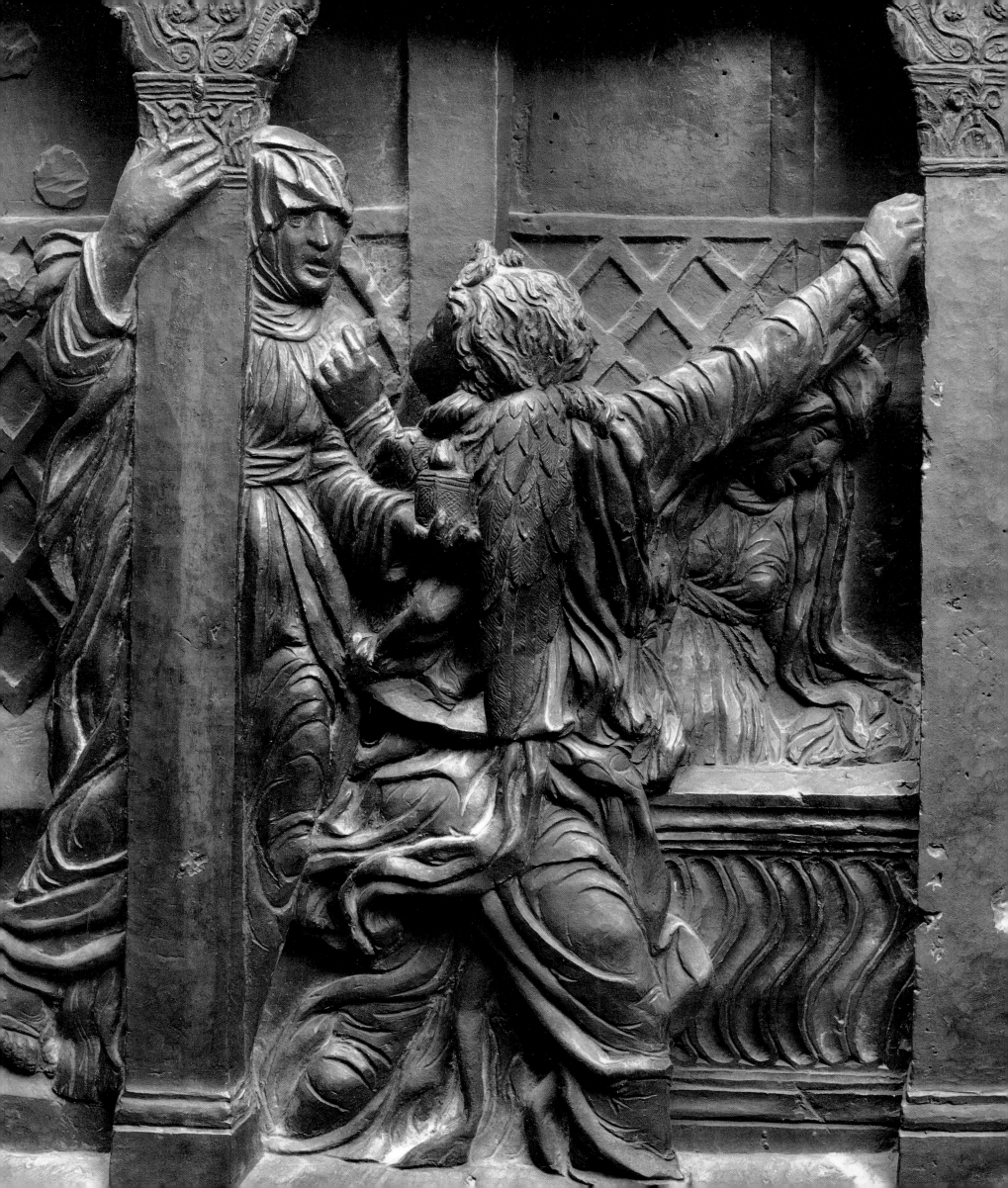

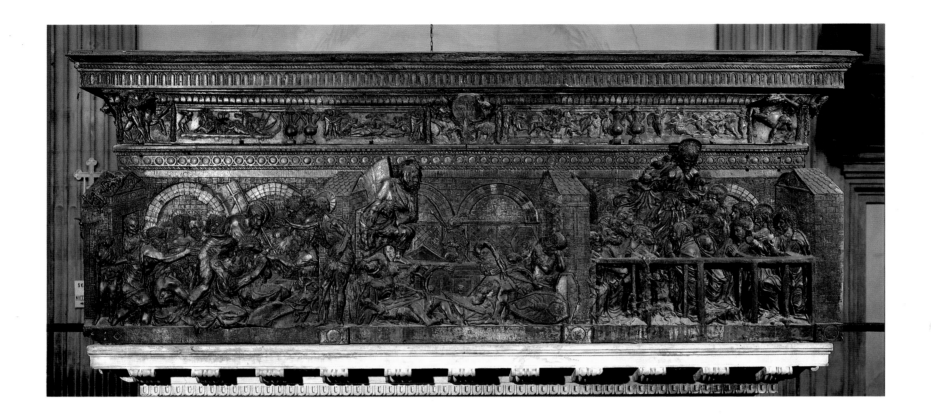

FIGURE 297.
Donatello, *Christ in Limbo,*
Resurrection and Ascension.
Bronze. North pulpit,
San Lorenzo, Florence.

nails, and to the left, against the shaft of the first cross, stands a Van der Weyden–like figure in prayer, seemingly a portrait of Cosimo de' Medici. This horizontal central group is framed at the sides by vertical blocks of standing figures, on the left Longinus and St. Mary Magdalen with hand raised to her head in grief, and on the right two maenadlike women, one of whom, with both arms raised, advances on the central group. Across the flat background are riding figures that have no visible support. They are lightly modeled or incised, as they would have been in a wax model for the scene, and recall the rear figures in the Medici *Crucifixion*, which are supported by a rocky landscape. These phantom figures have a quality of contemporaneity that brings us closer than any other work to Donatello's imaginative faculty. Reading the relief not as a work of art, but as a bronze cast, we are left in no doubt that it was made from a model by Donatello in which the foreground was all but finished and the background was no more than roughly sketched out. Work on the foreground figures seems to have been completed by a younger hand, almost certainly that of Bertoldo, who is mentioned as Donatello's principal assistant in the pulpit reliefs.

The distinction between this relief and the *Crucifixion*[47] to its left is so manifest that it is surprising to find the *Crucifixion* included in books on Donatello. Instead of a low viewing point, the viewing point is central, on the level of Christ's feet. The cross rises from a rock in the center of the front plane, and the crosses of the two thieves are set flat on the relief field, a little to the rear of the main cross. The Virgin and St. John stand at the front beneath the cross, flanked by confused groups of

Fig. 290

figures, a few of which, like Longinus and the Magdalen, can be identified. The modeling of the crucified figures is crude and inarticulate. There is no reason to suppose that any model by Donatello underlies the scene, and the hand in this case must be that of the second of Donatello's assistants on the pulpits, Bellano. The relief on the back of the pulpit, *The Agony in the Garden*, is by the same sculptor as

Fig. 289

the *Crucifixion.*[48] Its authorship can be demonstrated by comparison with Bellano's later, less ambitious reliefs in the choir of the Santo at Padua, where the same piled-up compositions and the same stumpy trees appear. The relief is unusual in that all the apostles are shown, three sleeping in a fold of rock near Christ, four in a lower fold of rock on the left-hand side, and four in the foreground, with legs spreading across the base of the relief. That this inchoate scene cannot depend from a design by Donatello can be confirmed by comparison with the reliefs on the pulpit opposite.

Fig. 307

The relief at the east end of the pulpit shows the two scenes of *Christ before Pilate and Christ before Caiaphas.*[49] They take place in the common setting of a vaulted hall, which recalls that of the Padua *Miracle of the Mule*; it is as though the outer sections of the Padua relief were linked and the central section were suppressed. The diminution of the rectangles in the vaulted roof, however, is less precisely calculated than vaulting of the scene at Padua. The hall is divided at the center by a brick pier surmounted by the base of a spandrel, and is closed on both sides by a wide fluted pilaster. Against the fronts of the lateral pilasters are Salomonic columns, and at the center is a column with a spiral relief recalling the Trajan Column. On the three capitals are small unworked, naked figures. In the receding walls to right and left are doorways with grilles over them, and at the extreme back is a balcony supported by eight piers, terminating in a bronze grille. The foreground space between the façade of the palace and front of the relief is filled with figures. They are interlopers, not participants as they are at Padua, and the narrative action is confined to an inner area between the foreground figures and two small groups of spectators on a balcony at the back. Compositionally the central foreground figure, a soldier, perhaps Longinus, shielding his eyes with raised right hand, is of special consequence, since his head coincides with the vanishing point of the internal perspective scheme. The two scenes are visualized from a lower viewing point than the *Miracle of the Mule* at Padua, so that the figures at the sides, two soldiers on the left and protesting Jews opposite, are notably larger in scale than the key figures in the narrative; a number of soldiers across the foreground are severed at the shoulders or the waist. In the scene on the left Pilate is seated on a raised platform on the near side of the central doorway. He extends his left arm toward Christ, as though persuading him to speak. Below him is his wife appealing for Christ's life, and at the back is a two-faced youth holding a water jug and basin. Christ, standing in the center, is turned away from the spectator. His long hair covers his shoulders, and his head faces toward Pilate's wife. In the scene on the right, Caiaphas, seated on a high chair on the far side of the doorway, points his right hand at Christ, who stands with head bowed in profile against the central pier. The two figures are linked by a gesticulating man appealing with his left hand to the high priest and with his open right hand pointing toward Christ. A group of agitated Jews crowds around the steps.

It has been observed, correctly, that certain of the structural devices in this relief

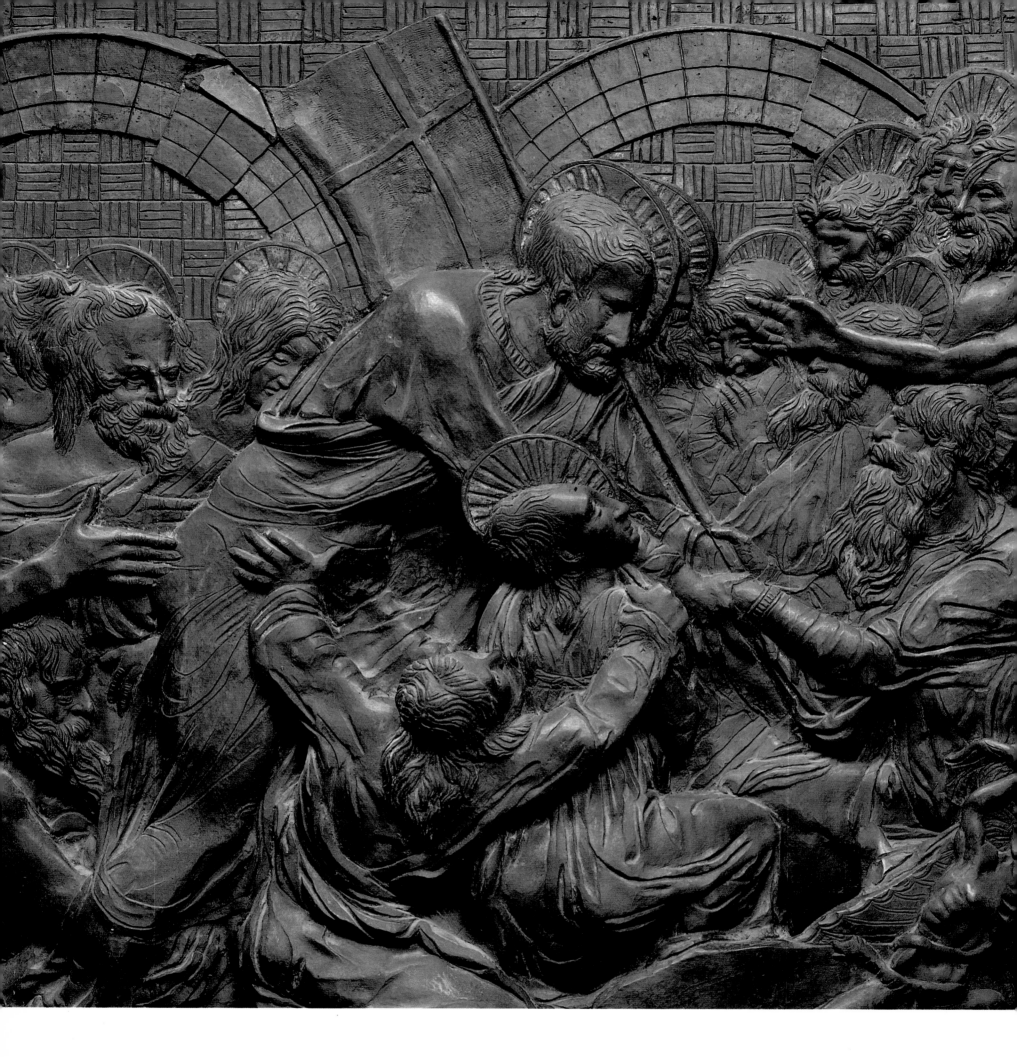

FIGURE 299.
Donatello, *Devil*, detail
of *Christ in Limbo*.

(the lateral fluted pilasters, the Salomonic columns, and the central support) are likely to derive from Roman terracotta reliefs, that the figure of Pilate is a memory image of a classical judgment scene, and, less appositely, that the device of half figures at the extreme front occurs on an Endymion sarcophagus in the Museo Capitolino. The double-faced youth holding a bowl behind Pilate depends from the Roman two-faced Janus, here employed as an expression of Pilate's ambivalence. But the essentials of the narrative—the compassionate Pilate, the Christ with head all but concealed, the prominence given to Pilate's wife, the diagonal movement across space from the Caiaphas to the profile Christ, the agitation of the Jewish crowd—can only be due to Donatello and are indeed some of the most moving evocations of Christ's condemnation in the whole of Western art. Technically,

301

however, the relief offers a host of problems. The three figures on the columns and the small figures on the balcony behind appear, like the horsemen in the *Lamentation*, to have been cast from a wax model whose detail was not defined. The figures in the foreground on the left side of the panel are more animated than those on the right, and though the figures in both scenes clearly originate with Donatello, the extent and quality of chasing varies markedly from one figure to the next. Here, as in the *Lamentation*, therefore, we are in the presence of a bronze cast made from a wax model by Donatello. The unfinished figures on the balcony and the statues on the columns are treated with the same respect as the horsemen in the *Lamentation*, but the chasing, in the left foreground, is far coarser and is likely to be due either to Bellano or to an anonymous member of Donatello's shop. The comparable figures on the right are more delicate to the touch than they appear in photographs.

Fig. 291

The corresponding relief at the west end of the pulpit, representing the Entombment, is a wholly homogeneous work.[50] It makes use of the same low viewing point as the scenes on the right-hand pulpit and the *Lamentation* but the modeling is so shallow that the figures seem to be drawn on the surface of the bronze. We might expect the setting to have something in common with the *Marys at the Sepulchre*, but the two scenes differ in every possible respect. Instead of a strigillated sarcophagus we see a paneled sarcophagus with a lion mask at one end. In place of the solid chamber of Donatello we have a scene set in the open air, where the tomb is protected only by a rustic roof supported on the thin tree trunks. The tall figures are predominantly linear with a bias toward silhouette; the profile of a youth in a hat on the left holding one end of the winding sheet is repeated in the bowed head of a youth behind him, while a similar figure, this time in left profile, supports Christ's feet. The features of the holy women are concealed by hair or by the angle of their veiled heads. At the back, the rock face that serves as background for the main scene recedes to what is apparently an area of sky. The smooth chasing of the scene recalls that of the foreground of the *Lamentation*, and there is no alternative but to suppose that the relief was executed *ab initio* by the same artist, Bertoldo. The scene, like the scenes on the front of the pulpit and that at the east end, is flanked by fluted pilasters. At either side of the *Christ before Pilate* and *Christ before Caiaphas*, the pilasters are filled with participating figures, the models for which must be due to Donatello. This practice is followed on the front of the pulpit, where on the left a soldier and a bearded man, cast separately, are bolted to the pilaster. The second and third pilasters on the front also contained figures, attachments for which are visible on the chief surface, and the *Entombment* does so, too. But whereas the figures beside the *Crucifixion* are by Bellano, those at the west end of the pulpit are by Bertoldo. Since they are in very deep relief they must be ranked as Bertoldo's earliest-known bronze statuettes.

How do these observations affect our view of the two pulpits? Though they are mentioned about 1485 by Vespasiano da Bisticci, they were not necessarily assembled in the form of pulpits at that time. The first specific reference to them occurs in 1510 in Albertini's *Memoriale di molte statue . . . di Fiorenza*, where they are described as "two bronze pulpits for the Gospels and Epistles." If they were installed when Albertini wrote, they were later taken down, and only in 1515, when Leo X visited

302

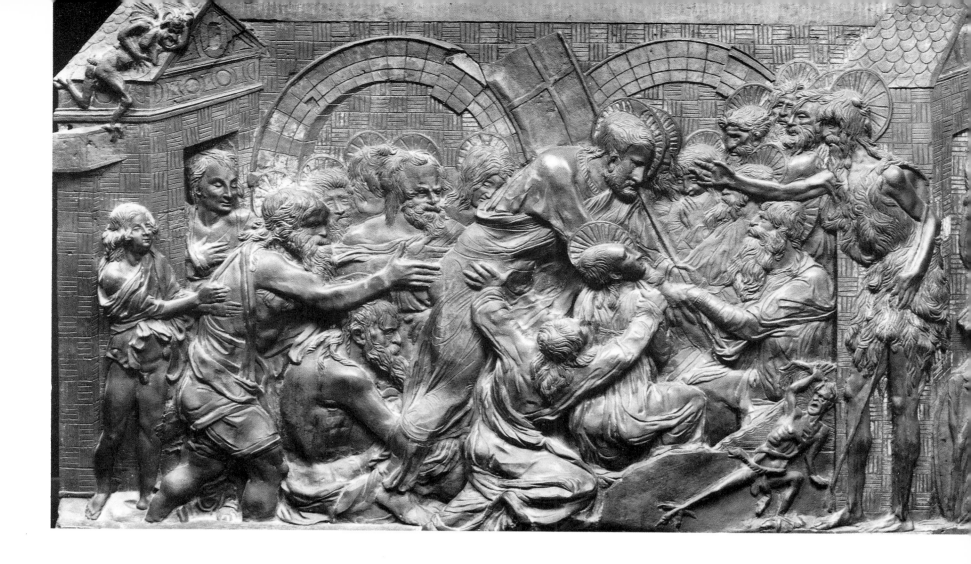

FIGURE 300.
Donatello, *Christ in Limbo*.
Bronze, H. 75 cm, W. 108.5 cm
(H. 29½ in., W. 42¾ in.).
North pulpit, San Lorenzo,
Florence.

Florence after his election to the papacy, were they set up in the church. They were placed, as they are now, lengthwise along the nave, but against the faces of the pilasters. Between 1619 and 1637 they were moved to the freestanding positions they now occupy, and the vacant areas of the backs were filled with wood reliefs. In 1515 the smaller pulpit, that is, the left pulpit, was in three parts. The pieces of the right-hand pulpit were brought into the church and assembled at the same time. From the standpoint of Donatello, the later history of the two pulpits is of no more than tangential interest, and for their earlier history there is no evidence other than that provided by the reliefs themselves. The most plausible chain of causation would be that Donatello, after leaving Siena, started work in or soon after 1460 on a tomb or altar for Cosimo de' Medici. The earliest of the reliefs to be completed was the *Martyrdom of St. Lawrence* and the latest the *Pentecost*. These reliefs were highly unorthodox, and the commission for the tomb or altar was superseded by a commission for what is now the left-hand pulpit. Donatello made models for two of the reliefs, the *Judgment* scene and the *Lamentation over the Dead Christ*. They were cast before his death, and their chasing was entrusted, respectively, to Bellano and Bertoldo, who treated them with such respect that no attempt was made to finish or to modify those parts that were incomplete. When Donatello died, three scenes he should have executed but for which he left no sketches were allocated to Bertoldo and Bellano. The pulpit was completed with a frieze of putti and wine jars running above the narrative reliefs, modeled by Bertoldo and chased partly by Bertoldo and partly by studio hands. The paired centaurs holding a label in the center are by

303

Bertoldo. Above this was an angled frieze, no doubt conceived by Bertoldo but executed in the studio, and below the reliefs was a second frieze with a row of circular studs. The problem of the post-Passion scenes on the right-hand pulpit was more intractable, and the decision taken was to provide an upper section corresponding in length to the interior of the three reliefs in front, with the protruding ends exposed, and in width to the existing end reliefs. Again there is a frieze of putti with classical horse tamers at the ends.

Much time has been devoted to a search for prototypes for the pulpit reliefs. To take two examples only, it has been claimed that the *Lamentation over the Dead Christ* reveals knowledge of a panel of the Lamentation in Siena by Ambrogio Lorenzetti, and that the flat crosses in the *Crucifixion* also depend from some trecento prototype. The fact is that the imagery throughout the scenes (save those for which he was not responsible) is personal to Donatello and represents his last thoughts on the central theme of Christian iconography. The *Lamentation* does not look back to Ambrogio Lorenzetti, but forward to the sixteenth century and the work of Tintoretto in San Cassiano, and the two Judgment scenes owe their importance not to their classical sources, but to the working of a fervid, highly personal, dramatic imagination, which has no equivalent in Western art before the Passion etchings of Rembrandt.

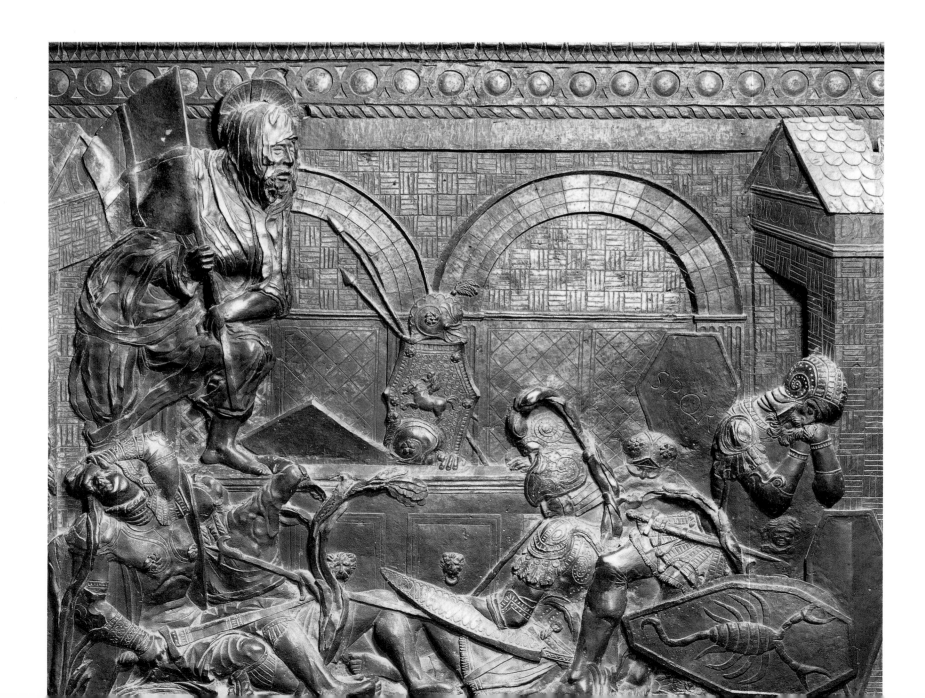

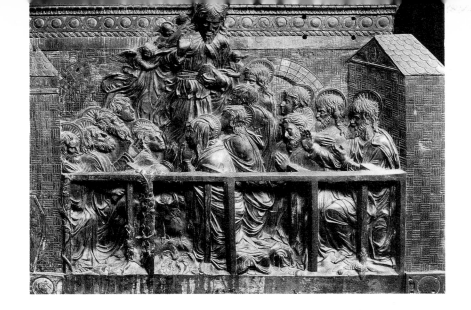

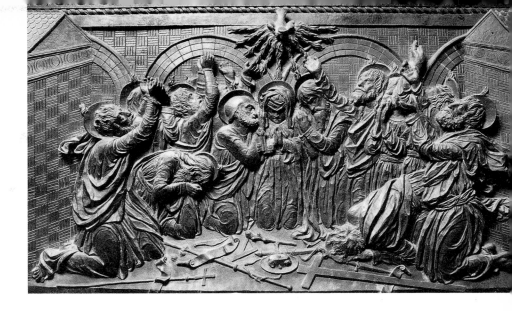

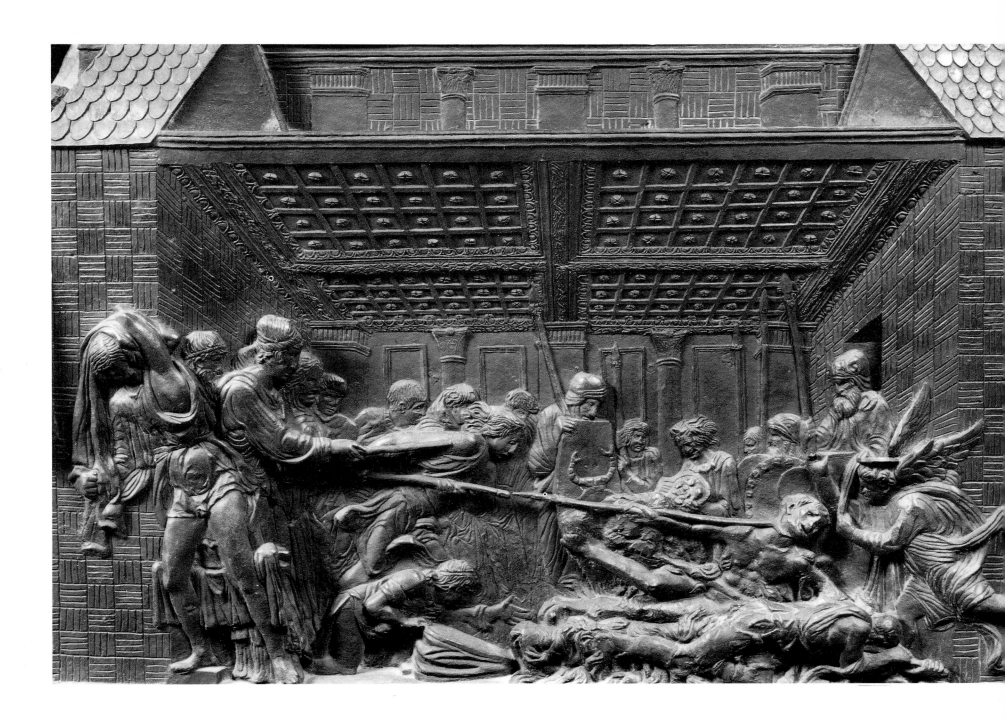

305

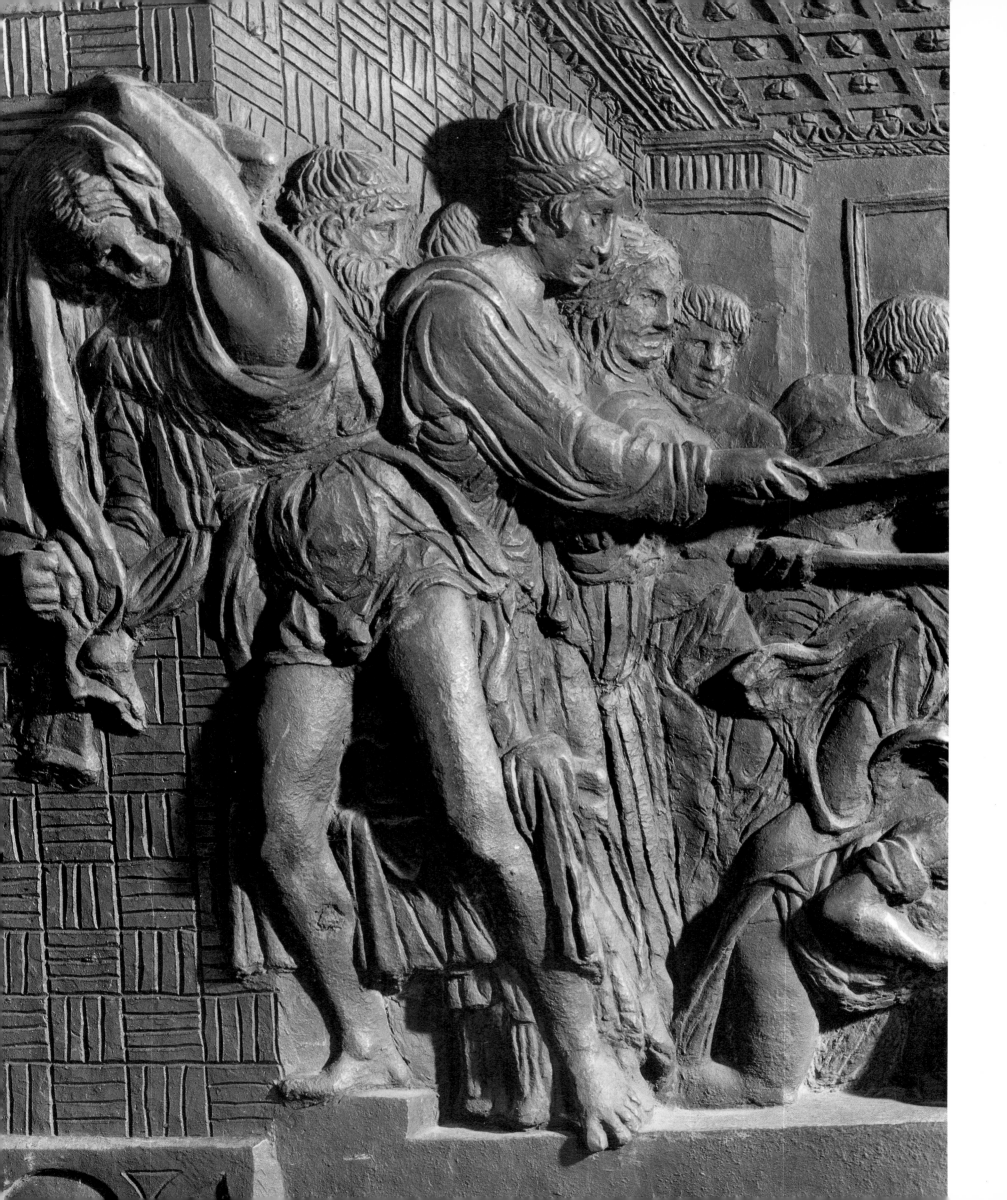

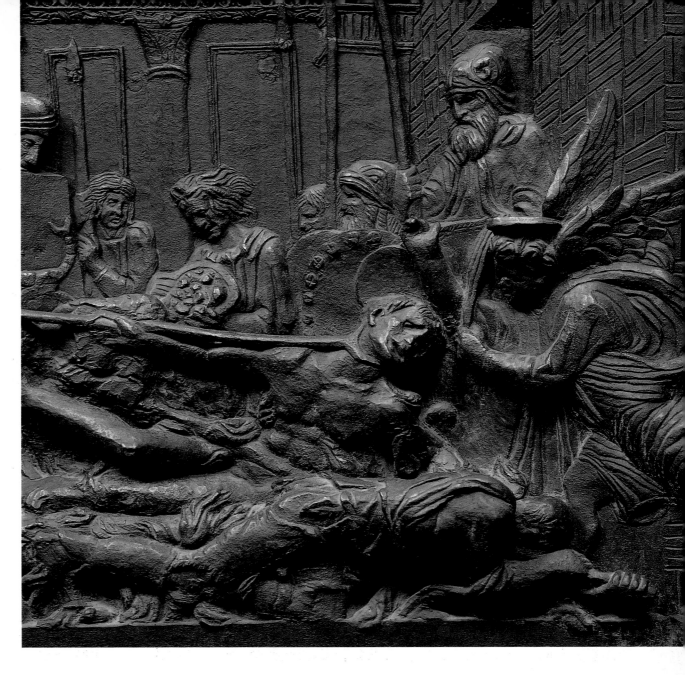

opposite: FIGURE 305.
Donatello, *Martyrdom of St. Lawrence*
(detail).

FIGURE 306.
Donatello, *Martyrdom of St. Lawrence*
(detail).

FIGURE 307.
Donatello, *Christ before Pilate and
Christ before Caiaphas.* Bronze,
H. 86 cm, W. 150 cm
(H. 33⅞ in., W. 59 in.).
South pulpit, San Lorenzo,
Florence.

FIGURE 308.
Donatello, *Christ before Pilate*
(detail).

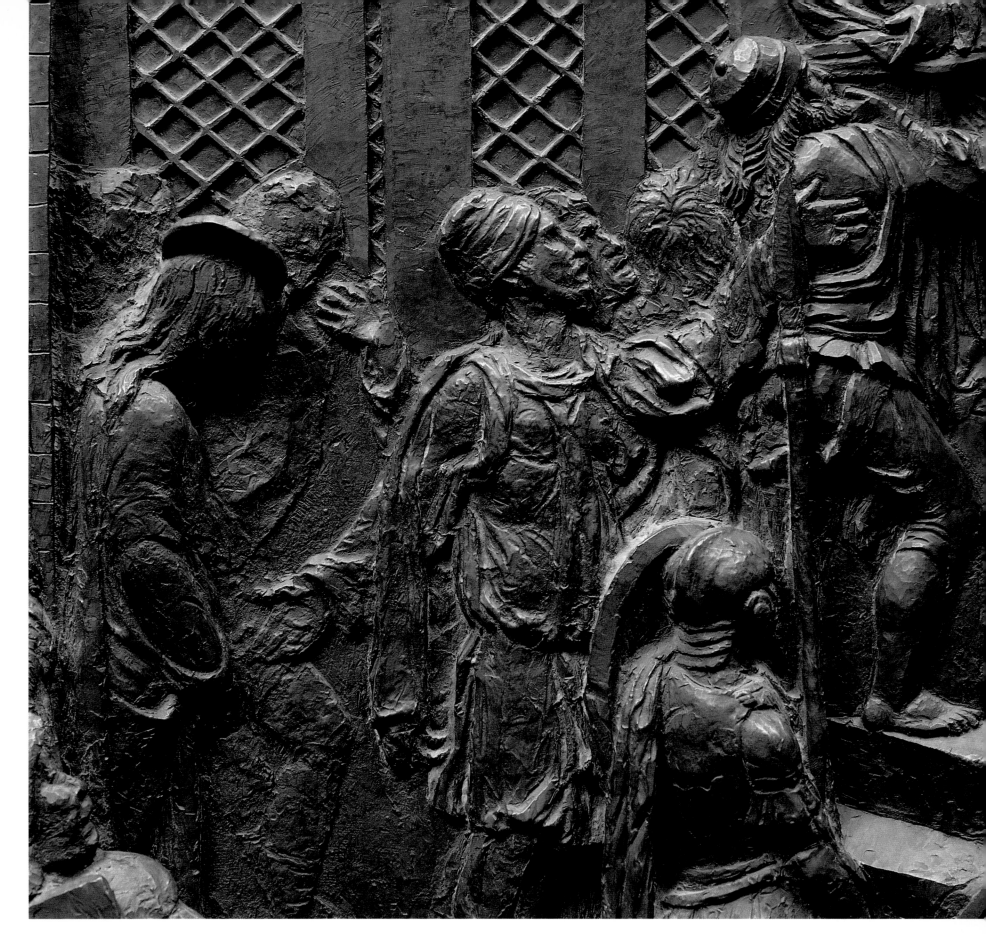

FIGURE 309.
Donatello, *Christ before Pilate*
(detail).

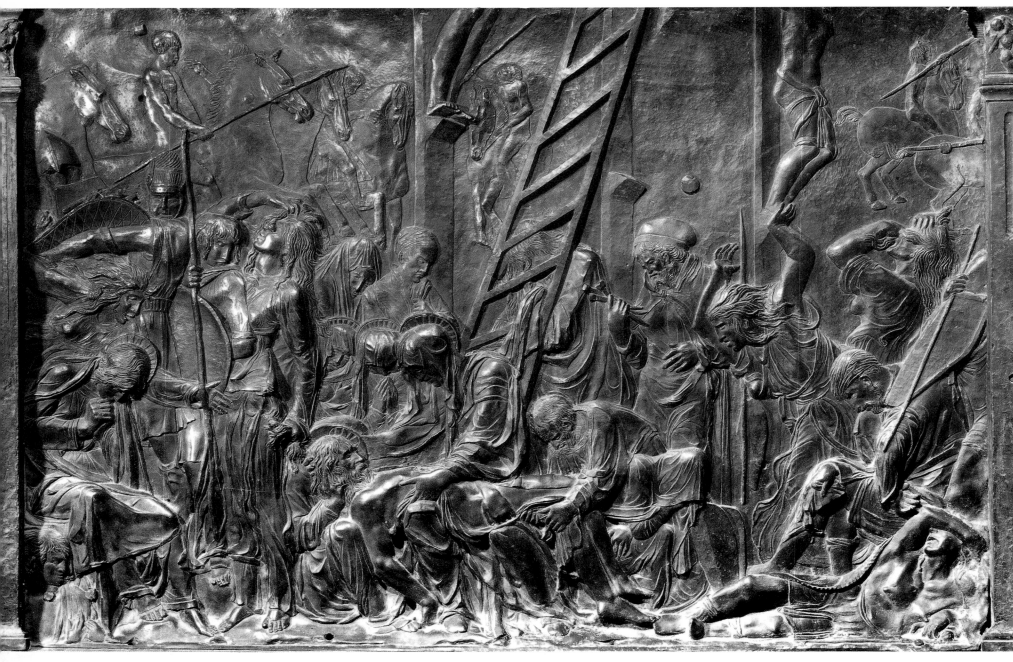

FIGURE 310.
Donatello, *Lamentation over the
Dead Christ*. Bronze, H. 88 cm, W. 123 cm
(H. 34⅝ in., W. 48½ in.).
South pulpit, San Lorenzo,
Florence.

opposite: FIGURE 311.
Donatello, *Lamentation over the
Dead Christ* (detail).

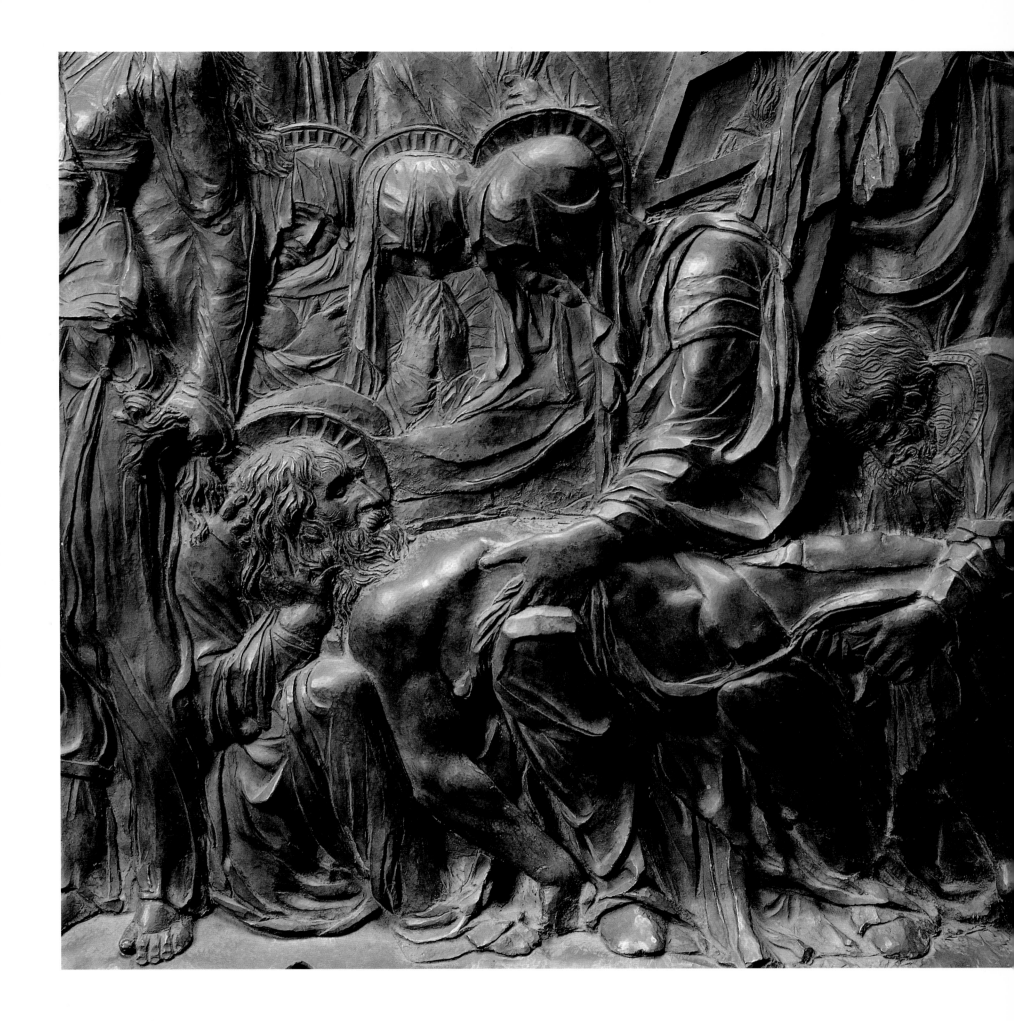

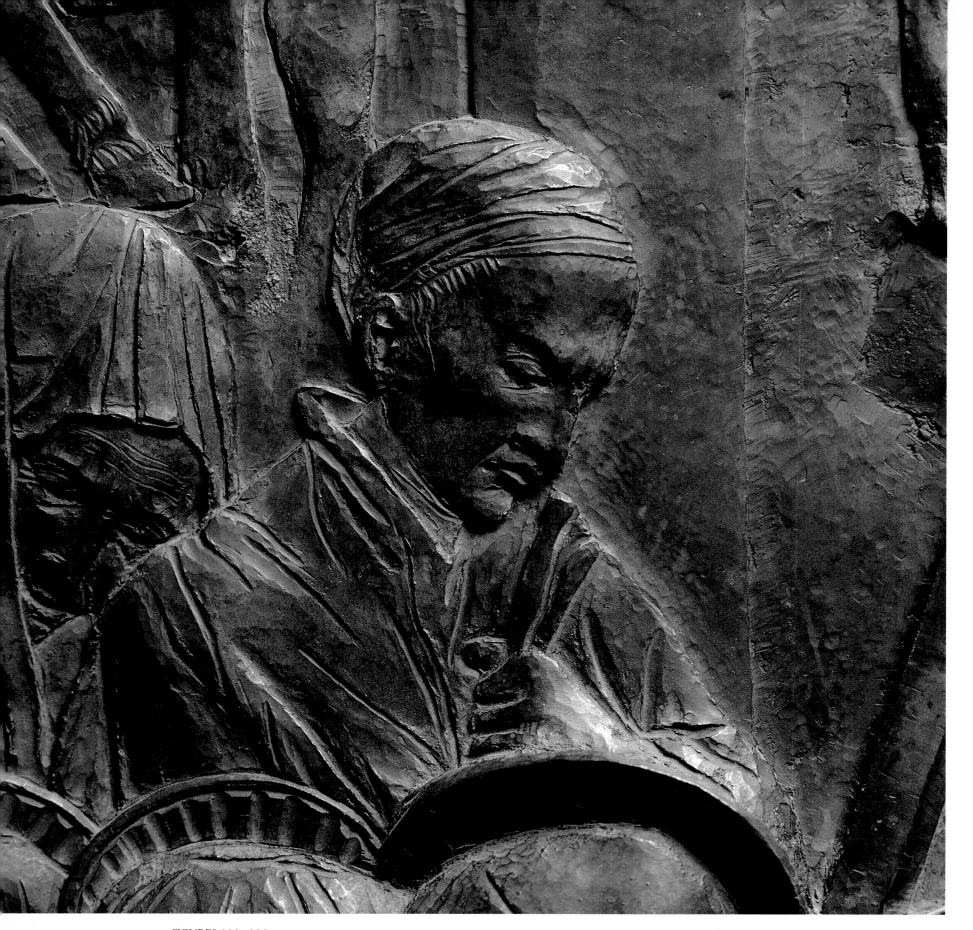

FIGURES 312, 313.
Donatello, *Lamentation over the
Dead Christ* (details).

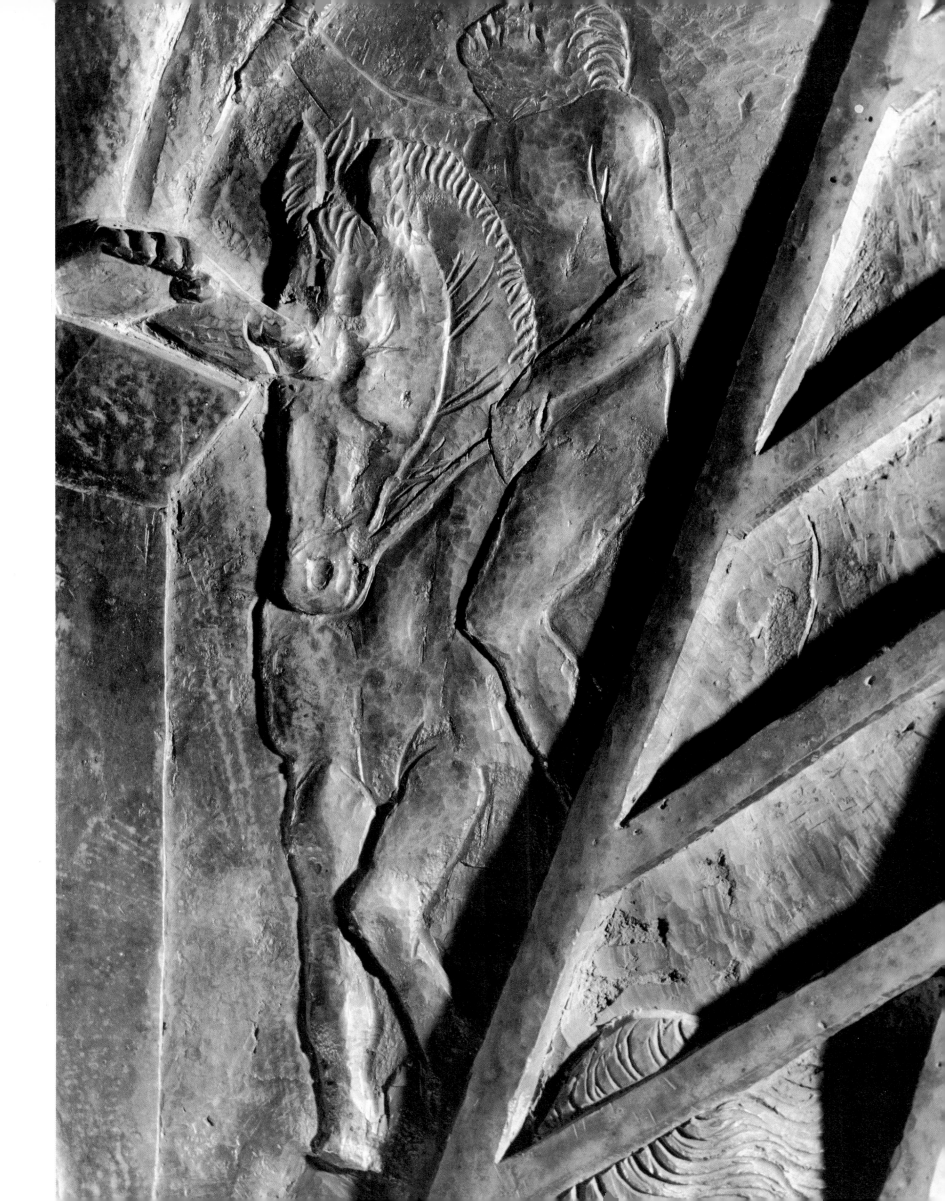

Conclusion

DONATELLO DIED on December 13, 1466, and was buried in the crypt of San Lorenzo near the tomb of Cosimo il Vecchio in a space that had been allotted to him by Piero de' Medici three years earlier.[1] "The citizens," Vasari tells us, "sorrowed greatly at his death, as well as the artists and all who knew him. Thus, in order to honor him more in death than they had done when he was alive, they gave him a stately funeral in that church, all the painters, architects, sculptors, goldsmiths, and indeed practically the whole population of the city accompanying the cortege."[2] Among the pallbearers was Andrea della Robbia, who told Vasari that "he had been one of those who carried Donato to his grave, and I recall with what pride the worthy old man spoke of this."[3]

Vasari's phrase "per onorarlo più nella morte che e' non avevano fatto nella vita" suggests that, before he died, Donatello had ceased to play a central role in the art world of Florence. When, in 1464, the four Prophets on the north face of the Campanile were moved to the more visible west face, the *Jeremiah* and the *Habakkuk* among them, in substitution for the Prophets of Andrea Pisano, those who looked up at them must have been forcibly reminded of the debt their city owed to Donatello. But the distance traversed between these public works and the pulpit reliefs in San Lorenzo was unbridgeable.

Donatello's influence is most clearly evident in Florence in the work of Desiderio da Settignano. It is conceivable that Desiderio, who was extremely precocious, worked with Donatello about 1442–43. Until his death in 1464 he read Donatello's mind with greater intelligence than any other marble sculptor, and in the Martelli *Baptist* in the Museo Nazionale he produced a statue so Donatellesque that it has been repeatedly ascribed to Donatello. His early works are redolent of Donatello, and none more so than the Martelli *stemma*, which shows a heavy shield of arms suspended from a riband around the neck of a supporting figure and is likely, on historical grounds, to have been carved soon after 1446.[4] The base of Donatello's bronze *David* must have been entrusted to him about this time. Desiderio, moreover, was the only Florentine sculptor other than Donatello to work in *rilievo stiacciato*, and the technical subtlety of his relief of *St. Jerome and the Lion* in Washington, or of his later low relief of the Virgin and Child in London would be inexplicable had he not learned at Donatello's hands the technique with which they were carved.

An unregenerate admirer of Donatello's work was Leonardo, who was shown some early drawings by Bandinelli and "lo confortò a seguitare ed a prendere a lavorare di rilievo; e gli lodò grandemente l'opera di Donatello." When Rustici,

with Leonardo's aid, confronted the problem of public communication in the group of *St. John the Baptist between a Levite and a Pharisee* over the north entrance to the Baptistry, their minds instinctively returned to the most directly expressive bronze statue of the fifteenth century, the *Baptist* in Siena Cathedral.

Vasari's account of Donatello is one of the weakest of his *Lives*. Writing in the middle of the sixteenth century, when art in Florence had, in his view, reached its zenith, he regarded Donatello as an evolutionary figure whose prime achievement was to have enabled Florentine sculpture to attain the perfection it had reached in his own day. "Artists," writes Vasari, "should recognize his art as greater than that of any other artist born in modern times, for he eased the difficulties of art through the copiousness of work involving invention, design, technique, judgment, and any other faculty that can or ought to be expected in a man of genius."

Throughout his whole career Donatello retained an empirical attitude toward technique. The artist who, jointly with Brunelleschi, prepared models covered with gilded lead for the buttresses of the Cathedral is the same artist who introduced the concept of directed light in silver and gold damascening in the Padua reliefs; the same artist who, through the innovative use of large scale models, invested statuary in marble with the properties of modeled sculpture; the same artist whose reliefs contributed to the reform of painting in Florence in the middle of the third decade of the century; the same artist who revealed the expressive possibilities of pigmented wooden sculpture; the same artist who investigated the aesthetic implications of sectional bronze casting; and the same artist who awoke to the potential of the life cast. But these innovations were not adopted for their own sake; they resulted from the pressure of the sculptor's empathetic faculty. For Donatello, as for all visionary artists, the creative moment was that at which the image was conceived. We can, through analysis, establish some small part of the process by which the Cantoria or the *Cavalcanti Annunciation* assumed the form we know. What cannot be reconstructed is the moment of inspiration at which the boisterous, ebullient putti on the Cantoria and the miraculous vision of the restrained, classical *Annunciation* rose to the surface of Donatello's mind. This is an artist for whom precedents were in large part irrelevant. The commissions for the *Gattamelata* and the *Magdalen* and the *Judith* seem to have induced an act of the imagination whereby not just the principles behind the figure but the message it was to convey formed a starting point for technical experiment. In the quattrocento only one other artist, Leonardo, operated in somewhat the same way.

No monograph on Donatello can succeed unless it partakes of the nature of biography. Information may be scanty, but his sculptures have the force of affirmations, and his personal convictions, both on a moral and aesthetic plane, determined the course of his career. From the 1440s on, unless he felt a deep-seated commitment to some proposal, he turned commissions down, and when his interest in large projects lapsed, as it did with the Prato pulpit and the sculptures for the Padua High Altar, he abandoned them. The creative psychology of great sculptors can be read more easily in models than in finished works, and, since their cleaning, the freely modeled stucco reliefs in the Old Sacristy in San Lorenzo bring us closer to Donatello's working method than any of his other sculptures.

It is a commonplace that, in the fifteenth century in Florence, painting and sculpture were regarded as one art. "Sculpture and painting," writes Ghiberti, "are a science which is the highest invention of all the other arts." For Alberti they were "cognate arts, nourished by one and the same genius, painting as well as sculpture." This view was shared by Donatello. In the first quarter of the fifteenth century painters followed where he led, and in the second quarter the interchange was total. That it was so is evident from the projection of his reliefs, from the *Ascension with Christ Giving the Keys to St. Peter* through the stucco reliefs in the Old Sacristy and the marble *Feast of Herod* to the *Miracles of St. Anthony* at Padua and the San Lorenzo pulpit reliefs. It is anybody's guess whether Domenico Veneziano's tondo of the *Adoration of the Magi* in Berlin precedes or follows the roundel of *St. John on Patmos*, what is the exact connection between the structure of the *Miracles of St. Anthony* at Padua and the work of Jacopo Bellini, how far the figure groups in the reliefs influenced Mantegna's early figure style, and exactly how the personalities of Donatello and Castagno interlock. To a sculptor concerned, as Donatello was, with affectivity, the factor of color was one of great significance. So long as his concern lay with the heroic statues for the Duomo and the Campanile he operated as a marble sculptor in the traditional sense. But from 1420 on the pictorial implications of his use of gilding became increasingly apparent. They do so first in the Coscia monument in the Baptistry, where it is employed as a means of visual emphasis, and then in the *St. Louis of Toulouse*, the effect of which, in its monochrome tabernacle, must have been strikingly pictorial. In the reliefs at Padua it serves to clarify both the architecture and the thematic content of the reliefs. But gilding is no more than a part of this strange story. The stained-glass window of the *Coronation of the Virgin* in the Duomo is strongly colored and two-dimensional; the *Scenes from the Life of St. John the Evangelist*, like the late Madonnas, are paintings in relief, and the brilliantly pigmented wooden *Baptist* and the *Magdalen* likewise have as strong a relevance to painting as to sculpture.

The number of assistants in Donatello's workshop must have been very large. The earliest documentary reference to "suoi lavoranti" occurs in 1416 in connection with the marble *David* for the Palazzo della Signoria. Probably, these "lavoranti" were on the payroll of the Opera del Duomo and would have assisted in the blocking out of the Campanile statues. On the Coscia monument in the Baptistry, three marble sculptors in addition to Michelozzo seem to have been employed. From the time of the *St. Louis of Toulouse* and the partnership with Michelozzo, the Florentine workshop appears to have expanded. In the early 1430s, during work on the Prato pulpit and the Cantoria, a second workshop was, for a time, maintained in Pisa. We have no lists of Donatello's Florentine assistants as we have of the assistants of Ghiberti, but his staff must, like Ghiberti's, have been constantly replenished with new recruits. The few names that appear on record are those of Pagno di Lapo Portigiani (whose work has never been seriously investigated), Maso di Bartolomeo (by whom a number of works in bronze are known), his brother Giovanni, and Michelozzo. If the Agostino who is mentioned on one occasion in the Prato documents is Agostino di Duccio, he may also have been a *garzone* in Donatello's workshop. At Padua we have the names of five bronze sculptors employed on reliefs

for the High Altar of the Santo, who may also have served as assistants on the Gattamelata monument. The fact that these assistants were commissioned *in propria persona* to execute reliefs for the High Altar and that their reliefs differ markedly from one another suggests that the members of Donatello's shop were encouraged to operate individually and that supervision of their work was comparatively lax. The role played by Pizzolo in Donatello's Paduan studio is unclear, and his career was cut short by death. One member of the shop, Giovanni da Pisa, seems to have executed an extremely accomplished terracotta altarpiece for the Eremitani, and the others formed a diaspora that carried memories, often confused memories, of Donatello's style to other centers in Italy: Urbano da Cortona to Siena, Antonio Chellini to Prato and Naples, and Francesco del Valente probably throughout Tuscany. There is one payment to an otherwise unknown Polo d'Antonio da Ragusa, who, for all we know, may have returned home and carried his crude recollection of Donatello's sculptures to Dalmatia. The workshop in Florence responsible for the *Judith* and the Siena *Baptist* must, once more, have been a large one, but for work on the reliefs that constitute the San Lorenzo pulpits it was reduced to four assistants.

The size of Donatello's studio and his studio practice are fundamental for study of the large number of reliefs that, in the nineteenth century, and again in the Florence exhibition of 1986, were ascribed to Donatello. The authorship and attribution of the reliefs form a jigsaw puzzle in connoisseurship. Differences of quality in the Madonna reliefs are very marked. A beautiful marble Madonna and Child with five angels in London may conceivably depend from a Donatello model or cartoon, whereas the terracotta relief known as the *Pietra Piana Madonna* in Florence is no more than generically Donatellesque. The basis of attribution is similitude, and many students who have written on these reliefs have done so without an understanding of what the term "similitude" should signify. The problem is how these reliefs relate to one another, not how they relate to Donatello.

It is easy enough to close a book on Donatello with the glib affirmation that he was a modern sculptor. But the term "modern sculptor" remains to be defined. It means, on the lowest level, that, six hundred years after his death, figurative sculptors were still learning from the lessons that he had to teach. In his hands sculpture became an expressive vehicle of incomparable directness and resource. But it was the product not of free-ranging inspiration, but of inspiration tethered by intelligence. The problems presented by each work—contextual, formal, technical, representational, or imaginative—were analyzed freshly and almost without regard to precedent, and before their final form was reached they were subjected to rigorous self-criticism that has no Early Renaissance parallel. With no great sculptor are we so conscious as we are with Donatello of the influence exerted by his character over his work. The only patron who put on record an assessment of his personality, Lodovico Gonzaga, describes him as having "un cervello facto a questo modo che se non viene de li no li bisogna sperare." He moved in the direction in which instinct told him he should go, with an obstinate, solipsistic self-concentration that in his own time was unique.

One of the enduring problems posed by Donatello is the diversity of styles in

which he worked. As one stylistic phase succeeds another, we inevitably ask ourselves how it was that the artist of the *Ascension*, steeped in the idiom of the Ara Pacis, became the anticlassicist of the late pulpit reliefs, and how the classicizing sculptor of the svelte *Dovizia* became the carver of the wooden *Magdalen*. The answer is that the style in which he worked was invariably determined by the nature of the commission that he undertook. The relief of *St. George and the Dragon* is addressed to the public in the street, and the Siena *Feast of Herod* speaks to the visitors to the Baptistry. The less legible reliefs at Padua, on the other hand, were designed for close inspection by members of the Franciscan community, and the introverted post-Passion scenes in San Lorenzo seem to have been originally planned not for a pulpit, but for an altar or a tomb. Donatello's prime concern was to address the minds of those who came in contact with his work. The marble statues from the Campanile and at Or San Michele, like the bronze *David* and the *Judith*, are moral statements, and though we look at them today simply as works of art, this is not the way in which they, or indeed any of his works, were intended to be seen. They are messages transmitted to posterity by one of the most purposeful, most human, and most self-revealing artists who has ever lived.

NOTES

CHAPTER I

1. The best summary of the evidence for the date of Donatello's birth remains that of Semper (1875, pp. 231–33). According to Vasari (1550) "nacque Donatello l'anno MCCCLXXXIII nella citta di Firenze." In a *catasto* (tax) return of July 1427 (for the full text of which see p. 25, n. 1), however, his age is given as forty-one ("Donato d'anni 41"). In a further return of 1433 it is stated as forty-seven ("Donato detto d'eta d'anni 47"), and in another of 1457 as seventy-five ("in eta di 75 anni"). The chronicle of Bartolomeo Fontio records his death in 1466 at the age of seventy-six ("1466. Donatus florentinus sculptor insignis sexto et septuagesimo anno Florentie obiit IV Idus Decembris"). The date of birth, according to these passages, would have been 1387, 1386, 1381, or 1390. The earlier references are likely to be the more reliable, and Donatello would therefore have been born in 1386 or 1387.

2. Diane Finiello Zervas, *The Parte Guelfa, Brunelleschi and Donatello*, New York, 1987, pp. 30–31, 33, 42–45. The prime source for the incident at Pisa is Buonaccorso Pitti, *Cronica*, ed. A. B. della Lega, Bologna, 1905, p. 44. The brother of Niccolò di Betto Bardi, Donato, was likewise a *tiratore di lana*. An unrecorded sister of Donatello's, Caterina, received a dowery of fl. 70 in June 1421 on her marriage to a shoemaker, Lapo di Niccolò (A.S.F., *Note* antec. 11319: Bartolomeo Lombardi, Calignano, c. 510).

3. Vasari, *Le Vite de' più eccellenti pittori, scultori, e architettori nelle relazioni del 1550 e 1568*, ed. Bettarini and Barocchi, n.d., vol. 3, p. 203: "Fu allevato Donatello da fanciullezza in casa di Roberto Martelli, e per le buone qualità e per lo studio della virtu sua non solo meritò d'essere amato da lui, ma ancora da tutta quella nobile famiglia." For an account of the Martelli family see L. Martines, "La famiglia Martelli e un documento sulla vigilia del ritorno dall'esilio di Cosimo dei Medici (1434)," in *Archivio storico italiano*, vol. 117, no. 19, pp. 29–43. The family owed its prominence in the third quarter of the fourteenth century to Roberto, "spadarius," whose name was assumed by his sister and her nine sons, one of whom, Roberto (1408–64), is the figure mentioned by Vasari (see above). The Martelli were early supporters of Cosimo de' Medici. According to Litta (*Le famiglie illustri d'Italia*, vol. 15), Roberto by the mid-1430s disposed of considerable wealth, lending 12,000 florins for the cost of the ecumenical council of Ferrara and a further 22,000 when the Council moved from Ferrara to Florence. In 1457 Ro-

berto Martelli was engaged in supervising, in the absence of Piero de' Medici, the frescoes by Benozzo Gozzoli in the chapel of the Palazzo Medici (Grote, in *Journal of the Warburg and Courtauld Institutes*, vol. 27, 1964, p. 321). An excellent analysis of the putative association between Roberto Martelli and Donatello is provided by A. Civai ("Donatello e Roberto Martelli: nuove acquisizioni documentarie," in *Donatello-Studien*, Munich, 1989, pp. 253–62). The only recorded point of contact between them is a payment of two florins made by Martelli, for an unspecified purpose, in June 1442 ("Anno dato a di 6 di giugno per me a Donatello intagliatore f. 2").

4. Vasari, ed. cit., vol. 3, pp. 220–22.

5. The *Facetie* were reprinted in 1564. For a modern edition see Wesselski, *Angelo Polizianos Tagebuch*, Jena, 1929, nos. 42, 43, 44, 230, 231, 322, 367. The attribution to Politian is discredited. It is inferred by Wesselski that the collection dates from 1477–79. Lodovico Domenichi, *Facetie, Motti, et Burli, di Diversi Signori et Persone Private*, Florence, 1564.

p. 90: "Simile fu il motto di Donatello, il quale essendo domandato, qual fusse la miglior cosa, che facesse mai Lorenzo di Bartoluccio scultore, rispose; a vendere Lepriano: perciochè questa era una sua villa da trarne poco frutto. Et questo ancho non fu goffo."

p. 90: "Mandando più volte il Patriarcha Vitelleschi per Donatello, e non vi andando egli, al fine, pur sollecitato rispose; dì al Patriarcha, che io non vi vò venire; che io sò cosi Patriarcha nell'arte mia, come esso sia nella sua. Arrogante."

p. 91: "Il predetto faceva una statua di bronzo del Capitano Gattamelata, e essendo troppo sollecitato, prese un martello, e schiacciò il capo a detta statua. Inteso questo la Signoria di Vinegia fattolo venire a se, fra più altre minaccie gli disse; che si voleva schiacciare il capo a lui, come egli haveva fatto a quella statua. E Donatello a loro; io son contento, se vi dà il cuore di rifare il capo a me, come io lo rifarò al vostro Capitano. Libero."

p. 232: "E rise a me, e io risi a lui. Questo nacque da Donatello, dal quale essendosi partito un giovane suo discepolo, con chi havea fatto quistione, se n'andò a Cosmo per trar lettere al Marchese di Ferrara, dove era il giovane fuggito. Affermãdo a detto Cosmo che in ogni modo voleva andargli dietro, e ammazzarlo. Ora conoscendo Cosmo la sua natura, gli fè lettere come a lui parve, e per altra via informò il Marchese della qualità di detto Donatello. Il Signore gli diede licentia di poterlo uccidere, dove lo trovasse. Ma incontrandosi il garzone in esso commincio di lungi a ridere. E Donatello a un tratto rappacificato corse ridendo in verso

lui. Domandavalo poi il Marchese; s'egli lhavesse morto: a cui Donatello; non in nome del Diavolo; che egli rise a me, e io risi a lui. Licentioso."

6. No. 1272. H. 42 cm, W. 210 cm (H. 16½ in., W. 83 in.). The painting is attributed by Vasari in the first edition of the *Vite* to Masaccio and in the second to Uccello. For its history and literature see Pope-Hennessy, *Paolo Uccello*, 2d. ed., Oxford, 1969, pp. 157–58.

7. For Vasari's adaptation of the portrait by Uccello in the second edition of the *Vite*, see W. Prinz, "La seconda edizione del Vasari e la comparsa di 'vite' artistiche con ritratti," in *Il Vasari*, vol. 21, 1963, pp. 1–14, and "Vasaris Sammlung von Künstlerbildnissen," in *Mitteilungen des Kunsthistorischen Institutes in Florenz*, Beiheft. vol. 19, 1966, p. 76. The frescoed portrait in the Casa Vasari in Borgo Santa Croce is reproduced in *La Toscana nel '500: Giorgio Vasari*, Florence, 1981, fig. 106.

8. P. Meller, "La Cappella Brancacci: Problemi ritrattistici e iconografici," in *Acropoli*, fasc. 3, 1960–61, pp. 186ff.; fasc. 4, pp. 273 ff. L. Berti, "Donatello e Masaccio," in *Antichità Viva*, vol. 5, no. 3, 1966, pp. 3–12.

9. G. Tanturli, ed., Antonio Manetti, *Vita di Filippo Brunelleschi*, Milan, 1976, p. 67.

10. The document recording Donatello's presence at Pistoia is published by L. Gai, "Per la cronologia di Donatello: un documento inedito del 1401," in *Mitteilungen der Kunsthistorischen Institutes in Florenz*, vol. 18, 1974, pp. 355–57.

11. The implications of Donatello's presence in Pistoia are explored in an article by J. Beck, "Ghiberti giovane e Donatello giovanissimo," in *Lorenzo Ghiberti nel suo tempo*, 1980, pp. 111–34, with which I am in substantial agreement, save for the attribution to Donatello of a half-length figure on the silver altar, variously described as Daniel and David.

12. The terminal dates for the competition for the bronze door are the winter of 1400, when the competition was announced, and the last months of 1402, when the commission was awarded to Ghiberti. The account of the competition given by Ghiberti makes no mention of the name of Donatello. Vasari, on the other hand (*Vite*, ed. cit. vol. 3, pp. 146–47), lists Donatello among the competitors and, after recording the presence of Brunelleschi's trial relief "nel dossal dell'altare" in the Sagrestia Vecchia of San Lorenzo, notes that "quella di Donatello fu messa nell'Arte del Cambio." The relief in the Arte del Cambio, of which there is no other record, may well have been the work of another of the five sculptors involved.

13. For the Roman journey of Brunelleschi and Donatello, see Manetti, loc. cit., and Vasari's life of Brunelleschi (*Vite*, ed. cit., vol. 3, pp. 147–49): "Fatta l'allogazione a Lorenzo Ghiberti, furono insieme Filippo e Donati e risolverono insieme partirsi di Fiorenza et a Roma star qualche anno per attender Filippo all'architettura e Donato alla scultura . . . egli e Donatello . . . non perdonarono ne a tempo ne a spesa, ne lasciarono luogo che eglino et in Roma e fuori in campagna non vedessino e non misurassino tutto quello che potevano avere che fusse buono." According to this account, Donatello returned alone to Florence, while Brunelleschi remained in Rome.

14. R. Krautheimer, *Lorenzo Ghiberti*, Princeton, 1970, vol. 2, p. 369, Doc. 28.

15. Krautheimer, op. cit., p. 369, Doc. 31.

16. G. Poggi, *Il Duomo di Firenze*, ed. Margaret Haines, Florence, 1988, no. 362: "Donato Niccholai, scarpellatori et qui fecit profetas marmoris pro ponendo ad et seu super portam ecclesie s. Reparate per quam itur ad ecclesiam Servorum s. Marie de Florentia, pro parte sui laboris et mercedis dicti laborerii profetarum, fl. x aur. Die 23 Novembris 1406 fuit confessus habuisse a Marcho camerario." Further payments to Donatello, almost certainly for the same sculpture, are printed by Poggi as No. 366. "1408, Febbraio 17. Donato Nicolai Betti Bardi pro. fl. XVI au. pro una figura marmi longitudinis brachiorum unius et tertii unius, quem debet poni ianue qve vadit versus ecclesiam fratrum Servorum de Florentia, ut patet in libro duorum qq a c. 98, de quibus restat habere fl. x au., ut patet in dicto libro a c 4; de quibus restat habere fl. VI au. A Donato ai Nicholo di Betto Bardi fiorini XVI d'oro per pregio d'una figura di marmo di lunghezza di br. I¹/₂, la quale s'aporre alla porta verso i Servi . . . fiorini XVI."

Trachtenberg ("Donatello's first work," in *Donatello e il suo Tempo*, Florence, 1968, pp. 361–67) suggests that "Donatello on the basis of good connections and high promise was commissioned several small prophets to be placed on the Porta della Mandorla." This theory rests on the use of the plural "profetas" in the document of 1406 and is not confirmed by any other source. A statuette of a Prophet, now disintegrated, formerly over the second window from the Porta della Mandorla, is published by Trachtenberg (pl. 84) as an early work of Donatello.

For the bibliography of the Porta della Mandorla Prophets see Janson, *The Sculpture of Donatello*, Princeton, 1957, vol. 2, pp. 219–22, supplemented by L. Bellosi in *Donatello e i suoi*, Florence, 1986, nos. 15, 16, pp. 122–24. The Prophet originally on the right of the door is by

Nanni di Banco (not, as has recently been suggested, by Luca della Robbia), and the figure on the left is by an unidentified hand.

17. Poggi, nos. 406–11. The initial document reads "1408, Febbraio 20. Item deliberaverunt quod Donatus Betti Bardi possit . . . pro dicta ecclesia edificare seu facere unam figuram de uno duodecim profetis ad honorem David profetae, cum modis et condictionibus pactis et salario olim factis cum Johanne Antonii Banchi, magistro unius figure per eum accepte ad construendum pro quodam alio profeta, que poni debeant super spronis unius tribune que ad presens edificata seu completa consistit."

18. Poggi, no. 411: "1409, Giugno 13. Deliberaverunt quod Donatus Nicolai Betti Bardi, de figura per ipsum facta de quodam profeta, habeat fl. C aur., et quod camerarius de pecunia dicte opere pro residuo det et solvat, deductis habitis, pro ipsius residuo Donato predicto, fl. XXXVI au."

19. For the widely accepted identification of the statue of a Prophet in the Duomo with Nanni di Banco's *Isaiah* see Lányi, "Il Profeta Isaia di Nanni di Banco," in *Rivista d'Arte*, vol. 18, 1936, pp. 137–78. The contrary case, whereby the *Isaiah* is identified as Donatello's *David*, is argued by M. Wundram, *Donatello und Nanni di Banco*, Berlin, 1969, and "Donatello e Nanni di Banco negli anni 1408–1409," in *Donatello e il suo tempo: Atti dell'VIII Convegno Internazionale di Studi sul Rinascimento Firenze-Padova*, Florence, 1968, pp. 69–75; and is elaborated by V. Herzner, "Donatello und Nanni di Banco," in *Mitteilungen des Kunsthistorischen Institutes in Florenz*, vol. 17, 1973, pp. 2–28.

20. *PROPHET (DAVID?).* Museo dell'Opera del Duomo, Florence. Marble, H. 188 cm, W. 65 cm, D. 40 cm (H. 74 in., W. 25¹/₂ in., D. 16 in.). The hands are much abraded, and the fingers of the right hand are missing. Unlike the later statues carved by Donatello for the Campanile, the figure is fully worked up behind and has metal insertions behind the shoulders, presumably for attachment in the position to which it was later relegated. The front point of the pentagonal base has been cut away. The attribution of the statue goes back to Albertini (1510) and was still maintained by Richa (1754–62) and Follini Rastrelli (1798–1802). According to Vasari (vol. 3, ed. cit., p. 209), Donatello "dalla parte di verso la canonica, sopra la porta del campanile, fece uno Abraam che vuol sacrificare Isaac, et un altro Profeta, le quali figure furono poste in mezzo a due altre statue." Attention was first drawn to the significance of the base by H. Kauffmann (*Donatello*, Berlin, 1935, pp. 208, 209, 260), who recognized that the figure must originally have been intended for

the buttresses of the Cathedral. That the present figure and the statue in the Cathedral must be identical with the two Prophets carved in 1408 by Nanni di Banco and Donatello for the *sproni* of the Cathedral is accepted by Wundram (*Donatello und Nanni di Banco*, Berlin, 1969, passim) and Herzner ("Bemerkungen zu Nanni di Banco und Donatello," in *Wiener Jahrbuch für Kunstgeschichte*, vol. 26, 1973, pp. 74–95), who regard the present figure as Nanni di Banco's *Isaiah* and the statue in the Cathedral as Donatello's *David*. Conclusive arguments for identifying the Duomo *Prophet* with Nanni di Banco's *Isaiah* are advanced by Lányi ("Il Profeta Isaia di Nanni di Banco," in *Rivista d'Arte*, vol. 18, 1936, pp. 137–78). If the Duomo statue is by Nanni di Banco, the Opera del Duomo Prophet must be the *David* of Donatello. It is, however, given by Brunetti (*Il Museo dell'Opera del Duomo di Firenze*, vol. 1, Florence, n.d., pp. 265–66) to Nanni di Bartolo, and by Lányi ("Zur Pragmatik der Florentiner Quattrocentoplastik," in *Kritische Berichte*, vol. 5, 1932–33, pp. 126–31) to Giuliano da Poggibonsi, who is mentioned in the Duomo documents in 1422 (Poggi, no. 359), but by whom no work is known. A tentative attribution to Donatello is proposed by Bellosi ("Ipotesi sull'origine delle terracotte quattrocentesche," in *Jacopo della Quercia*, 1977, pp. 163–79, and *Donatello e i suoi*, Florence, 1986, no. 17, pp. 124–26). The difference in handling between the present figure and Nanni di Banco's *Isaiah* is very marked. The veins on the realistic hands and feet are carved with greater delicacy, and the lips are parted as though in song. The dress, especially the cuff of the raised arm and the girdle, is rendered with great skill, and the forms employed at the base of the tunic are closely related to those of the bottom of the dress of the *St. John the Evangelist*, from the Cathedral façade in the Museo dell'Opera del Duomo.

21. *PROPHET WITH HEAD UPTURNED.* Museo dell'Opera del Duomo, Florence. Marble, H. 87.5 cm, W. 30 cm, D. 25 cm (H. 34¹/₂ in., W. 12 in., D. 10 in.). The figure wears a cap and holds a scroll in the right hand; the left hand is missing. Along with a companion figure, now also in the Museo dell'Opera del Duomo, the statuette was installed on February 5, 1431, over the doorway of the Campanile (Poggi, no. 307). It was previously stored "in opera." The close connection between the present statuette and the *Prophet* from the Campanile was recognized by Lányi ("Le statue quattrocentesche dei Profeti nel Campanile e nell'antica facciata di Santa Maria del Fiore," in *Rivista d' Arte*, vol. 17, 1935, pp. 121–59, 244–80), who ascribed both works to the same sculptor. Both figures were subsequently given by Brunetti (op. cit., no. 122, pp. 264–65) to Nanni di Bar-

tolo and, tentatively, by Herzner ("Zwei Früh-werke Donatellos: Die 'Prophetenstatuetten' von der Porta des Campanile in Florenz," in *Pantheon*, vol. 37, 1979, pp. 27–36 and in *Donatello e i Suoi*, nos. 12–13, p. 121) to Donatello. The statuettes are manifestly by two different hands, one, with head turned to the right, by Donatello, and the other, with head turned to the left, by Nanni di Banco. The respective points of reference are supplied by the *Prophet David* of Donatello, in the Museo dell'Opera del Duomo, and the *Isaiah* of Nanni di Banco, in the Cathedral. Though there is a discrepancy of 10 cm (4 in.) between the heights of the two statuettes and the stipulated height of the Prophets for the Porta della Mandorla, it is likely that the statuettes are those to which the commission of 1406 (Poggi, nos. 361, 362) refers.

22. Poggi, no. 164.

23. Poggi, no. 172. "1408, Dicembre 19. Deliberaverunt quod Nicholaus Pieri Lamberti, Donatus Nicholai Betti Bardi et Nannes Antonii, et quilibet eorum habeat una figuram et seu lapidem marmoreum pro quatuor Evangelistis deputatis et quarta lapis intelligatur esse concessa illi ex dictis tribus qui melius fecerit eius figuram; cum salario seu provisione per operarios alias ordinanda."

24. Poggi, no. 220. "1415, Ottobre 8. Donato Niccolai Betti Bardi, intagliatori, pro resto et integra solutione unius figure marmoris albi santi Johannis evangeliste, quam fecit pro dicta opera, que appretiata fuit in totum fl. CLX au., et que missa est in facie anteriore supradicte ecclesie, fl. LX au."

25. For the payments to Donatello for the *St. John the Evangelist* see Poggi, nos. 174, 175, 177, 178, 194, 195, 199, 206, 210, 211, 215, 216, 218, 220.

26. The sequence and siting of the Evangelists on the Cathedral façade is established by Munman, "The Evangelists from the Cathedral of Florence: A Renaissance Arrangement Recovered," in *Art Bulletin*, vol. 62, 1980, pp. 207–17, who successfully correlates the documentary, descriptive, and visual evidence. The statues beside the central doorway were Ciuffagni's *St. Matthew* (north), and Donatello's *St. John* (south), and those outside them were Nanni di Banco's *St. Luke* (north), and Lamberti's *St. Mark* (south). The original terms of the contract were such as to leave open the possibility that the *St. John* would have been paired with a *St. Matthew* also by Donatello. Ciuffagni's *Evangelist* was evidently planned after Donatello's *St. John* had assumed its present form.

27. Munman, "Optical Corrections in the Sculpture of Donatello," in *Transactions of the American Philosophical Society*, 1985, pp. 10–14. Wundram (*Donatello und Nanni di Banco*, Berlin, 1969, pp. 22–25), in an excellent account of the figure, notes that "die Betrachter hatten also die Figuren stets in leichter Unteransicht vor sich. Um diese Unteransicht auszugleichen, hat Donatello den Oberkörper seiner Figur verhältnismässig stark überlangt."

28. *ST. JOHN THE EVANGELIST.* Museo dell'Opera del Duomo, Florence. Marble, H. 210 cm, W. 88 cm, D. 54 cm (H. 83 in., W. 35 in., D. 21 in.). The main problems presented by the statue are discussed by L. Becherucci, *Il Museo dell'Opera del Duomo a Firenze*, vol. 1, no. 119, pp. 262–64. Installed in its niche on the façade of the Cathedral in October 1415, it remained there until the destruction of the façade in 1587, when it was moved with the three other Evangelist statues to a chapel in the central tribune. There it remained until 1904, when it was placed in an aisle of the nave. It was removed from the church in 1940 and after World War II was installed in the Museo dell'Opera del Duomo. In the early literature the statue is much praised (e.g., *Libro di Antonio Billi*, "a figure truly perfect in every part"; Vasari, *Vite*, vol. 3, pp. 206–7, "il quale è molto lodato"), but after the removal of the four statues from the façade some confusion arose as to their identities. Not until 1884 was the *St. John* conclusively identified by Bode (in Burckhardt, *Cicerone*, 1884, p. 346) as the work of Donatello. An elaborate analysis by Janson (pp. 13–16) of the precise date at which the *St. John the Evangelist* was carved is vitiated by failure to take account of the payments for the three other Evangelists, which follow the same pattern as those to Donatello. It seems from these that, after the work on the Evangelists had been begun, the artists responsible were diverted to the guild statues on Or San Michele. Only when work on them had reached an advanced stage was the carving of the Evangelists resumed. The tip of the nose of the *St. John* is damaged. The carving of the pupils is ascribed by Janson to the late sixteenth century on the ground that "had Donatello intended to give the eyes of the St. John a focused glance, he undoubtedly would have treated them" in the same fashion as the eyes of the statues on Or San Michele. In a retouched photograph in Janson (pl. 5d) in which the incisions on the eyeballs are eliminated, "the expression of the face becomes calmer and more pensive—psychologically 'neutral' as it were." This involves a fundamental misinterpretation of the statue.

29. For Brunelleschi's participation in the silver altar see L. Gai, *L'altare argenteo di San Jacopo nel Duomo di Pistoia*, Turin, 1984, pp. 148–60. After matriculating as a goldsmith in the Arte della Seta in 1398, Brunelleschi worked on the silver altar between 1399 and 1401.

30. *CRUCIFIX.* Santa Croce, Florence. Pigmented pear wood, H. ca. 168 cm, W. ca. 173 cm (H. 66 in., W. 68 in.). The traditional attribution to Donatello goes back to Albertini (1510) and the *Libro di Antonio Billi* (ca. 1530) and is accepted by most scholars. Lányi ("Zur Pragmatik der Florentiner Quattrocentoplastik," in *Kritische Berichte*, vol. 5, 1932–33, pp. 126–31) and Parronchi ("Il Crocifisso del Bosco," in *Scritti di storia dell'arte in onore di Mario Salmi*, vol. 2, Rome, 1962, pp. 233–62, and *Donatello e il potere*, Florence, 1980), however, ascribe it to Nanni di Banco. The *Crucifix* at Bosco ai Frati is by Desiderio da Settignano and dates from about 1455–60. The Santa Croce *Crucifix* was cleaned in 1973–74 (for a report on this restoration see A. Paolucci and O. Caprara, *Il Crocifisso di Donatello dopo il restauro*, Florence, 1974) and was exhibited in 1977 along with the cleaned *Crucifix* of Brunelleschi from Santa Maria Novella (*Brunelleschi scultore*, Florence, 1977). The *Crucifix* has mobile arms. Before the application of priming, the wrists were extended by metal braces intended to increase their length (for this see Baldini, in *La Nazione*, October 9, 1974). The right side of the face (the left from the viewer's standpoint) was carved separately and attached. Early sources (up to and including Vasari) record the *Crucifix* as hanging in the Barbigia Chapel under a fresco by Taddeo Gaddi on the choir screen of the church. According to a later source, Bocchi-Cinelli (1678), the *Crucifix* was commissioned by "Bernardo, o Niccolò del Barbigia"; there is no confirmation of this. When Santa Croce was adapted to the Tridentine rite, the *Crucifix* was installed in a wooden tabernacle designed by Vasari (lost). The *Crucifix* has been variously dated between 1408 and ca. 1420. The folds of the perizoma recur in the drapery across the waists of the *Prophet David* and the *St. John the Evangelist*. On this evidence the work is likely to date from about 1412–15. A *Crucifix* of about 1420 in San Felice, Florence, also has hinged arms and seems likely to have been used, like Donatello's, in the Holy Week liturgy. Its connection with the Crucifixion relief on Ghiberti's first bronze door is less close than Janson, pp. 9–12, suggests. A well-reasoned account of its place in the development of the wood Crucifix in Florence is given by Lisner ("Intorno al Crocifisso di Donatello in Santa Croce," in *Donatello e il suo tempo*, Florence, 1968, pp. 115–29, and *Holzkruzifixe in Florenz und in der Toskana*, Munich, 1970, pp. 54–57). Vasari (in his lives of Brunelleschi and Donatello, *Vite*, ed. cit., vol. 3, pp. 144–45, pp. 204–6) records that Donatello's *Crucifix* was

criticized by Brunelleschi as "un contadino e non un corpo simile a Gesu Cristo, in quale fu delicatissimo et in tutte le parti il più perfetto uomo che nascesse gia mai. Udendosi mordere Donato, e più a dentro che non pensava, dove sperava essere lodato, rispose: 'Se cosi facile fusse fare come giudicare, il mio Cristo ti parrebbe Cristo e non un contadino: pero piglia legno e pruova a farne ancor tu.' " According to Vasari, Brunelleschi took up this challenge and after many months completed his own Crucifix, and invited Donatello to see it. Struck with admiration, Donatello declared "a te e conceduto fare i Cristi et a me i contadini." This story is dismissed by Janson (pp. 10–12) on the ground that "the tale of the contest between Brunelleschi and Donatello can be fully understood only in the context of a systematic general study of the anecdote about artists and works of art, and its meaning in Renaissance thought." It is, however, supported, first, by the relative date of the two Crucifixes—Brunelleschi's *Crucifix* in Santa Maria Novella seems to date from about 1420—and, second, by the contrast between their styles.

31. Poggi, nos. 417, 418, 419, 420, 421.

32. Poggi, nos. 423, 424.

33. The following works have been, in my view, wrongly ascribed to the young Donatello:
Man of Sorrows. Museo dell'Opera del Duomo, Florence. Marble, H. 42 cm, W. 66 cm (H. 16¹/₂ in., W. 26 in.). The relief, which comes from the Porta della Mandorla of the Cathedral, is published as an early work of Donatello by Lisner ("Zum Frühwerk Donatellos," in *Münchner Jahrbuch der bildenden Kunst*, vol. 13, 1962, pp. 63–68). The morphology of the arms and the weak head preclude this attribution.
David. National Gallery of Art, Washington, D.C. Marble, H. 163 cm (H. 64 in.). The statue originates from the Palazzo Martelli. On the strength of its pedigree, it was for a long time widely accepted as an early work of Donatello. Janson argues (pp. 21–23) that it was begun ca. 1412 and was completed, in a second sculptural campaign, in 1420–30. The statue seems to have been begun about 1470–75 and is by Antonio Rossellino (Pope-Hennessy, "The Martelli *David*," in *Burlington Magazine*, vol. 101, 1959, and *Essays on Italian Sculpture*, London, 1968, pp. 65–71).
Creation of Eve. Museo dell'Opera del Duomo, Florence. Terracotta, H. 34.5 cm, W. 34.5 cm (H. 13¹/₂ in., W. 13¹/₂ in.) Part of a lost cassone front of which the companion piece, with three scenes from Genesis, is in the Victoria and Albert Museum, London. The unwarranted attribution to Donatello of these reliefs, as well as of a seated Virgin and Child at Detroit, two reliefs

of the Nativity in the Detroit Art Institute and the Museo Bardini, Florence, and of a number of Madonna reliefs, is due to Bellosi ("I problemi dell'attività giovanile," in *Donatello e i suoi*, Florence, 1986, pp. 37–54). The Detroit *Madonna* and the four Genesis scenes are by Nanni di Bartolo, and the Nativity reliefs are Ghibertesque. (For the London cassone front see Pope-Hennessy, *Catalogue of Italian Sculpture in the Victoria and Albert Museum*, London, i, 1964, no. 51, pp. 57–59).

CHAPTER II

1. D. F. Zervas, *The Parte Guelfa, Brunelleschi and Donatello*, 1987, pp. 87–97, offers an incomparably rich resource for information on the Parte Guelfa and the artistic commissions that it sponsored.

2. For Ghiberti's statues at Or San Michele see R. Krautheimer, *Lorenzo Ghiberti*, Princeton, vol. 1, 1970, pp. 71–100, and for the statues by Nanni di Banco see P. Vaccarino, *Nanni*, Florence, 1950, pp. 34–43. The only significant addition to the bibliography of Nanni di Banco since the publication of Vaccarino's book is that made by M. Bergstein ("La vita civica di Nanni di Banco" in *Rivista d'Arte*, vol. 39, serie quarta, 3, 1987, pp. 35–77), who interprets the group of the Quattro Santi Coronati as "una concreta affirma degli ideali repubblicani sottoscritti dai membri delle Arti fiorentine che dirigevano la vita pubblica della città" and concludes that "al pari di Leonardo Bruni che nei suoi scritti aveva usato modelli classici per esultare il repubblicanesimo fiorentino, Nanni ha utilizzato antichi modelli per esprimere un medesimo *ethos* corporativo."

3. *St. Peter*. Or San Michele, Florence. Marble, H. 237 cm (with plinth), W. 72.5 cm (H. 93 in., W. 28¹/₂ in.). The statue of St. Peter in the tabernacle of the Arte dei Beccai is linked in all pre-Vasarian sources with the *St. Mark* of the Arte de' Linaiuoli as a work of Donatello. According to the *Libro di Antonio Billi* (before 1530), the two statues were commissioned jointly from Brunelleschi and Donatello, but were executed by Donatello. They are mentioned twice in the first edition (1550) of the *Vite* of Vasari (ed. cit., vol. 3, p. 145) in the life of Brunelleschi ("le quali Filippo lasciò fare a Donato da se solo, avendo preso altre cure, e Donato le condusse a perfezione") and then (ed. cit., vol. 3, pp. 207–8) in the life of Donatello. On the basis of these accounts, the *St. Peter* was regarded by Semper (*Donatello: seine Zeit und Schule*, Vienna, 1875, pp. 85ff.) and many later students up to and including Kauffmann (*Donatello*, Berlin, 1935, pp. 29ff.) as a work of Donatello. A contrary view, that the statue is a work

by Nanni di Banco, was advanced by Pastor (*Donatello*, Giessen, 1892) and accepted by Bode (*Denkmäler der Renaissance-skulptur Toskanas*, Munich, 1892–1905). The ascription to Nanni di Banco is rightly dismissed by Middeldorf (*Art Bulletin*, 1936, p. 579) and Planiscig (*Nanni di Banco*, 1946, p. 27). An attribution to Ciuffagni is advanced by Lányi ("Zur Pragmatik der Florentiner Quattrocentoplastik," in *Kritische Berichte*, 1936, p. 129) and is accepted by Janson (vol. 2, pp. 222–25). Comparison of the figure with Ciuffagni's documented *St. Matthew* (Museo dell'Opera del Duomo, Florence) leaves little doubt that this attribution is correct. It affects, however, only the execution of the statue, not its design, which is strongly Brunelleschan. The use of geometrical motifs in the marble lining of the tabernacle suggests that the statue may well, as tradition insists, have been planned by Brunelleschi.

4. *ST. MARK*. Or San Michele, Florence. Marble, H. 236 cm (with plinth), W. 74 cm (H. 93 in., W. 29 in.). The statue of St. Mark, the patron of the Arte dei Linaiuoli, can be confidently dated on the basis of five documents. The first four of these (published by Gualandi, *Memorie originali italiane riguardanti le belli arti*, vol. 4, Bologna, 1843, no. 138, pp. 104–7, and by Herzner, *Regesti*, nos. 10, 11, 22, 23) cover a period between 1409 and 1411. The earliest payment is one of 28 florins to Niccolò di Pietro Lamberti, for selecting at Carrara a marble block 3³/₄ braccia high for use for the statue in the guild tabernacle at Or San Michele. Two years later, on February 16, 1411, the marble block was accepted and a committee of five members of the Arte was instructed to allot it to a sculptor. The statue was commissioned from Donatello on April 3, 1411, with the stipulation that it be completed by November 1, 1412. Local surface gilding referred to in this document was recovered in a recent restoration. A further document of April 29, 1413 (for which see Franceschini, *L'Oratorio di San Michele in Orto*, Florence, 1892, p. 82, and Herzner, op. cit. no. 33) contains instructions for the completion of the statue "di quanto vi mancha," and the work is likely to have been installed later in that year. In the third quarter of the fifteenth century (*XIV uomini singhulari in Firenze dal 1400 innanzi* in Milanesi, *Opere istoriche edite ed inedite di Antonio Manetti*, Florence, 1887, p. 164) the *St. Mark*, like the *St. Peter*, is listed as a work of Donatello. In the *Libro di Antonio Billi*, however, the two statues are described as having been commissioned jointly from Donatello and Brunelleschi. In the first edition of Vasari's *Vite* (1550) this attribution is reproduced, and in the second edition (1568) it is elaborated in the form "A San Michele in Orto di detta città lavorò di

marmo per l'Arte de' Beccai la statua del San Piero che vi si vede, figura savissima e mirabile, e per l'Arte dei Linaiuoli il San Marco Evangelista; il quale avendo egli tolto a fare insieme con Filippo Brunelleschi, finì poi da sé, essendosi così Filippo contentato. Questa figura fu da Donatello con tanto giudizio lavorata, che, essendo in terra, non conosciuta la bontà sua da chi non aveva giudizio, fu per non essere dai Consoli di quell'Arte lasciata porre in opera; per il che disse Donato che li lasciassero metterla su, che voleva mostrare, lavorandovi attorno, che un'altra figure e non più quella ritornerebbe. E così fatto, la turò per quindici giorni, e poi senza altrimenti averla toccata la scoperse, rimpiendo di maraviglia ognuno." Both parts of this account are rejected by Janson (pp. 17–20), the first as propaganda "to enhance Brunelleschi's reputation as a sculptor," and the second on the ground that "distortions—assuming there are any—[which] ought to show up well in photographs of the statue," fail to do so. The presence of distortions in the figure is accepted by Semper and Kauffmann and is demonstrated in a conclusive fashion by Munman ("Optical Corrections in the Sculpture of Donatello," Philadelphia, 1985, pp. 14–16). The statue was removed from its niche in 1977 and was cleaned in 1984–86. For an account of the restoration, whereby much of the gilding on the edges of the dress, cloak, and cuffs was recovered, see Sisi (in *Capolavori e Restauri*, Florence, 1986, pp. 47–52). The statue was well preserved throughout the nineteenth century; the mutilation of the nose, the left hand, and the book occurred during the 1920s. The change in condition is reflected in the literature of the statue, which was seen in sharper focus in the nineteenth century than by later scholars. The cushion at the base is widely regarded as an emblem of the *rigattieri*, who were inscribed in the Arte dei Linaiuoli.

5. The classical sources of the *St. Peter* and *St. Mark* are discussed by M. Greenhalgh, *Donatello and His Sources*, 1982, pp. 35–41, and M. Lisner, "Gedanken vor frühen Standbildern Donatellos" in *Kunstgeschichtliche Studien für Kurt Bauch*, Munich, 1967, pp. 77–92. For the related Roman busts see H. von Heintze in *Römische Mitteilungen*, vol. 63, 1956, pp. 56–65.

6. *DAVID WITH THE HEAD OF GOLIATH*. Museo Nazionale, Florence. Marble, H. 191 cm, W. 57.5 cm, D. 32 cm (H. 75 in., W. 22⅝ in., D. 12⅝ in.). The statue was installed in the Sala dell'Orologio of the Palazzo della Signoria in 1416. It was transferred to the Uffizi in the spring of 1781 and was moved to the Museo Nazionale in 1874. The discovery of a record of the earlier inscription cited in this book is due to Donato (in *Journal of the Warburg and Courtauld Institutes*, vol. 54, 1991, pp. 83–98) on the basis

of a *Zibaldone* of ca. 1468 in the Biblioteca Riccardiana, 1133, f. 46r., of which a copy exists at Würburg. The phrase has a close parallel in Leonardo Bruni's *Laudatio Florentinae Urbis*, and the titulus may therefore have been devised by Bruni. The later inscription is recorded by Laurentius Schrader, *Monumentorum Italiae . . . libri quatuor*, Helmstedt, 1592, f. 78v. The inscription is likely to have been incised in the front face of a platform in which the lower part of the present base would have been inset. At the back of the figure is a hole for attachment to the wall; this is set at angle to the front plane of the present base, and gives grounds for supposing that the prime view of the statue was to the left of its present front view. The construction of the figure, and especially the vacant area of cloak to the left of the rear leg, confirms that this was so. The principal area of damage is on the right elbow, which appears to have been broken and replaced with new marble, possibly in the eighteenth century. The sling, one side of which is damaged, rests on Goliath's head, and is likely originally to have been attached with a leather thong to David's right hand. The present statue was for long identified as that made for the *sproni* of the Cathedral in 1408. This case is argued by Kauffman (*Donatello*, p. 208), and was at one time accepted by many students, including the present writer. If it were correct, the terms "in aptando et perficiendo" in the document of August 27, 1416 (Poggi, no. 426) would refer to the adaptation of the statue of 1408 to a new use. Since the base of the present figure is rectangular, not pentagonal, this cannot be correct. It is argued by Lányi (in *Rivista d'Arte*, vol. 18, 1936, pp. 137–78) that the fold of cloak held in David's left hand is the remains of a scroll surviving from the statue of 1408, which was eliminated in 1416. Janson (pp. 3–7) presents a variant of this case according to which a scroll held in the right hand was cut away. There is no evidence whatever that the figure has been recut. Janson (loc. cit.) conflates the documents of 1408 and 1416 with gravely misleading results. The stylistic case against a very early dating for the David is argued by Colasanti (*Donatello*, 1927, p. 39), Schottmüller (in *Zeitschrift für Kunstgeschichte*, vol. 1, 1932–33, p. 336), and Planiscig (*Donatello*, 1947, p. 19), who date the statue ca. 1416. The more plausible case for a dating of ca. 1412 is presented by Wundram (*Donatello und Nanni di Banco*, Berlin, 1969, pp. 26–29) and Herzner ("David Florentinus: Zum Marmordavid Donatellos im Bargello," in *Jahrbuch der Berliner Museen*, vol. 20, 1978, pp. 43–115). The statue is probably identical with a figure of David for which Donatello received part payment on August 12, 1412 (Poggi, no. 199). The last part of the statue to be finished is likely to have been the

Goliath head, in which the carving conforms to that of the gable relief over the *St. George* on Or San Michele. The commission for a commemorative patriotic statue may have been inspired by the events of 1412, when exiled Florentine patricians made a last, unsuccessful attempt to overturn the state, or by the death of Ladislaus of Naples (1414), which freed Florence from a Ghibelline threat no less menacing than that offered earlier by Gian Galeazzo Visconti. The word *Patria* signifies, as it did in antiquity, *City* (Kantorowicz, *Selected Studies*, New York, 1965, pp. 308–24), and recalls Cicero's "Patria mihi vita mea carior est." The first unambiguous reference to the marble David occurs in a document of July 6, 1416 (Poggi, no. 425), in which the Operai of the Duomo record the receipt of a request "eis trasmisso per magnificos dominos priores artium et vexilliferum Justitie populi et communis Florentie de presente mense Julii, in quo continetur in effectu quod dicti operarii teneantur mictere ad palatium et in palatio dictorum dominorum quandam figuram marmoream David existentem in dicta opera." On August 27, 1416 (Poggi, no. 426) a payment of five florins was made to Donatello "pro pluribus diebus stetit una cum aliis eius discipulis in aptando et per ficiendo figuram Davit, que destinata fuit per dictos operarios in palatium dominorum priorum artium" and for "più opere di sè e di suoi lavoranti mise in compiere a acconciare la figura di David che si mandò in palagio per comandamento de' Signori," and on September 18, 1416 (Poggi, no. 427) payments were made for the transport to the Palazzo della Signoria of "due becchatelli di marmo . . . per la detta figura," the transport of the statue itself, a supply of gold and silver foil, azure, cinnabar, and glass tessere for the decoration of the consoles, and of "50 pezzi di oro battuto . . . per adornare la detta figura." The Opera del Duomo was funded directly by the Commune, and it need not therefore be supposed that the statue was produced for any other destination than the Palazzo della Signoria. It seems to have been regilt in 1459, when, on April 30, the painter Ventura di Moro received over nineteen lire "per dorare, dipingere et hornare. E. lione et Dauit" (ASF, Camera del Comune, Massai di Camera, Deb. e Cred., 1, cc. 396, 411).

7. M. Trachtenberg, "An Antique Model for Donatello's Marble *David*," in *Art Bulletin*, vol. 50, 1968, pp. 268–69.

8. Greenhalgh, op. cit., p. 34, notes a relationship between the head and a bust of Lucius Verus at Copenhagen, and representations of Antinuous (Clairmont, *Die Bildnisse des Antinous*, 1966, nos. 17, 20, 27, and 37). These parallels are inconclusive. According to Janson (vol.

2, p. 6), the wreath of amaranth signifies undying memory.

9. *ST. GEORGE.* Museo Nazionale, Florence. Marble, H. 209 cm (without base), W. 67 cm (at plinth) (H. 82 in., W. 26³/₈ in.). In the gable of the tabernacle on Or San Michele, *God the Father.* H. 68 cm, W. 64 cm (H. 27 in., W. 25 in.). For the predella with the scene of St. George and the Dragon now in the Museo Nazionale, Florence, see Chapter 6, note 5. The single document for the *St. George* is a payment of February 17, 1417, by the Arte dei Corazzai to the Opera del Duomo for a block or slab of marble for the base of the tabernacle. The entry (Archivio dell'Opera di Santa Maria del Fiore, II, 1-70, Deliberazioni, first semester of 1417, ca. 8) is published by Wundram ("Albizzo di Piero," in *Hubert Schrade zum 60 Geburtstag,* Stuttgart, 1960, p. 176) and reads

1416/7 febbraio 17
Item quod vendatur arti corazariorum de marmore quantum volent pro base quam ponere volunt sub figura de marmore quam dicta ars vult poni facere in facie scti. Micaelis in orte, pro pretio tamen soldorum viginti pro quolibet centinario etc., ut est consuetum etc.

There are two deletions, after "facie," of the word "orto," and after "viginti," of the word "octo." In the margin is the word "habuit." It is claimed by Siebenhühner (in *Kunstchronik,* vol. 7, 1954, pp. 266ff.) that a "figura" (block of marble, not a statue) was sold by the Opera del Duomo to the Arte dei Corazzai in October 1415. This document cannot be traced and remains unpublished. If it is correct, the statue would have been begun late in 1415, and the base of the niche (or the predella) would have been carved in the course of 1417. For a lucid account of its critical history see G. Gaeta Bertelà (*San Giorgio,* Florence, 1986). Always one of Donatello's most widely admired works, its reputation reached its apogee in the third quarter of the nineteenth century. As a result of damage to the nose (1858), it was superficially restored and transferred (1868) to the deep tabernacle in the south face now containing the *Madonna della Rosa.* In 1887 it was replaced in its original niche, and in 1892 it was transferred to the Bargello, where, in 1950, it was placed in a plaster reproduction of the original tabernacle. The predella with St. George and the Dragon remained in situ on Or San Michele till 1976, when, in much impaired condition, it was also transferred to the Bargello. The account given by Janson (p. 25) of the movement of the statue in the nineteenth century is incorrect. In the head, above the nose, ears, and forehead, as well as the left thigh and certain other areas, there are drill holes containing traces of metal. Janson (vol. 2, p. 26) deduced from them that the statue was originally equipped with a helmet, lance, and sword "not furnished by Donatello but by some specialized craftsman." There is, however, no reference in any account of the figure to the presence of metal accoutrements. It is possible that the drill holes on the head were for the attachment of a wreath rather than a helmet, and that they date from the seventeenth or eighteenth century. Apart from the nose (which was restored by Bartolini), the main area of damage is the right side of the shield.

10. B. Rackham, *Catalogue of Italian Majolica in the Victoria and Albert Museum,* 2d. ed., 1977, p. 104, no. 308, pl. 59.

11. Vasari, *Vite,* ed. cit., vol. 3, p. 208.

12. A. F. Doni, *I Marmi* (ed. Chiorboli, Bari, 1928, p. 75). Mention should also be made of a poem by Anton Francesco Grazzini (d. 1584) praising the physical charm of the statue as "my beautiful Ganymede" (C. Verzone, *Le rime burlesche . . . di Anton Francesco Grazzini,* 1882, pp. 526ff.).

13. F. Bocchi, *Eccellenza della statua di San Giorgio di Donatello,* Florence, 1584.

14. A definitive account of the Parte Guelfa tabernacle and of the *St. Louis of Toulouse* is given by Zervas, op. cit., pp. 101-61. For the cult of St. Louis of Toulouse see M. N. Toynbee (*St. Louis of Toulouse and the Process of Canonisation in the Fourteenth Century,* Manchester, 1929, pp. 5-26).

15. St. Louis of Toulouse was adopted as the patron of Florence by the Florentine commune, under Guelph pressure, in 1388, when his feast day was proclaimed a public holiday. He owed this position to the historical sympathy of Florence for the Angevin royal house. His feast day was celebrated at Santa Croce. According to the life of St. Louis by Bartolomeo da Pisa (*De Conformitate Vitae Beati Francisci ad Vitam Domini Nostri Jesu Christi,* 1399), when the Saint's body was deposited for burial at Marseilles, a vision appeared over the altar of the Saint as a mitered Bishop with right hand raised in benediction and holding a crozier. This iconography is followed in frescoes in Santa Croce by Agnolo Gaddi and Giovanni da Milano and was adopted by Donatello.

16. The earlier literature of the Parte Guelfa tabernacle, including two important articles by C. von Fabriczy ("Uber die Statue des Hl. Ludwig von Donatello" in *Repertorium für Kunstwissenschaft,* vol. 17, 1894, pp. 78-79, and "Donatellos Hl. Ludwig und ein Tabernakel an Or San Michele," in *Jahrbuch der Königlich Preussischer Kunstammlungen,* vol. 21, 1900, pp. 242-46) and the relevant entry in Janson, who presumes extensive intervention by Michelozzo, is superseded by a careful study by Zervas, loc. cit., who infers, from the *all'antica* architectural elements "that Donatello himself ultimately controlled the tabernacle design." The documentation of the tabernacle and statue by Zervas (pp. 349-68) likewise supersedes earlier transcriptions. The proportional principles that determined the form of the tabernacle and statue of St. Matthew commissioned by the Arte del Cambio from Ghiberti are the subject of an article by Zervas ("Ghiberti's *St. Matthew* Ensemble at Or San Michele: Symbolism in Proportion," in *Art Bulletin,* vol. 58, 1976, pp. 35-43). Ghiberti's statue appears to have been cast before the tabernacle was formally commissioned. The ratio between the figure and niche provides a precedent for the Parte Guelfa statue and tabernacle.

17. *ST. LOUIS OF TOULOUSE.* Museo dell'Opera di Santa Croce, Florence. Gilt bronze, H. 266 cm, W. (base) 85 cm, D. ca. 75 cm (H. 105 in., W. 33¹/₂ in., D. 29¹/₂ in.). The complicated history of the Parte Guelfa niche and the statue of St. Louis of Toulouse is best recorded by Zervas, loc. cit. Though the central tabernacle on the east face of Or San Michele was allotted to the Parte Guelfa in 1339, the tabernacle and the statue it contained seem to have been commissioned only about 1420. A resolution of the Captains of the Parte Guelfa of May 20, 1423, that "offitiales ymaginis Beati Lodovici que poni debeat in pilastro ecllesie sancti Michaelis in orto ut perfici possit floreni trecento auri" suggests that the statue was completed in the second half of 1423 or in the following year. The statue is likely to have been installed before November 1425, when it was enjoined that offerings on the feast day of the Saint should be made at Or San Michele as well as in the church of Santa Croce. A document of January 15, 1460, gives the date of 1422 for the execution of the tabernacle. In this year the tabernacle was sold by the Parte Guelfa to the Mercanzia. The statue was removed between 1451 and 1459 and placed in a position high on the façade of Santa Croce. It remained there till 1860, when it was placed first in the church and then (1903) in the refectory, the present Museo dell'Opera di Santa Croce. The unorthodox pose of the *St. Louis* has given rise to the suggestion (Becherucci, "Come era il San Lodovico di Tolosa?" in *Donatello-Studien,* 1989, pp. 183-85) that on Or San Michele the statue was turned with the left foot in the front plane. Since the indentation caused in the platform by the base of the crozier is clearly visible, this cannot be correct. A more persuasive explanation is offered by Zervas (op. cit., p. 137): "With his gaze directed towards the Cathedral end of via Calzaiuoli, Saint Louis appears to be blessing the official processions

which would have passed on the way to the Piazza della Signoria. In fact, the most satisfactory view of the statue is the one from the right, as spectators would have seen it while proceeding from the Cathedral to Or San Michele. From this taking view, all the elements which appear awkward when the *Saint Louis* is viewed frontally or from the left . . . are perfectly balanced." The main technical accounts of the *St. Louis* are due to Bearzi (in *Donatello: San Lodovico*, New York, 1949, pp. 25–30, and "La tecnica fusoria di Donatello" in *Donatello e il suo tempo*, 1968, pp. 97–105). For the technique of Brunelleschi's *Sacrifice of Isaac* see *Brunelleschi scultore*, 1977, pp. 23–27. According to the codex of Buonaccorso Ghiberti (Florence, Bibl. Naz. BR 228, f. 27), the total sum received by Donatello for the *St. Louis*, ungilded and exclusive of its tabernacle, was 449 florins "la ffiura del Santo Lodovico, sanza l'oro e sanza el tabernacholo d'or za Michele. A Donatello per suo maestero e di chi a ttenuto con lui f. 449/per libre 3277 d'ottone/per libre 350 di ciera/per rame e ffero libre 122 on. 3 d. 4/per charboni f. 41, L. 94, s. 0). White ("Paragone: Aspects of the Relationship between Sculpture and Painting," in *Art, Science and History in the Renaissance*, 1967, pp. 43–108) explains the heavy drapery of the statue as a metaphor for the psychological burden sustained by St. Louis as Archbishop, and compares the weight of the cope to the drapery of the *Habakkuk* on the Campanile. The most clearly innovative aspect of the statue, other than its sectional casting, is the application of wax-modeled drapery to what must originally have been a freely modeled core. The use of overall gilding has been associated with a reference in Pliny's *Natural History* to the production of golden statues in antiquity.

18. For the form of the crozier see especially M. Lisner ("Zur frühen Bildhauerarchitektur Donatellos," in *Münchner Jahrbuch der bildenden Kunst*, vols. 9–10, 1958–59, pp. 72–127). A number of tentative but not wholly convincing precedents for the niches on the crozier are listed by Greenhalgh (*Donatello and His Sources*, 1982, pp. 74–75).

19. Zervas, op. cit., pp. 138–62.

20. G. B. Gelli, *Vite d' Artisti*, ed. Mancini, in *Archivio storico italiano*, 5 serie, vol. 17, 1896, p. 59.

21. Vasari, *Vite*, ed. cit., vol. 3, p. 218.

22. F. Bocchi, *Le Bellezze della Città di Firenze*, 1591, p. 160.

23. A useful review of the available material on bronze casting in Florence is provided by Zervas, op. cit., pp. 366–68.

CHAPTER III

1. A thorough account of the trecento statues on the Campanile is given by G. Kreytenberg, *Andrea Pisano und die toskanische Skulptur des 14. Jahrhunderts*, Munich, 1984, *passim*. The figures filled the niches on the south and west faces. The niches vacant in the quattrocento were those on the north and east faces. The first group of quattrocento prophets was designed for the east face, and the later group for the north niches facing the Cathedral. In 1464 the statues on the north and west faces were transposed.

2. Poggi, no. 222: "1415. Dicembre 5. Item deliberaverunt quod Donatus Niccolai Betti Bardi, intagliator, possit facere duas figuras marmoris albi videlicet . . . pro mictendo et aptando in campanili et ad faciendum sibi dictas figuras locaverunt." For other documents on the first two prophets see Poggi, nos. 226, 227, 228, 229. The final payment of December 18, 1418 (Poggi, no. 230) reads "Donato Niccolai Betti Bardi quos recipere debet ab opere pro resto pretii unius figure marmoree per eum sculte sive intaglate pro opere extimate in totum fl. C au., pro dicto resto f. XLV aur."

3. For the documents relating to the second prophet see Poggi, nos. 222, 232, 238. On the completion of the statue in July 1420 Donatello received the sum of ninety-five florins (Poggi, no. 243).

4. *BEARDED PROPHET.* Museo dell'Opera del Duomo, Florence. Marble, H. 193 cm, W. 64 cm, D. 44 cm (H. 76 in., W. 25 in., D. 17⅛ in.). The surface is much weathered, especially in the head, and is impaired by the deterioration of a protective coating applied at an uncertain date. The bridge of the nose is missing, and the fingers of the left hand and the left shoulder are extensively abraded. It is claimed by Janson (p. 38), following Poggi, that the *Beardless Prophet* is the earlier and the *Bearded Prophet* the later of the two figures, since in the first "there is in its drapery a certain preference for curvilinear seams and a pliability that link it with similar residues of the International Style in the St. Mark and the St. George." This sequence is accepted by Becherucci (*Il Museo dell'Opera del Duomo a Firenze*, Florence, vol. 1, n.d., nos. 125, 126).

5. *BEARDLESS PROPHET.* Museo dell'Opera del Duomo, Florence. Marble, H. 190 cm, W. 64 cm, D. 43 cm (H. 75 in., W. 25 in., D. 17 in.). The surface is much weathered, though less prejudicially than that of the companion figure. The issue of workshop execution is raised by Janson ("It is only in the drapery that an occasional lack of incisiveness suggests

the hand of an assistant") and Becherucci, who suggests that the *Bearded Prophet* may have been executed in association with Nanni di Bartolo. To statues so severely weathered, this form of connoisseurship is inapplicable, and it receives no support from documents. This and the companion statue, along with the other prophets from the Campanile, were removed from their niches and transferred to the Museo dell'Opera del Duomo in 1936. A distinction must be made between accounts of them after this time and accounts prepared when they were still inaccessible. Fundamental for their later literature is, however, an article by Lányi written before their transfer ("Le statue quattrocentesche dei Profeti nel Campanile e nell'antica facciata di Santa Maria del Fiore," in *Rivista d'Arte*, vol. 17, 1935, pp. 121–59, 244–80).

The heads of the *Beardless Prophet*, the *Zuccone*, and the *Jeremiah* present three separate problems: (1) whether they were designed as portraits of specific individuals; (2) whether, if they were not planned as portraits, they were nonetheless modeled from life; and (3) their relationship to Roman portraiture. The earliest references to the statues (*XIV uomini singhulari in Firenze dal 1400 innanzi*, before 1472, ed. Milanesi, Florence, 1887, p. 164; Albertini, 1510, p. 10) draw attention to their quality, but make no reference to portraiture. In the *Libro di Antonio Billi* of before 1530, however, the two later prophets are described as representing Giovanni di Barduccio Cherichini and the young Francesco Soderini. These identifications are followed by the *Codice Magliabecchiano* (1537–42) and Gelli (ca. 1550) and were incorporated in Vasari's life (1550) of Donatello (*Vite*, ed. cit., vol. 3, p. 209: "quattro figure di braccia cinque, delle quali die ritratte dal naturale sono nel mez[z]o: l'una e Francesco Soderini giovane, e l'altra Giovanni di Balduccio Cherichini, oggi nominato il Zuccone." There is no historical identification for the *Beardless Prophet*, but the resemblances between its head and Roman busts of the type of an elderly man in the Vatican (A. Nicholson, "Donatello: Six Portrait Statues," in *Art in America*, vol. 30, 1942, fig. 19) are so strong as to suggest, first, that it is based on the study of Roman portraiture and, second, that it must, like equivalent Roman portraits, have been modeled from the life. For the heads regarded in the sixteenth century as likenesses of historical figures, Soderini and Cherichini, life modeling must also have been employed. A point of comparison is afforded by the portrait heads introduced by Masaccio in the Brancacci Chapel, and it would not be surprising if deliberate portraiture (not necessarily of the two men named) had been involved. In the case of the *Joshua* (see note 7 below), the face closely recalls that of Poggio Bracciolini recorded in a manuscript of his *De varietate for-*

tunae in the Vatican (Bibl. Vaticana, Urb. lat. 224, f. 2).

6. Leon Battista Alberti, *On Painting and On Sculpture*, ed. and trans. C. Grayson, London, 1972, pp. 122, 123.

7. *Joshua*. Duomo, Florence. H. 182 cm, W. 63 cm, D. 38 cm (H. 71⅝ in., W. 25 in., D. 15 in.). For documents see Poggi, nos. 221, 223, 224, 225, 226, 241, 242, 244, 247, 250. The statue, though originally commissioned for the Campanile, seems after its completion to have been allocated to the Cathedral façade.

8. *MARZOCCO*. Museo Nazionale, Florence. Pietra di macigno, H. 135.5 cm, W. 38 cm (H. 53⅜ in., W. 15 in.). The *Marzocco* is not mentioned by Vasari and was accorded little attention before 1812, when it was substituted for the trecento *Marzocco* on the *ringhiera* of the Palazzo della Signoria. The lion and the inlaid shield of arms which it supports, deteriorated in the open air, and in 1847 the sculpture was placed in the Uffizi. It was moved to the Bargello in 1865. Payments to Donatello for the *Marzocco*, in January and February 1420, were published by Semper (1875, p. 278, docs. 36, 37). In the third quarter of the fifteenth century the earlier *Marzocco* was set on a base later occupied by Donatello's lion. This was, until the publication of Kauffmann's book, sometimes ascribed to Donatello.

9. *ABRAHAM AND ISAAC*. Museo dell'Opera del Duomo, Florence. Marble, H. 168 cm, W. 56 cm, D. 45 cm (H. 66 in., W. 22 in., D. 18 in.). The group, like its companion figures, is much weathered; it has the same blotchy surface as the two earlier Prophets. The right foot of Isaac, which protruded from the niche, is heavily abraded, and the tip of the nose of Abraham is damaged. The diverse judgments passed on the two figures should be read with its condition constantly in mind. The Isaac is substantially by Nanni di Bartolo, and the strongest section is the right arm and wrist of Abraham, which must have been executed by Donatello. For a summary of the diverse qualitative judgments passed on the group see especially Becherucci, *Il Museo dell'Opera del Duomo a Firenze*, vol. 1, Florence, n.d., no. 127. The commission dates from March 10, 1421 (Poggi, no. 245), and was accepted by Nanni di Bartolo "absente dicto Donato." Interim payments were made in May and August 1421 (Poggi, nos. 248, 249: "unius figure prophete cum uno puero nudo ad pedes"), and the balance of the 125 gold florins due for it was paid to both sculptors on November 6, 1421 (Poggi, no. 251).

10. *JONAH* (?) (so-called *JOHN THE BAPTIST*). Museo dell'Opera del Duomo, Flor-

ence. Marble, H. 207 cm, W. 63 cm, D. 44 cm (H. 81½ in., W. 25 in., D. 17⅜ in.). On the base is a later inscription with the name DONATELLO and on the cartellino are the words ECCE AGNVS DEI. The statue, which occupied the easternmost niche on the north face of the Campanile before its transfer to the west face, is among the most weathered of the Campanile statues. The head is carved separately. This figure, the most problematical of the Campanile statues and the least well preserved (it is discolored by an effort at consolidation made after its removal from the Campanile), is fully carved behind and seems originally to have been destined for the façade of the Cathedral and transferred to the Campanile in 1464. Its attribution to Donatello is accepted by Becherucci (op. cit., pp. 270–72), who gives a careful account of the theories that have been woven around it. The stance of the figure recalls that of the *St. George*, and it was perhaps produced from a design by Donatello. Its unruly hair seems to have been more boldly carved than that of Rosso's *Obadiah* and is very possibly the work of Donatello. Donatello's authorship is categorically rejected by Lányi in *Rivista d'Arte*, vol. 17, 1935, pp. 254f.) and Janson (pp. 228–31), who finds it "neither necessary nor desirable to credit Donatello with any part of the 'St. John.'" In the present state of the figure, it is difficult to form any firm view of its quality, but it may be identical with a figure commissioned from Nanni di Bartolo on July 12, 1419, which is referred to again in an entry at the end of the same month. On August 2, 1419, the sculptor was authorized "facere et intagliare figuram sibi locatam pro opere in duobus petiis marmoris, videlicet in uno petio caput cum collo et in alio petio residuum." By March 1420 the figure was complete (Poggi, no. 240).

11. Poggi, no. 265: "1423, Settembre 28. Item (consules artis lana una simul cum operariis opere) deliberaverunt atque anullaverunt omnes et quascunque locationes factas de quibuscunque figuris de scoltura que vel quas non essent seu essent incepte vel principiate."

12. The date of the commission is not recorded. For the progress of work see Poggi, no. 260 ("1423, Marzo 9. Donatello Nicholai Betti Bardi, pro parte denariorum super certa fighura quam ipse ad presens laborat marmi albi pro mictendo in campanile, in totum fl. au. xx"); no. 263 (a further interim payment of twenty-five florins); no. 272 (a further interim payment of eighteen florins); nos. 279, 280. The penultimate document provides for the valuation of the figure by "Lippus pittor habitator in via que dicitur Gualfonda, Niccola Niccolai de Aretio aurifex et Andreas Nofri lastraiuolus." The final document contains the valuation of the asses-

sors at the customary price of ninety-five florins, subject to deduction of the interim payments.

13. Poggi, no. 284 (interim payment of twenty-five florins "per una fighura fane di quelle ch'anno a stare nel champanile").

14. Poggi, no. 316 (payment of twenty-two florins). The identity of the statue of Habakkuk is noted in two concluding payments of June 15, 1435 (Poggi, no. 322, interim payment of ten florins), and January 11, 1436 (Poggi, no. 323, final valuation of ninety florins and payment of the balance of twenty-one florins). The marble block from which the statue is carved seems to have been purchased by Donatello, who, at the end of January 1436, was reimbursed for its purchase price (Poggi, no. 324). This unusual procedure and the slow progress of work on the statue seem to have resulted from the suspension of activity on the Cathedral sculptures for a three-year period in March 1428 (Poggi, no. 293).

15. The sequence in which the two final Prophets were carved is of fundamental importance for an understanding of Donatello's statuary. Since one Prophet is inscribed on its scroll with the name GEMIA (Jeremiah), it was rightly inferred by Poggi (p. lx) and Lányi (loc. cit.) that the companion figure known as the *Zuccone* must be the *Habakkuk*. This sequence is rejected on stylistic grounds by Kauffmann (*Donatello*, Berlin, 1935, p. 26) and Janson (p. 39). The *Jeremiah*, on the analogies between its dress and the cope of the *St. Louis of Toulouse*, must be the earlier figure of the two, the later figure being the Zuccone or Habakkuk (which is mentioned in the *catasto* return of Michelozzo in 1427).

16. *JEREMIAH*. Museo dell'Opera del Duomo, Florence. Marble, H. 191 cm, W. 45 cm, D. 45 cm (H. 75 in., W. 18 in., D. 18 in.). On the *cartellino* held in the left hand is the name GEMIA (Jeremiah), and on the base is the inscription OPVS DONATELLI. The eroded condition and discolored surface are those common to the other Campanile Prophets. The preservative coating applied to the figure has been in part removed on the hair and face. For the documentation see note 12, above. The head is compared by Nicholson (loc. cit), not inappositely, to a head of Galienus in the Museo Nazionale delle Terme. The beard, however, is incised and does not protrude from the surface of the jaw. The treatment of the area above the upper lip is less schematic than in the *Beardless Prophet*. The antithesis established between the naked body and right arm and the heavy cloak reflects the modeling style of the *St. Louis of Toulouse*. Greenhalgh (op. cit., p. 68) discusses the cloak in relation to the classical toga, himation, and pal-

lium, and observes that the figure wears "a close approximation to the toga." There is no reason why any Prophet should be shown wearing a toga, and this form of analysis is irrelevant. The stance and cloak are alike free inventions in the style of the antique.

17. *HABAKKUK.* Museo dell'Opera del Duomo, Florence. Marble, H. 195 cm, W. 54 cm, D. 38 cm (H. 77 in., W. 21¼ in., D. 15 in.). The condition is comparable to that of the other Prophets from the Campanile. The carving of the head and of the sparse hair over the ears seems originally to have been more delicate than in the *Beardless Prophet* or the *Jeremiah*, and much of the surface working has been abraded or effaced. The form of the skull leaves little doubt that a life model was employed. The right hand inserted in the strap of the cloak is more complex than comparable details in the earlier Prophets. Over and above the records of payments in the Archivio dell'Opera del Duomo, the figure is almost certainly identical with a statue listed in 1427 in the *catasto* return of Michelozzo ("Una figura di marmo di braccia 3¹/₃ per S.M. di fiore, che fornita ³/₄, pagano a stima—fior. 90 in 100, abiamo auti fior. 100. Abiamo auti in conto fi. trentasette, cioe 37 d'oro in oro." This is mistakenly referred by Caplow (*Michelozzo*, New York and London, vol. 1, 1977, p. 393) to the *Jeremiah*. Comparison with the standing figures carved by Michelozzo for the Aragazzi monument at Montepulciano proves the incompatibility of the carving of the body and cloak of the *Zuccone* with Michelozzo's autograph works. The name "Zuccone" appears for the first time ca. 1550 in Gelli, and is employed again in 1550 by Vasari (*Vite*, ed. cit., vol. 3, p. 209), who records that at that time it was "tenuta cosa rarissima e bella quanto nessuna che facesse mai."

A number of third-century precedents for the portrait head and a careful examination of classical parallels for the cloak are supplied by Greenhalgh (op. cit., pp. 70–72), who argues that "Donatello is seeking a new kind of interpretation of prophecy based on reinterpretation of the antique, and not attempting to develop a 'realistic' style of art."

CHAPTER IV

1. Donatello's first *catasto* return, written by Michelozzo ("Io michelozo di bartolomeo a fatta q(u)esta scritte di volũta di detto donato") was published by Gaye (*Carteggio inedito d'artisti dei secoli XIV, XV, XVI*, Florence, 1839, vol. 1, pp. 120–22) and in a more precise form by R.G. Mather ("Donatello debitore oltre la tomba," in *Rivista d'Arte*, vol. 19, 1937, pp. 181–92):

Denunzia de' beni di Donatello agli Uffiziali del Catasto. Da Firenze 1427. Donato di Nicholo di betto, intagliatore, prestanziato nel quartiere di Sco. Spirito, gonfalone nichio, in fior. 1, s. 10, den. 2. Sanza niuna sustanzie, eccietto un pocho di maserizie p(er) mio uso e della mia famiglia. E piu es(er)cito la detta arte isieme e a copagnia co Michellozzo di bartolommeo sanza niuno chorpo salvo 30 in più ferameti et maserizie p(er) detta arte. E di detta compagni e botegha tralgho quelle sustanzie e quel modo. E per la scritta della sustanzia di Michelozzo sop(r)adetto appare nel quartiere di So. G. dragho, che dice i lionardo di bartolomeo di gherardo e frategli. Eppiu o avere dall'op(er)aio di duomo di Siena fj 180 p(er) chagioe duna storia ʃottone che feci più tepo fa. Epiu dal covento e fratj dognisanti o avere p(er) chagione duna mezza fighura di bronzo di so rossore della q(u)ale no se fatto merchato niuno chredo restare avere più che fj. 30. truovomi cõ questa familia in chasa:

Donato di nicholo di Betto deta an 41
Ma. Orsa mia madre detta dannj 80
Ma. tita mia sorochia vedova sanza date dannj 45
Giuliano Figliuolo di detta Ma. tita atratto deta danni 18
Sto a pigione in Iachasa di gugliemo adimari, posta nel chorso degli adimarj e nel poplo di sõ. Christofano paghone fior. 14 l'anno.

The appended list of Creditori reads as follows:

A mo lachopo di mo piero ĩtagliatore da Siena p[er] chagione di q[u]ella storia p(er) lop[er]a di Siena come disotto appare fi quarãtotto fj.48
A Giovanni Turinj horafor dassiena p[er] più tempo havuto ĩ detta storia fj. 10
A lop[er]a di duomo di Siena fj. vẽti cinq[ue] per dorare detta storiacon [?] sua richiesta fj. 25
A San Mãxtellini fj trẽ cinque come pel libro suo appare fj. 35
A ghuglielmo adinarmi fj trenta sono p[er] pigione di due anni passati dela chasa i che abito fj. 30
A giovanni diachopo degli strozzi f. q(u)indici sono p(er) chagione duna fighura di so. rossore mi gitto più volte alfornello e altre cose fj. 15
A più p[er]sone p[er] più chagioni ĩ pichole some f. q[ui]ndici fj. 15
A debito col comune di Firenze de p[re]stanzioni vecchi da ¹/₁₀e uno al ¹/₂₄ e tuttj e prestanzioni nuovi fj. 1.

From Michelozzo's tax return of the same date and month (for which see R. G. Mather, "New documents on Michelozzo," in *Art Bulletin*, vol. 24, 1942, pp. 226–31), which corroborates much of the material in Donatello's, we learn that he and Donatello owned a mule, "una mulatta," purchased for ten florins "per ci conviene andare per bisogno intorno spesso." Donatello's claim for exemption on behalf of his sister-in-law and nephew was disallowed, and he was taxed at s. 8 d'oro.

2. *SAN ROSSORE.* Museo Nazionale di San Matteo, Pisa. Gilt bronze, with silver-plated eyes, H. 56 cm, W. 60.5 cm (H. 22 in., W. 24 in.). The top of the head is hinged to give access to the head of the Saint, which was originally contained in the reliquary. It is sometimes claimed that the collar is of later date. If this were so, it would replace an earlier collar. The relic of the head of the Sardinian saint, San Rossore, who was decapitated under Diocletian, was acquired by the Ognissanti in Florence in 1422. In the third quarter of the sixteenth century the bust was transferred, with the community of Umiliati of the Ognissanti, to Santa Caterina degli Abbandonati. In 1571 Santa Caterina was taken over by the Knights of St. Stephen, and in 1591, when the church again changed hands, the relic of San Rossore was transferred to the church of St. Stefano dei Cavalieri at Pisa, whence the reliquary was moved in 1946 to the Museo di San Matteo at Pisa. The first formal publication of the bust is due to Fontana, *Un'opera di Donatello esistente nella Chiesa dei Cavalieri di Santo Stefano di Pisa*, Pisa, 1895. A *terminus post quem* for the bust is provided by the date of the transfer of the relic to the Ognissanti (1422) and a *terminus ante quem* by a reference in Donatello's *catasto* return of July 12, 1427, recording a sum of thirty florins due for the bust ("una mezza figura di bronzo di San Rossore della quale s'e fatto mercato niuno credo restare avere più che fl. 30"). A second reference to the bust occurs in the same tax declaration, where Donatello records a debt of fl. 15 to the bronze caster Giovanni di Jacopo degli Strozzi "per chagione d'una figura di S. Rossore mi gitto piu volte al fornello e altre cose." The term "piu volte" can signify either that the bust was cast several times or that the head, the lid at the crown of the head, the collar, and the sections of the base were cast separately. The *catasto* return of Giovanni di Jacopo Strozzi (A.S.F., Catasto 77, c. 87, for the reading and transcription of which I am indebted to R. Bagemihl) lists the sum due from Donatello ("Donatello intagliatore fl. quindici"), but contains nothing that might explain the words "altre cose" in Donatello's return. Since the bust is not mentioned in the joint tax return of Donatello and Michelozzo, it is likely to have been completed before the two sculptors entered into partnership, and it cannot, therefore, be assumed that Michelozzo had any share in it. The shop run by Giovanni di Jacopo Strozzi and his two brothers was established near the church of San Miniato fra le torri, and seems to have specialized in fire gilding. At the Ognissanti, the bust stood on a lateral altar dedicated to the Saint and decorated with a fresco of San Rossore (lost), perhaps dating from the same time. The Saint is shown in armor, and the corselet is covered on the left shoulder with a cloak, part of which extends over the right

shoulder, leaving the armor on the upper arm exposed. A brilliant account of the problems arising from the bust is presented by Lànyi ("Problemi della Critica Donatelliana," in *La Critica d'Arte*, fasc. 19, 1939, pp. 9–23). The problem posed by the head, which has all the character of modeling from the life, is discussed by Lányi (loc. cit.), Lavin ("On the Sources and Meaning of the Renaissance Portrait Bust," in *Art Quarterly*, vol. 33, 1970, pp. 207–26), and Moskowitz ("Donatello's Reliquary Bust of San Rossore," in *Art Bulletin*, vol. 63, 1981, pp. 41–48). There are some parallels with Uccello's portrait of Donatello in the Louvre, but there is no reason, given the liturgical function of the bust, to suppose that it was intended either as a portrait or as a self-portrait.

3. A clear account of the legal status of artistic partnerships and of the rules by which they were governed is given by Caplow ("Sculptors' Partnerships in Michelozzo's Florence," in *Studies in the Renaissance*, vol. 21, 1974, pp. 145–75).

4. Krautheimer, *Lorenzo Ghiberti*, Princeton, 1970, vol. 2, p. 399, Doc. 155. The legal difficulties resulting from Michelozzo's rupture with Ghiberti were not resolved till April 1426 when they were referred to an unnamed third party (A.S.F., Notarile antcosmiano 1501, Niccolò Diedi, c. 00).

5. *MONUMENT OF CARDINAL BAL-DASSARE COSCIA*. Baptistry, Florence. Marble with gilt bronze effigy, H. 732 cm (288 in.). Base: H. 38 cm, W. 228 cm (H. 15 in., W. 90 in.). Base with garlands: H. 55 cm, W. 231 cm (H. 21⅝ in., W. 91 in.). Figurated area: H. 139 cm, W. 202 cm (H. 55 in., W. 79½ in.). Sarcophagus: H. 70 cm, W. 213 cm (H. 27½ in., W. 84 in.). Effigy: L. 191 cm (75 in.). Section with shell niche and relief: H. 135 cm, W. 236 cm (H. 53 in., W. 93 in.). Inscribed on a scroll on the sarcophagus:

IOAÑESQVÕDAMPAPA
XXIII OBIITFLORENTIEA
NÕDNIMCCCCXVIIIIXI
KALENDASIANVARII

Between the consoles under the sarcophagus are the arms of Coscia with papal insignia (*left*), the papal arms (*center*), and the arms of Coscia surmounted with the insignia of a Cardinal (*right*). Coscia died on December 22, 1419. The claim that the marble carvings on the tomb were colored is incorrect (for this see Lightbown, *Donatello and Michelozzo*, vol. 1, London, 1980, pp. 30–31), save for the bier, which is painted red, the pall and pillow, which are blue, and the shields of arms, which are likely to have been colored heraldically. From the first, therefore, emphasis was designed to rest on the gilt-bronze effigy. There is no record of the date at

which work on the tomb was begun. It is argued by Lightbown (op. cit., p. 35) that its architectural scheme precedes the Parte Guelfa tabernacle. A good analysis of the architectural scheme is provided by Lisner ("Zur frühen Bildhauerarchitektur Donatellos," in *Münchner Jahrbuch der bildenden Kunst*, vols. 9–10, 1958–59, pp. 72–127). The bulk of the work seems to have been carried out after January 1, 1425, and the monument is mentioned in Michelozzo's *catasto* return of 1427: "Una sepoltura per in Sco. Giovanni di firenze per messer Baldassare Coscia, cardinale di firenze; abiamo avere a farla a tutte nostre spese fior. 800, de' quali abiamo avuti fior. 600—e anchora non e finita, e pero non posciamo arbitrare incircha, se resti la chosa da patto."

To judge from the carved sections of the monument, some importance seems to have been attached to speed of execution. The half-length Virgin and Child above the effigy is seemingly the work of Michelozzo. The putti on the tomb chest are by two separate hands, of which one, responsible for the left-hand putti, is the sculptor of the spandrel reliefs on the Parte Guelfa tabernacle. The figures of Virtues at the base were carved by two separate hands, one responsible for the Faith and Hope and the other for the Charity; the first of these hands may be Michelozzo's. The lion supports of the bier are likewise by two different hands, of which one, responsible for the left-hand lion, is strongly Donatellesque. The effigy, cushion, and bier cloth are due to Donatello. The cost of gilding would have far exceeded the cost of the effigy itself. There is no reference to the effigy or its gilding in the 1427 *catasto* return of Giovanni di Jacopo Strozzi, who was responsible for the casting and gilding of the San Rossore, and it is likely that the casting of the figure was undertaken by Michelozzo and the gilding entrusted to a firm specializing in this class of work. The highly innovative scheme of the monument exercised great influence. There is no means of determining whether its architecture was due to Michelozzo or to Donatello, but the part played in it by Donatello seems to have been preponderant.

6. The Orvieto commission dates from February 10, 1423 (Fumi, *Il Duomo di Orvieto*, Rome, 1891, p. 331, and Herzner, no. 72).

7. A good account of work on the Siena Baptismal Font is provided by E. Carli (*Donatello a Siena*, Rome, 1967).

8. *PRESENTATION OF THE BAPTIST'S HEAD TO HEROD*. Baptistry, Siena. Gilt bronze, H. 60 cm, W. 60 cm (H. 23⅝ in., W. 23⅝ in.). The scattered documents relating to the relief (for the date of which, see p. 33) are

assembled in a reliable fashion by Paoletti (*The Siena Baptistry Font*, New York, 1979, passim.). The geometrical structure of the relief has been the subject of discordant views (for a summary of these see Paoletti, pp. 169–70). White ("Developments in Renaissance Perspective II," in *Journal of the Warburg and Courtauld Institutes*, vol. 14, 1951, pp. 45–48, summarized in White, *The Birth and Rebirth of Pictorial Space*, London, 1957, pp. 149–51) points out correctly that there is, in a narrow geometrical sense, no single vanishing point. Janson (p. 69) inferred that this was due to faulty casting. It has also been claimed that the scheme involves the use of two vanishing points. Discussion on these lines is theoretical, in so far as the focus of Donatello's interest was not a Brunelleschan norm, but an approximate vanishing point, which would deceive the eye of the spectator but would not be defensible through logical analysis. Given the depth of the relief, true single-point perspective, of the type used in the predella panels of Domenico Veneziano, would have been unattainable. In the cases in which it is rigorously employed (e.g. by Ghiberti in the *Story of Jacob and Esau* on the Porta del Paradiso) it invalidates the relief as narrative. No less problematical is the relationship of the scene to the antique. Greenhalgh (op. cit.) suggests that "frescoes possibly in the Pompeian Fourth Style provided the basic impulse towards the construction of a series of half-hidden but intriguing spaces, peopled with the necessary actors" and relates its rough wall surfaces to "masonry which had lost its suave marble or stucco facing." Analogies, though not specific sources, for the Salome occur in Tanagra figurines and in Aretine ware. The two male heads in the middle ground on the left and the profile of the server holding a platter with the head seem to depend from Roman coins.

An interesting, speculative account of the architecture is supplied by Morolli (*Donatello: Immagini di Architettura*, Florence, 1987, p. 31).

9. *FAITH*. Baptistry, Siena. Gilt bronze, H. 52 cm (20½ in.). *HOPE*. Baptistry, Siena. Gilt bronze, H. 52 cm (20½ in.).

On May 9, 1427, in a letter (Herzner, *Regesti*, no. 97) to the Opera del Duomo at Siena, Donatello and Michelozzo refer to two statuettes that had been commissioned for the tabernacles between the reliefs on the Siena front, and inquire which Virtues they are to represent. Payment of L. 160 for the two gilt-bronze figures was made on October 26, 1428 (Herzner, *Regesti*, no. 107). The Virtues were modeled and cast in Florence (presumably under the eye of Michelozzo) and seem to have been delivered already gilt. For Janson (p. 72) the two figures "display a lyricism of feeling and an ideality of form such as Donatello had never achieved be-

fore" and reflect the influence of Ghiberti. Among the innovative features of the *Faith* are the right foot, which protrudes across the base, and the right hand, which is extended as though toward the adjacent relief. The siting of the *Hope* in its tabernacle has given rise to the suggestion that the figure was originally set differently. With hands raised and head upturned, it is planned to be seen from above like Donatello's narrative relief.

10. *DANCING PUTTO.* Baptistry, Siena. *PUTTO WITH TRUMPET.* Baptistry, Siena. *PUTTO WITH TAMBOURINE.* Staatliche Museen, Berlin. Bronze, H. 36 cm (14 in.). A further Putto, in the Museo Nazionale, Florence, which appears to have been substituted for a lost or damaged figure on the font in the third quarter of the fifteenth century, was at one time also ascribed to Donatello. The three authentic Putti seem to have been modeled in Siena in the course of 1429, since Donatello received from the Operaio of the Cathedral on April 16 "libbre 12 di cera . . . per fare le forme di cierti fanciulini ignudi" for the Baptismal Font (Herzner, *Regesti*, no. 113). He was still in Siena at the end of the month, when he acted as godfather to the daughter of a goldsmith, Tomaso di Paolo di Vannuccio, and received the sum of L. 38 for the purchase of gold. The Putti, therefore, unlike the two gilt-bronze Virtues, were modeled and cast in Siena. In pose and type, all three figures mark a striking advance on the putti on the crozier of *St. Louis of Toulouse.* While they were evidently inspired by classical bronze statuettes, no exact prototype has been established. The contrapposto of the three figures is personal to Donatello, as is the sense of insecurity established by the shells on which they stand. Janson (p. 93) relates them to figures on the handles of Etruscan vessels. Given their highly individual, wholly quattrocento character, the search for precedents is futile. The figures explore the principle of ponderation in whatever Roman statuettes may have been locally available. The dimensions of the rejected tabernacle door can be established, from the aperture in the marble surround and from the bronze replacement relief, as approximately 40 × 20 cm (16 × 8 in.). In the final settlement with the Opera del Duomo Donatello proved to have been paid L. 18 s. 11 more than the sum of L. 720 due to him, and this was set off against the cost of the rejected tabernacle door (Herzner, *Regesti*, no. 173).

11. *TOMB SLAB OF GIOVANNI PECCI, BISHOP OF GROSSETO.* Duomo, Siena. Bronze, L. 247 cm, W. 88 cm (L. 97¼ in., W. 34⅝ in.). Inscribed beneath the base of the effigy OPVS DONATELLI and, on a protruding *cartellino* beneath unrolled by two putti:

REVEREN. DŇO. D.IOHANNI
PECCIO. SENEŇ. APOSTO
LICO. PROTONOTARIO. EPŎ.
GROSSETANO. OBEVNTI.
Kĺ. MARTII. MCCCCXXVI.

The stemmi at the ends of the scroll, each surmounted by a miter, seem to have been enameled. The decoration of the miter was treated in the same way. Janson (p. 75) writes that "the slab, cast in three separate pieces, is presumably still in its original location." This is doubtful. From material assembled by Lusini (*Il Duomo di Siena*, Siena, 1939, pp. 75–76) it transpires that the original Pecci chapel was dedicated to St. James and was on the north side of the Cathedral adjacent to the chapel of St. Sebastian. An attempt was made by the Bishop's brother, Jacopo di Marco Pecci, to secure, in place of this chapel, the more prominent chapel of Saint'-Ansano. After Jacopo Pecci's death (1429), this plan was pursued by his brother Pietro. The earliest reference to the tomb slab occurs in December 1453, when orders were given that in the new chapel "la tavola di bronzo della sepoltura del r. p. misser Giovanni Pecci vescovo di Grosseto ripongasi in duomo dove fu seppelito il suo corpo, con un pezzetto di marmo all'intorno." The word "ripongasi" suggests that the slab has been laid down elsewhere, presumably in the earlier Pecci chapel. There is no reference to the bronze slab in the joint *catasto* return of Donatello and Michelozzo, and it is likely for this reason, as well as on grounds of style, that the commission dates from after 1434.

12. For the Dati tomb slab see Krautheimer (op. cit., vol. 1, pp. 147–48).

13. *MONUMENT OF CARDINAL RAINALDO BRANCACCI.* Sant'Angelo a Nilo, Naples. Marble, H. 907 cm, W. 387 cm (H. 357 in., W. 152⅜ in.), Caryatid figures H. 170 cm (67 in.). The inscription above the effigy seems to date from 1605. An exhaustive account of the historical background of the monument is given by Lightbown (*Donatello and Michelozzo*, vol. 1, 1980, pp. 51–127). It is generally agreed that the architecture of the monument is due to Michelozzo, not Donatello. The scheme is described by Janson, mistakenly, as "far closer to such precedents as the Orsi tomb by Tino di Camaino . . . or the Pazzi Tomb by Alberto di Arnoldo (S. Croce) than to the traditional Neapolitan type." Lightbown offers convincing reasons for supposing that the scheme was more closely supervised by Brancacci and his executors (one of whom was Giovanni di Bicci de' Medici) than had previously been supposed. The settlement of Brancacci's estate (according to Lightbown) was administered by Cosimo de' Medici and Bartolomeo de' Bardi. The

monument itself was carved at Pisa, in a studio rented by Donatello and Michelozzo from Barolomeo di Gaspare da Lavriano adjacent to the church of San Sepolcro, the lease of which was negotiated through the bank of Andrea de' Bardi. An advance of 188 florins to Donatello and Michelozzo "per una sepultura del Cardinale Branchacci" is recorded in the *catasto* return of Cosimo and Lorenzo de' Medici in the summer of 1427. The 1427 *catasto* return of Michelozzo lists, under works in progress, "Una sepoltura per napoli di messer Rinaldo, cardinale di Branchacci di napoli, dobiamo avere fior. 850 di camera; e a tute nostre spese labiamo a conpiere e condurre a napoli, lavoriamolla a pisa." The monument may have been erected by July 1428, when the chapel for which it was destined was ceded to the Seggio di Nido. In S. Angelo a Nilo it seems originally to have stood behind the high altar of the church, and was moved to its present position in 1565 (Lightbown). Owing to lack of funds, much of the figure sculpture was dispatched to Naples in an unfinished state. The attribution of the figurative carvings on the monument is problematical (for a careful, but not wholly convincing, analysis see V. Martinelli, "La 'compagnia' di Donatello e di Michelozzo e la sepoltura del Brancacci a Napoli," in *Commentari*, vol. 14, 1963, pp. 211–26, and Martinelli, "Per una rilettura del monumento Brancacci," in *Napoli Nobilissima*, n.s., vol. 4, 1964, pp. 3–11). The strongest figures are the three Virtues supporting the sarcophagus, which seem to have been executed by Michelozzo possibly from models by Donatello. The two Angels behind the sarcophagus are of lower quality, but the Virgin and Child in the lunette, shown with open hand directing the Child's attention to the effigy, appears to have been planned and may indeed have been roughed out in marble by Donatello.

CHAPTER V

1. The prime sources for the documentation of the Prato pulpit are C. Guasti, *Il pergamo di Donatello nel Duomo di Prato*, Florence, 1887; M. Lisner, "Zur frühen Bildhauerarchitektur Donatellos," in *Münchner Jahrbuch der bildenden Kunst*, dritte folge, vols. 9–10, 1958–59, pp. 72–127; G. Marchini, *Il Tesoro del Duomo di Prato*, 1963; and F. Guerrieri, *Donatello e Michelozzo nel Pulpito di Prato*, Florence, 1970 (with photographs of the reliefs made in 1942–44, when they were removed for protective purposes, and in 1968, when they were finally removed from the pulpit and transferred to the Museo dell'Opera del Duomo). The documents referred to in the text of this book are reproduced or summarized by Herzner (*Regesti*, nos. 103 ff.).

2. *EXTERNAL PULPIT* Duomo, Prato. Marble with bronze capital. For overall dimensions see Guerrieri, op. cit., figs. 5–9. The figurated reliefs have gold mosaic backgrounds (H. 73.5 cm, W. 79 cm–82 cm [H. 29 in., W. 31–32¼ in.]). Casts of two of the reliefs, that in the center and that to its left, made in 1878, afford some impression of the state of the marble surface at that time. Six early casts from the reliefs are known; two are now in the Wallace Collection, London; two in the Fondazione Horne, Florence; one in the Rijksmuseum, Amsterdam, and one formerly in a Berlin collection (1929). Two of these reproduce the central relief and the others the three reliefs to its right. The casts show no trace of the mosaic background and are flat, not convex. It is inferred from this by Marchini ("Calchi Donatelliani," in *Festschrift für Klaus Lankheit*, Cologne, 1973, pp. 132–33) that they were made before the marble reliefs were installed in the pulpit. It is also possible that they reproduce models by Donatello like those shown in two drawings ascribed to Pisanello that seem to have been made before the reliefs assumed their final convex form. The source of inspiration for the figure carvings is Roman sarcophagi of the type of the sarcophagus with putti playing athletic games in the Uffizi, where the putti are grouped as four units linked in a continuous horizontal scheme. In the Prato pulpit the concept of linkage is maintained, and the putti dance in a space determined at the back by the gilt background and the upper molding, and at the front by paired pilasters that sever their legs or wings. Each of the seven groups of figures is, however, self-consistent. The two panels on the extreme right are more confused in design and somewhat weaker in execution than the remaining scenes. The three central panels are also superior to the two panels on the left. The method of production seems to have involved the preparation of autograph models that were blocked out in marble by assistants and then, to a greater or lesser extent, worked up by Donatello, whose participation is greatest in the three central reliefs. Only with the last panel on the right, where the types of the children are coarser and their movement heavier, does the possibility arise of a model made by some other hand than Donatello's. The source of the classical motifs in the architecture of the pulpit is discussed by Janson ("Donatello and the Antique," in *Donatello e il suo Tempo*, Florence, 1967, pp. 79–82), and Greenhalgh (*Donatello and His Sources*, London, 1982, pp. 109–12).

3. The height of the capital, which is confined to the west face of the support and a narrow section on the north face adjacent to it, is approximately 90 cm (35½ in.). In 1550 Vasari (*Vite*, ed. cit., vol. 3, p. 213–14) explained the absence of the capital on the south face by the story that the second face was removed by Spanish troops ("Di più fece per reggimento di detta opera due capitelli di bronzo, uno dei quali vi è ancora, e l'altro dagli Spagnuoli, che quella terra misero a sacco, fu portrata via"). Prato was sacked by Spanish troops in 1512, and Vasari's account, written no more than thirty-eight years after this event, is likely to be correct. It is, however, challenged by Janson (p. 114): "Who mutilated the capital and thus made the present 'wrong' installation necessary? No marauding Spaniards obviously. There must have been an accident, probably in the casting of the piece, or perhaps in the chasing, which damaged that side." Janson argues that the present capital was originally planned for the south face. This case is implausible. A document of 1553 authorizes negotiations for the completion or replacement of the present capital.

4. The drawings are respectively in the Ambrosiana in Milan (F. 214 inf., no. 13) and the Kupferstichkabinett, Berlin (no. 1358). For both see Annegrit Schmitt, *Disegni di Pisanello e di maestri del suo tempo*, Venice, 1966, nos. 9, 16). The first shows the scene to left of center in a perspective box, which is unrelated to the space in the relief. It is projected from a higher viewing point than the marble, from which it differs in the more rudimentary handling of the drapery, in the alignment of the feet, and certain other details. The second copies the left half of the central relief. Here the space relationship of the two left-hand figures is significantly modified.

5. The document is published by Marchini, op. cit., 1963, p. 111, no. 85, and summarized by Herzner, *Regesti*, no. 350.

6. For the genesis, history, and style of Luca della Robbia's Cantoria see Pope-Hennessy, *Luca della Robbia*, Oxford, 1980, pp. 19–29.

7. Poggi, no. 1286.

8. *CANTORIA*. Museo dell'Opera del Duomo, Florence. Marble (with local pigmentation, Cosmatesque inlay in the architectural elements, and gold mosaic inlay in the background of the figurated reliefs). For dimensions see text, p. 104. Payments for the Cantoria run from July 10, 1433, to January 12, 1440, when it had already been installed over the door of the south sacristy. For the commission see Poggi no. 1287, and for interim payments Poggi, no. 1288 (November 19, 1433)–no. 1314 ("1440, Febbraio 5: A Donato di Nicholo di Betto Bardi, intagliatore, fior. C d'oro per parte di paghamento del perghamo a fatto e posto nella chiesa maggiore di Firenze, stanziati per gl'operai insino a di 12 di Gennaio 1439/40"). The value of the Cantoria was assessed on February 23, 1446, six years after its completion, at 896 florins. For the document see Poggi, no. 1315: "Item operarii, intellecto qualiter Donatus Nicolai Betto Bardi, intagliator, fecit et composuit unum pergamum super ianuam secunde sacrestie et habito super predictis colloquio cum intelligentibus de predictis intelligentibus deliberaverunt et declaraverunt quod provisor ponat Donatum predictum creditorem de fl. au. DCCCLXXXXVI, computando omne magisterium materiam tam marmi quam bronzi et omne compensum in predictis spiritellis et duas testas factas et postias et diebus factis usque i presentem diem." An assurance was given to "Cosimo de Medici et sociis" that the shortfall between the total value and the sums paid to Donatello in course of its execution would be settled within six months of the date of casting of the bronze door commissioned from Donatello for the sacristy. This stipulation was due to the fact that Donatello, though under contract to the Opera, had moved in 1443 to Padua.

For the classical sources for the architectural motifs throughout the Cantoria see especially Greenhalgh, op. cit., pp. 86–98.

The iconography of the Cantoria has been extensively discussed. Luca della Robbia's Cantoria contains an inscription from Psalm 150. On Donatello's Cantoria there is no such inscription. The probability, therefore, is that the same psalm is illustrated. From the early documents on Donatello's Cantoria (in which the frieze was to be constructed of individual panels like those employed by Luca della Robbia) it is evident that the two Cantorie were intended to be a true pair, and that this intention was disrupted only when a continuous frieze of dancing figures was substituted. There is no reason to believe that in its final form it was intended to be read (Janson, pp. 122–28) as two separate zones—that below pagan and that above Christian—nor (Spina Barelli, "Note iconografiche in margine alla Cantoria di Donatello," in *Storia dell'Arte*, nos. 15–16, 1972–74, pp. 283–91) that its imagery was inspired by Niccolò Niccoli and depends from the *De Voluptate* of Lorenzo Valla. It was planned on the commission of an official body for an orthodox Christian context, and its singularity is due to its figure style, not to its context or imagery.

9. The distinction between the relief styles of the two Cantorie is defined by Vasari (1568), *Vite*, ed. cit., vol. 3, pp. 51–52, in the following terms:

Se bene Donatello, che poi fece l'ornamento dell'altro organo che è dirimpetto a questo, fece il suo con molto più giudizio e practica che non aveva Luca, come si dira al luogo suo, per avere egli quell'opera condotta quasi tutta

in bozze e non finita pulitamente, acciò che apparisse di lontano assai meglio come fa, che quella di Luca; la quale se bene è fatto con buon disegno e diligenza, ella fa nondimeno con la sua pulitezza e finimento che l'occhio per la lontananza la perde e non la scorge bene come si fa quello di Donato, quasi solamente abbozzato.

The thinking behind this passage is elaborated in the life of Donatello (p. 207):

Fece ancora dentro la detta chiesa l'ornamento dell' organo che è sopra la porta della sagrestia vecchia, con quelle figure abbozzate, come si è detto, che a guardarle pare veramente che siano vive e si muovano. Onde di costui si può dire che tanto lavorasse con giudizio quanto con le mani, attesoche molte cose si lavorano e paiono belle nelle stanze dove son fatte, che poi cavate di quivi e messe in un altro luogo et ad un altro lume o più alto fanno varia veduta e riescono il contrario di quello che parevano, là dove Donato faceva le sue figure di maniera che nella stanza dove lavorava non apparivano la meta di quello che elle riuscivano migliori ne' luoghi dove ell'erano poste.

10. A document of October 12, 1439 (Poggi, no. 1312) records the casting of a bronze head for the Cantoria: "Deliberaverunt quod compresetetur Donato Nicholai Betti Bardi, intagliatori, libras 300 bronzi pro quadam texta que debet fieri in pergamo per eum facto ex parte posteriori in quadam bucha sive foramine subtus dictum perghamum, prout est una alia texta." The two bronze masks now built into the lowest register of the Cantoria were transferred from the Museo Nazionale to the Museo dell'Opera del Duomo and were identified by Corwegh as the heads to which this payment refers. The association was denied by Poggi and others, but is accepted by Janson (p. 124) on the ground that their size (H. 39 cm [15⅜ in.]) is well suited to the space they occupy (Diameter 63 cm [25 in.]) and that they were designed to be mounted against a vertical surface above eye level. Another bronze head in the Bargello was identified by Lányi as one of the two heads from the Cantoria. Lányi's case is almost certainly wrong, but there is no means of confirming the more plausible proposal of Janson. The document refers to two heads, one of which was antique, and to a companion mask made by Donatello. Whether or not the two masks are of different dates, it is clear that they differ markedly from one another, and it is conceivable that the left-hand mask was produced in Donatello's shop. Information is largely lacking as to the antiques available in Florence in the fourth decade of the century. Bagemihl, however, notes that Lodovico Trevisan, also known as Cardinal Scarampi or Mezzarota, later one of the great collectors of antiquity, became Archbishop of Florence in 1437, at a time when work on the Cantoria was well advanced.

11. The identity of the sculptors working in Donatello's studio on the Cantoria relief has been much discussed. No simple solution—like that of Bode, who gave the left half to Buggiano and the right half to Donatello—is permissible. The left half has also been ascribed (Lányi) to Michelozzo. From the known works of Buggiano it is inconceivable that he could have carved with the freedom and massive undercutting of the Cantoria putti. Michelozzo, on the other hand, might well have done so. What is involved is a problem less of connoisseurship than of the pattern of production in Donatello's shop. The two reliefs after the antique are markedly different in style from the main frieze; they were carved by weak assistants and seem from the first to have been intended to contrast with the liveliness and actuality of the frieze above. Attempts have been made to trace the deep undercutting of the main frieze back to Byzantine ivory carvings of the class of the Veroli Casket, but the notion that a small ivory carving was expanded to the scale of the Cantoria relief is inherently improbable. Not dissimilar figures playing with wreaths occur on an ivory casket in the Museo dell'Opera del Duomo at Pisa, with which Donatello was certainly familiar. The frieze can be understood only if we abandon the search for prototypes and concentrate instead on the many more important aspects of it that are original.

12. Poggi, no. 713.

13. Poggi, no. 717.

14. Poggi, no. 719: "Prefati operarii . . . actendentes ad duo disegna facta ad instantiam opere super uno quorum fieri debet oculus vitrei storie et actus incoronationis domini nostri Jesu Christi facti eius matri virgini Marie, videlicet unum per Donatum Niccolai et Laurentii Bartolucci ad quedam consilia habita a quampluribus intelligentibus et magistris videlicet sacre theologie et a pluribus pittoribus et magistris fenestrarum et oculorum vitrei de declarando et consulendo quale dictorum duorum designorum est pulcrius et honorabilis pro ecclesia et magnificentius tante ecclesie et intellecto per dicta consilia designum factum per dictum Donatum esse melius honorabilis et magnificentius designo facto per dictum Laurentium Bartoli, deliberaverunt quod secundum designum factum per dictum Donatum Niccolai oculus vitrei fiendus super oculo existenti super capellam s. Zenobii et qui est coram corpore ecclesie veteris fiat et fieri debeat et non secundum designum dicti Laurentii et non possit fieri dictus oculus cum aliquo alio designo nisi solum et dum taxat cum designo Donati Niccolai."

15. This document, which was published by

Semper, 1875, p. 283, no. 76, and later by Herzner, *Regesti*, no. 177, is ignored by Poggi. The record relates to a payment of eighteen florins "per uno disegno d'un occhio alla cappella di S. Zenobio e quali sono per lui (Donatello) e per Bernardo (di Francesco) e per Pagholo Uccello."

CHAPTER VI

1. Vasari, *Vite*, ed. cit., vol. 1, p. 95: "La terza spezie si chiamano bassi e stiacciati rilievi, i quali non hanno altro in se che'l disegno della figura con amaccato et stiacciato rilievo."

2. Pope-Hennessy, "The Interaction of Painting and Sculpture in Florence in the Fifteenth Century," in *Journal of the Royal Society of Arts*, vol. 117, 1969, pp. 406–24.

3. Vasari, *Vite*, ed. cit, vol. 1, loc. cit.

4. *BAPTISM OF CHRIST.* Duomo, Arezzo. Marble, H. 63.6 cm, W. 40.5 cm (H. 25 in., W. 16 in.). The relief is ascribed by Vasari (ed. cit., vol. 3, p. 247) to a supposed brother of Donatello named Simone: "Per lo battesimo similmente del Vescovado d'Arezzo lavorò, in alcune storie di basso rilievo, un Cristo battezzato da San Giovanni." This attribution is retained in the *Memorie istoriche per servire di guida al forestiero in Arezzo* (1819) and not till the ninth edition of Burckhardt's *Cicerone* was its relation to the work of Donatello noted by Bode and Fabriczy. It was first ascribed to Donatello by Schottmüller (in *Monatshefte für Kunstwissenschaft*, vol. 2, pp. 38–45), who supposed it to be a work executed in the 1420s. The relief was then ignored until it was republished (Pope-Hennessy, "Some Donatello Problems," in *Studies in the History of Art Dedicated to William E. Suida on His Eightieth Birthday*, London, 1959, pp. 47 ff.). This case is accepted, with strong supporting arguments, by A. Rosenauer (*Studien zum frühen Donatello*, Vienna, 1975, pp. 72–75): "Bei Donatello ist der prinzipielle Gegensatz von Figur und Grund, der bisher bestand aufgehoben. Nicht mehr die tastbaren, sondern die sichtbaren Qualitäten der Dinge bestimmen die Gestaltung, und machen es möglich, das Relief als Reliefbild, als Ausschnitt der Wirklichkeit aufzufassen."

5. *SAINT GEORGE AND THE DRAGON.* Museo Nazionale, Florence. Marble, H. 40 cm, W. 120 cm (H. 16 in., W. 47¼ in.). On the strength of documentation of the statue and niche on Or San Michele (for which see pp. 17–18), the relief can be dated to 1417–1418. When the statue of St. George was moved to the Museo Nazionale, the predella remained exposed, suffering considerable damage. It was removed and cleaned in 1976 and is now installed beneath the statue in the Museo

Nazionale. To judge from old photographs and from a fifteenth-century gesso cast in the Victoria and Albert Museum (no. 7606-1861), the relief was greatly blunted in the last century of its exposure. An excellent assessment of the critical history of the relief is provided by Gaeta Bertelà in *Omaggio a Donatello*, Florence, 1985, pp. 142–57. The relief and the related relief of God the Father in the gable of the tabernacle are described by Vasari (*Vite*, ed. cit., vol. 3, p. 208: "E nel basamento che regge il tabernacolo di quella, lavorò in marmo in basso rilievo quando egli amazza il serpente, ove e un cavallo molto stimato e molto lodato." Vasari's use of the term "mezzo rilievo" is significant in that the figures are strongly recessed and only the background is carved in *rilievo stiacciato*. The best account of the structure is that of White ("Developments in Renaissance Perspective II," in *Journal of the Warburg and Courtauld Institutes*, vol. 14, 1951, pp. 44–45), who notes the presence of faintly scratched orthogonals on the ceiling in front of the arches and behind the foremost arch on the left. The projection is not adjusted to the height at which the relief was set, and the intended viewing point is approximately one and a half times the width of the relief, that is 180 cm (71 in.). Janson (p. 30) observes, correctly, that the orthogonals of the squared floor and the side wall "run in the general direction of the main vanishing point. The entire building is not 'constructed' with ruler and compass but sketched freehand, so that it defies any test of accuracy in the mechanical sense." The figure of the Princess probably depends from a classical model in silver or Aretine ware, and the mounted Saint, shown without stirrups, seems to have been evolved from a classical sarcophagus.

6. *ASSUMPTION OF THE VIRGIN*. Sant'Angelo a Nilo, Naples. Marble, H. 53.5 cm, W. 78 cm (H. 21 in., W. 30¼ in.). For the date of execution of the Brancacci Monument see pp. 37–38 above. The exact date of Donatello's relief on the sarcophagus cannot be established, but it is likely to have been completed at Pisa, where the rest of the monument was carved, in 1426–27. Though the bulk of the figure carving on the monument is due to Michelozzo and assistants, there can be no reasonable doubt that the relief of the Assumption is an autograph work by Donatello. Donatello's presence at Pisa is recorded from April 6 until December 18, 1426. The scheme depends, with many variations, on the traditional Assumption iconography of Orcagna's relief in Or San Michele, where, however, the elderly Virgin is shown centrally, and the surrounding mandorla is represented. In the Brancacci *Assumption*, the Virgin's seat is represented perspectively, and

she is turned three-quarters to the right, while the mandorla is indicated by a depression in the space she occupies. The lateral figures of angels, represented as though swimming or diving with their arms raised above their bodies, have a number of parallels in Nereid sarcophagi, notably in a sarcophagus in the Vatican (K. Clark, *The Nude*, London, 1956, fig. 221). That the relief proceeds from knowledge of a number of Nereid sarcophagi is suggested by the torsion of the bodies, which have a parallel on a sarcophagus in Siena (Museo dell'Opera del Duomo) and on another in the Giardino della Pigna in the Vatican (Bober and Rubinstein, *Renaissance Artists and Antique Sculpture*, Oxford, 1986, nos. 99, 104). The Siena sarcophagus was available in the 1420s when Donatello was working in Siena. There are no classical precedents, however, for the linking of the figures, for the rendering of the sky, or for the rolling, cloud-filled surface of the relief. Not only does the relief avoid the sharp distinction between low and *stiacciato* relief present in the *St. George and the Dragon*, but its figures and the clouds that surround them are conceived in terms of *stiacciato* carving, which alone made such an image possible.

7. The altarpiece by Castagno (for which see Horster, *Andrea del Castagno*, Oxford, 1980, pp. 177–78) dates from 1449–50.

8. For the *Itinerario* of Abraham, Bishop of Souzdal, see A. d'Ancona, *Origini del teatro italiano*, Turin, 1891, vol. 1, p. 253), Kauffmann (pp. 69 ff.), and Pope-Hennessy (*Donatello's Relief of the Ascension*, London, 1949, p. 5, reprinted in *Essays on Italian Sculpture*, London, 1968, pp. 37–46).

9. *ASCENSION WITH CHRIST GIVING THE KEYS TO ST. PETER*. Victoria and Albert Museum, London. 7629-1861, Marble, H. 40.6 cm, W. 114.3 cm (H. 16 in., W. 45 in.). The relief is first recorded in an inventory of his possessions made after the death of Lorenzo de' Medici in 1492 ("uno quadro di marmo, chornicie di legn ame atorno, entrovi, di mezo rilievo, una Accensione di mano di Donato"). It passed, through the marriage of Lorenzo's daughter Lucrezia to Jacopo Salviati, to the Salviati family and is recorded in 1591 (Bocchi, *Le Bellezze della Città di Firenze*, Florence, 1591, pp. 185–86) in the Palazzo Salviati. The relief later formed part of the Museo Campana, for which it was acquired in Florence before 1859. For the association of the relief with the program of the Brancacci Chapel see pp. 56–58. It is argued mistakenly by Molho ("The Brancacci Chapel: Studies in its Iconography and History," in *Journal of the Warburg and Courtauld Institutes*, vol. 40, 1977, p. 53), that the relief "could

just as easily have been located in a Roman church," and that "the two principal biblical references used to support the claims of papal authority of the Church over the State" were omitted from the program of the frescoes because "the sponsors' and iconographer's intention was to avoid raising the enormously controversial question of the superiority of the Church over the State." Both contentions are unhistorical. The view that the relief was in some fashion connected with the tabernacle now in St. Peter's is also espoused by Morolli (*Donatello: Imaggini di Architettura*, Florence, 1987, p. 36).

10. A very good analysis of the structure of the relief is provided by White (op. cit., p. 48), who notes the low viewing point, "slightly below the centre of the lower edge of the relief," its effect on the foreshortening of the figures, and the fact that "the figure of Christ hovering in the ambient air is not foreshortened from below." The superimposed profiles on the left side of the relief are loosely related to those on the Ara Pacis, but the prototype Donatello knew cannot be identified.

11. The theory that the relief originates from the Brancacci Chapel and was carved for the altar of the chapel is put forward by Pope-Hennessy (loc. cit., and *Catalogue of Italian Sculpture in the Victoria and Albert Museum*, vol. 1, London, 1964, pp. 70–73). When it was first advanced it seemed possible that the relief formed the predella of a marble altarpiece. One of the unexpected results of the cleaning of the Chapel has been the discovery, at the bottom of the original base of the window, of a strip of angled fresco that would originally have been above the altar. The Ascension relief cannot, therefore, have formed part of a marble altarpiece. Its proportions, however, correspond with those of the conjectural altar, and it is likely to have been set on the front face of the altar, which would necessarily have been raised on steps; this would account for the unusually low viewing point of the relief.

12. For the relevant document see Poggi, no. 1080. This contains a commission to Luca della Robbia on April 20, 1439, to carve altar frontals for the chapels of Sts. Peter and Paul in the Cathedral:

ad faciendum et construendum duo altaria pro duobus capellis s. Maria del Fiore infrascripto modo et cum infrascripo designo, videlicet: in capella titolata et sub titolo santi Petri apostoli, in dicta ecclesia, unum altare marmoris longitudinis et latitudinis secundum modellum lignaminis . . . videlicet in qualibet testa, in quibus sint storie santi Petri predicti, prout dabuntur et designabuntur ei et a parte posteriori prout alias deliberabitur. Secundum

vero altare sit in capella titolata sub vocabulo santi Pauli apostoli, illius longitudinis et largitudinis prout supra dicitur de alio superiori, et secundum modellum eis dandum, quod factum fuit de cera per Donatum Nicholai Betti Bardi, quod est in dicts opera, videlicet super quatuor colonnis et in part intus cum forma ovale cum storiis et figuris circum circha santi Pauli predicti.

Two unfinished marble reliefs by Luca della Robbia for the first altar exist in the Museo Nazionale, but Donatello's wax relief is lost.

13. See Bocchi (above).

14. J. Beck, *Masaccio: The Documents*, New York, 1978, p. 19, doc. 19: "Ane avuto Maso soprascritto da me contanti fiorini dieci in grossi in botegha mia, li quali di presente paghò a maestro Donatello marmoraio da Firenze, carta n'appare per ser Piero notaio soprascritto adi 24 di Luglio 1427 (s.c. 1426) f.x."

15. In favor of the view that full-scale models were used in the Brancacci Chapel is the fact that Masolino, in the second register of the Chapel, worked in a style closely related to Masaccio's, but that after he ceased work there he reverted to the late Gothic style of his earlier works.

16. *ENTOMBMENT.* St. Peter's, Rome. Marble. For dimensions see note 17. The execution of the *Entombment* relief seems to be wholly autograph. The emotions in it and the gestures they inspire are more violent than in the *Ascension*, and the figures, despite the shallowness of the carving, are more tactile and more freely posed. The scene is once more represented from a low viewing point.

17. *TABERNACLE.* St. Peter's, Rome. Marble, H. 225 cm, W. 120 cm (H. 88½ in., W. 47¼ in.). The single early reference to the tabernacle is in a sentence of Vasari (*Vite*, ed. cit., vol. 3, p. 216: "Partitosi poi da Firenze, a Roma si trasferì per cercar d'imitare le cose degli antichi più che pote; e quelle studiando lavorò di pietra in quel tempo un tabernacolo del Sacramento che oggidi si truova a Roma"). In the sixteenth century the tabernacle was transferred from whatever place it occupied to Antonio da Sangallo's Altar of the Sacrament in St. Peter's (begun 1542, completed 1548). It is now in the Sagrestia dei Beneficiati. It is widely assumed (e.g., by Gnoli, "Le Opere di Donatello in Roma," in *Archivio Storico dell'Arte*, 1888, pp. 24–32, and Martinelli, "Donatello e Michelozzo a Roma," in *Commentari*, vol. 8, 1957, pp. 167–94, and vol. 9, 1958, pp. 3–24) that while in Rome in 1432–33 Donatello and Michelozzo set up a workshop in which the tabernacle and the Crivelli tomb slab were carved. This thesis is accepted by Janson (pp. 95–101). The taber-

nacle is relatively small, and it may well have been commissioned for a chapel in the Vatican rather than for St. Peter's. It is made sectionally, and it could readily be transported and installed. Since the secondary hands involved in it can be traced again in the Prato pulpit, it is more likely to have been carved in Florence than in Rome. It was possibly commissioned by Eugenius IV, whose court, after 1434, was resident in Florence. The postulates that underlie an account of the tabernacle by Morolli (*Donatello: Immagini di Architettura*, Florence, 1987, pp. 38–39) are incorrect.

18. *PRESENTATION OF THE BAPTIST'S HEAD TO HEROD.* Musée des Beaux-Arts, Lille. Marble, H. 50 cm, W. 71.5 cm (H. 19⅝ in., W. 28 in.) (without surrounding molding, H. 43.5 cm, W. 65 cm [H. 17 in., W. 25½ in.]). The relief is likely to be identical with "a panel of marble with many figures in low relief and other things in perspective . . . of St. John, by Donatello, 30 florins" listed in the 1492 inventory of the collection of Lorenzo de' Medici. Nothing is known of its later history till it was purchased (probably in Italy, but possibly in France) by Wicar, by whom it was bequeathed to the city of Lille (1834). Though the relief is widely accepted in the Donatello literature, it is uncharacteristic of the artist, first, in that the perspective structure is not coordinated with the narrative and, second, in that the carving of the individual figures lacks the incisiveness of the London *Ascension* and the St. Peter's *Entombment*. The first of these problems can be resolved only if it is accepted that its construction depends from, or was actually planned by, Alberti, and that the relief, though begun by Donatello, was completed by Desiderio da Settignano. The only stiacciato narrative relief by Desiderio that we know, the *St. Jerome* in the National Gallery of Art, is a relatively late work of about 1460, and leaves little doubt that he learned the technique of *stiacciato* carving from its only serious practitioner, Donatello. As noted by Herzner (*Donatello e i suoi*, Florence, 1986, pp. 140–41) in an admirable analysis, the relief has no devotional function and appears to have been carved as an independent work of art.

19. It is pointed out by Krautheimer (*Lorenzo Ghiberti*, Princeton, 1959, pp. 270 ff.) that the lower edges of panels of the Porta del Paradiso, with the stories of Isaac and Jacob, are likewise divided into nine sections, which provide a module for the figures.

20. *BLOOD OF THE REDEEMER.* Ospedale Maestri, Torrita. Marble, H. 39.8 cm, W. 67 cm (H. 15⅝ in., W. 26⅜ in.). The relief shows the figure of Christ, naked save for a loin cloth, standing in a mandorla-like indentation

in the cloudy sky sustained by angels, one of whom holds a chalice to collect his blood. To left and right are two standing angels and, next to them, with heads and shoulders protruding above the base of the relief, two figures who may represent praying donors (Carli) or St. John the Evangelist (*left*) and the Virgin (*right*). Though an orthodox iconography of the Precious Blood is found in the fifteenth century, for which see Middeldorf, *Raccolta di scritti*, vol. 2, Florence, 1979–80, pp. 56–58, there is no other portrayal that resembles this relief. The relief was evidently the lunette of a tabernacle, and it was at one time suggested by the present writer ("Some Donatello Problems," in *Studies in the History of Art Dedicated to William E. Suida on His Eightieth Birthday*, London, 1959, pp. 60–61, reprinted in *Essays on Italian Sculpture*, London, 1968, pp. 56–58) that the lunette formed the upper part of the tabernacle in St. Peter's. On grounds of style, this cannot be correct, and the relief must be regarded as a remnant of another, later tabernacle complex. The pose of Christ, with shoulders set diagonally across the space his body occupies, and the treatment of the two clothed angels suggests that the relief may be post-Paduan and is likely to have been carved about 1457 as proposed by Carli (*Donatello in Siena*, Rome, 1963, p. 140) while Donatello was working in Siena. The principal figures seem likely to have been carved by Donatello, but the flying angels and the notably unatmospheric clouds are probably the work of an assistant.

21. Alberti, *On Painting and Sculpture*, ed. Grayson, London, 1972, p. 55:

Let me tell you what I do when I am painting. First of all, on the surface on which I am going to paint, I draw a rectangle of whatever size I want, which I regard as an open window through which the subject to be painted is seen; and I decide how large I wish the human figures in the painting to be. I divide the height of this man into three parts, which will be proportional to the measure commonly called braccio; for as may be seen from the relationship of his limbs, three braccia is just about the average height of a man's body. With this measure I divide the bottom line of my rectangle into as many parts as it will hold; and this bottom line of the rectangle is for me proportional to the next transverse equidistant quantity seen in the pavement. Then I establish a point in the rectangle wherever I wish; and as it occupies the place where the centric ray strikes, I shall call this the centric point. The suitable position for this centric point is no higher from the base line than the height of the man to be represented in the painting, for in this way both the viewers and the objects in the painting will seem to be on the same plane.

22. Alberti, ed. cit., p. 83:

Then, I like there to be someone in the "historia" who tells the spectators what is

going on, and either beckons them with his hand to look, or with ferocious expression and forbidding glance challenges them not to come near, as if he wished their business to be secret, or points to some danger or remarkable thing in the picture, or by his gestures invites you to laugh or weep with them.

CHAPTER VII

1. *SAINT JOHN THE BAPTIST.* S. Maria dei Frari, Venice. Pigmented wood (probably poplar), H. 140 cm, W. (at base), 42.5 cm (H. 55 in., W. 16¾ in.); on a polychrome and gilded nut wood base, measuring H. 16.5 cm, W. 50.5 cm, D. 33.2 cm (H. 6½ in., W. 20 in., D. 13 in.). The statue is described by Vasari (*Vite,* ed. cit., vol. 3, p. 216: "Per il che di Padova partitosi, nel suo ritorno a Vinegia per memoria della bontà sua lasciò in dono alla nazione fiorentina, per la loro cappella ne'Frati Minor, un San Giovanni Battista di legno lavorato da lui con diligenzia e studio grandissimo."). A dating in the vicinity of that advanced by Vasari (ca. 1453) is accepted by all writers on Donatello up to and including Janson. The fundamental study of the statue after restoration is that of Valcanover ("Il San Giovanni Battista di Donatello ai Frari," in *Quaderni della Soprintendenza ai Beni Artistici e Storici di Venezia,* vol. 8, 1979, pp. 23–32). Cleaning in 1972 revealed on the faces of the hexagonal base (in place of a later inscription DONATELLUS FLOR.) the words

MCCCCXXXVIII
OPVS DONATI DE
FLO RENTIA.

The statue was not, therefore, carved in Padua, as was commonly supposed, but in Florence in 1438. Criticism based on the theory that the statue is a late work (e.g., Janson, pp. 187–89: "The physical and spiritual being are no longer in harmony here—the spirit has overpowered the body so that physical structure and function no longer have their old importance. . . . He conveys the metaphysical reality of faith through a deepened insight into the nature of religious experience on the psychological plane") can therefore be ignored. Its directness is due not to Donatello's state of mind at the time it was carved, but to the medium, which encouraged a freedom of expression that is otherwise found only in the reliefs of the Old Sacristy. An article by Stiberc ("Polychrome Holzskulpturen der Florentiner Renaissance," in *Mitteilungen des Kunsthistorischen Institutes in Florenz,* vol. 33, 1989, pp. 205–28) establishes that this and other mid-fifteenth-century wooden statues were produced not by excavating the block, but by using it in its entirety. Cleaning (for which see an appendix by Lazzarini to Valcanover's article in *Quaderni,* loc. cit.) has revealed much of the original pigmentation,

especially in the face. Before pigmentation the figure was covered with a coating of glue and gesso, applied thickly in the hair and more sparingly in the face. There is every reason to suppose that the original paint surface was applied by Donatello. The frequently cited northern parallels for the figure are a by-product of the belief that it was carved in North Italy. Cleaning has revealed the original epigraphy on the scroll held in the left hand, which, like the inscription on the base, is likely to have been carried out by Donatello. There is some damage to the fingers of both hands. The figure is fully carved behind. The right arm is carved from the same block as the remainder of the figure and is not an addition, as claimed by Huse ("Beiträge zum Spätwerk Donatellos," in *Jahrbuch der Berliner Museen,* vol. 10, 1968, p. 125).

2. *ST. JEROME.* Museo Civico, Faenza. Polychrome poplar wood, H. 139 cm, W. 36.5 cm (H. 54¾ in., W. 14⅜ in.). Vasari (*Vite,* ed. cit., vol. 3, p. 216) records that Donatello "nella città di Faenza lavorò di legname un S. Giovanni et un S. Girolamo, non punto meno stimati che l'altre cose di lui." There is no record of the statue of the Baptist, which has been wrongly identified with a marble head of the Baptist by Rossellino also in the Museo Civico. Vasari's statement that the *St. Jerome* was paired with a companion statue of the Baptist is likely to be correct. The attribution of the *St. Jerome* to Donatello has often been disputed. This was intelligible before its restoration in 1940–41, when the deeply undercut hair was clogged with recent priming and repaint. Earlier accounts of the figure by Schottmüller and Cruttwell should be read with this point in mind. It is, however, also rejected by Janson (pp. 248–49) and Wohl (in *Art Bulletin,* vol. 73, 1991, p. 317). The case for its reinstatement as a work of Donatello is argued by Poeschke, *Donatello,* Munich, 1980, p. 81, who asks: "Doch wem anders als Donatello wäre diese Erfindung schon, das Bild dieses nackten, frommbegierigen Alten, dessen Gebärde an die eines Venus Pudica erinnert, im Quattrocento zuzutrauen?", and by Boucher ("The St. Jerome in Faenza: A Case for Restitution," in *Donatello-Studien,* Munich, 1989, pp. 186–93). The representation differs from that of the Frari *Baptist,* first in that the figure is nude and, second in that the back, though fully carved, was not intended to be exposed. The *contrapposto* of the body may have been determined with reference to the companion figure. The frail body is carved with a precision of which no other artist than Donatello would have been capable. The only areas directly comparable to the Frari *Baptist* are the feet, where the analogies are highly convincing, and the hair and beard, where the undercutting

is closely similar. Kauffmann (*Donatello,* Berlin, 1935, p. 154) and Boucher rightly compare the articulation of the back view of the figure with that of the bronze *David* in the Bargello.

3. *TOMB SLAB OF GIOVANNI CRIVELLI, ARCHDEACON OF AQUILEIA.* Santa Maria in Aracoeli, Rome. Marble, L. 235 cm, W. 88 cm (L. 92½ in., W. 34⅝ in.). Since 1881 the slab has been shown vertically to the right of the entrance to the church. Around it is the inscription HIC IACET VENE[RABILIS] VIR DŇVS IOŇES DE CRIVELLIS DE MEDIOLANO ARCHIDIACONVS AQUILEGEŇET C[ENSOR] MEDIOLAŇ AC LITTERAR [VM APOSTOL]ICAR SCPTOR E ABBREVIATOR. QVI OBIIT A.D. MCCCC DIE XXVIII[I] IVLII PONT S DNI EVG[ENII PP] IIII [A II] CVIVS ANIA REQVI[ESC]AT IN PACE AMEN OPVS DONATELLI FIORENTINI. It is presumed by Janson (p. 102) and most earlier Donatello scholars that the tomb slab was carved in Rome during a span of months established by the Archdeacon's death in July 1432 and Donatello's return to Prato in the spring of 1433. It is clear, however, from the epigraphy of the inscription that it was carved before the summer of 1432, while Crivelli was still alive, and that his death date was inserted subsequently. There is every reason to suppose that the slab was carved in Florence, not in Rome. It is suggested by Janson that it was carved not for the Aracoeli but for Santa Maria sopra Minerva. This inference is incorrect. Padre Francesco Casimiro, in his *Memorie storiche della Chiesa . . . di Santa Maria in Aracoeli* (1736), records that a drawing of the slab in S. Maria in Aracoeli existed in the Biblioteca Albani. This drawing, which was made for Cassiano del Pozzo, is now in the Royal Library at Windsor Castle (Cod. 201, f. 56, no. 11770).

4. *DEAD CHRIST TENDED BY ANGELS.* Victoria and Albert Museum, London, (7577–1861). Marble, H. 80.6 cm, W. 114.3 cm (H. 31¾ in., W. 45 in.). Nothing is known of the history of the relief before its appearance in the Gigli collection in 1855. Once widely ascribed to Donatello, the relief (for which see Pope-Hennessy, *Catalogue of Italian Sculpture in the Victoria and Albert Museum,* vol. 1, London, 1964, pp. 73–75, and "Some Donatello Problems" in *Studies in the History of Art Dedicated to William E. Suida,* London, 1959, pp. 52–61, reprinted in *Essays on Italian Sculpture,* London, 1968, pp. 46–64) is ignored by Janson. The relief is carved in one with its frame. While there can be little doubt that it was designed by Donatello, the execution is so unequal as to show the presence of one or more assistants, especially in the background figures in low relief. In the Christ the head and the left arm appear to have been carved by Donatello, whereas the raised shoulder and its attachment to the torso are

faulty and reveal the intervention of an assistant. The angel on the left supporting Christ's head is superior in quality to the angel on the right-hand side. It is suggested by Martinelli ("Donatello e Michelozzo a Roma, I," in *Commentari*, fasc. 7, 1957, pp. 188–89) that the relief was carved by Michelozzo from a design by Donatello. The studio hand (or hands) apparent in the relief, however, recur on the Prato pulpit (notably in the first, second, and third reliefs on the left-hand side), and may include that of Pagno di Lapo Portigiani. The relief is likely to have been carved concurrently with the Prato pulpit in 1434–36.

5. *NICCOLÒ DA UZZANO*. Museo Nazionale, Florence. Pigmented terracotta, H. 46 cm, W. 44 cm (H. 18 in., W. 17³/₈ in.). From the Palazzo Capponi delle Rovinate (1881). The bust was accepted by Bode and most other critics in the nineteenth century as the work of Donatello, but to scholars in this century, among them the present writer, it appeared, in its overpainted state, to be unattributable. Accepted by Kauffmann, it was dismissed by Middeldorf, who condemned "the lack of style in the modeling of the face," by Janson (pp. 237–40), and by Wohl (in *Art Bulletin*, vol. 73, 1991, p. 316). Cleaning (for which see Andreoni, in *Omaggio a Donatello*, Florence, 1985, p. 258) proved that beneath the overpaint the original paint surface was well preserved. The features were modeled from a life mask, not a death mask (as is assumed by Janson), made in two separate molds, the ears being modeled separately and attached. Since Niccolò da Uzzano died in 1432, the bust must have been made before that time. There is ample evidence, from the San Rossore and from the heads of the later statues on the Campanile, of Donatello's interest in portraiture, and if, as is likely, these heads represent living sitters, the technique of the *Niccolò da Uzzano* would provide evidence for the way in which they were produced. A second similar head in the Palazzo Capponi is recorded in a report of 1881 cited by Semper (1875, p. 263n.), which refers to "i famosi busti di Niccolò da Uzzano e di Bernardo suo fratello, anzi quest'ultimo è stato recentemente alienato." There is no other record of the second bust. For the identification of the portrait as that of Niccolò da Uzzano (and not, as is sometimes suggested, of Neri Capponi) see Barocchi and Bertelà (in *Omaggio a Donatello*, 1985, pp. 246–53). The feature of the bust most commonly reproduced in later derivatives is the rhetorical movement of the head, which, in conjunction with the very distinguished modeling of the jaw, mouth, eyes, and forehead, is fully consistent with what we know of Donatello's creative processes in the late 1420s.

6. *DOVIZIA*. Formerly Mercato Vecchio, Florence. Pietra di macigno. For the column on which the *Dovizia* stood see especially M. Haines, "La Colonna della *Dovizia* di Donatello," in *Rivista d'Arte*, vol. 37, serie quarta, I, pp. 348–57. The first document regarding the transfer of the column dates from May 12, 1429, and the second, relating to its erection, from March 20, 1430. The column (which has a height of 5.94 m [19¹/₂ ft.]) is of gray granite. The columns in the Baptistry vary slightly in height and circumference, and there is some doubt as to whether the *Dovizia* column, which is somewhat lower, in fact came from the Baptistry, since it was, at the time the gift was made, in the hands of Opera del Duomo, not of the Opera di San Giovanni. There is no record of the date of Donatello's statue, which was probably commissioned about 1430. The statue is described by Vasari (*Vite*, ed. cit., vol. 3, p. 206: "In Mercato Vecchio, sopra una colonna di granito, è di mano di Donato una Dovizia di macigno forte tutta isolata, tanto ben fatta che dagl'artefici è da tutti gli'intendenti è lodata sommamente."). It disintegrated in the early eighteenth century. A frontal view of Donatello's statue appears in an anonymous painting of the Mercato Vecchio in the Bertini collection at Calenzano (published with other related material in an excellent survey by D. Wilkins, "Donatello's Lost Dovizia for the Mercato Vecchio: Wealth and Charity as Florentine Civic Virtues," in *Art Bulletin*, vol. 65, 1983, pp. 401–23).

7. The term *Dovizia*, signifying prosperity or wealth, was exalted by Poggio Bracciolini and Leonardo Bruni as the prerequisite of Charity. The capital of the column was Corinthian, not Ionic, as it is today. The meaning of the *Dovizia* is discussed in relation to classical precedents by Sarah Wilk ("Donatello's *Dovizia* as an Image of Florentine Political Propaganda," in *Artibus et Historiae*, vol. 7, 1986, pp. 9–28).

8. K. Clark, "Leon Battista Alberti on Painting," in *The Art of Humanism*, London, 1983, p. 91.

9. *ANNUNCIATION*. Santa Croce, Florence. Pietra di macigno. The present gilding dates in great part from a restoration of 1889. Tabernacle: H. 420 cm, W. (base) 248 cm, (top) 274 cm (W. [base] 97⁵/₈ in., [top] 108 in.) Interior niche: H. 218 cm, W. 169 cm, D. 33 cm (H. 86 in., W. 66¹/₂ in. D. 13 in.). Standing terracotta putti: H. 76 cm (30 in.). The Cavalcanti *Annunciation* is described by Vasari (*Vite*, ed. cit., vol. 3, pp. 203–4):

Ma quello che gli diede nome e lo fece per quello che era conoscere, fu una Nunziata di pietro di macigno, che in Santa Croce di

Fiorenza fu posta all'altare e cappella de'Cavalcanti, alla quale fece un ornato di componimento alla grottesca, con basamento vario et attorno e finimento a quartotondo, aggiugnendovi sei putti che reggono alcuni festoni, i quali pare che per paura dell'altezza, tenendosi abbracciati l'un l'altro, si assicurino. Ma sopra tutto grande ingegno et arte mostrò nella figura della Vergine, la quale impaurita dall'improviso apparire dell'Angelo, muove timidamente con dolcezza la persona a una onestissima reverenza, con bellissima grazia rivo gendosi chi la saluta, di maniera che se le scorge nel viso quella umiltà e gratitudine che del non aspettato dono si deve a chi lo fa, e tanto più quando il dono è maggiore. Dimostrò oltra questo Donato, ne' panni di essa Madonna e dell'Angelo, lo essere bene rigirati e maestrevolmente piegati; e col cercare l'ignudo delle figure come e' tentava di scoprire la bellezza degli antichi, stata nascosa gia cotanti anni. E mostrò tanta felicità et artifizio in questa opera, che insomma più non si può, dal disegno e dal giudizio, dallo scarpello e dalla pratica, disiderare.

The *Annunciation* still occupies the site for which it was designed and was originally adjacent to the *tramezzo* of the church, which was removed in the course of reconstruction by Vasari. There is a Cavalcanti tomb slab in its vicinity. No reference to a Cavalcanti Chapel in Santa Croce occurs before the sixteenth century, but an altar must have been associated with the Annunciation relief from about the middle of the fifteenth century; a painted predella by Giovanni di Francesco in the Casa Buonarroti originally filled the space between the two modilions of the tabernacle. The predella, which shows three scenes from the Life of St. Nicholas (for this see Bellosi, in *Pittura di Luce*, Milan, 1990, p. 56), is likely to have been commissioned by Niccolò Cavalcanti, to whom the commission for the *Annunciation* may also be due. It is widely agreed that the tabernacle was produced during the 1430s, though Janson (pp. 103–8) follows Kauffmann (p. 79) in relating the two figures to the bronze statuettes on the Siena Baptismal Font and infers that the Annunciation relief dates from the late 1420s, and that the tabernacle frame was carved in a second stage in 1430–32. This is an implausible, indeed impossible, working sequence, which involves a misreading of the style both of the Annunciation relief and of the architecture of the frame. The two elements are homogeneous, and it is highly unlikely that work on them did not proceed concurrently. There is no evidence of Michelozzo's intervention in the architecture or the sculpture. His partnership with Donatello ended in 1434, and the Cavalcanti *Annunciation* is likely to have been carved about 1437–40. The planning of the architecture involves a more refined and more sophisticated attitude to the antique than that of the Cantoria, especially

where motifs from the same source, e.g., the cornice of the temple of Vespasian, are employed. (I am indebted to Matthew Kennedy for an analysis of this point.) A list of classical decorative motifs related to those used in the frame is supplied by Greenhalgh (pp. 84–95) and Trudzinski (*Beobachtungen zu Donatellos Antikenrezeption*, Berlin, 1986, pp. 47–96). The architecture is distinguished by a prevailing sense of movement more evident in the original than in photographs. Above the consoles at either side, the Cavalcanti arms are set at an angle, covering the molded frame of the rectangle behind them as though applied to the surface of the monument. The frieze between them is concave, and the winged wreath in the center recedes from the front of the platform to the wall surface. The bases of the pilasters have the form of inverted capitals with protruding lions' feet. The pilasters taper toward the top, and the receding wall on the left in the interior of the tabernacle is cut at an angle to accommodate the angel's wings. The entablature likewise results from a bold and highly personal synthesis of classical motifs.

Neither of the two figures is based directly on a known classical original, though their forms and drapery reveal a close study of Roman sculpture.

10. *DAVID WITH THE HEAD OF GOLIATH*. Museo Nazionale, Florence. Bronze (with traces of gilding), H. 158 cm, D. of wreath 51 cm (H. 62 in., D. 20 in.). For its provenance and history see text. The bronze is cast sectionally, but the quality of casting is very different from that of the *St. Louis* and is in some respects superior to the *Judith* and the Siena *Baptist*. The lack of any true parallel or precedent in Florence has given rise to the suggestion that the *David*, though commissioned in Florence, may have been cast in Padua, after Donatello moved there (for this see Pope-Hennessy, "Donatello's Bronze David," in *Scritti di storia dell'arte in onore di Federico Zeri*, vol. 1, 1984, pp. 122–27). This suggestion is, however, hypothetical.

The fact that the bronze *David* was intended to be seen at a specific height is of key importance for the interpretation of the figure. Shown at eye level, it can be regarded as (Janson, p. 85) "not the classical ephebos but the beautiful apprentice; not an ideal but an object of desire, strangely androgynous in its combination of sinewy angularity with feminine softness and fullness," or as having (Greenhalgh, p. 167) "distinctly and exclusively female characteristics." But this is not the way in which it was intended to be viewed. Just as in the early marble statues, the proportions of which are adjusted to the site the figures were to occupy, so

here, in a naked figure that is fully three-dimensional, the same empirical adjustments have been made. When, therefore, Greenhalgh declares that "the rump is female . . . in fact the positioning known as lordosis, where the forward tilt of the pelvis, an aid to childbirth, hollows out the small of the back," his account rests on a misunderstanding of the structure of the figure. The area above the buttocks is artificially extended in a fashion that is disconcerting at eye level, but would be acceptable if the statue still stood on its column in the Palazzo Medici. The *David* is commonly described as "the first large-scale nude bronze produced since antiquity," but it is also the first fully freestanding nude figure, and its anatomy cannot be understood unless account is taken of its likely sources and of the terms in which the problem of the fully freestanding figure were viewed by Donatello. The search for sources for the figure has been pursued in statues, gems, coins, and work in other media, some of which Donatello certainly knew, but none of which resemble the statue so closely as to be admissible as prototypes. The marble *David* for the Palazzo della Signoria seems to derive from an Etruscan bronze, and the bronze *David*, as symbol not only of Florence but of Etruria, may well have grown from the same soil. Seymour ("Some Aspects of Donatello's Methods of Figure and Space Construction: Relationships with Alberti's *De Statua* and *Della Pittura*," in *Donatello e il suo Tempo*, pp. 195–206), following Kauffmann, establishes Donatello's use of the exempedum construction described by Alberti in the *De Statua*, whereby the standing figure was divided into six units; this was a comparatively simple scheme, which is used by Ghiberti in the *Samson* on the Porta del Paradiso and by Michelozzo in the standing figures of the Aragazzi monument. It is also used in a somewhat unorthodox form in the bronze *David*, as is its corollary, the principle of *Finitio*, "the means whereby we record with sure and accurate method the extensions and curves of lines, and the size and shape and position of all angles, protuberances and recesses" (for Alberti's text see C. Grayson, *Alberti on Painting and on Sculpture*, London, 1972, p. 129).

11. Vasari (1550), ed. cit., vol. 3, p. 400: "Fece nella sua giovanezza il basamento del David di Donato ch'è in palazzo de' Signori in Fiorenza, nel quale Desiderio fece di marmo alcune Arpie bellissime et alcuni vitacci di bronzo molto grazioso e bene intesi."

12. Janson, p. 80. For photographs of the headdress of the *David* from above see C. Del Bravo ("Primo Quattrocento" in *Artista*, Florence, 1990, p. 153).

13. Herzner, in an elaborate and informative

discussion of the figure ("David Florentius II," in *Jahrbuch der Berliner Museen*, vol. 24, 1982, pp. 63–142) distinguishes between the ivy leaves in David's cap and the laurel wreath on which he stands.

14. Janson, p. 84. The error is repeated by Ames-Lewis ("Art History or *Stilkritik*? Donatello's Bronze *David* Reconsidered," in *Art History*, vol. 2, 1979, pp. 139–55.)

15. E. Spina Barelli, "Note iconografiche in margine al David in bronzo di Donatello," in *Italian Studies*, vol. 29, 1974, pp. 28–44.

16. The case for regarding the statue as Mercury (which I at one time entertained), or as a David/Mercury was first adumbrated by Lányi and is developed by Parronchi ("Mercurio e non David," in *Donatello e il Potere*, Florence/Bologna, 1980, pp. 101–15). For Lányi this case was attested by the reverse of Sperandio's medal of Alessandro Tartagni, where a naked Mercury is shown wearing boots and a petasus, and for Parronchi it was supported by a literary source, the description of the *Certame Coronario* of 1441.

17. C. M. Sperling, "Donatello's Bronze David and the Demands of Medici Politics," in *Burlington Magazine*, vol. 134, 1992, pp. 218–24. The manuscript (Bibl. Riccardiana, Ms. 660, i. 83r) was compiled between 1466 and 1469. Sperling mistakenly associated the verse with Filelfo, and regards it as evidence that David was commissioned ca. 1428.

18. For the old Palazzo Medici see especially Doris Carl ("La Casa Vecchia dei Medici e il suo giardino," in *Il Palazzo Medici Riccardi di Firenze*, Florence, 1990, pp. 38–43).

19. *BOY FAUN TREADING ON A SNAKE*. Museo Nazionale, Florence. Bronze, H. 104 cm (41 in.). The two arms are cast separately; it was at one time supposed that the right arm was wrongly attached. The figure is described by Vasari (1568), ed. cit., vol. 3, p. 219: "In casa ancora di Giovanbattista d'Angol Doni, gentiluomo fiorentino, è un Mercurio di metallo di mano di Donato alto un braccio e mezzo, tutto tondo e vestito in un certo modo bizzarro, il quale è veramente bellissimo e non meno raro che l'altre cose adornano la sua bellissima casa." For the Doni collection see Barocchi (in *Omaggio a Donatello*, Florence, 1985, pp. 224–30), who prints in full the documents regarding the sale of the figure to the Grand-Ducal gallery in 1778. The various interpretations of the figure as Cupid, Harpocrates, Atys, a Faun, Amor-Hercules, Mercury, a winged Mithras, Priapus, Atys-Amorino, and a Genius of Wine (Janson, pp. 143–47) are summarized by Barocchi. A well-reasoned, though incorrect, study by E. Simon ("Der sogenannte

Atys-amorino des Donatello," in *Donatello e il suo tempo*, Florence, 1968, pp. 331–51) identifies the bronze as a fountain figure of Priapus Superbus. The only interpretation that explains all of its peculiarities is that of T. Buddensieg ("Donatellos Knabe mit dem Schlangen," in *Forma et Subtilitas: Festschrift für Wolfgang Schöne zum 75 Geburstag*, Berlin and New York, 1986, pp. 43–49).

20. *David*, Staatliche Museen, Berlin. Bronze, H. 37 cm (14½ in.). A circumspect review of the evidence relating to this statuette is presented by U. Schlegel ("Problemi intorno al David Martelli," in *Donatello e il so Tempo*, Florence, 1968, pp. 245–58), who retains the attribution to Donatello. Exhibited in 1986 in Florence at the Donatello exhibition, it was described by D. Lewis (in *Donatello e i suoi*, Florence, 1986, pp. 143–44) as "fusione da un modello di Donatello." A version of the bronze formerly owned by Lord Clark of Saltwood and there attributed to the late fifteenth century is a late nineteenth-century cast. I am indebted to Dr. Volker Krahn of the Staatliche Museen, Berlin, for a detailed report on this puzzling figure.

21. *PUGILIST*. Museo Nazionale, Florence. Bronze, H. 28.8 cm (11⅜ in.). The history of the bronze goes back to 1784, when it was listed in the Galleria. For the attribution to Donatello see Pope-Hennessy, "Donatello and the Bronze Statuette," in *Apollo*, vol. 105, 1977, pp. 30–33, reprinted in *The Study and Criticism of Italian Sculpture*, New York, 1980, pp. 129–34. Collareta (in *Omaggio a Donatello*, Florence, 1985, p. 276) associates the pose convincingly with that of the left-hand Dioscurus on Montecavallo.

CHAPTER VIII

1. The initial record, of February 14, 1437, refers to the making of a single door (Poggi, no. 1482: "Prefati operaii deliberaverunt quod provisor dicte opere debeat locare Donato Niccolai, magistro intagli, unam ex duabus sacristiis novis maioris ecclesie florentine de bronzo"). On February 21, 1437, however, the commission to Donatello provides for bronze doors for both sacristies for an overall sum of 1,900 florins (Poggi, no. 1483). According to a further record of February 28, 1437 (Poggi, no. 1484), a model of the doors had been made ("quod dicte porte laborentur modo et forma prout apparet per quemdam modellum, qui stare debeat pro exemplo in audientia dictorum operariorum"). The delivery dates and the sums payable to Donatello in respect of the two doors are specified in a further record of March 27, 1437 (Poggi, no. 1488: "A Donatello intagliatore fu alloghato per insino di 27 di marzo

1437 a fare due porte di bronzo delle quali dovea dare fatte l'una per tutto aprile 1439 e l'altra per tutto aprile 1441: e della prima dovea avere flor. MC e dell'altra fior. DCCC e anne avuto f. CCL.").

2. For Donatello's salary see Poggi, no. 1485.

3. For the employment of Nanni di Miniato see Poggi, no. 1490.

4. There is no information about the figurative content of the two doors, but it is wrong for that reason to infer, with Herzner ("Donatello und die Sakristei-Türen des Florentiner Domes," in *Wiener Jahrbuch für Kunstgeschichte*, vol. 29, 1976, p. 55), that "einem Künstler wie Donatello wurde demnach ein erstaunliches Mass an Freiheit bei der Themenwanl zugestanden. Es hat beinahe den Anschein, als sei es den Operai wichtiger gewesen, ein Werk Donatellos zu erhalten, als was auf den Türen darzustellen wäre."

5. Poggi, no. 1514: "1439, Giugno 30. A Antonio di Nofri di Romolo, righatiere, L. LXXIX s. x d. IV p. per lb. 367 di bronzo e ottone vechio si conperò dallui per s. IV d. IV la lb. per fare le porte della saghrestia che dee fare Donatello." This payment covers no more than a small part of the bronze that would eventually have been required.

6. For the history of the later door see Pope-Hennessy, *Luca della Robbia*, Oxford, 1980, pp. 68–72. The contract (which specifies both the form of the door and its content) is printed by Poggi, no. 1560. Herzner (op. cit., pp. 53–63) mistakenly assumes that the model referred to in this contract is identical with the model made by Donatello, and that the present door was therefore based on Donatello's design.

7. Poggi, no. 1576. The document relates to the lease of a house on via del Cocomero.

8. Paatz, vol. 2, pp. 479–82, 497–500.

9. Janson, p. 135.

10. For the condition and extensive bibliography of the cupola fresco see I. Ballerini, "L'emisfero celeste della Sagrestia Vecchia: rendiconti da un giornale di restauro," in *Donatello e la Sagrestia Vecchia di San Lorenzo*, Florence, 1986.

11. A. Manetti, *Vita di Brunellesci*, ed. Toesca, Florence, 1927, pp. 65–66.

12. For the perspective structure of the eight reliefs see P. Ruschi, "La Sagrestia Vecchia di San Lorenzo: Per un disegno delle vicende costruttive," in *Donatello e la Sagrestia Vecchia di San Lorenzo*, Florence, 1986, pp. 15–23.

13. Pope-Hennessy, *Luca della Robbia*, Oxford, 1980, pp. 33–44.

14. *Filarete's Treatise on Architecture*, ed. Spencer, New Haven, 1965, p. 115:

> My lord's son asked me what decoration I thought would be best. I replied . . . that it could be decorated in many ways, and that all would be beautiful. I thought the noblest and the best way would be to make first a beautiful pavement and then to decorate the vaults with gold and ultramarine. This would be necessary in any case. "But tell me what will be done on the interior of the vaults. I think it should be made like sky full of gold stars, on a blue ground." "Yes, but let us make all the signs in the sky, the planets and the fixed stars." "I like this arrangement, but how will it be painted?" "My lord, I want to make a certain paste of lime and other things, and make low reliefs of it as I have done in many other places. The ancients used it in their buildings and especially in Rome. I believe that you have seen it in the Colosseum and many other places. It will be beautiful here." "Yes, but I should like you to teach me how to make the paste." "I would be glad to, but I shall teach it to you another time, when I teach you about related matters and some other things that will please you enough."

15. E. J. Shepherd, "L'antico e Donatello: Archeologia e sperimentazione tecnica," in *Donatello e la Sagrestia di San Lorenzo*, Florence, 1986, pp. 47–57, concludes that "l'uso donatelliano del cocciopesto nei rilievi della Sagrestia Vecchia verrebbe ad essere un recupero sperimentale fondato sulla tradizione letteraria antica," as well as to knowledge of the stucco decoration in the Colosseum and the Villa Adriana, where the use of nails to attach the stucco to the walls and the free modeling of the figures anticipate the technique of the reliefs in the Sagrestia Vecchia.

16. *DECORATION OF THE OLD SACRISTY*, San Lorenzo, Florence:

ATTEMPTED MARTYRDOM OF ST. JOHN OUTSIDE THE LATIN GATE
ST. JOHN ON PATMOS
RAISING OF DRUSIANA
ASCENSION OF ST. JOHN
ST. JOHN THE EVANGELIST
ST. MATTHEW
ST. MARK
ST. LUKE
Diameter: ca. 215 cm (84⅝ in.).
ST. LAWRENCE AND ST. STEPHEN
H. ca. 215 cm, W. ca. 180 cm (H. 84⅝ in., W. 71 in.).
ST. COSMAS AND ST. DAMIAN
H. ca. 215 cm, W. ca. 180 cm (H. 84⅝ in., W. 71 in.).
Stucco with local pigmentation and gilding.

The four narrative reliefs are concave and comprise stucco figures and properties applied with nails to a reddish-brown stucco ground.

They were cleaned in 1911–12, when a coat of whitewash that had been applied to them was removed, and they remained in this unhappy state till a new (and strikingly successful) campaign of restoration was begun in 1983. The initial campaign covering the altar wall, with the relief of *St. John the Evangelist*, the *Attempted Martyrdom of St. John outside the Latin Gate*, *St. John on Patmos*, and the paired Saints over the doorways, was completed in 1986, and thereafter the three remaining Evangelists, the *Raising of Drusiana*, and the *Ascension of St. John* were also cleaned. The standard publication, *Donatello e la Sagrestia Vecchia di San Lorenzo*, Florence, 1986, deals only with the first phase of this campaign, but its findings are applicable also to the remainder of the restoration. An accurate English summary of the findings is provided by Caroline Elam, in *Donatello at Close Range*, London, 1987, also published in the *Burlington Magazine* (1987), which contains translations of the technical articles in the 1986 catalogue. The technique used in the decoration of the Old Sacristy was throughout experimental. The cupola fresco over the altar is painted *a secco* on a uniform blue background on which the astronomical details and the small stars were incised and gilded and the figurated constellations were then added freehand without preliminary drawings. Donatello's four narrative reliefs are built up on a reddish ground, apparently inspired (Danti) by "the red-brick masonry with fragments of marble and stucco decoration adhering to it" that he would have seen in Rome, and incised with guide lines or orthogonals. Working on some form of scaffolding, Donatello applied by hand the stucco figures and other protruding elements, "using very few simple tools for the finishing." In the Saints Lawrence and Stephen over the left-hand door, Donatello adheres to this technique, though the figures are more fully modeled and on a considerably larger scale. The related figures of Saints Cosmas and Damian over the right-hand door differ from them both in style and technique. The technique, as is observed by Danti, is more strictly sculptural, and the rigid classicism of their style recalls the work of Michelozzo on the Aragazzi monument. Danti notes "the presence of consistent overpainting with lead white in an oil medium over a gesso preparation, extended over all the figures and all the objects in white plaster, in the relief of St. John the Evangelist, the two adjacent narrative scenes and the paired Saints above the doorways." In the four large Saints and the St. John, elaborate gilt patterning has been revealed. It is unclear whether the white overpainting was part of Donatello's original scheme or was applied after he left Florence by Michelozzo. Three of the four narrative reliefs are constructed with an orthodox vanish-

ing point, and the consistency of the projection suggests that all of them were planned to be seen from the tomb in the center of the floor; the perspective system has a local relevance within each scene, but it is also the means by which the roundels are integrated in the architecture of the sacristy.

The classical sources of the reliefs are exhaustively discussed by Greenhalgh (*Donatello and His Sources*, London, 1982, pp. 113–31). The figure of St. John in *St. John on Patmos* is associated by Janson (p. 92) with Etruscan tomb effigies. It depends, rather, from Giotto's fresco in the Peruzzi Chapel, which may in turn have had a Roman source. The structure of the *Ascension of St. John* is related by Greenhalgh to study of lost Fourth Style Roman frescoes, of the class of those in the Casa di Livia and the Domus Aurea. This connection, like all of the connections posited with Roman painting, is conjectural. The form of the basilica is Albertian; this is likely to be due, not, as Greenhalgh suggests, to the use of common sources, but to Donatello's personal familiarity with Alberti. In the Evangelist roundels, the use of animated lecterns is regarded by Janson as an invention of Donatello's, and by Greenhalgh as the updating of a strong medieval tradition. The poses of the four Evangelists seem to have evolved from a Byzantine manuscript of the type of MS. 4 in the Stauronikita at Mount Athos, or Cod. Gr. 364 in the Vatican Library (for which see A. M. Friend, "The Portraits of the Evangelists in Greek and Latin Manuscripts," in *Art Studies*, vol. 5, p. 115–47 and vol. 7, pp. 3–29). The seats and altars seem not to have been transposed directly from the antique, though the use and misapplication of Roman architectural motifs (e.g., the scrolled acroterion used for the arm rest of St. Luke) is general.

17. *MARTYRS' DOOR and APOSTLES' DOOR*. Bronze, H. 235 cm, W. 109 cm (H. 92½ in., W. 43 in.). The doors at each side of the altar were cleaned in 1945–46, when it transpired that their modeling and chasing were finer than had previously been supposed. The two door frames have been convincingly ascribed to Michelozzo (Janson). It is difficult to form any impression of the probable sequence of work on the two wall faces. Whereas the execution of the eight roundels (as distinct from the planning period that preceded them) seems to have been rapid, the modeling, casting, and chasing of the two doors would have proceeded more slowly. The only indication we have of the probable duration of work on the Martyrs' Door, is afforded by the commission for the bronze doors of the sacristies in the Cathedral, of which one was to be delivered two years and one month after the signing of the contract. For

the style and the iconography of the two doors see text p. 87–89. The proportional system used by Donatello in the construction of the door is established by White (in *Art Bulletin*, vol. 51, 1969, pp. 119–41). Though each pair of figures is set on a neutral ground, the flat surface behind them has, through the placement of the figures, a strong spatial character; it is as though the pairs of figures were first planned perspectivally, and the perspectival constructions were then eliminated.

18. *LAMENTATION OVER THE DEAD CHRIST*. Victoria and Albert Museum, London (8552–1863). Bronze, H. 32.6 cm, W. 40 cm (H. 13 in., W. 15¾ in.). For the relief see Pope-Hennessy, *Catalogue of Italian Sculpture in the Victoria and Albert Museum*, vol. 1, London, 1964, no. 63. The relief was regarded by Kauffmann (*Donatello*, Berlin, 1935, pp. 184, 254n.) as a model made by Donatello for one of the reliefs on the doors of Siena Cathedral (1457). This theory is accepted by Janson (pp. 206–8) on the grounds first of facture and then of the width of the relief (three-quarter of a *braccio*), which corresponds with that of a wax demonstration panel for the Cathedral door listed in an inventory of 1639. This theory is rejected by Herzner ("Donatello in Siena," in *Mitteilungen des Kunsthistorischen Institutes in Florenz*, vol. 15, 1971, pp. 172–74). The rough execution and chasing constitute its main link with Donatello's late work. The geometrical structure (with long diagonals running from the left foot of the Virgin to the head of the woman in the background on the left, and from the extended arms of the Magdalen to the raised left thigh of Christ) has no parallel in Donatello's late reliefs, but finds a point of reference in the Martyrs' Door in the Old Sacristy. The relief is regarded by Rosenauer (*Donatello e i suoi*, Florence, 1986, nos. 169 and 53) as post-Paduan. The background has been excised, perhaps on account of casting flaws. A stucco cast made after the excision of the background is in the Museo Bardini, Florence (Enrica Neri Lusanna e Lucia Faedo, *Il Museo Bardini a Firenze*, vol. 2, Milan, 1986, p. 256, no. 190). The London relief is stated to have been in the "Palazzo Mocenigo di S. Luca in Venice."

19. Michelozzo, *Tomb Slab of Pope Martin V*. S. Giovanni in Laterano, Rome. Bronze, L. 286 cm, W. 124 cm (L. 112½ in., W. 49½ in.). The tomb slab is mentioned by Vasari (1568) *Vite*, ed. cit., vol. 3, pp. 219–20: "Dicesi che Simone, fratello di Donato, avendo lavorato il modello della sepoltura di Papa Martino Quinto, mandò per Donatello, che la vedesse inanzi che la gettasse. Onde andando Donato a Roma, vi si trovò appunto quando vi era Gismondo imperatore per ricevere la corona da Papa Eugenio

Quarto; per che fu forzato, in compagnia di Simone, adoperarsi in fare l'onoratissimo apparato di quella festa, nel che si acquistò fama et onore grandissimo." An attempt to identify the sculptor or metalworker Simone (mentioned by Vasari) is made by Martinelli ("Donatello e Michelozzo a Roma I, II", in *Commentari*, fasc. 8, 1957, pp. 167–94, and vol. 9, 1958, pp. 3–24.) The attribution of the tomb slab to Donatello was accepted by scholars up to and including Kauffmann (*Donatello*, Berlin, 1935, pp. 91–92, 98n.) but was rejected by Marchini ("Di Maso di Bartolomeo e d'altri," in *Commentari*, vol. 3, 1952, p. 121) and Janson (pp. 232–35). It is assumed throughout the Donatello literature that the relief, whether or not by Donatello, was cast in Rome. It has, however, since been proved by Arnold and Doris Esch, in an analysis of customs declarations made for imported goods at Ostia and Rome ("Die Grabplatte Martins V und andere Importstücke in den Römischen Zollregistern der Frührenaissance," in *Römische Jahrbuch für Kunstgeschichte*, vol. 17, 1978, pp. 211–17) that this cannot be the case. Two of the works described are a "lapidem brunci pro sepultura domini pape Martini" and a "lapida una de bronzo per la sepoltura de Papa Martino." The declaration is dated April 7, 1445. There can thus be no doubt, first, that the tomb was executed in Florence, and, second, that it was completed fifteen or eighteen months after Donatello left for Padua. Though the tomb slab is related to, and indeed derives from, the Pecci tomb slab in Siena, its perspective structure is more academic, and its dry, rather schematic effigy, attenuated putti, and lifeless ornament are consistent with the view that it is the work of Michelozzo.

CHAPTER IX

1. On March 21, 1443, Donatello purchased a house at Figline di Prato, the value of which was assessed, in a later *catasto* return of March 1458, as 23 florins (Herzner, *Regesti*, nos. 243, 368). On March 29, 1443, before the Tribunale di Mercanzia, Maso di Bartolomeo sued the Operai of the Cappella della Cintola at Prato for a balance of Fl. 600 due to him for the *cancellata* of the chapel on the basis of an estimate supplied by Donatello and Michelozzo.

2. Sartori, in *Il Santo*, I, i, 1961, p. 47: "19 giugno: Maistro Donatello da Firencie de' dare . . . le quale ave de cera bianca da Batista Caveale per fare el Crocifiso." Sartori, *Documenti*, p. 87: "Maistro Donatello da Firencie de' dare, per libre 46 de ferro ave da Piero Mangion per fare el Crocifisso, tolse maistro Zuane so compagno da botega de Piero Mangion, L. 4: 12." It is

claimed (Sartori) inferentially from a later document that the *Crucifix* was completed by June 30, 1445. Its casting, but not its chasing, may have been finished by that time. A copper halo for it was prepared at the end of 1448 or in the first month of 1449 (Sartori, in *Il Santo*, loc. cit.): "1449, 22 gennaio. A maestro Andrea Calderario fo per una diadema de rame de' per lo Crocifisso, L. 1.8" and the balance of Donatello's fee (L. 89) was paid on June 23, 1449.

3. *CRUCIFIX*. Basilica del Santo, Padua. Bronze, H. 180 cm, W. 166 cm (H. 71 in., W. 65⅜ in.). A payment to a stonecarver, Giovanni Nani di Firenze, for a large pedestal (*sotope*) made for a Crucifix in the Cappella Grande (Sartori, in *Il Santo*, I, i, p. 48) relates not to the mounting of Donatello's *Crucifix*, but to a painted "crucem magnam" referred to in a document of 1377. It is demonstrated by Sartori, from a number of payments of 1449, that Donatello's Crucified Christ was attached to a cross painted and gilded by Niccolò Pizzolo, which stood "a meço la iexia" (halfway up the church).

4. Michele Savonarola, *Libellus de magnificis ornamentis Regie civitatis Padue*, in Muratori, *Rerum italicarum scriptores* vols. 24 and 25, Città di Castello, 1902, p. 32. The epitaph of Cyriacus of Ancona is printed by Eroli, *Erasmo Gattamelata da Narni, suoi monumenti e sua famiglia*, Rome, 1876, p. 221f.

5. Gianantonio Porcelli de' Pandoni, *Commentari comitis Jacobi Piccinini sive Diarium* (1452), in Muratori, *Rerum italicarum scriptores*, vol. 20, Milan, 1731, p. 98.

6. *Urbis Romae ad Venetias Epistolion*, in *Atti e Memorie, R. Accademia di Scienze di Padova*, n.s. 9, vol. 2, 1902–3: "Hoc ego con curiis sanctis, magnisque Camillis/Hoc non Sciapidae dederam, certoque Catoni/At ut nescio quem mellatam munere Gattam/Insigni, et facto donasti ex aere caballo/Premia magna fugae subitae, rerumque tuorum/Discrimen dubium, Patavinae dedecus Urbis,/Quo fugit infelix statua monstratur ahena."

7. Marin Sanudo, *Le vite de' Duchi di Venezia*, in Muratori, *Rerum italicarum scriptores*, vol. 12, Milan, 1733, col. 1106. For the letters of Alfonso V of Naples see J. Rubio, in *Miscellania Puig i Cadafalch*, vol. 1, Barcelona, 1947–61, pp. 33–35.

8. Vasari (1550), ed. cit., vol. 3, p. 214:

Avvenne che in quel tempo la Signoria di Vinegia, sentendo la fama sua, mandò per lui accio che facesse la memoria di Gattamelata nella città di Padova, che fu il cavallo di bronzo su la piazza di Santo Antonio; nel quale si dimostra lo sbuffamento et il tremito del cavallo, et il grande animo e la fierezza vivacissimamente espressa dalla arte nella

figura che lo cavalca. E dimostrossi Donato tanto mirabile nella grandezza del getto, in proporzioni et in bonta che veramente si può aguagliare a ogni antico artefice in movenza, in disegno, in arte, in proporzione et in diligenza; perche non solo fece stupire allora que' che lo videro, ma ogni persona che al presente lo puo vedere.

9. For the record of payments see Sartori ("Il Donatelliano monumento equestre a Erasmo Gattamelata," in *Il Santo*, I, i, 1961, pp. 327–31).

10. The final settlement is printed by Sartori, op. cit., p. 331–34, when the statue and its base were estimated at Duc. 1650.

11. For the Arco del Cavallo see F. Borsi, *Leon Battista Alberti*, London, 1977, pp. 19–26; and Morolli, *Donatello: Immagini di Architettura*, Florence, 1987, pp. 66–67, 92–93.

12. Filarete, *Trattato dell'architettura*, ed. Oettingen, Vienna, 1890, p. 622: "Non come fece (Donatello) nella sua statua equestre in memoria di Gattamelata, che ê cosi inadatta da far i che recevesse piccola lode. Perche se voi dovette raffigurare un uomo della nostra epoca, non raffiguratelo in costume antico ma in abiti che egli abitualmente usasse." The armor worn by Gattamelata does not fall into either category. It is a form of classicizing ceremonial armor that must have constituted something of a novelty in the middle of the fifteenth century but recurs repeatedly in the sixteenth.

13. Janson, p. 161.

14. *EQUESTRIAN STATUE OF GATTAMELATA*. Piazza del Santo, Padua. Bronze with marble base and limestone pedestal, H. of statue ca. 340 cm, L. 390 cm (H. 134 in., L. 153½ in.); H. of pedestal and base 780 cm, W. ca. 410 cm (H. 307 in.; W. 161½ in.). On the front of the marble base is the inscription OPVS DONATELLI FLO. Two much-weathered marble reliefs with putti supporting the arms of Gattamelata are in the cloister of the Santo (H. ca. 120 cm, W. ca. 175 cm [H. 47¼ in., W. 69 in.]) and have been replaced by copies.

15. A useful summary of the classical parallels for the Gattemelata base is provided by Greenhalgh (*Donatello and His Sources*, London, 1982, pp. 132–47).

16. For the documentation of the statue see Sartori, in *Il Santo*, vol. cit., pp. 326–34.

17. Bottari, *Raccolta di lettere*, Milan, 1822–25, vol. 1, p. 70, prints a letter from Bandinelli to Cosimo I, which contains the sentence "Some who were with Donatello have told me that he always had eighteen or twenty assistants (*garzoni*) in his workshop, otherwise he never could have completed an altar of St. Anthony in Padua, together with other works."

18. The innumerable reconstructions of the altar, save for those of Planiscig (*Donatello*, Florence, 1947, pp. 86, 87) and White ("Donatello's High Altar in the Santo at Padua," in *Art Bulletin*, vol. 51, 1969, pp. 1–14, 119–41, reprinted in *Studies in Renaissance Art*, London, 1983, pp. 132–212), have been omitted from the book. In the second and later editions of my *Italian Renaissance Sculpture*, I accepted White's reconstruction of the altar. I no longer do so, because a rereading of the published documents reveals so many imponderable factors that no logical reconstruction of the altar seems to me admissible. Of the gaps in our knowledge the most important is the lack of any contract for the main figures on the altar, the Virgin and Child and the four Patrons of Padua. White, like Fiocco, regards the first contract of which there is a record (that for the Saints Francis and Louis of Toulouse and the bronze reliefs throughout the altar), as the initial contract. But it was almost certainly preceded by a prime contract for the five figures in the main group. In the mass of documents that have been published, there is no conclusive proof that the altar (as distinct from its sculptural decoration) was commissioned from Donatello. We know that the supports and a relief of God the Father on the front of the *chua* were carved in Donatello's workshop, but it cannot be wholly ruled out that the bronze statues were to be inserted in an antecedent scheme. White's closely argued reconstruction rests on two assumptions that cannot be satisfactorily demonstrated, first that the altar was a great masterpiece that transformed style in northeast Italy, and second that it must, as a work of art, have possessed the same integrity as the Cavalcanti *Annunciation* and Donatello's major Florentine commissions. Against this may be set the fact that Donatello abandoned the commission while the sculptures were still incomplete, that the quality of finish throughout the figures is impermissibly unequal, and that the design and execution of many of the angel reliefs and the symbols of the Evangelists were subcontracted to individual members of Donatello's shop. In the light of what we know of Donatello's creative processes elsewhere, none of this would be explicable if the entire scheme originated in his mind and if he were, as on the Cantoria and the Prato pulpit, engaged in realizing a self-generated imaginative concept. By Sartori and other students it is assumed that when the names of individual members of Donatello's shop cease to appear in the records of the Santo, they left Padua. The true position is likely to be the opposite, that the sculptors recruited by Donatello as assistants on the *Gattamelata* were briefly diverted to work on the High Altar. We have no information as to the length of time they were employed in Padua.

19. The relation of the Padua High Altar to Alberti is well discussed by Morolli (*Donatello: Immagini di Architettura*, Florence, 1987, pp. 75 ff.) in the light of the following passages in the *De Re Aedificatoria* VII, 10, 9: "All'interno del tempio piuttosto che affreschi sulle pareti, sono preferibili pitture su tavola, amio parere; anzi mi piacerebbe, ancor piu di questi, delle statue"; VII, 17, 10: "Sull'altare sara più conveniente collocare due statue o al massimo tre"; VII, 17, 10: "Non vorrei pero vedere un dio in posizione da pugile e da istrione. Al contrario, dal suo viso e dal intero suo corpo devono spirare, communicandosi ai fedeli, una grazia e una maesta degne di una natura divina: quasi accolga i presenti benevolmente col capo e con la mano, spontaneamonte disposto ad esaudire le preghiere." These paraphrases represent no more than an approximation to Alberti's text.

The documentation of work on the Padua altar, though exceptionally rich, is diffuse. The principal documentary sources are

B. Gonzati, *La Basilica di Sant'Antonio di Padova descritta ed illustrata*, Padua, 1854

A. Gloria, *Donatello fiorentino e le sue opere mirabili nel tempio di S. Antonio di Padova*, Padua, 1895

C. Boito, *L'altare di Donatello e le altre opere nella Basilica Antoniana di Padova*, Milan, 1897

R. Band, in *Mitteilungen des Kunsthistorischen Institutes in Florenz*, v, 1940, pp. 334 ff.

A. Sartori, "Documenti riguardanti Donatello e il suo altare di Padova," in *Il Santo*, I, i, 1961, pp. 37–99.

Herzner, "Donatellos 'pala over ancona' für den Hochaltar des Santo in Padua: Ein Rekonstruktionsversuch," in *Zeitschrift für Kunstgeschichte*, vol. 33, 1970, pp. 89–126.

A. Sartori, *Documenti per la storia dell'arte a Padova*, Vicenza, 1976, pp. 87–95.

Archivio Sartori I, Basilica e Convento del Santo, a cura di P. Giovanni Misetto, Padua, 1983.

20. Bartolomeo Facio, *Da viris illustribus*, ed. L. Mehus, Florence, 1745, p. 51.

21. *Der Anonimo Morelliano*, ed. Frimmel, Vienna, 1888, p. 2:

Nella chiesa del Santo, sopra l'altar maggiore le quatro figure di bronzo tutte tonde attorno la nostra Donna, e la Nostra Donna. Et sotto le ditte figure nello scabello le due istoriette davanti et le due da dietro pur di bronzo di basso rilievo. Et li quattro evangelisti nelli

cantoni, due davanti et dui da dredo, di bronzo e di basso rilievo, ma mezze figure. E da driedo l'altar, sotto lo scabello il Christo morto cunle altre figure a circo, et le due figure da man dextra, cun le altre due da man sinistra, pur di basso relievo, ma di marmo, furono di mano di Donatello.

22. Vasari, *Vite* (1550), ed. cit., vol. 3, p. 214:

Per la qual cosa cercarono i Padovani con ogni via di farlo lor cittadino e con ogni sorta di carezze fermarlo; e per intrattenerlo gli allogarono a la chiesa de' Frati Minori, nella predella dello altar maggiore, le istorie di Santo Antonio da Padvoa, le quali sono di basso rilievo a telmente con giudizio condotte che gli uomini eccellenti di quella arte ne restano maravigliati e stupiti, considerando in esse i belli e variati componimenti con tanta copia di stravaganti figure e prospettive diminuite. Similmente nel dossale dello altare fece bellissime le Marie che piangono il Christo morto.

23. Planiscig, *Donatello*, Florence, 1947, pp. 85ff. This mistake is repeated by Herzner, "Donatellos 'pala over ancona' für den Hochaltar des Santo in Padua," in *Zeitschrift für Kunstgeschichte*, vol. 33, 1970, pp. 89–126.

24. Sartori, *Documenti*, p. 89 (AdA, reg. 336, c. 64 v.):

Nota che adì 23 zugno per Messer Antonio e per Messer Bartollo e per my Zuanferigo fo concluxo merchà con Donato soprascritto de le 4 instorie de S. Antonio, de S. Francesco e de S. Luixe, scritto per Andrea da Buvolenta notaro soprascritto adì dicto, con questo che de le instorie abia ducati 85 per una, dagandolle, nete e polite da dorare, e de S. Francesco e de S. Luixe ducati 40 de l'uno, dagandolli nicti e politi ut supra, con questo che pexo de le dicte cosse non exceda le stanpe e le cosse honeste, e questo perché el San Luixe, el quale la stanpa over forma se avrì el quale el ne à promesso de refare o redurlo al pexo de la stanpa de sora verso la testa conveniente, scritto ut supra.

25. It is argued by Vertova ("La mano tesa, contributo alle ipotesi di ricostruzione dell'Altare di Donatello a Padova," in *Donatello-Studien*, Munich, 1988, pp. 209–18) that the extended hands of Saints Giustina and Daniel were addressed to the spectator, not to the central Virgin and Child, and that they were consequently placed on the extreme left and extreme right of the altar. This conflicts with the degree of finish of the two heads and with the posture of the statues.

26. *VIRGIN AND CHILD ENTHRONED.* Basilica del Santo, Padua. Bronze, H. 159 cm (62½ in.). On the back of the throne, visible only from the rear of the altar, is a relief of the Fall of Adam and Eve.

The seat is related by Greenhalgh to a Roman copy of a Greek throne in San Gregorio Magno,

Rome, and thrones in San Pietro in Vincoli, St. John Lateran and elsewhere. The throne is, however, a synthesis of sources, not a reproduction of a specific throne. The sphinxes, commonly interpreted as symbols of the Sedes Sapientie, are each supported by a single leg. This has a precedent in a marble table support in the Vatican. The Virgin's head is strongly classical and is related by Greenhalgh to figures of Cybele enthroned with sphinx supports. The quality of finish throughout the figures is unequal. The winged seraph in the center of the Virgin's crown has been chased with great care, whereas the similar seraph on the chest is in a more rudimentary state. The right hand of the Child is left almost in the rough, and the two sphinx heads are unrefined and inexpressive and seem to have been chased by a workshop assistant. The figures of Adam and Eve on the back of the throne, on the other hand, are fully finished autograph works. Greenhalgh relates the two figures to Campanian terracotta reliefs showing figures on each side of a central acanthus. This connection is unconvincing. The careful classical modeling of the figures argues some knowledge of Roman or Byzantine metalwork of the class of the sixth-century silver plate with Adonis and Aphrodite in the Cabinet des Médailles of the Bibliothèque Nationale.

STA. GIUSTINA. Basilica del Santo, Padua. Bronze, H. 154 cm (60⅝ in.). The most complex and most carefully worked up of the four Saints, her dress is of great elaboration and, like her stance, is reminiscent of the Virgin Annunciate in the Cavalcanti *Annunciation* in Santa Croce. It is not clear whether the flaw in the left wrist is due to faulty casting or to later damage. The back of the left hand and its fingers have not been worked up. Had the figure been fully finished, the crown would, in all probability, have been damascened.

ST. LOUIS OF TOULOUSE. Bronze, H. 164 cm (64½ in.). The upper part of the crozier above the shoulder is a replacement, corresponding with the crozier of St. Prosdocimus. A settlement of June 23, 1447, refers to the need to "refare or redurlo al pexo de la stampa de sora verso la testa conveniente." This may be connected with the weight of the miter.

ST. FRANCIS OF ASSISI. Bronze, H. 147 cm (58 in.). The face is modeled with great care and is finished on both sides. The hands holding the book, the book itself, and the Crucifix resting on the Saint's shoulder are of impeccably high quality. The handling of the habit, above all of the cowl over the shoulders, is far superior to that of the *St. Anthony of Padua.*

ST. DANIEL. Basilica del Santo, Padua. Bronze, H. 153 cm (60 in.). Janson (p. 162)

concludes, probably correctly, that the circular base held in the Saint's right hand held, or was to hold, a model of the city of Padua. In paintings, the Saint commonly holds a model of the city (Kaftal, *Iconography of the Saints in the Painting of Northeast Italy*, Florence, 1978, p. 254).

ST. PROSDOCIMUS. Basilica del Santo, Padua. Bronze, H. 163 cm (64 in.). The ewer held in the right hand is a replacement of 1751. The upper section of the crozier seems to have been made in the same workshop.

ST. ANTHONY OF PADUA. Basilica del Santo, Padua. Bronze, H. 145 cm (57 in.). The *St. Anthony* is, surprisingly, the least fine and least worked up of the four Saints on the altar and is markedly inferior in modeling and finish to the *St. Francis.*

27. Sartori, *Documenti*, p. 87: "11 febbraio. Per libre 2 onze 3 zera bianca, de un dopiro bruxà, dà a Donatello da Fiorença per le figure dela anchona, el fo, L. 1:10."

28. Sartori (in *Il Santo*, 1961, p. 90) infers, from a document of April 16, 1454, entrusting the goldsmith Niccolò del Papa with further work on the altar, that the Massari were dissatisfied with Donatello's work and that he was, on leaving Padua, compelled to refund part of the sum he had received to defray the cost of whatever further work was necessary. The altar seems finally to have been completed in 1477, when a substantial quantity of leaf gold was purchased in Venice for use on it. It has, however, been claimed (e.g., by L. Grassi, *Tutta la Scultura di Donatello*, Milan, 1958) that in June 1450 the altar "è terminato completamente e solennemente scoperto."

29. Sartori, *Documenti*, p. 88:

"27 aprile. (. . .) Spect. et generosus miles Dnus Antonius de Oppicis et Spect. miles et doctor egregius D. Bartholus de Zabarelis et egregius et sapiens doctor Dnus Reprahandinus de Ursatis et Nob. Dnus Iohannesfedericus de Capitibuslistae, Massarii et Deputati ad sacram Archam S. Antonii confessoris, pro se et suis successoribus in dicta Archa et nomine ipsius Archae ex parte una, et magister Donatus, quondam Nicolai, de Florentia, sculptor excelentissimus, et magister Nicolaus pictor, filius ser Petri, publicus mercator, et magister Urbanus quondam Petri, habitator Paduae in contrata Sancti Georgii, et magister Iohannes, filius Chechi, de Pisis habitator Paduae in contrata Stratae, et magister Antonius, filius Choelini de Pissis de contracta sancti Georgii, et magister Franciscus, filius Antonii, de Florentia habitator Paduae in contracta Sancti Antonii in domo a pisce, omnes sculptores et discipuli praefati magistri Donati, ex parte altera unanimiter et concorditer venerunt ad hanc compositionem et pactum in hac forma videlicet: praefati magister Donatus et

magister Nicolaus et magistri disipuli praelibati magistri Donati promisserunt praelibatis Dominis Massariis ex sua industria faere et perficere et complere decem angelos de metalo, videlicet rami duri, quos angelos iam fuderunt, et taliter perficere quod ipsi angeli possint deaurari notabiliter, et quod maculae et incisura aliquae in ipsis non reperiantur, sed per aurifices et alios inteligentes aprobentur et aprobati habeantur ita et taliter quod deaurari possint:
promitentes insuper praedicti cum omni diligentia et studio et absque aliis intromissionibus vacare circa praedictum opus usque ad plenam satisfactionem. Et si videbitur praedictis comissaris quod fiat unum canale vel redundinum circa cornicem ipsorum angelorum, quod tunc praedicti teneantur ipsam cornicem vel redundinum facere cum omni diligentia, ut supra. Insuper quoque se obligant praedicti, quatuor evangelistas, qui iam formati sunt in cera et cohoperti terra et stampa et forma iam paratae sunt ad fundendum, qui sunt in forma animalium prout pinguntur, in mensura unius pedis cum dimidio pro quolibet quadro, dare praedictos fussos et perfectos in sculptura et delimatos, ita et taliter quod deaurari possint, et non vacando ad alia opera sed continuando usque ad plenam satisfactionem. Ex alia parte praefati Domini Deputati, per se et suos successores in dicta Archa, promisserunt, pro eorum manifactura et mercede et industria, dare et solvere praefatis magistris, ibidem praesentibus stipulantibus pro se et suis haeredibus, pro quolibet angelo ducatos duodecim auri et de ipsis evangelistis ducatos sexdecim auri. De qua quantitate praedicti magistri iam receperunt ducatos triginta et soldos triginta sex, videlicet Iohannes de Pisis praenominatus habuit ducatos sex et libram unam et soldos decem, Antonius de Pisis habuit ducatos sex et libras IV, soldos septem, Urbanus habuit ducatos sex et libras quator soldos septem, et Franciscus habuit ducatos sex et libras quatuor soldos duodecim. Residuum vero habebunt, secundum eorum necesitates et ad beneplacitum dictorum Massariorum, prout in opere procedent.
Ad preces et instanciam praedictorum magister Nicolaus Iohannes (Nani) fideiussit et fideiussorem se constituit de pecuniis perceptis et percipiendis pro dicto opere, et quod praedicti stabunt in opere continuo sine intromissione alterius sculpturae vel operis usque ad perfectionem dictarum figurarum, sub poena et obligatione restituendi omnem pecuniam quam praedicti recepissent de dicta opera et damni et interesse sancti Antonii pro dicta opera quotiens contrafactum fuerit, tam in negligendo opus quam in non satisfattiendo ad perfectionem ipsius operis laudabiliter secundum promissa."

30. *CHRIST IN THE TOMB MOURNED BY TWO ANGELS.* Bronze, H. 58 cm, W. 56 cm (H. 22¾ in., W. 22 in.). The figure of Christ is severed through the thighs. Each of the two Angels supporting the curtain behind him has one hand pressed to the face. The raised knees of

the Angels are set on the same horizontal as Christ's elbows, and the forearms of Christ, when protracted, correspond with the raised elbows of the Angels. The wings of the two Angels extend over the decorated border. At the back are three groups of four pierced circles. A loose derivative is found in the Giovanni Bellini *Pieta with Two Angels* in the Museo Civico Correr. The relief is flanked by

TWO ANGELS SINGING FROM A BOOK. Bronze, H. 58 cm, W. 21 cm (H. 22⁴/₅ in., W. 8¹/₄ in.).

TWO ANGELS SINGING AT A LECTERN. Bronze, H. 58 cm, W. 21 cm (H. 22¹/₄ in., W. 8¹/₄ in.).

There is no means of ascertaining whether the two reliefs were intended to occupy their present place flanking the Pietà or formed the concluding feature, at right and left, of the ten single Angel reliefs. The two reliefs were modeled and worked up by Donatello.

31. *ANGEL PLAYING A DIAULOS.* Bronze, H. 58 cm, W. 21 cm (H. 22¹/₄ in., W. 8¹/₄ in.). The Angel is turned away from the spectator, blowing his pipe into an area behind the frame. His wing protrudes over the margin of the relief.

ANGEL WITH CYMBALS. Bronze, H. 58 cm, W. 21 cm (H. 22³/₄ in., W. 8¹/₄ in.). The body beneath the dress is modeled with the utmost care. The wings are cut at each side of the frame, and both feet protrude over the front edge of the relief.

ANGEL WITH A TAMBOURINE. Bronze, H. 58 cm, W. 21 cm (H. 22³/₄ in., W. 8¹/₄ in.). This brilliant, maenad-like figure is alone in filling the whole height of the relief. The foreshortened tambourine abuts on the upper frame, and the right foot protrudes over the base. Owing to the free pose the height of the two wings is disparate.

ANGEL TURNED TO THE LEFT PLAYING A DOUBLE PIPE. Bronze, H. 58 cm, W. 21 cm (H. 22³/₄ in., W. 8¹/₄ in.). The pose is established by the strong *contrapposto* of the figure. The dress, twisted around the legs, adds a factor of strong movement to the pose, and the instrument, the wing, and the right foot protrude beyond the frame. Broken at the left, where the lower part of the curtaining frame is missing.

Workshop of Donatello, *Angel Blowing A Pipe.* Bronze, H. 58 cm, W. 21 cm (H. 22³/₄ in., W. 8¹/₄ in.). The modeling of the figure is flat and inorganic. Perhaps developed from a drawing by Donatello.

Workshop of Donatello, *Angel Playing A Mandoline.* Bronze, H. 58 cm, W. 21 cm (H. 22³/₄ in.,

W. 8¹/₄ in.). The head, which is bent forward, has an angled halo. The drapery forms are slack, and the attachment of the head and body is weak. The modeling is perhaps due to the same artist as the *Symbol of St. Matthew.*

Workshop of Donatello, *Angel Playing A Pipe.* Bronze, H. 58 cm, W. 21 cm (H. 22³/₄ in., W. 8¹/₄ in.). The attachment of the wings is inorganic and the modeling of the body flat and loose. The hanging drapery has something in common with the drapery over the book in the left foreground of the *Symbol of St. Luke.*

Workshop of Donatello, *Angel Playing A Harp.* Bronze, H. 58 cm, W. 21 cm (H. 22³/₄ in., W. 8¹/₄ in.). The garland in the background is modeled, not incised. The torsion of the body at the waist is inadequately rendered, as are the rotund head and cheeks.

Workshop of Donatello, *Angel With A Tambourine.* Bronze, H. 58 cm, W. 21 cm (H. 22³/₄ in., W. 8¹/₄ in.). The chasing in this efficient, rather prosaic figure has something in common with that of the *Symbol of St. John.*

Workshop of Donatello, *Angel Playing A Rebec.* Bronze, H. 58 cm, W. 21 cm (H. 22³/₄ in., W. 8¹/₄ in.).

Workshop of Donatello, *Symbol Of St. John.* Bronze, 59.8 cm (23¹/₂ in.) square.

Workshop of Donatello, *Symbol Of St. Matthew.* Bronze, 59.8 cm (23¹/₂ in.) square.

Workshop of Donatello, *Symbol Of St. Mark.* Bronze, 59.8 cm (23¹/₂ in.) square.

Workshop of Donatello, *Symbol Of St. Luke.* Bronze, 59.8 cm (23¹/₂ in.) square.

The four symbols of the Evangelists were contracted to Giovanni di Pisa, Urbano da Cortona, Antonio Chellini, and Francesco del Valente, each of whom was responsible for one relief as well as for a number of the angel panels. Janson, pp. 179–80, observes that the Angel reliefs attain "a surprisingly uniform level of quality." Their quality is, in fact, notably unequal. In the nineteenth-century Donatello literature attempts were made to identify individual hands. These were unsuccessful, since certain essential visual data were, and are still, missing. The problem, however, is a real one and cannot be ignored.

32. *ENTOMBMENT.* Pietra di Nanto, (limestone), H. 138 cm. W. 188 cm (H. 54³/₈ in., W. 74 in.). A payment of L. 500 for the relief was made on April 16, 1449 (Sartori, in *Il Santo,* I, i, p. 68). It at one time hung on the wall of the church and was considered by earlier students to be in terracotta (Semper, 1887, p. 96). It is referred to in the contract of 1579 for Cam-

pagna's high altar (*Archivio Sartori,* p. 232: "si ubligamo incassarvi quel Christo i pietra di Nanto quale ora si trova dietro l'altar grande e si ubligamo restaurarlo et nettarlo e fargli una ramata sopra per conservarlo"). The figurated surface is covered with the remains of varnish or paint. The form of the sarcophagus containing three slabs of hardstone with elaborate framing is atypical of Donatello, as are the decorative rectangles that punctuate the background. Though the expressive style of the figures must be due to Donatello, the quality of execution is reminiscent of Bellano, and the image is in sharp contrast to that of the bronze Pietà from the front of the altar and the four Miracle reliefs. It has no close parallel in Donatello's earlier or later works.

33. V. Gamboso, "La 'Sancti Antonii confessoris de Padua Vita' di Sicco Polentone (c. 1435)" in *Il Santo,* vol. I, 1961, pp. 199–283.

34. Sartori, *Documenti,* p. 89 (see note 24). The full list of scenes is given in a contract of June 23, 1447, printed by Sartori in *Il Santo,* I, i, 1961, p. 50.

35. *MIRACLE OF THE NEWBORN CHILD.* Bronze, H. 57 cm, W. 123 cm (H. 22¹/₂ in., W. 48¹/₂ in.). For source see Gamboso, op. cit., p. 241.

36. *MIRACLE OF THE MULE.* Bronze, H. 57 cm, W. 123 cm (H. 22¹/₂ in., W. 48¹/₂ in.). For source see Gamboso, op. cit., p. 243.

37. *MIRACLE OF THE WRATHFUL SON.* Bronze. H. 57 cm, W. 123 cm (H. 22¹/₂ in., W. 48¹/₂ in.). For source see Gamboso, op. cit., p. 247. The classical references in this and in the other reliefs are discussed by Greenhalgh, op. cit., p. 161.

38. The figure of the wrathful son is commonly associated with the Pentheus on a Roman sarcophagus at Pisa. The raised arm and raised leg, however, have (as noted by Janson, "Donatello and the Antique," in *Donatello e il suo tempo,* Florence, 1968, pp. 86–88, following F. Bürger, "Donatello und die Antike," in *Repertorium für Kunstwissenschaft,*" vol. 30, 1907, pp. 1–13) a closer relationship to a soldier fallen from his horse on the Trajan column and a Satyr thrown by a centaur on a sarcophagus in the Vatican. The seated mother on the left also depends from the antique. For this see also Greenhalgh, op. cit., p. 161.

39. *MIRACLE OF THE MISER'S HEART.* Bronze, H. 57 cm. W. 123 cm (H. 22¹/₂ in., W. 48¹/₂ in.). For source see Gamboso, op. cit., p. 240. The relation of this scene to Roman illusionistic painting is discussed by Greenhalgh, op. cit., p. 161. An excellent account of the gilding, silvering, and damascening used

throughout the reliefs is given by White, in *Le Sculture del Santo di Padova*, Vicenza, 1984, pp. 66–67. White also gives an interesting analysis of the interrelated dimensions of the reliefs.

40. The relationship of Donatello and Jacopo Bellini is of fundamental importance for both artists. A case has been advanced by Röthlisberger ("Notes on the Drawing Books of Jacopo Bellini," in *Burlington Magazine*, vol. 98, 1956, pp. 358–64) for supposing that Bellini's perspectivism derives from Donatello, and that his drawings must postdate the Padua reliefs; this is implausible because the handling of space in Donatello's four Paduan reliefs is altogether different from the handling of space in the immediately antecedent scenes in the Old Sacristy. A brilliant, though in part overimaginative, account of the Albertian architecture employed in the Miracle reliefs at Padua is given by Morolli (*Donatello: Immagini di Architettura*, Florence, 1987, pp. 66–95, and "Donatello e Alberti 'amicissimi,' " in *Donatello-Studien*, Munich, 1989, pp. 43–67).

41. Herzner, *Regesti*, nos. 323, 324, and Sartori, in *Il Santo*, I, i, pp. 63–64.

42. Herzner, *Regesti*, nos. 329–38, 343, 344. C. Rosenberg, "Some New Documents Concerning Donatello's Unexecuted Monument to Borso d'Este," in *Mitteilungen des Kunsthistorischen Institutes zu Florenz*, vol. 17, 1973, pp. 149–52.

43. Herzner, *Regesti*, nos. 325–28, 339, 342. Donatello's negotiations with Lodovico Gonzaga fall into two phases, the first conducted from Padua and the second (and later) from Siena. In 1482 a new design for the chapel was prepared by Mantegna.

44. Workshop of Donatello, *Blood of The Redeemer*. Palazzo Ducale, Mantua. Tufo, H. 122 cm, W. 66 cm (H. 48 in., W. 26 in.). The relief is regarded by Pope-Hennessy as "a transcription of a design of Donatello's by a member of his Paduan studio," and is given by Vaccari (in *Donatello e i Suoi*, Florence, 1986, no. 35) to a follower of Donatello. Its affinities with Mantegna are stressed by Paccagnini ("Il Mantegna e la plastica dell'Italia Settentrionale," in *Bollettino d'Arte*, vol. 46, 1961, pp. 65–100). The relief is much weathered but recalls the marble *Lamentation over the Dead Christ* in London, where a very similar border motif is employed. The iconography of the *Redeemer with Angels Carrying the Instruments of the Passion* is reviewed by Middeldorf, "Un rame inciso del Quattrocento," in *Raccolta di scritti (Collected Writings)*, vol. 3, Florence, 1979.

45. Herzner, *Regesti*, no. 340. See note 7 above.

46. *CRUCIFIXION*. Musée du Louvre, Paris, Coll. Camondo, Bronze, H. 46 cm, W. 28.8 cm (H. 18 in., W. 11³/₈ in.). Pope-Hennessy, in *Apollo*, vol. 91, 1975, pp. 82–87. Probably identical with a relief in the *guardaroba* of Cosimo I, described by Borghini (*Il Riposo*, Florence, 1584, p. 321) as "un altro quadro pur di metallo, in cui si vede Cristo in croce e con altre figure appartenenti all'istoria."

47. *MARTYRDOM OF ST. SEBASTIAN*. Musée Jacquemart-André, Paris. Bronze, H. 24 cm, W. 26 cm (H. 9¹/₂ in., W. 10¹/₄ in.). For the relief and its source, see Pope-Hennessy (*Apollo*, vol. 103, 1976, pp. 172–91, and *The Study and Criticism of Italian Sculpture*, New York, 1980, pp. 95–96), Gavoty (*Sculpture Italienne: Musée Jacquemart-André*, Paris, 1975, No. 23), and, with fuller bibliography, Darr (in *Donatello e i Suoi*, Florence, 1986, pp. 163–64).

48. *CRUCIFIXION*. Museo Nazionale, Florence. Bronze, partly gilded, with gold and silver inlay, H. 97 cm, W. 73 cm (W. 38 in., W. 28³/₄ in.). For a full bibliography see Collareta in *Omaggio a Donatello*, Florence, 1986, pp. 328–29. The relief is described by Vasari, *Vite* (1568), ed. cit., vol. 3, p. 219: "Nella medesima guardaroba è in un quadro di bronzo di basso rilievo la Passione di Nostro Signore con gran numero di figure." The relief is perhaps identical with a bronze relief dispatched to Florence when Donatello left Padua. There is some reason to believe (Civai, "Donatello e Roberto Martelli: nuove acquisizioni documentarie," in *Donatello-Studien*, Munich, 1989, pp. 253–62) that the relief later belonged to the Martelli, from whom it passed to Cosimo I. It is not mentioned in any Martelli inventory after 1529.

CHAPTER X

1. Workshop of Donatello, *MADONNA AND CHILD*. Bronze examples of this relief are encountered relatively frequently. For an example in the Victoria and Albert Museum, London (7474-1861), see Maclagan, *Catalogue of Italian Plaquettes*, 1924, p. 16. H. 11.6 cm, W. 9.4 cm (H. 4¹/₂ in., W. 3³/₄ in.). The framed version in pigmented stucco is discussed by Pope-Hennessy, *Catalogue of Italian Sculpture in the Victoria and Albert Museum*, vol. 1, London, 1964, no. 68, pp. 83–85.

2. For an example of this popular relief in the Victoria and Albert Museum (4080-1857) see Maclagan, loc. cit., where the design is attributed to Donatello. H. 9.8 cm., W. 7.75 cm. (H. 4 in., W. 3 in.). A good version is also found in the National Gallery of Art, Washington, D.C. (Kress Collection) for which see Pope-Hennessy, *Renaissance Bronzes from the Samuel H. Kress Collection*, London, 1965, no. 60, pp. 22–23.

3. Terracotta with gilding and polychromy, H. 69.8 cm, W. 43.2 cm. The attribution is due to Valentiner (*Exhibition of Italian Gothic and Early Renaissance Sculptures*, Detroit Institute of Arts, 1938, no. 25) and is widely accepted (e.g., by Pope-Hennessy, "The Sixth Centenary of Ghiberti," in *The Study and Criticism of Italian Sculpture*, New York, 1980, pp. 63–70, and by Passavant, "Zu einigen Toskanischen Terrakotta-Madonnen der Frührenaissance," in *Mitteilungen des Kunsthistorischen Institutes in Florenz*, vol. 31, 1987, pp. 197–236). By Bellosi ("Ipotesi sull'origine delle terracotte quattrocentesche," in *Jacopo della Quercia*, 1977, pp. 163–79, and "Donatello e il recupero della scultura in terracotta," in *Donatello-Studien*, Munich, 1989, pp. 130–54) and Darr (*Donatello e i suoi*, no. 23, pp. 132–35), it is ascribed, on wholly factitious grounds, to Donatello. For two earlier reliefs (in London and Rochester), probably by the same hand, see Pope-Hennessy, loc. cit., figs. 24, 25.

4. Conservatorio delle Signore Montalve alla Quiete. A third version in terracotta was formerly in the collection of Prince Nicholas of Romania.

5. For the relationship between the two reliefs see Pope-Hennessy, op. cit., vol. 1, 1964, no. 52, pp. 59–60. Passavant, loc. cit., reproduces a number of examples of both versions of the relief, which he attributes, in my view correctly, to the workshop of Ghiberti.

6. National Gallery of Art (Kress Collection, K. 1278), Pigmented and gilded terracotta, H. 102.5 cm, W. 62.2 cm (H. 40³/₈ in., W. 24¹/₂ in.). I cannot follow the view of Middeldorf (*Sculpture from the Samuel H. Kress Collection*, London, 1976, p. 13.) that this splendid work depends from a superior original.

7. Polychrome terracotta, H. 140 cm, W. 48 cm (H. 55 in., W. 19 in.). Transferred in 1561 to the Ognissanti from San Salvatore in Monte or (Gentilini, *La Civiltà del Cotto*, Impruneta, 1980, pp. 93–94) from San Miniato al Monte. Attributed by Meller (verbally) to Nanni di Bartolo, it was published by Bellosi ("Ipotesi sull'origine delle terracotta quattrocentesche," in *Jacopo della Quercia*, 1977, pp. 163–79.).

8. Terracotta, with traces of polychromy and gilding, H. 68.6 cm (27 in.). The statuette, long attributed to Ghiberti, is the work of Nanni di Bartolo. It is wrongly ascribed by Bellosi (loc. cit.) and Darr (loc. cit.) to Donatello.

9. Painted and gilded terracotta, H. 120.9 cm, W. 47.2 cm, D. 33.5 cm (H. 47¹/₂ in., W. 18¹/₂ in., D. 13 in.). Traditionally given by Bode

and other students to Donatello, it was described, in a perceptive article by Valentiner (in *Art Quarterly*, vol. 3, 1940, pp. 196–200), as an early work of Michelozzo combining the styles of Ghiberti and Donatello. The attribution to Michelozzo seems to me to be correct. I have long suspected that this figure (which is officially ascribed to Donatello) and the half-length Madonna in Washington noted above (which is officially ascribed to Ghiberti) are by one and the same hand.

10. *Il Museo Bardini a Firenze*, a cura di Enrica Neri Lusanna e Lucia Faedo, Milan, 1986, no. 172, as attributed to Donatello. Pigmented terracotta H. 90 cm, W. 64 cm (H. 35¹/₂ in., W. 25 in.). The relationship of the relief to the two Washington Madonnas is very close.

11. Michael Knuth, "Die Berliner 'Maria mit dem Kinde im Mantel'—ein Frühwerk Donatellos," in *Forschungen und Berichte*, Berlin, 1990, pp. 201–10. The quality and condition are alike inferior to those of the Bardini Madonna, but the original was possibly by the same hand.

12. *PAZZI MADONNA*. Staatliche Museen Berlin. Marble, H. 74.5 cm, W. 69.5 cm, D. 8 cm (H. 29¹/₈ in., W. 27³/₈ in., D. 3 in.). A notably misleading catalogue entry by Janson (pp. 44–45) makes no reference to the physical state of the relief, but contests its provenance. The relief was bought for the Kaiser Friedrich Museum by Bode in 1886 from Conte Lamponi-Leopardi, who had acquired it not long before from the Palazzo Pazzi. The relief is described in 1677 by Bocchi (*Le Bellezze della Città di Firenze*): "Casa di Francesco Pazzi nella quale è una bellissima Vergine di Basso rilievo in marmo di Donatello: e il Bambino Gesù a sedere sopra un Guanciale, e con la destra la Vergine il sostegni mentr'egli con la sinistra alata regge i lembi del velo che dal capo della Madonna pendono; e vaga in ogni sua parte, ed i panneggiamenti sono bellissimi, esprime la Vergine l'affetto verso il figliuolo, con grand arte ed è tale, che nelle divise seguite tra Pazzino, la prese Alessandro padre di Franceso per sc. 500 second o la stima che ne fu fatta." There is nothing in this description that is incompatible with the relief in Berlin. The fact that the viewing point is in the center of the base, not in the center of the relief, suggests that the *Madonna* was carved for a specific architectural context, and the existence of many coarse stucco reproductions of the two figures without the architectural setting may indicate that the original was a popular object of devotion and was publicly accessible.

13. *PROPHET* and *SIBYL*. Duomo, Florence. Marble, H. ca. 64 cm (25 in.). For the reliefs ("2 teste di profeti intagliate che mancavano nela storia della Nunziata") see Poggi, no. 391, and Janson, pp. 43–45. Doubts as to their autograph character were dispelled by Lányi, who relates them to the Salome in the *Feast of Herod* and to the statuette of Faith on the Siena Font.

14. Domenico Veneziano's *Madonna and Child* from the Carnesecchi tabernacle adjacent to the church of Santa Maria Maggiore (now in the National Gallery, London) is dated by Wohl (*The Paintings of Domenico Veneziano*, New York, 1980, pp. 114–16), ca. 1432–37. The fresco has a central vanishing point.

15. *MADONNA OF THE CLOUDS*. Boston Museum of Fine Arts. Marble, H. 33.5 cm, W. 32.2 cm, D. 2–3 cm (H. 13 in., W. 12⁵/₈ in., D. ³/₄–1 in.). The relief was acquired by bequest from Quincy Adams Shaw. Its earlier history is assembled by Kauffmann (pp. 69, 218ff.) and Swarzenski ("Donatello's 'Madonna in the Clouds' and Fra Bartolomeo," in *Bulletin of the Boston Museum of Fine Arts*, vol. 40, 1942, 64–77). The relief is twice mentioned by Vasari, in the life of Fra Bartolomeo (1568; *Vite*, ed. cit., vol. 4, p. 89) as in the possession of the Piagnone supporter Piero del Pugliese, who commissioned Fra Bartolomeo to paint two wings for it, which showed, when open, the Nativity and Circumcision and, when closed, the Annunciation. The wings are now in the Uffizi, and though much smaller than the Madonna may well have been painted for the tabernacle in which, to judge from its flat frame, it was contained. The relief is mentioned again by Vasari (1568; *Vite*, ed. cit., vol. 3, p. 28) in the *guardaroba* of Cosimo I. A late sixteenth-century marble copy of the relief is in the Victoria and Albert Museum and a related drawing, on the same scale, is in the Uffizi. The relief was cleaned in 1986.

16. *MADONNA OF HUMILITY WITH TWO ANGELS*. Kunsthistorisches Museum, Vienna. Gilt bronze, diameter 27 cm (10⁵/₈ in.). The relief, which is set in a marble frame carved about 1475 by Francesco di Simone, is reproduced in a late sixteenth-century drawing in the Uffizi along with the Boston *Madonna of the Clouds*, and may therefore also have been in the Medici *guardaroba*.

17. *VERONA MADONNA*. Via delle Foggie, Verona. Terracotta, H. 95.3 cm (37¹/₂ in.). The relief exists in a large number of versions (for some of which see Pope-Hennessy, *Catalogue of Italian Sculpture in the Victoria and Albert Museum*, vol. 1, London, 1964, pp. 84–85). A useful critical examination of versions of the relief is contained in a *Mémoire de diplome* of 1989 by Marie-Noelle Payre.

18. Terracotta, H. 84 cm, W. 68 cm (H. 33 in., W. 26³/₄ in.). The relief (for which see *Don-atello e i Suoi*, 1986, no. 41) enjoyed some popularity, and a pigmented version (paint surface not in the main authentic) is at San Giuliano a Settimo (op. cit., no. 42). The relief is the work of an unidentified Donatello follower and seems to date from about 1455. A weak case for reascribing it to Donatello is made by Avery (loc. cit. and "Donatello's Madonnas Revisited" in *Donatello-Studien*, Munich, 1989, pp. 219–34).

19. Staatliche Museen, Berlin. See Fiocco, *Mantegna*, Milan, 1937, Fig. 9.

20. *MADONNA AND CHILD*. Musée du Louvre, Paris. No. 389. Pigmented and gilded terracotta, H. 102 cm, W. 74 cm (H. 40 in., W. 29 in.). When reviewing the Donatello Madonnas ("The Madonna Reliefs of Donatello," in *Apollo*, vol. 103, 1976, p. 178), I expressed some doubt as to whether the relief was made in Florence about 1440 or after 1443 in Padua. The weight of evidence is in favor of the later date.

21. *MADONNA AND CHILD WITH FOUR CHERUBIM*. Staatliche Museen (former Bode Museum), Berlin. Terracotta, formerly pigmented and gilded, H. 102 cm, W. 72 cm (H. 40 in., W. 29 in.). One of the greatest of Donatello's reliefs, the Madonna was almost completely destroyed at the end of World War II, and its pigmented surface was virtually obliterated, though some traces of priming remain. The relief itself was fragmented and coarsely reintegrated in Moscow; it has since been further treated. The Virgin, with hair parted in the center, is closely related to the Virgin of the Padua High Altar, and her long, delicately modeled fingers recall those of the Santa Giustina.

22. *MADONNA AND CHILD WITH FOUR ANGELS*. National Gallery of Art, Washington, D.C. (Kress Collection). Bronze, diameter 22.2 cm (8⁵/₈ in.). The relief has a medium brown, not a dark patina. The second version, in a private collection, is identical in size, but has a dark patina with extensive gilding in the striations of the cloak and on the angels on the left-hand side. For the bibliography of the Washington relief, which was given by Bode, correctly, to Donatello "von fremder Hand sauber ziseliert," and later, wrongly, to Bertoldo, see Pope-Hennessy (*Renaissance Bronzes from the Samuel H. Kress Collection*, London, 1965, no. 56, p. 20).

23. J. Lawson, "New Documents on Donatello," in *Mitteilungen des Kunsthistorischen Institutes in Florenz*, vol. 18, 1974, pp. 357–62. The letter dates from April 14, 1458, and reports a conversation with "misser Mariano, che già 4 anni ve lo menavo da Padova, avendo esso grande affection d'essere a Siena, per non mor-

ire fra quelle ranochie di Padova; che poco ne manchò."

24. For Chellini's *ricordo* see Lightbown, "Giovanni Chellini, Donatello and Antonio Rossellino, in *Burlington Magazine*, vol. 104, 1962, pp. 102–4, and Janson, "Giovanni Chellini's 'Libro' and Donatello," in *Studien zur toskanischen Kunst: Festschrift für Ludwig Heinrich Heydenreich*, Munich, 1964, pp. 131–38. An analysis of Chellini's tax returns (M. Battistini, "Giovanni Chellini medico di S. Miniato," in *Rivista di Storia delle Scienze Mediche e Naturali*, vol. 18, 1927, pp. 3–13) proves him to have been a man of substantial wealth with large investments in land and in the Monte del Commune.

25. *MADONNA AND CHILD WITH FOUR ANGELS.* Victoria and Albert Museum, London. Bronze, parcel gilt, diameter 28.5 cm (11¼ in.). Latex casts of the mold on the reverse produced an image identical with that on the front face. The phrase in Chellini's *ricordo* "suso vetro strutto" has given rise to a suggestion by Radcliffe and Avery ("The Chellini Madonna by Donatello," in *Burlington Magazine*, vol. 118, 1976, pp. 377–87) that the mold on the back was designed specifically to permit the making of glass reproductions. The evidence for this contention is confused, and the mold affords no indication of the media in which reproductions were to be made. Coarse stucco derivatives are in the Museo del Castelvecchio at Verona and at Vicchio di Rimaggio.

26. *MADONNA AND CHILD WITH TWO ANGELS.* Kunsthistorisches Museum, Vienna. Pigmented stucco, H. 62 cm, W. 48 cm (without frame) (H. 24½ in., W. 19 in.). The relief is a rough squeeze from a superior original, which is likely to have been in bronze, in view of (1) analogies between the balustrade and that of the Chellini *Madonna*; (2) the handling of the Virgin's veil; and (3) the relationship between the angels and the friezes of putti on the San Lorenzo pulpits.

27. *MADONNA AND CHILD WITH THREE ANGELS.* Museo dell'Opera del Duomo, Siena. Marble with green marble inlay, H. 89 cm, W. 95 cm (H. 35 in., W. 37½ in.). At one time set over the Porta del Perdono of Siena Cathedral (where it has now been replaced by a reproduction), the relief was carved for the interior of the Cathedral. It was long assumed (for this see E. Carli, *Donatello a Siena*, Rome, 1967, p. 26) that the chapel for which it was destined was that of the Madonna delle Grazie, which was under reconstruction in 1457, when Donatello moved from Florence to Siena, and where the relief is described by Landi (*Memorie intorno alle pitture, statue et altre opere che si ritrovano nel Tempio della Cattedrale di Siena*; Ms. Soprintendenza alle Gallerie di Siena, c. 125 f.). It is, however, mentioned in inventories of 1458 and 1467 (for this see Herzner, "Donatello in Siena," in *Mitteilugen des Kunsthistorischen Institutes in Florenz*, vol. 15, 1971, p. 168) as in the chapel of St. Calixtus, for which it appears to have been carved. Since its removal from the Porta del Perdono it has been cleaned, and the broadly unfavorable verdicts on its quality before that time have, as a result, to be revised. The Virgin, whose features and dress recall those of the *Judith*, is substantially by Donatello, and only the heads of cherubim in the background are of inferior quality. A partial copy of the two main figures in the convent of the Murate in Florence (H. 85 cm, W. 50 cm [H. 33½ in., W. 19⅝ in.]), dating from the late nineteenth or early twentieth century, is published by Bonsanti as a work of Donatello (*Donatello e Suoi*, 1986, no. 46, pp. 158–59).

28. *MADONNA AND CHILD.* Musée du Louvre, Paris, Coll. Piot, No. 710. Terracotta, with traces of priming for pigmentation, D. 73 cm (28¾ in.). At one time officially ascribed to "Ateliers Florentins, XVe. siècle," the relief is closely related to the Chellini *Madonna* and is a characteristic late work of Donatello. The background is covered with a pattern of circular recesses, which were originally filled with *verre eglomisée* roundels. Some of these survive. The relief was grossly overcleaned in 1959, and the missing roundels have been replaced in plastic.

A pigmented version in stucco, in an original frame dating from about 1455–65, is in the collection of Sir Harold Acton. The complexity of the veil over the head suggests that the Louvre relief may be identical with a Madonna noted by Vasari (1568; *Vite*, ed. cit., vol. 3, p. 219) in the house of Bartolomeo Gondi ("una Nostra Donna di mezzo rilievo, fatta de Donato con tanto amore e diligenza che non è possibile di veder meglio ne imaginarsi come Donato scherzasse nell'acconciatura del capo e nella leggiadria dell'abito ch'ella ha indossa").

29. *MADONNA AND CHILD.* Victoria and Albert Museum, London, 57–1867. Gilt terracotta, H. 74.3 cm, W. 55.9 cm (H. 29¼ in., W. 22 in.). Old (possibly original) gilt is preserved in the recessed areas; in the raised areas the gold is missing and has been replaced by bronze-colored paint. The relief is modeled, not cast, and was viewed with intermittent skepticism in the nineteenth century. Its connection with the *Judith*, which is now generally accepted, suggests that it was modeled about 1455–60 Pigmented variants of the composition are known (see Pope-Hennessy, *The Study and Criticism of Italian Sculpture*, New York, 1980, p. 100, fig. 33).

30. Good examples of the three interrelated reliefs exist in the Museo Bardini, Florence (*Il Museo Bardini a Firenze*, vol. 2, *Le Sculture*, a cura di Enrica Neri Lusanna e Lucia Faedo, nos. 187, 188, 189). A link between these reliefs and the work of Urbano da Cortona is established by the heads of prophets in the spandrels of a version in the Victoria and Albert Museum (Pope-Hennessy, op. cit., no. 278, and "Some Donatello Problems: V, Three Stucco Reliefs," in *Studies in the History of Art Dedicated to William E. Suida on His Eightieth Birthday*, London, 1959, pp. 61–65).

31. *MADONNA AND CHILD WITH TWO ANGELS.* Cryan collection, Boca Raton. Pigmented terracotta, H. 85.5 cm, W. 68 cm (H. 33⅝ in., W. 26¾ in.). Stated to have come from the church of San Felice, Florence. A later adaptation in marble is in the cloister of SS. Annunziata. Published by Pope-Hennessy, "A Terracotta Madonna by Donatello," in *Burlington Magazine*, vol. 125, 1983, pp. 83–85. For the later literature see Darr, in *Donatello e i Suoi*, Milan, 1986, no. 39, pp. 150–52.

32. Vasari, *Vite* (1568), ed. cit., p. 219: "Similmente in casa degli eredi, che fu ottimo cittadino e vero gentiluomo, e un quadro di Nostra Donna di mezzo rilievo nel marmo, che è tenuta cosa rarissima."

33. Vasari, loc. cit.: "Messer Antonio de' Nobili ancora, il quale fu depositario di Sua Ecc., aveva in casa un quadro di marmo di man di Donato, nel quale è di basso rilievo una mezza Nostra Donna tanto bella che detto messer Antonio la stimava quanto tutto l'aver suo; ne meno fa Giulio suo figliuolo, giovane di singolar bontà e guidizio et amator de' virtuosi e di tutti gl'uomini eccellenti."

34. See note 28, above.

35. Vasari, loc. cit: "Parimente messer Lelio Torelli, primo auditorio e segretario del signor Duca, e non meno amator di tutte le scienze, virtù e professioni onorate che eccellentissimo iurisconsulto, un quadro di Nostra Donna di marmo di mano dello stesso Donatello."

CHAPTER XI

1. Sartori, *Documenti*, pp. 94–95.

2. Herzner, *Regesti*, no. 346. The marble slabs were to be handed over to "Marino, araldo del Comune di Padova . . . su richiesta di Donatello."

3. The instructions and payments to Niccolò del Papa on and after March 12, 1454 (for which see Sartori, *Documenti*, p. 356), cover the fixing of reliefs and other work, and give some im-

pression of the state of the altar when Donatello left for Florence. The balance of the rent due for Donatello's house in Padua "libras duodecim pro completa solitudine dicti affictus anni 1453" was paid on November 19, 1454 (Sartori, *Documenti*, pp. 94–95).

4. Herzner, *Regesti*, no. 348. The lease involved a payment to Michelozzo, who had been the tenant of these premises, for sums that he had spent "per copertura et alia reactamenta."

5. It is not clear whether the studio was leased to Donatello and sublet to Michelozzo for the period of Donatello's absence or was the subject of a new lease.

6. Herzner, *Regesti*, no. 351.

7. Information about Donatello's activity in Florence is contained in two letters published by Foster ("Donatello Notices in Medici Letters," in *Art Bulletin*, vol. 62, 1980, pp. 147–50). The first is a letter of September 12, 1454, from Piero di Cosimo de' Medici at Faenza to "Sandro factore di Cosmo in Caffagiuolo," reporting that four cases containing "balle, fortieri e altre cose" were being despatched to Caffagiuolo, and asking that the "vecturali" responsible for the consignment should be treated with "quanto honori t'e possibile." The cases contained the property of Piero, as well as that of Amerigo Benci and Tommaso Niccolini. The list concludes with the words
Una tavola di bronzo
Una testa di bronzo sono di Donatello.
Una capsa vechia
The normal route from Padua to Florence was by way of Faenza, and the "tavola di bronzo" may conceivably be the large Medici *Crucifixion* in the Bargello, which seems to have been cast and damascened in Padua. The "testa di bronzo" is untraced. The second letter, of October 9, 1455, is addressed by Giovanni di Luca Rossi in Florence to Giovanni di Cosimo de' Medici at Trebbio, and reads as follows:

Al nome di dio a dì 9 d'ottobre 1455

Honorando et magior mio. Ieri vi schrisse alla ventura; facendovi risposta a una vostra de' dì 6.
Sono stato chon Donato ed ògli dato f[iorini] tre p[er] r[e]sto di due Vergine Marie, nonestante lui non era ben chontento; p[r]ossimi [sic] ristorallo, questo farete voi.
Iermattina a buon' ora andò Donato a volterra p[er] chonducere l'op[er]a de' marmi p[er] 'l vostro schrittoio, e a llui fe' dare f[iorini] otto d' oro p[er] l' andare lui et lo chompagnio et per mandare i detti marmj.
I chappellinai sono forniti e detto dì gli mandò le Vergine Marie e chappellinai a fFiesole.
Fuvi hieri e maestri. Non vi lavorono nè [ie]ri nè l'altro p[er] la piova, e pocho vi

possono lavorare p[er]chè non è chalcina nè rena; ò fatto e fo quel buono ch' io posso p[er]chè voi usciate di noia. E ci è chi vuole vi stiate dentro p[er]chè ne trae. Io me lo tengho a me, a boccha ve 'l dirò; a me non date la cholpa.
Chon Bernardo sono stato e dettogli della porta del neciessario; dicie vole a ogni modo asettare voi. I chonci sono mezzi fatti i[n] modo venerdj o sabato gli troverete fatti.
Io vi mandai cholla lett[era] di Ierj quel marmo che Donatello mi diè, ed è di quello che va a ffare nelo schrittoio.
Arei fatto farvi le berrette rechasti da milano, se monna chontessina l' avessi trovate, a Ant(oni)o di tTaddeo, tinto in panno di ghrana p(er) mandarllo a Roma a' nostri p(er) l° chardinale.
Per parte di monna chontessina dite a sandro mandi delli ovo et de' pollastrj chè non cie n' è.
Altro. X[rist]o vi ghuardj.
Bisogna ci siate Inanzi domenicha a volere sodisfare p[er] la domenicha passata. E se ò ffare più l^a chosa che un' altra me lo mandate a dire. V[ost]ro s[er]vido[re],

Giovanni di lucha Rossi
i[n] firenze
Chosimo et M[adonn]a chontessina et chosimino et tutta altra brighata stanno bene.

[On the verso of the letter:]
Nobile uomo Giovanni di chosimo de medi[ci] a trebbio.

There is no evidence of the price normally paid for half-length Madonnas by Donatello, and the sum cited in this letter probably represents no more than the balance of a larger payment. The reliefs seem to have been consigned either to the chapel of the Villa Medici at Fiesole or to the nearby church of San Girolamo. The Villa Medici (for which see *Filarete's Treatise on Architecture*, ed. Spencer, New Haven, 1965, vol. 2, Bk. 25, f. 188v, and C. Bargellini and P. de la Ruffinière du Prey, "Sources for the Reconstruction of the Villa Medici, Fiesole," in *Burlington Magazine*, vol. 111, 1969, pp. 597–605) was in course of building in 1453.

8. There is no proof of Donatello's participation in the new Palazzo Medici in Florence before the commission for the *Judith* in the garden, which is datable on inferential grounds to about 1454–55. The roundels after the antique in the courtyard of the Palazzo Medici, which were long attributed to Donatello, seem, in fact, to have been carved in the shop of Michelozzo.

9. Herzner, *Regesti*, no. 252.

10. The bibliography of Castagno is conspicuously weak, and at least one major work—the frescoed decoration that surrounded the *Virgin and Child with Two Saints* from the Contini-Bonacossi Bequest in the Palazzo Pitti, in the chapel of the Pazzi Castello di Trebbio at Santa

Brigida—remains unpublished. The best monograph is that of M. Horster, *Andrea del Castagno*, Oxford, 1980.

11. For the enameled terracotta reliefs of the Apostles in the Pazzi Chapel see Pope-Hennessy, *Luca della Robbia*, Oxford, 1980, pp. 236–38.

12. F. Albertini, *Memoriale di molte statue et picture sono nella inclyta Cipta di Florentia*, Florence, 1510.

13. *ROUNDELS WITH THE EVANGELISTS*. Pazzi Chapel, Santa Croce, Florence. Enameled terracotta, diameter of frames 170 cm (5 ft. 9 in.). An article by Janson ("The Pazzi Evangelists," in *Intuition und Kunstwissenschaft: Festschrift für Hanns Swarzenski*, Berlin, 1973, pp. 439–48) contains an interesting analysis of the epigraphy in the four volumes of Gospels held by the Evangelists. For the attribution to Donatello see Pope-Hennessy ("The Evangelists Roundels in the Pazzi Chapel," in *Apollo*, vol. 106, 1977, reprinted in *The Study and Criticism of Italian Sculpture*, New York, 1980, pp. 106–18). The postures of the four Evangelists were later (1491) imitated by Andrea della Robbia in Santa Maria delle Carceri at Prato, where the types are no longer Donatellesque, and the bold modeling is softened and trivialized.

14. *ST. MARY MAGDALEN*. Museo dell'Opera del Duomo, Florence. Polychrome poplar wood, H. 184 cm (72½ in.). As noted by Janson (pp. 190–91), the earliest reference to the *Magdalen* in the *Spogli Strozziani* on October 30, 1500, is published in the Frey edition of Vasari's *Vite* (Munich, 1911, p. 347); it reads: "The image of St. Mary Magdalen that used to be in the Baptistry and was then removed and placed in the workshop, is being put back in the church." From the time of Albertini (1510), the statue is described as in the Baptistry. Vasari (1550; *Vite*, ed. cit., vol. 3, p. 206) notes its presence in the Baptistry ("Vedesi nel medesimo tempio, a dirimpetta a questá opera [the Coscia Monument] di mano di Donato una Santa Maria Maddalena di legno in penitenza, molto bella e molto ben fatta") and adds (1568) "essendo consumata dai digiuni e dall'astinenza, in tanto che pare in tutte le parti una perfezione di notomia benissima intesa per tutto." The figure stood against the southwest wall of the Baptistry till 1688, when it was stored. In 1735 it was replaced in the Baptistry in a niche in which it is shown in a photograph reproduced by Schubring (1910). In 1921 it was removed from the niche and placed on a new pedestal, on which it remained until the Baptistry was flooded in November 1966. On the altar on which it was set up in 1635 was the inscription

VOTIS PUBLICIS
S. MARIAE MAGDALENAE SIMULACRUM
INSIGNE DONATI OPUS
PRISTINO LOCO
ELEGANTIORIQUE REPOSITUM
ANNO MDCXXXV.

The halo made for the statue in 1500 is still visible in the photograph of 1910. The surface was much darkened and overpainted, and though a superficial effort to clean it seems to have been made in 1861, it was fully cleaned only after 1967. Settesoldi (*Donatello e l'Opera del Duomo di Firenze*, Florence, 1986, pp. 60–62) infers from the fact the back is fully carved that the statue may not originally have been destined for the Baptistry. This is unlikely.

15. For S. Antonino's dedication to the cult of St. Mary Magdalen see *Lettere di Sant'Antonio Arcivescovo di Firenze, preceduta della sua vita scritta da Vespasiano*, Florence, 1859, pp. 112–16, lettera ottava. Though the Magdalen had, for S. Antonio, lost her corporeal virginity, she reacquired mental virginity, and therefore her celestial crown, through penitence.

16. For these documents, discovered and admirably published by Hartt and Corti, see the texts printed in "New Documents Concerning Donatello, Luca and Andrea della Robbia, Desiderio, Mino, Uccello, Pollaiuolo Filippo Lippi, Baldovinetti and Others," in *Art Bulletin*, vol. 44, 1962, pp. 158–59, 165–66, nos. 20a, 20b. The passage in question reads: "MCCC-CLVI. Donatello di Nichola intagliatore de' dare adi 14 d'ottobre L. trenta due piccioli, per lui a Cristofano di Bartolomeo calderaio, porto contanti: sono per lib. 100 di rame rotto compero da lui . . . f. vii, s. xii, d. iiii." There follows an itemized list of payments by Donatello for the purchase of copper, bronze, iron, and coal evidently made in connection with the casting of bronze sculpture. One of the most interesting of the itemized entries involves the name of "Bartolomeo di Belano da Padova," who was evidently working with Donatello at this time. The concluding entry (20b) for an aggregate sum of one hundred florins reads: "Donatello di Nicholo intagliatore de' avere adi XIIII d'ottobre f. cento, per lui da Bartolomeo Serragli, posto debi dare i questo, C. 259 f. C." The document is summarized by Herzner (*Regesti*, no. 353), who notes that no individual payment was made directly to Donatello; the purchases included 965 *libbre* of bronze, to a total of f. 63, s. l, d. 6, 160 *libbre* of iron, and 60 *libbre* of wax. Further investigation by R. Bagemihl reveals no trace of the individual or institution on whose behalf the payment was made. The peculiarity of the account, however, and the intimacy between Serragli and Giovanni de' Medici (Hartt and Corti, op. cit., pp. 157–58) may indicate

that the account regarded work for the Medici.

17. A related payment for the purchase of bronze occurs in Siena in September 1457: "1457 di Settembre. Maestro Urbano di Pietro da Cortona die dare a di . . . di Settembre ducati vinticinque che per noi de' Ghalgano di Jachomo Bichi, banchiere; ebe per comprare matalo per fare mezza fighura di Guliatte a Donatello in Firenze. E a di 28 di Settembre lire cinque sol. Quatordici dise pagho a Firenze per chabella d'una mezza fighura di Santo Giovanni, di mano di Donatello." The word "Guliatte" is amended by Herzner (*Regesti*, no. 355) to "Giuletta."

18. This notion appears to have arisen from a verbal suggestion by Clarence Kennedy reported by Janson (p. 203), who asks, "Could it have been destined for the Loggia di San Paolo, or perhaps the Fonte degli Ebrei?" The answer to both questions must be a decisive negative. The matter has since been pursued in a more systematic fashion by A. Natali ("Exemplum salutis publicae," in *Donatello e il restauro della Giuditta*, Florence, 1988, pp. 19–32). The strong case for rejecting the association of the Siena document with Donatello's *Judith* is reaffirmed by Herzner ("Die 'Judith' der Medici," in *Zeitschrift für Kunstgeschichte*, vol. 43, 1980, pp. 159–63). It is argued by Natali that the statue was destined for the Loggia della Mercanzia in Siena and, like the reliefs of Cardinal Virtues by Urbano da Cortona and of Roman heroes by Federighi on the benches of the Loggia, was political in inspiration.

19. *JUDITH*. Palazzo della Signoria, Florence. Bronze, parcel gilt, H. 236 cm, W. 185 cm (overall) (H. 93 in., W. 73 in.); H. of base 55 cm, W. of base 85.5 cm (H. 21⅝ in., W. 33⅝ in.); H. of base reliefs 43.5 cm, W. of base reliefs 57 cm (H. 17 in., W. 22½ in.). On the cushion is the inscription .OPVS.DONATELLI. FLO. The letters FLO are the sole basis for supposing that the statue was designed for some other center than Florence. Around the top of the pedestal are the words .EXEMPLVM.SAL.PVB. CIVES.POS .MCCC-CXCV. (recording the installation of the group after its transfer from the Palazzo Medici). The column originally carried two inscriptions transcribed in the text, p. 130. The source for the first of these inscriptions is Fontio, *Zibaldone*, Bibl. Riccardiana. Cod. Ricc. 907, f. 141 ff., in an annotation to a letter of condolence to Piero de' Medici on the death of his father in 1464 by Fra Francesco Micheli del Padovano (for this see Pratesi, in *Archivium Francescanum Historicum*, vol. 47, 1954, pp. 293–366; vol. 48, 1955, pp. 73–130) who may have been responsible for the original inscription. The second inscription is cited by Passerini (Agostino Ademollo, *Marietta*

de' Ricci, Florence, 1845, vol. 1, p. 758, no. 39) quoting "a small fifteenth century codex in my possession." This record (first noted by Kauffmann, pp. 171–72, 249) has been confirmed by Dr. Christine Sperling ("Donatello's Bronze 'David' and the Demands of Medici Politics,"*Burlington Magazine*, vol. 134, 1992, pp. 220–24 from a *zibaldone* of 1466–69 in the Bibl. Riccardiana, Ms. 60, f. 85r). The siting of the statue has been variously described as the garden of the Palazzo Medici and the Medici garden at San Marco. There can be no such uncertainty since the statue is described by Fontio as standing "in aula medicea." For the inscriptions see also Gombrich (in *Art Bulletin*, vol. 35, 1953, p. 83n). For the garden of the Palazzo Medici see *Il Palazzo Medici Riccardi di Firenze*, a cura di Giovanni Cherubini e Giovanni Fanelli, Florence, 1990, figs. 36–42. The presence of the garden is noted by Galeazzo Maria Sforza and Enea Silvio Piccolomini, but without reference to the fountain or to a statue. Examination of the interior of the group leaves no doubt that it was from the first planned as a fountain figure, and that water was extruded from the cushion onto a basin beneath. On its removal from the Palazzo Medici in 1495, the *Judith* became a symbolic statue set on a new base (which is still preserved) on the *ringhiera* of the Palazzo della Signoria (for this see K. Weil-Garris, "On Pedestals: Michelangelo's *David*, Bandinelli's *Hercules and Cacus* and the Sculpture for the Palazzo della Signoria," in *Römisches Jahrbuch für Kunstgeschichte*, vol. 20, 1983, pp. 378 ff.). In 1506 the *Judith* was moved to the westernmost bay of the Loggia dei Lanzi, where (Landucci, *Diario*, Florence, 1883, p. 117) the foundations were strengthened to support its weight. It was later transferred to the east end of the Loggia to make way for the *Rape of the Sabines* of Giovanni Bologna. Later it was placed on the *ringhiera* and was moved thence to the interior of the Palazzo Vecchio (1984).

20. The statue was removed for safe keeping during World War II and, between 1940 and 1946 (when it was reinstated in its position outside the Palazzo della Signoria), was cleaned superficially by Bearzi, whose report is printed in *Bollettino d'Arte*, vol. 16, 1950, pp. 119–23 (and in *Donatello e il Restauro della Giuditta*, Florence, 1988, pp. 64–70). According to this analysis, work started with a nude or almost nude female figure on which fabric was superimposed and covered with wax. A piece of the fabric is visible across the forehead. The legs and feet of Holofernes appear to be nature casts, made separately and inserted in the thighs. The statue is in eleven sections, the head and shoulders of Judith; her two arms to the ends of the sleeves; her right hand and the scimitar; her body from

the waist to the horizontal girdle on the level of Holofernes' head; her left hand, the body of Holofernes, and the cushion; the three faces of the base and the three balusters at its angles. There are large numbers of patched casting flaws. The recent cleaning, of 1984–88, has made the whole work sharper and more legible, but it has also revealed differences of color in the bronze, which were not evident in its precleaning state. A report on the bronze used (M. Leoni, "Considerazioni sulla fonderia d'arte ai tempi di Donatello. Aspetti tecnici del gruppo della Giuditta," in *Donatello e il Restauro della Giuditta*, pp. 55–63) concludes that "le indagini chimiche, strutturali e microanalitiche, hanno evidenziato una profonda differenza di composizio re dei bronzi utilizzati per la realizzazione dell'opera." This seems to have been due to two factors, first that Donatello, according to a specialist, Pomponius Gauricus, "nunquam fudit ipse, campanarium usus opera semper," and, second, that in bronzes cast sectionally the constituents of the bronze varied from one casting to another.

21. Vasari (1550; *Vite*, ed. cit., vol. 3, p. 209) was unaware of the provenance of the group from the Palazzo Medici:

> Fuse per la Signoria di quella città un getto di metallo che fu locato in piazza in uno arco della loggia loro, et e Giudit che a Oloferne taglia la testa, opera di grande eccellenzia e di magisterio; la quale a chi considera la semplicita del difuori nell'abito e nello aspetto di Giudit, manifestamente scuopre nel di dentro l'anima grande di quella donna e lo aiuto di Dio, si come nella aria di esso Oloferne il vino e il sonno e la morte nelle sue membra, che per avere perduti gli spiriti si dimostrano fredde e cascanti. Questa fu da Donato talmente condotta che il getto con sottilita e venuto e con pazienzia e con grandissimo amore, et appresso fu si rinetta che maraviglia grandissima e a vederla.

22. The three reliefs on the base are constructed with a central viewing point and afford our only evidence of the height at which the group was shown. The second and third reliefs clearly depend from drawings or models by Donatello, but the complicated *contrapposto* of the figures evident in the autograph relief seems to have presented difficulties to the artist or artists by whom they were modeled. This difference in quality is reflected also in the pilasters framing the scenes, each of which contains two small superimposed figures, those flanking the front relief being much superior to those at the sides. The prototype of the reliefs is a sarcophagus at Pisa (Bober and Rubinstein, *Renaissance Artists and Antique Sculpture*, London, 1986, fig. 53B). The figure of the child bending over the rim of the basin in the second relief corresponds in reverse with a drawing after a sarcophagus

made for Cassiano del Pozzo (op. cit., fig. 53A). I find no supporting evidence for Greenhalgh's suggestion that "the meanings of these bas reliefs are as convoluted and various as the possible meanings for the group above them." The mask in the center of the front relief contains the pipe through which water entered the fountain.

23. Milanesi, *Documenti per la storia dell'arte senese*, vol. 2, Siena, 1854, p. 297. The payment of 5 lire 14 soldi for a "mezza figura" of the Baptist was made on September 28, 1457. A month later, on October 24, the statue arrived in Siena in three sections, the head and upper part of the figure weighing 224 *libre*; the body, to the knees, weighing 221 *libre*; and the legs and base, weighing 143 *libre*. At the time of delivery the right arm was missing ("mancho uno braccio mancho").

24. *ST. JOHN THE BAPTIST*. Duomo, Siena. Bronze, H. 185 cm (73 in.). The statue is likely to have been commissioned for the Baptistry. Its front view is dominant, and it seems originally to have been intended to be shown in a tabernacle or against a wall. Since the right arm was missing, it was stored "nello ridotto di sotto della Residenzza dell'Opera," where it is recorded in an inventory of 1467, and was then transferred to the sacristy of the Cathedral, where it is listed in an inventory of 1482. On the construction of a new chapel dedicated to the Baptist, it was transferred to its present site. For the relevant documents see Carli, *Donatello a Siena*, Rome, 1967; Huse, "Beiträge zum Spätwerk Donatellos," in *Jahrbuch der Berliner Museen*, n.f. vol. 10, 1968, pp. 125ff.; and Herzner, "Donatello in Siena," in *Mitteilungen des Kunsthistorischen Institutes in Florenz*, vol. 15, 1971, pp. 161–86. The principal problem presented by the figure is its right arm. Opinion was long divided as to whether this was or was not original. The statue was shown at eye level in the exhibition *Donatello e i Suoi* in 1986 (no. 55), where it transpired beyond all reasonable doubt that the right arm, as Janson (pp. 196–97) observed, is not by Donatello. It is not, however, as Janson claimed, by Vecchietta. The first reference to the arm occurs in a document of 1474 published by Herzner (op. cit., p. 180, no. 10: "A di xxii di giugno dei a misser nostro operaio el braccio di bronzo de la figura di sto. Giovanni fe' Donatello"). The heavy, rather coarse chasing of the hair seems to indicate the intervention of Bellano, who was a member of Donatello's studio in Florence at the time.

25. See Herzner, *Regesti*, no. 353.

26. For these documents, which were first published by Milanesi, see Herzner, op. cit., p. 79, docs. 4, 5.

27. The relevant documents were first published by Gaye, *Carteggio*, Florence, 1839, pp. 120–21, and Milanesi, *Documenti per la storia dell'arte senese*, vol. 2, Siena, 1854, pp. 297ff. The documents relating to Donatello's arrival in Siena are printed by Carli, *Donatello a Siena*, Rome, 1967, p. 27. There is still some doubt as to whether Donatello's initial involvement was with the chapel of the Madonna delle Grazie or with that of St. Calixtus. It was concluded by Lusini (*Il Duomo di Siena*, vol. 2, Siena, 1939, pp. 123ff.) that the plan for the chapel of the Madonna delle Grazie underwent a fundamental change in September 1459 ("veduto che il disegno primo venne abbandonato e che i primitivi lavori vennero guastati").

28. In his *catasto* return for 1457 Donatello mistakenly declared his age as seventy-five.

29. Herzner, op. cit., p. 182, no. 18: "Et etiam deliberaverunt et diceverunt quod Donatello sculptori detur ad sculpendum et fabricandum statuam et figuram marmoream sancti Bernardini, non excedendo summam pretii dicte figure florenus sessaginta otto denariorum Senensium vel ad plus vantagium opere."

30. The documents relating to the bronze doors of the Cathedral are printed in extenso by Bacci (*La Porta di Bronzo che mena alla Cappella detta del Voto fondata da Papa Alessandro VII Chigi*, Siena, 1946, pp. 5–10) and by Herzner "Donatello in Siena," pp. 172–77, 180–83).

31. Donatello's first approach to Lodovico Gonzaga dates from June 5, 1458, and is reported in a letter from Gianfrancesco Suardi Capitaneus Senarum to Lodovico (Herzner, *Regesti*, no. 380). For the later correspondence see Herzner, *Regesti*, nos. 381, 382, 383, 385, 386, and 387.

32. Herzner, *Regesti*, no. 390.

33. Vasari, *Vite* (1568), ed. cit, vol. 3, pp. 216–17.

34. Vasari (1550), loc. cit. The earlier and more vivid account reads:

> Ritornando a Fiorenza e da Siena passando, tolse a fare una porta di bronzo per il batisterio di S. Giovanni. Et avendo fatto il modello di legno, e le forme di cera quasi tutte finite et a buon termine con la cappa condottele per gittarle, vi capitò Bernardetto di mona Papera orafo fiorentino, amico e domestico suo, il quale tornava da Roma et era persons molto intendente e di bonissimo ingegno in tale arte. Costui, poco amico de' Sanesi, vedendo preparata cosi bella opera ad onore di quella città, commossa da individia e malignità comminciò con molte ragioni a persuadere a Donato che non solamente e' non dovesse finire tale opera, ma guastare ancora tutto quello che aveva fatto; e non restando giorno ne notte da questa empia persuasione, lo condusse

pur finalmente dopo una lunghissima resistenzia a macchiare la chiarissima bontà sua con questo errore. Avendoli dunque già persuaso Bernardetto che il guastare le sole fatiche sue, non anchora messe in opera, non era uno ingiuriare i Sanesi ma solamente se stesso et in una cosa usitatissima, essendo lecito ad ogni artefice rimutare disegno e concetti, aspettarono un giorno di festa che i garzoni erano andati a spasso, e spezzarono tutte le forme, con grande dolore di Donato. E subitamente messasi la vi fra i piedi, se ne fuggirono a Fiorenza. . . . Di tutti questi disordini fu cagione la malignità di Bernardetto, che troppo gagliardamente operò nella semplicità di Donatello; il quale troppo più credendo allo amico che e'non doveva, tardi si accorse dello error suo.

35. Vasari, *Vite* (1550), ed. cit., vol. 3, pp. 220–21.

36. Vasari, *Vite* (1550), ed. cit., vol. 3, p. 229.

37. Vespasiano da Bisticci, *Vite di uomini illustri del secolo XV*, ed. Aulo Greco, Rome, 1930, pp. 193–94:

Di scultura egli n'era intendentissimo, et molto favoriva gli scultori e tutti gli artefici degni. Fu molto amico di Donatello e di tutti i pittori e scultori, e perche ne' tempi suoi quest 'arte degli scultori alquanto venne che'egli erano poco adoperanti, Cosimo, a fine che Donatello non si stesse li allogo certi pergami di bronzo per sancto Lorenzo, et fecegli fare certe porte che sono nell sagrestia, et ordino al banco, ogni settimana, che avessi una certa quantità di danari, tanto che bastassino a lui e a quattro garzoni che teneva, et a questo modo lo mantenne. Perche Donatello andava vestito come Cosimo arebbe voluto, Cosimo gli dono uno mantello rosato e un capuccio, a fecegli una cappa sotto il mantello, et vestito tucto di nuovo; e una mattina di festa gieli mando, a fine che li portasse. Portolli una volta o dua, di poi gli ripuose, e non gli volle portare più, perche dice che pareva essere dileggiato. Usava Cosimo di questa liberalità a uomini che avessino qualche virtù, perche gli amava assai.

38. Vasari, *Vite* (1550), ed. cit., vol. 3, p. 218: "Ordinò ancora i pergami di bronzo, dentrovi la Passion di Cristo, cosa che ha in sé disegno, forza, invenzione et abbondanza di figure e casamenti; i quali non potendo egli più per vecchiezza lavorare, finì Bertoldo suo creato, et a ultimo perfezzione li ridusse." Vasari uses the term *paraletico* to describe Donatello's condition in the last years of his life. The aid given him by the Medici seems to have represented living expenses only, and not to have reduced the substantial indebtedness of his estate. At his death he owed forty years' rent to the hospital of Santa Maria Nuova.

39. Vasari, *Vite* (1550), ed. cit., vol. 3, p. 226: "Rimase a Bertoldo suo creato ogni suo lavoro, massimamente i pergami di bronzo di San Lorenzo, che da lui furono poi rinetti la maggior parte e condotti a quel termine che è'si veggono in detta chiesa."

40. For the presumed participation of Bellano in the *Ascension* and *Pentecost* on the right pulpit see Semrau (loc. cit.) and F. Negri Arnoldi, "Bellano e Bertoldo nella bottega di Donatello," in *Studi in onore di Luigi Grassi: Prospettiva*, vols. 33–36, 1983–84, pp. 93–101.

41. Semrau's measurements for the Pulpits, which are repeated by Janson (p. 209), show, for the left-hand pulpit, a height of 137 cm (54 in.) and a length of 280 cm (110¼ in.). The corresponding figures for the right-hand pulpit are 123 cm (48½ in.) and 292 cm (115 in.). These figures exclude the columns on which the bronze superstructure is supported (right pulpit, H. 246 cm [97 in.]; left pulpit, 236 cm [93 in.]) and the marble slab on which the pulpits proper rest (H. 23 cm [9 in.]). The height of the pilasters separating the reliefs on the left pulpit is 89 cm (35 in.). Until the pulpits are dismantled and cleaned, it is impossible to make precise statements about their structure.

The four major contributions to study of the pulpits are those of Semrau, Lavin ("The Sources of Donatello's Pulpits in San Lorenzo," in *Art Bulletin*, vol. 41, 1959, pp. 19–38), Herzner ("Die Kanzeln Donatellos in San Lorenzo," in *Münchner Jahrbuch der Bildenden Kunst*, Dritte Folge, vol. 23, 1972, pp. 101–64), and Becherucci (*Donatello: i Pergami di San Lorenzo*, Florence, 1979). The article by Lavin is primarily iconographical. Herzner, on the other hand, introduces a number of new factors into the discussion, and Becherucci represents a far from unsuccessful attempt to apply to the whole problem criteria of credibility. The evidence for the commission is very sparse, and, from the standpoint of Donatello as a sculptor, the only valid starting point is to discuss the two pulpits not as coherent works of art but as two groups of narrative scenes, one, on the right-hand pulpit, running from the Marys at the Sepulchre to the Pentecost and the Martyrdom of St. Lawrence, and the other, on the left-hand pulpit, running from the Agony in the Garden to the Entombment. One of the few points on which we can be confident is that the post-Passion scenes on the right-hand pulpit precede the Passion scenes on the pulpit opposite. We can be certain of this, first, because the reliefs are finished, that is fully worked up, whereas the autograph scenes on the left pulpit are unfinished, and conform at many points to the description given in Vasari's *Ragionamenti* of Donatello presenting to Cosimo de' Medici, whose "anima e corpo" he was, "le cere da fare gittare di bronzo i pergami di San Lorenzo, ed il modello dell'altar maggiore con la sepoltura di Cosimo a' piedi." There is no means of establishing the nature of the work for which the reliefs on the right-hand pulpit were planned; the three scenes in the center, which are cast in one, would be admissible both in a tomb and altar. The recessive relief style employed in them is very different from the low reliefs in the pulpit opposite, but any judgment as to whether this represents a difference of date or was inherent in the function the two groups of scenes were intended to fulfill, is necessarily subjective. It has been suggested that the large-scale purchase of bronze by Donatello in 1456–57 was bound up with preparatory work on the pulpit reliefs as well as with the *Judith* and the *Baptist*, but this cannot be demonstrated, and the safest assumption is that work started on the post-Passion reliefs after Donatello's return from Siena. However close the imaginative links between Cosimo il Vecchio and Donatello, the style of the reliefs on the right-hand pulpit would have been unacceptable to the decorative, classicizing taste of Piero de' Medici, the dominant force in Medici commissions after about 1455, and work on the altar or tomb may have been suspended on that account. The Passion scenes, on the other hand, seem from the first to have been designed as pulpit reliefs. It should be emphasized that the task confronting Donatello in both cycles of reliefs had little in common with that presented by the Miracles of St. Anthony at Padua. At Padua his purpose was to transmute scenes from daily life into works of art. In San Lorenzo, in contrast, he invests the life of Christ with a new actuality. The reliefs aim to explore or reconstruct in imagination the psychological responses of the central figures and the secondary participants to the sufferings of the incarnate Christ.

A preliminary report on the condition of the bronze reliefs (Matteini and Moles, "Indagini scientifiche su tre opere di Donatello," in *Donatello-Studien*, 1989, pp. 126–29) shows that both sets of reliefs were covered with a form of oleaginous brown varnish. There are traces of gilding—with gold leaf, not mercury gilding—in the architectural background and in the halo of the Risen Christ, on the right-hand pulpit. The little gilding that has been recovered in test areas is coarsely executed and of uncertain date.

42. *MARYS AT THE SEPULCHRE*. The scene is described by Lavin as "a fanciful Renaissance crypt," and, more appropriately, by Greenhalgh (pp. 197–98) as related to the representation of the burial chamber on the Monza ampullae. The cursive dress of the angel with back turned suggests that use may have been made, here and elsewhere in the reliefs, of a Romanesque manuscript source. The relation of the Old Sacristy reliefs of the Evangelists to

Byzantine illumination may well have had a Western parallel in this and later scenes.

43. *CHRIST IN LIMBO; RESURRECTION; ASCENSION (or CHRIST APPEARING TO THE APOSTLES).* The three scenes are cast in one. Herzner (loc. cit.) plausibly relates the scene of *Christ in Limbo* to a miniature mosaic icon formerly in the Baptistry, now in the Museo dell'Opera del Duomo, which reached Florence in 1394 and which Donatello would certainly have known. For the scheme of the *Christ in Limbo*, Greenhalgh suggests a relationship to Byzantine depictions of the scene (see also K. Weitzmann, "Various Aspects of Byzantine Influences in the Latin Countries," in *Dumbarton Oaks Papers*, vol. 20, 1966, pp. 3ff.). The Christ in the *Resurrection* is connected by Lavin, certainly correctly, with a classical Meleager sarcophagus reproduced in a drawing in the Codex Coburgensis. There are extensive traces of gilding throughout these reliefs. The third relief bears traces of widespread studio intervention. The figure of Christ bent slightly forward with right hand raised, though elevated from the ground, suggests descent rather than Ascension. Since the cycle culminates in the Pentecost, the scene is concerned not with the ascension as an event, but with Christ's prediction in the Acts of the Apostles: "To whom he showed himself alive after his Passion. . . . And being assembled together with them, commended them that they should not depart from Jerusalem, but wait for the promise of the Father, which, saith he, you have heard of me. For John truly baptised with water, but ye shall be baptised with the Holy Ghost not many days hence."

44. *PENTECOST.* In design and imagery this is one of the most remarkable of the reliefs, and there can be no reasonable doubt that it was planned and modeled by Donatello. The chasing, on the other hand, is due to Bellano, and neither the inspired image of the Paraclete nor the symbols of the Apostles scattered on the ground register as they would have done if the chasing were wholly autograph.

45. *MARTYRDOM OF ST. LAWRENCE.* The scene is inscribed 1465 ADI 15 GUG (for this see Previtali, "Una data per il problema dei pulpiti di San Lorenzo," in *Paragone*, vol. 12, 1961, pp. 48–56). This must relate either to the modeling of the relief or to the date at which the wax model was cast. The second explanation is the more probable, since the structure of the scene—with the receding orthogonals of the ceiling, the strong horizontals of the back wall, the foreground, and the long fork held by the executioner—is developed from that of the Padua reliefs. The foreground figure on the right is not, as Janson supposes (p. 217), "a compan-

ion on the grill," but an executioner burned by the flames. At close quarters a burned patch in the leggings and the scorched knee beneath are clearly visible. The relief is given by Semrau to Bertoldo, but is manifestly the work of Donatello.

46. *LAMENTATION OVER THE DEAD CHRIST.* Spatially the most original of Donatello's pulpit reliefs. There is no precedent for the magnificent rendering of the three Crosses, or for the means by which the eye is led down by the diagonal ladder to the body of Christ, or for the way in which the horizontal central scene is suspended between vertical groups of standing figures at the sides. The roughly incised horsemen in the background indicate that the wax model was still unfinished at the time when it was cast, and since the central group is highly chased it is likely that Bertoldo worked on the chasing of the scene. If he did so, he found in the wax model no indication of the way in which the horsemen were to be integrated spatially. The standing figure of Nicodemus holding the nails may be a self-portrait.

47. *Crucifixion.* The scene is rightly given by Semrau to Bellano, whose presence is manifest not simply in the chasing, but through the entire design. The scene takes place in figure-constructed space, and the scale of the rear figures is arbitrary and empirical. It is conceivable that the three figures of St. Mary Magdalen, the Virgin, and St. John derive from drawings by Donatello, but the coarseness with which they are represented seems to preclude the possibility that they depend from Donatello models.

48. *Agony in the Garden.* The style is a crude paraphrase of Donatello's, and neither in design nor in execution is there anything to warrant an ascription to Donatello. The relief carries the hallmarks of Bellano's style and is likely to have been designed, modeled, and cast by Bellano, when, after Donatello's death, it was decided to complete the pulpit reliefs. It is given by Semrau to Bellano.

49. *CHRIST BEFORE PILATE AND CHRIST BEFORE CAIAPHAS.* The relief, like the *Lamentation over the Dead Christ*, seems to have been cast from a wax model by Donatello. Its status is clearly evident from the figures on the columns at the sides, where the roughly indicated model has not been finished off or modified, as well as by the figures in the gallery at the back. In the middle ground of the two main scenes Donatello's model must have been relatively highly finished, and its character is faithfully preserved. There is some studio intervention in the subsidiary foreground figures, for which Bellano or another assistant may have been responsible. The iconography of

the two judgment scenes is discussed in a remarkable article by S. Pfeiffenberger, "Notes on the Iconology of Donatello's Judgement of Pilate at San Lorenzo," in *Renaissance Quarterly*, vol. 20, 1967, pp. 437–54, where the bicephalous servant is explained as a symbol of Pilate's doublemindedness, as described in the apocryphal gospels of Peter and Nicodemus, and the central Longinus blinded by light is explained as a unique variant of a theme depicted on Early Christian sarcophagi, deriving from a common literary tradition. Dante, in the *De Monarchia*, stresses the need for Christ to be sentenced by a righteous judge with jurisdiction over all men. The contents of the library of Cosimo il Vecchio reveal an interest in apocryphal literature, and the depiction and meaning of the scenes is likely to have been discussed by Cosimo and Donatello.

50. *Entombment.* Like the *Agony in the Garden*, this scene appears to have been designed for the pulpit after Donatello's death. In its linear design, and in the elongation of the flattened figures it is a characteristic work of Bertoldo, who seems also to have been responsible for the standing figures against the pilasters at each side and for the frieze of putti and the decoration of the top section of the pulpit.

CONCLUSION

1. The date of Donatello's death is given by Matteo Palmieri, in *De Temporibus*, as 1468. The artist's death in 1466 is, however, confirmed by the *Libro de' Morti di Firenze* (for this see Vasari, *Vite*, ed. Milanesi, Florence, 1906, vol. 2, p. 421). Vasari adds the sentence: "e fu sotterrato nella chiesa di San Lorenzo vicino alla sepoltura di Cosimo, come egli stesso aveva ordinato, a cagione che cosi fusse vicino il corpo già morto, come vivo sempre gli era presso con l'animo." Manni, in his notes to Baldinucci, records as evidence of Donatello's wish to be buried in San Lorenzo a description by the Prior Piero Bonichi of places of burial in the crypt. The entry is contained in a manuscript volume in the Archivio del Capitolo di s. Lorenzo (22.4, c. 1). The schedule was begun in 1463, and the bulk of the notices date from the early 1470s. The relevant passage reads "A maestro Donato . . . nobilissimo sculptore, per commessione del magnifico Piero di Cosmo de' Medici. La prima del secondo filare di detta croce allato al predetto filare tra pilastro e pilastro che sostenghono le volte incominciando appie lo scaglione di sotto la cappella della Madonna, allato alla sagrestia de' Medici ch'entra nel cimitero che insino a hora sono sepulture . . . finite." The space was reallocated in 1557 to the Scalandroni.

2. Vasari, *Vite*, ed. cit., vol. 3, p. 222.

3. Vasari, ed. cit., vol. 3, pp. 56–57: "Morì Andrea l'anno 1528; et io, essendo ancor fanciullo, parlando con esso lui gli udii dire, anzi gloriarsi, d'essersi trovato a portar Donato alla sepoltura; e mi ricorda che quel buonvecchio di ciò ragionando n'aveva vanagloria."

4. *STEMMA OF THE MARTELLI FAMILY.* Palazzo Martelli, Florence. Pietra di macigno, painted and parcel gilt, H. 193 cm, W. 77 cm (H. 84½ in., W. 36 in.). The finest of all Florentine carved *stemmi*, the relief shows a male figure supporting, from a thong worn around the neck, a heavy shield with the arms of Martelli (a gryphon rampant). The shield (which is wrongly described by Bonsanti, in *Donatello e i suoi*, Florence, 1986, p. 143, as carved in red marble) is painted dull red; the gryphon is gilded. Both the red paint and the gilding date from 1802. The *stemma* was transferred in 1791 from its original site in the Palazzo Martelli on Via Larga to its present position in the interior of the Palazzo Martelli on Via Zanetti. The shield is likely originally to have been pigmented; the inside of the upper beak of the gryphon reveals slight indications of original red paint. Once widely accepted as a work of Donatello, its attribution has since been generally abandoned, and is supported only by Bennett and Wilkins (*Donatello*, Oxford, 1984, pp. 59–60: "the fluttering decorative ribbons favoured by Donatello suggest that it was designed, if not executed, by him") and by Bonsanti (loc. cit.). The head of the male supporting figure is closely related to those in the antependium relief by Desiderio in San Lorenzo. A pietra di macigno *stemma* of the Minerbetti family at Detroit was evidently made in the same shop. Both *stemmi* are closely related to a pietra di macigno chimneypiece by Desiderio in the Victoria and Albert Museum, London, which is datable to 1463. The marble *Baptist* by Desiderio in the Museo Nazionale, Florence, likewise originates from the Palazzo Martelli; and Desiderio seems also to have been responsible for the design and execution of the fictive basketwork sarcophagus of Niccolò and Fioretta Martelli in San Lorenzo, "reintroduced into Donatello's oeuvre" by Bennett and Wilkins (loc. cit.). As is shown by Civai ("Donatello e Roberto Martelli; nuove acquisizioni documentarie" in *Donatello-Studien*, Munich, 1989, p. 256), the sarcophagus was commissioned by Robert Martelli in 1463–64.

BIBLIOGRAPHY

Agosti, G., and V. Farinella, "Calore del marmo: Pratica e tipologia delle deduzioni iconografiche." In S. Settis, ed., *Biblioteca di storia dell'arte: Memoria dell'antico nell'arte italiana. I, L'uso dei classici*, pp. 373–444. Turin, 1984.

Alberti, L. B. *L'archittetura (De re aedificatoria)*, ed. G. Orlandi and P. Portoghesi. 2 vols. Milan, 1966.

——. *Opere volgari*, ed. C. Grayson. 3 vols. Bari, 1960–73.

——. *On Painting and Sculpture*, ed. and trans. C. Grayson. London, 1972.

Albertini, F. *Memoriale di molte statue . . . di Florentia . . .* [1510], ed. H. P. Horne. Florence, 1909.

Alpatov, M. V. *Chudožestvennye problemy ital'janskogo vozroždenija*. Moscow, 1976.

Ames-Lewis, F. "Art History or *Stilkritik*? Donatello's Bronze *David* Reconsidered." *Art History*, 2 (1979), pp. 139–55.

——. *Drawing in Early Renaissance Italy*. New Haven and London, 1981.

——. "A New Perspective on Early Renaissance Florentine Art?" [Review of M. Horster, *Andrea del Castagno*; R. W. Lightbown, *Donatello and Michelozzo*; J. Pope-Hennessy, *Luca della Robbia*; H. Wohl, *The Paintings of Domenico Veneziano*.] *Art History*, 4 (1981), pp. 339–44.

——. "Sources Ancient and Modern." [Review of M. Greenhalgh, *Donatello and His Sources*.] *Art Review Yearbook*, 1 (1982), p. 22.

——. *The Library and Manuscripts of Piero di Cosimo de'Medici* (Garland Series). New York and London, 1984.

——. "Donatello 1986: the Florence Exhibitions." *Renaissance Studies: Journal of the Society for Renaissance Studies*, 1 (1987), pp. 173–82.

——. "Donatello's Bronze *David* and the Palazzo Medici Courtyard." *Renaissance Studies*, 3 (1989), pp. 235–51.

Amsterdam, Rijksmuseum. *Meesters van het brons der Italiaanse Renaissance*. Exh. cat., intro. by J. Pope-Hennessy, 1961.

Androsov, S. O. "Zametki o poddelkah ital'janskoj renesančnoj skul'ptury." *Muzej: Chudožestvenye sobranija SSSR*, 2 (1981), pp. 23–30.

——. "Rel'jef masterskoj Donatello v Jerevane." *Muzej: Chudožestvenye sobranija SSSR*, 4 (1983), pp. 100–6.

——. "Master Renessana." *Chudožnik*, 10 (1986), pp. 44–49, 63.

Angiola, E. M. "The 'Gates of Paradise' and the Florentine Baptistry." *Art Bulletin*, 60 (1978), pp. 242–48.

Angelini, A. *Disegni italiani del tempo di Donatello*, intro. by L. Bellosi. Exh. cat. Florence, Gabinetto Disegni e Stampe degli Uffizi, 1986.

Antal, F. "The Maenad under the Cross." *Journal of the Warburg Institute*, 1 (1937–38), pp. 71–73.

Arcangeli, F. "Un nodo problematico nei rapporti fra Leon Battista Alberti e il Mantegna." In *Il Sant'Andrea di Mantova e Leon Battista Alberti*, pp. 189–203. Mantua, 1974.

Armstrong, L. *The Paintings and Drawings of Marco Zoppo* (Garland Series). New York and London, 1976.

Asai, T. "Sui problemi del rilievo schiacciato di Donatello." *Annuario: Istituto giapponese di cultura in Roma*, 12 (1974–75), pp. 21–33.

Avery, C. *Florentine Renaissance Sculpture*. London, 1970.

——. *Studies in European Sculpture*. London, 1981.

——. " 'La cera sempre aspetta': Wax Sketch Models for Sculpture." *Apollo*, 119 (1984), pp. 166–76.

——. "Donatello Celebrations. A Major Exhibition at Detroit, Fort Worth and Florence." *Apollo*, 123 (1986), pp. 14–18.

——. "Donatello's Madonnas Reconsidered." *Apollo*, 124 (1986), pp. 174–82.

——. "Donatello's Madonnas Revisited." In *Donatello-Studien*, pp. 219–34. Munich, 1989.

——. *Donatello, catalogo completo delle opere*. Florence, 1991.

Bacci, P. *La porta di bronzo che mena alla cappella detta Del Voto fondata da Papa Alessandro VII Chigi*. Siena, 1946.

Bagnoli, A. "Su alcune statue lignee della bottega di Jacopo." In *Jacopo della Quercia fra Gotico e Rinascimento*, pp. 151–54. Florence, 1977.

Balcarres, Lord. *Donatello*. London, 1903.

Baldini, U. "Il *Cristo* contadino di Donatello." *Michelangelo*, 3 (1974), pp. 20–23.

——. *Teoria del restauro e unità di metodologia*. 2 vols. Florence, 1978–81.

——. "Il crocefisso di Donatello." In U. Baldini and B. Nardini, eds., *Il complesso monumentale di Santa Croce*, pp. 263–64. Florence, 1983.

Baldini, U., and G. Galli. "Donatello: San Giorgio e la Principessa." In *Metodo e scienza, operatività e ricerca nel restauro*, pp. 124–26. Exh. cat. Florence, Palazzo Vecchio, 1982.

Baldini, U., and F. Kumar. "Donatello: Madonna dei Cordai." In *Metodo e scienza, operatività e ricerca nel restauro*, pp. 155–57. Exh. cat. Florence, Palazzo Vecchio, 1982.

Balogh, J. *Katalog der ausländischen Bildwerke des Museums der bildenen Künste in Budapest, IV–XVIII. Jahrundert*. 2 vols. Budapest, 1975.

Band, R. "Donatellos Altar im Santo." *Mitteilungen des Kunsthistorischen Institutes in Florenz*, 5 (1940), pp. 315–41.

Bandini, F., et al. "Donatello at Close Range: An Initial View of the Restoration of the Stuccoes in the Old Sacristy, S. Lorenzo, Florence." *Burlington Magazine*, 129 (1987), pp. 217ff. (numbered pp. 1–52).

Barasch, M. "Character and Physiognomy: Bocchi on Donatello's St. George: A Renaissance Text on Expression in Art." *Journal of the History of Ideas*, 36 (1975), pp. 413–30.

——. *Gestures of Despair in Medieval and Early Renaissance Art*. New York, 1976.

Bargellini, C., and P. de la Ruffinière du Prey. "Sources for the Reconstruction of the Villa Medici, Fiesole." *Burlington Magazine*, 111 (1969), pp. 597–605.

Bargellini, P., and E. Guarnieri. *Le strade di Firenze*. Vol. 3. Florence, 1977.

Baro, G. "Giotto and Donatello in their Times." *Art in America*, 54 (1966), pp. 100–101.

Barocchi, P. "Il valore dell'antico nella storiografia vasariana." In *Il mondo antico nel Rinascimento*, pp. 217–36. Florence, 1958.

————. *Donatello, Atys* (Lo specchio del Bargello, 22). Florence, 1986.

Barocchi, P., and G. Gaeta Bertelà. *Donatello, Niccolò da Uzzano* (Lo specchio del Bargello, 32). Florence, 1986.

Barolsky, P. *Infinite Jest: Wit and Humor in Italian Renaissance Art.* Columbia and London, 1978.

Battisti, E. *Filippo Brunelleschi.* Milan, 1976.

Bauch, K. *Das mittelalterliche Grabbild: Figürliche Grabmäler des 11. bis 15. Jahrunderts in Europa.* Berlin and New York, 1976.

Baxandall, M. "Bartholomeus Facius on Painting: a Fifteenth-Century Manuscript of the *De viris illustribus.*" *Journal of the Warburg and Courtauld Institutes*, 27 (1964), pp. 90–107.

————. "Alberti and Cristoforo Landino: the Practical Criticism of Painting." In *Atti del convegno internazionale indetto nel V centenario di Leon Battista Alberti*, pp. 143–54. Rome, 1974.

Bearzi, B. "La tecnica fusoria di Donatello." In *Donatello e il suo tempo*, pp. 97–105. Florence, 1968.

————. "Un itinerario tra i bronzi di Donatello." In *Atti del convegno sul restauro delle opere d'arte*, vol. I, pp. 95–100. Florence, 1981.

————. "Considerazioni di tecnica sul San Ludovico e la Giuditta di Donatello." In *Donatello e il Restauro della Giuditta*, pp. 64–70. Florence, 1988.

Becherucci, L. "Donatello e la pittura." In *Donatello e il suo tempo*, pp. 41–58. Florence, 1968.

————. *Donatello: I pergami di San Lorenzo.* Florence, 1979.

————. "Il San Lodovico e l'Annunciazione di Donatello." In U. Baldini and B. Nardini, eds., *Il complesso monumentale di Santa Croce*, pp. 267–70. Florence, 1983.

————. "Come era il San Lodovico di Tolosa?" In *Donatello-Studien*, pp. 183–85. Munich, 1989.

Becherucci, L., and G. Brunetti. *Il Museo dell'Opera del Duomo a Firenze.* 2 vols. Milan, 1969–70.

Beck, J. H. "Donatello's Black Madonna." *Mitteilungen des Kunsthistorischen Institutes in Florenz*, 14 (1969–70), pp. 456–60.

————. "Masaccio's Early Career as a Sculptor." *Art Bulletin*, 53 (1971), pp. 177–95.

————. "Ghiberti giovane e Donatello giovanissimo." In *Lorenzo Ghiberti nel suo tempo*, vol. I, pp. 111–34. Florence, 1980.

————. "Desiderio da Settignano (and Antonio del Pollaiuolo): Problems." *Mitteilungen des Kunsthistorischen Institutes in Florenz*, 28 (1984), pp. 203–24.

————. "Recent Donatello Exhibitions in Italy and the United States." *Source: Notes in the History of Art*, 5 (1986), no. 3, p. 207.

————. "Jacopo della Quercia and Donatello: Networking in the Quattrocento." *Source: Notes in the History of Art*, 6 (1987), no. 4, pp. 6–15.

Becker, M. B. *Florence in Transition: II. Studies in the Rise of the Territorial State.* Baltimore, 1968.

Bellini, F. "Da Federighi a Nanni di Bartolo? Riesame di un gruppo di terracotte fiorentine." In *Jacopo della Quercia fra Gotico e il Rinascimento*, pp. 180–88. Florence, 1977.

Bellosi, L. "Ipotesi sull'origine delle terracotte quattrocentesche." In *Jacopo della Quercia fra Gotico e il Rinascimento*, pp. 163–79 Florence, 1977.

————. "La rappresentazione dello spazio." In G. Previtali, ed., *Storia dell'Arte italiana*, prima parte, pp. 6–39, Turin, 1980.

————. "Donatello's Early Works in Terracotta." In *Italian Renaissance Sculpture in the Time of Donatello*, pp. 95–103. Exh. cat. The Detroit Institute of Arts, 1985.

————. "I problemi dell'attività giovanile." In *Donatello e i suoi: Scultura fiorentina del primo Rinascimento*, pp. 47–54. Exh. cat. Florence, Forte di Belvedere, 1986.

————. "Da una costola di Donatello: Nanni di Bartolo." *Prospettiva*, 53–6 (1988–89), pp. 200–13.

Bennett, B. A., and D. G. Wilkins. *Donatello.* Oxford, 1984.

Bergstein, M. "La vita civica di Nanni di Banco." *Rivista d'Arte*, 39 (1987), no. 3, pp. 55–82.

Berlin, Staatliche Museen. *Bildwerke der Christlichen Epochen von der Spätantike bis zum Klassizismus.* Cat., P. Metz, ed. Münster, 1966.

Bertaux, E. *Donatello.* Paris, 1910.

Berti, L. *Masaccio.* Milan, 1964 (English edition, University Park, 1967).

————. "Donatello e Masaccio." *Antichità viva*, 5 (1966), no. 3, pp. 3–12.

Bertoni, F. *Faenza: la città e l'architettura.* Faenza, 1978.

Bertoni, G., and P. Vicini. "Donatello a Modena." *Rassegna d'Arte*, 1905, pp. 69–72.

Beschi, L. "Le antichità di Lorenzo il Magnifico: caratteri e vicende." In *Gli Uffizi: Quattro secoli di una Galleria*, pp. 161–76. Florence, 1983.

Bettini, S. "Bartolomeo Bellano 'ineptus artifex'?" *Rivista d'Arte*, 13 (1931), pp. 45–108.

Bialostocki, J. "The Door of Death: Survival of a Classical Motif in Sepulcral Art." *Jahrbuch der Hamburger Kunstsammlungen*, 18 (1973), pp. 7–32.

Bisticci, V. da. *Vite di uomini illustri*, ed. P. D'Ancona and E. Aeschlimann. Milan, 1951.

Blume, D. "Antike und Christentum." In *Natur und Antike in der Renaissance*, pp. 84–129. Exh. cat. Frankfurt am Main, Liebighaus, 1985.

Blumenthal, G. "The Science of the Magi: the Old Sacristy of San Lorenzo and the Medici." *Source: Notes in the History of Art*, 6 (1986), no. 1, pp. 1–11.

Bober, P. Pray, and C. Vermeule. "European Art and the Classical Past." *Art Bulletin*, 49 (1967), pp. 75–77.

Bober, P. Pray, and R. Rubinstein. *Renaissance Artists and Antique Sculpture: A Handbook of Sources.* London and Oxford, 1986.

Bocchi, F. *Le Bellezze della Città di Firenze.* Florence, 1591.

————. *Le Bellezze della Città di Firenze*, ed. G. Cinelli. Florence, 1677.

————. "Eccellenza della statua di San Giorgio di Donatello." In P. Barocchi, ed., *Trattati d'arte del Cinquecento fra manierismo e controriforma*, vol. 3, pp. 125–94, 417–500. Bari, 1962.

Bode, W. von. *Denkmäler der Renaissance-Sculptur Toskanas.* 11 vols. Munich, 1892–1905.

———. *Florentiner Bildhauer der Renaissance.* Berlin, 1902.

———. *The Italian Bronze Statuettes of the Renaissance,* ed. J. D. Draper. New York, 1980.

Boeck, W. [Review of H. W. Janson, *The Sculpture of Donatello.*] *Zeitschrift für Kunstgeschichte,* 21 (1958), pp. 187–93.

Boito, C. *L'altare di Donatello e le altre opere nella Basilica Antoniana di Padova.* Milan, 1897.

Borsi, F. *Leon Battista Alberti.* Milan, 1975.

Borsook, E., and J. Offerhaus. "Storia e leggende nella Cappella Sassetti in Santa Trinita." In *Scritti di storia dell'arte in onore di Ugo Procacci,* vol. 1, pp. 289–310. Milan, 1977.

Boucher, B. "Detroit and Fort Worth: Sculpture in the Time of Donatello." *Burlington Magazine,* 128 (1986), pp. 67–68.

———. "The St. Jerome in Faenza: A Case for Restitution." In *Donatello-Studien,* pp. 186–93. Munich, 1989.

Bresciani Alvarez, G. "La basilica del Santo nei restauri e ampliamenti del Quattrocento al tardo Barocco." In G. Lorenzoni, ed., *L'edificio del Santo di Padova,* pp. 83–124. Vicenza, 1981.

Brunelleschi: *Brunelleschi scultore* (Mostra celebrativa nel sesto centenario della nascita), E. Micheletti and A. Paolucci, eds., Exh. cat. Florence, Museo Nazionale del Bargello, 1977.

Brunelleschi: *Filippo Brunelleschi, la sua opera e il suo tempo* (Convegno Internazionale di Studi, Florence, 1977), 2 vols. Florence, 1980.

Brunetti, G. "Su alcune sculture di Orsanmichele." In *Studien zur toskanischen Kunst: Festschrift für Ludwig Heydenreich,* pp. 29–36. Munich, 1964.

———. "Riadattamenti e spostamenti di statue fiorentine del primo Quattrocento." In *Donatello e il suo tempo,* pp. 272–82. Florence, 1968.

———. "Una testa di Donatello." *L'arte,* 5 (1969), pp. 80–93.

———. "Una vacchetta segnata A." In *Scritti di storia dell'arte in onore di Ugo Procacci,* vol. 1, pp. 228–35. Milan, 1977.

———. "Un'aggiunta all'iconografia brunelleschiana: ipotesi sul 'profeta imberbe' di Donatello." In *Filippo Brunelleschi, la sua opera e il suo tempo,* vol. 1, pp. 273–77. Florence, 1980.

Bruschi, A. "Note sulla formazione architettonica dell'Alberti." *Palladio,* 1 (1978), pp. 6–44.

Bucci, M. "Un Donatello inédit." *Vie des arts,* 27 (1982), no. 109, p. 66.

Buddensieg, T. "Donatellos Knabe mit dem Schlangen." In *Forma et Subitilitas: Festschrift für Wolfgang Schöne zum 75 Geburstag,* pp. 43–49. Berlin and New York, 1986.

Burckhardt, J. *Der Cicerone: eine Anleitung zum Genuss der Kunstwerke Italiens.* 2 vols. Leipzig, 1884.

Burns, H. "Quattrocento Architecture and the Antique: Some Problems." In R. R. Bolgar, ed., *Classical Influences on European Culture A.D. 500–1500,* pp. 269–87. Cambridge, 1971.

———. "Un disegno architettonico di Alberti e la questione del rapporto fra Brunelleschi ed Alberti." In *Filippo Brunelleschi: la sua opera e il suo tempo,* vol. 1, pp. 105–23. Florence, 1980.

Busignani, A. *Donatello: L'altare del Santo.* Florence, 1965.

Caplow, H. M. "Sculptors' Partnerships in Michelozzo's Florence." *Studies in the Renaissance,* 21 (1974), pp. 145–75.

———. *Michelozzo* (Garland Series). 2 vols. New York and London, 1977.

Caprara, O. *Il Crocifisso di Donatello dopo il restauro.* Florence, 1974.

Cardellini, I. *Desiderio da Settignano.* Milan, 1962.

Carl, D. "La casa vecchia dei Medici e il suo giardino," in *Il Palazzo Medici-Riaccardi,* ed. G. Cherubini and G. Fanelli, pp. 28–43. Florence, 1990.

Carli, E. *Scultura lignea italiana dal XII al XVI secolo.* Milan, 1961.

———. *Donatello a Siena.* Rome, 1967.

———. "Urbano da Cortona e Donatello a Siena." In *Donatello e il suo tempo,* pp. 155–61. Florence, 1968.

———. *Il Duomo di Siena.* Genoa, 1979.

———. "Un tondo di Urbano da Cortona." *Antologia di belle arti,* 21–22 (1984), pp. 11–14.

Carriveau, G. W., and V. S. Bortolot. "Thermoluminescence Dating Following X-ray Radiography." *Journal of the European Study Group on Physical, Chemical and Mathematical Techniques Applied to Archaeology,* 9 (1983), pp. 241–44.

Casanova, M. L. "Antonio di Padova. V. Iconografia." In *Biblioteca Sanctorum,* vol. 2, pp. 179–86. Rome, 1962.

Castelfranco, G. *Donatello.* Milan, 1963.

———. "Sui rapporti tra Brunelleschi e Donatello." *Arte antica e moderna,* 34–36 (1966), pp. 109–22.

Cessi, F. *Donatello a Padova.* Padua, 1967.

Chambers, D. S. *Patrons and Artists in the Italian Renaissance.* London, 1970.

Chastel, A. "Mesure et démesure de la sculpture florentine au XVᵉ siècle." *Critique,* 138 (1958), pp. 960–75; reprinted in *Fables, formes, figures,* vol. 2, pp. 17–31. Paris, 1978.

———. "Note sur le Sphinx à la Renaissance." In *Umanesimo e simbolismo,* pp. 179–82. Padua, 1958.

———. *Art e humanisme à Florence au temps de Laurent le Magnifique: Etudes sur la Renaissance et l'humanisme platonicien.* Paris, 1959.

———. "Le traité de Gauricus et la critique donatellienne." In *Donatello e il suo tempo,* pp. 291–305. Florence, 1968.

———. "Le principe de l'imitation à la Renaissance." *Revue de l'art,* 21 (1973), pp. 13–16; reprinted in *Fables, formes, figures,* vol. 2, pp. 559–69. Paris, 1978.

———. "Le arti nel Rinascimento." In *Il Rinascimento. Interpretazioni e problemi: Volume dedicato a Eugenio Garin nel suo settantesimo compleano,* pp. 273–322. Rome and Bari, 1979.

———. "Donatello tra Roma e Firenze." *Art dossier,* 3 (1986), pp. 4–5.

Chatelet, A. *Cents chefs-d'oeuvre du Musée de Lille.* Lille, 1970.

Cherubini, G., and G. Fanelli, eds. *Il Palazzo Medici Riccardi di Firenze.* Florence, 1990.

Chiarlo, C. R. " 'Gli fragmenti della sancta antiquitate': studi antiquari e produzione delle immagini da Ciriaco d'Ancona a Francesco Colonna." In S. Settis, ed., *Biblioteca di storia dell'arte: Memoria dell'antico nell'arte italiana. I. L'uso del classici,* pp. 269–97. Turin, 1984.

Ciardi Dupré dal Poggetto, M. G. "Una nuova proposta per il 'Niccolò da Uzzano." In *Donatello e il suo tempo,* pp. 283–89. Florence, 1968.

Civai, A. "Donatello e Roberto Martelli: nuove acquisizioni

documentarie." In *Donatello-Studien*, pp. 253–62. Munich, 1989.

Clark, K. [Review of H. W. Janson, *The Sculpture of Donatello.*] *Apollo*, 68 (1958), pp. 225–27.

———. "The Artist Grows Old." In *Moments of Vision*, pp. 160–80. London, 1981.

———. "Donatello and the Tragic Sense in the Quattrocento." In *The Art of Humanism*, pp. 10–42. London, 1983.

Clearfield, J. "The tomb of Cosimo de' Medici in San Lorenzo." *The Rutgers Art Review: The Journal of Graduate Research in Art History*, 2 (1981), pp. 13–30.

Colasanti, A. *Donatello*. Rome, [1927].

Cole, B. *Masaccio and the Art of Early Renaissance Florence*. Bloomington and London, 1980.

Collareta, M. "Considerazioni in margine al *De Statua* ed alla sua fortuna." *Annali della Scuola Normale Superiore di Pisa*, 12 (1982), no. 1, pp. 171–87.

———. *Donatello in Toscana: Itinerario*. Florence, 1985.

———. "Testimonianze letterarie su Donatello 1450–1600." In *Omaggio a Donatello, 1386–1986: Donatello e la storia del Museo*, pp. 7–47. Exh. cat. Florence, Museo Nazionale del Bargello, 1985.

Coolidge, J. "Observations on Donatello's *Madonna of the Clouds.*" In *Festschrift Klaus Lankheit*, pp. 130–31. Cologne, 1973.

Corti, G. and F. Hartt. "New Documents Concerning Donatello, Luca and Andrea della Robbia, Desiderio, Mino, Uccello, Pollaiuolo, Filippo Lippi, Baldovinetti and Others." *Art Bulletin*, 44 (1962), pp. 155–67.

Covi, D. A. "Lettering in Fifteenth-Century Painting." *Art Bulletin*, 45 (1963), pp. 1–18.

Crawford, D. A. *Donatello*. London, 1903.

Cropper, E. "Prolegomena to a New Interpretation of Bronzino's Florentine Portraits." In *Renaissance Studies in Honor of Craig Hugh Smyth*, vol. 2, pp. 149–61. Florence, 1985.

Czogalla, A. "David und Ganymedes. Beobachtungen und Fragen zu Donatellos Bronzeplastik 'David und Goliath.' " In *Festschrift für Georg Scheja zum 70. Geburstag*, pp. 119–27. Sigmaringen, 1975.

Dalli Regola, G. "David trionfante: una ipotesi e un disegno poco noto." *Antologia di belle arti*, 3 (1979), 9–12, pp. 32–42.

Dani, A. "Una restituzione a Niccolò Pizzolo scultore." *Arte Veneta*, 29 (1975), pp. 119–26.

Danilova, I. "Sull'interpretazione dell' architettura nei bassorilievi del Ghiberti e di Donatello." In *Lorenzo Ghiberti nel suo tempo*, vol. 2, pp. 18–23. Florence, 1980.

Danti, C. "Gli stucchi donatelliani nella Sacrestia Vecchia di San Lorenzo a Firenze." *Quaderni dell'Opificio delle pietre dure e laboratori di restauro di Firenze*, 1 (1986), pp. 18–23.

Degenhart, B., and A. Schmitt. "Gentile da Fabriano in Rom und die Anfänge des Antikenstudiums." *Münchner Jahrbuch der bildenden Kunst*, 11 (1960), pp. 59–151.

———. *Corpus der italienischen Zeichnungen 1300–1450, Teil I. Süd-und Mittelitalien*. 4 vols. Berlin, 1968.

Del Bravo, C. "Proposte e appunti per Nanni di Bartolo." *Paragone*, 12 (1961), 137, pp. 26–32.

———. *Scultura senese del Quattrocento*. Florence, 1970.

———. "Primo Quattrocento." *Artista: Critica dell'arte in Toscana*, 1990, pp. 152–63.

De Panizza Lorchi, M. "*Pulchra facies* and *simulacrum*: Reflections on Valla's Theory of Pleasure and Donatello's Art." *Source: Notes in the History of Art*, 5 (1983), no. 3, pp. 12–15.

Detroit, The Detroit Institute of Arts. *Catalogue of an Exhibition of Italian Gothic and Early Renaissance Sculpture*. Exh. cat. by W. R. Valentiner, 1938.

———. *Italian Renaissance Sculpture in the Time of Donatello*. Exh. cat. A. Darr, ed., 1985.

Di Stefano, R. "La chiesa di S. Angelo a Nilo e il seggio di Nido." *Napoli nobilissma*, 4 (1964), nos. 1–2, pp. 12–21.

Dixon, J. W. R. "The Drama of Donatello's David. Reexamination of an 'Enigma.' " *Gazette des Beaux-Arts*, 93 (1979), pp. 6–12.

Doebler, J. "Donatello's enigmatic *David*." *Journal of European Studies*, 1 (1971), pp. 337–40.

Dolcini, L., ed. *Donatello e il restauro della Giuditta*. Florence, 1988.

Donatello: *Donatello e il suo tempo*. (Atti dell'VIII convegno internazionale di studi sul Rinascimento, Florence-Padua, 1966). Florence, 1968.

Donatello: *Donatello-Studien* (Italienische Forschungen herausgegeben vom Kunsthistorischen Institut in Florenz. Dritte Folge, XVI), ed. M. Cämmerer. Munich, 1989.

Donato, M. M. "Hercules and David in the Early Decoration of the Palazzo Vecchio: Manuscript Evidence." *Journal of the Warburg and Courtauld Institutes*, 54 (1991), pp. 83–98.

Draper, J. D. "Winged Infant: a Fountain Figure." In *The Metropolitan Museum of Art, Notable Acquisitions 1983–1984*, pp. 26–27. New York, 1984.

———. *Bertoldo di Giovanni: Sculptor of the Medici Household*. Columbia and London, 1992.

———. "The Feast of Herod." In *Masterworks from the Musée des Beaux-Arts, Lille*, pp. 180–83. Exh. cat. New York, Metropolitan Museum of Art, 1992.

Dunkleman, M. L. "Donatello's Influence on Italian Renaissance Painting." Ph.D. diss., University of Michigan, 1978.

———. "Donatello's Influence on Mantegna's Early Narrative Scenes." *Art Bulletin*, 62 (1980), pp. 226–35.

Dussler, L. "Zum Corpus der italienischen Zeichnungen." [Review of B. Degenhart and A. Schmitt, *Corpus der italienischen Zeichnungen 1300–1450, Teil I.*] *Pantheon*, 27 (1969), pp. 491–93.

Edgerton, S. Y., Jr. "Alberti's Perspective: A New Discovery and a New Evaluation." *Art Bulletin*, 49 (1967), pp. 77–80.

———. *The Renaissance Discovery of Linear Perspective*. New York, 1975.

Eiam, C. "Lorenzo de' Medici's Sculpture Garden." *Mitteilungen des Kunsthistorschen Institutes in Florenz*, 36 (1992), pp. 41–83.

Erfa, H. M. von. "Judith-Virtus virtutum-Maria." *Mitteilungen des Kunsthistorischen Institutes in Florenz*, 14 (1969–70), pp. 460–65.

Esch, A., and D. Esch. "Die Grabplatte Martins V und andere Importstücke in den Römischen Zollregistern der Frührenaissance." *Römische Jahrbuch für Kunstgeschichte*, 17 (1978), pp. 209–17.

Evans, M. L. "Un motif italianisant dans le 'Boccace' de Munich

de Fouquet." *L'art*, 67 (1985), pp. 45–48.

Even, Y. "The Sacristy Portals: Cooperation at the Florentine Cathedral." *Sources: Notes in the History of Art*, 6 (1987), no. 3, pp. 7–13.

Fabriczy, C. von. "Uber die Statue des H1. Ludwig von Donatello." *Repertorium für Kunstwissenschaft*, 17 (1894), pp. 78–79.

————. "Donatellos H1. Ludwig und ein Tabernakel an Or San Michele." *Jahrbuch der königlich Preussischer Kunstsammlungen*, 21 (1900), pp. 242–46.

Facio, B. "Die Bildhauerfamile Ferrucci aus Fiesole." *Jahrbuch der Preussischen Kunstsammlungen*, XXIX (1908), pp. 1–28.

————. *De viris illustribus*, ed. L. Mehus. Florence, 1745.

Fehl, P. "On the Representation of Character in Renaissance Sculpture." *Journal of Aesthetics and Art Criticism*, 31 (1972–73), pp. 291–307.

Ferrara, M., and F. Quinterio. *Michelozzo di Bartolomeo*. Florence, 1984.

Fiocco, G. "Il museo immaginario di Francesco Squarcione." *Memorie dell'Accademia patavina di scienze, lettere ed arti*, 71 (1958–59), pp. 59–72.

————. "L'altare grande di Donatello al Santo." *Il Santo*, 1 (1961), pp. 21–36.

————. "La statua equestre del Gattamelata." *Il Santo*, 1 (1961), pp. 300–17.

————. *Donatello al Santo*. Padua, 1965.

————. "Donatello a Padova." *Fede e arte*, 14 (1966), pp. 272–89.

————. "Tracce di Donatello a Padova." In *Donatello e il suo tempo*, pp. 399–404. Florence, 1968.

————. "Tracce di Donatello a Padova." *Il Santo*, 10 (1970), pp. 161–65.

Florence, Casa Buonarotti. *Il giardino di San Marco: Maestri e compagni del giovane Michelangelo*. Exh. cat. P. Barocchi, ed., 1992.

Florence, Forte di Belvedere. *Donatello e i suoi*. Exh. cat. A Darr and G. Bonsanti, eds., 1986.

Florence, Istituto statale d'arte. *Donatello e il primo Rinascimento nei calchi della Gipsoteca*. Exh. cat. L. Bernardini et al., eds., 1985.

Florence, Museo Nazionale del Bargello. *Omaggio a Donatello, 1386–1986: Donatello e la storia del Museo*. Exh. cat. P. Barocchi et al., eds., 1985.

Florence, Palazzo Vecchio. *Capolavori e Restauri*. Exh. cat. by C. Sisi et al., 1986.

Florence, Palazzo Vecchio, Sala dei Gigli. *Donatello e il restauro della Giuditta*. Exh. cat. L. Dolcini, ed., 1988.

Florence, S. Lorenzo, Sagrestia Vecchia. *Donatello e la Sagrestia Vecchia di San Lorenzo*. Exh. cat. by C. Danti et al., 1986.

Follini, V., and M. Rastrelli. *Firenze antica e moderna illustrata*. 8 vols. Florence, 1789–1802.

Fontana, G. *Un'opera del Donatello esistente nella Chiesa dei Cavalieri di S. Stefano di Pisa*. Pisa, 1895.

Fossi Todorow, M. "Un taccuino di viaggi del Pisanello e della sua bottega." In *Scritti di storia dell'arte inonore di Mario Salmi*, vol. 2, pp. 133–61. Rome, 1962.

Foster, P. "Donatello Notices in Medici Letters." *Art Bulletin*, 62 (1980), pp. 147–50.

Franchi, R., et al. "Researches on the Deterioration of Stonework: VI. The Donatello Pulpit." *Studies in Conservation*, 23 (1978), pp. 23–37.

Frey, C., ed. *Il Codice Magliabechiano*. Berlin, 1892.

Friend, A. M. "The Portraits of the Evangelists in Greek and Latin Manuscripts." *Art Studies*, 5 (1927), pp. 115–47, and 7 (1929), pp. 3–29.

Frimmel, T., ed. *Der Anonimo Morelliano*. Vienna, 1888.

Fusco, L. "The Use of Sculptural Models by Painters in Fifteenth-Century Italy." *Art Bulletin*, 64 (1982), pp. 175–94.

Gaeta Bertelà, G. *Donatello*. Florence, 1973.

————. *Donatello, San Giorgio* (Lo specchio del Bargello, 25). Florence, 1986.

Gai, L. "Per la cronologia di Donatello: un documento inedito del 1401." *Mitteilungen des Kunsthistorischen Institutes in Florenz*, 18 (1974), pp. 355–57.

Gamba, F. "Il pulpito del Duomo di Prato." *Prato: Storia e arte*, 1 (1960), pp. 11–14.

Gamboso, V. "La 'Sancti Antonii confessoris de Padua Vita' di Sicco Polentone (c. 1435)." *Il Santo*, 1 (1961), pp. 199–283.

————. *La Basilica del Santo. Guida storico artistica*. Padua, 1966.

————. *Omaggio a Donatello*. Padua, [1966].

Gamboso, V., trans. and ed. *La vita del Santo raccontata dai contemporanei (Assidua-Rigaldina)*. Padua, 1982.

Garzelli, A. "Nuovi documenti figurativi quattrocenteschi per la ricostruzione degli apparati di arredo monumentale di Donatello." In *La scultura decorativa nel primo Rinascimento*, pp. 55–66. Rome, 1983.

Gasparotto, C. "Tito Livio in Donatello." *Atti e memorie dell'Accademia patavina di scienze ed arti*, 80 (1967–68), no. 3, pp. 125–38.

————. "Iconografia antoniana: i 'miracoli' dell'altare di Donatello." *Il Santo*, 8 (1968), pp. 79–91.

————. "Sant'Antonio nell'altare maggiore di Donatello al Santo di Padova." *Il Santo*, 15 (1975), pp. 339–44.

Gauricus, P. *Del scultura* (1504), ed. A. Chastel and R. Klein. Geneva and Paris, 1969.

Gavoty, F. "Gli angeli reggicandelabro del Museo Jacquemart-André." In *Donatello e il suo tempo*, pp. 353–59. Florence, 1968.

————. *Sculpture italienne. Musée Jacquemart-André*. Paris, 1975.

Gaye, G. *Carteggio inedito d'artisti del secoli XIV, XV, e XVI*. 3 vols. Florence, 1839–40.

Gelli, G. B. "Venti Vite d' Artisti," ed. G.G. Mancini. *Archivio storico italiano*, 17 (1896).

Gentilini, G. "Nella rinascita delle antichità." In *La civiltà del cotto: Arte della terracotta nell'area fiorentina dal XV al XX secolo*, pp. 67–88. (Exh. cat. Impruneta.) Florence, 1980.

————. *I cartoni di Agostino e Giovanni Lessi per le cantorie di Donatello e Luca della Robbia* (Lo specchio del Bargello, 28), Florence, 1984.

Ghiberti, L. *I commentarii*, ed. O. Morisani. Naples, 1947.

Ghiberti: *Lorenzo Ghiberti nel suo tempo*. (Atti del convegno internazionale di studi, Florence, 1978). 2 vols. Florence, 1980.

Gilbert, C. "The Archbishop on the Painters of Florence." *Art Bulletin*, 41 (1959), pp. 75–88.

Gill, S. J., J. *The Council of Florence*. Cambridge, 1959.

Gioseffi, D. *Perspectiva artificialis: Per la storia della prospettiva, spigolature e appunti.* Trieste, 1957.

Giusti, A. M., E. Tucciarelli, and A. Venticonti. "Note su un restauro in corso: il San Marco marmoreo di Donatello." *OPD restauro: Quaderni dell'Opificio delle pietre dure e laboratori di restauro di Firenze,* 1 (1986), pp. 87–90.

Giusti, A. M., and A. Venticonti. "Schede di restauro: Madonna con Bambino." *OPD restauro: Quaderni dell'Opificio delle pietre dure e laboratori di restauro di Firenze,* 1 (1986), pp. 87–90.

Giusti, A. M., et al. "Il sepolcro di Baldassare Cossa: il restauro dei marmi." *OPD restauro: Quaderni dell'Opificio delle pietre dure e laboratori di restauro di Firenze,* 2 (1987), pp. 94–98.

Gloria, A. *Donatello fiorentino e le sue opere mirabili nel tempio di S. Antonio di Padova.* Padua, 1895.

Gnoli, D. "Le opere di Donatello in Roma." *Archivio storico dell'arte,* 1 (1888), pp. 24–32.

Godby, M. "A Note on *schiacciato.*" *Art Bulletin,* 62 (1980), pp. 635–37.

Goldner, G. "The Tomb of Tommaso Mocenigo and the Date of Donatello's 'Zuccone' and of the Coscia Tomb." *Gazette des Beaux-Arts,* 83 (1974), pp. 187–92.

_____. *Niccolò and Piero Lamberti* (Garland Series). New York and London, 1978.

Goldthwaite, R. A. *The Building of Renaissance Florence: An Economic and Social History.* Baltimore and London, 1980.

Golfieri, E. *Pinacoteca di Faenza.* Faenza, 1964.

Gombrich, E. H. "The Early Medici as Patrons of Art." In *Norm and Form,* pp. 35–57. London, 1966.

_____. "The Leaven of Criticism in Renaissance Art: Texts and Episodes." In *The Heritage of Apelles,* pp. 111–31. Oxford, 1976.

Gonzati, B. *La Basilica di Sant'Antonio di Padova descritta ed illustrata.* Padua, 1854.

Gosebruch, M. "Varietà bei Leon Battista Alberti und der wissenschaftliche Renaissancebegriff." *Zeitschrift für Kunstgeschichte,* 20 (1957), pp. 229–38.

_____. *Donatello: Das Reiterdenkmal des Gattamelata.* Stuttgart, 1958.

_____. "Osservazioni sui pulpiti di San Lorenzo." In *Donatello e il suo tempo,* pp. 369–86. Florence, 1968.

Grabski, J. "L'Amor-Pantheos di Donatello." *Antologia di belle arti,* 3 (1979), pp. 23–26.

Grassi, L. *Tutta la Scultura di Donatello.* 2 vols. Milan, 1958.

_____. "Donatello nella critica di Giorgio Vasari." In *Donatello e il suo tempo,* pp. 59–68. Florence, 1968.

Greenhalgh, M. *Donatello and His Sources.* London, 1982.

Grohn, H. W. "Report on the Return of Works of Art from the Soviet Union to Germany." *Burlington Magazine,* 101 (1959), pp. 56–62.

Gurrieri, F. *Donatello e Michelozzo nel Pulpito di Prato.* Florence, 1970.

Haines, M. *La Sacrestia delle Messe del Duomo di Firenze.* Florence, 1983.

_____. "La colonna della *Dovizia* di Donatello." *Rivista d'Arte,* 1 (1984), pp. 347–59.

Hall, M. B. "The *tramezzo* in S. Croce, Florence and Domenico Veneziano's fresco." *Burlington Magazine,* 112 (1970), pp. 797–99.

_____. "The *tramezzo* in Santa Croce, Florence, Reconstructed." *Art Bulletin,* 56 (1974), pp. 325–41.

Hamme, N. S. "A Study of Donatello's Bronze David." *Apocrypha,* 3 (1978), pp. 27–34.

Hartt, F. "The Earliest Works of Andrea del Castagno I, II." *Art Bulletin,* 41 (1959), pp. 159–81, 225–36.

_____. "Art and Freedom in Quattrocento Florence." In *Essays in Memory of Karl Lehmann* (*Marsyas: Studies in the History of Art,* Supplement, I), pp. 114–31. New York, 1964.

_____. *Donatello: Prophet of Modern Vision.* New York, 1973.

_____. "Thoughts on the Statue and the Niche." In *Art Studies for an Editor: 25 Essays in Memory of Milton S. Fox,* pp. 99–116. New York, 1975.

Herzner, V. "Donatellos 'pala over Ancona' für den Hochaltar des Santo in Padua: Ein Rekonstruktionsversuch." *Zeitschrift für Kunstgeschichte,* 33 (1970), pp. 89–126.

_____. "Donatello in Siena." *Mitteilungen des Kunsthistorischen Institutes in Florenz,* 15 (1971), pp. 161–86.

_____. "Donatellos Madonna vom Paduaner Hochaltar—eine 'Schwarz Madonna'?" *Mitteilungen des Kunsthistorischen Institutes in Florenz,* 16 (1972), pp. 143–52.

_____. "Die Kanzeln Donatellos in San Lorenzo." *Münchner Jahrbuch der Bildenden Kunst,* 23 (1972), pp. 101–64.

_____. [Review of M. Wundram, *Donatello und Nanni di Banco,* 1969.] *Pantheon,* 30 (1972), pp. 82–84.

_____. "Donatello und Nanni di Banco: Die Prophetenfiguren für die Strebepfeiler des Florentiner Domes." *Mitteilungen des Kunsthistorischen Institutes in Florenz,* 17 (1973), pp. 1–28.

_____. "Bemerkungen zu Nanni di Banco und Donatello." *Wiener Jahrbuch für Kunstgeschichte,* 26 (1973), pp. 74–95.

_____. "Donatello und die Sakristei-Türen des Florentiner Domes." *Wiener Jahrbuch für Kunstgeschichte,* 29 (1976), pp. 53–64.

_____. "David Florentinus: I. Zum Marmordavid Donatellos im Bargello." *Jahrbuch der Berliner Museen,* 20 (1978), pp. 43–115.

_____. "Regesti donatelliani." *Rivista dell'Istituto Nazionale d'Archeologia e Storia dell'Arte,* 2 (1979), pp. 169–228.

_____. "Zwei Frühwerke Donatellos: Die 'Prophetenstatuetten' von der Porta des Campanile in Florenz." *Pantheon,* 37 (1979), pp. 27–36.

_____. "Die 'Judith' der Medici." *Zeitschrift für Kunstgeschichte,* 43 (1980), pp. 139–80.

_____. [Review of R. W. Lightbown, *Donatello and Michelozzo: An Artistic Partnership and its Patrons in the Early Renaissance.*] *Zeitschrift für Kunstgeschichte,* 44 (1981), pp. 300–13.

_____. "David Florentinus II. Der Bronze-David Donatellos im Bargello." *Jahrbuch der Berliner Museen,* 24 (1982), pp. 63–142.

_____. [Review of J. Pope-Hennessy, *The Study and Criticism of Italian Sculpture,* 1980.] *Pantheon,* 40 (1982), pp. 167–68.

_____. "Ein neues Donatello-Dokument aus dem Florentiner Domarchiv." *Zeitschrift für Kunstgeschichte,* 46 (1983), pp. 436–43.

_____. [Review of M. Greenhalgh, *Donatello and His Sources*, 1982.] *Pantheon*, 42 (1984), pp. 208–9.

Heydenreich, L. H. "Strukturprinzipien der Florentiner Frührenaissance-Architektur: 'Prospectiva aedificandi.' " In *Studies in Western Art: Acts of the Twentieth International Congress of the History of Art*, vol. 2, pp. 108–22. Princeton, 1963.

Horster, M. " 'Mantuae sanguis preciosus.' " *Wallraf-Richartz Jahrbuch*, 25 (1963), pp. 151–80.

_____. *Andrea del Castagno*. Oxford, 1980.

Huse, N. "Beiträge zum Spätwerk Donatellos." *Jahrbuch der Berliner Museen*, 10 (1968), pp. 125–50.

Hyman, I. "Notes and Speculations on S. Lorenzo, Palazzo Medici, and an Urban Project by Brunelleschi." *Journal of the Society of Architectural Historians*, 34 (1975), pp. 98–120.

_____. *Fifteenth-Century Florentine Studies: The Palazzo Medici and a Ledger for the Church of San Lorenzo* (Garland Series). New York and London, 1977.

_____. "Examining a Fifteenth-Century 'Tribute' to Florence." In *Art the Ape of Nature: Studies in Honor of H. W. Janson*, pp. 105–26. New York, 1981.

Impruneta. *La civiltà del cotto: Arte della terracotta nel'area fiorentina dal XV al XX secolo*. Exh. cat., 1980.

Jacopo della Quercia: Jacopo della Quercia fra Gotico e Rinascimento (Atti del convegno di studi, Siena, 1975). Florence, 1977.

Janson, H. W. *The Sculpture of Donatello, Incorporating the Notes and Photographs of the Late Jenö Lányi*. 2 vols. Princeton, 1957.

_____. *The Sculpture of Donatello*. 2nd ed., 1963.

_____. "Giovanni Chellini's 'Libro' and Donatello." In *Studien zur toskanischen Kunst: Festschrift für Ludwig Heinrich Heydenreich*, pp. 131–38. Munich, 1964.

_____. "Bardi, Donato, detto Donatello." In *Dizionario biografico degli Italiani*, vol. 4, pp. 287–96. Rome, 1964.

_____. "Donatello and the Antique." In *Donatello e il suo tempo*, pp. 77–96. Florence, 1968.

_____. [Review of M. Wundram, *Donatello und Nanni di Banco*, 1969.] *Art Bulletin*, 54 (1972), pp. 546–50.

_____. "The Pazzi Evangelists." In *Intuition und Kunstwissenschaft: Festschrift für Hanns Swarenski zum 70 Geburstag*, pp. 439–48. Berlin, 1973.

_____. *16 Studies*. New York, 1973.

_____. [Review of A. Rosenauer, *Studien zum frühen Donatello*. 1975.] *Art Bulletin*, 59 (1977), pp. 136–39.

_____. "La signification politique du David en bronze de Donatello." *Revue de l'art*, 39 (1978), pp. 33–38.

Joannides, P. "Masaccio, Masolino and 'Minor' Sculpture." *Paragone*, 38 (1987), no. 451, pp. 3–24.

Kauffmann, G. "Zu Donatellos Sängerkanzel." *Mitteilungen des Kunsthistorischen Institutes in Florenz*, 9 (1959–60), pp. 55–59.

Kauffmann, H. *Donatello: eine Einführung in sein Bilden und Denken*. Berlin, 1935.

Kemp, M. *The Science of Art*. New Haven and London, 1990.

Knabenhuse, P. D. "Ancient and Medieval Elements in Mantegna's Trial of St. James." *Art Bulletin*, 41 (1959), pp. 59–74.

Knuth, M. *Skulpturen der italienischen Frührenaissance. Staatliche Museen Berlin, Skulpturensammlung*. Berlin, 1982.

_____. "Die Berliner 'Maria mit dem Kinde im Mantel'—ein Frühwerk Donatellos." In *Forschungen und Berichte*, pp. 201–10. Berlin, 1990.

Komorowski, M. "Donatello's *St. George* in a Sixteenth-Century Commentary by Francesco Bocchi: Some Problems of the Renaissance Theory of Expression in Art." In *Ars auro pro: Studia Ioanni Biaostocki sexagenario dicta*, pp. 61–66. Warsaw, 1981.

Krahn, V. *Bartolomeo Bellano: Studien zur Paduaner Plastik des Quattrocento*. Munich, 1988.

Kratz, A. "An Examination of Donatello's Sculpture of St. Mark on the Church of Orsanmichele in Florence." In *I.I.C., Conference on Conservation of Stone and Wooden Objects*, pp. 77–83, New York, 1970.

Krautheimer, R. *Studies in Early Christian Medieval and Renaissance Art*. New York and London, 1969.

Krautheimer, R., in collaboration with T. Krautheimer-Hess. *Lorenzo Ghiberti*. 2 vols. 2nd ed. Princeton, 1970.

Kreytenberg, G. "Giovanni d'Ambrogio." *Jahrbuch der Berliner Museen*, 14 (1972), pp. 5–32.

_____. "Contributo all'opera di Jacopo di Pietro Guidi." *Prospettiva*, 16 (1979), pp. 34–44.

_____. "Perfetto di Giovanni e Albizzo di Piero: Sulla scultura tardogotica all'inizio del Quattrocento a Firenze." *Prospettiva*, 18 (1979), pp. 48–53.

_____. "Masaccio und die Skulptur Donatellos und Nanni di Bancos." In *Studien zu Renaissance und Barock: Manfred Wundram zum 60. Geburstag. Eine Festschrift*, pp. 11–19. Frankfurt am Main, Bern, and New York, 1986.

Kumar, F., and C. Sisi. "Un rilievo in stucco del Museo Bardini: la tecnica e il restauro." *OPD Restauro: Quaderni dell'Opificio delle pietre dure e laboratori di restauro di Firenze*, 1 (1986), pp. 10–17.

Langedijk, K. "Baccio Bandinelli's *Orpheus*: A Political Message." *Mitteilungen des Kunsthistorischen Institutes in Florenz*, 20 (1976), pp. 33–52.

Lányi, J. "Donatello's Angels for the Siena Font: A Reconstruction." *Burlington Magazine*, 85 (1939), pp. 142–47.

_____. "Problemi della Critica Donatelliana." *La Critica d'Arte*, 19 (1939), pp. 9–23.

_____. "Il Profeta Isaia di Nanni di Banco." *Rivista d'Arte*, 18 (1936), pp. 137–78.

_____. "Tre rilievi inediti di Donatello." *L'Arte*, 38 (1935), pp. 284–97.

_____. "Le statue quattrocentesche dei Profeti nel Campanile e nell'antica facciata di Santa Maria del Fiore." *Rivista d'Arte*, 17 (1935), pp. 121–59, 244–80.

_____. "Zur Pragmatik der Florentiner Quattrocentoplastik." *Kritische Berichte zur kunstgeschichtlichen Literatur*. 1932–33 (Leipzig, 1936), pp. 126–31.

Lavin, I. "The Sources of Donatello's Pulpits in San Lorenzo." *Art Bulletin*, 41 (1959), pp. 19–38.

_____. "Bozzetti and Modelli; Notes on Sculptural Procedure from the Early Renaissance through Bernini." In *Stil und Überlieferung in der Kunst des Abendlandes*, vol. 3, pp. 93–104. Berlin, 1967.

_____. "On the Sources and Meaning of the Renaissance Portrait Bust." *Art Quarterly*, 33 (1970), pp. 207–26.

Lawson, J. G. "New Documents on Donatello." *Mitteilungen des Kunsthistorischen Institutes in Florenz*, 18 (1974), pp. 357–62.

Leach, A. "Images of Political Triumph: Donatello's Iconography of Heroes." Ph.D. diss., University of Michigan, 1986.

Leoni, M. "Considerazioni sulla fonderia d'arte ai tempi di Donatello. Aspetti tecnici del gruppo della Giuditta." In *Donatello e il restauro della Giuditta*, pp. 54–57. Florence, 1988.

Liedtke, W. *The Royal Horse and Rider: Painting, Sculpture, and Horsemanship, 1500–1800*. New York, 1989.

Liess, R. "Beobachtungen an der Judith-Holofernes-Gruppe des Donatello." In *Argo: Festschrift für Kurt Badt zu seinem 80. Geburstag.* pp. 176–205. Cologne, 1970.

Lightbown, R. W. "Giovanni Chellini, Donatello, and Antonio Rossellino." *Burlington Magazine*, 104 (1962), pp. 102–4.

————. *Donatello and Michelozzo: An Artistic Partnership and Its Patrons in the Early Renaissance*. 2 vols. London, 1980.

————. *Mantegna*. Oxford, 1986.

Lisner, M. "Die Büste des heiligen Laurentius in der Alten Sakristei von S. Lorenzo: Ein Beitrag zu Desiderio da Settignano." *Zeitschrift für Kustgeschichte*, 12 (1958), pp. 51–70.

————. "Zur frühen Bildhauerarchitektur Donatellos." *Münchner Jahrbuch der bildenden Kunst*, 9–10 (1958–59), pp. 72–127.

————. "Gedanken vor frühen Standbildern des Donatello." In *Kunstgeschichtliche Studien für Kurt Bauch zum 70. Geburtstag von seinen Schülern*, pp. 77–92. Munich and Berlin, 1967.

————. "Intorno al Crocifisso di Donatello in Santa Croce." In *Donatello e il suo tempo*, pp. 115–29. Florence, 1968.

————. *Holzkruzifixe in Florenz und in der Toskana von der Zeit um 1300 bis zum frühen Cinquecento*. Munich, 1970.

————. "Josua and David. Nannis und Donatellos Statuen für den Tribuna-Zyklus des Florentiner Doms." *Pantheon*. 32 (1974), pp. 232–43.

————. "Appunti sui rilievi della Deposizione nel sepolcro e del Compianto su Cristo morto di Donatello." In *Scritti di storia dell'arte in onore di Ugo Procacci*, vol. 1, pp. 247–53. Milan, 1977.

Lloyd, C. "A Bronze Cupid in Oxford and Donatello's 'Atys-Amorino.'" *Storia dell'arte*, 1976, pp. 215–16.

Longhurst, M. H. *Notes on Italian Monuments of the 12th to the 16th Centuries*. 2 vols. London, 1962.

Lusini, V. *Il Duomo di Siena*. Vol. 2. Siena, 1939.

McHam, S. Blake. "Donatello's Tomb of Pope John XXIII." In R. Goffen, M. Tetel, and R. Witt, eds., *Life and Death in Fifteenth-Century Florence*, pp. 146–73, 232–42. Durham, North Carolina, 1989.

————. "Donatello and the High Altar in the Santo, Padua." In *IL60: Essays Honoring Irving Lavin on His Sixtieth Birthday.* pp. 75–89. New York, 1990.

————. "Donatello's High Altar in the Santo, Padua." *Andrea del Verrocchio and Late Quattrocento Sculpture: The Acts of Two International Symposia Commemorating the 500th Anniversary of his Death*, pp. 1–11. Florence, 1990.

Macchioni, S. "Il San Giorgio di Donatello: storia di un processo di musealizzazione." *Storia dell'arte*, 1979, pp. 135–56.

Manetti, A. *Vita di Brunelleschi*, ed. I. Toesca, Florence, 1927.

————. *The Life of Brunelleschi*, ed. H. Saalman. University Park and London, 1970.

Manicardi, A. "I trionfi modenesi dei Duchi d'Este (1452–1584)." *Atti e memorie della Deputazione di storia partria per le antiche province modenesi*, ser. XI, 6 (1984), pp. 105–39.

Marchini, G. "Di Maso di Bartolomeo e d'altri." *Commentari*, 3 (1952), pp. 108–27.

————. *Il pulpito donatelliano del Duomo di Prato*. Prato, 1966.

————. "Maso di Bartolommeo aiuto di Donatello.'" *Prato: Storia e arte*, 7 (1966), no. 17, pp. 7–29.

————. "Maso di Bartolommeo." In *Donatello e il suo tempo*, pp. 235–43. Florence, 1968.

————. "Calchi Donatelliani." In *Festschrift Klaus Lankheit*, pp. 132–34. Cologne, 1973.

————. "Le vetrate." *Antichità viva*, 26 (1987), no. 2, pp. 8–18.

Mariani, V. *Incontri con Roma nel Rinascimento. L. B. Alberti–Donatello–A. Mantegna–Raffaello*. Rome, 1960.

Marquand, A. "The Martelli David and the Youthful St. John the Baptist." *Art in America*, 4 (1916), pp. 358–66.

Martinelli, V. "Donatello e Michelozzo a Roma (I, II)." *Commentari*, fasc. 8 (1957), pp. 167–94; fasc. 9 (1958), pp. 3–24.

————. "La 'compagnia' di Donatello e di Michelozzo e la sepoltura del Brancacci a Napoli (I)." *Commentari*, 14 (1963), pp. 211–26.

————. "Il non-finito di Donatello." In *Donatello e il suo tempo*, pp. 179–94. Florence, 1968.

Martines, L. "La famiglia Martelli e un documento sulla vigilia del ritorno dall'esilio di Cosimo dei Medici." *Archivio storico italiano*, 117 (1959), pp. 29–43.

Matteini, M., and A. Moles. "Indagini scientifiche su tre opere di Donatello." In *Donatello-Studien*, pp. 126–29. Munich, 1989.

Mazzariol, G., and A. Dorigato. *Donatello: le sculture del Santo*. Padua, 1989.

Meiss, M. "Toward a More Comprehensive Renaissance Paleography." *Art Bulletin*, 42 (1960), pp. 97–112; reprinted in *The Painter's Choice*, pp. 151–75. New York, 1976.

Meller, P. "La Cappella Brancacci: Problemi ritrattistici ed iconografici." *Acropoli*, 1 (1960–61), fasc. 3, 4, pp. 186–227, 273–312.

————. "Physiognomical Theory in Renaissance Heroic Portraits." In *Studies in Western Art: Acts of the Twentieth International Congress of the History of Art*, vol. 2, pp. 53–69. Princeton, 1963.

Middledorf, U. [Review of H. Kauffmann, *Donatello*, 1935.] *Art Bulletin*, 18 (1936), pp. 570–85.

————. "Un rame inciso del Quattrocento." In *Scritti di storia dell'arte in onore di Mario Salmi*, vol. 2, pp. 273–89. Rome, 1962.

————. *Sculptures from the Samuel H. Kress Collection: European Schools XIV–XIX Century*. London, 1976.

————. "Some Florentine Painted Madonna Reliefs." In *Collaboration in Italian Renaissance Art*, pp. 77–90. New Haven and London, 1978.

————. *Raccolta di scritti (Collected Writings)*. 3 vols. Florence, 1979–81.

Milanesi, G. *Documenti per la storia dell'arte senese*. vol. 2. Siena, 1854.

Milanesi, G., ed. *XIV uomini singhulari in Firenze dal 1400 innanzi.* Florence, 1887.

Molho, A., "The Brancacci Chapel: Studies in its Iconography and History." *Journal of the Warburg and Courtauld Institutes*, 40 (1977), pp. 50–98.

Mori, M. "First Public Sculpture in Early Renaissance Florence. Donatello's Lost Dovizia." *Art History*, 6 (1984), pp. 39–71.

Morisani, O. *Studi su Donatello.* Venice, 1952.

————. "Per una rilettura del Monumento Brancacci a Napoli." *Napoli Nobilissima*, n.s. 4 (1964), pp. 3–11.

————. "Il monumento Brancacci nell' ambiente napoletano del Quattrocento." In *Donatello e il suo tempo*, pp. 207–13. Florence, 1968.

Morolli, G. "Le fasi di San Lorenzo." In F. Borsi et al., *Brunelleschi*, pp. 87–88. Rome, 1979.

————. *Donatello: Immagini di Architettura.* Florence, 1987.

————. "Donatello e Alberti 'amicissimi.'" In *Donatello-Studien*, pp. 43–67. Munich, 1989.

Morselli, P. "Il soffitto del pulpito di Donatello nel Duomo di Prato." *Prato: Storia e arte*, 27 (1968), 68, pp. 4–7.

Moskowitz, A. F. "Donatello's Reliquary Bust of Saint Rossore." *Art Bulletin*, 63 (1981), pp. 41–48.

Munman, R. "The Evangelists from the Cathedral of Florence: A Renaissance Arrangement Recovered." *Art Bulletin*, 62 (1980), pp. 207–17.

————. "Optical Corrections in the Sculpture of Donatello." In *Transactions of the American Philosophical Society*, vol. 75, part 2. Philadelphia, 1985.

Müntz, E. *Donatello.* Paris, 1887.

————. *Les collections des Médicis au XV siècle.* Paris, 1888.

Muraro, M. "Donatello e Squarcione. Proposta per un'esposizione sul Rinascimento a Padova." In *Donatello e il suo tempo*, pp. 387–97. Florence, 1968.

Murray, P. *An Index of Attributions Made in Tuscan Sources before Vasari.* Florence, 1959.

Natali, A. "Exemplum salutis publicae." In *Donatello e il restauro della Giuditta*, pp. 19–32. Florence, 1988.

Negri Arnoldi, F. "Bellano e Bertoldo nella bottega di Donatello." *Prospettiva*, 33–36 (1983–84), pp. 93–101.

Nicco Fasola, G. "Bassorilievi donatelleschi nel Museo Calvet." In *Studi in Onore di Matteo Marangoni*, pp. 176–81. Florence, 1957.

Nicholson, A. "Donatello: Six Portrait Statues." *Art in America*, 30 (1942), pp. 77–104.

————. [Review of H. W. Janson, *The Sculpture of Donatello*, 1957.] *Art Bulletin*, 41 (1959), pp. 203–13.

Northampton, Massachusetts, Smith College Museum of Art. *Renaissance Bronzes from American Collections.* Exh. cat., intro. by J. Pope-Hennessy, 1964.

Northampton, Massachusetts, Smith College Museum of Art. *Antiquity in the Renaissance.* Exh. cat. by W. Stedman Sheard, 1978.

Onians, J. "Brunelleschi: Humanist or Nationalist?" *Art History*, 5 (1982), pp. 259–72.

Paatz, W., and E. Paatz. *Die Kirchen von Florenz.* 6 vols. Frankfurt am Main, 1940–54.

Paccagnini, G. "Il Mantegna e la plastica dell'Italia Settentrionale." *Bolletino d'Arte*, 46 (1961), pp. 65–100.

Panofsky, E. *Renaissance and Renascenes in Western Art.* Stockholm, 1960.

————. *Tomb Sculpture. Four Lectures on Its Changing Aspects from Ancient Egypt to Bernini.* New York, 1964.

Paoletti, J. T. "The Bargello *David* and Public Sculpture in Fifteenth-Century Florence." In *Collaboration in Italian Renaissance Art*, pp. 99–111. New Haven and London, 1978.

————. *The Siena Baptistry Font: A Study of an Early Renaissance Collaborative Program, 1416–1434* (Garland Series). New York and London, 1979.

Paolozzi Strozzi, B. *Donatello. David* (Lo specchio del Bargello, 29). Florence, 1986.

Paolucci, A. *Donatello.* 2 vols. Milan, 1966.

Parronchi, A. "Sul 'Della statua' albertiano." *Paragone*, 10 (1959), 117, pp. 3–29.

————. "Il Crocifisso del Bosco." In *Scritti di storia dell'arte in onore di Mario Salmi*, vol. 2, pp. 233–62. Rome, 1962.

————. "Il soggiorno senese di Donatello del 1457–1461." In *Donatello e il suo tempo*, pp. 163–77. Florence, 1968.

————. *Donatello e il potere.* Bologna and Florence, 1980.

————. "Donatello in San Lorenzo: I tondi della Sagrestia Vecchia, le porte bronzee, i pulpiti, le decorazione." In U. Baldini and B. Nardini, eds., *Complesso monumentale di San Lorenzo*, pp. 80–119. Florence, 1984.

————. "Le statue per gli sproni." *Antichità viva*, 28 (1989), nos. 2–3, pp. 80–85.

Passavant, G. *Verrocchio.* London, 1969.

————. "Beobachtungen am Lavabo von San Lorenzo in Florenz." *Pantheon*, 39 (1981), pp. 33–50.

————. "Zu einigen Toskanischen Terrakotta-Madonnen der Frührenaissance." *Mitteilungen des Kunsthistorischen Institutes in Florenz*, 31 (1987), pp. 197–236.

Perina, C. "Scultura e arti minori." In *Mantova. Le arti. II. Dall'inizio del secolo XV all metà del XVI*, pp. 501–87. Mantua, 1961.

Pernis, M. G. "Greek Sources for Donatello's *Annunciation* in Santa Croce." *Source: Notes in the History of Art*, 5 (1986), no. 3, pp. 16–20.

Pfeiffenberger, S. "Notes on the Iconology of Donatello's Judgement of Pilate at San Lorenzo." *Renaissance Quarterly*, 20 (1967), pp. 437–54.

Pillsbury, E. P. "Vasari's Staircase in the Palazzo Vecchio." In *Collaboration in Italian Renaissance Art*, pp. 125–41. New Haven and London, 1978.

Pippal, M. "Zur Chronologie der ersten beiden Campanile-Propheten Donatellos." In L. O. Larsson and G. Pochat, eds., *Kunstgeschichtliche Studien zur Florentiner Renaissance*, vol. 1, pp. 52–61, 80–83. Stockholm, 1980.

Planiscig, L. *Piccoli bronzi del Rinascimento.* Milan, 1930.

————. *Donatello.* Florence, 1947.

Poeschke, J. [Review of M. Wundram, *Donatello und Nanni di Banco*, 1969.] *Kunstchronik*, 24 (1971), pp. 10–23.

————. [Review of A. Rosenauer, *Studien zum frühen Donatello*, 1975.] *Kunstchronik*, 30 (1977), pp. 340–45.

————. *Donatello: Figur und Quadro*. Munich, 1978.

————. *Die Skulptur der Renaissance in Italien: I. Donatello und seine Zeit*. Munich, 1990.

Poggi, G. *Il Duomo di Firenze: Documenti sulla decorazione della chiesa e del campanile tratti dall'Archivio dell'Opera*, ed. M. Haines. 2 vols. Florence, 1988.

Poggi, G., with L. Planiscig and B. Bearzi. *Donatello: San Lodovico*. New York (Wildenstein), 1949.

Pope-Hennessy, J. *Donatello's Relief of the Ascension with Christ Giving the Keys to St. Peter*. London, 1949; reprinted in *Essays on Italian Sculpture*, pp. 37–48. London, 1968.

————. "The Genius of Donatello." [Review of H. W. Janson, *The Sculpture of Donatello*, 1957.] *Times Literary Supplement*, September 5, 1958, pp. 489–90.

————. "Some Donatello Problems." In *Studies in the History of Art Dedicated to William E. Suida on His Eightieth Birthday*, pp. 47–65. London. 1959; reprinted in *Essays on Italian Sculpture*, pp. 47–64. London, 1968.

————. "The Martelli *David*." *Burlington Magazine*, 101 (1959), pp. 134–39; reprinted in *Essays on Italian Sculpture*, pp. 65–71. London, 1968.

————, with the assistance of R. W. Lightbown. *Catalogue of Italian Sculpture in the Victoria and Albert Museum*. 3 vols. London, 1964.

————. "The Italian Plaquette." *Proceedings of the British Academy*, 50 (1964), pp. 63–85; reprinted in *The Study and Criticism of Italian Sculpture*, pp. 192–222. New York and Princeton, 1980.

————. *Renaissance Bronzes from the Samuel H. Kress Collection*. London, 1965.

————. *The Portrait in the Renaissance*. New York, 1966.

————. "The Fifth Centenary of Donatello." In *Essays on Italian Sculpture*, pp. 22–36. London, 1968; Italian transl., *Donatello*, Florence, 1985; German trans., *Donatello*, Frankfurt am Main, 1986.

————. "Round and too Rosy." [Review of G. Castelfranco, *Donatello*, 1963.] *Times Literary Supplement*, January 27, 1966, p. 56.

————. "Sculptor Who Stands Alone in the Fifteenth Century." *The Times*, December 20, 1966, p. 12.

————. *Essays on Italian Sculpture*. London, 1968.

————. *Paolo Uccello*. 2nd ed. London and New York, 1969.

————. "Facets of Donatello." [Review of *Donatello e il suo tempo*, 1968.] *Times Literary Supplement*, May 8, 1969, p. 491.

————. "The 'Aemulus' of Donatello." [Review of G. Passavant, *Verrocchio*, 1969.] *Times Literary Supplement*. November 13, 1969, p. 1296.

————. "The Interaction of Painting and Sculpture in Florence in the Fifteenth Century." *Journal of the Royal Society of Arts*, 117 (1969), pp. 406–24.

————. "Shots of Donatello." [Review of F. Hartt, *Donatello: Prophet of Modern Vision*, 1973.] *New York Review of Books*, 20 (1974), January 24, pp. 7–9.

————. "The Forging of Italian Renaissance Sculpture." *Apollo*, 99 (1974), pp. 242–67; reprinted in *The Study and Criticism of Sculpture*, pp. 223–70. New York and Princeton, 1980.

————. "The Medici Crucifixion of Donatello." *Apollo*, 101 (1975), pp. 82–87; reprinted in *The Study and Criticism of Italian Sculpture*, pp. 119–28. New York and Princeton, 1980.

————. "The Madonna Reliefs of Donatello." *Apollo*, 103 (1976), pp. 172–91; reprinted in *The Study and Criticism of Italian Sculpture*, pp. 71–105. New York and Princeton, 1980.

————. "Donatello and the Bronze Statuette." *Apollo*, 105 (1977), pp. 30–33; reprinted in *The Study and Criticism of Italian Sculpture*, pp. 129–34. New York and Princeton, 1980.

————. "The Evangelists Roundels in the Pazzi Chapel." *Apollo*, 106 (1977), pp. 262–69; reprinted in *The Study and Criticism of Italian Sculpture*, pp. 106–118. New York and Princeton, 1980.

————. *Luca della Robbia*. Oxford, 1980.

————. "The Sixth Centenary of Ghiberti." In *The Study and Criticism of Italian Sculpture*, pp. 39–70. New York and Princeton, 1980.

————. *The Study and Criticism of Italian Sculpture*. New York and Princeton, 1980.

————. "A Terracotta Madonna by Donatello." *Burlington Magazine*, 125 (1983), pp. 83–85.

————. *Italian Gothic Sculpture: An Introduction to Italian Sculpture*. 3rd ed. New York and London, 1985.

————. *Italian High Renaissance and Baroque Sculpture: An Introduction to Italian Sculpture*. 3rd ed. New York and London, 1985.

————. *Italian Renaissance Sculpture: An Introduction to Italian Sculpture*. 3rd ed. New York and London, 1985.

————. "Donatello sconosciuto." *FMR*, 42 (1986), pp. 59–83.

Pozza, N. "Iconografia antoniana a Padova." In A. Poppi, ed., *Storia e cultura al Santo*, pp. 649–51. Vicenza, 1976.

Presicce, C. P. *Il Marco Aurelio in Campidoglio*. Milan, 1990.

Previtali, G. "Una data per il problema dei pulpiti di San Lorenzo." *Paragone*, 12 (1961), 133, pp. 48–56.

Prinz, W. "La seconda edizione del Vasari e la comparsa di 'vite' artistiche con ritratti." *Il Vasari*, 21 (1963), pp. 1–14.

————. *Vasaris Sammlung von Künstlerbildnissen*. Florence, 1966.

————. "L'autoritratto di Donatello." *Antichità viva*, 28 (1989), no. 4, pp. 36–39.

Procacci, U. "L'uso dei documenti negli studi di storia dell'arte e le vicende politiche ed economiche in Firenze nel loro rapporto con gli artisti." In *Donatello e il suo tempo*, pp. 11–39. Florence, 1968.

Puppi, L. "La basilica del Santo (con l'oratorio di S. Giorgio e la scoletta del Santo)." In C. Bellinati and L. Puppi, eds., *Padova: Basiliche e Chiese*. vol. 1, pp. 169–98. Vicenza, 1975.

Radcliffe, A., and C. Avery. "The 'Chellini Madonna' by Donatello." *Burlington Magazine*, 118 (1976), pp. 377–87.

Ragghianti, C. L. "La mostra di scultura italiana a Detroit (U.S.A.)." *Critica d'arte*, 3 (1938), pp. 170–83.

————. "Pluralità della prospettiva." *Critica d'arte*, 49 (1984), pp. 93–96.

Ramade, P. "Dessins de la Renaissance. Collection du Musée des Beaux-Arts de Rennes." *Bulletin des amis du Musée de Rennes*, 1 (1978), pp. 25–42.

Reid, J. D. "The True Judith." *Art Journal*, 28 (1969), pp. 376–87.

Richa, G. *Notizie istoriche delle chiese fiorentine*. 10 vols. Florence, 1754–62.

Richter, E. M. "Donatello's *Saint John the Baptist* in Siena." *Source: Notes in the History of Art*, 5 (1983), no. 3, pp. 21–26.

Rigoni, E. *L'arte rinascimentale in Padova: Studi e documenti*. Padua, 1970.

Roche-Pézard, F. "Travaux récents sur Donatello." [Review of *Donatello e il suo tempo*, 1968.] *Revue des études italiens*, 16 (1970), pp. 71–91.

Romanini, A. M. "Donatello e la 'prospettiva.'" *Commentari*, 17 (1966), pp. 290–323.

Rose, P. "Bears, Baldness, and the Double Spirit: The Identity of Donatello's *Zuccone*." *Art Bulletin*, 63 (1981), pp. 31–41.

Rosenberg, C. M. "Some New Documents Concerning Donatello's Unexecuted Monument to Borso d'Este in Modena." *Mitteilungen des Kunsthistorischen Institutes in Florenz*, 17 (1973), pp. 149–52.

Rosenauer, A. *Studien zum frühen Donatello*. Vienna, 1975.

————. "Donatellos Campanilefiguren in Rahmen seiner frühen Statuarik." In L. O. Larsson and G. Pochat, eds., *Kunstgeschichtliche Studien zur Florentiner Renaissance*, vol. 1, pp. 35–41, 78–79. Stockholm, 1980.

————. "Zum Geremia vom Florentiner Campanile." *Münchner Jahrbuch der bildenden Kunst*, 33 (1982), pp. 67–76.

————. [Review of Trudzinski, *Beobachtungen zu Donatellos Antikenrezeption*.] *Burlington Magazine*, 129 (1987), pp. 539–40.

————. "Zu Donatellos Putten im Musée Jacquemart-André." *Wiener Jahrbuch für Kunstgeschichte*, 40 (1987), pp. 295–301.

————. "Zum Stilpluralismus im Werk Donatellos." In *Donatello-Studien*, pp. 24–27. Munich, 1989.

Ruschi, P. "La Sagrestia Vecchia di San Lorenzo: Per un disegno delle vicende costruttive." In *Donatello e la Sagrestia Vecchia di San Lorenzo*, pp. 15–23. Exh. cat. Florence, 1986.

Saalman, H. "Filippo Brunelleschi: Capital Studies." *Art Bulletin*, 40 (1958), pp. 113–37.

Sachs, H. *Donatello*. Berlin (DDR), 1981.

Salmi, M. "Antico e nuovo in Donatello." In *Donatello e il suo tempo*, pp. 1–10. Florence, 1968.

Sanpaolesi, P. "Il pergamo di Prato." *Prato: Storia e arte*, 11 (1970), 29, pp. 5–56.

Sartori, A. "Documenti riguardanti Donatello e il suo altare di Padova." *Il Santo*, 1 (1961), 1, pp. 37–99.

————. "Ancora su Donatello e sul suo altare." *Il Santo*, 1 (1961), 3, pp. 337–44.

————. "Il cosidetto bastone di comando del Gattamelata." *Il Santo*, 1 (1961), 3, pp. 334–37.

————. "Il Donatelliano monumento equestre a Erasmo Gattamelata." *Il Santo*, 1 (1961), pp. 318–34.

————. "Il sagrato del Santo." *Il Santo*, 1 (1961), 3, pp. 345–76.

————. "Di nuova sulle opere donatelliane al Santo." *Il Santo*, 3 (1963), pp. 347–58.

————. *Documenti per la storia dell'arte a Padova*, C. Filarini, ed. (Fonti e studi per la storia del Santo a Padova, 3). Vicenza, 1976.

————. *Archivio Sartori, documenti di storia e arte francescana. I, Basilica e convento del Santo. II, La provincia del Santo*, 2 vols. *III,*

La evoluzione del Francescanesimo, 2 vols. *IV, Guida della Basilica*. Padua, 1983–89.

Scalia, F. "Stefano Bardini antiquario e collezionista." In F. Scalia and C. De Benedictis, *Il Museo Bardini a Firenze*, vol. 1, pp. 5–91. Milan, 1984.

Schlee, E. L. "Die Bekrönungszone des Silberaltars in Pistoia: Zur Florentiner Skulptur um 1400." In *Sitzungsberichte. Kunstgeschichte Gesellschaft zu Berlin*, pp. 8–12. Berlin, 1976–77.

Schlegel, U. "Observations on Masaccio's Trinity Fresco in Santa Maria Novella." *Art Bulletin*, 45 (1963), pp. 19–34.

————. "Zu Donatello und Desiderio da Settignano. Beobachtungen zur physiognomischen Gestaltung im Quattrocento." *Jahrbuch der Berliner Museen*, 9 (1967), pp. 135–55.

————. "Problemi intorno al David Martelli." In *Donatello e il suo tempo*, pp. 245–58. Florence, 1968.

————. "Dalla cerchia del Ghiberti. Rappresentazioni della Madonna di Nanni di Bartolo." *Antichità viva*, 18 (1979), pp. 21–26.

Schneider, L. "Donatello's Bronze David." *Art Bulletin*, 55 (1973), pp. 213–16.

————. "Some Neoplatonic Elements in Donatello's Gattemelata and Judith and Holofernes." *Gazette des Beaux-Arts*, 87 (1976), pp. 41–48.

————. "Donatello's Judith and Holofernes: A Further Dimension." *Gazette des Beaux-Arts*, 93 (1979), pp. 18–19.

————. "More on Donatello's Bronze David." *Gazette des Beaux-Arts*, 94 (1979), p. 48.

Schottmüller, F. *Donatello*. Munich, 1904.

————. "Zur Donatello Forschung." *Monatshefte für Kunstwissenschaft*, 2 (1909), pp. 38–45.

————. "Ein Jugendwerk Donatellos im Kaiser-Friedrich-Museum." *Zeitschrift für Kunstgeschichte*, 1 (1932), pp. 336–40.

Schröder, K. "Zur Chronologie von Donatellos Markus und den Propheten mit der erhobenen Hand." In L. O. Larsson and G. Pochat, eds., *Kunstgeschichtliche Studien zur Florentiner Renaissance*, vol. 1, pp. 42–51, 79–80. Stockholm, 1980.

Schroeteler, H. "Zur Rekonstruktion des Donatello-Altars im Santo zu Padua." *Il Santo*, 16 (1976), pp. 3–45.

Schubring, P. *Donatello*. Stuttgart and Leipzig, 1907.

Schulz, A. M. *The Sculpture of Bernardo Rossellino and His Workshop*. Princeton, 1977.

Schuyler, J. *Florentine Busts: Sculpted Portraiture in the Fifteenth Century* (Garland Series). New York and London, 1976.

————. "Death Masks in Quattrocento Florence." *Source: Notes in the History of Art*, 5 (1986), no. 4, pp. 1–6.

————. "Emperor John VIII Paleologus: Donatello's First Portrait Bust of a Living Person?" *Source: Notes in the History of Art*, 5 (1986), no. 3, pp. 27–32.

Semper, H. *Donatello, seine Zeit und Schule (Quellenschriften für Kunstgeschichte, IX)*. Vienna, 1875.

————. *Donatellos Leben und Werke*. Innsbruck, 1887.

Semrau, M. *Donatellos Kanzeln in San Lorenzo (Italienische Forschungen)*. Breslau, 1891.

Settesoldi, E. *Donatello e l'Opera del Duomo di Firenze*. Florence, 1986.

Seymour, C. "The Younger Masters of the First Campaign of the Porta della Mandorla, 1391–1397." *Art Bulletin*, 41 (1959), pp. 1–17.

————. *Sculpture in Italy 1400–1500.* Harmondsworth, 1966.

————. "Homo magnus et albus: The Quattrocento Background for Michelangelo's David of 1501–04." In *Stil und Überlieferung in der Kunst des Abendlandes: Akten des 21. internationalen Kongresses für Kunstgeschichte*, vol. 2, pp. 96–105. Berlin, 1967.

————. "Some Aspects of Donatello's Methods of Figure and Space Construction: Relationships with Alberti's *De statua* and *Della Pittura*." In *Donatello e il suo tempo*, pp. 195–206. Florence, 1968.

————. *Jacopo della Quercia, Sculptor.* New Haven and London, 1973.

Shapiro, M. L. "Donatello's *Genietto*." *Art Bulletin*, 45 (1963), pp. 135–42.

Shepherd, E. J. "L'antico e Donatello: Archelogia e sperimentazione tecnica." In *Donatello e la Sagrestia di San Lorenzo*, pp. 52–57. Exh. cat. Florence, 1986.

Simon, E. "Dionysischer Sarkophag in Princeton." *Mitteilungen des Deutschen Archäologischen Instituts: Römische Abteilung.* 69 (1962), pp. 136–58.

————. "Der sogenannte Atys-amorino des Donatello." In *Donatello e il suo tempo*, pp. 331–51. Florence, 1968.

Sisi, C., et al. "Schede di restauro. San Marco." in *Restauro di marmo: Opere e problemi, numero speciale del OPD restauro. Quaderni dell'Opificio delle pietre dure e laboratori di restauro di Firenze*, pp. 134–50. Florence, 1986.

Soranzo, G. "Due note intorno alla donatelliana statua equestre del Gattamelata." *Bolletino del Museo Civico di Padova*, 46–47 (1957–58), pp. 21–50.

Spencer, J. R. "Filarete's Bronze Doors at St. Peter's: A Cooperative Project with Complications of Chronology and Technique." In *Collaboration in Italian Renaissance Art*, pp. 33–57. New Haven and London, 1978.

Spencer, J. R., ed. *Filarete's Treatise on Architecture: Being the Treatise by Antonio Averlino known as Filarete.* 2 vols. New Haven, 1965.

Sperling, C. M. "Donatello's Bronze 'David' and the Demands of Medici Politics." *Burlington Magazine*, 134 (1992), pp. 220–24.

Spina Barelli, E. "Note iconografiche in margine alla Cantoria di Donatello." *Storia dell'arte*, 1972, pp. 283–91.

————. "Note iconografiche in margine al Davide in bronzo di Donatello." *Italian Studies*, 29 (1974), pp. 28–44.

————. "Donatello's Judith and Holofernes: An Extreme Moral Instance." *Gazette des Beaux-Arts*, 92 (1978), pp. 147–48.

Stang, R., and N. Stang. "Donatello e il Giosuè per il Campanile di S. Maria del Fiore alla luce dei documenti." *Acta ad archaeologiam et artium historian pertinentia Institutum Romanum Norvegiae*, 1 (1962), pp. 113–30.

Stokes, A. *The Quattrocento. A Different Conception of the Italian Renaissance: Florence and Verona: An Essay in Fifteenth Century Architecture and Sculpture.* London, 1932.

Strom, D. "A New Chronology for Donatello's Wooden Sculpture." *Pantheon*, 38 (1980), pp. 239–48.

Swarzenski. G. "Donatello's 'Madonna in the Clouds' and Fra Bartolommeo." *Bulletin of the Boston Museum of Fine Arts*, 40 (1942), pp. 64–77.

Tolnay, C. de. "Donatello e Michelangelo." In *Donatello e il suo tempo*, pp. 259–75. Florence, 1968.

Trachtenberg, M. "Donatello's First Work." In *Donatello e il suo tempo*, pp. 361–67. Florence, 1968.

————. "An Antique Model for Donatello's Marble *David*." *Art Bulletin*, 50 (1968), pp. 268–69.

————. *The Campanile of Florence Cathedral, 'Giotto's Tower.'* New York, 1971.

Trudzinski, M. *Beobachtungen zu Donatellos Antikenrezeption.* Berlin, 1986.

Valcanover, F. "Il San Giovanni Battista di Donatello ai Frari (con note technice sul restauro di Lorenzo Lazzarini)." *Quaderni della Soprintendenza ai Beni Artistici e Storici di Venezia*, 8 (1979), pp. 23–32.

Valentiner, W. R. "Donatello and Ghiberti." *Art Quarterly*, 3 (1940), pp. 182–215.

————. "Towards a Chronology of Donatello's Early Works." In *Festschrift für Friedrich Winkler*, pp. 71–83. Berlin, 1959.

Vasari, G. *Le vite de' più eccellenti pittori, scultori ed architettori*, ed. G. Milanesi. 9 vols. Florence, 1906.

————. *Le vite de' più eccellenti pittori scultori e architettori nelle redazioni del 1550 e 1568*, R. Bettarini and P. Barocchi, eds. 6 vols. Florence, 1966–87.

Verdon, T. "Donatello and the Theater: Stage Space and Projected Space in the San Lorenzo Pulpits." *Artibus et Historiae*, 7 (1986), 14, pp. 29–55.

Vertova, L. "La mano tesa, contributo alle ipotesi di ricostruzione dell'Altare di Donatello a Padova." In *Donatello-Studien*, pp. 209–18. Munich, 1989.

Wackernagel, M. *The World of the Florentine Renaissance Artist: Projects and Patrons: Workshop and Art Market.* Trans. by A. Luchs. Princeton, 1981.

Washington, D.C., The National Gallery of Art. *Circa 1492: Art in the Age of Exploration.* Exh. cat. J. Levenson, ed., with catalogue entries by M. Kemp et al. 1991.

Weihrauch, H. R. *Europäische Bronzestatuetten.* Brunswick, 1967.

Weil-Garris, K. "On Pedestals: Michelangelo's *David*, Bandinelli's *Hercules and Cacus* and the Sculpture for the Piazza della Signoria." *Römisches Jahrbuch für Kunstgeschichte*, 20 (1983), pp. 377–415.

Weiss, R. *The Renaissance Discovery of Classical Antiquity.* Oxford, 1969.

White, J. "Developments in Renaissance Perspective I." *Journal of the Warburg and Courtauld Institutes*, 12 (1949), pp. 58–79.

————. "Developments in Renaissance Perspective II." *Journal of the Warburg and Courtauld Institutes*, 14 (1951), pp. 42–69.

————. *The Birth and Rebirth of Pictorial Space.* London, 1957.

————. "Donatello's High Altar in the Santo at Padua. Part One: The Documents and Their Implications. Part Two: The Reconstruction." *Art Bulletin*, 51 (1969), pp. 1–14, 119–41, 412; reprinted in *Studies in Renaissance Art*, London, 1983.

————. *Studies in Renaissance Art.* London, 1983.

————. "Donatello." In G. Lorenzoni, ed., *Le Sculture del Santo*

di Padova (Fonti e studi per la storia del Santo a Padova, 4), pp. 31–94. Vicenza, 1984.

Wester, U., and E. Simon. "Die Reliefmedaillons im Hofe des Palazzo Medici zu Florenz." *Jahrbuch der Berliner Museen*, 7 (1965), pp. 15–91.

Wildmoser, R. "Das Bildnis des Ugolino Martelli von Agnolo Bronzino." *Jahrbuch der Berliner Museen*, 31 (1989), pp. 181–214.

Wilk, S. Blake. "La decorazione cinquescentesca della Cappella dell'Arca di S. Antonio." In G. Lorenzoni, ed., *Le sculture del Santo di Padova* (Fonti e studi per la storia del Santo a Padova, 4), pp. 109–71. Vicenza, 1984.

————. "Donatello's *Dovizia* as an Image of Florentine Political Propaganda." *Artibus et Historiae*, 7 (1986), 14, pp. 9–28.

Wilkins, D. G. "Donatello's Lost *Dovizia* for the Mercato Vecchio: Wealth and Charity as Florentine Civic Virtues." *Art Bulletin*, 65 (1983), pp. 401–23.

Wind, E. *Pagan Mysteries in the Renaissance*. London, 1958.

Wittkower, R., and M. Wittkower. *Born under Saturn: The Character and Conduct of Artists, a Documented History from Antiquity to the French Revolution*. London, 1963.

Wohl, H. *The Paintings of Domenico Veneziano, ca. 1410–1461*. Oxford, 1980.

————. [Review of *Donatello-Studien*, Munich, 1989.] *Art Bulletin*, 73 (1991), pp. 315–23.

————. "Two Cinquecento Puzzles." *Antichita Viva*, 30 (1991), pp. 42–48.

Wolters, W. "Freilegung der Signatur an Donatellos Johannesstatue in S. Maria dei Frari." *Kunstchronik*, 27 (1974), p. 83.

Wundram, M. "Donatello und Ciuffagni." *Zeitschrift für Kunstgeschichte*, 22 (1959), pp. 85–101.

————. *Donatello: Der heilige Georg*. Stuttgart, 1967.

————. "Donatello e Nanni di Banco negli anni 1408–1409." In *Donatello e il suo tempo*, pp. 69–76. Florence, 1968.

————. *Donatello und Nanni di Banco*. Berlin, 1969.

Zawrel, P. "Zuccone und Jeremias." In L. O. Larsson and G. Pochat, eds., *Kunstgeschichtliche Studien zur Florentiner Renaissance*, vol. 1, pp. 62–68, 83–84. Stockholm, 1980.

Zervas, D. F. "Ghiberti's *St. Matthew* Ensemble at Or San Michele: Symbolism in Proportion." *Art Bulletin*, 58 (1976), pp. 36–44.

————. *The Parte Guelfa, Brunelleschi and Donatello*. Locust Valley, New York, 1987.

Zervas, D., and M. Hirst. "Florence: The Donatello Year." *Burlington Magazine*, 129 (1987), pp. 207–10.

PHOTOGRAPHY CREDITS

The numbers below refer to figure numbers unless otherwise noted.

Alinari/Art Resource, New York: 9, 10, 19, 20, 53, 78, 79, 91, 107, 130, 140, 144, 175–84, 190, 191, 210, 211, 290, 291, 301, 310.

Archivio Fotografico Soprintendenza, Florence: 17, 34, 36, 44, 45, 47, 72, 81

Archivio Opificio delle Pietre Dure, Florence: 22, 23, 25–27, 66, 150, 153, 154, 156, 160, 164, 165, 171, 264, 265, 278–80, 282–86

Artini: 67–69, 73, 74, 133–36

Bazzechi: 103–6

Ditta G. Brogi di Laurati, Florence: 38, 89, 102, 109, 289

Cabinetto Fotografico Nazionale, Roma: 198, 200–202, 206, 207

Elio Ciol: 5, 6, 7, 12–15, 24, 40, 49–52, 55–57, 59–62, 92–99, 124, 125, 188, 189, 193–95, 197, 199, 203, 204, 212–19, 221–40, 243, 244, 247, 250, 276, 277, 296, 298–300, 302–4, 306, 308, 309, 311, 312

Davidoff Studios: 270

Detroit Institute of Arts/Founders Society: 251, 252

Editech, Florence: 126, 151, 152, 155, 157–59, 161–63, 166–72

Kunsthistorisches Institut, Florence: 82–88, 123, 131, 205, 287, 288

Francesco Lazzeri: 30, 31, 33, 35, 37, 138, 139, 141, 143

Ralph Lieberman: 21, 142

W. F. Mansell/Elfin Works: 293

Lorenzo de Masi: 196

Musée des Beaux-Arts, Lille: 118–22

Copyright © National Gallery of Art, Washington, D.C.: 255

Nimatallah/Art Resource, New York: 32

Takashi Okamura: 4, 8, 11, 18, 29, 43, 48, 54, 65, 100, 132, 137, 292, 295, 297

Liberto Perugi: p. 9, 241, 245, 246, 248, 249, 294, 305, 307, 313

Réunion des Musées Nationaux, Paris: frontispiece, 242, 263, 267

Scala/Art Resource, New York: 1, 2, 3, 16, 41, 58, 63, 64, 70, 71, 76, 77, 80, 101, 108, 116, 117, 145, 146, 148, 149, 173, 174, 253, 272–75, 281

Staatliche Museen, Berlin: 75, 90 (photograph by Jorg P. Anders)

Victoria and Albert Museum/Board of Trustees, London: 39, 111–14, 261